searches
·gland's
have

CE

WILLIAM CASLON
1693-1766

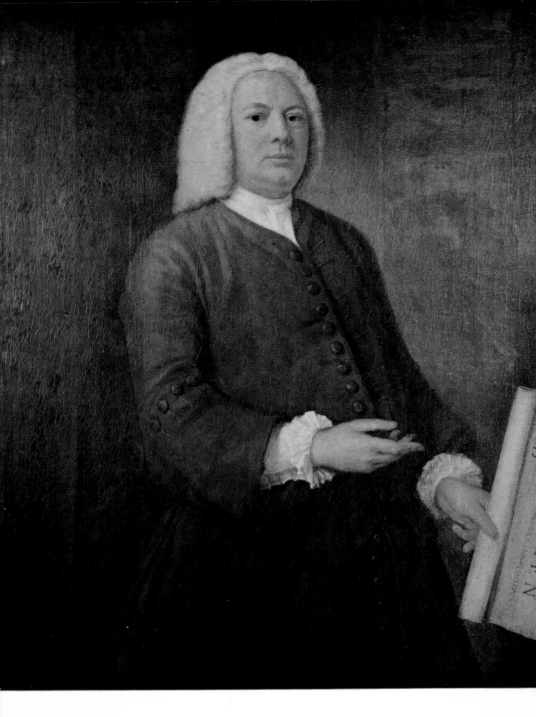

William Caslon I.
Colour plate reproduced from the painting by Francis Kyte, 1740,
now in the possession of The Monotype Corporation Limited.

WILLIAM CASLON
1693-1766

*The ancestry, life and connections of
England's foremost letter-engraver
and type-founder*

by

JOHNSON BALL

Ph.D., M.A., B.Sc. (Eng.), C.Eng., M.I.Mech.E., etc.,
*Principal of Halesowen Technical College,
Worcestershire, 1938-1952*

Kineton : The Roundwood Press
1973

First published 1973 by The Roundwood Press (Publishers) Limited,
Kineton, Warwick

The publication of this book has been assisted by the Marc Fitch Fund

Set in 'Monotype' Caslon series 128 and printed on English antique laid paper,
by Gordon Norwood, at The Roundwood Press Limited, Kineton, in the
County of Warwick, England

Made and printed in Great Britain

Contents

List of Illustrations

Figures in the Text

List of Pedigrees

Foreword

IT IS NOW twenty years since the author began collecting material bearing on the ancestry, life and connections of William Caslon. The subject was originally conceived as part of a long-term project relating to the history of Halesowen, Worcestershire, Caslon's birthplace, for which in 1957 the author was awarded a Leverhulme research grant. The research has been carried on against the exigent requirements of directing and teaching in an independent school and side by side with other historical and art interests.

In 1962 the subject was offered to and accepted by Sheffield University as a project suitable for a higher degree. It seemed appropriate that the research should be carried out in part under the aegis of the University at Sheffield, the city which houses Stephenson Blake & Co. Ltd., now the sole repository of the old English letter-founders, including H. W. Caslon Ltd., successors to the Caslon dynasty, who were absorbed in 1937. The Sheffield foundry then took the name of the Caslon Letter Foundry, thus perpetuating the most famous name in English letter-founding. The research has continued since the author's retirement from professional life in 1965.

The book which has grown out of this research incorporates a careful revision of what has been written previously together with new material gathered since the original thesis was presented. It is the first account of William Caslon's origins and ancestry ever published and the first attempt to present his life, associates and achievements in a book devoted solely to that object. The book has been created out of what was originally an unpromising subject, so sparse were the real facts then known about Caslon, and while future historians will doubtless add to the account set down herein, the author believes that his work will retain its definitive value for many years.

Introduction

IT IS a remarkable fact that in a rapidly changing world the *format* of the printed book, one of the most powerful factors in promoting a revolution in our environment by rendering the exchange of ideas and diffusion of knowledge almost infinitely fluid, has itself remained practically unchanged through five hundred years. Indeed, the printed word has become almost the only symbol of stability in the modern world, the only means by which bewildered mankind can preserve a sense of history and impart meaning and purpose to life. Seeing himself as the product of the past, it is the printed word that inspires man's imagination, fires his enthusiasm, and strengthens his determination to change his visions into reality. Yet it must be thought almost equally remarkable that only relatively few appear to have any well-defined ideas regarding the process of printing, the central operation of book production, whilst it is nothing less than paradoxical that many of those engaged in the craft which contributes most to man's knowledge of himself and his environment, his modes of expression and his multifarious interests and activities must also admit to so much ignorance and mystery concerning the progenitors and improvers of their own craft.

Coming directly to the subject of the present work, it is astonishing that so little truth has been recorded of the origins and early life of William Caslon, who has an undeniable eminence in a branch of the art of printing, 'the art preservative of all arts,' and who holds the well-deserved title of 'the foremost English typefounder.'

The bicentenary of Caslon's death was marked as recently

as 1966, so that a definitive life of one who was called 'the Elzevir of England' in his own life-time is long overdue. Many historians of printing have recorded his achievements as a letter-founder from the time his special talents made their mark on his contemporaries in the world of print and some of their commendations will be seen again in the course of this work. It is not the author's purpose here, however, to follow in the footsteps of the eighteenth-century antiquary and historian Edward Rowe Mores,[1] nor merely to record again what has been so ably done by the prince of letter-founder historians Talbot Baines Reed and his reviser A. F. Johnson,[2] nor by the American writer on typography D. B. Updike.[3]

Whilst these accounts are naturally used as sources of reference in the present work, the emphasis of these writers has been on Caslon's achievements as a letter-founder, whereas the author's principal aim has been to trace Caslon's ancestry, mark the arrival of his family in Halesowen, reveal his West Midlands connections and the facts of his early life, and explain the circumstances and influences which introduced him to fame. By adding to these a re-assessment of Caslon's work as an engraver of letter-punches, it is hoped that the scanty accounts which have come down to us are now satisfactorily enlarged.

Just as the success of a publisher is determined by the way he meets the need of his readers in the class of publication he undertakes, so it is the reader who ultimately determines in the long run the acceptability of a particular type-face. The fortune which John Baskerville amassed by his japanning business was almost dissipated by the reluctance of both publishers and the reading public to accept Baskerville's letters as a worth-while vogue for the trade. In the same way the lack of success of the brothers Fry to vend their Baskerville style letters compelled them to revert to a pattern styled on Caslon. Whatever judgments typographers make on the typefaces current in their own day they must all submit to the verdict of history and as to new assessments of the merits of the great punch-cutters of the past most will be shown by that same token to be mere ephemera.

The processes of printing and letter-founding as conducted in the printing-houses and type-foundries of the seventeenth and

eighteenth centuries, the period with which the author is here particularly concerned, are no longer cloaked in the 'art and mystery' of Caslon's own time. The author has not set out to produce a book for the typographical expert, but for a wider readership, bringing out sufficient of the social, art, and industrial history of the period to show Caslon clearly in the several environments in which he lived and worked and the fortuitous circumstances which operated to make him the man of the moment in English letter-founding.

The account of Caslon's ancestry and family history is entirely new, as are also the facts concerning his apprenticeship and career as a loriner. Much of the history of Caslon's native place, Halesowen, and its neighbourhood is the result of extensive new searches. Many extracts from parish registers and other sources occur throughout the text.

The discovery of Caslon's apprenticeship in the archives of the City Chamberlain in London Guildhall is quite new. Some account of the Worshipful Company of Loriners and of the Gunsmiths, as well as of the relations between the Birmingham and London gun trade helps to put Caslon's work in its proper setting. No known example of ornamental engraving on guns has been recognised as Caslon's work but the illustrations of such work given here show that they had distinct artistic merit. Although it cannot be said that the modern craftsman is beset by the same limitations which Caslon's contemporaries had to overcome, modern examples of decorative engraving nevertheless demand considerable skill.

A review of the printing and bookselling trades in the late seventeenth and early eighteenth centuries is an essential preliminary to the study of Caslon's achievements and since artists, engravers and writing-masters were closely concerned with these trades and contributed significantly both to meeting trade customs and stimulating public taste, some account is given of English art and its related practices as Caslon knew them in London. Fortunately, many of the personalia of the printing and bookselling trades has been preserved in the list of subscribers to the fund created to assist the elder William Bowyer when his house and business premises were destroyed by fire. This disaster

occurred in 1713, six months before Caslon completed his apprenticeship as a loriner.

One of the most important discoveries in Caslon's history identifies his master, Edward Cookes, a native of Stoke Prior, near Bromsgrove, and a citizen and freeman of London in the Company of Loriners, as an uncle of William Shenstone, the poet, letter-writer and landscape gardener of the Leasowes, Halesowen, whose will refers to the loriner's son as 'my Dear Cousin Edward Cooks of Edinburgh.' The discovery in the bishop's transcripts of Alvechurch of the marriage of the poet's grandfather William Shenstone to Elizabeth Pearman of Clent was the essential clue to the Halesowen connection between Edward Cookes the loriner and his apprentice William Caslon. Caslon's master had married Elizabeth Shenstone, the poet's aunt, Furthermore, it also becomes clear that Caslon's first marriage to Sarah Pearman, though it took place in London, came about through the Shenstone-Pearman relationship, for the bride was the daughter of Thomas Pearman, a butcher of Clent, whose wife was Mary Cookes, sister to Edward Cookes, Caslon's master. In short, Caslon married his master's niece.

Caslon's first important commission in letter-founding was for a fount of Arabic type for the S.P.C.K. of which society Dr. Thomas Bray was the virtual founder. Dr. Bray was the perpetual curate of St. Botolph's, Aldgate, the London parish where Caslon first came to notice, as well as rector of Sheldon in Warwickshire. This fact prompted investigation into connections between Halesowen and this part of Warwickshire, adding new knowledge of Bray to that contained in H. P. Thompson's biography, especially regarding Bray's early life and the marriage of Bray's daughter to the Rev. Jonathan Carpenter, one of a family prominent in Halesowen in the late seventeenth and early eighteenth centuries and, moreover, shown to be connected with the Caslons. When we find not only that Bray's curate was a native of Halesowen and married to his daughter, but that some time before, another native of Halesowen, Samuel Butler, was appointed master of the new school at Sheldon, the appointments can scarcely be regarded as merely coincidental in relation to Caslon's selection by the S.P.C.K.

Because Caslon's outstanding talents were first brought to notice under the patronage of the S.P.C.K., the work includes some account of the missionary enterprise of the period as carried on against the background of English trade abroad, the degree of reliability of contemporary accounts and illustration of foreign travel, and the standard of linguistic studies, particularly of Arabic, amongst merchants and scholars of the period.

From this point the book records Caslon's introduction to his life-work, his appearance before the S.P.C.K. Committees, his selection to cut the punches for the Arabic type and his relations with the printer Samuel Palmer and the Arabic scholar Salomon Negri.

It has been long known that Caslon's early patrons included William Bowyer the elder, printer and publisher, his step-son-in-law James Bettenham, and John Watts, who once employed Benjamin Franklin and had his printing office in Lincoln's Inn Fields. The story reveals for the first time, however, the fact that it was a far weightier influence, no less a person than Thomas Guy, the London bookseller and philanthropist, founder of Guy's Hospital, who actually recommended Caslon to the S.P.C.K. Committee as an engraver capable of cutting the punches for a fount of Arabic for the Psalter and New Testament. A further discovery of biographical interest is that Thomas Hollis, the first of the Hollises who became benefactors to Harvard, endowing the first two professorial chairs there, was a mutual acquaintance linking Henry Newman, the American secretary of the S.P.C.K., with Thomas Guy, William Bowyer, and William Caslon.

Then follows the account of Caslon's rapid rise to fame as England's foremost engraver of letter-punches and of his successive type-foundries culminating in the famous Chiswell Street foundry. The merits of all the letters displayed on the first specimen sheet issued by Caslon in 1734 are discussed, including not only the Latin typefaces, but the Hebrew, Greek and Exotic faces also. Tabular statements are included of the alphabets and other apparatus available in Caslon's foundry in 1734 and at the time of his death in 1766.

In view of Caslon's musical interests, a brief account is given of music printing by engraving and in type, with a more complete

and accurate documentation of the lives of Caslon and his son, as well as the evidence of Caslon's continuing connection with his native place.

While Caslon's remarkable skill became yoked to the cause of improving the debased typography of his country, some of his Halesowen relations achieved a minor fame in pictorial art. Although Caslon's male line failed in his great-great-grandson, there can be no doubt that the talent which appeared in him was carried down under other names, for besides the art of the brothers James, Amos and Benjamin Green and their later relations in Birmingham, the talent also appeared in the work of the brothers J. T. and A. Wilmore of Birmingham, engravers of the great school who worked from the drawings of J. M. W. Turner and there must be others whose lines of descent are lost.

Many historians of printing and letter-founding have wondered what influences deflected the attention of Edward Rowe Mores from the more usual antiquarian channels and inspired him to write the history of English letter-founders. The answer is to be found here in the connections between Mores and Caslon's artist-relations, the Green brothers of Halesowen. It can be said, too, that while John Baskerville's interest in letters had its roots in his earlier years as a writing master and a sculptor on slate headstones, we have it on his own confession that his practical interest in letter-founding and printing was inspired by Caslon's achievement, but Baskerville's interest was not translated into action until after Amos Green of Halesowen had been apprenticed to him.

Leaving contemporary testimonials to Caslon's merits to be reproduced later it will be appropriate here to consider the opinions of some later writers. For instance, Douglas McMurtrie in 1943[4] asked the question, 'What is the best type for all purposes which has been designed from the beginning of printing until the present day?' And answering his own query, he said, 'To this question there can be no uncertain answer. The type is that designed and cut by William Caslon. It can be used for years for all purposes without palling on the taste. One American printer, who was among the first to establish a reputation for fine and forceful composition in the field of commercial printing, had for

many years nothing in his cases but Caslon. And his work never lacked sparkle and spontaneity. The type is today, in spite of all the good faces now available, still the dependable standby of advertising typographers. Caslon is, too, as good a book type as has ever been produced. It is legible in the highest degree . . .'

McMurtrie, asking again for the reason for this undoubted supremacy, went on to say, 'I think the secret lies in the stress placed comparatively, in the mind of the designer, on legibility and beauty. When we seek legibility only, we obtain a readable type which is stupid and monotonous ; when we seek alone beauty of form, we obtain a type of great charm in individual letter forms but tiring in mass, because the element of design is too consciously apparent. In Caslon we have the product of a master designer who made drawing the servant of readability rather than its master.'

'Caslon's type could not be regarded as an entirely original creation on the part of its designer. It represented a synthesis of the best elements in the letter designs of the Dutch founders. But in adopting the best features of the Dutch types Caslon went further, putting into his design a spirit and virility that makes his types far greater than the models on which they were based. The reason for the difference is simple : William Caslon was a master of surpassing genius rather than a mere craftsman. *That genius has left an influence on typography which seems destined never to be effaced.*' (The author's italics).

T. B. Reed and A. F. Johnson, in their excellent account of the achievements of Caslon,[5] remind us that printing had reached a low ebb in England in the early years of the eighteenth century. They inform us that a glance through any of the common public prints of the day, such, for instance, as official broadsides, political pamphlets, works of literature, or even Bibles, points to a depression and degeneration so marked that one is tempted to believe that the art of Caxton and Pynson and Day was rapidly becoming lost in a wilderness of what a contemporary satirist terms

'Brown sheets and scurvy letter'

Few printers of the day were contributing anything towards the revival of good printing, or even towards the maintenance of such a standard as did exist. Scarcely a work with any pretension

to fine printing was the expression of honest English type.

The three best London letter foundries of the second half of the seventeenth century were that of Joseph Moxon; that of his successors, Robert and Silvester Andrews, one which was well furnished in roman, italic, and learned founts, as well as Anglo-Saxon and Irish characters; and the foundry of James and Thomas Grover, who possessed types which came from Day, Wynkyn de Worde, and others, and a remarkable Greek uncial fount later owned by the James foundry. But the types of most seventeenth century English books were Dutch. For this there were several reasons. One was the success of the Elzevirs, then the prominent publishers and printers of Europe, whose types were Dutch. Then, repeating D. B. Updike,[6] there was the influence of fashion, for 'the caprices of the Court have always been to some extent responsible for the evolution of taste,' and court taste was to some degree Dutch. Moreover, with the Revolution, English restrictions on the importation of types were removed, and the use of Dutch founts came about partly because, on account of previous hampering governmental regulations, there were not enough trained letter-cutters left in England to produce good types. That was the most potent reason of all for the general English use of the Dutch letter.

When Dr. Fell, Dean and later Bishop of Oxford, who did so much to build up the resources of the Oxford University Press, was negotiating about 1671 with Abraham, son of Christoffel van Dyck, the celebrated type-cutter, and Dirk Voskens for the purchase of Dutch type, he employed Dr. Thomas Marshall, afterwards Dean of Gloucester, to buy some of them. A phrase in one of Marshall's letters is prophetic. 'I se,' he says, 'in this Printing-designe, we English must learn to use oᵣ own hands at last to cut Letters as well as print wᵗʰ them. For yᵉ Founders here being reasonably furnished wᵗʰ Matrices from Franckfort, yᵉ old van Dijke, etc., have no regard to cutting & justifying, unles perhaps to supply a Defect, or two. So that some famous Cutters, they say, are gone, to other Countries for want of imployment. And now not one here to be found.'

At the beginning of the eighteenth century, the James foundry, which contained material produced by De Worde, Day,

the London Polyglot founders, Moxon, and many more, was procuring its types from Holland. Thomas James's purchases in 1710 from Athias, Voskens, Cupi, and Rolu emphasise, as T. B. Reed comments 'the intimate relations which existed at that period between English printers and Dutch founders.'7 He adds, 'There was probably more Dutch type in England between 1700 and 1720 than there was English. The Dutch artists appeared for the time to have the secret of the true shape of the Roman letter; their punches were more carefully finished, their matrices better justified, and their types of better metal, and better dressed, than any of which our country could boast.'

James Watson, who played no small part in making Edinburgh one of the most important centres of printing and publishing, issued in 1713 his *History of the Art of Printing*, containing specimens of the Dutch types used at his press. In his preface on the history of Scottish printing, the earliest treatise on the subject, he laments the decay of Scottish printing in his own day and confirms his reliance on Dutch workmen and presses. The Dutch, he says, the neatest printers in the world, allow their pressmen to work 8–9 hours a day 'lest by working much he work not well, but here and in England he that works Seventeen or Eighteen hours is reckon'd a choice Workman. For my part I'd rather give a Crown a day to a good Press-Man who brings reputation to his work and preserves my Letter, than Eighteen-pence to one who must certainly destroy it by careless and base working. And therefore I recommend it earnestly to you to get Home good Press-Men from Holland (as I have done with no small Charge) till we bring ourselves into a fair and comely Way of Working to the Press.'7

The rise of William Caslon, the greatest of English letter-founders, stopped the importation of Dutch types, and so changed the history of English type-cutting, that after his appearance the types used in England were most of them cut by Caslon himself, or else they were founts modelled on the style which he made popular. The types displayed in the specimen in Watson's *History of the Art of Printing* show what the Dutch types were, and Caslon's various specimens show the English style. These, with Baskerville's specimens are the chief sources for the

study of eighteenth century English type-forms.[9]

No doubt many contemporary typographers will consider the opinions of Reed, Updike and McMurtrie, dating from the late nineteenth and early twentieth centuries, as long out of date. Modern production methods have brought about great changes in the printing industry and have placed at the disposal of the printer and publisher a range of typefaces which in earlier times would never have secured a vogue, so great was the economic deterrent. Caslon's performance, however, was outstanding in his own day and when we in later times try to asses his achievements it is unhistorical to ignore the limitations in materials and mechanical aids with which he had to contend. Most typographers are concerned only with variants of the Latin typefaces. It might be pertinent to ask how many of the type designers of the last century and a half whose names survive in the specimen books of today have produced anything outside variants of the roman and italic? By comparison with these pygmies Caslon's range of founts cut by his own hand was astonishing. There is little relevance in looking at the eighteenth century type founder through the eyes of the typographic specialist of today unless that specialist has a respect for history and takes the trouble to seek out and accept the facts of history. The facts on which the present account is based have been gleaned from the times in which Caslon lived and they cancel the fables which the typographical 'experts' have accepted for two centuries.

It remains now for the writer to express his obligations to those who have assisted him in producing this work. Foremost among these is Mr R. E. F. Garrett, a Fellow and former Chairman of the Executive Committee of the Society of Genealogists whose many kind offices are too numerous adequately to acknowledge; it was due to his searching that Caslon was first identified as a loriner, a discovery that was followed by the names of his master, his master's master, and his two earliest apprentices, information which led to a train of interesting discoveries in London and the West Midlands. The records of the Worshipful Company of Loriners having been destroyed in the blitz, Mr Garrett, with the kind permission of Mr J. F. V. Woodman, Clerk of the City Chamberlain's Court at Guildhall, searched the records

of citizens granted their freedom by apprenticeship in the city companies, a search in which the Clerk of the Worshipful Company of Loriners, Denis J. Barlow, LL. B., also co-operated, with the happy results already noted. The writer also acknowledges the interest and help of Mr David J. Caslon, a great grandson of Thomas White Smith, who was manager of the Caslon Foundry (under Henry W. Caslon, the last of the Caslon line), becoming proprietor in 1895, whose sons took the name of Caslon by deed poll. Mr D. J. Caslon searched for early forms of the name in places outside the West Midlands, with the results shown in Chapter I. The late Mrs Nancie Burns, author of *Family Tree: An Adventure in Genealogy*, who was a fellow-worker and correspondent in local history for many years, by her work in London libraries, assisted in the earlier stages of the work. Mr A. E. Barker, Public Relations Officer and Archivist of the S.P.C.K., has kindly taken extracts from the minutes of the Society during the time Caslon was preparing his new fount of Arabic.

Thanks are due also to Miss Margaret Henderson and other staff of the County Records Office at Worcester who have been unfailingly helpful in searches in the county archives, to Mr Godfrey Thompson, Librarian at London Guildhall, and to the Keeper of the Department of Prints and Drawings at the Victoria and Albert Museum. The incumbents of several churches have also been most considerate in allowing searches to be made in their parish registers and in some instances allowing registers to be copied in their entirety. The staffs of the London Library, Birmingham Reference Library, and other public libraries have also always been helpful.

At a late stage in the writing of the work, an article by Mr James Mosley,[9] Librarian of the St. Bride Printing Library, was published in the *Journal of the Printing Historical Society*, No. 3, 1967, from which the author has allowed extracts to be made, including some additional details of Caslon's work for the Board of Ordnance, and the actual number of puncheons and matrices Caslon made for the fount of Arabic type. Mr H. L. Blackmore of the Tower Armouries also gave permission for material to be used from his book *British Military Firearms, 1650-1850*, and

supplied other information acknowledged where it occurs, while Mr Harry Carter and Mr Christopher Ricks allowed the use of extracts from the biographical introduction on Edward Rowe Mores prefixed to their 1961 edition of Mores' *magnum opus*, *A Dissertation upon English Typographical Founders and Founderies, 1778*.

Grateful acknowledgment is made to the Monotype Corporation Limited for permission to reproduce the frontispiece portrait of William Caslon and for supplying the photographic transparency of Francis Kyte's painting.

All the reproductions of title-pages in various styles and periods as well as the engraved views were taken from books in the author's collection, the photography being undertaken by Charles Male of Great Witley, Worcestershire.

The book specimens of printing types issued by Stephenson Blake & Co. Ltd. include a chart showing the descent of the present Caslon Letter Foundry from its predecessors and displaying in broad and comprehensive fashion the numerous mergers and successions which have occurred in English letter founding since the time of Caxton and Wynkyn de Worde. This is reproduced in Chart 11 by kind permission of Stephenson Blake & Co. Ltd., who also supplied the plate of William Caslon's surviving punches in canon roman size.

[1] A Dissertation upon English Typographical Founders and Founderies, 1778.
[2] A History of the Old English Letter Foundries, 1952.
[3] Printing Types, Their History, Forms and Use, Second Edition, 2 vols., 1937
[4] The Book—The Story of Printing and Bookmaking, O.U.P. 3rd Edition, 1943, pp. 576-8.
[5] P.229 et seq.
[6] Vol. II, p. 99.
[7] Reed-Johnson, pp. 206-210.
[8] Updike, Vol. II, p. 100.
[9] The Early Career of William Caslon.

Chapter One

WILLIAM CASLON'S ANCESTRY

W HEN IN 1920 the proprietors of the Caslon Letter Foundry decided to mark the bicentenary of the founding of this famous establishment by the publication of a historical brochure[1] they invited John Findlay McRae to write the text. The book is a beautiful production, regarding which the colophon makes generous acknowledgments to 'Mr George W. Jones, one of the most eminent of living typographers.' The colophon also informs us that McRae worked mainly from authentic documents supplied by H. W. Caslon & Co. Ltd.

Whilst one hesitates to impugn the writer of this racy account—perhaps the word 'authentic' was not very happily chosen—it must be said that his journalistic flair outran his zeal for historical accuracy. McRae declared that 'no apology need be offered for the title of this book,' proceeding quite appropriately to justify the choice of *Two Centuries of Typefounding*, rather than the alternative which first suggested itself, 'Bicentenary of the Caslon Letter-Foundry.' The sub-heading, however, 'Annals of the Letter Foundry established by William Caslon in Chiswell Street, London, in the Year 1720,' is misleading, since Caslon was in the letter-founding business at two previous addresses before moving to Chiswell Street in 1737. This error is repeated in the caption below the frontispiece portrait of William Caslon I.

If this criticism be thought somewhat pedantic in a publication which offers so much of typographical and period interest,

I

what apology can be made for the representatives of this great firm when, prior to celebrating the bicentenary of the founder's first performance, they neglected to institute the most elementary enquiry into his origins? Instead, they gave currency to the fable that Caslon's surname was 'originally Caslona, after a town in Andalusia, Spain, whence the child's father came to England in 1688 with William III, in honour of whom, it seems obvious, the infant was named.' Even Updike in his classic work repeats this absurd story. The most cursory examination of the parish registers of Halesowen where he was baptised reveals entries of the name and its variants back to the period of the Commonwealth and in other West Midlands parishes the name is found even in the sixteenth century. But McRae also says: 'Like Garrick, who was of Huguenot descent, William Caslon had foreign ancestors, and probably both men, in common with so many other distinguished artists, owed much of their talent to their mixed blood.' The notion that artistic genius is to be expected only in those of foreign or mixed extraction is quite unfounded as well as unjust to native talent wherever it is found.

Another writer who made statements on flimsy evidence was Joseph Hill, whose work *The Book Makers of Old Birmingham —Authors, Printers and Booksellers*, 1907, contains a mass of curious but ill-arranged and sometimes inaccurate information. This is what he said about Caslon:

> 'William Caslon, the Elzevir of England, was in 1692 born near Birmingham, at Cradley, Halesowen, a district which, being well supplied with wood and water, relieved Birmingham of considerable trade in smelting, smithing, and rolling, and attracted many of its iron workers.
>
> 'That the family of Castledowne, Castledone, Castleton, or Caslon, belonged to Birmingham is shown by the numerous entries in St. Martin's Registers and other records in the seventeenth century. Walter Caslon died 1620 and Philip 1621. In 1665 a Philip Caselton, living in the High Street, paid for five hearths, whilst Philip, Henry, Ralph, and Humphry were all family men. The last-named married, in 1657, Abygall Brooksby, presumably the daughter of the Free School Master.
>
> 'William Caslon served an apprenticeship to engraving gun-locks, an art identical with that of engraving ordinary

2

locks then in vogue, in which Birmingham excelled. The gun trade had but recently been introduced to Birmingham, and the grinding of gun barrels at water mills would in part be performed at Cradley, *but the engraving could only be learned in Birmingham.* (The author's italics).

'Removal to the wider field of London was a natural step for Caslon to take. In 1716 he was in business for himself, and turned his attention to cutting letters for book-binders and subsequently to type-cutting, eventually becoming the leading typecutter in England.'

Joseph Hill wrongly assumed that because entries of the name of Caslon and its variants are found in one Birmingham register and in the hearth tax returns, therefore the letter founder's family must belong to Birmingham. Also Caslon's route to London was by an entirely different path from that which the author supposed, and he was mistaken too, in believing that the manufacture of gun barrels and the engraving of gun locks were necessarily carried out in close proximity. Even before 1700 the manufacture of guns was divided into different processes and the engraving of the locks for the more ornamental types might easily be performed by engravers outside Birmingham, as skill of this order was not restricted to Birmingham alone.

In 1935 William Bennett of Birmingham wrote a twenty-four page monograph[2] which was printed and published by the City of Birmingham School of Printing under the direction of Leonard Jay. Although this is one of the more recent accounts of William Caslon it is greatly to be regretted that the textual accuracy of the work falls so much below the high reputation enjoyed by the School of Printing in regard to its typography. On pages 16 and 17, under the heading 'William Caslon the Second,' Bennett says, quoting from I know not whom, 'William Caslon the First was married three times. His first wife, by whom he had two sons and a daughter, was named Warton; the name of the second, Longman; the third, Waters. With his second and third wife (sic) he had a "good fortune".' As will be seen later, none of the three wives is named correctly. Again, on page 17, quoting from a mistaken report in the *Gentleman's Magazine*, he says, 'William Caslon the Second married the only daughter of Dr. Cartlich, of Basinghall Street, London, with whom he had a

fortune of £10,000. Dr. Cartlich was a refiner of metals and very wealthy.' Actually, John Cartlich, the refiner, whose granddaughter Elizabeth became the wife of William Caslon II, was a different person from Dr. John Cartledge, M.A., of the Royal College of Physicians, her father being William Cartlich of the Royal Mint.

Attention is drawn to this slight work of William Bennett's because on page 17, he says, 'I have to confess that the paucity of material, especially in regard to the childhood, youth and early manhood of the one who became the most notable and successful English typefounder of the eighteenth century, is a cause of regret to the present writer, who has searched in many paths, but has only found in one, the musical path, any new matter.'

Bennett concludes with an extract from Henry R. Plomer, who says,[3] 'It must be confessed that the early part of William Caslon's biography is vague and unconvincing.'

All accounts of the manner in which Caslon came to notice and rose to the head of his profession lean heavily on the particulars of his career preserved in Nichols's *Anecdotes of Bowyer*, and the larger work into which that was subsequently expanded. The elder Bowyer's intimate connection with Caslon's first ventures in letter-founding give Nichols's work a special authority in the matter. But even here, says A. F. Johnson,[4] there exists a certain confusion in the earlier part of the narrative which it is difficult completely to harmonise.

Having dealt briefly with what other writers have said on the subject of Caslon's origins and early life, we may now consider what a more thorough search reveals. An entry in the Halesowen parish register in the Commonwealth period, when Edward Paston was the minister and registrar, enables us to say that the branch of the Caslon family to which the typefounder belonged was located at Beoley in Worcestershire in the second half of the sixteenth century. By the end of the following century it had spread in small numbers to Lapworth, Aston and Birmingham, in Warwickshire, to Halesowen, then in Shropshire, to Kidderminster and Oldswinford in Worcestershire, and possibly to a few other West Midland parishes where the records have not been examined. Isolated entries of the name are also found in the parish

4

registers of Kinver, Belbroughton, Clent and Rowley Regis. In West Midlands parishes the name occurs most frequently at Beoley, but even here there are only twenty-two entries in the parish register from 1589 to 1679, a period of ninety years ; the earliest entry of all is in the Kinver register in 1560, where the first marriage entered in the register reads as follows :

'The 25th of Julye were maryed Denis Castelldon and Cristabell Atkys widdo.'

The variations in the spelling of names by parish clerks and incumbents in earlier centuries are invariably a source of difficulty to the local historian, and the following variants of the name Caslon have been noted in West Midlands parishes :

Beoley—Casleton, Casledyne, Castledine, Casteldin, Castledyne, Casteldine.

Kinver—Castelldon, Castelldone, Castellon, Castelon.

Oldswinford—Castleton, Cassleton, Castledon.

Aston-juxta-Birmingham—Castledowne.

Birmingham (St. Martin's)—Castelon, Castlon, Caslldon, Caslon, Caston, Castelton.

Kidderminster—Caslin, Casline.

Rowley Regis—Caslon.

Clent—Castleton.

Belbroughton—Ceslon, Keslam,

Halesowen—Casteldowne, Castledown, Casseltoune, Caseltoune, Castlelon, Caslton, Castlon, Casselon, Casselone.

A most extraordinary difference in the spelling of the name occurs in entries at Halesowen and Belbroughton recording the marriage of the typefounder's grandfather, in the form prescribed in the Commonwealth period, that is, by the publication of banns and a declaration before a magistrate. The entry at Halesowen reads as follows :—

'These are to certifie whom it shall concerne that publicacon was made of an intention of marriage between William Castledowne of the towne and parish of Hales-owen shooemaker son of Edward Castledowne of Beeley yeoman and Elianor Green daughter of William Greene of the pish of Bel-broughton Whirler three sevall times in the pish church

5

of Hales-owen aforesaid viz., September 17, 24 and October the first and nothing was objected or excepted but they may proceed to the act of Marriage to the knowledge of Edward Paston Reg.'

'Hales-owen Oct. 7, 1654.'

In the entry of the same declaration of intent in the Belbroughton parish register the bridegroom's name is rendered as William Keslam, exhibiting an astonishing variant of the same person's name.

An entry in the Beoley register concerns the burial of a great-uncle of the typefounder at the time when the Woollen Acts were in force. The Act of 1678 (succeeding one of 1666) provided that 'no corpse of any person (except those who shall die of the plague) shall be buried in any shirt, shift, sheet, or shroud or anything whatsoever made or mingled with flax, hemp, silk, hair, gold or silver, or in any stuff or thing, other than what is made of sheep's wool only—or be put into any coffin lined or faced with—any other material but sheep's wool only.' The entry reads :

'2 April, 1679—John Castledine was buried ye 2nd day of April, 1679 and was wound up in woollen onely of wch affidavit was made by Elizabeth Casteldine before Thomas Vernon, Esq.'[5]

Efforts to resolve the origin of the name Caslon suggest that the persistent 'd' sound in the last syllable, as in the earliest known parish register entry of the name at Kinver in 1560, viz., 'Castelldon,' is a characteristic to be borne in mind. The form Casteldine is in evidence in parish registers in Derbyshire and Nottinghamshire from 1700 onwards, and in the records of the Society of Genealogists there is a list of occurrences of the name Castledine in parish registers and census returns for certain parishes in Derbyshire and Leicestershire (1700–1861).[6]

According to county and diocesan lists of wills and marriages[7] the name Casteldine (and its variants) is well in evidence around the year 1600 in Leicestershire, Nottinghamshire, Rutlandshire, Huntingdon and Lincolnshire. The following entries form a sample only of this sort of evidence :

(a) 1585. 'Thomas Caslon of Branston.'
(Wills of Consistory Court of Lincoln, Vol. I).

(b) 1607. 'John Casteldine of Botolphbridge.'
 1638. 'Joan Caslen of Botolphbridge.'
 (Huntingdon Wills and Administrations).
Bearing in mind the 'd' sound as in Castelldon, there is a reference
to a certain 'Agnes de Casteldonyngton,'[8] accused of theft at
Stamford in 1371, two centuries before Dennis Castelldon's time,
and it seems that Castledonington might be the early form of a
name which, undergoing successive abbreviations, was contracted
to Castledon, and later to the form adopted by William Caslon.
Castledonington, too, is within the area where the name has been
most frequently found in the form Castledine.

West Midlands records of the mid-fourteenth century show
that in 1460, Dns Willms Castelyn was enrolled a member of the
Guild of Knowle.[9] It also appears from the Hagley Charters[10]
that about 1350 one Gilbert Chastelleyn was Lord of Frankley,
Worcestershire, where later the Lytteltons reigned.

In the thirteenth century when the population of the country
was small and rural communities very thinly dispersed, while the
names of some of the nobility and leading families had already
become fixed, steady surnames were still unknown in the peasant
class. Even manorial lords such as the Chastelleyns sustained
their identity for only a relatively short time and were then elimin-
ated by war or pestilence ; conditions of life for the smaller tenants
and peasantry were so precarious that even if a family became of
some local note in one generation its identity might become ob-
scured or obliterated by a local or wider catastrophe in the next,
or at best its name might persist in a modified form.

It seems, therefore, that in the century 1350–1450, when
surnames were beginning to take settled form, the name
Chastelleyn was reduced to Castelyn. Neither of these forms,
however, contains the 'd' sound so often found in the typefounder's
surname, and on the whole the writer considers the evidence to be
in favour of a Castledonington origin.

However, the change from Chastelleyn to Castelyn in the
records quoted also raises the question as to whether the names
Castledon, Casseldon, Cheselden, might have a common origin.
Nichols supplies us with information on the Leicestershire
Cheseldens,[11] the most famous of whom was William Cheselden

7

(1688–1752), the celebrated surgeon and anatomist, a native of Burrough in Leicestershire, who lectured on anatomy at St. Thomas's Hospital, London, for twenty years, and whose brilliance in operations for the stone and in ophthalmic surgery made his name a landmark in the history of surgery.[12]

If the names Cheselden and Caslon had a common origin in Leicestershire, it is curious to reflect that William Caslon and William Cheselden, displaying such high skill in their respective arts of letter-cutting and surgery, were contemporary and almost certainly acquainted. Without drawing too close a comparison between the two men, it was certainly the opinion of the most competent critics that Cheselden's genius was inventive and his true bent mechanical; indeed, it is said that he drew the plans for the old Putney bridge, whilst his book *Osteography, or the Anatomy of the Bones*, 1733, not only displays great artistic merit in the plates, but also extreme accuracy; it detailed the bone structure of humans as later George Stubbs analysed the anatomy of the horse.

Having regard to the widespread currency of the form Casteldine in Leicestershire and the central counties of England, it seems most likely that the typefounder's surname was probably a contraction from the place-name Castledonington. What is certain from the extracts from parish registers and other records which have been cited is that the story of a foreign extraction for Caslon is completely fictitious.

Returning now to the Beoley, Worcestershire, branch of the Caslon family, it should be noted that about two miles from Beoley is the site of Bordesley Abbey, a Cistercian monastery. The abbey at one period owned the advowson of the church of Kinver, Staffordshire,[13] and as a result of this some relationships were set up between families at Kinver and Beoley; three of Denis Casseldon's children were baptised at Kinver between 1561 and 1574, although Denis Casseldon himself was buried at Beoley in 1593.

After the Dissolution of Monasteries by Henry VIII, Bordesley Abbey was in 1543 given to Andrew Lord Windsor in exchange for Stanwell, Middlesex, which Henry wanted for his own use. There is no evidence, however, that the Caslons came

from Middlesex with Lord Windsor and whilst the destruction of the monasteries caused a tremendous upheaval in the ownership of manors and the creation of new rights, the position of yeomen and small occupiers of land often remained unaffected. Only a few felt passionate enough about protestant or papist issues to die for their cause; indeed, few were in such circumstances that they were compelled to commit themselves one way or the other; for the most part they were more concerned for their daily bread; if that were not true, the blood-baths of successive religious feuds would have been more terrifying than in fact they turned out to be. Henry VIII's agent in the exchange of Stanwell for Bordesley was Sir William Whorwood, the King's attorney-general, of the family of Whorwood of Compton in the parish of Kinver; the Whorwoods held the advowson of Kinver church for a long period.

One link between Kinver and Beoley came about through the Sheldon family, who acquired the manor of Beoley from Richard Neville, Lord Mortimer, in the time of Edward IV. Sir William Whorwood, the same as previously mentioned, married Margaret,[14] daughter of Sir Henry Brooke (Corbyn), Chief Baron of the Exchequer. After Sir William Whorwood's death she re-married William Sheldon of Beoley, who by his first wife Mary, daughter of William Willington,[15] had acquired Barcheston in Warwickshire also. William Sheldon died in 1570 and his widow in 1589.

Apart then from the question of the original form of name and place of settlement of the family of Caslon, the earliest holder of the name we have met with in West Midlands parishes is Denis Castelldon, occurring in 1560 at Kinver and later at Beoley, and it is therefore possible that, having established some sort of connection with William Whorwood and his wife, lord and lady of the manor of Kinver, Dennis Castelldon and his family, through the lady's subsequent marriage to William Sheldon, then became yeomen at Beoley. Defects in the earliest portion of the register at Beoley make it impossible to be certain on this point, although the known dates certainly support such a theory.

The William Sheldon just named first introduced tapestry weaving to this country. John Humphreys informs us[16] that for centuries, though a good many tapestries were woven in France,

Flanders was the chief centre of the industry, and supplied various European countries with tapestries and hangings of a similar character. Cloths of Arras were in demand for English country houses, and large purchases were made from time to time by the richer nobles. It was, however, at the beginning of the sixteenth century that tapestries came increasingly into demand and favour in England, as is evident by the fine collection made by Cardinal Wolsey for Hampton Court, and that of King Henry VIII for his own palaces. The inventory taken after his death records over 2,000 specimens, while a writer states that 'one ship from the Continent carried no less than one thousand tapestries for the King of England.' Agents were employed in Flanders to secure the finest specimens as they were woven.

In many of the smaller English mansions at the beginning of the sixteenth century, since the price of these expensive hangings was prohibitive, substitutes for them in the shape of painted cloths were used, and in wills and inventories of the period they are frequently mentioned. For instance, Lady Hastings by her will in 1503 bequeaths several such pieces of 'lynen paynted, as now hang in the chappell.'[17] A French visitor to England in 1558 wrote: 'The English make a great use of Tapestries, and of painted linens which are well done, and on which are magnificent roses, embellished with fleur-de-lis, and lions, for you can enter but few houses where you do not find these tapestries.'[18] Harrison's description of England in 1573 states: 'In the days of Elizabeth, the walls of our houses on the inner side are either hanged with tapestry, arras work, painted cloths wherein either divers histories, or herbs, beasts, knots, and such like are stained.'[19]

Shakespeare makes Falstaff use hangings as an illustration, when he refers to his wretched troops (in *Henry IV*), saying 'They are as ragged as Lazarus in the painted cloth.' And in *Love's Labour's Lost* we find the words 'You will be scraped out of the painted cloth for this.' In 1523 Cardinal Wolsey bought many pieces of painted cloths, counterfeit and real arras, from the bishop of Durham.[20] Few examples of painted cloths now remain, the earliest in the Victoria and Albert Museum not being older than the end of the seventeenth century. They evidently perished rapidly, but continued in use until the end of the seventeenth century or even later.

The inventory of the goods and chattels of Henry Castlon of Lapworth, Warwickshire,[21] connected with the Beoley family, who died in 1593, included 'A bedstead and ij paynted clothes' valued at twelve pence. Taken together with the other goods listed one gains the impression that the Caslons were then of good yeoman

class. It is greatly to be regretted that no evidence seems to have survived which would inform us of the occupation of the earliest member of the family, Dennis Castelldon, and in particular the reasons for his movements between Kinver and Beoley.

William Sheldon's tapestry factory at Barcheston was the first large scale production, so far as is known, established in this country, though single panels may have been made by immigrant workmen or natives taught abroad. At the dissolution of the monasteries Sheldon was the trusted agent of Thomas Cromwell in the suppression of Pershore Abbey, and acquired many large properties in consequence, and at the sale of 'the contents of Bordesley Abbey he made several large purchases of stuff.'[22] He was receiver for the King of all the monastic estates in the County of Warwick in 1546–7. Thomas Habington, in his *Survey of Worcestershire*, says 'This William Sheldon first introduced the working of tapestry into England at Barcheston, having at his own expense brought workmen from Flanders and employed them in weaving maps of the different counties of England, and other curious pieces, several of which are still in being at Weston.'[23] Sheldon purchased the manor of Weston in South Warwickshire in 1545, and obtained a licence to impark 300 acres of ground, to be called Weston Park for ever, and built a large mansion there. He also bought Skiltes, an estate only a few miles from Beoley, where he made another park, in which the great mansion of Beoley is shown enclosed on the tapestry map of Warwickshire. Sheldon acquired Barcheston, probably by purchase, in 1561, and this gives an approximate date for the beginning of tapestry weaving there, under the direction of William Sheldon and his manager or foreman Richard Hicks.

The reputation of the Barcheston tapestry works was widely established early in Elizabeth's reign, and after William Sheldon's death in 1570, his wishes concerning the continuance of the work were faithfully carried out by his son Ralph Sheldon. Richard Hicks lived in the parsonage adjoining the Barcheston manor house, being on friendly terms with the parson William Lane. He died in October, 1621, at the great age of ninety-seven, his work being carried on by his son Francis Hicks. The Barcheston weavers were intimately connected with the work of the Great Wardrobe for a considerable period, and some interesting particulars survive of the Lord Chamberlain's payments to the arras makers for the period 1558 to 1614, but of these no details can be given here.

However, among the Worcester manuscripts in the Birmingham Reference Library, is one which is of distinct interest[24]

showing that business relations were still carried on between Ralph Sheldon (son of William) and Thomas Hoerd, son of William (Whorwood) in 1605, after Denis Castelldon's time.

'Agreement between Rauff Sheldon of Beoley esq., and Thomas Hoerd of London, esq., Article 3.

'Item whereas the said Thomas Hoerd doth demand of the said Rauff Sheldon, the sum of three score and odd pounds, over and above the above-mentioned sum of four and twenty thousand pounds by him supposed to be due unto him as part of arrearages of certain "rents charge" and also the delivery of "certain Hangings of Tapestrie" for the furniture of two chambers, and one bed throughlie furnished, etc.'

The Sheldon tapestry industry existed from 1561 to 1647, about eighty-six years, and it was in Ralph Sheldon's time that the family attained the summit of their greatness in wealth and vast possessions. and in their alliances with the leading noble families of the Midlands. The Beoley mansion house was burnt down in the Civil War by the royalist forces, in order to prevent its use by the enemy, the same thing happening to Frankley, the home of the Lytteltons.

Interesting as the connection of the Sheldons may be, both with Beoley and with the tapestry industry, no evidence has been found linking the Caslons with the Barcheston weavers, yet the connection of Dennis Castelldon with the Whorwood manor of Kinver in 1560 and his subsequent migration to Beoley when William Whorwood's widow married William Sheldon gives rise to intriguing conjectures.

Letters of Administration of the estate of Dennis Castelldon[25] were granted in 1593 to John Sara, as follows :—

'The Condicon of this obligacon ys such that if John Sara admtor of the goods and chattells and Detts of Dennise Castledine decessed late whiles he lived of Beoley in the Diocs of Worcr and shall well and truely pay his Detts so farre as his goods will extend and do also pay the legacies and bequests of the said Defunct conteyned and specified in the will and testamt of the said Deceased, annexed to ys lres of admon and do yeld and rendr a p'fect account of his admon made in and upon the sayd goods and chattells unto the ordinary of the Diocesse of Worcr for the time beinge or any other Judge co'petente in that behalfe when and wher as she (sic) shall be therunto required and also do and shall wel and truly p'forme

the order or decre of the sayd ordinary or like Judge touch-
inge the disposinge or dividinge of the sayd goods and
chattells to any p'son or p'sons whatsoever and also do and
shall exhibit unto the sayd ordinary or lik co'petent Judge
A true and p'fecte Inventory of all ye sayd goods and chattells
on this side Whitsonday next ensuinge, And also yf ye sayd
administrator Do and shall Defend and save harmlesse the
sayd obliges and every of them alwayes agaynst all p'sons
for grauntinge sealinge and deliveringe unto him lres of
administration or Auctoritie to administer the sayd goods
and chattells and for all other causes wch may ensue by
reason or occasion thereof that then this p'sent obligacon to
be voyd or ells to remayne in full force and strength.'

It is most unfortunate that the will of Dennis Castelldon, said
to be attached to the letters of administration, is missing as this
would probably have resolved the testator's precise relationship
to later members of the family. The certificate issued with the
administration, bearing the names of Richard Cosin, Master in
Chancery, and Arthur Purefoy, Chancellor of Worcester Diocese,
has the signatures of John Sara of Beoley, yeoman, and John
Walker of Wichenford, yeoman, charged with administering the
effects.

The next testamentary evidence met with concerning the
Caslons is the administration of Henry 'Castlone' of Lapworth,
Warwickshire, also dated 1593, and evidently a close relative of
Dennis Castelldon, for the name of John Sara is mentioned in the
inventory of his goods.

'The condition of this obligacon is such that if Phillipp
Castlone administrator of the goods and chattells and Detts
of Henry Castlone his late father decessed late of Lapworth
in the Dioc's of Warr do and shall--- on this side the feast of
St. Bartholomew apostle next ensuing [24 August]---'
[1593].

The certificate issued with the administration, has the
signatures of Phillipe Castlon, yeoman, and his witness Gabriel
Cliffe, cleric, who became incumbent of Ipsley, a parish in War-
wickshire just south of Beoley, in 1588.

Henry Castlon's Inventory
A true note and Inventorye of all such goods as Henry Castlon late

of Lapworthe Deceased Died possessed of taken the xvjth day of
March Ao 1593.

Imprimis two woolle beddes	vjs	viijd
It. towe bolsters and ij pillowes	ijs	vjd
It. ij twillyes	ijs	
a Bedsteade and ij paynted clothes		xijd
It. v sheetes	vs	
It. ij shertes ij bands a table napkinge a corner kerchiefe?	ijs	
A greate coffer	ijs	
two little coffers		xvjd
a buffin stoole ij chussions		iiijd
It. ij platters iiij pottingers ij porrigge dishes a saucer a salte a litle cuppe iij spewnes	iiijs	iiijd
It. ij candlestickes iiij kettels a posnet	iijs	
It. his apparell	xiijs	iiijd
It. rumble and trashe		xijd

It. un byle of xs- - - to be payd at St. Jhon Baptiste
 day next by Richard Smeth of Rowenton
It. on obligacon of xls to be payd at Bartholmewe tide?
 by Harvye Clarke of Lapworthe
It. on- - - ? to be payd of vijs due at Or Ladys day
 com- - - by haaye- - - ewslee of Beoley and
 John Sara of ye sam parishe
It. Yt Thomas Whit of Rownton owethe xxˢ
 Summa totalis xxij£ iijs vjd
 23 August A. Dni 1593.

The information to be gleaned from the above inventory is
somewhat scanty. In the absence of more precise knowledge of the
appraisers and their relationship to the deceased the completeness
of the inventory remains doubtful. No particulars of status or
occupation are given and the inventory does not refer to different
apartments of the house of the deceased, as, for instance, to hall,
kitchen, or 'chambers' above the ground floor. Since no tools of
his trade are mentioned, it is a fair assumption that he was of some
age and had probably handed over his business to his son ; indeed,
he may have also vacated his house and business premises to live
in a nearby cottage, although his retention of such articles as
painted cloths, a great coffer and two little coffers might suggest
otherwise. Items such as a buffin stool and cushions suggest a
standard of comfort which, even if not luxurious, was certainly

not common in the sixteenth century, and this is confirmed by the unusually high value attached to his apparel, viz., 13s. 4d.

The most noteworthy feature of the inventory, however, is that money was owing to the deceased by four different parties, suggesting that Henry Castlon advanced loans to persons of sufficient security. It is possible that the role of the small money-lender in country places might be traced in examples such as this, as in many cases men in temporary need in a scattered community would prefer to turn for help to a neighbour of known sympathy and integrity.

Possibly Henry Castlone had been a yeoman of middle standing, but the inventory of Thomas Bekensall, vicar of Dudley, in 1573, amounted to no more.[26] It seems likely that John Sara of Beoley, whose name occurs in connection with both Dennis Castelldon of Beoley and Henry Castlon of Lapworth, was related to the Caslons.

There is no further testamentary evidence at Worcester Record Office concerning the Caslons until the will of George Casteldine in 1674. An abstract of this will is given below:

Abstract of the last will and testament of George Casteldine:

To my mother Ales Casteldine widdow £20;
To my brother Symon Casteldine 20 shillings;
To my sister Elizabeth Smyth £20;
 'and my desire is that my Executor hearafter named and my Overseer shall looke into it that it be disposed for her good.'
To my brother John Casteldine £20;
To my brother William Casteldine of Hailes £20;
To my brother William's son George Casteldine £10;
To his other children William Casteldine and Jone Casteldine 'five pounds apeece;'
To old Edward Willis five shillings and to his son Nicholas Willis five shillings;
To my Overseer Peter Morgan 20 shillings;
The rest of my goods moveable and immoveable (my funeral expenses being discharged) to my brother John Casteldine whom I doe constitute and appoint for my Executor of this my last Will and testament.
Witnesses:
 Peter Morgan George Casteldine his marke O
 Ales Casteldine her marke X

Chart 1.
Ancestors of William Caslon
at Beoley, Worcestershire

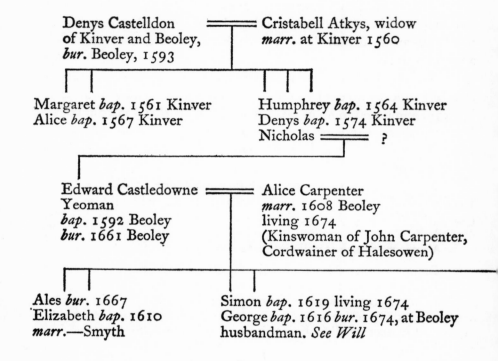

Denys Castelldon ======= Cristabell Atkys, widow
of Kinver and Beoley, _____ *marr.* at Kinver 1560
bur. Beoley, 1593

Margaret *bap.* 1561 Kinver Humphrey *bap.* 1564 Kinver
Alice *bap.* 1567 Kinver Denys *bap.* 1574 Kinver
Nicholas ===== ?

Edward Castledowne ===== Alice Carpenter
Yeoman *marr.* 1608 Beoley
bap. 1592 Beoley living 1674
bur. 1661 Beoley (Kinswoman of John Carpenter,
 Cordwainer of Halesowen)

Ales *bur.* 1667 Simon *bap.* 1619 living 1674
Elizabeth *bap.* 1610 George *bap.* 1616 *bur.* 1674, at Beoley
marr.—Smyth husbandman. *See Will*

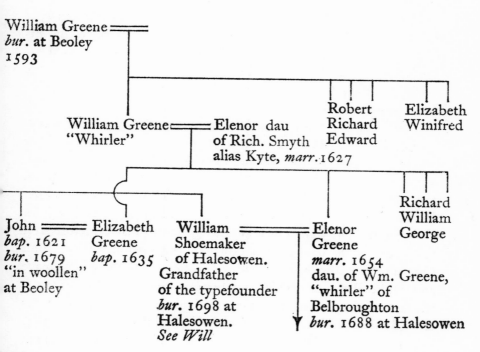

William Greene ═══
bur. at Beoley
1593

William Greene ═══ Elenor dau Robert Elizabeth
"Whirler" of Rich. Smyth Richard Winifred
 alias Kyte, *marr.* 1627 Edward

 Richard
 William
John ═══ Elizabeth William ═══ Elenor George
bap. 1621 Greene Shoemaker Greene
bur. 1679 *bap.* 1635 of Halesowen. *marr.* 1654
"in woollen" Grandfather dau. of Wm. Greene,
at Beoley of the typefounder "whirler" of
 bur. 1698 at Belbroughton
 Halesowen. *bur.* 1688 at Halesowen
 See Will

N.B.—John & William Castledowne
married sisters Elizabeth & Elenor Greene

See Chart 2 for descendants of
William Castledowne & Elenor Greene

George Casteldine was evidently in a prosperous way of business, for though the residue of his estate left to his brother John is not known, the other legacies, amounting to over £100, including four legacies of £20 each, suggest that he was one of the more substantial inhabitants of Beoley in the second half of the seventeenth century. The value of the will here, however, is that it has helped substantially towards linking the typefounder's family with its forerunners. William Caslon's father George Casteldine was the senior nephew of the testator. The testator's mother, who outlived him, was Alice Carpenter,[27] and from this it is reasonable to conclude that she was connected with John Carpenter, a cordwainer of Halesowen. It is quite evident that George Casteldine, the testator, placed little reliance on his brother-in-law Smyth, leaving a particular injunction that his sister Elizabeth's interests should be safeguarded. Chart I shows the pedigree of the Casteldines of Beoley, Worcestershire, compiled from probate documents and parish register extracts.

It seems certain that William Castledowne, the type-founder's grandfather, secured a settlement in Halesowen in the mid-seventeenth century through being apprenticed in the town, and though no particulars of his apprenticeship have been found, the fact that his mother was formerly Alice Carpenter and that William became a shoe-maker (or cordwainer) suggests that John Carpenter, a cordwainer of Halesowen, was his master. Moreover, the name Alice was carried down in the Caslon family. John Carpenter is known to have had connections with the Bromsgrove and Stoke Prior district,[28] and became connected by marriage with the family of Lea, of the Grange, Halesowen, and in 1665 was elected a feoffee of the Free School, being bailiff thereof in 1673–4, dying in 1688. The account book of Halesowen Free School shows John Carpenter to have been an accomplished penman, and there are examples of his signature in different styles. His son Jonathan was elected a feoffee in 1701 and was bailiff in 1706, the year William Caslon was apprenticed. A pedigree of John Carpenter's family showing his clerical descendants exhibits connections with Warwickshire and London that throw light on Caslon's acquaintances.[29] William Castledowne died in 1698.

Abstract of the will of William Castledown of the Town and Borough of Halesowen, co. Salop, Shoemaker. Made 31 July 1698 ; Proved 28 June, 1699 (Worcester Consistory Court)[30]

In the name of God Amen- - -

To be buried in the parish churchyard of Halesowen as near as conveniently may be to my wife.

To George Caslon my son one shilling and to his three children twelve pence apiece.

To my daughter Joane Taylor that feather bed and bolsters and two blankets whereon I lie and one shilling, and to her children twelve pence apiece.

To my daughter Alice Milward one shilling and to her two children twelve pence apiece.

To my daughter Elizabeth Caslon and to her heirs and assigns for ever all that house and garden where I now dwell and that one piece of ground called Brickehill Inage in the Borough of Halesowen. To my daughter Elizabeth Caslon my two kine and all my household goods and all else that is mine and I make her sole executrix. I desire my two friends Thomas Wight and John Lea, both of the Town of Halesowen, to be overseers of this my will.

Witnesses : Anthony Smyth
 Joshua Smith
 William Smith

Probate : 28 June, 1699, to Executrix named.

Inventory : 28 December, 1698, of the goods of 'William Castleton of Halesowen lately deceased.' Total £15–9–6. Taken by Thomas Wight, George Caslon and Tho : Wright.

The will serves to clarify doubtful points in the pedigree compiled from the parish register entries.[31] William Castleton's first son William, born in 1655, grew to manhood, married a wife Margery and had two sons, Simeon, born in 1680, and Samuel, born in 1686. Since the elder William Castleton makes no mention of a son William in his will, it seems likely that his death occurred and possibly the deaths of his wife and son Simeon, during the neglectful vicariate of the Rev. John Westwood.[32] It is curious, however, that no mention is made of Samuel, who is heard of in London in William Caslon's typefounding career and afterwards in Birmingham. The name of Elizabeth, the elder William Caslon's daughter, is also missing from the parish register in this period, and as the only daughter remaining unmarried at

her father's death, who seems to have been not ungenerously treated, it is possible that the orphaned Samuel had been brought up in his grandfather's home and Elizabeth had had the care of him. This, however, must remain a conjecture. William Castleton's son George was most likely already established in his father's business and this was probably regarded as a sufficient provision for him. In other respects the surviving children and grandchildren at the date of the will are treated exactly alike, each being given one shilling, the will being obviously designed to ensure that the unmarried daughter received her father's house and belongings. It must be remembered, however, that his two daughters Joane Taylor and Alice Milward would also have been provided with a dower of some sort on their marriage.

William Castleton appointed his friends Thomas Wight and John Lea as overseers of his will. Thomas Wight was a man of good family whose father had been one of the jurors chosen to enquire into the use of the town charities in 1652, an enquiry which led to the re-endowment of the Free School.[33] John Lea was one of the family of Lea of the Grange, Halesowen, who had married Elizabeth, daughter of the John Carpenter previously mentioned.

The witnesses were all named Smyth or Smith, and since William's sister Elizabeth had married a Smyth,[34] it is probable that at least one of the witnesses was the testator's nephew. Anthony Smyth was a church-warden at Frankley in 1680.[35]

Chart 2 shows the family and connections of the Halesowen Caslons constructed from the will of William Castledowne, shoemaker, who died in 1698, together with all occurrences of the name in the Halesowen parish register.

William Castledowne's second son George, the father of the typefounder, baptised in 1661, married in 1688 Mary Steven, the daughter of Ralph Steven and Margaret Wright of Rowley Regis, and sister of Ralph Steven the younger. The family of William Caslon's mother is mentioned again in Chapter 13. The entry of the first-born child of the type-founder's parents in the parish register reads as follows:

'19 Jan. 1689—William child of Geo. Casseltoune de Cradley by Mary his wife baptised'

In March of the same year the burial of this child is recorded:

'William Casseltoune infant buried.'

It is the baptism of this earlier William which has given rise to the oft-repeated but unfounded tradition that the great typefounder, a later William, was born at Cradley. Moreover, it is the only reference to Cradley in any of the Caslon entries in the parish register. The property of William Castledowne the shoemaker was at Halesowen, his executors were of Halesowen, and the connections of the future typefounder, the Carpenters, the Shenstones, etc., were all at Halesowen, and the legend that William Caslon was a native of Cradley must, on all the evidence, be abandoned.

The baptismal entry of the typefounder himself reads as follows:

'23 April, 1693—Wm. child of George Casselon by Mary his wife baptised,'

thus exposing another error in the traditional account, which states that William Caslon was born in 1692. In those days infant mortality was so high that it was the almost invariable custom to baptise infants as soon as possible after birth, frequently within a few days, so that the true year of Caslon's nativity was undoubtedly 1693.

Of the other children of George and Mary Caslon none appear to have survived infancy except Caslon's sister Mary, baptised in 1696. In 1719 Mary Caslon married Humphrey Coley at Halesowen. Humphrey, baptised in 1681, was the only surviving son of an earlier Humphrey who married Mary Mucklow at Halesowen in 1680, this branch of the Coleys having probably migrated from Birmingham about the same time as the Robertsons, another family once prominent in Halesowen. Humphrey Coley and Mary Caslon had four children baptised at Halesowen, but no attempt has been made to trace them further.

Joane Castledowne, the typefounder's aunt, married in 1680, at Hagley, Thomas Taylor, a nailer of Cradley, the bride's name being given in a transcript of the Hagley register as Casterton. Thomas and Joane Taylor had three children, Thomas, 1689, John, 1693 and Mary, 1696, baptised as of Cradley. It is

quite feasible, therefore, that when George and Mary Caslon's first William was born, Mary lay in at her sister-in-law Joane Taylor's at Cradley, so that the child was registered as 'of Cradley.' Old William Castledowne's wife Elinor Greene had died in 1688, as well as an infant grand-daughter Elinor, so that although the Shropshire Hearth Tax roll for 1672 shows that the typefounder's grandfather was taxed on two hearths for his house in 'The Burrough,' the old man evidently felt unable to accommodate George and Mary's family, for Elizabeth and Alice were still unmarried and the orphaned Samuel was probably also still at home although approaching the age for apprenticeship. In that same year, however, Thomas and Joane Taylor began their own family, so that George and Mary Caslon's further children were born and baptised in Halesowen.

In April, 1727, John Snape of Birmingham Aston and Mary Taylor of the parish were married at Halesowen. These were almost certainly the parents of that John Snape who became a well-known land surveyor in Birmingham. In Bisset's *Magnificent Directory of Birmingham*, 1800, Snape advertised himself as Land Surveyor and Civil Engineer. His name appears on canal surveys in Birmingham and the Midlands in the last thirty years of the century. In 1727 Mary, daughter of Thomas Taylor and Joane Caslon was thirty years of age, and there is thus a possibility that John Snape the younger had Caslon blood in his veins.

The family of Henry Castlon of Lapworth who died in 1593 was transmitted through his son Philip, reappearing at Aston, Birmingham, where the register, somewhat defective, records the baptism in 1628 of Philip the son of Henry and Ann Castledowne. This Philip evidently migrated to Birmingham, for we find his marriage recorded in the St. Martin's register, his bride being one of a Birmingham family of some importance in the mid-seventeenth century.
'28 July, 1657—Phillip Casllon & Katherine Moreland, both of this parish, married.'
Baptisms and burials of some of his family follow, but the register was shockingly kept at this period. In 1653 'Alice Castelon widdow' was buried and in 1667 'Mrs Castelton widdow' was also buried. Philip Castlon was taxed on five hearths, so he must have been a substantial man.
In 1655 Mary Castlon, presumably Philip's sister,

married a certain Joseph Cottrell, one of a family prominent in the annals of Birmingham over a long period. Then in 1657 'Humphry Caston (sic) and Abigall Brooksby' were married, the bride being the sister of Nathaniel Brokesby, one of the most notable of the early headmasters of Birmingham King Edward's School. After Humphrey Caslon's death, his widow married a second husband named Davies and was living at Shifnal in Shropshire when Nathaniel Brokesby made his will in 1687[36]

Nathaniel Brokesby's first wife belonged to the Kidderminster family of Freestone and it was probably through this relationship that Walter Caslon migrated from Birmingham to Kidderminster, this accounting for the few entries of the name in Kidderminster records. It is clear that the relationship between the Birmingham and Halesowen Caslons was extremely tenuous by the end of the seventeenth century when William Caslon was a boy.

Some of the historical records of London show that William Caslon was not the first of his name to be established in the metropolis. Long before the great typefounder's day, the Barbican was a watch-tower built over Cripplegate which lasted until the reign of Queen Mary. It is not known when it was demolished but even in 1720 there was a house on the site. Cripplegate commanded the great north road and in olden times waggons and carts with their loads of goods came to and went from the Old Whitehorse yard by the Cripplegate once a fortnight, then once a week, and later two or three times a week, between London and the great clothing towns of the north, which after the Restoration had started into fresh activity. At the outbreak of the Civil War, one Castlon, or Caslon, was one of the two postmasters who had the exclusive right to supply travellers with posthorses and to forward letters between the metropolis and the provinces, and who lived and had his office in the Barbican.[37]

There is evidence of the name at an earlier date in the parish of SS. Anne and Agnes, Aldersgate Street, as shown in the following abstracts of parish leases.[38]

> 1627 : Lease by the Parson and Wardens of St. Anne's to Andrew Kinge, citizen and draper, of the great messuage known as the Bell Inn, excepting a house that lately belonged to the said inn and is now in the occupation of John Casslon, chandler, for 21 years at £20 rental.
>
> 1627 : Another lease by the Parson and Wardens to John Castland (sic), citizen and tallow-chandler.

Chart 2.
Descendants of William Castledowne of Halesowen

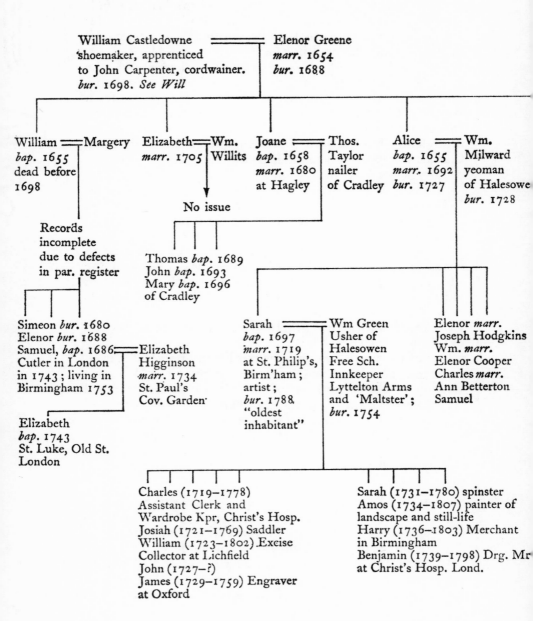

William Castledowne 'shoemaker, apprenticed to John Carpenter, cordwainer. *bur.* 1698. *See Will* ══ Elenor Greene *marr.* 1654 *bur.* 1688

William ══ Margery *bap.* 1655 dead before 1698

Elizabeth ══ Wm. *marr.* 1705 Willits

Joane ══ *bap.* 1658 *marr.* 1680 at Hagley ══ Thos. Taylor nailer of Cradley

Alice ══ Wm. *bap.* 1655 Milward *marr.* 1692 yeoman *bur.* 1727 of Halesowe *bur.* 1728

No issue

Records incomplete due to defects in par. register

Thomas *bap.* 1689
John *bap.* 1693
Mary *bap.* 1696
of Cradley

Simeon *bur.* 1680
Elenor *bur.* 1688
Samuel, *bap.* 1686 ══ Elizabeth
Cutler in London Higginson
in 1743; living in *marr.* 1734
Birmingham 1753 St. Paul's
 Cov. Garden

Sarah ══ Wm Green
bap. 1697 Usher of
marr. 1719 Halesowen
at St. Philip's, Free Sch.
Birm'ham; Innkeeper
artist; Lyttelton Arms
bur. 1788. and 'Maltster';
"oldest *bur.* 1754
inhabitant"

Elenor *marr.*
Joseph Hodgkins
Wm. *marr.*
Elenor Cooper
Charles *marr.*
Ann Betterton
Samuel

Elizabeth
bap. 1743
St. Luke, Old St.
London

Charles (1719–1778)
Assistant Clerk and
Wardrobe Kpr, Christ's Hosp.
Josiah (1721–1769) Saddler
William (1723–1802) Excise
Collector at Lichfield
John (1727–?)
James (1729–1759) Engraver
at Oxford

Sarah (1731–1780) spinster
Amos (1734–1807) painter of
landscape and still-life
Harry (1736–1803) Merchant
in Birmingham
Benjamin (1739–1798) Drg. Mr
at Christ's Hosp. Lond.

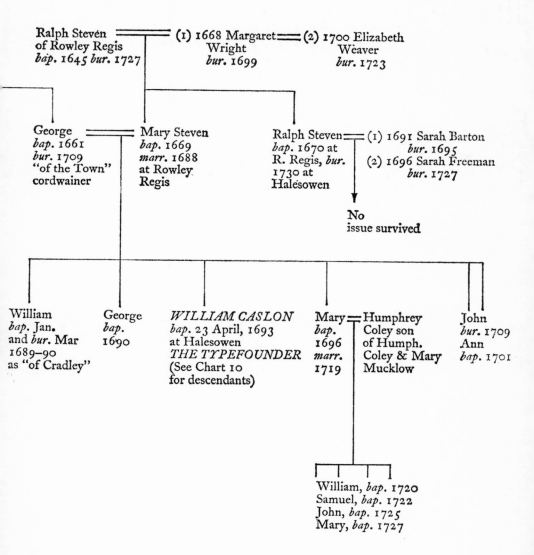

Ralph Steven ═══════ (1) 1668 Margaret ══ (2) 1700 Elizabeth
of Rowley Regis Wright Weaver
bap. 1645 *bur.* 1727 *bur.* 1699 *bur.* 1723

George ═══════ Mary Steven Ralph Steven ══ (1) 1691 Sarah Barton
bap. 1661 *bap.* 1669 *bap.* 1670 at *bur.* 1695
bur. 1709 *marr.* 1688 R. Regis, *bur.* (2) 1696 Sarah Freeman
"of the Town" at Rowley 1730 at *bur.* 1727
cordwainer Regis Halesowen

 No
 issue survived

William George *WILLIAM CASLON* Mary ══ Humphrey John
bap. Jan. *bap.* *bap.* 23 April, 1693 *bap.* Coley son *bur.* 1709
and *bur.* Mar 1690 at Halesowen 1696 of Humph. Ann
1689–90 *THE TYPEFOUNDER* *marr.* Coley & Mary *bap.* 1701
as "of Cradley" (See Chart 10 1719 Mucklow
 for descendants)

 William, *bap.* 1720
 Samuel, *bap.* 1722
 John, *bap.* 1725
 Mary, *bap.* 1727

25

1644 : Another lease showing that the house formerly occupied by John Castlon (sic) was now occupied by John Beaves, jeweller.

As a final note on variants of the name Caslon, it can be said that in the period 1727 to 1729 when the typefounder had first moved to Ironmonger Row, the parish records render his name as Castlane. His foundry was then in the parish of St. Giles, Cripplegate, for it was not until 1732 that the parish of St. Luke, Old Street, was separated from it and constituted a separate parish. Unfortunately, the first eleven years of the register are missing.

[1] J. F. McRae, Two Centuries of Type-founding,1920.
[2] William Caslon, 1692 (sic)-1766, ornamental engraver, typefounder and music lover.
[3] A Short History of English Printing (1476-1898)
[4] Reed-Johnson, p. 230 (footnote).
[5] Thomas Vernon of Worcester, registrar to the Bishop of Worcester and a county magistrate, one of the Hanbury family. (See Nash, Vol. I; pedigree facing p. 549).
[6] Donor, A. W. Rolfe, 1963.
[7] Index Series.
[8] Lincs. Record Society, Vol. 30.
[9] Register of the Guild of Knowle in the County of Warwick, 1451-1535, transcribed by W. B. Bickley.
[10] Catalogue of Charters and Muniments of the Lyttelton Family, I. H. Jeayes, 1893.
[11] History and Antiquities of Leicestershire, Nichols. (P. 19, Visitation of 1619, Cheselden of Allexton; p. 408, Cheselden of Leicester and of Gaddesby.
[12] D.N.B.
[13] Shaw's Staffordshire, Vol. II, Kinver, p. 263.
[14] Mary in Shaw's Staffordshire.
[15] Died 1553.
[16] Elizabethan Sheldon Tapestries, John Humphries, 1929.
[17] Ibid.
[18] Perrins, Description of the Kingdom of England and Scotland.
[19] Quoted in Morgan, Readings in English Social History, p. 256.
[20] W. G. Thompson, Tapestry Weaving in England, p. 29.
[21] See p. 25.
[22] Op. cit.
[23] Quoted by Nash, Vol. I, p. 66.
[24] Cat. No. 167897.

[25] Worcester Record Office.

[26] J. S. Roper, Dudley Probate Inventories (1544-1603), 1965.

[27] Beoley parish register.

[28] Herald and Genealogist, Vol. 7, p. 270.

[29] See Chap. 10, Chart 8.

[30] Worcester Record Office.

[31] See Chart 2, appended to this chapter.

[32] Halesowen parish register.

[33] F. Somers, Halas, Hales, Halesowen, Privately printed 1932.

[34] George Castledine's Will, 1674.

[35] Frankley parish register.

[36] Dugdale Society Publications, Vol. XII, pp. 131-4.

[37] Fifth Report of Commission on Hist. MSS. pp. 60, 62, 66.

[38] William McMurray, The Records of Two City Parishes—SS. Anne and Agnes, Aldersgate, and St. John Zachary, London, 1925.

Chapter Two

HALESOWEN SCHOOLS DURING
CASLON'S BOYHOOD

EARLY IN THE eighteenth century few people saw anything of life in towns and cities. Most villagers remained all their lives under the influence of the environment and traditions of their native place. The pabulum of English children consisted largely of cottage fireside tales, of giants and dwarfs, fairies and goblins, witches and ghosts, such as to cause a shudder even if only half believed. There were few books. The cottager and even the yeoman saw little printed matter apart from the Bible and Prayer Book, nursery rhymes, and possibly chap-books. Primitive modes of communication ensured that each parish had its own traditions and character. Newspapers, radio and television stamped no uniform mentality on the nation. The only sensation they found was in the daily happenings of their own village, its quarrels and love-affairs, the estrangement of parson and squire, the brawl at the inn, while occasionally the news of some unusual event such as the Battle of Blenheim made them momentarily aware that they belonged to a great nation.

Trevelyan reminds us, however, that in spite of its educational defects, the eighteenth century produced a larger proportion of remarkable and original men than our highly sophisticated age is able to do. Perhaps, despite our much vaunted claims to progressive improvements in our methods of education we might still learn something from the successes of a former age, which still found

much happiness in childhood, and when those who had inclination towards study might still escape from the company of their fellows and were spared the conditioning influences and the dubious blessings of mass-communication.

When Caslon was a boy, the squire's children often sat at school beside the sons of yeomen and shopkeepers who had been selected for a clerical career; alternatively, they were taught at home by a neighbouring parson, or in wealthier families by the private chaplain. In that age of patronage the explanation of many a poor young man's preferment is to be found in a fortunate friendship struck up at school with the son of squire or local gentry. In middle-class families the defects of local education were supplied by a private tutor, who was sometimes a Huguenot refugee, for educated men of this type were welcomed for their French.

In the eighteenth century, education for such as desired it was largely dependent on ancient endowments such as the free schools, often continuations of chantry and other monastic schools, or re-established as the grammar schools of King Edward VI, or on the Blue Coat Schools, of which a typical example was Thomas Foley's Hospital at Oldswinford; others were founded on the recovered funds of misdirected charities of more recent date than Edward VI's time, and augmented by later benefactions, Halesowen Free School being of this type, and lastly, there were the recently established charity schools similar to those formed in London or the Greencoat School for boys and the Greycoat School for girls, also in London. Many charitably disposed persons left funds for educational purposes, but in many cases their uses were subverted and the objects neglected. One of the scandals of English education during the seventeenth and eighteenth centuries, and indeed until well into the nineteenth century when rapidly increasing population compelled attention to the problem, was the widespread neglect and misuse of these ancient charities. Even some of the now better-known schools have had very shady periods in their history. One of the most potent factors leading to misuse and neglect of these institutions was the wide-spread ignorance which it was the schools' function to remedy, and in many cases it was only the vigilance and sense of

public duty of a few individuals which rescued the charity for the use of the local community.

For many of these charities the available funds were so scanty that the schoolmaster took in fee-paying boarders to eke out his salary, a device which though saving the school from extinction also led to neglect of the free boys. In other cases the schoolmaster or his usher engaged in some business entirely different from teaching. At Halesowen the first usher appointed was a maltster and his wife was the landlady of the local coaching inn.

Under this condition of affairs it was to be expected that private fee-paying schools would flourish, of which scarcely any record remains. In the dame schools children of up to seven or eight years of age were taught their letters in a single cottage room. It was a dame schoolmistress named Sarah Lloyd in Halesowen whom William Shenstone committed to posterity in 1742 in his poem, *The Schoolmistress* :—

> 'In every village mark'd with little spire,
> Embower'd in trees, and hardly known to fame,
> There dwells, in lowly shed and mean attire,
> A matron old, whom we schoolmistress name ;
> Who boasts unruly brats with birch to tame ;'

But for most poor people even the dame school was a luxury and the only school thousands of children knew was the school of hard work and experience. Before they were old enough to be apprenticed, small children were set to work in their parents' cottages at an age quite as early as the factory children of later times. Defoe informs us that at Colchester and in the Taunton clothing region 'there was not a child in the town or in the villages round it of above five years old but, if it was not neglected by its parents and untaught, could earn its bread.'[1] In the clothing dales of the West Riding, too, he found 'hardly anything above four years old but its hands were sufficient for its support.' Not only so, but Defoe notes these things with approval, as if they were the natural lot of children of the working class of his day.

Children selected for apprenticeship, therefore, might regard that condition as a substitute for the teaching and discipline of school. Indeed, whether children had enjoyed the advantage of a school training or not, those who became apprentices served in

another school, the old English school of craftsmanship and of character, and though the apprentice system was often abused by cruel masters and mistresses, these cannot be regarded as typical of their class, for in that case English trades would have starved for lack of juvenile entrants. In fact, apprenticeship was invaluable for the discipline and skilled training that it provided in the teen-age period. One of its most valuable features was that the apprentice lived in and was part of his master's family; consequently if he had the good fortune to be lodged in a more genteel home than his own, he benefited from the cultural and moral tone of his new surroundings.

In Queen Anne's time, therefore, leisure had little meaning for any but the wealthier classes. All members of the family in the poorer classes found their time so deeply engrossed in the struggle for a livelihood that only a small number of children could spend part of their daylight hours at the dame school or at the free-school; the time of most had to be given to the family occupation. Some few, by the sacrifice of their parents, might be taught the rudiments of letters and number in the evening by some enter-prising local dominie offering opportunities to the aspiring poor at so much a subject.

The duty of maintaining its own poor was imposed upon every parish in the seventeenth century. The question as to who were to be considered as the poor of the parish was a matter of considerable dispute until 1674, when it was decided that any person who should reside undisturbed for forty days in a parish should be considered as belonging to it, or as it was termed, should gain a settlement in it; but that within that time any stranger should be sent back whence he came by the order of two justices, unless he either rented a house worth ten pounds a year, or could give a bond to secure the parish against any charges arising from future poverty.[2]

A list of these bonds given to the parishioners of Clent is still in existence, but the earlier removal orders under the Act are missing. Frauds were often committed, the poor of one parish being bribed to go into another and remain concealed there for forty days, when they would gain a settlement in a fresh place; and so it was enacted that the forty days should be considered to run

after a notice had been delivered in writing to the overseers, of the number of an incomer's family and the place of his abode. But parish officers in some cases turned out no more honest in regard to their own than they had been with respect to other parishes, and connived at these intrusions, taking no proper steps on receiving the notices. So, as all the parishioners were supposed to be interested in the prevention of such intrusions, it was further enacted that the forty days should commence only after the due publication of the notice following divine service in the church. There were, besides the conditions of residence, four ways in which a settlement might be obtained ; first, by being rated in the parish and paying the rates ; second, by serving a year in some parish office ; third, by serving an apprenticeship in the parish ; and fourth, by being hired into service for a year, and continuing in it the whole time.[3]

These statutes nearly destroyed the mobility of labour, and to restore this in some degree, it was enacted in 1696 that a poor person might remove from one parish to another provided he took with him a certificate from the officers of the parish he had left acknowledging his settlement, and his chargeability to them if he came to poverty.

The question of the school which William Caslon attended as a boy invites some speculation. It would be easy to conjecture that he attended Halesowen Free School, which was re-established in 1652 on the proceeds of charities recovered as the result of an inquisition into their misuse and augmented by other benefactions. The misappropriation of benefactions intended for educational purposes was a scandal to which frequent reference is made by historians of the period, and the Halesowen Free School is no exception in having a chequered and disturbed history. There was little continuity in the mastership until the Rev. Josiah Read was appointed in 1665, who remained until 1693, when he was appointed to the William Sebright School at Wolverley, near Kidderminster, a post he retained until shortly before he died in 1719.[5] In 1671 Josiah Read married Anne the daughter of Robert Durant who had been rector of Churchill in Halfshire (that is, near Kidderminster) from 1661 to 1670.[6] Robert Durant was succeeded in the Churchill rectory by Francis Peirce,[7] who remained until 1676 when he was appointed vicar of Halesowen[8]

and master of Hartlebury Free School.[9] Josiah Read then succeeded as rector of Churchill, remaining rector until his death,[10] and retaining the mastership of Halesowen Free School until 1693 when, as stated above, he was appointed to the Wolverley School. At Halesowen he was succeeded in the Free School mastership by his wife's brother,[11] Robert Durant the younger who in 1691 had become curate of Frankley and St. Kenelm's chapels in succession to John Brown.[12] The last-named was master at Stourbridge School from 1692[13] and curate of Hagley from 1697 until his death in 1703.[14] Robert Durant the younger resigned the mastership at Halesowen on being appointed rector of Hagley in 1706, but retained the chapelries of Frankley and St. Kenelm until succeeded by his son in 1730.[15] At Hagley Robert Durant had succeeded the minor poet William Bowles.[16] The feoffees of Halesowen Free School then invited Joseph Chillingworth[17] to be master who had been usher of Kinver Grammar School, also acting as curate of Hagley while William Bowles was doing duty as rector of Enville. But the Halesowen mastership evidently did not appeal to Chillingworth for he declined it and in the following month succeeded Thomas Parkes as minister of Areley.[18] In 1719 on the death of Josiah Read, Chillingworth was presented to the rectory of Churchill,[19] retaining this and the incumbency of Areley till his death in 1758. In 1728 his son Joseph became master of Queen Mary's Grammar School, Walsall.[20] Upon Joseph Chillingworth declining the mastership at Halesowen, the feoffees appointed Joseph Thorpe[21] of Oldswinford, who remained until 1721, to which in 1716 he added the curacy of Oldbury which had just been endowed under Queen Anne's bounty.[22]

The above account makes it clear that although the Lytteltons were the nominal patrons of these livings certain families contrived to ingratiate themselves in the good opinion of the patron and secure his favour, so that schoolmasters, curates, vicars and rectors became a sort of mutual benefit society and by various means managed to confine these preferments within a small perimeter. Whilst the abuses of nepotism cannot be discussed fully here, its evils and the equally vicious consequences of pluralism have been sufficiently confirmed by historians of the

period to warrant the statement that generally the effect was to depress the standards of the free schools, the masterships of which tended to become a perquisite to eke out the pittance of curates, to the easement of vicars and rectors. This is not to say that conscientious schoolmasters did not exist here and there, but the calling was certainly degraded by these practices.

Robert Durant, therefore, was the master of the Free School at Halesowen when William Caslon was at school. In April, 1693, Robert Durant married at Halesowen Elizabeth Robertson,[23] a member of a family which continued to exercise influence in the town for over a century. The family had migrated from Birmingham in the first half of the seventeenth century. Elizabeth Robertson was the daughter of Robert Robertson, a local baker, and the parish register also names William Robertson, locksmith, in 1683, Robert Robertson, mercer, 1707, and many others without the occupations being specified.

Although Halesowen was the nearest free school where the boy Caslon might have attended, there were other schools in the vicinity where equally he might have been taught. William Smith of the Breach, Hunnington, near Halesowen and of Stoke Prior, died in December, 1684, and by his will[24] charged his estates in the parish of Halesowen producing about £15 per annum, to support a school for the education of twenty poor children at Hunnington. It has been already noted that the witnesses to the will of William Caslon's grandfather were three members of the ubiquitous family of Smith; Anthony spelt his name with a 'y', but Joshua and William were content to be plain Smith. It would be a tenuous theory indeed which depended solely on the identity of a William Smith as a basis for recognising the school where William Caslon was educated. However, John Amphlett's school at Clent was not founded until 1704,[25] so it is highly probable that some Clent children attended the Hunnington school from its establishment in 1684, and it follows that if William Caslon were one of its scholars, he may have become acquainted there with the families who played a large part in his early life, the Pearmans, the Cookes' and the Shenstones. Before becoming established at the Leasowes, the Shenstones were at Illey, and both Illey and Hunnington are neighbouring hamlets in the parish of Romsley,

34

one of the so-called Quarters of Halesowen.

Though little of the early history of William Smith's school at Hunnington has survived, we know something about an early Romsley schoolmaster named John Underhill who, on the death of John Brown in 1703, was a candidate for the mastership of Stourbridge Free School. Joseph Foster [26] records two men of this name and period :

(a) John Underhill of Clent; Pembroke College, 1664–5, aged 17 ; B.A. 1699 (sic); Lincoln's Inn 1667.
(b) John Underhill of Ludlow, gent; Pembroke College 1691–2, aged 16 ; B.A. 1695 ; M.A. 1698.

The year of the first John Underhill's graduation is obviously a mistake for 1669, and this makes him a man of some age at the time of his application. If he were actually registered as of Lincoln's Inn, the intention was probably not acted upon, for in view of the evidence which has survived there can be no doubt about the Clent man being the Stourbridge candidate.[27] John Underhill was actually appointed master according to a resolution signed by four governors, one of whom was John Sparry, a member of a prominent Clent family, yet owing to some dispute among the governors Underhill's appointment was set aside, and he had to retire a disappointed man. The minute appointing Underhill reads as follows :[28]

'We Governors whose names are hereunto subscribed doe as farr as in us lyes Nominate Elect and appoint John Underhill of Pembroke College Oxon Master of Arts to be Chiefe Schoolmaster of the ffree Grammar Schoole of Sturbridge in the Countie of Worcester. Witness our hands this third day of Maii Ano Dmi 1704.
Sturbridge free schoole house Humphrey Jeston
ye day and yeare above written John Sparrye
 Edw. Milwarde
 Tho : Oliver'

Four Governors (Dr. William Hallifax, rector of Oldswinford, Baker, Tristram and Wheeler) proposed John Woodin,[29] who was not a graduate and this resulted in a popular objection. The other four, the Jesson faction, then proposed 'Mr. John Underhill, M.A., who was of a considerable time standing and had been resident constantly in the University of Oxford and was and is

there employed as a Tutor to young students.' This proposal was in deference to popular request, it appearing that Underhill was well-known in the locality. Then the other four proposed John Wentworth, a stranger to all except Hallifax. The Jesson faction agreed to abide by an 'examination' by local learned men. Wentworth and Underhill consented, but the Hallifax group set up Mr Painter 'being the son of a person that is workman to the said John Wheeler at one of his Iron Mills,' and this 'although Dr. Hallifax cannot pretend that Mr. Painter is equal in learning, birth or education with Mr. Underhill, Mr. Painter having been Mr. Underhill's servitor and pupil in the University and an undergraduate and entered of the College he was of at such time as Mr. Underhill had taken his Master's Degree and being yet a youth . . .'[30]

The ultimate appointment of John Wentworth is of interest for two reasons, first, he was master of the Stourbridge School when Samuel Johnson the future lexicographer was in attendance for a few months, and second, when Wentworth was dismissed in 1732 for giving the boys too long a holiday, he refused to accept the Governors' decision and, owing to a flaw in the conditions of his appointment, was able to enforce the continued payment of his salary until his death in 1740!

There is a further slight reference to John Underhill in which the authoress gives some particulars of members of the Milward family,[31] extracted from the Prattinton Collection, including the following :—

> Elizabeth Milward living 1702–20–24 Grimbey (sic). She married Philip Orton of Bicknell, co. Worcester (sic), living 1724. They had an estate at Churchill, but mortgaged 1710, he living 1715–16. She at Grimbey (sic) 1718. Their issue, Thomas, at Mr Underhill's School at Romsley, and Jenny and Elizabeth, both young 1717[32]

It is a fair assumption, then, that John Underhill was schoolmaster at Romsley from about 1703 to 1717 at least, taking in boarders in order to eke out the pitifully small endowment of £15 a year provided for the school at Hunnington. The practice of combining the emoluments of schoolmasters and curates to the advantage of vicars and rectors has been mentioned.

After the Dissolution the incumbent of Frankley chapel, called a perpetual curate, received a stipend of £10 per annum, but about 1675 Sir Henry Lyttelton endowed the curacy with the greater part of the tithes, thus increasing the stipend to about £40 per annum, the living being a donative in the gift of the Lyttelton family. Similarly, the chaplaincy or curacy of St. Kenelm's chapel was formerly valued at only £5 per annum, until Sir Henry Lyttelton in 1675 endowed it with the great tithes of Romsley, thus increasing the stipend to about £35 per annum.[33]

For the purpose of comparison, it can be said that the stipend of the Schoolmaster at Stourbridge in the late seventeenth century was £35 per annum, at Halesowen £20 per annum, and at Hunnington, as we have seen, £15 per annum. At Thomas Foley's Hospital at Oldswinford, founded in 1670, the early masters were paid a stipend of £30 per annum, plus their 'dyet and the use of a horse.'[34]

In 1706 a certain Mr Hall occurs in Halesowen parish register as curate of St. Kenelm's Chapel, Romsley, and while he might have eked out his stipend by teaching, as chaplain to the Lytteltons, his need was not as great as Underhill's. Hall is not in Nash's list. H. M. Colvin[35] makes interesting reference to this Mr Hall, in discussing the missing cartulary of Halesowen Abbey. He says 'The attempts of Bishop Charles Lyttelton to recover this cartulary in 1736 are described in his letters to William Mytton, the Shropshire historian.[36] In May he wrote that 'Mr. Hodges who was formerly Steward to my Grandfather had it in his possession and showed it to Mr. Hall our old Chaplain now living,' but that Hodges papers had passed to his son-in-law Mr Keeling, steward to Lord Dudley, and that as there was a coolness between the Lytteltons and Keeling he had little hope of recovering the manuscript.'

Whilst the foregoing does not get very far towards resolving the identity of Caslon's school and schoolmaster, what does emerge is that it is far from conclusive that he attended Halesowen Free School. Whilst the names of Carpenters and Shenstones among the feoffees during Caslon's boyhood lends some support to the idea that Caslon was one of its scholars, William Smith Junior was also a feoffee and his father had founded the school at

Hunnington. Moreover, after the departure of Josiah Read to Wolverley Sebright School, Halesowen seems to have passed through a disturbed period and was low in reputation. The fact that there was a school at Romsley attracting scholars not only from the immediate locality but from neighbouring counties seems to confirm that the Halesowen Free School was at a low ebb, and whilst it is true that a few years later the poet Shenstone, after leaving Sarah Lloyd's dame school, attended the Free School for a time, he did not remain there long, but was transferred to Solihull School, where John Crompton gave him the necessary grounding for proceeding to Oxford.[37] Moreover, the fact that Caslon's earliest known connections were with the Pearmans of Clent, that Caslon's master Edward Cookes and his master Adam Bell were both connected with Stoke Prior, that Hunnington School was founded by William Smith of the Breach, Hunnington, and of Stoke Prior, that the Carpenters had connections also with Stoke Prior, and that the will of Caslon's grandfather was witnessed by three men of the name Smith, one of whom, Anthony, had earlier been a church warden of Frankley seems to weigh far more heavily in favour of the Hunnington School as the place of Caslon's upbringing. Very few even of well-known public and grammar schools still have lists of scholars going back to Caslon's time and though it is unfortunate that records of the Romsley school in John Underhill's time are no longer extant, it seems unlikely that the question of Caslon's education can ever be carried beyond conjecture.

[1] Defoe, Tour through the Whole Island of Great Britain.
[2] Amphlett, A Short History of Clent, 1907.
[3] Ibid.
[4] Somers, Halas, Hales, Halesowen, p. 82.
[5] History of Wolverley Sebright School.
[6] Churchill parish register.
[7] Ibid.
[8] Somers, Halas, Hales, Halesowen, p. 110.
[9] Inf. courtesy of A. J. Perrett.

[10] Churchill parish register.

[11] Somers, Halas, Hales, Halesowen, p. 82.

[12] Nash, Vol. I, p. 520.

[13] Burley, History of King Edward's School, Stourbridge, 1948.

[14] Pedmore parish register.

[15] Nash, Vol. I, p. 520.

[16] Ibid.

[17] Halesowen Free School Account Book.

[18] Over Areley parish register.

[19] Churchill parish register.

[20] F. W. Willmore, History of Walsall, 1887.

[21] Somers, Halas, Hales, Halesowen, p. 82.

[22] Nash, Vol. I, p. 522.

[23] Halesowen parish register.

[24] Harris, History and Antiquities of Halesowen, 1836.

[25] Amphlett, A Short History of Clent, 1907.

[26] Alumni Oxonienses.

[27] Experience in the use of Foster's list of Oxford graduates shows that it is sometimes in error. Pembroke College itself has not been able to supply an explanation .

[28] Worcester Diocesan Collection.

[29] Curate of Sarnesfield, near Weobly, co. Hereford; see Sarnesfield parish register published by the Parish Register Society, 1898. (Woodin's case is an instance of the far-flung influence of the principal iron-masters, of whom Wheeler was one). Chancery Proceedings—Hamilton: Before 1714, Bundle 567, No. 1 (P.R.O.).

[30] Mrs F. F. Milward-Oliver, Memoirs of the Hungerford, Milward and Oliver

[31] Families, privately printed, 1930, p. 97.

[32] The book abounds in errors: Grimbey should read Grimley, co. Worcester, and Bicknell should read Bickenhill, co. Warwick, a connection mentioned later.

[33] Nash, Vol. I, p. 520.

[34] Minute Book of the Feoffees.

[35] The White Canons in England, 1951, App. VII, p. 380.

[36] Society of Antiquaries, Prattinton Collections, XVI, ff. 12 et seq.

[37] D.N.B. art. William Shenstone.

Chapter Three

HALESOWEN IN THE WEST MIDLANDS
IRON TRADE, 1650–1720

IT IS DIFFICULT for the people of modern Halesowen, eye-wit-
nesses to a transformation in their surroundings only paralleled
in the building of a completely new town, to appreciate how
much the lives of their forebears in the seventeenth century were
dependent on the iron industry. Most Halesonians derive their
notions of the old town and its inhabitants from the novels of
Francis Brett Young (1884–1954) the doctor son of the town's
former medical officer of health, perhaps qualified by family tradi-
tions of a century or more of misery when the townsfolk were
slowly crushed into realisation that the Stour could no longer serve
as a life-giving artery to local industry. In the time of William
Caslon, however, the Stour and other streams of the district with
their tributaries were the principal sources of power, and in the
course of the previous century, local industry had become in-
creasingly concerned with the exploitation of the mineral wealth of
the district by processes of conversion and fabrication concentrated
on these water courses. It is essential, therefore, if we are to appreci-
ate what Halesowen and the nearby villages were like in and before
Caslon's time, to give some account of the iron industry of the
district.

The gun trade, of the early years of which some account is
given in a later chapter,[1] was only one branch of a wide-spread
concern with manufactures in iron which affected the daily lives
of vast numbers of people in the West Midlands.

Thomas Habington (1560–1647), the early Worcestershire historian, writing of Pensnett Chase in the early years of the seventeenth century, says : 'The inhabitantes, thoughe certaynly descended from Seth, yet follow in professyon Tubal Cain, the inventor of the smythe's hammer ; the rest are myners delving into the bowells of the earthe for our fuell, theyre profytt, and have all of them the reputation of bould-spirited men.'[2]

West Midlanders down the ages have had good cause to realise their descent from Cain, having suffered their full share in his condemnation, 'In the sweat of thy face shalt thou eat bread,' for who sweats more than the worker in iron? The poet Charles McKay (1814–1889) derived some of his inspiration from direct experience,[3] for he was once employed by an ironmaster :

> Old Tubal Cain was a man of might,
> In the days when earth was young ;
> By the fierce red light of his furnace bright
> The strokes of his hammer rung ;
> And he lifted high his brawny hand
> On the iron glowing clear
> Till the sparks rushed out in scarlet showers,
> As he fashioned the sword and spear ![24]

It is no exaggeration to say that the exploitation of the mineral wealth lying under the surface of Pensnett Chase long heralded the Industrial Revolution in the West Midlands. One of the most colourful characters who promoted this exploitation was Dud Dudley (1599–1684),[5] the fourth natural son of Edward Sutton, fifth baron Dudley by his concubine Elizabeth Tomlinson. This 'bastard sone of a lewd collier's daughter,' having been sent up to Balliol College, Oxford, by his noble father, was recalled to manage his father's furnaces and forges on the Chase. The method of smelting the ores was practically the same as had been practised by smiths for many hundreds of years — the ironstone was smelted with charcoal, a process in which the charcoal-burner, or 'wood-collier' was a key-man. An inn on the main road through Bewdley to the Wyre and Far Forests is still called 'The Wood-colliers Arms.' In Dud's time the woodlands had been already denuded of much of the timber needed not only for iron-smelting and glass-making, but also for the ships of the King's navy. Even

as early as the reign of Elizabeth an act was passed for the preservation of timber in Sussex, Surrey and Kent.

In his *Metallum Martis* Dudley says that 'wood and charcole growing then scant and pit-coles in great quantities abounding near the furnace, did induce me to alter my furnace, and to attempt, by my new invention, the making of iron with pit-cole.' Dudley found the quality of his iron 'to be good and profitable, but the quantity did not exceed three tuns per week.' His father obtained for him a patent from the King for fourteen years, but he had many difficulties to contend with, first a disastrous flood which ruined his own and several other ironworks, the envy and misrepresentation of the charcoal iron-masters, the vandalism of workmen and the expenses of litigation.

Later, he renewed his operations at Himley and then, in a larger furnace which he had built at Hasco (Askew) Bridge, Sedgley, Dud Dudley produced what was then the British record of seven tons of pig-iron weekly, and despite financial failure and the disparagement of others, there can be little question that this ingenious and persistent man should be credited with the first successful use of coke for smelting iron ore. But his secret died with him and it was not until about 1738 that the process was perfected by Abraham Darby II of Coalbrookdale, whose father had migrated from the very place where formerly Dud Dudley had conducted some of his experiments.

Before Dud Dudley died at Worcester in 1684 another star had risen in the metallurgical firmament of the West Midlands in the person of John Haydon.[6] At Bromley village on the slope of Pensnett Chase near Wordsley, Haydon was making steel by the cementation process, obtaining his raw material from Sweden and Spain, and if the truth were known, it seems likely that the source of John Haydon's raw material was also the source of the 'cock-and-bull' story which became attached to the names of both Richard Foley and his father-in-law William Brindley of the Hyde, Kinver, concerning the Swedish origin of the slitting mill. It seems far more likely that the cementation process of steel-making, as adapted by Haydon, had a Swedish origin.

Probably John Haydon had some connection with Sir John Haydon, a Lieutenant of the Ordnance under Charles I in 1645,

who gave his name to Haydon Square in the Minories, London, especially as one of the vicars of Kingswinford, Ithiel Smart, M.A., who died in 1692, married Mary, daughter of Robert Haydon of the City of London.[7] In the sixteenth century the Haydons were of The Grove, Watford, Hertfordshire.[8] The Hadens of Rowley Regis were a different family.

It is well known that the Foleys were the greatest family of ironmasters in the West Midlands in the seventeenth and eighteenth centuries. Entries of the name Foley, or Fooley, occur in the Dudley parish registers from 1577. The highest name in the Foley pedigree[9] so far known is that of Richard Fooley (sic), Nailer, whose will was proved at Worcester, March 4, 1600. It mentions his wife Anne, daughter Katherine Robinson, and sons John, Edward, and Richard. Richard was to be sole executor and the overseers Richard Shaw of Dudley and John Fooley. Richard Foley, senior, was buried at St. Thomas's church, Dudley. Richard Foley, the executor of his father's will, was baptised at Dudley in 1580, and as early as 1616 was deemed worthy to fill the office of Mayor of his native town. It was this Richard of whom Sir Simon Degge (1612–1704), the Staffordshire historian, recorded that he was first a seller of nails, afterwards a forgemaster, and a very honest man in Worcestershire.

Richard Foley removed from Dudley to Stourbridge about 1630, when he purchased the manor of Bedcote from Nicholas Sparry, who had bought it in 1626, and the first entry of a Foley in the Oldswinford registers is the baptism in 1631 of his youngest son John. Richard Foley married twice, his first wife being Ellen Henzell. It is uncertain whether she was one of the family of Enzell, or whether Henzell was a corruption of Henzey, the well-known family of Lorraine glass-makers. By his first wife he had a son Richard, of Longton, in Staffordshire, who died without surviving male issue. His second wife was Alice, daughter of William Brindley of the Hyde, Kinver, himself an 'ironmonger.' It is in some of the ten children of his second marriage that industrial and social historians are particularly interested, for here in a single generation was made a romantic fortune from the iron trade, a fortune that founded the great family seats of Witley, Worcestershire, Stoke Edith, Herefordshire, and Prestwood, Staffordshire.[10]

Most people are familiar with the story of 'Fiddler' Foley, the name by which Richard is best known, as told in Samuel Smiles's *Self Help*.

'Fiddler,' an excellent player on the violin, being moved by a serious decline in the nail trade, said to be due to the Swedes having discovered an improved method of slitting iron for nail rods, determined to solve the problem. Suddenly disappearing from his usual haunts and taking his violin with him, he made his way to Sweden and, posing as a harmless wandering musician, he fiddled his way into the ironworks where, acting the part of a fool, he took every opportunity of observing the working of the slitting mill. Returning to this country and backed by a member of the Knight family and another person, he attempted to set up a machine similar to that he had seen working in Sweden. However, his observations proving faulty and the machine failing to work, Foley once again crossed the seas and, fiddling his way to the ironworks as before, was welcomed with open arms by the Swedes. This time Foley made his observations more thoroughly, and returning home again, by his discovery laid the foundation of his fortune. Another account says it was William Brindley of the Hyde, Kinver, Richard Foley's father-in-law, who made the journey to Sweden, but in either case, it is regrettable that such a story of industrial espionage should be presented by Smiles or any other writer as an enterprise worthy of emulation.

Rhys Jenkins stresses the fact of the matter, as hard as cold iron, in an address to the Newcomen Society in 1928, viz., that a slitting-mill was at work under patent at Dartford in Kent as early as 1599. In Foley's time it was still at work and the patent still in force.

W. H. B. Court[11] states that the slitting machine under this patent was being used illegally, Richard Foley being one of the offenders, his operations presumably marking the introduction of the slitting-mill to the Midlands. In short, 'Fiddler' Foley seems to have really earned his nickname by his pirating of the slitting-mill patent more than by his skill as a violinist.

A contemporary historian[12] observed 'Slitting Mills as they are now exercised in their perfection, the improvement whereof we shall find very great if we look back upon the methods of our ancestors- - - not to mention again the vast advantage they have from the new invention of Slitting Mills

for cutting their Barrs into Rodds above what they had anciently.'

In earlier times the only way to make iron nailrods was to heat the bars in charcoal fires and then cut them by hand with a kind of chisel, a very tedious process. As early as 1619 'John Wyeldsmith of Stourbridge, Slitter of Yron,' was indicted for stealing a sheep and two loins of mutton at Stourbridge.[13]

It will be easily understood how busy Foley would be at the outbreak of the Civil War in supplying armaments from his furnaces, mills and forges at the Hyde, Kinver, Caunsall and elsewhere, and there can be no doubt of the importance of the Foley enterprises in the national economy in the second half of the seventeenth century.

Richard Foley died in July, 1657, and was buried in front of the chancel steps in Oldswinford Church.

By his will he left to Robert Foley his son, Mr Taylor, Minister, Thomas Dudley, and thirteen others the school house he had built in Dudley for the use of the Schoolmaster at the Grammar School, and also made provision for the eight almshouses for the poor of Dudley in which he was interested. To the Governors of the Free Grammar School in Stourbridge he bequeathed £20 to be 'yearly lett out to foure or more poore younge beginners of the said Towne att twelve pence per pound, they and every of them giving good and sufficient security unto the said Governors for payinge in of the same att the yeares end, the money to be disbursed yearly att or upon every Easter even.' The overseers were his sons Thomas and Robert, and his sons-in-law Edward Dyson and Henry Glover. The will was attested by Daniel Tittery, John Plimley, Thomas Jukes and Roland Alport. Testator's beloved wife Alice was made sole executrix. The will states that he has already made provision for his sons Thomas and Robert, by which it is understood they were succeeding to his ironworks and slitting mills. It also mentions the 'mansion' in the High Street of Stourbridge wherein he then dwelt and which he bequeaths to his son John and failing issue to his son Samuel. This house,[14] called in a later document 'the Brickhouse,' still stands, greatly altered, of course, and well-known as the Talbot Hotel.

Richard Foley's second son Thomas was perhaps the most notable of all the family, though Samuel became Bishop of Down and Connor in Ireland. There are many contemporary references[15]

45

to Thomas Foley, and to his extensive contracts with the Navy, and it can be safely assumed he had substantial backing from his father, old 'Fiddler' Foley. Thomas Foley was reputed to have an income of £5,000 a year, an enormous sum for those days. He was a great friend of Richard Baxter, who speaks of him as a religious faithful man who purchased the patronage of several great places, among them Stourbridge and Kidderminster, and chose the best conformable ministers for them.

Samuel Pepys in his *Diary*, under date 10th June, 1668, tells how Thomas Foley had been at Christ's Hospital, 'to see how their lands were settled,' obviously having in mind the Hospital he founded in 1670 at Oldswinford for 60 poor boys. Thomas Foley's London house was in Austin Friars. He died in 1677 and was buried at Witley.

Thomas's brother, Robert Foley senior (1626–1676) was also early engaged in the iron trade. He was appointed Ironmonger to the Navy Office in 1660 by James, Duke of York, and Robert Foley, junior, his son, by James II in 1686. The younger Robert Foley was for a time one of the Commissioners of the Navy Office, but was doubtless forced out of office when, following the 'bloodless revolution of 1688,' William and Mary replaced James II.[16]

Pepys has five references to the Foleys, one of which, Thomas Foley's visit to Christ's Hospital, has been already noted. Although Lord Braybrooke[16] ascribed all five references to Thomas Foley, it seems more likely that the entries concerning Foley, the ironmonger, first entertaining Pepys and his friends to a good plain dinner at the Dolphin 'but I expected musique, the missing of which spoiled my dinner,' next, to delivering an iron chest 'to pay for it, if I like it,' as Pepys naively puts it, then to Foley's coming with a box of carpenter's and joiner's tools, 'which please me mightily; but I will have more,' and finally, £50 worth in locks and keys which Lord Brouncker had from 'Foly the ironmonger,' refer to Robert Foley. The connection of the two men with the Navy probably brought them into contact.

Robert Foley married Anne, second daughter of Dudley, Lord North. Both were buried at Oldswinford, and there is a tablet to their memory near the roof in the chancel.

Robert Foley left his 'well beloved wife Elizabeth' £50

per annum from the rents of his properties in Dudley, charging his son Robert to take care that the rents were duly paid. She was also to have 'all the cloathes wearing Apparell Jewells and other ornaments which she hath or usually weareth or useth.' He remembered the poor of Dudley and Stourbridge, the minister of Oldswinford Church, and his own household servants. He made his son Robert sole executor and heir to his personal estate, and if his debts could not be met otherwise they were to be discharged out of the rents of the manors, lands, etc., bequeathed to Robert. There were difficulties and litigation over the execution of the will, but these need not be enlarged on here.

After the death of Robert Foley the elder a new contract with the Navy Commissioners became necessary, and this was made by Robert Foley the younger on September 10th, 1677.[18]

It is worthy of note that in 1698 five Foleys were elected to Parliament, Paul Foley Esq., Philip Foley Esq., Thomas Foley Junr. of Witley, Esq., Thomas Foley Junr., Esq., and Thomas Foley of Stoke, Esq.

Another Stourbridge ironmaster, Ambrose Crowley, a Quaker, in 1688 granted by indenture the Friends' Meeting House and Burial Ground at Stourbridge for one thousand years at a pepper-corn rent. He engaged largely in the iron trade of the district and raised a considerable fortune. The name occurs frequently in the parish registers of Harborne, Rowley Regis and other places in the West Midlands and in the register of the Society of Friends at Stourbridge. He established works and a warehouse for his ironmongery in Thames Street, London, and his fortune was inherited by his son, Sir Ambrose Crowley, who was Sheriff of London in 1706–7. Sir Ambrose is said to have been the 'Jack Anvil' *alias* 'Sir John D'Enville,' of *The Spectator*; his daughter Elizabeth in 1725 married John, 10th Lord St. John of Bletshoe.[19]

For many years the Crowleys had the most extensive ironworks on the Tyne, at Swalwell, Winlaton, and other places where, besides employing hundreds of smiths on implements for husbandry, spades, mattocks, hoes, etc., they forged anchors of vast size and, in course of time, chain cables for our naval vessels and East Indiamen. The buildings of Crowley's works lasted until

the advent of this century, when there still remained at Swalwell an ancient sun-dial on the wall of the old moulding shop, and a stone slab beneath it, bearing the inscription 'Ambrose Crowley, Anno 1713,' the year Sir Ambrose Crowley died.[20]

The two Ambrose Crowleys, father and son, maintained contact with the West Midlands, particularly with Stourbridge, and it is interesting to note that they apprenticed no less than eight of the boys from Thomas Foley's Hospital at Oldswinford in their Thames Street premises.[21]

The advantages of the Stour Valley as an iron manufacturing district were considerable in the seventeenth and eighteenth centuries. Abundant water power was there for all types of iron-works, whether for producing blast in the furnaces, for lifting tilt-hammers in the forges or for turning rolls and cutters in the slitting mills. For the furnaces iron stone was plentiful, and for furnaces and forges the charcoal resources within economic reach seem to have been adequate for the works in operation at the end of the seventeenth century. Coal, too was readily available for those forge and mill processes which could use it. There was thus a combination of favourable circumstances promoting the remarkable concentration of ironworks, particularly forges, on the Stour, so often commented upon by later topographers.

Although accurate information regarding the conditions prevailing in a particular parish at the turn of the seventeenth century is difficult to obtain there can be little doubt that Hales-owen and many other places shared in the general prosperity of the West Midlands during the exploitation of the mineral re-sources of the area and while the river Stour remained the principal source of power. B. L. C. Johnson[22] draws attention to two valuable sources of information : (a) Surviving ironworks account books formerly in the possession of Major H. T. H. Foley, J.P., (b) MS. (The Cradley Deed) : Dudley Reference Library.[23]

These sources reveal something of the activities of some Stour Valley ironmasters who in 1692 formed a consortium which controlled the greater part of the iron trade of the Stour Valley. The partners were John Wheeler of Wollaston, Richard Wheeler, Richard Avenant of Shelsley, Paul Foley of Stoke Edith, Hereford, and his brother Philip Foley of Prestwood, Staffordshire. John

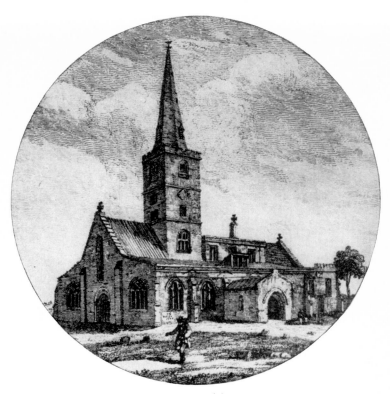

PLATE I(a)

Halesowen Church.
From an engraving by Benjamin Green, circa 1780

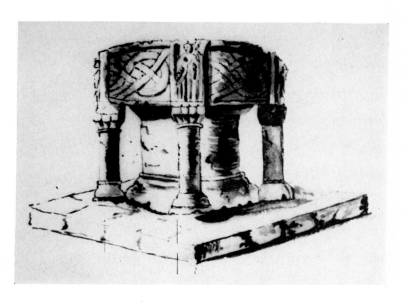

PLATE I(b)

Saxon Font in Halesowen Church at which William Caslon was baptised.
From a water-colour sketch by James Green, 1749,
in the possession of the Society of Antiquaries

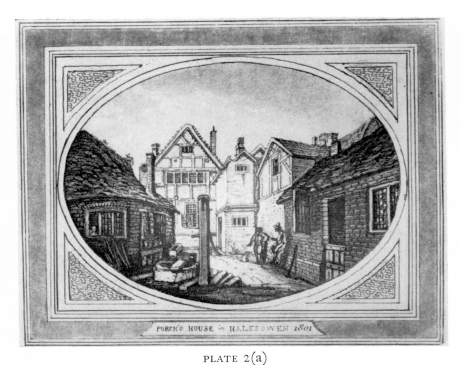

PLATE 2(a)

The Porched House: View in Halesowen in the eighteenth century.
From an engraving by Benjamin Green

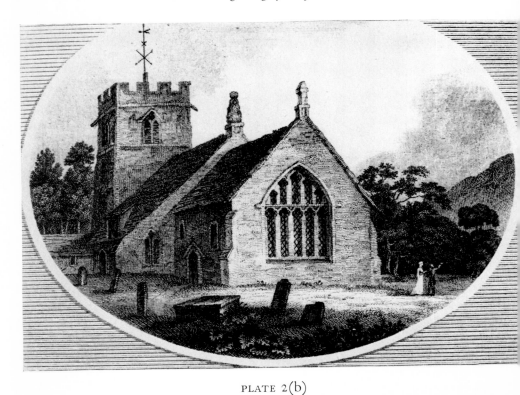

PLATE 2(b)

Clent Church, where Caslon's first wife was baptised and buried.
Engraved from a drawing by David Parkes, 1802

Wheeler, who acted as managing director, had interests in common with Philip Foley in other iron-making concerns in North Staffordshire, Nottingham and Derbyshire.

The ironworks controlled by the partnership in 1692 comprised furnaces, forges and slitting mills. The more important group of blast furnaces was situated in the Forest of Dean, but contributed a large proportion of its pig iron output to the Stour forges. In the Stour Valley was Halesowen Furnace and on a headstream of the Smestow Brook near Tettenhall stood Grange Furnace. The forges were all on the Stour—Wilden, Upper and Lower Wolverley, Cookley, Whittington, Stourton and Cradley—as also were the slitting mills, at Cookley, Wolverley, Wilden, and Cradley. In addition to these manufacturing units, Bewdley storehouse was an essential element in the organisation. The consortium is a remarkable early instance of a wide-spread but closely knit industrial organisation.

Pig iron was the chief product of the Stour furnaces, though castings were also made. Grange Furnace concentrated on supplying pig iron to the partnership's Stour forges, to Stourton, Whittington, Cookley and Wolverley Upper Forges. Halesowen pig had a wider market, including Wilden and Whittington Forges, but more went to the Tame Valley Forges of John Jennens at Wednesbury, Bromwich and Little Aston, to Zachary Downing at Cradley, and to John Soley, probably at Mitton. Pig from these works rarely travelled beyond the region, unlike certain of the cast iron manufactures. Heavy hammers and anvils, the machine tools of the forge master, were dispatched far and wide, from Halesowen and Grange to the Forest of Dean, Pembrokeshire and North Staffordshire, as well as to many places nearer at hand. Other castings of a more domestic nature—firebacks, stoves, smoothing irons—found a local market. Rolls for slitting mills went to the partnership's works, to Thomas Brindley of the Hyde, to John Cooke of Stourton and to mills in North Staffordshire, while cast plates were in demand for the working floors of furnaces, finery forges and mills, and for the hearths of chafery forges.

By contemporary standards Halesowen and Grange furnaces were of average size, Halesowen casting about 470 tons a year and Grange between 500 and 600 tons. The average output, however, depended to a large extent on seasonal factors such as heavy rains and hard winters, easily

49

understood when the primitive transport facilities by river and overland are considered. The wear of furnace linings and unforeseen accidents made a blow of 30 weeks in the course of a year seem satisfactory.

The proximity of coal had a considerable effect on the cost of production, effecting economies in the use of charcoal, and in 'drawing out' Ordinary Mill Bar in the chafery forge coal was used exclusively. The saving was greatest at Cradley Forge where the pits were quite near at hand.

By far the greater part of the output of the Stour Valley forges was bar iron, most of which was destined to be slit into rods for the characteristic manufacture of the area, the chief of these, of course, being nails. In 1692–3, 300 tons of bar iron including 48 tons from Shelsey and 28 tons from Thomas Jukes's forge at Strangeworth, near Kington, were sold to 90 customers.[24]

Halesowen men had a considerable hand in getting the raw materials for the ironmasters. Ironstone, limestone and charcoal were the common ingredients at Grange, Halesowen and Cradley and the Cradley Deed gives some details of the locations from which the mineral raw materials were drawn. Lord Ward of Dudley Castle granted John and Zachary Downing of Halesowen 'liberty to enter into and upon the waste ground called Amblecoat or the enclosure there made ... to dig and sink pitts, dig, get, draw and lay upon the premises, load, take and carry away . . . one thousand loads or blooms of ironstone yearly.'[25] Many of the places named in the Cradley Deed can be recognised today. It is probable that Halesowen and Grange Furnaces had other sources of ironstone as well, but the fact that they purchased their requirements from John Downing suggests that the Amblecote area may have contributed to them. The Cradley Deed includes an inventory of stock, dated 1724, in which several sources of ironstone are mentioned, including besides Amblecote, Darlaston, Coneygree (Tipton), Broadhurst and New Park. Later records for Halesowen Furnace show Wednesbury, Darlaston and the Dudley area as the principal sources.

Limestone was not used in very large quantities, but here again the Downings of Halesowen had a hand in supplying it. The most obvious source was the Wenlock Limestone of the Silurian inliers at Sedgley, Wrens Nest and Dudley Castle Hill,

confirmation of this source being found in the Cradley Deed, by which the Downings could take 'sufficient limestone . . . to be used . . . about any two furnaces where John and Zachary Downing should please, not exceeding three dozens in a week (one week with another) the same being the Chattle or Offall of his (Lord Ward's) store, and to be taken . . . in the grounds . . . called Cunningree (Coneygree) and the Old Park in the Parish of Dudley or Sedgeley.'[26]

Mention should also be made of the Sandstone of Himley which was in regular use for relining the furnaces at Cradley, Halesowen and Grange. The 'boshes' and hearth had to be renewed at least once yearly on the 'blowing-out' of the furnace, as it was in these lower parts of the furnace 'cave' that the heat was greatest and the walls suffered the most wear.

Iron ore (usually previously calcined), limestone, and charcoal were at that time the necessary ingredients in smelting in the blast furnace and something has been already said about the supplies, sources from as far distant as 10–20 miles from the Stour, such as Abberley, the Wyre Forest, and around Bridgnorth, having to be drawn upon. At Halesowen Furnace in 1704–5 charcoal constituted 71 % of the costs, ironstone 22 %. The wide area over which the Downings exercised their privilege under Lord Ward is illustrated in an item in the Grange Furnace (Tettenhall) accounts for the year 1692–3 :—

'Mr Downing a year's salary. . . £60—0—0'.

There are numerous entries of the name Downing in the Halesowen register but only a few which obviously relate to John and Zachariah Downing of 'the furnace.' In September, 1677, Zachariah Downing and Sarah Harrison were married at Frankley but entered only in the Halesowen register. At Rowley Regis a north gallery was added to the church in 1699 by Zachariah Downing, John Parkes, Henry Haden and John Turton for themselves and their tenants and in 1697 and 1698 Zachariah Downing was a church warden at Halesowen.

Owing to defects in the Halesowen register, the baptism of only one son of John Downing, senior, 'of the furnace,' is recorded :

'Aug. 1669—James, son of John and Marie Downing baptised.'

However, the issue of this James Downing provides a most interesting line of descent, as shown in the attached pedigree.[27] The Hagley register records in 1688 the marriage of James Downing of Halesowen and Bridget, daughter of Mr William Bowles of Hagley. William Bowles seems to have had some political or business connection with the Lytteltons and he and his wife Bridget became established at Hagley at the time of the Restoration. Their daughter, Mary, in 1681 married Thomas, the son of Thomas Nash of Clent, a family dating back to the earliest part of the Clent register in the 1560's, and for a long period prominently associated with scythe making. Bowles Nash, the son of Thomas Nash and Mary Bowles, was married at St. Matthew Friday Street, London, at the time William Caslon was making a name for himself and, as we shall see, there was no lack of other connections between London and the Halesowen district. William Bowles junior in 1687 married Abigail, daughter of the Rev. George Southall, rector of Pedmore and Enville. It was through this relationship that the advowson of the rectory of Enville passed to the Downing family. There was another son, Henry Bowles, senior to William, whose name does not occur in the Hagley register, but who was schoolmaster at Stourbridge for a short time. Nash[28] refers to the scholastic abilities of the brothers William and Henry Bowles.

We have seen earlier that the Foleys invested their business profits in the purchase of landed estates, the lordship of several manors, and the advowsons of church livings. Several members of the Foley family later enjoyed these benefices and even when the incumbent did not bear the Foley name, he was frequently a relative, or was prefrerd because he was a friend of the family or had some business connection with it.

In the same way the pedigree of the Downings, stemming from John Downing 'of Halesowen furnace,' indicates several of his descendants as incumbents of Enville and nearby parishes. In September, 1696, 'John Downing ye younger of ye furnace' was buried and in July, 1699, his father 'John Downing de ffurnice' was buried.[29]

In the next chapter we shall see to what extent the iron industry and other occupations of the inhabitants of Halesowen

in and before the time of Caslon are traceable in the parish register, with the object of showing more clearly the background from which the typefounder sprang and providing more information regarding the families and individuals with whom he was acquainted. Yet it is already clear that in the seventeenth and eighteenth centuries Halesowen was one of the important iron-smelting centres of the West Midlands and it follows that the existence of 'Halesowen furnace' gave a strong bias to the local industries.

[1] See Chapter 6.
[2] Quoted by D. R. Guttery, The Story of Pensnett Chase, 1950.
[3] D.N.B. art. Charles McKay.
[4] Mrs Valentine, Gems of National Poetry.
[5] D.N.B. art. Dud Dudley.
[6] D. R. Guttery, The Story of Pensnett Chase.
[7] Nichols, History and Antiquities of Leicestershire, p. 636.
[8] Clutterbuck, History of Hertfordshire.
[9] H. E. Palfrey, Foleys of Stourbridge, 1944. Trans. Worcs. Archaeological Society.
[10] Ibid.
[11] The Rise of the Midland Industries, 1938.
[12] Plot, History of Staffordshire, 1686.
[13] Willis Bund, Quarter Sessions Papers, Worcs. Hist. Society.
[14] Chan. Procs., Hamilton, 482/61, Jan. 19, 1671–2.
[15] State Papers Domestic.
[16] H. E. Palfrey, Foleys of Stourbridge.
[17] Editor of Pepys's Diary.
[18] H. E. Palfrey, Foleys of Stourbridge.
[19] H. S. Grazebrook, Heraldry of Worcestershire.
[20] 'Evening World,' 14 Aug., 1929. (Circulating in Gateshead and Newcastle region)
[21] Admissions & Bindings Register, Oldswinford Hospital.
[22] The Stour Valley Iron Industry in the late seventeenth century. Trans. Worcs. Arch. Society, 1950.
[23] Dudley Estate Collection, Bundle 7, Box 5.
[24] B. L. C. Johnson, The Stour Valley Iron Industry.
[25] Ibid.
[26] Ibid.
[27] Chart 3 appended to this chapter.
[28] Nash, Vol. I, p. 507.

[29] Whilst any information derived from the parish register is valuable in its contribution to knowledge of parish history, the results are often fragmentary unless supplemented by similar information from neighbouring parishes. The foregoing view of the Stour Valley industries shows that comprehensive searches must be made over a wide area if worthwhile results are to be obtained.

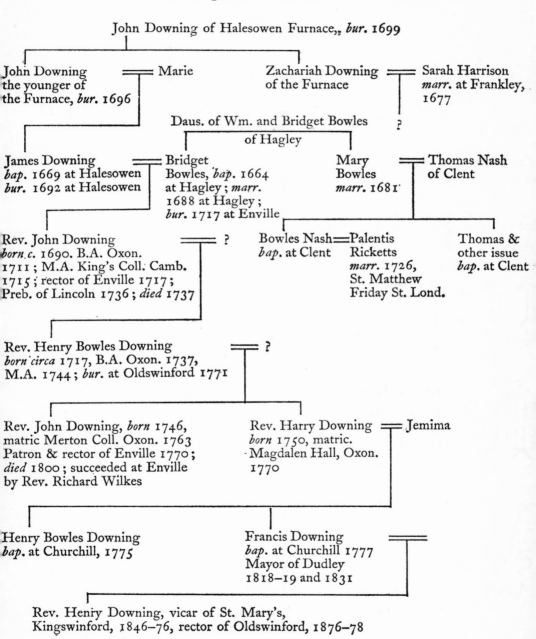

Chart 3.
The Downings of Halesowen Furnace

John Downing of Halesowen Furnace,. *bur.* 1699

John Downing
the younger of
the Furnace, *bur.* 1696 ══ Marie

Zachariah Downing
of the Furnace ══ Sarah Harrison
marr. at Frankley,
1677

?

Daus. of Wm. and Bridget Bowles
of Hagley

James Downing
bap. 1669 at Halesowen
bur. 1692 at Halesowen ══ Bridget
Bowles, *bap.* 1664
at Hagley; *marr.*
1688 at Hagley;
bur. 1717 at Enville

Mary
Bowles
marr. 1681 ══ Thomas Nash
of Clent

Rev. John Downing ══ ?
born c. 1690. B.A. Oxon.
1711; M.A. King's Coll. Camb.
1715; rector of Enville 1717;
Preb. of Lincoln 1736; *died* 1737

Bowles Nash══Palentis
bap. at Clent Ricketts
marr. 1726,
St. Matthew
Friday St. Lond.

Thomas &
other issue
bap. at Clent

Rev. Henry Bowles Downing ══ ?
born circa 1717, B.A. Oxon. 1737,
M.A. 1744; *bur.* at Oldswinford 1771

Rev. John Downing, *born* 1746,
matric Merton Coll. Oxon. 1763
Patron & rector of Enville 1770;
died 1800; succeeded at Enville
by Rev. Richard Wilkes

Rev. Harry Downing ══ Jemima
born 1750, matric.
Magdalen Hall, Oxon.
1770

Henry Bowles Downing
bap. at Churchill, 1775

Francis Downing
bap. at Churchill 1777
Mayor of Dudley
1818–19 and 1831 ══

Rev. Henry Downing, vicar of St. Mary's,
Kingswinford, 1846–76, rector of Oldswinford, 1876–78

Chapter Four

CASLON'S BIRTHPLACE AS SEEN IN THE PARISH REGISTER, 1650–1720

THE INFORMATION ABOUT a parish and its inhabitants entered in the registers in earlier times depended wholly on the vocational spirit of the incumbent and parish clerk. It is well known that most parish registers are defective during the Civil War years, and those of Halesowen are no exception, there being no entries for the ten years 1643 to 1653. However, Edward Paston, who served the parish as minister and registrar during the Commonwealth times, actually from 1653 to February, 1661, kept the registers most conscientiously and neatly. Unfortunately, his successor, John Westwood, son-in-law of an earlier vicar Thomas Littleton, and brother-in-law of the English-Latin lexicographer Adam Littleton (1627–1694) neglected his duties most shamefully, for there are complete gaps in the entries from June, 1666, to January, 1668, and from October, 1671, to April, 1676. These successive gaps in the register are a serious obstacle to compiling accurate records of Halesowen families in the seventeenth century and sometimes, even with the help of probate records, it proves impossible to trace lines of descent with certainty.

In general it was not until Lord Hardwicke's Marriage Act of 1755 that marriage entries followed a prescribed form providing for the signatures (or marks) of witnesses, and it was not until George Rose's Act of 1812 that separate books were prescribed for baptisms, marriages, and burials, in which the entries were to

be made on printed forms requiring additional information such as the abodes and descriptions of the parents in baptismal entries, and the age and place of abode of the deceased in burial entries.

In the early years of the eighteenth century, the Downings were succeeded at Halesowen furnace by another ironmaster Clement Acton, son of Thomas Acton, of Gatacre Park, Salop, by Mabel, daughter of Clement Stonor of London, and grandson of Sir Edward Acton of Aldenham, first baronet. The family and connections of Clement Acton are shown in that monumental work *The Reades of Blackwood Hill and Dr. Johnson's Ancestry*.[1] In 1699 Clement Acton married at Pedmore, Mary, daughter of Gregory Hickman of Stourbridge, clothier, whose widow remarried Dr. Joseph Ford, uncle of Dr. Samuel Johnson, the great lexicographer. Clement Acton's first-born is entered in the Kinver register in February, 1701 :

'Thomas, son of Mr. Clement Acton and Mary his wife born,'

suggesting that Clement Acton gained some experience in the Kinver or Whittington ironworks before taking charge of the Halesowen furnace. Clement Acton then had four sons and two daughters baptised at Halesowen between 1704 and 1720. His second son, Clement, described as of Coombs, Halesowen, married Jane (his cousin), daughter of John Whitmore, of Ludstone, Claverley, Salop, and it seems probable that the house at Coombs was in the Holloway on the Gorsty Hill side of the Stour where it is known that an interesting half-timbered house survived until the early years of this century. The graves of several of the Actons are at Tasley, near Bridgnorth.[2]

Another instance of a connection between the church and the iron trade occurs at Halesowen where Thomas Jukes was vicar from 1696 to 1719. The witnesses to the will of old 'Fiddler' Foley in 1657, included one Thomas Jukes and we have seen that the Jukes family operated ironworks at Strangeworth, near Kington, Herefordshire, in the latter part of the seventeenth century. The family, however, had been established in the manor of Wolverley as early as the fifteenth century.[3] During the Commonwealth and King Charles II's time, the water corn mills in the manor were converted into forges and iron mills.[4]

'All that Water Corn Mill lately erected and built by sd. Samuel Jewkes in and upon the heath or wast, belonging to their Manor or Lordshippe of Wolverley, co. Worcester, and also the pools, springs, water-courses there which do run into, and drive the sd. Mill, etc., to have and to hold the sd. Water Corne Mill for a term of 21 years - - - Not to demise, grant, assign, any part of sd. Mill, etc., except to his wife, child or children without special licence, and consent of sd. Dean and Chapter in writing, under their common Seal, etc.'

One mill, called 'Sleepy Mill,' near Island Pool, was situated on the highway from Kidderminster to Dudley and Wolverhampton, and included four pools with water course in continuation before arriving at the Mill.

Grazebrook[5] informs us that Samuel Jukes, of Wolverley, married Frances, daughter of William Talbot, of Whittington Hall, Worcestershire, and of Stourton Castle, Kinver, sister of William Talbot, Dean of Worcester, who became successively Bishop of Oxford, then of Salisbury, and finally of Durham, who was himself much concerned with mining rights and leases. Talbot Jukes, son of Samuel Jukes and Frances Talbot, was Serjeant-at-Arms in the reigns of Queen Anne and George I and in 1696 had a residence at Kinver.

According to Joseph Foster,[6] Thomas Jukes, vicar of Halesowen from 1696 to 1719, was the son of John Jukes (described as of Bridgnorth at the time of his son's matriculation), but there can be no doubt that the vicar was connected with Samuel Jukes of Wolverley, for the latter's brother-in-law, William Talbot, the future bishop, was Dean of Worcester when Thomas Jukes was presented to the Halesowen living. However, Foster records another Thomas Jukes, also described as the son of John, but of Whittington, co. Stafford, and it is this Thomas who is more probably to be identified with the vicar of Halesowen; he was baptised at Kinver on 6 August, 1668, as the son of Thomas Jukes by his wife Elizabeth Moseley. In the Kinver register, in addition to the above-named Thomas Jukes, wife Elizabeth, and graduate son Thomas, there are also his grandson Thomas, other grandchildren, and three great-grand-daughters.

In 1710 the Halesowen register records the marriage of the vicar's daughter:

'John Coleson and Sarah Jukes were married Feb. 12.'

We identify a son of this marriage in 1772 as a member of the Society for the Encouragement of Arts, Manufactures and Commerce ; the entry reads :

'Mr. Jukes Coulson, Iron Merchant, Thames Street,'[7]

In 1728 a certain Thomas Jukes, an ironmaster, nephew of the Halesowen vicar, appears in the list of bankrupts, and immediately afterwards we find another ironmaster, Anthony Deane, at the Whittington Slitting Mill. He was a connection of Sir Anthony Deane, the noted ship-builder in the time of Charles II, associate and friend of Samuel Pepys. Deane had married Susannah, daughter of Francis Clare, of Caldwell Hall, Kidderminster, who also had a residence at Clent. In the Kinver register we find the following entries :

'7 Oct. 1724—Anthony, son of Anthony Deane, Esq., and Susannah bapt.

17 April 1728—Frances Eleanor, dau. of Anthony Deane, Esq., and Susannah bapt.'

Anthony Deane senior, besides operating at Whittington, extended the range of his iron-mongery and later had business transactions with Matthew Boulton, senior, of Soho. He was also in business with the Knights of Lea Castle, Wolverley, descended from Richard Knight, of Castle Green, Madeley, Salop,[8] who acquired a fortune in the iron trade during the Commonwealth, operating mills on the Stour at both Kinver and Whittington. In 1747, Samuel, son of Talbot Jukes, surrendered his properties (copyholds) in Wolverley, to Edward Knight, of Wolverley, ironmaster.

Edward Knight, junior, of Wolverley and of Portland Place, London, and Anthony Deane, junior, of Hagley, and later of East Bergholt, Suffolk, and of Bath, who married one of the Whitmores of Apley, near Bridgnorth, were close friends, and the last-named being nephew and heir to Francis Clare at Clent brought the two young men into frequent touch with Halesowen people and places, and through their literary and artistic interests they became acquainted with William Shenstone, poet and landscape gardener, of the Leasowes, Halesowen, in whose letters they are frequently mentioned.

Shenstone's estate was situated on that very stream which gave wealth to the forge-masters and a livelihood to the artisans they employed. In a letter to his friend the Rev. Richard Graves, dated May 20, 1762,[9] suggesting to him a subject for poetry, Shenstone says, 'There is a subject here, which I would recommend to you, if by so doing I should lay you under no restraint. It is my principal cascade. Its appearance well resembles the playfulness of fancy; skipping from side to side, with a thousand antic motions, that answer no other purpose than the mere amusement of the proprietor.—Other similitudes, etc., would here occur: "Cuienim nascenti faciles arriserunt Musae, etc." It then proceeds a few hundred yards, where it rolls and slits iron for manufactures of all kinds; resembling the graver toils of manhood, either in acquiring money, or furnishing the conveniences, comforts, or ornaments of life: and, in this manner, it proceeds, under the name of The Stour, supplying works for casting, forging, and shaping iron, for every civil or military purpose. Perhaps you may not know that my rills are the principal sources of this river; or that this river supplies more ironworks than almost any single river in the kingdom; for so my friend Mr. Knight told me.'

Most of the incumbents of Halesowen made their entries in the registers with such brevity that only a few of the names add anything to local history. The periods of office of Edward Paston (1653–1662), Francis Pierce (1676–1682), and Thomas Jukes (1696–1719) are a little more informative and by combining the information with that in other records, it is possible to glean some idea of the activities, occupations and characteristics of the inhabitants.

Nailers are mentioned as early as the sixteenth century and in the Commonwealth period they are recorded more frequently than men of any other occupation, and as at this time the term nailer is to be construed to mean a man working on his own account and employing out-workers, both men and women, one gains the impression that the place was becoming prosperous. These men were probably small masters working at and from their own premises, but not nailmasters such as we meet in later times, who employed more hands and had erected warehouses in which to store their nail rods and finished goods. In 1703, 'Thomas Shenstone, nayler,' a relative of the poet, was buried.

Blacksmiths, too, are mentioned, who supplied saddlers' ironmongery, horse-tracery, and ironwork for agricultural and other uses; blacksmiths must be distinguished from smiths doing work for the more considerable ironmasters, whose workers were generally anonymous except for specialists such as 'Samuell the Smith de Cradley Forge,' who was buried in 1705 and whose real name was Samuel Newton. It may be presumed that 'Georg Hadley alius Smiter,' buried in 1709, was also employed as a hammer-man in one of the forges. Scythe-smiths were about as numerous as blacksmiths; they devoted their attention almost exclusively to the making of scythes and other edge tools, axes, mattocks, and spades for the agricultural community, the edge-tool trade being distinct from other forms of smith work.

In the early eighteenth century the term ironmonger came into more general use. In 1714, Thomas Cox, ironmonger, of Cradley, was buried. He must have been in a considerable way of business for in 1721 his widow paid tax on nineteen windows. In 1716 both Joshua Male and William Howell are termed ironmongers in the register, the first-named becoming well-known and in 1728 was elected a feoffee of the Free School.

In 1655 John Coley was a locksmith at the small village of Frankley. John Wight, locksmith, was buried at Halesowen in 1678; in 1683 William Robertson and in 1703 Thomas West are termed locksmiths. We cannot be sure what kind of locks these men manufactured, but while locks for doors and household chests were undoubtedly a necessity the demand for these articles in Halesowen itself at that period would be quite small. This sort of evidence suggests that even before 1700 local craftsmen were doing work for such centres of the lock trade as Willenhall, Wednesbury and Wolverhampton. The growth of the gun trade in Birmingham and district suggests also that workers in Halesowen were engaged in the gun-lock trade as early as 1700, and possibly earlier, matters which will be discussed more fully in the two succeeding chapters.

In the period under review it is clear that the occupations of the inhabitants of Halesowen and district were principally related to the metal-working industries and this emphasis remained while industrial appliances continued to be operated by water-power and while the mineral resources of the district were readily available. Caslon's boyhood environment was still changing

61

rapidly due to the drive and initiative exercised by the forgemasters and the rapidly increasing demands of the Birmingham and London markets. Such evidence as is available suggests that the furnaces and forges experienced their greatest activity in the time of Clement Acton about 1720, that the production of cast-iron and merchant bar then declined, being gradually replaced by smaller-scale manufacture of complete units or parts of fabricated articles, the production of nails in their many forms continuing throughout the period. The pattern of the primary industries changed radically, of course, with the new era introduced by Boulton and Watt at Soho later in the eighteenth century.

Turning to other information derived from the Halesowen parish registers, by the end of the seventeenth century there were not many of the rank of yeomen remaining, although husbandry was still a principal occupation in the outer districts of the parish, Hasbury, Romsley, Lapal and Lutley. Richard Prinne 'of Ludley, husbandman,' was married by a magistrate in 1656 and in 1665 became a feoffee of the Free School;[10] Edward Weston, husbandman, occurs in 1657, and George Golden was a husbandman in 1702. In 1682 Richard Parkes, 'cowshewer' and in 1702 William Parks 'thacher' were buried.

Tanning was of some importance in the town. John and William Wight, both tanners, were two of the jurors when an inquisition was held at Halesowen in 1652 to enquire into the disposition of money and land given to charitable uses.[11] William Cookes, tanner, was buried in 1655 and in 1697 entries of the family of Robert Bell, tanner, are written in the register in larger characters. The site of 'The tanpits' passed into the possession of the Free School,[12] and when tanning was given up there late last century, a gas-works was built on the site. Some old half-timbered 'Bark Mill' houses in Cornbow and adjoining the tanpits were demolished about thirty years ago.

Trades associated with tanning were naturally represented in the town. As already noted, in 1654 the grandfather of William Caslon the typefounder 'William Castledowne of the towne and parish of Hales Owen, shoemaker,' was married, and his master, John Carpenter, was a 'cordwainer,' the terms 'shoemaker' and 'cordwainer' being often equated. A cordwainer was a maker of

shoes in Spanish leather (leather from Cordova or Corduba), originally goat-skins tanned and dressed. Perhaps in Caslon's time a shoemaker made little else but shoes, while a cordwainer made a wider range of leather goods such as horse-furniture, aprons, hold-alls, bellows, etc. It is worth noting here that the personal name Cordiven, Cordiwen, Cordiwent, derived from Cordovan, often occurs in the Clent register, and in the form Cordiwent is still current in the district. In 1702 John Foley, 'cordwinder,' that is, cordwainer, occurs, and in 1703 Joshua Brettle 'shoemaker de Ramsley' was buried. When William Caslon's father George Caslon was buried in 1709 his occupation was not stated, but William's apprenticeship indenture styles him 'cordwainer.'

In 1656 John Blicke of Halesowen was a glover, the sheep reared on Romsley hill being an obvious source for his leather. Even in the eighteenth century Romsley was often written Ramsley in the parish register.

In addition to the occupations already mentioned, there are also entries of weavers, mercers (an indication of some prosperity in the town), tailors, bakers, maltsters, a woodcutter, a glazier, a cooper, two brickmakers, and a white smith (probably a tinsmith), all these occurring between 1653 and 1720. There are a few references to the burial of apprentices, but without stating their masters' occupations.

In 1656 Michael Weston of Halesowen, freemason, was married and in 1704 John Brettle, a mason, of Cradley, had a child baptized. In 1703 Ralph Archer, ragman, was buried. At that time a paper-mill was called a 'rag-mill,' but it is difficult to say whether there was a paper-mill locally. Rag-mills were in operation in Birmingham, at Perry Bar, and there was Sir Lister Holte's rag-mill, and another at Hurcott, near Kidderminster.

The names are given of three successive keepers of the pound in which stray cattle were detained until they were redeemed by their owners. After surviving until the period of the second world war this relic of the past was destroyed to make way for modern 'improvements.'

There were so many Hadleys in the town that some were distinguished by the nicknames Shim, King, Nutts, and Fiddler.

63

In 1705 William Parks, alias 'Guy' was buried, another William Parks being known as 'Broad.' In 1708 Henry Phillips of the Courthouse was buried; he may have lived at the Town Hall, built in 1540, across the oak lintel of which was carved the legend 'Fear God and Honour the King,'[13] but more probably he lived at Warley Hall.

In 1657 John Wight the tanner lived at 'The Porchhouse,' named from its porch which was evidently considered an interesting architectural feature, for in the eighteenth century it was the subject of an engraving published by Benjamin Green, Drawing-master at Christ's Hospital, who was William Caslon's half-cousin.

There were at least two lawyers in the town. In 1706, Thomas Tyrer, 'Counsler,' was buried. He was the solicitor to Thomas Foley's Hospital at Oldswinford,[14] and was elected a governor of Birmingham K. Edward's Grammar School in 1681, being connected with a family named Tyrer at Hope Mansel, Herefordshire, a representative of which we find at Wombourn, Staffordshire, and there was another branch at Alvechurch, Worcestershire. In 1705 'Mr. Alan Garway of the Town' was buried. Alan Garway had migrated from the parish of St. Andrew, Holborn, London. at the end of the seventeenth century.[15] He had two sons, Alan and Powle, who were also both in the law. Alan Garway the younger was buried at Halesowen in 1710. It will be seen, therefore, that there was no lack of connections between Halesowen, Birmingham and London in the seventeenth century.

At the time of the Popish Plot some form of voluntary militia seems to have been set up at Halesowen, judging by the following entries in the register:

'1679—William Green "Governour de Rudgeacre" (Ridgeacre) buried.'

'1680—Ann daughter of Adam Haden "de Garrison" by Elizabeth his wife baptised.'

By 1688 Adam Haden was living at Hunnington. Ridgeacre is on the high point of the watershed between Quinton and Weoley Castle, and may have been selected for its commanding position in proximity on the one side to Birmingham and nearby trouble spots, and on the other providing ready access to the centres of

PLATE 3. William Shenstone (1714–1763), poet and landscape gardene
From the portrait in oils by Edward Alcock now in the National Portrait Galler

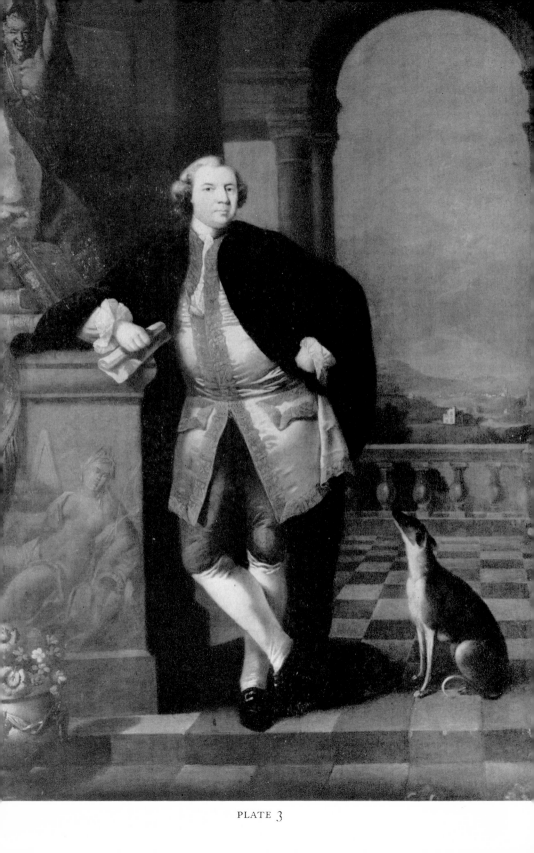

PLATE 3

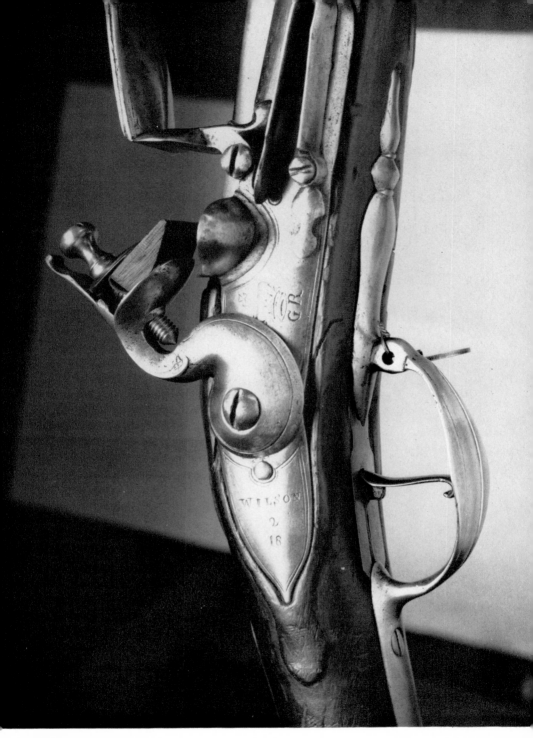

PLATE 4

Lock of a musket engraved in 1718 for the Board of Ordnance.
From 'The Early Career of William Caslon,' by James Mosley, 1967

recusancy in Worcestershire where it was known that papist sympathies ran high.

This is a reminder of another difficulty in documenting the history of the period, for the parish register gives few particulars of papists and dissenters. In the year 1676 Archbishop Sheldon gathered statistics of the inhabitants of all parishes over the age of sixteen, and the form of faith they professed. In Halesowen at that time there were 554 conformists, 3 papists, and 4 non-conformists. The preponderance of conformists is startling, if the figures are to be relied on. As time went on, of course, the proportion of Quakers and other forms of dissent increased considerably, and the identity of the non-conforming section of a community is always difficult for the biographical historian. Parishes near to Halesowen made the following returns : Clent, 160 conformists ; Belbroughton, 500 conformists ; Broom, 31 conformists ; Chaddesley Corbet, 447 conformists, 28 papists, 5 non-conformists ; Hagley, 274 conformists ; Churchill, 28 conformists ; Rowley Regis, then joined to Clent, 420 conformists. The return was made by the minister and churchwardens of each parish. The total population of Halesowen in 1700, estimated by Cox's method, was approximately 1850.[16]

We can give no more than a few further names of families who were busy changing the industrial scene in seventeenth century Halesowen. In 1658 the register records the names of 'John and Alice Wheeler of ye forge,' connected, no doubt, with the Wheelers who later resided at Wollaston Hall, Stourbridge, and Wooton Lodge, co. Stafford,[17] one of whom, John Wheeler, jointly with Henry Glover, Richard Foley's son-in-law, founded a charity school at Red Hill, Stourbridge, the properties of which ultimately passed into the hands of the feoffees of Stourbridge Grammar School, and where the headmaster of that school now resides. At the end of the century, as already stated, John Wheeler and his brother Richard were two of the partners in the West Midlands consortium which largely controlled the Stour Valley iron industry.

In 1659 'John Atwood de furnace' was buried at Halesowen. The Attwoods of Wolverley Court, Park Attwood, and Perdiswell, a very ancient family, possessed an estate at Trimpley and

Wolverley in very early times. Sir John Attwood founded a chantry at Trimpley in Edward III's time, which he endowed with lands in Kidderminster, Wolverley, and Rushock.[18] Abel Atwood, who died in 1726, aged 66, is described as 'the last heir male of that elder house,' but descendants of junior branches of the family occur in many West Midlands parishes. In 1680 at Halesowen 'Edward Atwood senior de le furnace' was buried and in 1704 'Edward Atwood de Furnice' was also buried.

In 1679 John Atwood and Elizabeth Spencer were married at Halesowen, the bride being the daughter of William and Elizabeth Spencer 'of Cradley mille,' the baptisms of whose children appear in the register from the later years of the Commonwealth. William Spencer died in 1670. John Atwood's brother-in-law, William Spencer the younger, in 1676, married at Alvechurch, Elizabeth Penn, sister of William Penn of Harborough Hall, Hagley. The children of William Spencer the younger and of William Penn were thus first cousins. It is well-known that Anne Penn, one of the daughters of William Penn by Mary, daughter of William Tristram of Oldswinford, became the wife of Thomas Shenstone and mother of William Shenstone (1714–1763), the poet and landscape gardener.[19]

John Spencer, the eldest son of William Spencer and Elizabeth Penn, doubtless through the influence of his uncle William Penn, was in 1716 appointed Steward of Thomas Foley's Hospital at Oldswinford,[20] continuing in that office till his death in 1743. Previous writers have stated that when William Shenstone's mother, Anne Penn, died, the future poet being then seventeen years of age, Shenstone's uncle, Thomas Dolman, rector of Broome, who had married Mary Penn, acted as Shenstone's guardian. This is not so. The certificate of guardianship[21] clearly names John Spencer as guardian, but bears the signatures of both Spencer and Dolman.

The pedigree of William Shenstone the poet[22] includes new information on his family, but its usefulness in relation to William Caslon is that it shows how the marriage at Alvechurch of the poet's grandfather, an earlier William Shenstone, to Elizabeth Pearman of Clent, brought that family into closer connection with Halesowen. Although Caslon's master, Edward Cookes, was a

native of Stoke Prior, his connection with the Pearmans brought about his marriage to Elizabeth Shenstone, the poet's aunt, and it was probably through this relationship that George Caslon, the cordwainer of Halesowen, was enabled to apprentice his son William to Elizabeth Shenstone's husband, Edward Cookes the loriner.

[1] A. L. Reade, privately printed, 1906.

[2] A. L. Reade's pedigree of the Actons is based largely on the will of Mary, widow of Clement Acton, 1742, but she makes no reference to the first son, Thomas.

[3] P. W. L. Adams, A History of the Jukes family, 1927.

[4] Indenture of Lease No. B.895 (Worcester Cathedral Library), 3 July, 21 Charles II.

[5] Heraldry of Worcestershire.

[6] Alum. Oxon. (1st Series).

[7] A List of the Society, Jan. 23, 1772 (penes the writer.)

[8] Grazebrook, Heraldry of Worcestershire.

[9] Marjorie Williams, The Letters of William Shenstone, 1939.

[10] Somers, Halas, Hales, Halesowen, App. p XI.

[11] Ibid, p. 50.

[12] Halesowen Free School Account Book.

[13] Harris, History and Antiquities of Halesowen, 1836.

[14] Oldswinford Hospital Minute Book.

[15] See Chester's London Marriage Licences and Foster's Alum. Oxon.

[16] 30 times the annual number of baptisms, averaged over ten years.

[17] Grazebrook, Heraldry of Worcestershire.

[18] Ibid.

[19] Ibid.

[20] Oldswinford Hospital Minute Book.

[21] Worcester Record Office.

[22] Chart 4, appended to this Chapter.

Chart 4.

Family of William Shenstone the elder
of Halesowen

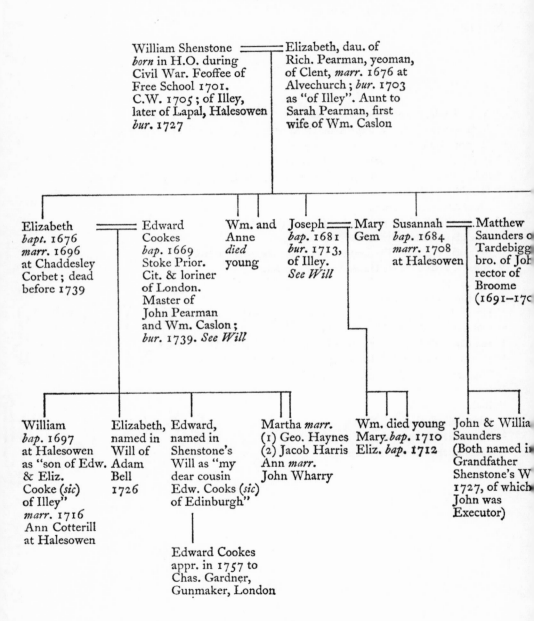

William Shenstone ══════ Elizabeth, dau. of
born in H.O. during │ Rich. Pearman, yeoman,
Civil War. Feoffee of │ of Clent, *marr.* 1676 at
Free School 1701. │ Alvechurch; *bur.* 1703
C.W. 1705; of Illey, │ as "of Illey". Aunt to
later of Lapal, Halesowen │ Sarah Pearman, first
bur. 1727 │ wife of Wm. Caslon

Elizabeth ══════ Edward │ Wm. and │ Joseph ══ Mary │ Susannah ══ Matthew
bapt. 1676 │ Cookes │ Anne │ *bap.* 1681 │ Gem │ *bap.* 1684 │ Saunders o
marr. 1696 │ *bap.* 1669 │ *died* │ *bur.* 1713, │ │ *marr.* 1708 │ Tardebigg
at Chaddesley │ Stoke Prior. │ *young* │ of Illey. │ │ at Halesowen │ bro. of Joh
Corbet; dead │ Cit. & loriner │ │ *See Will* │ │ │ rector of
before 1739 │ of London. │ │ │ │ │ Broome
│ Master of │ │ │ │ │ (1691–17c
│ John Pearman │
│ and Wm. Caslon; │
│ *bur.* 1739. *See Will* │

William │ Elizabeth, │ Edward, │ Martha *marr.* │ Wm. died young │ John & Willia
bap. 1697 │ named in │ named in │ (1) Geo. Haynes │ Mary. *bap.* 1710 │ Saunders
at Halesowen │ Will of │ Shenstone's │ (2) Jacob Harris │ Eliz. *bap.* 1712 │ (Both named i
as "son of Edw. │ Adam │ Will as "my │ Ann *marr.* │ │ Grandfather
& Eliz. │ Bell │ dear cousin │ John Wharry │ │ Shenstone's W
Cooke (*sic*) │ 1726 │ Edw. Cooks (*sic*) │ │ │ 1727, of which
of Illey" │ │ of Edinburgh" │ │ │ John was
marr. 1716 │ │ │ │ │ Executor)
Ann Cotterill │
at Halesowen │

Edward Cookes
appr. in 1757 to
Chas. Gardner,
Gunmaker, London

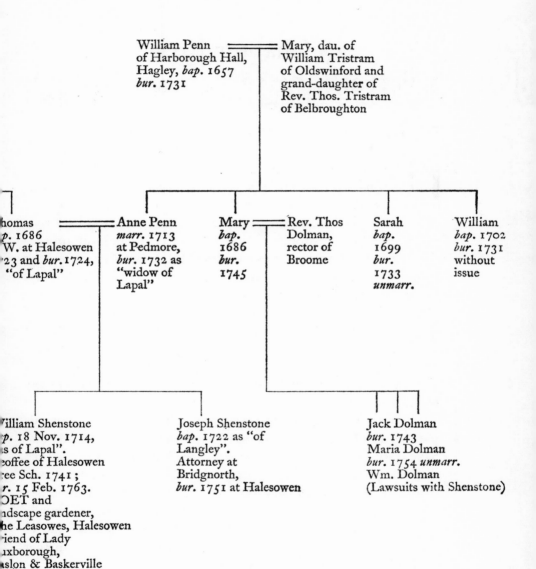

William Penn ══════════ Mary, dau. of
of Harborough Hall, William Tristram
Hagley, *bap.* 1657 of Oldswinford and
bur. 1731 grand-daughter of
 Rev. Thos. Tristram
 of Belbroughton

```
|                                                                                |
┌──────────┬──────────────┬──────────┬──────────┬──────────┐
```

homas ═══════ Anne Penn Mary ═══ Rev. Thos Sarah William
p. 1686 *marr.* 1713 *bap.* Dolman, *bap.* *bap.* 1702
W. at Halesowen at Pedmore, 1686 rector of 1699 *bur.* 1731
'23 and *bur.* 1724, *bur.* 1732 as *bur.* Broome *bur.* without
"of Lapal" "widow of 1745 1733 issue
 Lapal" *unmarr.*

ʼilliam Shenstone Joseph Shenstone Jack Dolman
p. 18 Nov. 1714, *bap.* 1722 as "of *bur.* 1743
s of Lapal". Langley". Maria Dolman
:offee of Halesowen Attorney at *bur.* 1754 *unmarr.*
ee Sch. 1741; Bridgnorth, Wm. Dolman
r. 15 Feb. 1763. *bur.* 1751 at Halesowen (Lawsuits with Shenstone)
ƆET and
ndscape gardener,
he Leasowes, Halesowen
iend of Lady
ıxborough,
ıslon & Baskerville

Chapter Five

WILLIAM CASLON BECOMES A LORINER

THE DIFFICULTIES IN searching for apprentices in London are quite considerable; there is no list of London apprentices as such. It is necessary to go to the records of each Company, the gunsmiths, girdlers, blacksmiths, cutlers, etc., and these vary very much in their accessibility. Some have separate books of apprentice bindings. In others it is necessary to extract these from the Court Minute Books covering all the business of the Company. They are rarely indexed. In many cases after 1696 where the Orphans' Stamp Book is still in existence, this provides a sort of index, but it records the name only of the apprentice, his date of binding and the fact that stamp duty had been paid. Another considerable problem is that even if the apprentice's eventual occupation is known, his master very often belonged to a Company which had nothing to do with his trade.

By a fortunate circumstance, however, from 1710 onwards indentures of apprenticeship were expected to be registered and have duty paid on them, a custom 'more honour'd in the breach than the observance,' especially in the case of the London Companies. The Society of Genealogists possesses a copy of the index to those indentures which were registered and by an equally fortunate circumstance this index yielded the essential clue to William Caslon's trade, thus providing a starting-point for further research. The entry reads as follows :—

'1718.—Joseph son of Edward Halfehide of Essex, yeoman, to William Caslen, citizen and loriner.'

'1720.—Edward son of Edward Hawes, citizen and founder, to John Pearman, citizen and loriner.'

The register of St. Peter's, Cornhill also records the following marriage entry :—

'29 August, 1717.—William Caslon of St. Botolph, Aldgate, co. Middlesex, and Sarah Pearman of St. Michael, Rude Lane, London, by Licence.'

Here then, besides Caslon and a certain John Pearman being freemen of the same city company, the two names are found together in Caslon's first marriage. We must, however, for the present resist the temptation to follow Caslon's domestic fortunes, and turn to the search for the identity of his master.

The Worshipful Company of Loriners is one of the minor city companies and is known to have been in existence as early as 1260, although it did not receive a Charter until Queen Anne granted one in 1712, actually during the time that Caslon was an apprentice. A 'loriner,' sometimes called a 'lorimer' was a maker of bits and the other metal parts of a horse's bridle. The origin of the word is obscure. It may have been derived from an old French word 'Lormier,' no longer to be found in the dictionaries. The word 'lorimer' may have been corrupted to 'loriner' during the seventeenth century when many Huguenots from Lorraine, called 'Lorrainers,' practised their craft in London, and this supposition is strengthened by the fact that many of these 'Lorrainers' were also glass manufacturers or glaziers, for the Company of Glaziers, which was very wealthy after the Great Fire, leased Loriners' Hall for many years, actually until 1747. The Company ceased to use its Hall in 1759, a circumstance which seems to have prompted the following doggerel verses in 'The Loriners Song :'

'In the reign of Queen Anne our famed Charter began,
 As I've seen it in ancient books writ,
And would you know the cause why she gave us our laws,
 Why her charger she ruled with the bit.

'Then a Hall, sirs, was raised, Queen Anne be praised,
 For Loriners to meet together :
But the place was ill planned as Bedlam was at hand,
 So the folks cried, "They're birds of a feather."

71

'This made the Loriners frown so they kick'd the Hall down,
 And swore by the heathen god, Jove,
That they wanted no Hall to unite them at all.
 They were linked, sirs, in brotherly love.'[1]

The song is misleading in suggesting that a hall was built after the granting of the charter. It is evident that in 1638 when the Foleys had a warehouse in London in a yard adjoining the south-east corner of Leadenhall, in the parish of St. Peter's, Cornhill, where 'Lorraners (Loriners) and sellers of iron ware' had their warehouses above stairs,[2] the loriners then had no hall, but Pepys in his diary in 1668 refers to 'Loriners' hall by Mooregate' being used for holding a funeral service for Sir Thomas Teddiman.

The fact that Caslon is said to have been an ornamental engraver of gun-locks and barrels illustrates again the difficulty of recognising a man's trade from his attachment to a particular company. It seems that the granting by a company of its freedom conferred on the grantee the right to practise his trade in the city without restricting him to the particular trade traditionally or nominally associated with that company. Even as far back as the fifteenth century it was possible to become free of a company by patrimony, that is, the son of a freeman could also be admitted a freeman without becoming a craftsman. Sometimes a single family became strongly represented in the government of a company with the industry of which it had long ceased to have any connection. This practice, and the custom of admission by redemption, that is, by purchase, together with changes in industry and commerce, gradually deprived nearly every company of all concern with its nominal purpose. While they were active, however, the companies pursued a monopolistic and protectionist policy, and jealously guarded the rights of their members. The granting of a Charter to the loriners as late as 1712 might at first be thought to be associated with the importance of horse-furniture during the Marlborough campaigns when cavalry became a prominent feature in increasing the mobility of troops in the Flanders wars, but it cannot be thought that many loriners at that time were engaged in the manufacture of bits and bridles ; freemen

72

of other companies such as the blacksmiths, coach makers and coach-harness makers, farriers, ironmongers, etc., would be just as likely to be engaged in such work, while vast quantities of horse-trappings would be manufactured outside London where the workers would not be subjected at all to the restrictions of a city company. As already stated, by 1712 most of the London guilds had largely lost control of their trades, and it seems highly probable that the desire for a charter was an attempt to improve the status of the company.

No history of the Worshipful Company of Loriners has been published and most of the early records, apart from their Charter and the Ordinances of 1711 and 1712, were destroyed by enemy action in 1940. In the eighteenth century the Loriners were governed by a master, two wardens, and twenty-four assistants with a livery of sixty-nine.[3]

As we have seen already, Loriners' Hall was used for other purposes besides transacting the Company's business. In the early part of the eighteenth century a Baptist congregation held its meetings at Loriners' Hall, a point of some interest in view of the fact that Thomas Guy, one of Caslon's patrons, had Baptist sympathies. A certain Thomas Harrison was one of the ministers there, and from 1715 to 1729 he was pastor of the Little Wild Street meeting.[4] In 1706 Daniel Neal (1678–1743) historian of the puritans and author of a *History of New England*, was ordained there as pastor of an independent congregation in Aldersgate Street.[5] In an endeavour to meet the upkeep of their halls, other companies hired them out for various functions. Boswell informs us that Coachmakers' Hall was noted in the eighteenth century as the resort of 'a kind of religious Robin Hood Society, which met every Sunday evening for free debate.' In the seventeenth century Curriers' Hall was used as a Dissenters' meeting house, where Calamy's son preached every Sunday. Founders' Hall and Pinners' Hall were used for similar purposes.

When the apprentice of a freeman of the City completed his term and was himself admitted to the freedom it was customary to preserve a copy of his indenture at the City Chamberlain's Office, where both master and apprentice attended to complete the formalities. A search of the surviving records shows that William

Caslon was admitted to the freedom of the City by apprenticeship in the Company of Loriners in June, 1717. The indenture supporting his admission describes him as the son of George Caslon of 'Halesowen in Com. Salop[7] Cordweynor' and states that he was apprenticed to Edward Cookes, citizen and loriner, from 17 May, 1706, for 7 years. The records do not reveal Edward Cookes' trade or craft, but his premises were then (May, 1706) in the Ward of Farringdon, and in June, 1717 he attended at the City Chamberlain's Office to testify orally that his apprentice had served him faithfully for the term of seven years.

The same records also yielded information about both Edward Cookes and John Pearman. Edward Cookes was admitted to the freedom of the City in December, 1691, having been apprenticed to Adam Bell, Citizen and Loriner from 31 July, 1683, for 7 years. His apprenticeship indenture showed that he was the son of John Cookes 'in Stokeprior in the County of Worcester Yeoman.' Adam Bell's premises were in Aldersgate Ward in July, 1683, but his trade is not stated and the record of his admission to the freedom is no longer extant. However, he was a Warden of the Loriners' Company in June, 1717, when he attended at the City Chamberlain's office to testify that William Caslon was free of the Loriners.

John Pearman was the son of Nicholas Pearman of Clent, co. Stafford, husbandman, and was apprenticed to his uncle, Edward Cookes, Citizen and Loriner, for 7 years from 15 October, 1696, and was admitted to the freedom of the City in July, 1709. Cookes' premises on 2 August, 1697, were in the Ward of 'Port' (that is, Portsoken).

The record of William Caslon's first marriage described the bride as of St. Michael's, Rude Lane, otherwise known as St. Michael Wood Street, London, but since a residence of only three weeks in a parish qualified a person to contract a marriage, it is fortunate that the apprenticeships cited located the Pearman family at Clent. There are entries of this name, for example, in Hertfordshire parishes, as well as some in other parishes in the West Midlands.

A search of the parish registers of Clent,[8] however, reveals that Sarah Pearman was the daughter of Thomas Pearman of

Clent, a butcher, and by combining information from parish registers, the Bishops' transcripts, Probate records,[9] and other sources, the pedigree of the Clent Pearmans has been constructed.[10]

Abstract of Will of Richard Pearman of Clent co. Stafford, yeoman, made 25 December, 1674; proved 12 February, 1675-6:

'In the Name of God Amen– – –

'To my son Thomas Pearman the lease of the barne and one joyne bed standing in the parlor at Hollowcross with all furniture thereto belonging– – – with the table board and forme standing in the Hall at Hollowcross House– – –

'To my daughter Elizabeth ten pounds worth of goods out of my dwelling house in uperclent and if soe be she doe mislike of the goods when they be "praised by to credible neighbours" then my will is that my Executor shall paye the ten pounds in mony and moreover I give to her– – –

'My will is that my wife shall have my little house at my foldgate in uperclent to live in if she please and that my Executor doe set the same in repaire convenient for her and that she have of all sorts of goods convenient for her use if she please to dwell in the saide house or elsewhere and the same goods to returne to my Executor at her decease.

'To my daughter Anne Green and to her husband and their children twentie shillings.

'My will is that my sons Nicholas and Thomas doe equally beare and share in my funerall charges and that they see that I am brought home in decent manner and I doe make and ordaine my son Nicholas to be my sole Executor of this my last Will and Testament and in witness hereof I have heareunto put my hand and seale this twentie-fifth day of December one thousand six hundred seventie foure.'

'Witnesses Tho: Walker Vic. Signed Richard Pearman
 Hen. Creswell his Mark X'
 Humphrey Greene.

Abstract of Will of Nicholas Pearman of Clent, co. Stafford, yeoman, made 5 January, 1722; proved 13 June, 1724:

'In the Name of God Amen– – –

All debts and funeral expenses to be first paid.

To my son John Pearman the sum of five shillings to be paid within six months next after my decease.

To my daughter Ann now wife of William Robinson of London the sum of five shillings to be paid six months next after my decease.

To my daughter Mary now wife of John Raybould Junr., Twenty Pounds to be paid within six months next after my decease being the remaining part of the marriage portion which is by Agreement to be paid at my decease.

To my son Ambrose Pearman the sum of £59–10–0 to be paid within six months next after my decease.

The security of the above several legacies amounting to £80 covered by Indenture of demise dated 21 March, 1709. Leased to Mr. Roger Waldron and William Cole a close of land called Pool Furlong upon trust that they or the survivor shall mortgage, sell and dispose of the same to raise and pay the said sum of £80.

I will and desire my son John Pearman being my eldest son to pay to my Grand-daughter Sarah Raybould the sum of £10 within twelve months next after my decease.

I will and desire my said son John Pearman to pay to my Grand-daughter Ann Raybould and my Grandson William Robinson the sum of £5 each within twelve months next after my decease.

Remainder to my said son John Pearman whom I appoint Sole Executor.

Witnesses : Thomas Hemming The mark of
The mark of Jonathan Staunton Nicholas Pearman'
 William Waldron

Abstract of Will of Thomas Pearman of Hollow Cross in the Parish of Clent, co. Stafford, Butcher, made 21 March, 1713; proved 3 December, 1714.

'In the Name of God Amen . . .

All such debts as I do owe or am in Conscience bound to pay to be fully paid and satisfied with what convenient speed they may.

To Mary my Loveing wife the use of my best bedd etc. . . . and after her decease the same bedd etc. . . . to my two daughters Sarah Pearman and Anne Pearman to be equally divided between them share and share alike. And all the rest and residue of my beds brass pewter household goods and household stuff whatsoever to my said two daughters Sarah Pearman and Anne Pearman to be equally divided etc,

All my implements of husbandry, stock, cattle, corn,

grain and hay, debts and rights whatsoever due and owing to me to my two sons John Pearman and Samuel Pearman and to my two said daughters Sarah Pearman and Anne Pearman to be equally divided, etc.

Whereas my son Ambrose Pearman in his marriage settlement with Mary his late wife hath contracted and agreed with me to pay the sum of £120 of current money to such of my younger children as I shall think fit according to my last will or other writing Now my will is that my said son Ambrose Pearman shall pay but £90—as follows—to my said two daughters Sarah Pearman and Anne Pearman £30 a piece and to my said two sons John Pearman and Samuel Pearman £15 a piece to be paid within twelve months next after the decease of me and Mary my now wife as in the same settlement is expressed: And £30 being the residue of the said £120 I give and bequeath to my said son Ambrose Pearman.

To my daughter Elizabeth Tompson wife of William Tompson Wheelwright the sum of Five Shillings.

Executors sons John Pearman and Samuel Pearman and daughters Sarah Pearman and Anne Pearman.

Witnesses : Nicholas Pearman Signed
 Zephaniah Creswell Tho. Pearman'
 Jo : Hamond

Consideration of these wills brings out the following points : Richard Pearman lived at Hollow Cross, now called Holy Cross, a hamlet on the main Hagley to Bromsgrove road, between Clent and Belbroughton. Hossall Lane, passing through Holy Cross Green, was the old pack-horse way for carriage of salt from Droitwich, the cross being merely the crossroads in the hollow and, contrary to popular belief, having no religious significance. Richard Pearman lived at Hollow Cross House and was evidently succeeded there by his younger son Thomas Pearman who carried on the trade of a butcher. White's Directory of 1834 shows that there was still a Thomas Pearman, butcher and maltster, at Holy Cross, although it is known that a William Timings then lived at Holy Cross House, who in 1836 published *A Guide to Clent Hills*, and in 1839 issued *The History and Antiquities of St. Kenelms*, two works having but slight historical value.

Richard Pearman's will establishes the identity of his daughter Elizabeth, whose baptism is not entered in the Clent

register but who is the essential link, as will be seen later, between the Pearmans and Halesowen, and hence between Edward Cookes and his apprentice William Caslon. Richard Pearman was a churchwarden at Clent in 1669 and his brother Ambrose, by his will dated 25 May, 1651, gave fifty shillings to the poor of Clent.

The will of the elder son Nicholas Pearman informs us that John Pearman who was apprenticed to Edward Cookes in 1696 was his eldest son. It was probably through John's London connection that Ann married William Robinson and in 1722 there was also a grandson William Robinson. Common as is the name Robinson, there was no family of the name at Clent at this period, but there is an isolated entry of the burial of a child John Robinson in July, 1728 ; he may have been another son of Ann Pearman who died while his mother was staying with her parents at Clent. Noting again that at the time of his marriage in 1717 William Caslon's bride Sarah Pearman was described as of St. Michael, Rude Lane, London, it is significant that among those paying Land Tax in 1717 in the parish of St. Michael, Wood Street, was Widow Robinson. It is therefore a reasonable assumption that Sarah Pearman was married from the home of her cousin Ann, who had married William Robinson, with whose widowed mother William and Ann were living at the time.

Nicholas Pearman's second wife was Sarah Waldron, a member of an influential and prolific Clent family. William Waldron, one of the witnesses to Nicholas's will, was her brother. He was a literate man and was the second schoolmaster of Amphlett's School in succession to Humphrey Pretty, brother-in-law to the vicar Thomas Walker, and was given the title of *Mr* William Waldron in the parish register. Along with Thomas Nash, Nicholas Pearman was a church warden in 1702, when they and the vicar, Thomas Walker, had their names cast on a sixth bell, a treble, which had been added by subscription in 1701.

The will of the younger son Thomas Pearman exhibits an unusual feature in that four children are named jointly as executors. His eldest surviving son Ambrose has already become a widower at the early age of thirty-five, and as is shown in the loriners' apprenticeship records later, is established as a butcher at Stoke Green, near Stoke Prior, Worcestershire. His younger

sons, John and Samuel, became established with their families at Clent, and it was these two sons and two unmarried daughters, Sarah and Ann, who executed their father's will.

William Caslon was apprenticed 17 May, 1706, and in the ordinary course of events was entitled to take up his freedom in the summer of 1713. His father George Caslon, the cordwainer of Halesowen, had died in 1709, and as the son of a widowed mother, Caslon was probably too poor to meet the fine of £10 necessary to become a freeman and therefore continued as a journeyman working for Edward Cookes for a further period. We have no means of knowing whether he met Sarah Pearman in London while she was visiting her cousin, John Pearman and his family, or her other London relations, or while he was at school, or when visiting his mother in Halesowen. When Caslon began his apprenticeship John Pearman had completed his term with the same master three years before, although he continued working for Cookes as a journeyman for a time before setting up in business for himself. Caslon might therefore have become acquainted with Sarah Pearman as long as ten years before they married.

It seems clear, however, that Thomas Pearman's burial on 12 October, 1714, opened up new horizons for Caslon, for his will shows that Ambrose Pearman had contracted to pay, amongst other sums, £30 to his sister Sarah within twelve months of the death of his father and mother. The entry of the burial of Thomas Pearman's widow Mary is not shown in the Clent register and she was probably buried outside the parish, possibly at Stoke Green. It seems most significant that Caslon took up his freedom in June, 1717, that on 29 August following he married Sarah Pearman, and that he took his wife's nephew, John, the son of Ambrose Pearman, as an apprentice in the same year. Although the terms of his marriage settlement are not known, it was probably funds made available by his wife and mother-in-law that enabled him to set up in business for himself in Vine Street in the Minories in 1717.

It is also to be noted that although John Pearman the elder loriner completed his term of seven years' apprenticeship to Edward Cookes in October, 1703, he was not admitted to the freedom of the City until July, 1709. Edward Cookes' premises in

79

1697 were in the Ward of Portsoken, outside the City proper, but he had moved to the Ward of Farringdon when Caslon became his apprentice in 1706. John Pearman ultimately settled in Little Minories, or Trinity Minories, also in the Ward of Portsoken, but we do not know when he went there. The length of time a journeyman remained with his former master might have depended on several factors. For example, a master might have withheld support for a journeyman's desire to take up his freedom for selfish reasons, or the company in question might have had its full complement of members. Whatever the reason, the facts are that John Pearman was not admitted to the freedom until six years after the completion of his term and William Caslon not until nearly four years after completion. In Caslon's case Adam Bell, a warden of the Loriners, accompanied Edward Cookes for the completion of the formalities, points to which we shall return in chapter 7.

It should also be noted that despite Caslon qualifying to practice in the City in 1717, he chose to set up his business in the Ward of Portsoken outside the City, probably because by that time he had set up closer relations with John Pearman and his wife's relations than with his former master Cookes.

As a further illustration of personal and trade relationships between the members of City companies abstracts are given below of the wills of Adam Bell and his former apprentice who became Caslon's master, Edward Cookes.

Abstract of Will of Adam Bell, citizen and loriner (P.C. C. 66 Plymouth), made 2 March, 1715-6, proved 15 April, 1726. Buried at Stoke Newington, Middlesex.

Mentioned:

God-daughter and kinswoman, Mary, daughter of Thomas Cookes.

God-daughter and kinswoman, Elizabeth, daughter of Edward Cookes.

Journeyman	William Pincord
Servant	Mary Watts
Niece	Margaret Bell
Nephew	John Hall (Executor)
Overseer:	William Richards of London, Merchant
Witnesses:	Jno. Willis, John Roberts, George Ivye

Abstract of Will of Edward Cookes of S. Mary White-chapel, citizen and loriner and engraver (P.C.C 175 Hench-man); made June, 1739, proved 29 August, 1739.

Mentioned:

Wife Deceased

Sons William : Edward (apprenticed)

Daughters Martha, previously wife of George Haynes deceased; now wife of Jacob Harris. Ann, wife of John Wharry.

The four daughters of deceased brother Thomas Cookes also mentioned.

Trustee: Mr. John Pearman of Trinity Minories, engraver.

Witnesses: William Trinder, J. Stephens.

These wills show at once that Adam Bell and Edward Cookes were related. A pedigree of the families of Bell and Cookes has been constructed[11] from the Bishops' Transcripts[12] but the fact that child-bearing in both families enters or spans the Civil War years renders it incomplete. The fact that John Pearman of Trinity Minories, engraver, was trustee to the will of Edward Cookes, loriner and engraver, increases the probability that Mary Cookes, John Pearman's mother, who married Thomas Pearman at Stoke Prior in 1676 and whose baptism is not in the register, was sister to Edward Cookes, who married Elizabeth Shenstone at Chaddesley-Corbet in 1696.

The following lists have been compiled from the index of apprenticeships at the Society of Genealogists :[13]

Company of Loriners

1683 Edward son of John Cookes of Stoke Prior, yeoman, to Adam Bell.

1696 John son of Nicholas Pearman of Clent, husbandman, to Edward Cookes.

1706 William son of George Caslon of Halesowen, cordwainer, to Edward Cookes.

1716 Thomas son of William Hilliard of Newington, victualler, to Edward Cookes.

1717 John son of Ambrose Pearman of Stoke Green, butcher, to William Caslon.

1718 Joseph son of Edward Halfhide of Essex, yeoman, to William Caslon.

1720	Edward son of Edward Hawes, citizen and founder, to John Pearman.
1726	John son of John Carey deceased to Joseph Halfhide.
1730	William son of Edward Hawes, citizen and founder, to Edward Cookes.
1732	Edward son of Henry Thorogood of Essex to Joseph Halfhide.

Company of Gunmakers

1705	Thomas son of Nicholas Pearman of Clent, husbandman, to John Sibley.
*1708	George son of Edward Halfhide of Little Parndon, Essex, to John Sibley.
**1757	Edward son of Edward Cookes, citizen and loriner, to Charles Gardner.

*George Halfhide was Master of the Gunmakers' Company in 1737.

**Almost certainly the grandson of Edward Cookes who was apprenticed to Adam Bell. The father of this Edward was probably a loriner by patrimony; we do not know his trade, his father's will merely stating that he was an apprentice in 1739.

Company of Founders

*1682	Edward son of Edward Hawes of Brackley, Northants, to Martin Wilson.
1696	Isaac son of Abraham Mead of Buckingham, labourer, to Edward Hawes.
1706	Henry son of John Robins of Brackley, deceased to Edward Hawes.
1711	Samuel son of Peter Ash of Duston?, Southants to Edward Hawes.

*Edward Hawes married in 1693 Bridget Patrick; he was buried at St. Botolph, Bishopsgate, in 1728, aged 57.

Whilst any analysis of such short lists of apprentices might seem of somewhat limited utility, yet one or two deductions might be drawn from them. Those loriners who directly or indirectly seem to be connected, Cookes, Joseph Halfhide, the two John Pearmans, and William Caslon, were all engravers and no doubt a part of the work of all of them was concerned with firearms. For this reason we also find the names Cookes, Halfhide and Pearman

connected with the Company of Gunmakers. The allocation of apprentices to different trades must have depended largely on when and where vacancies occurred and this is where an established connection or family relationship turned out to be valuable. It seems extremely doubtful whether a boy's aptitude was anything but a minor factor in determining his vocation, but if he had the good fortune to work for an engraver who undertook other work besides the engraving of gun-locks and barrels, he might develop a flair for chasing decorations on the softer metals brass and pewter, such as on clock faces and table ware. Unless the master had a more extensive establishment than usual, it seems unlikely that copper-plate engraving of maps, plans, or artists' drawings could be included in his range of work, yet all engravers must have recognised their common bond, and it seems unlikely that a book illustrator would regard a gun-lock engraver as beneath his notice ; indeed, they were all hacks.

The foregoing lists show that an apprentice might serve a master who came from his own part of the country and who may or may not have been a relative, or an apprentice might go to a particular master because of a friendship or business relationship between that master and the boy's father, or again, a boy might be apprenticed merely because the father wanted his son to be taught a trade and the master happened to have a vacancy at the time. It was all very precarious and, as later times have shown, very unsatisfactory if the boy had little aptitude for the work, but accepted it because it was the custom of the time.

The Clerk of the Worshipful Company of Loriners kindly supplied the writer with a list of the names occurring in the Charter of 1712. These are given below :

First and Present Master—John Gedney
First and Present Wardens—Mathew Markham and
Edmund Ferribbe

Members of the Court of Assistants

Sampson Gideon	John Goddard
John Letherland	Francis Lee
Robert Gaile	John Davies
Richard Stirt	David Strong
Obadiah Cawcutt	John Neal

Gabriel Church
Mathew Bagley
Robert Kelham
Richard Wooldridge
John Ambler
John Powell

John Higden
Samuel Monk
John Southern
Randolph Phillipps
Richard Diamond

The first name on the Court of Assistants, Sampson Gideon, is of some interest, as he was the uncle of another Sampson Gideon (1699–1762), a Portuguese Jew, who from starting at twenty years of age with £1,500, rose rapidly in the financial world, becoming a sworn broker in 1729 with a capital of £25,000. He was free of the Painter-Stainers' Company by patrimony and was the great oracle and leader of Jonathan's Coffee House in Exchange Alley, the forerunner of the Stock Exchange. He raised loans for the Government in the Seven Years' War and lent freely of his money and credit. At his death his estates were valued at the enormous sum of £580,000.[14] The financier's father was Rowland Gideon (died 1720), a West India merchant who was a freeman of the City by redemption and on the Court of the Painter-Stainers Company; there were therefore two brothers on the Courts of two City Companies before the younger Sampson Gideon rose to power. The Gideons changed their name from Abudiente on settling in England. Sampson Gideon the loriner was naturalised in 1688 and his first wife was buried in the Portuguese Jewish cemetery at Mile End in 1700, Sampson himself dying in 1721.[15]

Richard Stirt (or Sturt) might have been connected with the well-known engraver of writing-masters' copy books, John Sturt (1658–1730), who was also a writing-master himself and partnered Bernard Lens the drawing-master of Christ's Hospital in a drawing-school in St. Paul's Churchyard.[16] One William Sturt was connected with a firm which from 1684 to 1712 supplied certain delicacies called 'Pudding Pyes,' unpopular with the children of Christ's Hospital, and who in 1682 and 1689 was Steward of the Feast of Amicable Blues of the Hospital. But there were many Sturts in London at that period. An Anthony Sturt was a merchant in the Minories in 1677.[17]

John Neal may have been connected with Edward Neal, a London merchant in the Poultry in 1677 and with Daniel Neal (1678–1743), born in London, trained in Little Britain, and as previously mentioned, ordained at Loriners' Hall in 1706. About 1696 Daniel Neal, though still quite young,

was in favour with William III, and this supports the notion that despite the different manner of spelling the surname, he had some connection with Thomas Neale (died 1699), who was master of the mint and groom-porter under Charles II, James II and William III.[18]

Samuel Monk was a governor of St. Thomas's Hospital,[19] a connection between the Loriners and the hospital which is of interest in connection with Caslon's translation from gun-lock engraving to letter founding.

The connection of Matthew Bagley and Richard Wooldridge with the Office of Ordnance at the Tower of London is discussed in the next chapter.

It will be seen therefore that, apart from Sampson Gideon, Samuel Monk, Matthew Bagley and Richard Wooldridge, the loriners named in the Company's Charter of Incorporation are almost anonymous.

In addition to the names already listed of members of the Court of Assistants of the Worshipful Company of Loriners at the time of incorporation in 1712, lists are appended of the Livery in 1722 and in 1727, as well as of those Loriners who voted at the Sheriff's election on 24 March, 1724.[20]

Liverymen of the Worshipful Company of Loriners, 1722

Armit Theophilus
Ambler John
Bell Adam
 (Master of Edward Cookes
 and Warden in 1717)
Bradford Henry
Blackwell John
C Davis John
Darwin John
Daubur Stephen (Daubuz)
Emerson Marmaduke
Enever George
C Goddard John
Ghisclin Nicholas
Grey John
Grissold Samuel
C Gadney John (Gedney)
Gurney Daniel
Huipes George
Hart Robert

Bavine John
Bedy John (Body)
Benoist Nicholas
Cookes Edward
 (Master of William
 Caslon)
Carleton Charles
C Diamond Richard
Pearman John
 (Former apprentice of
 Edward Cookes)
Prestridge Francis
Philips George
Patington John
Radcliffe Ralph
C Strong David
Savery Michael
Sears John
Spicer Dickes
C Sturt Richard

Hebelt James (Hebert)
Hanbury John
C Higden John sen.
Hopkins William
Leigh Joshua
Moreton John
Matthew James
C Monck Samuel
Mayor John
C Markham Matthew
Meredith William
Margary Joseph
Mayor John jun.
Messiter Daniel
Maud Thomas
Newton Samuel
C Neal John
Ozell Austin
Orne Thomas (Arne)
Piggott Ralph
Partington Joseph

Saunderson Edward
Saunderson Edward jun.
Snoke Robert (Snooke)
Skyring Joseph
C Southern John
Sutton Jacob
Tapp William
Walker Thomas
Wilmot Daniel
Worsley Thomas
Wright Henry
Woolridge Richard (see chapter 7)
Welham Robert
Watson Johathan
Willey George
Wright John

The Charter members are marked with a letter C.

Liverymen of the Worshipful Company
of Loriners, 1727

C Armit Theophilus — Bridewell Precinct
C Ambler John — Featherstone Street
Bradford Henry — Mile End
Blackwell John — Queen Street, Cheapside
Bavine John — Tower Street
Body John — London Bridge
N Barratt John — Crutched Friars
N Budd Richard — Symonds Inn
N Billinsley Samuel — Chancery Lane
N Brown William — Croydon
Cookes Edward — Goodmans Fields
Carleton Charles — Covent Garden
N Camion Samuel (Campion) — College Hill
C Diamond Richard — Fenchurch Street
C Davis John — London Bridge
Darwin John — Botolph Lane
Daubur Stephen (Daubuz) — Threadneedle Street
Emerson Marmaduke — Paternoster Row
C Goddard John — Tower Hill
Ghisclin Nicholas — Hoxton

	Grissold Samuel	Fore Street
	Gurney Daniel	Strand
	Huipes George	Old Gravel Lane
	Hart Robert	Leadenhall Market
	Hebelt James (Hebert)	Fenchurch Street
	Hanbury John	Bucklersbury
N	Harvey Elias	Fleet Street
N	Hett John	Poultry
	Inver George (Ennever)	Jewin Street
N	Latham Francis	Cateaton Street
	Leigh Joshua	West Smithfield
	Moreton John	Leadenhall Street
	Mayor John	Little Moorfields
C	Markham Matthew	Shoe Lane
	Meredith William	Barbican
	Margary Joseph	Hoxton Square
	Messiter Daniel	Enfield
	Maund Thomas	Newgate Street
	Orne Thomas (Arne)	Mile End Newtown
	Piggott Ralph	Camomile Street
	Partington Joseph	Snow Hill
	Pearman John	Trinity Minories
	Philips George	Hounsditch
	Patington John	Grub Street
	Radcliffe Ralph jun.	Devonshire Square
	Savery Michael	Clements Lane
	Sears John	Tower Hill
C	Sturt Richard	Bishopsgate
	Sanderson Edward	Leadenhall Street
	Smith Thomas	Dowgate
	Skyring Joseph	Clapham
C	Southern John	Hackney
	Sutton Jacob	Maiden Lane
N	Stanley Jeremiah	Wood Street
N	Stevens John	Thames Street
N	Trueman Benjamin	Spitalfields
N	Worrall Robert	Noble Street, Aldersgate
	Walker Thomas	Newgate Street
	Wilmot Daniel	Lime Street
	Wright Henry	Epsom
	Woolridge Richard	Chancery Lane
	Welham Robert	Leadenhall Street
	Wright John	Threadneedle Street

N signifies new members since 1722.

The total number of the Livery in 1722 was 72. The Master, Wardens and Court of Assistants in 1712 totalled 24 members. A comparison of these names with the Livery lists of 1722 and 1727 shows that after ten years twelve of the charter names had disappeared and after a further five years only seven remained. Even allowing for the fact that the Court would naturally consist of the senior members of the Livery, the mortality rate seems to have been fairly high. Considering the total Livery from 1722 to 1727, twenty-seven members died and only twelve new members came in, so that by 1727 the Livery was reduced to 63 members. This trend seems to confirm that the move to obtain the charter of 1712 was an attempt to revive the declining fortunes of the Company, but these figures show that the attempt was a failure, a circumstance which would be sufficient to account for the closure of the Company's Hall in 1759.

Loriners who voted at the Sheriff's election
on 24 March, 1724

For Sir Edward Bellamy

Armit Theophilus
Ambler John
Blackwell John
Bell Adam
Benoist Nicholas
Britalle John
Cookes Edward
Carlton Charles
Davis John
Dymond Richard
 (Diamond)
Daubez Stephen
Fowler Israel
Gisling Nicholas (Ghisclin)
Gurney Daniel
Goddard John
Hanburgh John
 (Hanbury)
Margery Joseph
Monk Samuel
Mayor John sen.
Mayor John jun.
Newton Samuel
Phillips George

For Sir John Williams

Armit Theophilus
Bradford Henry
Baving John (Bavine)
Darwent John (Darwin)
Grisold John (Grissold
 Samuel)
Gray John
Gadny John (Gedney)
Hart Robert
Harbert James
Harvey Elias
Janiver George (Ennever)
Lessnor Daniel
Markham Matthew
Merradeth William
 (Meredith)
Maund Thomas
Orme Thomas (Orne or
 Arne)
Pattington John
Pearman John
Prestlige Francis (Prest-
 ridge)
Partington Joseph

88

Phipps George
Piggott Ralph
Ratcliffe Ralph (Radcliffe)
Savary Michael
Strange David (Strong)
Snooke Robert
Sanderson Edward sen.
Sanderson Edward jun.
Sutton Jacob
Southern John
Willy George
William Robert
Willmoth Daniel (Wilmot)
Woolrige Richard

Sturt Richard
Smith Thomas
Sears John
Skynn Joseph (Skyring)
Tap William (Tapp)
Walker Thomas
Wright Henry
Warren Robert(Welham)

Brief notes on the Livery Lists of the Loriners' Company

It has been already noted that nearly all the Charter members of the Loriners' Company have become anonymous since 1712, and it is at least equally difficult to resolve the identity of those who ranked no higher than the Livery at that time. Special investigation as in the cases of Adam Bell, Edward Cookes and John Pearman, might throw further light on their identity, but it is not thought that this would be rewarding in relation to William Caslon. The following brief notes are, however, appended to the lists.

Nicholas Benoist was certainly connected with Antoine Benoist (1721–1770) a draughtsman and engraver who was born at Soissons and came to England with the engraver Claude du Bosc, finding employment as a drawing master in many upper-class families.

Stephen Daubuz was doubtless connected with Charles Daubuz, an M.A. of Cambridge, a French Protestant divine who fled with his family to England on the revocation of the edict of Nantes and became vicar of Brotherton in Yorkshire. His principal work was a translation of *The Revelation* from the Greek, published in 1720 by Benjamin Tooke, London.

John Hanbury lived in Bucklersbury, and in 1735 was a Common Councilman for Cheap Ward.

James Hebert lived in Fenchurch Street, and in 1735 was a Common Councilman for Langbourn Ward.

Joshua Leigh was possibly related to Jared Leigh, the father of Jared Leigh (1724–69) an amateur artist of the topographical sort who accompanied young gentlemen on the grand tour, and was a friend of William Caslon the

89

Chart 5.
Family of Pearman of Clent
and Hollow Cross

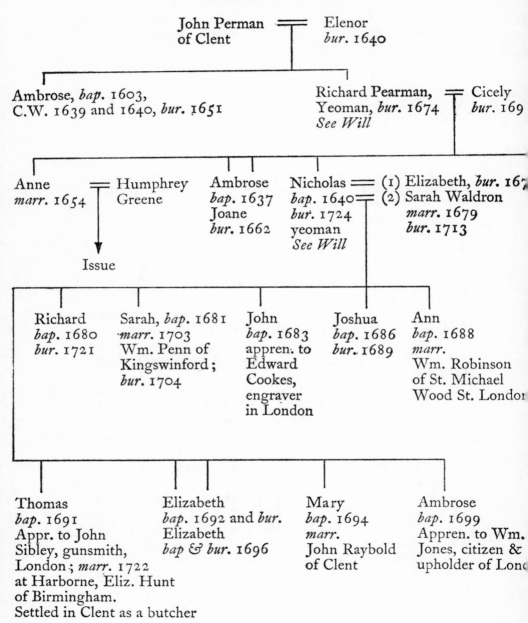

John Perman
of Clent ══ Elenor
bur. 1640

Ambrose, *bap.* 1603,
C.W. 1639 and 1640, *bur.* 1651

Richard **Pearman,** ══ Cicely
Yeoman, *bur.* 1674 *bur.* 169
See Will

Anne ══ Humphrey
marr. 1654 Greene

Ambrose
bap. 1637
Joane
bur. 1662

Nicholas ══ (1) Elizabeth, *bur.* 16͘
bap. 1640 ══ (2) Sarah Waldron
bur. 1724 *marr.* 1679
yeoman *bur.* 1713
See Will

Issue

Richard
bap. 1680
bur. 1721

Sarah, *bap.* 1681
·*marr.* 1703
Wm. Penn of
Kingswinford;
bur. 1704

John
bap. 1683
appren. to
Edward
Cookes,
engraver
in London

Joshua
bap. 1686
bur. 1689

Ann
bap. 1688
marr.
Wm. Robinson
of St. Michael
Wood St. Londor

Thomas
bap. 1691
Appr. to John
Sibley, gunsmith,
London; *marr.* 1722
at Harborne, Eliz. Hunt
of Birmingham.
Settled in Clent as a butcher

Elizabeth
bap. 1692 and *bur.*
Elizabeth
bap & bur. 1696

Mary
bap. 1694
marr.
John Raybold
of Clent

Ambrose
bap. 1699
Appren. to Wm.
Jones, citizen &
upholder of Lond

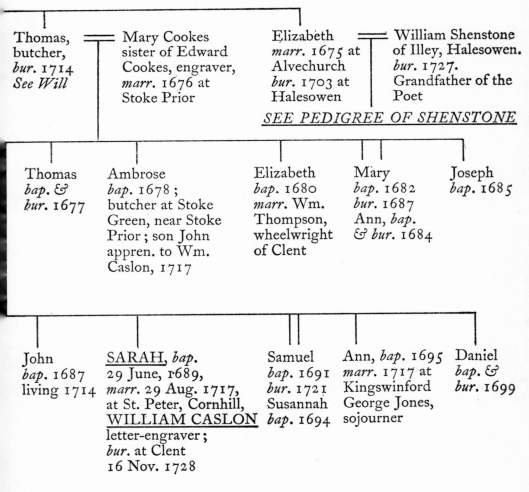

Thomas, butcher, *bur.* 1714 *See Will* ══ Mary Cookes sister of Edward Cookes, engraver, *marr.* 1676 at Stoke Prior

Elizabeth *marr.* 1675 at Alvechurch *bur.* 1703 at Halesowen ══ William Shenstone of Illey, Halesowen. *bur.* 1727. Grandfather of the Poet

SEE PEDIGREE OF SHENSTONE

Thomas *bap. &* *bur.* 1677

Ambrose *bap.* 1678; butcher at Stoke Green, near Stoke Prior; son John appren. to Wm. Caslon, 1717

Elizabeth *bap.* 1680 *marr.* Wm. Thompson, wheelwright of Clent

Mary *bap.* 1682 *bur.* 1687 Ann, *bap.* *& bur.* 1684

Joseph *bap.* 1685

John *bap.* 1687 living 1714

SARAH, *bap.* 29 June, 1689, *marr.* 29 Aug. 1717, at St. Peter, Cornhill, WILLIAM CASLON letter-engraver; *bur.* at Clent 16 Nov. 1728

Samuel *bap.* 1691 *bur.* 1721 Susannah *bap.* 1694

Ann, *bap.* 1695 *marr.* 1717 at Kingswinford George Jones, sojourner

Daniel *bap. &* *bur.* 1699

younger. In 1727 he was living in West Smithfield, not far from Caslon.

William Meredith lived in Barbican, and in 1735 was a Common Councilman for Cripplegate Ward while Edward Saunderson junior lived in Leadenhall Street and was a Common Councilman for Aldgate Ward.

Thomas Orne is of distinct interest in view of William Caslon's musical activities. The name Orne is probably a variant of Arne. The family of Young was well-known in London music circles and the fiddlers 'old Young and young Young' are referred to by Hawkins as playing at Caslon's concerts. Cecilia Young (1711–1789) was the daughter of Charles Young, organist of All Hallows, Barking, and in 1736 she married Dr. Thomas Arne (1710–1778) who was the son of Thomas Arne, an upholsterer, of King Street, Covent Garden, and may have been a cousin of Thomas Arne or Orne, the loriner. Further reference is made to Caslon's concerts in Appendix 2.

[1] Colonel R. J. Blackham, London's Livery Companies, n.d.

[2] Trans. Worcs. Arch. Soc. 1944. Vol. XXI, p. 4.

[3] William Maitland, History of London, 1739, p. 608.

[4] D.N.B. art. Thomas Harrison.

[5] Ibid. art. Daniel Neal.

[6] John Timbs, Curiosities of London, 1868.

[7] Halesowen was in Shropshire until 1844.

[8] Transcript of Clent parish registers (1560–1812) penes the writer.

[9] Worcester Record Office.

[10] Chart 5, appended to this Chapter.

[11] Chart 6, appended to this Chapter.

[12] Worcester Record Office.

[13] Courtesy of Mr R. E. F. Garrett.

[14] D.N.B. art. Sampson Gideon.

[15] Lysons, Environs of London, Vol. 3, Middlesex, pp. 477 & 479.

[16] D.N.B. art. John Sturt.

[17] The Little London Directory, 1677.

[18] D.N.B. arts. Daniel Neal and Thomas Neale.

[19] Stow's London revised by Strype, 1717.

[20] Courtesy of Mr R. E. F. Garrett.

Chart 6.
Families of Bell and Cookes
of Stoke Prior

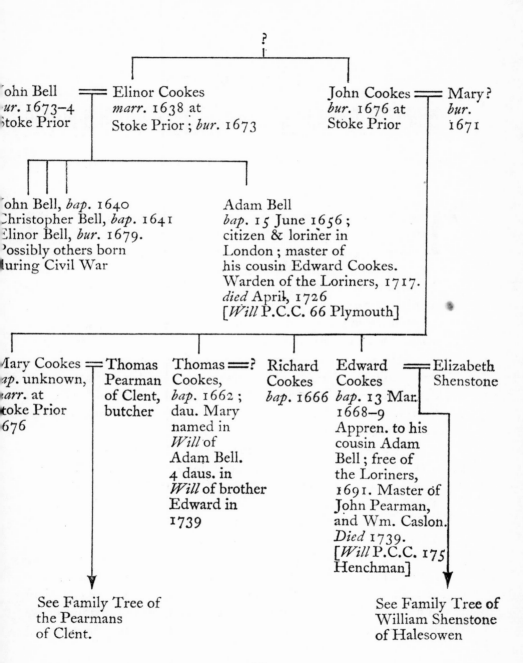

?

John Bell
bur. 1673-4
Stoke Prior

Elinor Cookes
marr. 1638 at
Stoke Prior ; *bur.* 1673

John Cookes
bur. 1676 at
Stoke Prior

Mary ?
bur.
1671

John Bell, *bap.* 1640
Christopher Bell, *bap.* 1641
Elinor Bell, *bur.* 1679.
Possibly others born
during Civil War

Adam Bell
bap. 15 June 1656 ;
citizen & loriner in
London ; master of
his cousin Edward Cookes.
Warden of the Loriners, 1717.
died April, 1726
[*Will* P.C.C. 66 Plymouth]

Mary Cookes
bap. unknown,
marr. at
Stoke Prior
1676

Thomas
Pearman
of Clent,
butcher

Thomas
Cookes,
bap. 1662 ;
dau. Mary
named in
Will of
Adam Bell.
4 daus. in
Will of brother
Edward in
1739

?

Richard
Cookes
bap. 1666

Edward
Cookes
bap. 13 Mar.
1668-9
Appren. to his
cousin Adam
Bell ; free of
the Loriners,
1691. Master of
John Pearman,
and Wm. Caslon.
Died 1739.
[*Will* P.C.C. 175
Henchman]

Elizabeth
Shenstone

See Family Tree of
the Pearmans
of Clent.

See Family Tree of
William Shenstone
of Halesowen

Chapter Six

THE GUNMAKERS OF BIRMINGHAM
AND LONDON

THE FOLLOWING BRIEF account of the early gun trade shows that despite the sparseness of surviving records there is some evidence that artisans from Halesowen were linked with the fortunes of the trade in Birmingham. The evidence is clearer that Edward Cookes and his apprentice William Caslon undertook the making of tools for silversmiths and punches for book-binders, in addition to engraving on fire-arms, because of the vagaries of the gun-trade and particularly on account of its decline at the end of the Marlborough campaigns. We shall have occasion to discuss more fully the opportunities presented to master and apprentice during the time Edward Cookes worked in Farringdon Ward, and for the Ordnance Office in the Tower of London, but first let us look at the gun trade in a general way.

It is perhaps surprising to find that it was as long ago as 1485 that firearms were first introduced as an official weapon of the Royal Guard. In that year, Henry VII established the Corps of Yeomen of the Guard, directing that one-half should be bowmen and the other half were to be equipped with the arquebus. Henry VIII obtained large quantities of the arms he needed from Belgium, Italy and Germany, but with a view to encouraging their manufacture in England, he invited to this country a number of skilled gunsmiths from the Continent. By the year 1545 he had in his service a number of Hainaulters who were skilled in the use and manufacture of the arquebus. These craftsmen were stationed

in the Tower of London and formed the nucleus of an industry which has been carried on in that neighbourhood ever since. They may be regarded as the originators of the firearms industry in England.

In the reign of Elizabeth I there were 37 accredited gun-smiths plying their trade in the Minories and the industry was growing rapidly. James I, however, bestowed the monopoly of gun-making on a certain Edmund Nicholson, thus bringing about a rapid decline in the trade, so much so that by 1607 only five gun-makers remained. These five petitioned Parliament to abolish the monopoly that threatened the extinction of the 'art and mystery of gun-making,' a petition which was ultimately granted and the trade once again made free.[1]

In 1631 a Commission was appointed to settle the rates, prices and standard of armament of the 'trained bands.' At the same time a Committee of the principal gun-makers was appointed to check throughout the country on the stocks of arms held at the common charge of 'every citie, towne or village,' and to 'remake, alter, amend, dress, repair, prove and stampe (as need shall require) all or any of the said armour, gunnes, pikes and bandaliers.' The official stamp was to be the letter 'A' with a crown, this being the hall-mark of the Worshipful Company of Workmen-Armourers of London, and it was decreed that no one was to be allowed to sell arms not stamped by the Company. The growth of the gun-making industry in London led in 1637 to the incorporation by Royal Charter of the London Company of Gunmakers.[2]

Despite Macaulay's statement that in 1685 the population of Birmingham was only 4,000, and that at that day nobody had heard of Birmingham guns, other authorities state that gun-making as a distinct local industry dates from about 1640, and although we do not know the kind of arms in question, it is a fact that Birmingham incurred the displeasure of Prince Rupert in 1643 for supplying arms to the Parliament forces during the Civil War.[3]

The Warwickshire Hearth Tax returns show that in 1663 the total number for Birmingham and Deritend together was slightly over 1,000, compared with over 800 for Stratford-on-Avon

and nearly 550 for Sutton Coldfield, so Birmingham at that time was not much larger than neighbouring market towns. Three hearth-money rolls of the early 1670's show from 1,200 to 1,300 houses in Birmingham, and allowing on an average six persons to each house, as 'political arithmeticians' of the time commonly did, we arrive at population figures between 1660 and 1675 of about 6,000 to not far from 8,000, figures greatly in excess of Macaulay's figure of 4,000 in 1685. The hearth-tax rolls also give the number of forges in 1671 as 69, whereas in 1683 there were 202.[4]

The story of how the Birmingham gun trade received a considerable impetus is not without interest and has some bearing on William Caslon's early career. William III (1689–1702) had expressed concern that guns were not being made in sufficient quantity in his own dominions, so that he was compelled to secure them from Holland at great expense and with considerable difficulty. The resources of the London Gunmakers were quite inadequate for William's needs, which had been made more urgent because the old 'matchlock musquett' was being replaced by the 'flintlock.'

The King's lament did not go unheeded. Sir Richard Newdigate, one of the members for Warwickshire, being present, expressed the view that his constituents were capable of satisfying his Majesty's demands. The King was delighted with this immediate response; Sir Richard was furnished with sample muskets, and despatched to his Birmingham constituents. Following upon this, Sir Richard received the following communication from the Office of Ordnance:

'For their Majesties Service:
To Sir Richard Newdigate, att Arbury near Warwick these Sir, pursuant to an order of this Board wee have directed the sending to you by the Tamworth Carriers two snaphand musquettes of differing sorts for patterns, desiring you will please cause them to be shewed to your Bermingham workmen and upon your return of their ability and readiness to undertake the making and fixing of them accordingly or the making of barrells or locks only, together with time a sufficient quantity of barrells can be made to answer the trouble and charge of sending an officer on purpose to prove the

same according to the Tower proof which is equall weight of powder to one of the bulletts alsoe sent you, and their lowest price either for a compleat musquett ready fixt, or for a barrell or a lock, distinct or together, as they will undertake to make them. We shall, therefore, cause further directions to be given as shall be most beneficial to their Majesties Services with a thankful acknowledgment of your great favour and trouble afforded us therein.

'We are, Sir, Your Most Humble Servants, Office of Ordnance, 10th January, 1689.' (i.e., 1689–90).

Sir Richard Newdigate's confidence in the skill of his constituents was fully justified. Recognising the capricious nature of royal favour and the probable consequences of failure, his belief in the ability of the Birmingham workmen to meet the royal needs must have been founded on his knowledge of what they had been able to accomplish previously. He was therefore certain that in the manufacture of arms Birmingham was already a town to be reckoned with. As a matter of fact, that first contract was completed within twelve months, a feat which could scarcely have been accomplished by inexperienced workmen.

The following Office of Ordnance Authorisation probably refers to the payment of £96 18s. od. by H.M. Treasury to the Birmingham Gunmakers for a batch of guns on the first contract negotiated by Sir Richard Newdigate.

'Mr. Bertie
'Out of such theire Maties Treasure as now remaynes in yor hands wee desire you to pay to John Smart for Thomas Hadley and the rest of the Gunmakers at Birmingham One Debenture of ffoure-score and Sixteen Poundes and Eighteen Shillinges Dated ye 14th of July, 1690 And the same shal be allowed you upon the Next List by
Sr
'Yor most affectionate freindes
'Office of Ordnance
15. July, 1690
Job Charlton Tho : Littleton
J. Gardiner' Wm : Boulter'[5]

In 1692 Birmingham was given a further government order, for which both the work done and the price charged were approved by the Board of Ordnance. But the award of this further contract

97

raised a storm with the London Company, whose members instantly complained to Parliament. It was finally resolved that the Board should be recommended to compose the matter in dispute and it appears that the differences were so far adjusted that another contract was drawn up in 1693 and duly executed between the Board and 'certain gunmakers of the town of Birmingham,' whereby the latter pledged themselves to supply 2,400 snaphance musquetts at the rate of 200 a month. The main clause of the contract reads as follows :

'Imprimis, the said William Bourne, Thomas Moore, John West, Richard Weston and Jacob Austin, do hereby severally covenant and agree to and with the said principal officers of Their Majesties Ordnance on behalf of themselves and the rest of the Gunmakers of Birmingham that they shall and will make and provide for their Majesties service two hundred snaphand musquetts every month for the space of one year from the expiration of their last contract bearing date the six and twentieth day of March, 1692, to be 3 feet 10 inches long with walnutt tree and ash stocks, and that one half of the said musquetts shall have flatte locks *engraven* and the other half round locks and that all of them shall have brass pipes cast and brass heelplates and all the stocks varnished and to have six good thrids in the breech screws and that all the said gun stocks shall be well made and substantiall and none of them glewed and also that the said musquett barrells shall be compleatly fixed before they are proved and that they shall be proved at Birmingham according to the Tower proof and a fitt person (who shall be empowered by this office) shall inspect the same and marke them with the Office marke and (when finished) to survey them and that powder and bulletts shall be provided and sent down at the charge of this office for the proofs of the said arms . . . that they shall be paid for the said arms in the manner following, viz., for every one hundred severall arms after the rate of seventeen shillings per piece, ready money by way of debenture within one week after the delivery thereof into their Majesties stores in the Tower of London or any other place within this Kingdom as the Board shall order and direct, and also that they shall be paid and allowed three shillings to the carriage of every one hundred weight from Birmingham to the Tower and so proportionately to any other place and that the money shall be paid to them without

any charge or trouble they shall direct and returne the same from time to time to Birmingham.

Sealed and delivered in the presence of Will Phelps
Thomas Littleton
Job Charlton
Wm. Boulter'

Goodwin[6] records that although at the time we are discussing, and for upwards of a century afterwards, the inhabitants of Birmingham were strangers to corporate rights and disabilities, the gunsmiths who had hitherto been associated together in what was simply a friendly contract, assumed to themselves the title of 'The Company of Gunmakers in Birmingham,' and sought to establish a monopoly as exclusive as that of their London rivals. Though assuming a quasi-corporate authority, however, it seems they were not ungrateful to their patron for his kind offices in their behalf, as the following letter will show:

'To the Worshipful Sir Richard Newdigate,
at Arbury, sent with a gunn,
Bermingham, November 4th, 1692.
Worthy Sir : Wee are much ashamed that wee have been soe long silent of acknowledgment of your great kindness that your Worship did us in helping us to the worke of making musketts for His Majesty in Bermingham and wee could not tell how to make your Worship any part of satisfaction for your great kindness that wee have always received from you. Therefore wee beg your Worship's acceptance of a small token which wee have sent by the bearer.
Hoping your Worship will pardon this trouble,
Wee remain,
Ever Your Worship's humble servants,
A Company of Gunmakers
in Bermingham.'

This letter, and the gun sent with it, have descended as heirlooms, and are still preserved at Arbury.[7]

The Birmingham gunsmiths were not incorporated and there is no evidence that the title they had assumed was retained. When the London Company of Gunmakers obtained their Charter in 1637, this step marked the introduction of 'proof' into England, although it is not clear whether private or trade proof houses were used.

99

It should be noted, however, that even in the reign of Elizabeth some kind of test was applied to both guns and gun-makers as the following extract from an addenda to the Calendar of State Papers for 1566–79 indicates :

> 'All guns to be surveyed by persons appointed by the Master of Ordnance. Everyone wishing to be a Gunmaker to make a proof piece in the workshop of a master or workman and to be admitted or not accordingly. All guns to be made to a model bullet of steel furnished by the Master of Ordnance.'[8]

Under the Gunmakers' Charter of 1637 a properly recognised 'proof house' for firearms was established, and power was given to the Company to stamp upon all weapons passing the proof test official marks which could be accepted as a guarantee of sound material and reliable workmanship. These marks were engraved on guns, dags, pistols, barrels and locks. The Birmingham makers, in the absence of an officially recognised 'proof house,' instituted certain proof methods of their own under the direction of Nathaniel Nye, born in 1624, who was styled the Master gunner of the City of Worcester.[9] This early practitioner in ballistics, known also as an almanack-maker, astronomer and mathematician, conducted proof for the Birmingham makers and for the trade generally. Nye's book, *A new Almanacke and Prognostication, for the yeare of our Lord God, 1642, calculated exactly for the faire and populous Towne of Birmicham in Warwickshire, where the Pole is elevated above the Horizon 52 degrees and 38 minutes, and may serve for any part of this Kingdome,* is believed to be the first book printed with special reference to Birmingham. Major Pollard[10] reproduces a variety of 'Proof Marks' as used both by the London Company of Gunmakers and by individual Birmingham gunmakers.

In 1698 a considerable impetus was afforded to English manufacturers by the opening of the African trade and the consequent exportation of guns, cutlery and hardware. This prosperity, however, was destined to receive a check by the operation of other causes. In 1706 the London Company of Gunmakers complained to Parliament that notwithstanding the statute passed in the first year of the reign of Queen Anne prohibiting the use of

foreign arms, etc., by troops in English pay, yet whilst they (the London Company) could obtain neither money nor orders from the Government, large quantities of guns were still manufactured in Holland and sent into this country to the detriment of English makers. It looks as if the same kind of piratical transactions were taking place with guns of Dutch manufacture as had long been the practice in the letter-founding and printing trades, except that in the case of firearms the national need was periodically more acute. Perhaps the London Company of Gunmakers behaved somewhat complacently in times of national emergency, leaning too heavily on their monopoly. In such circumstances it would be understandable if the Master General of His Majesty's Ordnance, exasperated by his inability to secure sufficient arms urgently needed in war-time, connived at obtaining supplies from other sources.

It should also be noted here that the term 'gun-maker' applied only to those who stocked and assembled the complete firearm. The barrel-makers and lock and furniture makers were separate traders, and it is certain that London was drawing its supplies of these articles from Birmingham and district long before the time with which we are dealing. Only a few barrel-makers ever existed in London and they were in a small way of business, making a few barrels for better quality sporting guns.

In 1707 four hundred of the Birmingham gunsmiths submitted a petition to the House of Commons with a view to ending the monopolistic practices of the London Guild, alleging that the London gunsmiths, having a monopoly of proof (for under their charter all firearms had to be proved by their Proof Master), had put hardships upon the petitioners, beaten down their prices, and had totally obstructed their trade with the plantations.

The London gunmakers did not succeed in eliminating Birmingham competition, however, and the Birmingham makers were supplying the Government with firearms throughout the Marlborough campaigns. 1710 witnessed the fall of the Whig Ministry, in 1712 Marlborough was dismissed and in 1713 came the Treaty of Utrecht. With the cessation of hostilities the demand for firearms was reduced, except for maintaining stocks of parts, providing new weapons as these were developed, and supplying

new theatres of activity in the colonies and plantations.

Following this brief account of the development of the gun trade in Birmingham and London up to the time of Caslon's apprenticeship, some attention must be given to the extent to which other places in the West Midlands participated in the trade. Although the evidence is sparse it supports the view that the trade developed in the outer districts almost as early as in Birmingham itself, suggesting that where materials and water power existed for forging, stamping and smithing in the neighbouring villages, there was no advantage to be gained by concentrating the fabrication in Birmingham. What is most surprising is that despite the prevailing restrictions on the movement of people between different parishes, so many artisans gained a settlement in places of new industry.

In this connection the following entry in the Halesowen parish register is to be noted :

'Feb. 1677—William Barnsley and Elizabeth Cookes married.'

The issue of this marriage were William, 1678, John, 1679 ; and Elizabeth, 1681, described as children of William and Elizabeth Barnsley 'de Cradley Forge.' The younger William Barnsley is almost certainly the one named in the Calendar of Hagley Court Documents[11] of which the following is an abstract :

'1709 : Indenture—
 Sir Charles Lyttelton and others, William Barnsley of Stourbridge, gunsmith, Joseph Palmer of Hagley and Joseph Shenstone of Illey :—Lands in Frankley.'

The brothers Joseph and Thomas Palmer were land bailiffs to Sir Charles Lyttelton, and Joseph Shenstone was uncle to the poet William Shenstone. Parish register references to the Barnsleys are quite scanty at Halesowen, but the fact that the elder William Barnsley was located at Cradley and that William Barnsley the younger was a gunsmith is evidence that the manufacture of firearms was carried on at least in part in Halesowen and district during Caslon's boyhood. No evidence has been obtained that Elizabeth Barnsley née Cookes had any connection with Edward Cookes, the engraver of gun-locks and barrels to whom William Caslon was apprenticed in London, but it is of interest to note that

Edward Cookes married Joseph Shenstone's sister Elizabeth.

The second son of William and Elizabeth Barnsley, John, baptised at Halesowen in 1679, is later found in Birmingham, for in 1706, in the register of St. Martin's, Birmingham, is entered 'John Barnsley and Mary Groves married,' and in 1720 he was appointed one of the Constables of the town of Birmingham.[12]

Some of the names of those prominently connected with the early gun trade in Birmingham occur frequently in the Halesowen register. The family of Hadley is prolific, and the names Weston, Moore and West are found repeatedly. John West's name occurs in the 1693 contract between the Board of Ordnance and the Birmingham gunmakers and it seems probable that the following entry in the Halesowen register refers to the same family:

> 'Jan. 1703—Thomas West Locksmith and Mary Tanner married.'

In this case the occupation 'locksmith' may have signified that the bridegroom was a maker of gun-locks.

After the peace of Utrecht the Birmingham gun-makers began to turn their attention to birding guns and fowling pieces. 'It is recorded that about 1730 gun manufacture was carried on in the town on a scale then thought considerable, by a "Mr." Jordan who had contracts with the Government, whose son succeeded him in the business and attained the honour of shrievalty, an honour to which other gunsmiths were subsequently exalted.'[13] It is necessary to point out, however, that the worthy gun-smith was appointed Sheriff rather for his good fortune in being related to Lord Dudley than for his industrial eminence.

In November, 1744, Shenstone wrote to his friend the Rev. Richard Graves,[14] as follows:

> ... 'From ye Birmingham Gazette—"We hear that on Thursday last was married at Hales-owen in Shropshire Mr. (Thomas) Jorden an eminent Gunsmith of this Town to a sister of ye Rt. hon[ble] Ferdinando Ld. Dudley." I was yesterday at ye Grange, where his old father (wth a number of People) was celebrating ye nuptials of his son; when in the midst of his Feasting, and high Jollity and grand Alliance the old Fellow bethought him of a Piece of Timber in ye neighbourhood yt was convertible into good Gunsticks, and had some of it sent for into ye Room by way of Specimen!'

The bride was Catharine Lea, one of five sisters, and was only eighteen years of age at the time. There was no issue of the marriage. It is evident that Shenstone considered the elder Jordan as somewhat limited in the social graces. Another of the family, Edward Jordan, was High Bailiff of Birmingham, in 1753.[15]

In 1756, when the Board of Ordnance gave Thomas Jordan an order for musket barrels, he was at the same time 'enjoined faithfully to keep his Promise not to entice or employ any Person now employed as a Dayman or Pieceman in the Tower of London or any Person at B'ham working for the Board.'[16]

R. A. Pelham[17] throws some light on the operation of the laws of settlement in the period in which we are interested. The approach to the subject, however, is mainly statistical and the results must remain inconclusive because only a small proportion of the 715 names listed have the occupation attached and not a single one of these is a gunsmith. As the author says, a proper analysis is a task for one with a knowledge of local family history. Nevertheless, for our present purpose, it may be observed that the immigrants to Birmingham in the stated period included 15 from Halesowen, 6 from Rowley Regis, and, surprisingly, 26 from London. The Halesowen immigrants are listed below:

1699	Richard Carpenter	1705	Thomas Moore
1690	Henry Feldon	1703	Francis Palmer
1712	John Field	1720	John Peach
1700	Thomas Hadley	1701	Simon Silk (Awl-
1700	Thomas Hadley		blade-maker)
	(Carpenter)	1712	Richard Stamps
1691	Joseph Hurley	1705	Thomas Vallient
1698	Robert Jones	1694	John Wells
1689	William Lathbury		

It will be seen that the occupations of only two of these are known and from what has gone before it would appear that only two of the others, Thomas Hadley and Thomas Moore, might conjecturally have joined relatives in Birmingham, who were gunsmiths, a somewhat inconclusive result.

One of the certificates of outgoing families, however, probably relates to a member of the earliest gun-making family in Birmingham, that of Hadley:

'To the church wardens and overseers of the poore of Aston Juxta Birmingham in the County of Warwick—

'We the church wardens and overseers of the poore of Birmingham in the county of Warwick aforesaid do hereby certifi that Gilbert Hadley Gonnsmith and Elizabeth his wife for theire better subsistence are gone to reside and dwell within youer said parish of Aston and we doe hereby owne and Acknowledg that the said Gilbert Hadley and Elizabeth his wife and what children they now have or here After may have to be Inhabitants legally settled in our said parish of Birmingham and we will receve them as such whenever they shall become chargable to the parish of Aston. In wittness where of we have here unto put our hands and seales this 16th day of May anno 1712.'

Sealed and Delivered in the presents of

Jno Holtham Thomas Greene[18]
Jno Britton William Jorden
Jos. May[19] Edwd Hiccox
Tho. Rainbow John Forcill[20]

Seen and allowed by us
Nov. [] th, 1712
Basill H. Nicholas
Wm. Inge

Further discussion of this subject is outside the scope of the present work, although finally, it might be noted that a Gilbert Hadley, presumably the one referred to above, appears as a witness in 1717 in two indentures[21] relating to land in Deritend belonging to a gun-barrel forger.

If we now refer to the partial lists of apprenticeships in the London Company of Gunmakers in Chapter 10, we note that Thomas the son of Nicholas Pearman of Clent was apprenticed to John Sibley, gunmaker, in 1705. However, Thomas Pearman did not take up his freedom in the Gunmakers, and we find him again in the West Midlands in the following entry in the parish register of Harborne, Birmingham:

'Dec. 1722—Thomas Pearman of Clent and Elizabeth Hunt of Birmingham married.'

The Clent register confirms that Thomas Pearman returned to Clent; two of his sons were baptised there in 1723 and 1729 and the younger son was buried there in 1737. We do not know when Thomas Pearman left London although it was between 1712 and

1722, but the fact that he did so is probably explained by the decline in the gun trade following the peace of Utrecht. In 1729 we find that Richard son of Edward Walter of Rowley was apprenticed to Thomas Pearman, of Clent, butcher,[22] so it seems likely that on the death of his uncle Thomas in 1714, he returned home to take up the family trade.

Howard L. Blackmore[23] provides some new information on the state of the gun-trade at the time Caslon was connected with it. The inability of the London Gunmakers to supply government needs in the late seventeenth century has been already mentioned, and the deplorable state of the organisation is shown by the fact that while the Storekeeper of the Ordnance, William Meester (Messiter?), in 1697, was arranging for payment for arms bought in Holland and desperately needed for the army in Flanders, the furbisher John Harris was transporting hundreds of carbines, pistols and bayonets up the Thames for the decoration of the walls of Hampton Court Palace and Windsor Castle.[24]

In the reign of Queen Anne when matchlocks and pikes were finally replaced by snaphance muskets the Ordnance Office was inundated with requests for the new arms, both for the colonies of North America and for the coastal towns at home which were preparing for attacks from the sea. Officials of the Ordnance evidently considered this an opportune moment to dispose of the remaining stock of match locks and old snaphance muskets, but the records show that this manoeuvre was resented. The Governor of the Leeward Islands protested that the matchlocks sent him were 'dangerous in marches through a Country full of Sugar Canes,' and the Lieutenant Governor of Jamaica complained to the Lords Commissioners of Trade and Plantations that 'he had received about 200 pieces of Iron that had been Firelocks but never can be made so again.' As the demands for new arms increased, the Ordnance Department was finally obliged in 1703 to acquaint Daniel Finch, Earl of Nottingham, Secretary of State, that the Department had 'no objection to supplying Firelocks which have undergone Tower proof and are very serviceable, But as for Firelocks after the new Pattern wee shall find it difficult to gett the Quantity already demanded for the envoy of Portugall.' This referred to the terms of a treaty with Portugal under which

England was to supply her ally with 6,500 stand of arms.[25]

As it turned out the combined efforts of the London and Birmingham gunmakers, indeed, of the whole country, were insufficient to meet the demand, so that in 1706, the Office of Ordnance contracted for the purchase of arms in Holland, a certain Major Wybault being sent with a pattern musket and appropriate punches and power for their view and proof.

These difficulties led to a reorganisation in the Ordnance Department's system of contracting. Until then, it had been customary for the contractors to supply the complete firearm, leaving them to sub-contract for the parts or for the whole as they might prefer. One of the requisites of a successful contractor, then as now, seems to have been the ability to wait for his money. Having given bond for security, the contractor was faced with a financial system of warrant and debenture which seemed reluctant to finalise itself in actual payment[26] and as we have seen in the case of the Birmingham gunmakers who were really a body of workmen with limited financial resources, they had in Sir Richard Newdigate a valuable ally who eased their difficulties when departmental purse-strings were too tight.

The new method was to place contracts for the various parts making up a complete gun. Instead of the supply being dependent on contractors who themselves dealt with the manufacture of the parts, the Ordnance Department took the assembly under its own control. In this way costs could be analysed more closely and the profits of contractors reduced ; moreover, stocks of parts could be built up, so that in times of stress, stocks could be drawn upon and complete exhaustion of supplies avoided long enough for remedial action to be effective. The new system was more flexible than the old in the circumstances then prevailing, and remained in vogue for close on a century, when under the impetus of the industrial revolution, new methods of production compelled further changes in the Ordnance Department's policy.

As already noted, from the beginning of the eighteenth century the Birmingham district was capable of producing more barrels and locks than London, and it was to the Midlands, therefore, that the bulk of the orders for these parts was given. The quantity of barrels and locks made in Birmingham and district

was so great that an Ordnance Viewer was available locally to view them. The parts were then sent to be proved and stored in the Tower, so as to be available to gunmakers (or assemblers) in the vicinity of the Tower to be made up into complete firearms. The London gunmakers, however, were unsurpassed for the quality of their woodwork, and the stocking of guns became their traditional responsibility.[27]

There were other parts, too, made in brass and iron, to make the complete gun assembly. The mounts, known as the furniture—the butt plate, trigger guard, rammer pipes, side plate and escutcheon—were made of cast brass and these were bought at so much a pound weight, depending on whether old or new brass was used. Early in 1715, Matthew Bagley and William Bargill were contracted 'to cast Brass Work for Small Arms according to patterns delivered . . . each Furniture to weigh $1\frac{1}{8}$lb. at $14\frac{1}{2}$d. per lb.'

Matthew Bagley was one of the Court of Assistants of the Loriners' Company when Queen Anne granted them a Charter in 1712.[28] Bagley was a bell founder at Chacombe, Northants, and he also had a brass foundry at Windmill Hill in Moorfields where it had been customary to cast brass ordnance. On 10 May, 1716, during the recasting of some of the French guns taken by Marlborough, a disastrous explosion occurred, killing seventeen persons, including Bagley and his son, and Mercator, the Ordnance Clerk and Proofmaster.[29] Poor Bagley's contract, therefore, did not last long.

The tragedy was probably caused by dampness in the moulds and it was as a result of this occurrence that the building of a new brass foundry was decided upon at the Warren (afterwards Woolwich Arsenal). After an advertisement dated 10 July, 1716, asking for applications from competent men for the position of master-founder, one Andrew Schalch (1692–1776) was appointed, who came from the cannon foundry at Douay on the recommendation of the British minister at Brussels. Schalch retained the position for nearly sixty years.

Returning now to the contracts for gun parts, those made in iron, the trigger, screws, loops, sights, etc., were usually made by a Birmingham forger. There were then small supplementary charges for filing the barrels and marking off the stocks. Some-

times the stocker supplied his own walnut, but usually the government's own rough stocks were issued, prices being adjusted accordingly.

The new system really got under way in 1715 and this is the time when the Ordnance Office records yield information about Caslon and his master Edward Cookes. The gun-locks were engraved separately in London, Edward Cookes being the engraver at this period, at a price of 4d. per lock. Another fourpence was allowed for hardening the lock afterwards. It will be recalled that Caslon completed his apprenticeship in May, 1713, although he was not admitted to the freedom of the City in the Company of Loriners until June, 1717, when he also had become an official engraver, cutting Edward Cookes' price to 3d. per lock. In April, 1719, a rival, Francis Adams, offered to do the engraving cheaper still, namely at 2½d. per lock and the Board of Ordnance warned that 'if Caslon do not do them well that Mr. Woolridge look out for another who will stay the course of the office.'[30]

Reading between the lines of this entry, one concludes that Caslon was already devoting so much attention to his other work that his performance for the Ordnance Office had become irregular; may be he was so busy that he was delegating work to his apprentices, John Pearman (1717) and Joseph Halfhide (1718), who were then quite young and insufficiently experienced.

The following short list of engravers who worked for the Board of Ordnance may interest the gun enthusiast.

Edward Cookes	1707–1716?	(4d. per lock).
William Caslon	1716–1719	(3d. per lock).
Francis Adams	1719–1724	(2½d. per lock).
Edward Cookes	1724–1734	(Price not known).

The men mainly responsible for controlling the manufacture of guns were officials of the Ordnance Office working in the Tower of London under the Principal Storekeeper. One of the divisions of his department at the Tower was the Small Gun Office, where a group of armourers, gunsmiths, furbishers and labourers worked under a Master Furbisher. The Board and the Master General of the Ordnance sought the technical advice of the Master Furbisher in their dealings with gun-makers and inventors, and often influenced the subsequent design of a firearm.

Although the temptation to follow H. L. Blackmore in the further development of firearms must be resisted it will be worthwhile to recognise the influences behind the appointments of some of the men engaged at the Tower. At the time of the Restoration Robert Stedman (or Steadman), a cutler, held the office of Furbisher, although his position is hard to define exactly; any responsibility he had for firearms was overshadowed by the Master Gunmaker to the Ordnance and the various gunmakers to the King, all of whom, as Blackmore tells us, were still able to carry on their own businesses while enjoying official remunerations. Robert Stedman was probably a son of Rowland Stedman (1630–1673) a non-conformist divine who became rector of Wokingham, Berkshire, and chaplain to Philip Lord Wharton. A later Robert Stedman fought at Fontenoy and Bergen-op-Zoom. Others connected with the Tower had country residences in the neighbourhood of Binfield and Wokingham, including Lieut.-General Adam Williamson, Deputy-Lieutenant of the Tower from 1722 to 1747.[31]

At the beginning of the eighteenth century, Henry Crispe, (mistakenly called Crips), a gunmaker, is mentioned[32] as the Furbisher. He was a Freeman of the Gunmakers' Company who shared in Government contracts from 1680 onwards. In 1703, however, his duties as an officer of the Ordnance took precedence, his bills then being mainly for the supply of gunsmiths' tools and travelling expenses in viewing arms. When he died, his widow, in 1715, was given a pension of 10s. a week as compensation for the house and sheds built by her husband near the west end of the chapel in the Tower.

In 1687 Eleazar Wiggan was Headborough of the Tower Liberty and Henry Crispe was the Scavenger.[33] It is scarcely likely that Crispe would perform these duties himself, but no doubt he saw that the labourers under his charge did the work for him. Eleazar Wiggan was a writing-master who had his premises at the 'Hand and Pen' on Great Tower Hill. Ambrose Heal[34] gives some particulars of Eleazar Wiggan, including his portrait engraved by John Sturt after Closterman.

There can be no doubt that family relationships entered into many of the Tower appointments. Chester's London Marriage

Licences records the following :—

George Macey, of the Tower of London, gent, widower, 48, and Abigail Crispe, of Clapham, co. Surrey, spinster, 29, at her own disposal—at St. Botolph's, Bishopsgate, Lond. or . . . 13 March, 1693–4. F.

Compare this with the following extract from Lt.-Col. Adam Williamson's Diary :—

1727. X ber (i.e. December, March being the first month of the year, Old Style):

„ 12. 'I got Mr. James Mace(y) a Lad not thirteen years of age to draw Mr. Plunket (1664–1734), (concerned in Atterbury's plot) the Prisoners picture (Plunket was remarkable for his ugliness) and behind him in Shade John Tuder his Warder, who was a very faithfull and carefull fellow.'

Henry Crispe was succeeded by another gunmaker, Richard Wooldridge or Wolldridge, who is first referred to as Master Furbisher in 1718. He was employed in the Ordnance Department before that date, although his duties are not clear. His name does not appear in any of the gunmakers' contracts, but it appears on a musket in the Tower dated 1704. He was on the Court of Assistants of the Loriners' Company along with Matthew Bagley when the Charter was granted in 1712. He voted at the Sheriff's election of 1724 and was still of the Livery in 1727.

Wooldridge appears to have taken charge of the Small Gun Office early in 1715, and in the following year he was in Birmingham arranging for the manufacture of iron fittings and 'shewing to ye workmen ye way to fitt locks to the mould.' Wooldridge's name is common in the West Midlands. He was probably connected with Sir John Wolrich (Wooldridge), 4th baronet and barrister-at-law, Gray's Inn 1661 (as son of Sir Thomas Wooldridge, of Dudmaston, Salop.), M.P. for Wenlock, 1679–81; drowned 1723. A Sir Tobias Wolrich was also a master in chancery about 1670, and Michael Woolrich was a Coffer Bearer in the Royal Household in 1720.

The family of Legge, Earls of Dartmouth, who succeeded the Whorwoods at Sandwell Park, West Bromwich, and had a considerable interest in Staffordshire mining properties, had a

close connection with the trade in arms. William Legge (1609–72) was lieutenant-general of the Ordnance under Charles II ; George Legge (1648–91), first Baron Dartmouth, was also lieutenant-general of the Ordnance and died in the Tower, and his son William Legge (1672–1750) first Earl of Dartmouth, was a Commissioner of the Board of Trade and foreign plantations. The Legges buried their dead in the family vault in Trinity Minories Church.

One further example will serve to illustrate the influences at work in Ordnance Office appointments. Leonard Smelt (1719–1800) was the son of William and the grandson of Leonard Smelt of Leases, Kirkby Fleetham, Yorkshire. The father, William Smelt, was M.P. for Northallerton in 1734 and receiver of H.M. casual customs of Barbados in 1746. The younger Leonard became a clerk in the Ordnance Office in 1734, then a captain in the royal engineers and sub-governor, under the Earl of Holderness as governor, to the Prince of Wales and Prince Frederick, ultimately being rewarded with the post of ranger of Richmond Park. When young and not engaged in his artillery duties Smelt was allowed to attend the drawing office in the Tower, where he acquired considerable skill in military sketching and map drawing, under Clement Lempriere and Desmaretz.[15] The reason for young Smelt being allowed these privileges is not far to seek, for his uncle, another Leonard Smelt, was a Commissioner for examining debts due to the Army under the Paymaster General.[36] Smelt's later career does not concern us here, although he was at Dettingen and Fontenoy, but the manner in which the Smelts first came to notice in the Tower of London should be noted.

As early as 1688 a piece of land in the precincts of the Tower was in the holding of Dr. Hickes.[37] This was Dr. Ralph Hickes, brother of George Hickes (1642–1715), the non-juring Bishop of Thetford, and of John Hickes (1633–1685), who was executed with Richard Nelthorpe in the Monmouth rebellion. The three brothers were the sons of William Hickes of Ness in the parish of Stonegrave, Yorkshire. George Hickes, and probably his brother also, attended Northallerton grammar school under Thomas Smelt,[38] and it seems significant that the families of Hickes and Smelt are later found connected with the Tower of London. George Hickes was living in St. Andrew Holborn in 1713. A certain Richard Smelt of Yorkshire was buried at Harrow on the Hill

PLATE 5

Specimens of ornamental engraving on guns, from 'Nouveaux Desseins d'Arquebuseries,'
by De la Collombe, 1749. (V. and A. Museum)

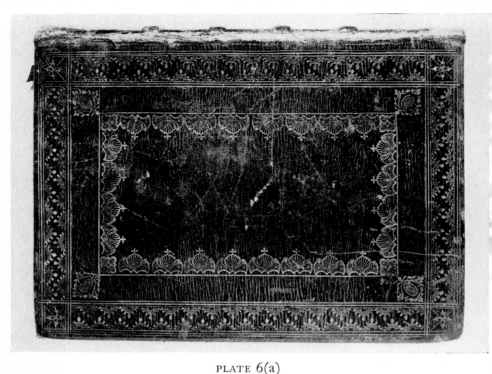

PLATE 6(a)

Tooled Cover of Field's Cambridge Bible, 1668,
showing resemblance between designs impressed on leather and printer's ornaments

PLATE 6(b)

Some Caslon ornaments
deriving from ancient arabesques and descending through continental printers

in 1701,[39] and another Richard Smelt, possibly his son, was living in 1717 in St. Mary Staining in the Ward of Aldersgate.[40]

We must now turn to a brief consideration of the part played by cutlers as well as by gunmakers in the manufacture of firearms in the time of Caslon, for not only do we find Samuel Caslon, a cutler, William Caslon's cousin, working with him as his mould-maker after he had entered on his new career as a letter-founder, but according to such evidence as the writer has so far found, one of the principal agents behind the scenes in advancing Caslon's claims when he engaged to cut the punches for a fount of Arabic type was a cutler, at any rate a cutler by trade.

In this connection Blackmore[41] refers again to the musket made by Richard Wooldridge, dated 1704, describing it as one of the first muskets made for socket bayonets. The bayonet was originally a short dagger first made at Bayonne towards the end of the sixteenth century. The memoirs of Puységur, a native of Bayonne reveal that when he was commanding troops at Ypres in 1647, his musketeers used bayonets consisting of a steel dagger fixed in a wooden haft, which fitted into the muzzle of the musket. These weapons were issued to part of an English dragoon regiment in 1672, and to the Royal Fusiliers when raised in 1685. The Foot Guards were armed with them in 1686. The risk incurred by the use of the plug-bayonet was, of course, that the plugging of the muzzle put the weapon out of use as a musket, a danger which was said to have been partially responsible for the English defeat at Killicrankie in 1689. This led to the use of the ring or socket-bayonet, so that the musket became a double-purpose weapon. Shortly after the Peace of Ryswick (1697) the English and Germans abolished the pike and introduced these bayonets.[42] From this date the bayonet, combined with the musket or other firearm, became the typical weapon of infantry.[43] Blackmore illustrates an interesting variety of plug-bayonets, but cautions against attaching a precise date to the introduction of the socket bayonet. But the important point here is to show how cutlers and gunmakers, originally makers of quite separate weapons and utensils, came to be associated in the manufacture of different parts of the same weapon.

Returning to the subject of Caslon's engraving for the Office of Ordnance at the Tower of London, we have found nothing in the account of his work likely to be inspiring to an artist. John Nichols[44] seems to have misquoted Edward Rowe Mores[45] regarding the nature of the work done by Caslon. Mores says, 'The late Mr. Caslon, the *Coryphaeus* of Letter-founders, was not trained to this business. He was originally a *Gun-lock-graver*, and was taken from that instrument to an instrument of very different tendency, *the propagation of the Christian faith*'. This is a precise definition of Caslon's work, yet Nichols says, 'He (Caslon) served a regular apprenticeship to an engraver of ornaments on gun-barrels ; and was taken from that instrument to an employment of a very different tendency, *the propagation of the Christian faith.*' The same sentence is reproduced exactly in Nichols' later work.[46]

A recent paper by James Mosley[46] catalogues documents at the Public Record Office summarising Caslon's work for the Board of Ordnance. A warrant of 18 January, 1716–17, specifies the work to be done as 'to engrave his Majesty's Cypher & Crown,wth the Broad Arrow & date of the Year, on the 600 Repaired Musqut Locks according to the Contract.' Briefly, the work done by Caslon for the Board of Ordnance included engraving the following weapons :

600 repaired musket locks (as above).
628 musket locks at 3d. each and 60 pairs of pistol locks at 6d. per pair.
600 musket locks and 550 pistol locks.
1000 musket locks at 3d. each and 200 pairs of pistol locks at 6d. per pair.
500 pairs each of musket and pistol locks.
750 pairs of pistol locks.
500 musket and 500 pistol locks.

The earliest date in this catalogue is that on a debenture of 6 December, 1716, so that Caslon had begun this work on his own account not later than the summer or autumn of 1716, and the latest date of payment to him was 26 June, 1719. This leads to the conclusion that he was engaged on *gun-lock-graving* on his own account for three years at the most, 8,400 locks in round figures passing through his hands during this period, bringing in approximately £105, or £35 a year.

In 1717 Caslon married and took his first apprentice John Pearman, his wife's nephew, the same year, taking a second apprentice, Joseph Halfhide, in 1718. It is quite clear, therefore, that with a wife and a growing establishment, there was no princely living to be obtained in engraving gun-locks. James Moseley[48] used three series of documents at the Public Record Office in compiling his catalogue of Caslon's work, but even if every Warrant for engraving work issued to Caslon has not been traced it cannot affect the conclusion that the engraving of these utilitarian marks on firearms provided only a meagre return for the engraver. The poor returns and the uncertainty of a regular flow of work must have compelled all such engravers to undertake other kinds of work. In this connection it would be helpful to know more about Edward Cookes, Caslon's master. Apprenticed in Aldersgate Ward, free of the Loriners in 1691, in Portsoken Ward in 1697, back in Farringdon Ward in 1706, contracted to do his first engraving work for the Board of Ordnance in 1707 and continuing until 1715, it would be highly informative to know what work or circumstances kept him in Farringdon Ward for, as with Caslon, it appears that it would have been more convenient to be near the Tower of London for the gun-lock engraving, as this would necessitate the carriage of gun-parts for only short distances, instead of transporting them to Farringdon Ward and back again. The fact that later we find Cookes in Goodman's Fields, Caslon in Vine Street, Minories, and John Pearman in Trinity Minories, suggests that all three were expecting work on firearms to be part of their work at the time each one moved there, even if Pearman was not personally contracted to do the work.

It seems especially important to note this in Caslon's case. Although he must have had plenty of experience of gun-lock engraving as an apprentice, he had not had the responsibility of getting the most out of other men and making a poor job pay its way. It appears from the little we know about Cookes that he was prepared to keep John Pearman as a journeyman for six years before sponsoring him as a freeman. Perhaps when Caslon himself became a master, he found he was unable to drive his boys as hard as he had been driven himself, for he was only twenty-four when he married and took his first apprentice.

The spite Row Mores later evinced against William Caslon II[49] is unquestionable, but he did not allow this to affect his testimony to the character of the first Caslon, of whom he says,[50] 'He died 23 Jan. 1766 aged 74 . . . leaving behind him the character of a tender Master, and an honest, friendly and worthy man . . .,'

There is another conclusion to be drawn from the dates of the Board of Ordnance documents. It seems probable that Caslon worked in Vine Street from the latter half of 1716 ; if that is true, his work for the printers and bookbinders had not then assumed such importance as to induce him to set himself up in the city ; indeed, he was not granted the freedom of the city until June, 1717, almost a year after he was first contracted to do the gun-lock engraving for the Board of Ordnance.

James Mosley shows a close-up view[51] of a musket lock preserved in the Tower Armouries which was engraved in 1718. If this was the only kind of gun-lock engraving done by Caslon it was a poor preparation for a future master of letters. No examples of ornamental engraving executed by Caslon on guns have yet come to light and indeed, it seems far more likely that the manufacture of bookbinders' punches, involving the cutting of letters and ornaments in relief on brass punches for hot pressing on leather and on steel punches for cold work was the more genuine preparation for Caslon's future work. In short, gun-lock engraving seems to have been a relatively minor factor in determining Caslon's career. [See Plates 4, 5, 6(a) & 6(b)].

[1] J. Goodwin, The Newdigates of Arbury: Early Memorials of the Birmingham Gun Trade, 1869.

[2] Clive Harris, The History of the Birmingham Gun-barrel Proof House, 1949, pp. 5–6.

[3] Ibid., p. 6.

[4] Conrad Gill, History of Birmingham, 1952, Vol. I, pp. 56–7.

[5] Harris, History of the Birmingham Gun-barrel Proof House, (in which the amount paid on this Treasury authorisation has been mis-read as a 'thousand' instead of 'four-score' pounds). P. 12 of Harris's work refers to another warrant issued from the Ordnance Office (still in existence) to pay 'John Smith for Thomas Hadley and the rest of the Birmingham Gunsmiths one debenture of four score and sixteen

pounds and eighteen shillings,' thus confirming the error on p. 9 as well as calling attention to a further error on p. 12 above, in naming the payee John Smith instead of John Smart.

6 The Newdigates of Arbury.

7 Harris, The Birmingham Gun-barrel Proof House, p. 13 (missing, however, in 1967).

8 Ibid.

9 D.N.B. art. Nathaniel Nye.

10 H. B. C. Pollard, A History of Firearms, 1926.

11 Birmingham Reference Library, No. 825.

12 William Hutton, History of Birmingham, 1795 Edition, p. 148.

13 Harris, The Birmingham Gun-barrel Proof House, p. 22.

14 Marjorie Williams, The Letters of William Shenstone, p. 91.

15 Hutton, History of Birmingham, p. 150.

16 H. L. Blackmore, British Military Firearms, 1650–1850, p. 50.

17 The Immigrant Population of Birmingham, 1686–1726, Trans. of the Birmingham Arch. Society, 1937.

18 Constable in 1709.

19 Constable in 1714.

20 Probably a mistake for John Foxall who was Constable in 1710, (Hutton's History of Birmingham, pp. 147–8).

21 Birmingham Reference Library. Deeds No. 181720 & 181721.

22 Apprenticeship Lists: Society of Genealogists.

23 British Military Firearms, 1650–1850.

24 Ibid. p. 38.

25 Ibid.

26 Ibid.

27 Ibid.

28 See Chapter 5.

29 D.N.B. art. Andrew Schalch.

30 British Military Firearms, 1650–1850, p. 40.

31 The Official Diary of Lieutenant-General Adam Williamson, Deputy-Lieutenant of the Tower of London, 1722–27: Camden Society, Third Series, Vol. XXII, 1912.

32 British Military Firearms.

33 John Bayley, History and Antiquities of the Tower of London, Vol. II, App. p. 126.

34 Ambrose Heal, The English Writing-Masters and their Copy-Books, 1931.

35 D.N.B. art. Smelt

36 Present State of the British Court, 1720.

37 John Bayley, History of the Tower of London, Vol. II, App. p. 119.

38 D.N.B. art. George Hicks, and Munk's Roll.

39 Lysons, Environs of London, Vol. II, Middlesex, p. 574.

40 Land-tax returns.

41 British Military Firearms, 1650–1850, p. 42.

[42] Surirey de St. Remy, Memoires d'Artillerie, Paris, 1697.

[43] Enc. Brit. 1951, art. bayonet.

[44] Biographical and Literary Anecdotes of William Bowyer, 1782, p. 316.

[45] Dissertation, p. 58.

[46] Literary Anecdotes of the Eighteenth Century, 1812–15.

[47] The Early Career of William Caslon, Journal of the Printing Historical Society, No. 3, 1967.

[48] Ibid.

[49] Dissertation, pp. 74–5.

[50] Ibid. p. 60.

[51] The Early Career of William Caslon, Plate 8.

Chapter Seven

CASLON AMONG THE GOLDSMITHS
AND SILVERSMITHS

WE HAVE SEEN in the last Chapter that in 1693 when the Ordnance Office contracted with the Birmingham Gun-makers for a further supply of arms, it was agreed that they should be proved at Birmingham according to the Tower proof and a fit person empowered by the Ordnance Office should inspect them and mark them with the Ordnance Office mark. Again in 1706, at a critical time in the Marlborough campaigns, when the combined efforts of the London and Birmingham gunmakers were insufficient to meet the demand, the Ordnance Office contracted for a further supply from Holland, Major Wibault being sent with a pattern musket and appropriate punches and power for their view and proof.

It is clear, therefore, that the viewers or inspectors used punches to mark the guns as they passed the test and this raises the question as to how far punches were used by gun-lock engravers to speed up what was a tedious process. The number of gun-locks engraved by Caslon in three years suggests that any method of expediting the process would be welcomed. Possibly in reducing Cookes' price from 4d. to 3d. Caslon was relying on using punches more than Cookes had done. Indeed, his more liberal use of the punch and chisel may have contributed to the Ordnance Office warning that 'if Caslon do not do them well' the Master Furbisher should 'look out for another who will stay the course of the office.'

119

James Mosley's close-up view of a gun-lock in the Tower Armouries, Plate 4, shows clearly that the letters and figures are cut more deeply than the crown; there is marked contrast between the royal cypher G.R. and the crown, suggesting that the letters were deepened by punching and trimmed afterwards.

In a note[1] on some surviving Caslon punches presented by the Monotype Corporation Ltd. to the Oxford University Press, Harry Carter says: 'In his (Caslon's) day, punch-cutters had to forge their steel, and Caslon did not waste it. Many of his punches are no more than an inch long. They are polygonal in section and thickest at half their length . . .' Carter then notes how different they are from those of the second Caslon: 'His punches are rectangular and neatly finished.'

Here we see the influence of each man's earlier experience. Whereas Caslon II probably never made a punch for use on any material harder than copper, his father's early work seems to have demanded short stout punches of great rigidity, capable of striking a pretty deep impression on the iron before hardening. At the present day, when we have an extensive range of steels from which to choose and can specify and be supplied with a suitable steel for the most exacting service, it is difficult for us to realise what obstacles Caslon and his contemporaries had to overcome. They made their own tools from materials much cruder than we have and a broken punch was a costly matter.

The traditional account of William Caslon[2] says that 'the ability he displayed in his art was conspicuous, and by no means confined to the mere ornamentation of gun-barrels—the chasing of silver and the designing of tools for bookbinders frequently occupying his attention. It appears that both Reed-Johnson and Updike[3] have misquoted Nichols,[4] who says, 'Mr. Caslon's first residence was in Vine Street in The Minories, where one considerable branch of his employment was to make tools for the bookbinders and for the chasing of silver plate.'

It now seems highly improbable that Caslon ever went beyond the manufacture of chasers and other tools for workers in precious metals, his skill being exercised in making, hardening, tempering and finishing tools for silversmiths as well as in making brass and steel tools for hot and cold pressing for the bookbinders.

His work would scarcely extend to actually working on silver.

The traditional account quoted above speaks somewhat disparagingly of the 'mere ornamentation of gun-barrels' but examples of the decorative treatment of gun-locks, etc. shown in Plate 5 prove that they are not to be despised as specimens of the engraver's art. The marks of identification engraved on government property by Edward Cookes and William Caslon certainly had very narrow artistic limits. Though Caslon might have done some ornamental engraving, no specimens of such work have come to light; for the present it would be safer to regard Caslon only as a toolmaker, letter-engraver, and punch-cutter.

However, before considering Caslon's connections with booksellers and printers it will be worthwhile looking at his earlier contacts with workers in precious metals. As the surviving records of the Loriners' Company disclose, Caslon's master, Edward Cookes, had his premises in Portsoken Ward outside the city in 1697, but by 1706 when Caslon became his apprentice, Cookes had moved into the city to Farringdon Ward. The Land Tax returns for 1706 and 1707,[5] however, do not reveal his name and he may, therefore, have carried on business in someone else's premises. John Pearman was Cookes' apprentice from 1696 to 1703. The conjecture that Cookes worked in someone else's premises is strengthened by the will of John Pearman's father, Nicholas Pearman of Clent,[6] revealing that John Pearman's sister Ann married William Robinson of London. When William Caslon married Sarah Pearman, his first wife, the bride was described as of St. Michael, Rude Lane, London, otherwise St. Michael, Wood Street. A list of inhabitants of Wood Street in 1717 who paid Land Tax and/or Poor Rate includes a certain 'Widow Robinson.' It seems impossible to resist the conclusion that 'Widow Robinson' was the mother of that William Robinson who married Ann Pearman of Clent and it seems likely that the pair had met while Ann Pearman was visiting her brother John in the premises nearby where Edward Cookes carried on his business.

We do not know how long Edward Cookes worked in Farringdon Ward, but it must have been for several years, for John Pearman was not admitted to the freedom of the city until 1709, having spent six years working for Cookes as a journeyman after

completing his seven-year term, a circumstance which suggests that there was then no immediate prospect of Cookes moving out of the city. Apart from the family relationship linking Cookes and Pearman, no doubt by 1709 they had established a close working relationship and Pearman was probably anxious that this should continue. Pearman remained on close terms with his uncle and on the death of Cookes in 1739 acted as the trustee of his will. Although Cookes, Pearman and Caslon all qualified to practise in the city, we find that for some reason at present not fully understood, Cookes moved to Goodman's Fields, Pearman to Trinity Minories, and Caslon to Vine Street, all outside the city.

It seems fairly conclusive, therefore, that for most of the period of Caslon's apprenticeship from 1706 to 1713, he had closer connections with Farringdon Ward and round about than with the area near the Tower of London, and as we shall see, it will be rewarding to consider Caslon's early background topographically.

If we refer to *London in 1731*, by Don Manoel Gonzales,[7] we find that Farringdon Ward within comprised St. Paul's Churchyard, Ludgate Street, Blackfriars, the east side of Fleet Ditch, from Ludgate Street to the Thames, Creed Lane, Ave Mary Lane, Amen Corner, Paternoster Row, Newgate Street and Market, Greyfriars, part of Warwick Lane, Ivy Lane, part of Cheapside, part of Foster Lane, part of Wood Street, part of Friday Street, and part of the Old Change, with several courts and alleys falling into them.

The same pseudonymous authority lists the public buildings in this ward as the Cathedral of St. Paul's, St. Paul's School, the King's Printing House, the Scotch Hall, Apothecaries' Hall, Stationers' Hall, the College of Physicians, Butchers' Hall, Saddlers' Hall, Embroiderers' Hall, the church of St. Martin Ludgate, Christ's Church and Hospital, the church of St. Matthew, Friday Street, St. Austin's church, the church of St. Vedast, and the Chapter House.

London and Its Environs Described,[8] gives the boundaries of Farringdon Ward as follows: 'On the north by Aldersgate ward, Cripplegate ward, and the liberty of St. Martin's le Grand; on the west by Farringdon without; on the south by Castle

Baynard ward, and the river Thames; and on the east by Castle Baynard ward, and Cheap ward.

If, therefore, we now look at a map of London, and suppose ourselves to be in Wood Street, we shall see that we are equidistant from Temple Bar in the west and The Minories in the east and therefore much nearer to those people with whom Caslon was traditionally associated from an early date, namely, John Watts the publisher and William Bowyer the printer. Moroever, Wood Street and the streets nearby abounded in workers in precious metals.

The founder of Farringdon Ward, a certain Sir Nicholas Farringdon as early as the thirteenth century, was himself a goldsmith and we are told[9] that in the early part of the seventeenth century 'the City greatly abounded in Riches and Splendor, such as former ages were unacquainted with; then it was beautiful to behold the glorious Appearance of Goldsmiths Shops in the South Row of Cheapside, which in a continu'd Course, reach'd from the Old-Change to Bucklersbury . . .'

The privileges of the Goldsmiths were preserved in their several successive charters. Although the Cutlers had a right of working in gold and silver, yet all articles made by them were to be assayed by the Goldsmiths, according to their ancient immunities, rights which were preserved till 1739. Indeed, the assay possessed by the Goldsmiths' Company compelled every article of manufacture in gold and silver to be marked with the 'hall mark' before it left the workman's hands. The 'touch-wardens' and assaymaster had steel puncheons and marks of different sizes, somewhat akin to letter puncheons. The 'hall mark' shows where the piece is manufactured, as the leopard's head for London. The 'duty mark' is the head of the sovereign, showing that the duty is paid. The 'date mark' is a letter of the alphabet, which changes with the year; thus from 1716 to 1755 the Goldsmiths' Company used Roman capital letters; from 1756 to 1775, small roman letters; 1776 to 1795, Old English letters; 1796 to 1815, Roman capital letters, from A to U, omitting J; and so on. The 'manufacturer's mark' consists of the initials of the maker.[10]

There was always a close connection between the Goldsmiths and the Royal Mint at the Tower and it was obviously in the interests of the gold and silver-smiths to encourage the striking of

medals to celebrate important events, the principal medallists being also the coin engravers engaged at the Mint. In the time of Charles II and James II the principal engravers were the Roettiers and though John Roettiers still held office in William III's time, he never acknowledged William and never engraved the coins for his reign. In January, 1697, it was discovered that the coin-dies of Charles II and James II had been stolen from Roettiers' house by labourers and had been used by coiners in the Fleet Prison for striking guineas of James II on gilded blanks of copper, as a result of which old Roettiers was removed from office.[11]

There seems to have been some confusion about this time between the overlapping authority of different engravers. Henry (sometimes called Captain) Harris is called chief engraver and seal-cutter in succession to East, and Harris was succeeded by Roos, yet in March, 1689–90, Harris is recorded as being appointed as 'chief graver of the stamps and irons of the King's Mint' (that is, chief engraver to the Mint) in the place of George Bower, lately deceased. No coins or medals by Harris are known ; he seems to have left the actual work of engraving to assistants, even the Roettiers being placed under him.[12]

John Croker (1670–1741) was one of the most notable of a line of accomplished engravers at the Mint. He was of German origin and in 1697 became an assistant under Harris, succeeding to the post of chief engraver after Harris's death in 1704. It was Croker who, in addition to engraving the dies for gold, silver and copper coinage, produced so many admirable medals commemorating historical events, a line of business in which he was even allowed a private pecuniary interest.[13]

All newly-coined money was submitted for the Trial of the Pix, when one of each coin was placed in a pix or casket, sealed with three seals, and secured with three locks ; and the coins were then compared with the trial plates at Westminster by a jury from the Company of Goldsmiths, the Lord Chancellor or the Chancellor of the Exchequer presiding.

The names of the most notable Mint engravers from the time of Charles I are as follows : Briot, Simon, Rawlins, the three Roettiers, Croker, Tanner, Dassier, Yeo, Natter, the two Pingos, Pistrucci, and the three Wyons.

All the mechanical appliances of the old Royal Mint were of the crudest character and the apparatus for minting the coinage of the realm filled but one room, and that not a particularly large one. The melting department was ridiculously small and the crucibles in use were easily moved about by hand, even when charged with metal. The rolling-mills, which might be described as of miniature size, were operated by four horses, ever going their 'weary rounds.' The blanking presses, operated by hand-levers, were of the most primitive construction, and are still preserved as curiosities, while the stamping presses were operated by the muscular strength of gangs of brawny labourers.[14]

Returning to that area of London populated by workers in precious metals it may be noted that in the combined parishes of SS. Anne and Agnes, Aldersgate, and St. John Zachary in Foster Lane, two churches very close together but in different wards, twenty-two silversmiths are recorded between the years 1690 and 1730.[15] The numbers in other parishes in and about Farringdon Ward are not known, but in all they must have been very numerous.

Dru Drury was a silversmith in Wood Street; he was the father of another Dru Drury (1725–1803) who made a name as a naturalist, especially as an entomologist,[16] whose excellent figures were engraved by Moses Harris (1731?–85).[17] In 1718 the engraver's uncle Moses Harris, of St. Andrew, Holborn, married Margery Eames of St. Dunstan-in-the-West, at St. Michael, Cornhill.[18] In 1703 John Stiles, silversmith, married Sarah Hodgson at St. Botolph's, Aldersgate.[19] Joseph Brasbridge (1743–1832) inherited a good business as a silversmith in Fleet Street, but neglecting his work became bankrupt, was re-established through the kindness of friends, and in old age published his memoirs *The Fruits of Experience*.[20]

Although the parishes of St. Mary Staining and St. Michael, Wood Street, were combined after the Great Fire, the church of St. Mary Staining was actually in Aldersgate Ward, and many of the interests and occupations of Farringdon Ward spread into the adjacent streets, parts of Noble Street and Foster Lane, St. Martin's-le-Grand, Little Britain and Aldersgate Street. The list of those paying land tax in 1717[21] in St. Mary Staining included

Mr John Cartlich, a goldsmith, who was rated at £73, the highest in the parish except Coachmakers' Hall, which was rated at £80. Haberdashers' Hall paid on £25 only, so that John Cartlich was a very substantial man. In 1715 he and Thomas Gouge were appointed to administer the Oath of Abjuration in the Ward of Aldersgate Within. His residence was in Oat Lane, near Goldsmiths' Hall. William Cartlich, his son, became master-melter of the Mint at the Tower.[22] But a point of special note here is that one of John Cartlich's neighbours was Adam Bell, Warden of the Loriners' Company in 1717,[23] the former master of Edward Cookes who became the official gunlock engraver to the Board of Ordnance, and Cookes in turn was responsible for training William Caslon. The will of Edward Cookes shows that he maintained his connection with Adam Bell, for the next name to Bell's in the land tax returns is that of Jacob Harris, who became the second husband of Martha, Edward Cookes's daughter. Adam Bell was rated at £9 and Jacob Harris also at £9, while Richard Smelt[24] paid tax on premises rated at £8 per annum. One of the highest rated of the lesser fry was William Williams, assessed at £20 on two houses.[25]

Although it has not been possible to pin-point the influence precisely, it is clear that there was a connection between this part of London and the Tower, since we find the Cartliches connected with it, the Smelts concerned with Ordnance Office appointments, and Cookes and Caslon concerned in Ordnance Office contracts for gun-lock engraving.

A pedigree is appended of the family of Cartlich, showing the connections with the families of Anderson and Burscoe. John Burscoe (or Burscough) of St. Michael, Wood Street was the son of the Rev. John Burscough, rector of Stoke next Guildford and Hannah Bowness of Stonbury, Little Hormead, Herts. John Burscough's aunt, Eleanor Bowness had married, in 1661 at St. Dunstan's in the West, Robert Anderson and it was their granddaughter Elizabeth Anderson who in 1727 married William Cartlich of the Royal Mint,[26] thus renewing an earlier connection of the Andersons with the Tower of London.

Robert Anderson (fl. 1668–1696) was a mathematician and silk-weaver of London who was helped in his studies by John

Collins (1625–83) F.R.S.[27] Anderson devoted special attention to the art of gunnery and for over twenty years from 1671 conducted some thousands of experiments with cannon mounted at his own expense on Wimbledon Common, showing that his means must have been considerable. 'I am very well assured,' he says,[23] 'I have done more, being a private person, than all the engineers and gunners with their yearly salaries and allowances, since the first invention of this warlike engine.' He published several other works on ballistics, one of which, *The Making of Rockets, etc.*, 1696, he dedicated to Henry Sidney, Earl of Romney, Master General of the Ordnance.

There is another well-documented connection of the Cartlich family which should be noted here.[9] John Cartlich and his second wife Martha Hawes were on terms of close friendship with the family of Jesson, deriving from West Bromwich, Staffordshire. Cornelius Jesson of Christ Church, Newgate, was at first an ironmonger by trade, although when he married Ann Whiting of St. Martin's, Ludgate, in 1678, he was then described as a tallow-chandler of St. Giles, Cripplegate. However, in 1703, Cornelius Jesson, citizen and ironmonger, was elected Steward of Christ's Hospital and remained in that office until his death in 1723. He was first cousin to Sarah Ford, the mother of Samuel Johnson.

When young Samuel was taken by his mother to London in 1712 to have him 'touched' by Queen Anne for 'the evil' (scrofula), mother and child stayed in Little Britain, only a stone's throw from Christ's Hospital, and it seems quite probable that on this occasion Cornelius Jesson escorted his country cousin through the streets of London. Johnson later relates,[30] 'We went in the stage-coach and returned in the waggon, as my mother said, because my cough was violent; but the hope of saving a few shillings was no slight motive . . . She sewed two guineas in her petticoat lest she should be robbed . . . We were troublesome to the passengers; but to suffer such inconvenience in the stage-coach was common in those days to persons in much higher rank.'

Cornelius Jesson's son, another Cornelius, was a canvas or sail-cloth merchant of St. Botolph's, Aldersgate, When he died in 1739, he left £10 to Mrs Martha Cartlich, widow of John Cart-

lich, late of Oat Lane, refiner. His widow, Christabella, died a few weeks afterwards, leaving, amongst other legacies, 'To Mary White, my friend Mrs. Martha *Carlitch's* (sic) maid-servant, £20. To the said Mrs. Martha *Carlitch* (sic) £200.[31]

Although Cornelius Jesson is not named in Pepys's *Diary*, the famous Samuel's connection with the administration of Christ's Hospital was so close that although Pepys was then at the end of his life, it is most likely that the diarist and the Jessons were well known to each other, especially as both the iron-monger and the sail-canvas merchant were concerned in supplies to H.M. Navy.

We have no means of knowing how long William Caslon had known the Cartliches, for it was not until 1751 that William Caslon II married Elizabeth Cartlich, but in view of Adam Bell being John Cartlich's neighbour it seems probable that Caslon I was acquainted with the family from his apprenticeship days. Moreover, we are beginning to realise that before Caslon began to specialise in letter-founding, he was prepared to undertake punch-cutting of any kind as part of his trade, as well as the making of tools for copper-plate engravers, silver chasers and book-binders. The later connection between the families suggests that as punch-cutters the Caslons might also have made puncheons for assay purposes but the point has not been resolved. All we can say at present is that Adam Bell and Edward Cookes, besides William Caslon, while working in and around Aldersgate and Farringdon Wards, undertook a range of work still not fully realised. It is unfortunate that we know so little of Adam Bell, especially as he rose to be Warden of the Loriners in 1717, but as previously stated, no record of his apprenticeship and master has survived.

Inhabitants of the parish of St. Michael, Wood Street, London, 1717, compiled from the Poor Rate and the Land Tax Assessments for that year. Those occurring only on the Poor Rate are marked (*) and those only on the Land Tax are marked (**); otherwise they occur on both.

Thomas Shepherd
William Smith
William Wilson

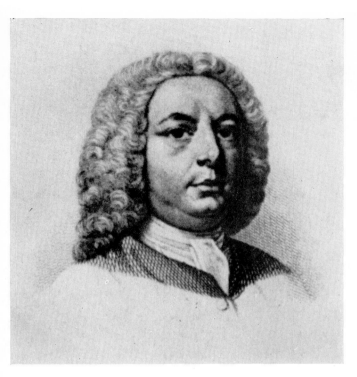

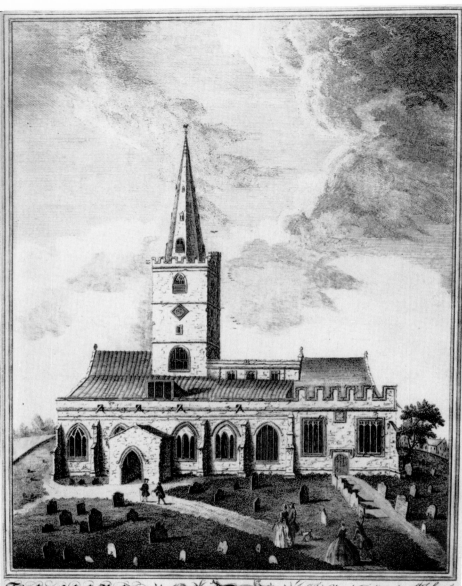

PLATE 8
South East Prospect of the Parish Church of Halesowen in Com. Salop. 1746
Line engraving by James Green (1729–59)

Samuel Wincope (Master of the Wood Street
Henry Stevens Compter)
Wid. Attaway (variant of Otway)
Christopher Knight
William Ford
William Timmes
John King
Madam Cross (Probably the actress Mrs Cross,
contemporary with the more cele-
brated Anne Oldfield)

John Burscoe (Son of John Burscoe (or Burs-
cough), M.A., rector of Stoke
next Guildford—see pedigree of
Cartlich for relationship to that
family)

Thomas Leach

Robert Dowley
Ham Randell
Richard Steel
Drue Drury (Silversmith—see D.N.B.)
Robert Foyle (Appointed in 1715 to administer
the Oath of Abjuration in the
Ward of Cripplegate Within)

Timothy Chebsey
Samuel Hewitt
Richard Terrill
John Smith
Nathaniel Adams
George Quick
Wid. Robinson (Mother of William Robinson
mentioned in Will of Nicholas
Pearman of Clent)
Wid. Lander (See relative below)
Robert Cox
Benjamin Whale (See relative below)
Henry Ventris (Probably connected with Sir
Peyton Ventris, 1645–91)

John Lander
*Herman Mackewan
Wid. Nelson
Thomas Peverton
Benjamin Whale
William Langbridge

Jeremiah Stanley
*James Bradshaw
Christopher Canner (Obviously connected with Chris-
 topher Canner, M.A., Vicar of
 Climping, Sussex, 1670)

John Picard
Mary Gillingham
John Gifford
Thomas Chivers
Thomas Wheatley
John Barton
Robert Purser (Possibly connected with John
 Purser the printer of George
 Stubbs's 'Anatomy of the Horse')

John Russell
Richard Forster
James Coward (Possibly related to William Cow-
 ard, D. Med. of Lombard Street;
 see Munk's Roll)
Nathaniel Ragdell (married Susannah Terry in
 1688; see Chester's M. Lic.)
Daniel Cale
John Pearse
William Sturt (Possibly connected with John
 Sturt, engraver of writing
 masters' copy-books)

Moses Langley
Joseph Stevenson
Downes Ward
John Egleton
Mark Allworth
John Vivers (Variant of Vivares)
George Scott
John Parkes
James Stacey
John Arden
John Green
*Thomas Farrington
Thomas Grimshaw
Charles Kent
Thomas Ruffield (see relative below)
Parrot Fenton
William Miller
Richard Bishop

John Jorden (Possibly connected with the Mid land gunsmith family, or with Thomas Jorden, city poet)

William Palmer

Thomas Honeywood (Possibly a connection of Sir Thomas Honeywood, the parliamentarian)

John Gibbons

*George Fuller

*Richard Philip

Matthew Bacon

Thomas Carpenter (No relationship to the Halesowen Carpenters has been established)

Robert Stent (Variant of Stennett. The Stennetts were well-known Baptists.)

Nathaniel Day

John Hargrave

Abraham Mitchell

John Brown

Joseph Chamberlain

Widow Threkeld

**William Chandler

**John Thompson

**James Branch

**Abram Harris

**Nathaniel Hollier

**Widow Ruffield

Inhabitants of the parish of St. Mary Staining, London, assessed for Land Tax in 1717

[The figures in the left-hand column represent the rateable value in pounds].

73 Mr. John Cartlich (Of Oat Lane, refiner. In 1715 he was appointed to administer the Oath of Abjuration in the Ward of Aldersgate Within, together with Thomas Gouge)

5 William Cooke

10 Widow Ash

20 William Williams (2 houses)

8 William Hayles

8 Robert Keble	(Possibly related to Samuel Keble of Fleet Street, bookseller)
9 Joseph Lemas	
20 Edward Lemas	
6 John Pickering	
8 Roger Handicocke	(Variant of Hancock)
8 Mary Spratt	
8 Joseph Ashby	
8 Richard Smelt	(Related to Smelts of the Ordnance Office, Tower of London)
8 Edward Tompson	
8 Charles Senell?	(Possibly connected with Charles Snell, Writing Master, who was born in the parish of St. Giles, Cripplegate. See Chapter 8)
8 Ju ?? Sherrer	
25 Haberdashers' Hall	
8 Francis Savage	
8 James? Packford	
9 Adam Bell	(Loriner and Master of Edward Cookes)
9 Jacob Harris	(Future son-in-law of Edward Cookes)
9 Henry Horsetone	
80 Coachmakers' Hall	
18 Thomas Wheeler	
18 Edward Beans	
8 John Bridgeman	(Probably related to William Bridgeman, who had a writing-school in Wood Street at the turn of the century.
14 John Lane	
William Bird lodger	
8 Widow Crosby	
10 William Guttliffe	
12 ?? Keddon	(See below)
10 Joseph Ward	
10 Peter More	
10 Henry? Dorrill	
18 William Brayfield	
8 Thomas Rampon	
10 Richard Booth	
11 George Tattnall	(Variant of Tettenhall)
6 Widow? Vittrall	

12 Robert Peache
6 Jno. Cowsey
8 Robert London
14 Edward Wright
8 Robert Plum
9 Thomas Keaddon
9 Thomas Smith

[1] Harry Carter, Caslon Punches: An Interim Note. Journal of the Printing Historical Society. No. I, 1965.
[2] Reed-Johnson, p. 230.
[3] Vol. II, p. 101.
[4] Anecdotes of William Bowyer, p. 586.
[5] Guildhall Library, London.
[6] Chapter 5.
[7] Assumed name of the writer of a 'Voyage to Great Britain, etc.,' from the Harleian Collection, published in Pinkerton's 'Voyages and Travels,' 1808–14.
[8] R. & J. Dodsley, 1761.
[9] Rushworth's Collections.
[10] Timbs, Curiosities of London, 1868.
[11] D.N.B. art. Roettiers.
[12] Ibid.
[13] Ibid.
[14] Timbs, Curiosities of London, 1868.
[15] Wm. McMurray. Records of Two City Parishes, 1925.
[16] D.N.B. art. Dru Drury.
[17] D.N.B. art. Moses Harris.
[18] Register of St. Michael, Cornhill.
[19] Register of St. Botolph, Aldersgate.
[20] D.N.B. art. Joseph Brasbridge.
[21] Appended to this Chapter.
[22] Chamberlayne's Magnae Britanniae Notitia, 1735.
[23] Land Tax Assessments.
[24] See Chapter 6.
[25] Lists appended to this Chapter.
[26] Foster's Alum. Oxon. and Chancery Case C.11/523/12 dated 1736, and Chart 7 appended to this Chapter.
[27] D.N.B. art. Robert Anderson.
[28] Genuine Use and Effects of the Gunne, 1674.
[29] A. L. Reade, The Reades of Blackwood Hill and Dr. Johnson's Ancestry, 1906.
[30] Boswell, Life of Johnson.
[31] A. L. Reade, previously quoted.

Chart 7.
Family of Elizabeth Cartlich, wife of William Caslon II

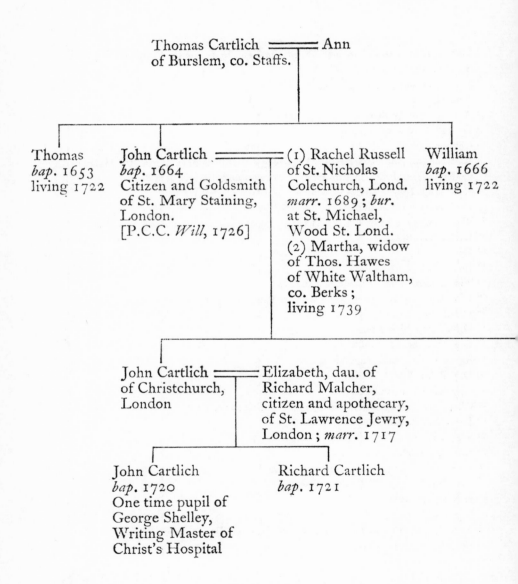

Thomas Cartlich ═══════ Ann
of Burslem, co. Staffs.

Thomas
bap. 1653
living 1722

John Cartlich ═══════ (1) Rachel Russell
bap. 1664
Citizen and Goldsmith
of St. Mary Staining,
London.
[P.C.C. *Will*, 1726]

(1) Rachel Russell
of St. Nicholas
Colechurch, Lond.
marr. 1689 ; *bur.*
at St. Michael,
Wood St. Lond.
(2) Martha, widow
of Thos. Hawes
of White Waltham,
co. Berks ;
living 1739

William
bap. 1666
living 1722

John Cartlich ═══════ Elizabeth, dau. of
of Christchurch,
London

Richard Malcher,
citizen and apothecary,
of St. Lawrence Jewry,
London ; *marr.* 1717

John Cartlich
bap. 1720
One time pupil of
George Shelley,
Writing Master of
Christ's Hospital

Richard Cartlich
bap. 1721

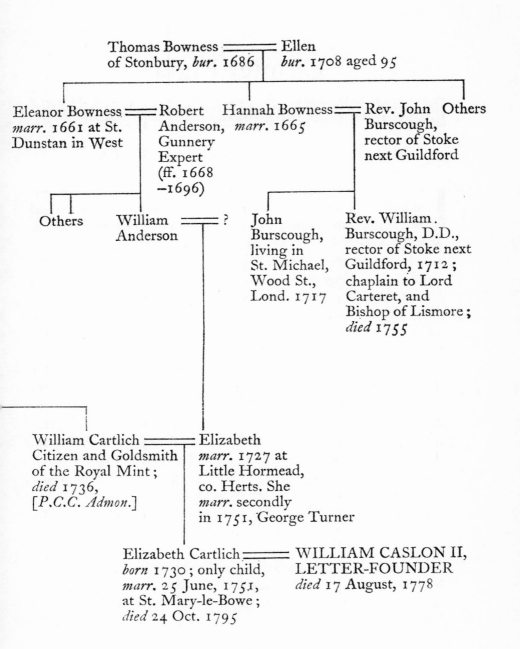

Thomas Bowness ════ Ellen
of Stonbury, *bur.* 1686 │ *bur.* 1708 aged 95

Eleanor Bowness ════ Robert Hannah Bowness ════ Rev. John Others
marr. 1661 at St. Anderson, *marr.* 1665 Burscough,
Dunstan in West Gunnery rector of Stoke
 Expert next Guildford
 (ff. 1668
 –1696)

Others William ════ ? John Rev. William.
 Anderson Burscough, Burscough, D.D.,
 living in rector of Stoke next
 St. Michael, Guildford, 1712;
 Wood St., chaplain to Lord
 Lond. 1717 Carteret, and
 Bishop of Lismore;
 died 1755

William Cartlich ════ Elizabeth
Citizen and Goldsmith *marr.* 1727 at
of the Royal Mint; Little Hormead,
died 1736, co. Herts. She
[*P.C.C. Admon.*] *marr.* secondly
 in 1751, George Turner

Elizabeth Cartlich ════ WILLIAM CASLON II,
born 1730; only child, LETTER-FOUNDER
marr. 25 June, 1751, *died* 17 August, 1778
at St. Mary-le-Bowe;
died 24 Oct. 1795

135

Chapter Eight

CASLON'S PROFESSIONAL BRETHREN

THE REIGN OF Queen Anne stands out in our history as a period of brilliant military and literary achievement. In war it witnessed the capture of Gibraltar and those military campaigns of Marlborough which led to the defeat of the armies of the greatest military power of the world. It has also been described as the Augustan age of English literature, when Swift, Pope, Defoe, and a host of others rendered the period illustrious. Whilst mention of the reign of Anne brings these names and events at once to the mind, we cannot similarly recall, at any rate not without effort, the names of any painters of her reign with the possible exception of Kneller, Richardson and Thornhill. When Anne came to the throne in 1702 there were no English painters or sculptors of particular note, for the arts in this country had sunk almost to their lowest ebb and there were as yet no indications of that great eighteenth century revival that was to bring forth Hogarth, Reynolds and Gainsborough. We had lost touch with the traditions of Holbein, Vandyck, and other foreign masters whose practice in this country had influenced our school in earlier times ; and Cornelius Johnson, William Dobson, Samuel Cooper and the rest of the seventeenth century painters of eminence had passed away.[1]

The gap in English art in the seventeenth century between Nicholas Hilliard (1573–1619), limner to Queen Elizabeth, and the coming of Rubens and Vandyck to the courts of James I and Charles I is bridged by the two Olivers, Isaac, a French-

man from Rouen, and his son Peter. Gerard Honthorst was another foreign painter who found generous patronage under Charles I. Despite the continuous introduction of Flemish and other European painters, Vandyck, Lely, Kneller and Dahl, to name but a few, native talent contrived to assert itself. William Dobson succeeded his patron and friend, Vandyck, as sergeant-painter in 1641 and the beautifully balanced character studies of the miniature painter Samuel Cooper graced English art in the Commonwealth and Restoration era. John Riley, whose genius deserves a better recognition than it has so far received, was born in 1646, the year of Dobson's death, and at his own death, in 1691, he held the rank of court painter to William and Mary. A Londoner by birth, Riley was the son of the then Lancaster Herald, and learnt his craft from Gerard Soest. John Greenhill was a contemporary of Riley. Dr. Wingfield Stratford[2] has a welcome passage justifying the Englishmen, Dobson, Greenhill, Gandy and Riley, against the best of the foreigners, who flourished at the expense of native talent and delayed the advent of an English School for the greater part of a century. Artistically, Riley was the 'father' of Jonathan Richardson (1665–1745), who married Riley's niece and inherited many of his pictures and studio effects. Richardson was the master of Thomas Hudson (1701–79) and he in turn the master of Sir Joshua Reynolds (1723–92), so that in the art of portraiture what may be regarded as a national strain was transmitted through these four men.[3]

At the beginning of the eighteenth century, however, Kneller's supremacy was unquestioned. The German artist had some talent but more vanity and the adulation he received made him believe that his achievements ranked with the great masters. The death of Sir Peter Lely had left him without a serious rival, and as it was impossible to carry out all his commissions single-handed he built up a picture factory established, as it has been said, 'upon as regular principles as the fabricating of carpets at Kidderminster,' building up portraits by combining the work of the periwig painter, the drapery painter, the ruffle painter, and so on, a process which led inevitably to a degradation of art. Flattered by such writers as Addison and Pope, and earning a princely income, Kneller lived in semi-state with liveried servants, a large

town house in Great Queen Street, Lincoln's Inn Fields, and a country seat at Whitton, near Hounslow. Between his town and country houses the painter travelled in his six-horsed coach, on one occasion while on the Heath suffering from the attentions of highwaymen.

For all his vanity and love of money, it is to Kneller that we owe the first attempt to found a school in London in which drawing and painting from the life could be practised. As early as 1662 John Evelyn, in his *Sculptura*, propounded a scheme for an academy, with professors of anatomy and perspective, charged with the duty of educating young artists, but nothing practical was done, so that at the latter end of the seventeenth century individual artists in England had to do the work which in France was done by officers of the Crown. In the early eighteenth century there were at least two artists' clubs in existence in London, the Rose and Crown, to which George Vertue was admitted in 1704, and the older and more important Society of Virtuosi of St. Luke. The meetings of these clubs offered no opportunities for study; they were held in taverns and were always of a more or less convivial nature.[4]

It was in 1711, late in Caslon's apprenticeship, that the first school of drawing and painting from the life was set up in London. Its cosmopolitan group of supporters included Sir Godfrey Kneller; Michael Dahl the Swedish portrait painter and Kneller's rival, Antonio Pellegrini, the Venetian; Louis Laguerre, the French decorative artist; and the Englishmen Jonathan Richardson and James Thornhill. Three zealous supporters of the arts, Edmund Anderson, Anthony Cope, and Henry Cooke, undertook to make the plan of the Academy known to London artists and to collect a subscription of a guinea each from those who agreed to support the undertaking; and suitable premises were found in Great Queen Street, not far from Kneller's house. Vertue, then twenty-seven years of age, who was one of the original students, says 'the place for drawing was a large room, ground floor, in the great house in the middle of Great Queen Street, near Lincoln's Inn Fields, where formerly many great noblemen had lived, and once the land-bank was kept there, but gone to decay and uninhabited.'

At the first election for a Governor and twelve directors held on St. Luke's Day, 18 October, 1711, Kneller was elected Governor and the Directors chosen included Louis Laguerre, James Thornhill, Jonathan Richardson, Thomas Gibson, Francis Bird, the sculptor who carved the statue of Queen Anne which once stood opposite the western front of St. Paul's, and the Frenchman Nicholas Dorigny who, although his country was then at war with England, had arrived in London the previous year to make engravings from the Raphael Cartoons at Hampton Court. Among those who took part in the election were Hugh Howard, the artist and connoisseur, James Gibbs, the architect, Christian Reisen, the seal engraver, John Simon, the mezzotinter, George Vertue, engraver and antiquary, and a number of painters, including Michael Dahl, Bernard Lens, John Wootten, Peter Tillemans, Joseph Goupy, Hans Huyssing, Peter Casteels, John Vanderbank, Robert Brown, and the deaf and dumb artist, Benjamin Ferrers.

Some of the members of the new Academy were not professional artists. James Seymour was a banker and wealthy collector who had known Lely and was friendly with Sir Christopher Wren; he was the father of James Seymour the artist who was reputed to be able to draw horses better than any man in England. Owen McSwiney was an Irish dramatist and theatrical manager concerned successively with the direction of Drury Lane and the Haymarket theatres. Among the twelve new members who joined the Academy in 1712 were Captain Marcellus Laroon, Stephen Slaughter, afterwards Keeper of the Royal Pictures under George II, Bartholomew Dandridge, the future portrait painter, and Sir Richard Steele the essayist, who became a Director.

Upon Kneller's resigning the leadership of the Academy in 1716, owing to advancing years, he was succeeded by his younger rival Thornhill, though some members would have preferred to see Laguerre as Governor. Thornhill had been apprenticed to his relation Thomas Highmore, who at his death in 1720 held the post of sergeant-painter. Thornhill ruled the Academy until he was deposed in his turn by another faction, whereupon he set up a school of his own at his house in Covent Garden; while the party that deposed him, headed by Louis Cheron, another Frenchman,

and Vanderbank the portrait painter, abandoned the room in Great Queen Street and established a new Academy in St. Martin's Lane, which was attended by many of the original members.

It was early in October, 1720, that Cheron and Vanderbank opened their Academy in St. Martin's Lane, in a 'great room' which had previously been used as a meeting house, according to William Hogarth, whose name appears this year for the first time in the list of members. He says that at St. Martin's Lane Cheron and Vanderbank engaged female models to pose for the life class with the idea of making it more attractive, a statement which suggests that at Great Queen Street only male models were employed. Next to Hogarth's name in the list is that of Alexander Gamble 'enameller,' who probably joined the Academy with him and was a relation of Ellis Gamble the silversmith to whom Hogarth was apprenticed. As will be seen presently Hogarth was related to the Gambles.

Another student of 1720 was William Cheselden, the famous surgeon of St. Thomas's Hospital, who no doubt joined the Academy to improve his knowledge of the technicalities of drawing. He has left a record of the difficulties he experienced in producing the illustrations for his *Osteographia*, or the *Anatomy of the Bones*, published in 1735, in which he was assisted by another artist-surgeon, John Green. Joseph Highmore (1692–1780) nephew of the sergeant-painter, was also among the students of 1720, and William Kent, architect and painter and later the target for many of Hogarth's satiric shafts, as well as Arthur Pond, painter, etcher, dealer and connoisseur.

Thornhill's attempt to found a private school of his own ended in failure. The attendance was small and an effort to extend it by admitting students free of charge was unsuccessful. Thornhill's Academy was soon closed, but that in St. Martin's Lane existed until 1735 when the treasurer embezzled the subscriptions. The landlord, unable to obtain his rent, seized the furniture, and it seemed likely that London would lose its art school until Hogarth, who had married Thornhill's daughter, came to the rescue and founded a second St. Martin's Lane Academy. This was not long after the death of Thornhill in 1734, when Hogarth had come into possession of the fittings of the life school founded

by his father-in-law at Covent Garden. This Academy survived about thirty years. At first Hogarth was asisted by John Ellis (or Ellys) probably another relation who had been a pupil of Thornhill and had assisted him in the decoration of the Painted Hall at Greenwich. Ellis was at one time high in favour with Sir Robert Walpole, whom he advised in the purchase of pictures ; and Walpole gave him the appointment—a singular one for an artist—of keeper of the Lions at the Tower, the salary and perquisites of which he enjoyed for many years.

Hogarth's picture of his students working round a nude model hangs in the Diploma Gallery at Burlington House, in testimony of the fact that the Royal Academy, as a teaching institution, traces its descent from Thornhill's Society of Artists, in 'Peter's Court, against Tom's Coffee-house in St. Martin's Lane.' It can be said, too, that exhibitions of contemporary pictures trace their descent from Hogarth, for it was the gift of his pictures to the Foundling Hospital which first led to a collection arranged for public exhibition and thus to the Royal Academy exhibitions.

Whilst we have seen that there were English painters before Hogarth, it will be readily understood why he is often accorded the title of 'the first of the English painters,' for Hogarth sought out English themes and proved them paintable. By a life-time of work he showed how a brush could be handled to express English ideas and ideals. He was also an organiser, rich in energy and fertile in expedients, who did much for his profession. For almost a century after his death the English school of painting was excelled by no art effort in Europe.[5]

William Hogarth was born in Bartholomew Close next door to the printing office of Joseph Downing, printer to the S.P.C.K., and it will be worth while to state here briefly what does not seem to have been previously recorded regarding his relations. According to the register of Great St. Bartholomew, West Smithfield,[6] William Hogarth was born 'in Barthw Closte, next door to Mr. Downinge's the Printers, November ye 10th, 1697, and was baptized ye 28th November, 1697.' A sister, Mary, was also born 23 November, 1699 and baptised 10 December at St. Bartholomew, and another sister, Ann, was born in October, 1701 and baptised 6 November at St. Sepulchre. A second son, Thomas,

was baptised on 12 November, 1703, and a third son, Edmund, on 19 August, 1705, both at St. James's, Clerkenwell, Their father, Richard Hogarth, was educated at St. Bees, and after keeping a school in Westmoreland, moved to London, where he had schools successively in Bartholomew Close, St. John Street, Clerkenwell, and in Ship Court, Old Bailey. In addition to his work as a schoolmaster, he was also occasionally employed as a corrector of the press, work he might have begun when living next door to Downing the printer. In 1712 William Taylor of the Ship in Paternoster Row published Richard Hogarth's book *Grammar Disputations, or an examination of the eight parts of speech by way of questions and answers, . . . Written for the use of the schools of Great Britain*, by Richard Hogarth, Schoolmaster.[7] Richard Hogarth was living in Long Lane, West Smithfield, at the time of his death, and he was buried 11 May, 1718.

It has been already mentioned that William Hogarth was apprenticed to a relation, a silver plate engraver named Ellis Gamble, at the sign of the Golden Angel in Cranbourne Street or Alley, Leicester Fields, and that Alexander Gamble, an enameller, and John Ellis, who assisted Hogarth in his drawing school, were also relations. Indeed, it is very probable that Hogarth had obtained his introduction to Sir James Thornhill through John Ellis having been a pupil of Thornhill's and Ellis Gamble obviously owed his Christian name to his Ellis relations.

Hogarth's relationship to the Gambles is revealed in his uncle's marriage recorded in Chester's London Marriage Licences:

'Edmund Hogarth, of St. Magnus, London, bachelor, 35, and Sarah Gambell, of St. Swithin, spinster, 30—at All Hallows-in-ye-Wall. 12 August, 1707, B.'

Hogarth's own marriage is also recorded thus:

'William Hogarth, of St. Paul, Covent Garden, Middlesex, bachelor, above 25, and Jane Thornhill, of same, spinster, above 21—at same. 20 March, 1728–9. F.'

The biography of John Gamble[8] (died 1687) musician and composer, besides testifying to the musical talent in the family, also provides a hint of the origin of the Ellis relationship. In 1656 John Gamble published *Ayres and Dialogues to be sung to the theorbo, lute, or base violl*. This music won Gamble renown at

142

Oxford and Anthony à Wood in July, 1658, was proud to entertain him and another eminent musician after their performance at Will Ellis's meeting house.[9] At the Restoration Gamble was admitted to the King's household, and his services as 'musitian on the cornet' were available at the Chapel Royal. In his will of 1680 he left music, etc., to his grandson John Gamble 'now servant to Mr. Strong.'[10]

Apart from the certainty that Caslon and Hogarth were well acquainted with each other, the former's musical interests providing a link between them, Hogarth's musical relations might provide a starting point for new work on an artist who figures so largely in the annals of English art and about whose connections little seems to be known.

Again, Hogarth is of particular interest as an artist who, though finding fame as a painter, served his apprenticeship to an engraver on silver plate at the time Caslon set up his business in Vine Street and the two must have had many mutual acquaintances amongst the engravers and book illustrators of the early eighteenth century.

In this brief sketch of the state of pictorial art in this country in the seventeenth century and the first quarter of the eighteenth century we have seen the efforts of native artists largely overshadowed by foreign immigrant painters brought over by the Stuarts and the English nobility. In the reproduction of pictures by line and mezzotint engravers the story is much the same, London being flooded with draughtsmen and engravers following in the wake of the painters. The condition of things in this respect may be shown from the illustrations in the books of the period. As a notable example, in 1716 John Baskett, the King's printer, issued his celebrated folio Bible, a work of great typographical beauty, styled by Dibdin 'the most magnificent of the Oxford Bibles.' However, it is also notorious as 'The Vinegar Bible,' from an error in St. Luke, Chapter XX, which has the astonishing mistake in the headline 'The parable of the vinegar' for 'The parable of the vineyard,' and was so carelessly printed that it was named 'A Baskett-full of printer's errors.' The illustrators[11] were James Thornhill, already mentioned as Kneller's successor in the governorship of his drawing academy and Hogarth's father-in-

law, Louis Cheron, a Frenchman who partnered Vanderbank in deposing Thornhill, and P. La Voigne, another Frenchman. The engravers were Elisha Kirkall, of Dogwell Court, Whitefriars, George Bickham, a well-known engraver of writing-masters' copy books, Michael Burghers, engraver of many of the early Oxford Almanacks before George Vertue, Michael Vander Gucht, one of a family of draughtsmen and engravers, Claude Du Bosc, who came to England with the Frenchman Dorigny in 1712, Charles Dupuis and Louis Du Guernier, two other Frenchmen. Here there are only three Englishmen among ten book illustrators, and the dictionaries of artists and engravers show the same preponderance of foreign names at this period.

It must not be thought, however, that the foreign artists were entirely monopolistic in their influence. The Parisian school of engravers was world famous and when its trainees came to England to take positions as drawing-masters in schools and private families or as freelance artists, book illustrators and engravers there was undoubtedly a beneficial effect on the work of our native craftsmen. The sharing of the artistic market with the foreign immigrant was the price we had to pay for our insularity and complacency when our continental neighbours were experiencing the upsurge of Renaissance art and ideals.

The fact that William Caslon was an engraver before becoming a letter-founder prompts our taking note of the engravers and book-illustrators working in London in the first quarter of the eighteenth century but, of course, there were many who left no record behind them. Among the best-known line-engravers were Michael Burghers (1653–1727), a Dutch engraver and designer; many of his head and tailpieces are found in Baskett's 'Vinegar Bible,' but he did most of his work at Oxford. John Sturt (1658–1730) worked long as a book-illustrator, and excelled as an engraver of writing masters' copy books and other lettering. His most remarkable production was the Book of Common Prayer, executed on 188 silver plates, all adorned with borders and vignettes, the frontispiece being a portrait of George I, on which are inscribed in characters so minute as to be legible only with a magnifying glass, the Creed, the Lord's Prayer, the Commandments, the prayer for the royal family, and the twenty-first psalm. 'London.

144

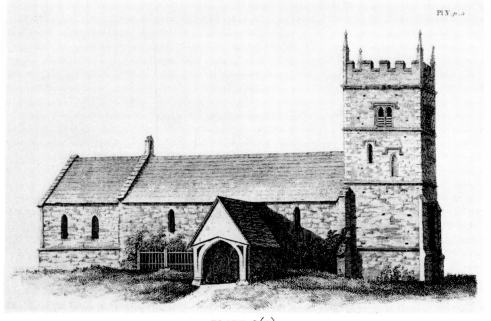

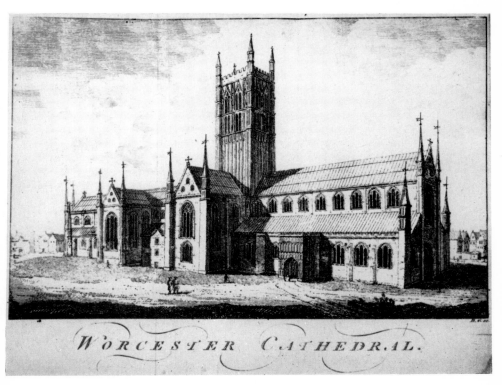

PLATE 9(a)

Great Coxwell Church, Berkshire.
Engraved by James Green in 1755 for Edward Rowe Mores, the typographical historian

PLATE 9(b)

Worcester Cathedral.
Engraved circa 1770 by Benjamin Green (1739–98)

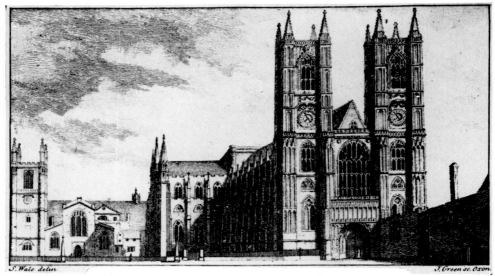

PLATE 10(a) The Abbey Church of St. Peter, Westminster. by James Green

PLATE 10(b) Tailpiece to 'Solomon's Song' in John Baskett's 'Vinegar Bible,' 1716.
A fine piece of 'poetry in line' engraved by Michael Burghers of Oxford

T O M Y
Honoured and Ingenious FRIEND
Mr. *GEORGE SHELLEY,*
𝕌𝕣𝕚𝕥𝕚𝕟𝕘-𝕄𝕒𝕗𝕥𝕖𝕣
Of CHRIST-HOSPITAL, in *LONDON.*

T H E
Art of WRITING
Confidered, as to it's
Origin, Ufe, *and* Improvements;
An E S S A Y.

By *ROBERT MORE,* WRITING-MASTER.

PLATE 11(a) and (b)
Letter-press title-pages from George Shelley's Copy-book,
The Second Part of Natural Writing, 1714
The head-band of ornaments over the name of George Shelley is badly inked-up,
but the similarity between both head-bands and those on Caslon's first specimen 1734
is easily seen

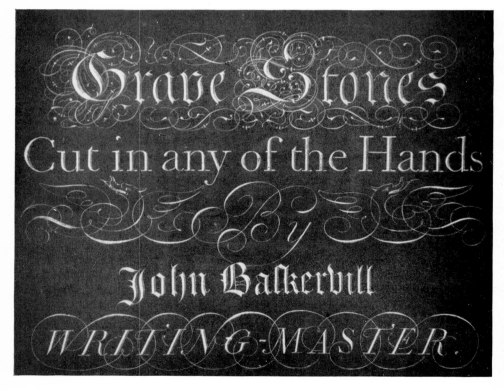

COME UNTO ME
ALL YE THAT LABOUR AND ARE HEAVY LADEN
AND I WILL GIVE YOU REST + TAKE
MY YOKE UPON YOU AND LEARN OF ME
FOR I AM MEEK AND LOWLY IN HEART
AND YE SHALL FIND REST UNTO YOUR SOULS

PLATE 12(a)

Specimen of lettering from one of the 'Tablets of the Word'
in the nave of Coventry Cathedral, 1962

Grave Stones
Cut in any of the Hands
By
John Baskervill
WRITING·MASTER.

PLATE 12(b)

Tradesman's slab cut in slate about 1737 by John Baskerville (1706–1775)

Engraven and Printed by the Permission of Mr. John Baskett Printer to the Kings most Excellent Majesty 1717. Sold by John Sturt Engraver, in Golden-Lion-Court in Aldersgate Street.'12 Sturt at one time kept a drawing-school in St. Paul's churchyard in partnership with Bernard Lens (1659–1725) who is chiefly known as a mezzotint engraver, the son of an earlier Bernard Lens (1631–1708) and also the father of Bernard Lens (1682–1740) drawing-master at Christ's Hospital and miniature-painter in water-colours.

Simon Gribelin (1661–1733) a French engraver who came to England in 1680, was a very neat engraver of portraits and of history. He engraved the plates for *A Book of Cyphers* by Colonel William Parsons (1658–1725), a guide for coach-builders, carvers and designers. This work contains six hundred ciphers or monograms, with examples of interlaced lettering such as would assist ornamental engravers of plate, swords and guns. Henry Hulsberg (died 1729) a native of Amsterdam, engraved plates for Colin Campbell's *Vitruvius Britannicus* and Sir Christopher Wren's plans for St. Paul's Cathedral.

John Harris, who flourished from 1680 to 1740, collaborated with John Kip in the engravings of country seats in *Britannia Illustrata*, 1709–31, and in the fourth volume of *Vitruvius Britannicus*, as well as engraving some of the *Oxford Almanacks*.

George Vertue (1684–1756) one of the most celebrated and prolific line engravers of the first half of the eighteenth century, was first apprenticed to a French heraldic engraver and afterwards to Michael Vander Gucht. He engraved very many portraits and cut the plates for the Oxford Almanacks from 1723 to 1751, his successor being James Green (1729–1759), of Halesowen. On the revival of the Society of Antiquaries in 1717 he became a member and was appointed its official engraver. For forty years he industriously gathered notes on art and artists in this country and these formed the basis of Walpole's *Anecdotes of Painting in England*. In a short notice such as this it is impossible to do justice to Vertue's abilities and industry.

John Pine (1690–1756), was a line engraver who is thought from the similarity of their styles to have been a pupil of the great French engraver at Amsterdam, Bernard Picart. One of Pine's

early works of note was the series of plates of the ceremonies observed at the revival of the Order of the Bath by George I in 1725 from drawings made by Joseph Highmore. Another notable work was the series of plates from tapestries in the House of Lords representing the defeat of the Spanish Armada, 1588, from drawings by Clement Lempriere, chief draughtsman in the Ordnance Office at the Tower, 1739. Other works of Pine fall outside the period we are considering.

Jacob Houbraken (1698–1780) was a celebrated Dutch engraver who worked in London and is best known by the series of engraved portraits of *Illustrious Persons* he produced.[13]

Among mezzotint engravers of eminence were John Smith (1652–1752) who was first apprenticed to a painter named Tillet in Moorfields and afterwards learnt mezzotint engraving from J. Vander Vaart (1647–1721) and Isaac Becket (1653–1719). Smith was a prolific worker throughout his long life. John Simon (1675–1755), a native of Normandy and trained on the continent, worked in the style of John Smith and produced very many plates. John Faber the younger (1695–1756) was born in Holland but came to England while still an infant; he became well-known for his portraits in mezzotint. Last to be named in this branch of engraving is Francis Kyte, who flourished from 1710 to 1745, and was both portrait painter and engraver in mezzotint. In 1740 he painted the three-quarter length portrait of William Caslon, a copy of which appears as the frontispiece to the present work as well as to J. F. McRae's bicentenary work *Two Centuries of Typefounding*, 1920. Faber's mezzotint portrait of Caslon, bust size, was taken from Kyte's painting.

All the engravers previously mentioned confined their attention to producing pictures in black or sepia on a white ground, either in line or scraped in mezzotint. If coloured reproductions were desired, these were generally line engravings tinted with flat washes of water-colour. This tinting of flowers, birds, insects, reptiles, etc., was hack work for the artists of that period, especially when it was applied to the whole or part of an edition of an illustrated work. These hand-coloured prints and books are now collectors' pieces, some being very skilfully and tastefully coloured.

James Christopher le Blon, or le Blond (1670–1741) was

born at Frankfort of French parents, became a miniature painter and developed a technique for producing mezzotints in coloured inks. He tried to establish the method in this country, but the process of working with multiple plates proved too expensive and the scheme failed for lack of sufficient funds. Le Blon's prints are now much valued by collectors.

Elisha Kirkall (1682–1742) was the son of a Sheffield locksmith from whom he learnt to work and engrave on metal. Coming to London about 1702 he was employed 'to grave arms, ornaments, etch and cut stamps in hard mettal for printing in books for several years,'[14] work similar to that done by William Caslon early in his career. Kirkall studied drawing in the new academy in Great Queen Street, Lincoln's Inn Fields. He married early in life, as appears from his trade card, preserved in the print room of the British Museum, which bears the name of Mr Elisha and Mrs Elizabeth Kirkall, and the date 31 August, 1707. He engraved some of the plates for Thomas's revised edition of Sir William Dugdale's *Warwickshire*, 1730, the copper-plate frontispiece to W. Howell's *Medulla Historiae Anglicanae*, 1712, the plates for Maittaire's edition of the works of *Terence*, 1713, for the translation of Ovid's *Metamorphoses* (Tonson and Watts), 1717, and for Rowe's translation of Lucan's *Pharsalia*, 1718. Certain cuts in Maittaire's edition of *Sallust*, 1713, and Dryden's *Plays* (Tonson and Watts), 1717, usually described as on wood and assigned to Kirkall, appear to be on metal. Some of the copperplates engraved by Kirkall show both artistic merit and technical skill. But he is better known for his mezzotint engravings, frequently printed in green ink, and occasionally in a variety of colours. In this manner he published by subscription sixteen views of shipping by William Van de Velde the younger, the seven cartoons of Raphael, three hunting scenes by J. E. Ridinger, etc. In 1722 he introduced a new method of chiaroscuro engraving, produced by adding fresh tints to the coloured mezzotint engravings by the superimposition of wood blocks in the manner of the early Italian chiaroscuro engravers. In this method he produced a copy of Ugo da Carpi's chiaroscuro engravings of *Æneas and Anchises*, after Raphael, and a number of reproductions of drawings by Italian masters. A collection of these is in the print room at the

147

British Museum. He also engraved in a similar manner a portrait of Sir Christopher Wren, by John Closterman, and a portrait of Dr. William Stukeley the antiquary, for whose works he likewise engraved some ordinary copper-plates. He continued to engrave plates for the booksellers, including the plates for an edition of Inigo Jones's *Stonehenge*, 1725. A portrait by Kirkall of Eliza Haywood (1693–1756) authoress, prefixed to her *Works*, 1724, earned for him a place in Pope's *Dunciad*, 'With flow'rs and fruit by bounteous Kirkall drest.' In 1732 Hogarth published his famous set of engravings, *The Harlot's Progress*. There was no legal protection for print publishers at this period, and Kirkall was first in the field with a pirated set of free copies in mezzotint, printed in green, and published at his house in Dogwell's Court, Whitefriars, in November, 1732. Among other engravings by Kirkall were thirty plates of flowers after Van Huysom and some plates of shipping after T. Baston. He died in Whitefriars in December, 1742, leaving a son, aged about twenty-two.

Kirkall is of particular interest because of the certainty that he was known to Caslon. He had his engraving business in Dogwell Court, Whitefriars, where also William Bowyer had his printing office. Kirkall also illustrated some of the works published by Tonson and Watts. John Watts has been named as Caslon's earliest patron, and William Bowyer the elder as his principal one. Nor is this all, for later in the century Amos and Benjamin Green, two of the Halesowen-born artists previously mentioned as relatives of Caslon, collaborated in producing a series of mezzotints printed in green ink in the manner of Kirkall, the flowers being coloured by hand and leaving the green mezzotint foliage and background. These were titled as follows :—

A Series of Six Bouquets. A. Green pinxt, B. Green pinxt. Published by R. Sayer and J. Bennett, April 14th, 1779.

Amos Green painted flower pieces in the manner of John Van Huysum and John Baptiste Monnoyer and probably had his attention directed to them through the prints of Kirkall. The mezzotint method was also used about 1800 in conjunction with colour printing in a few of the large decorative flower prints published by Dr. Thornton, but otherwise there are only one or two isolated instances of the application of the mezzotint method in the history of art.

Amongst the more widely disseminated examples of the line-engravers' art in the seventeenth and eighteenth centuries must be included the work of almanack makers and cartographers. The best-known sheet almanacks were undoubtedly those issued by the University of Oxford which set a much higher artistic and typographical standard than the alternative productions offered for the entertainment and possibly for the deception of the vulgar of that age. After an uncertain beginning the Oxford Almanack soon developed into the form it has maintained ever since, namely, a pictorial or emblematic heading having the Calendar of Saints' Days and University events suspended below it, and throughout the period of copper-plate engraving, the engravers cut all the lettering as well as the pictorial 'top'. Since some quite notable artists and engravers were engaged to produce the Almanacks, a study of the whole series of engraved plates contributes much to the study of English art and engraving and, moreover, such a study throws light on certain aspects not only of University history, but also of the social and political history of the nation, if sometimes it was deemed discreet to present it in allegory.

The following table shows the designers and engravers of the Oxford Almanack for the first one hundred years of issue.

Years	Designer	Engraver
1674 only	Probably Robert White	Robert White
1676—1719	Michael Burghers almost every year	Michael Burghers
1720—1721	Claude du Bosc	Michael Burghers and G. Vandergucht
1722—1724	Michael Burghers	Michael Burghers and George Vertue
1725—1726	W. Williams	John Harris Calendar engraved by J. Hulett (known later as an engraver of copy-books)
1727—1731	Not known	George Vertue
1732		No record
1733—1751	William Green of Oxford	George Vertue
1752—1759	Samuel Wale	James Green of Halesowen

1760—1762	Samuel Wale	Benjamin Green of Halesowen
1763—1765	?	John Müller (known as Miller)
1766	Samuel Wale	Benjamin Green
1767	John Baptist Malchair	J. Masson
1768	John Baptist Malchair	J. Bonnor (a name not in the records and probably a mistake for J. Bonneau, a French drawing-master in London, one of the tutors to the Royal family)
1769–1774	Edward Rooker and his son Michael 'Angelo' Rooker	

Among the artists employed at a later period were J. M. W. Turner, Edward Dayes and Peter De Wint, while the engravers include notable names such as Isaac Taylor, James Basire II, Joseph Skelton, Henry Le Keux, and William Radclyffe.[15]

Among well-known cartographers of the late seventeenth and early eighteenth centuries the projects of John Ogilby (1600–1676) in map-making must be mentioned. These were undertaken in his later years and though they pass under his name were completed by William Morgan and others. The most notable of these works applying to this country was *Britannia: Volume the first, or an Illustration of the Kingdom of England and Dominion of Wales, by a Geographical and Historical Description of the Principal Roads thereof*, printed on one hundred copper plates, fol., London, 1675. Among other atlases and maps produced by Ogilby was *Itinerarium Angliae, or a Book of Roads . . . of England and . . . Wales*, in which he was assisted by W. Morgan, fol., London, 1675. An 'improved edition' by John Senex was issued in 1719 in two oblong quarto volumes as *An Actual Survey*, and other editions, with descriptions of the towns by John Owen and maps by Emanuel Bowen, appeared in 1720, 1724, 1731, 1736, and 1753, under the title of *Britannia Depicta*.

John Senex (flourished 1719–1740), engraver and mapmaker, had a bookseller's establishment at the Globe in Salisbury Court, Fleet Street. Senex engraved the plates for the London Almanacks from 1717 to 1727, except that for 1723. He was,

however, chiefly known as a cartographer and globe-maker. He was admitted a Fellow of the Royal Society on 4 July, 1728, and died on 1 January, 1740, an obituary notice describing him as 'a sincere, worthy, honest man, and greatly valued by men of learning.' Senex is of interest because it was at his shop that Ephraim Chambers (1680?–1740), the encyclopaedist, was for some time his apprentice, and it was Senex who encouraged him in his desire for knowledge. The first edition of John Harris's *Lexicon Technicum* had been published in 1704 and was the only work of the kind in the language. Chambers forming the design of compiling a cyclopaedia on a larger scale, he left Senex and took chambers in Gray's Inn, where it was completed. In 1728 was issued by subscription, dedicated to the King, and in two volumes folio, his *Cyclopaedia, or an Universal Dictionary of Arts and Sciences ... compiled from the best authors*, etc. The price of the work was four guineas, but its value was at once recognised, and secured for its compiler the honour in 1729 of being elected a member of the Royal Society, soon after Senex had been similarly honoured. In 1738 a second edition was issued with some alterations and additions, which is noteworthy for the inclusion of a copy of William Caslon's first specimen of 1734, facing the article 'Letter.'

In 1739 Chambers issued a third edition, and after the compiler's death a fourth edition appeared in 1741, still carrying Caslon's famous broadside,[16] and this was followed by a fifth in 1746. A French translation of it gave rise to Diderot's and D'Alembert's *Encyclopedie*, and the English original was finally expanded into Rees's once well-known *Encyclopaedia*. Chambers suffered from poor health, and both as an author and an invalid he was most kindly treated by the first Thomas Longman, the founder of the Longman publishing house, who during Chambers's life-time became the largest shareholder in the *Cyclopaedia*. It seems clear, however, that Ephraim Chambers had some private means to enable him to devote his time to his chosen work.

Isaac Basire (1704–1768), a map-engraver, was the first of a line of four engravers in direct succession, the other three being named James, the several members of the dynasty witnessing the

developments in English art and engraving over a period of a hundred and fifty years, the fourth of the line dying in 1869. It is with Isaac Basire alone that we are here concerned, yet not much seems to be known about him. In the Archives Department of Nottingham Public Library is preserved a letter written to George Ayscough, printer, Nottingham, dated from London, 19 April, 1743.[17] It was written by Thomas Sandby, elder brother of Paul Sandby, both later to become founder-members of the Royal Academy of Art. At the time of writing the letter Thomas Sandby was employed as a military draughtsman under the Master General of the Ordnance in the old Map or Survey Office at the Tower. Presumably Isaac Basire, who carried on his engraving business at St. John's Gate, Clerkenwell, was the official engraver chosen to make the plates from the surveys carried out and laid down on paper by the military draughtsmen, and that is possibly one reason why so little of his map-work has survived. At any rate Sandby must have been on easy terms with Basire, or the latter was unusually kind, for Sandby to have permission to dismantle his rolling press and send details of it to George Ayscough, for that was the subject of the letter.

That same year, 1743, James Green of Halesowen was bound apprentice to Isaac Basire for seven years, probably by Caslon's arrangement, Green being his half-cousin. Three years later, in 1746, when James Green was a lad of seventeen[18] he engraved the *South East Prospect of the Parish Church of Halesowen in Com. Salop. humbly Inscribed to Sᵗ Thomas Lyttelton Bᵗ Patron thereof, by his most Obedient humble Servant, James Green.* Included in the title are the Lyttelton arms, well-known for having only one supporter, and a description of the Church.[19] The title itself is, however, veritably a specimen of the various hands practised by engravers of the period ; indeed the standard of the lettering is remarkably high—equal to that of engravers of writing masters' copy-books, emphasising the importance which the leading engravers attached to the titling and decoration of their prints. The styles exhibited include Old English with Decorations, Upper and Lower Case Roman, Upper and Lower Case Italic, and Cursive. The view of the church shows faults in perspective such as can be attributed to Green's immaturity at this time.

The first James Basire (1730–1802) was a year younger than James Green, and the two were thus trained together under the elder Basire. In 1751 Green was established at Oxford as engraver of the Oxford Almanacks in succession to George Vertue and in 1756, following the death of Vertue, James Green was appointed official engraver to the University, and in the following year was also appointed engraver to the Society of Antiquaries, thus preceding the son of his master in that office, the D.N.B. being in error in stating that James Basire succeeded George Vertue as engraver to the Society of Antiquaries. James Green died prematurely in 1759.

It is difficult to assess adequately the abilities of an artist cut off before his prime, but his abilities were undoubtedly of a high order. Recognised at seventeen years of age, engraving the Oxford Almanacks when barely twenty-two, appointed engraver to the University at twenty-six and to the Antiquarian Society at twenty-seven, his death before his thirtieth birthday cut short a career of great promise. His engraving of architectural subjects, as revealed especially in the Oxford Almanacks, is superior to the work of George Vertue, who achieved celebrity in the engraving art. Vertue, for all his experience, could never make his figures stand out on the lanscape and a great deal of his work was characterised by flatness and stiffness, although he was undoubtedly clever in engraving heraldic devices and portraits.

This is not the place to enlarge further on the work of James Green, although he must be referred to later because of his connections with William Caslon and Edward Rowe Mores. He is mentioned here because his early work tells us something of the training in lettering which young engravers had to undergo in the first half of the eighteenth century.

In the Livery list of the Company of Loriners for 1756 the following five engravers are named :

John Pearman of Haydon Yard, Minories.
Arthur Lester Silverside of same.
Joseph Mayo of same.
William Sharpe of same.
Joseph Halfhide of Vine Street, Minories.
Neither the list of loriners given in the Charter of 1712, nor

the Livery lists of 1722 and 1727, nor the list of those loriners who voted at the Sheriff's election of 1724 gives any indication of the actual trades the loriners followed, and we have to wait until as late as 1756 before we are afforded any clue to the loriners' occupations.

This list identifies a little colony of engravers, probably all engaged in gun engraving and similar work, all of whom are in the centre of the gun-trade. John Pearman's name does not appear in any published annals of art or engraving, but we now know quite a lot about him. Arthur Lester Silverside is similarly unknown to fame. The name of Joseph Mayo may be a variant of the names of John Mayor, senior and junior, occurring in earlier lists. Joseph Halfhide was Caslon's former apprentice who now worked on his own account in Vine Street, probably in the premises formerly occupied by Caslon, and is mentioned again later in this chapter.

William Sharpe was doubtless the father of that William Sharpe (1749–1824), engraver, who is mistakenly recorded by the D.N.B. as the son of a gunmaker living in Haydon Yard, Minories. Both father and son were engravers, and it will be interesting to glean a few particulars from such accounts as have survived. The younger Sharpe was apprenticed to Barak Longmate, an engraver who was also skilled in heraldry. He married a Frenchwoman and opened a shop as a writing-engraver in Bartholomew Lane, his early work as an apprentice having been on publicans' pewter pots. Sharpe maintained there was no degradation in such work, as 'it is the initiatory operation for all apprentices of bright engravers; even Hogarth had done the same.' Sharpe senior and Barak Longmate must have been acquainted with Hogarth and it is interesting to note that one of the first subjects engraved by Sharpe junior in the pictorial branch of engraving was of old Hector the lion at the Tower of London, whose keeper was Ellis, a relative of Hogarth.[20] Sharpe is described[21] as a celebrated line engraver, and even of extraordinary ability. He was not, like William Woollett, a landscape engraver, but worked on historical and scriptural subjects after the foremost masters from Guido to Sir Joshua Reynolds. In later life he developed eccentric interests, being a disciple of Richard Brothers, Joanna Southcott, and Emanuel Swedenborg. He died at Chiswick in 1824 and was buried in the same churchyard as Hogarth and de Loutherbourg.

These particulars of Sharpe are interesting if only for the slight reference to the circumstances of his training; the beginnings of so few engravers of the eighteenth century are known with any certainty, and even a glimmer of light on the employment of engravers' apprentices will help towards a better appreciation of Caslon's early life.

Thomas Bewick (1753–1828), the famous wood engraver, describing[22] his apprenticeship to Ralph Beilby, says, 'The first jobs I was put to do was blocking-out the wood about the lines on the diagrams (which my master finished) for the *Ladies Diary*, on which he was employed by Charles Hutton, and etching sword blades for William and Nicholas Oley, sword manufacturers, etc., at Shotley Bridge.

'It was not long till the diagrams were wholly put into my hands to finish. After these, I was kept closely employed upon a variety of other jobs; for such was the industry of my master that he refused nothing, coarse or fine. He undertook everything, which he did in the best way he could. He fitted up and tempered his own tools, and adapted them to every purpose, and taught me to do the same. This readiness brought him in an overflow of work, and the work-place was filled with the coarsest kind of steel stamps, pipe-moulds, bottle moulds, brass clock-faces, door plates, coffin plates, bookbinders' letters and stamps, steel, silver, and gold seals, mourning rings, etc. He also undertook the engraving of arms, crests and cyphers, on silver, and every kind of job from the silver-smiths; also engraving bills of exchange, bank notes, invoices, account heads, and cards. These last he engraved as well as did most of the engravers of the time; but what he excelled in was ornamental silver engraving . . .

. . . I think he was the best master in the world for teaching boys, for he obliged them to put their hands to every kind of work. Every job, coarse or fine, either in cutting or engraving, I did as well as I could, cheerfully; but the job of polishing copper plates, and hardening and polishing steel seals, was always irksome to me. I had wrought at such as this a long time and at the coarser kind of engraving (such as I have noticed before), till my hands had become as hard and enlarged as those of a blacksmith. I, however, in due time, had a greater share of better and nicer work given to me

to execute; such as the outside and inside mottoes on rings, and sometimes arms and crests on silver, and seals of various kinds, for which I made all the new steel punches and letters.'

Although William Sharpe the younger and Thomas Bewick were much later than William Caslon, the above accounts give a valuable insight into the varieties of general work that might have been put into the hands of William Caslon in addition to the engraving of gun-locks, as well as indicating the class of work undertaken by men who lacked the disposition or ability to become picture-engravers and book-illustrators. As we have seen,[23] the choice of work to which a boy was apprenticed in the eighteenth century was largely fortuitous and there must have been many who were quite ill-suited to the tasks they had to undertake. That so many men made good under such conditions cannot be said to justify the casual way in which they were chosen for their life's work, but is rather a testimony to the personal relationship on which an apprentice was accepted in his master's home and shop. It emphasises the effects on character which resulted from master and apprentice working in close touch with each other, especially advantageous if the relations were harmonious. This contrasts violently with the conditions prevailing in industry today, when the emphasis is on organisation and the control is impersonal.

In Caslon's time there was another class of professional men who worked as closely with the engravers as did the engravers with the artists and book-illustrators. The cult of the writing-master began to flourish in the Restoration period and was in its heyday throughout all Caslon's most vigorous years and he must have been just as well acquainted with the foremost exponents of the writing craft as with the leading artists and engravers of his day. Ambrose Heal's masterly work on the English Writing Masters is the essential reference for all who are interested in calligraphy.[24] In the compilation of his own work, Heal accords high praise to William Massey (1691–1764), a Wandsworth schoolmaster who in 1763 published *The Origin & Progress of Letters*, the first history of masters of calligraphy. Heal's book includes an essay by Stanley Morison on the development of hand-writing.

Just as Caslon's Latin type-faces were based on Dutch antecedents, the style of the principal English writing-masters before

and during Caslon's time owed much to the French and Dutch masters. Indeed, it was to be expected that when foreign artists and engravers exercised such an influence in pictorial art, the same influence would also be felt in varying degree in all related professions and crafts. The English copper-plate writing of the late eighteenth century was a synthesis of the more original hands of earlier calligraphers, but as a result of the merging of the characteristics of its predecessors it became somewhat colourless. In all the vicissitudes through which the craft of writing has passed since 1800 the sheer inability of the teaching profession to impart a respectable mastery of this simple craft remains a stinging reproach to modern education, an inability underlined by the feeble apology presented by the exponents of Marion Richardson's puerile script when their performances are compared with the 'strikers' of former times. Ambrose Heal pours scorn on this defect in our school training when he says : 'The boy's stance and his grip of a golf club are matters for professional tuition ; the cricket coach sees to it that he plays a straight bat, but no one troubles how he holds his pen. The Writing Master is dead. Long live the Games Master !'

In an age when highly developed production methods have placed at the disposal of printers and typographers a range of typefaces more extensive than ever before it seems necessary to emphasise that designers should maintain a proper respect for calligraphic origins in their letters. This is one of the defects of the machine age : there is just as much difference between Caslon's hand-produced profiles and the profiles of a new face laid down by a present-day designer backed by modern drawing techniques as between a Rembrandt etching and the draughtsman's orthographic drawing of a piece of modern printing machinery. It has been said previously that despite its educational defects, the eighteenth century managed to produce a greater proportion of original men than our sophisticated age is able to do. Whereas Caslon and his contemporaries, in the absence of mechanical or other helps, were proud of the productions of their hands, the pride of our own day is in mechanical, electrical and photographic aids, in automation, in the marvels of nuclear physics and computerisation, in continally accelerating rates of production, and in death on the roads !

The writing-masters of the late seventeenth and early eighteenth centuries sometimes marred their performances by indulgence in vain-glory and a vigorous denunciation of their competitors scarcely exceeded by the political pamphleteering of that age. It cannot be denied, however, that the standard they attained in their 'command of hand' was the result of an effort and self-discipline which cannot be matched today in any of the visual arts. The formlessness so rife today in painting and the graphic arts is a wide-open gateway to incompetence—its merit is in inverse ratio to the amount of verbiage used to explain its meaning. The trend towards looseness of outline has spread to typographical forms and is seen in the introduction of rapidly-drawn pen and brush scripts which, claiming to be the colloquial display alphabets of our age, merely show how far they might deviate from their calligraphic origins without becoming totally unrecognisable.

It is not the author's intention to attempt a summary of Ambrose Heal's fine work, but to emphasise the influence which artists, engravers, calligraphers and typographers exercised on each other. Stanley Morison has drawn attention to the influence of the writing-masters, especially in the development of script types. The examples of type-set and engraved title-pages illustrated in the present work will demonstrate how much the style of each title-page was subservient to the process which produced it.

Before and during Caslon's life-time, the writing-master in many of our leading schools, such as in Christ's Hospital, was accorded the status of second master, an indication of the importance allowed to the craft. While many of the best-known calligraphers known to us were attached to some of our famous schools, very many others set up schools of their own, practising in London as well as in our leading towns and cities.

Edward Cocker (1631–1676), although a writing-master and engraver of calligraphy, has handed his name down to posterity in the saying 'It's all according to Cocker,' that is, the question under discussion is settled by rules as plain as those laid down in Cocker's *Arithmetick*.

John Seddon (1644–1700) was the master of Sir John Johnson's Writing School in Priest's Court, Foster Lane. Seddon appears to have staked his reputation on the 'command of hand'

that enabled him to trace by the pen the most elaborate figures in one continuous line. A characteristic piece executed in this fashion is a picture of St. George and the Dragon. This is included in *The Pen-man's Paradise both Pleasant & Profitable*,[25] *Adorn'd with variety of ffigures and Flourishes done by Command of Hand. Each ffigure being one continued and entire Tract of the Pen, most whereof may be struck as well Reverse (or to answer both wayes) as Forward.* John Sturt, already mentioned, was Seddon's engraver, and it will generally be found that each master set up a relationship with a favourite engraver.

John Smith (fl. 1675–1714) was for twenty years master of the famous Writing School of Christ's Hospital. In the course of eight years from 1676 he raised the number of pupils from 60 to 200 and later the number was increased to nearly 400, yet in 1695 he fell from grace and was dismissed. John Sturt was Smith's engraver.

John Ayres (fl. 1680–1705) was the most eminent writing-master of his day. Ayres began life as a footman in the household of Sir William Ashurst, (Lord Mayor 1693–4), who noticed his abilities and arranged for his education, Thomas Topham, of the 'Hand & Pen' in Fetter Lane, being his writing-instructor. He was known as 'Colonel' or 'Major' Ayres, titles which appear to have derived from his connection with the trained bands of the City. Ayres issued several copy-books, advertising himself as 'Master of the Writing-School at the "Hand and Pen" in St Paul's Church Yard.' Some of his copybooks were engraved by John Sturt, who also in 1698 engraved the Colonel's portrait.[26] Ayres was one of those writing-masters given to unfavourable criticism of the work of his contemporaries. He gave his own abilities a blatant puff when he wrote the title under his portrait 'John Ayres Writing Mr,' for he performed the feat by tracing it in an unbroken line from the end to the beginning.[27]

Robert More Junior (1671–1727) deserves mention here because he was the author of an essay *The First Invention of Writing* which was first printed as a preface to Shelley's *Second Part of Natural Writing* (1714); see below. More took over Ayres' school in St. Paul's Church-yard in 1704 and is known thereafter at various addresses all passing by the name of the 'Golden Pen.'

Robert More's portrait prefixed to *The General Penman*, 1725, was engraved by William Sherwin, although the specimens of his calligraphy were engraved by George Bickham.

George Shelley[28] (1666–1736) was educated at Christ's Hospital from 1677 to 1682 during the time that John Smith was writing-master there. In addition to practising calligraphy, he was concerned in re-issues of Kersey's version of Wingate's *Arithmetic*. In 1710 he had the distinction of being appointed as writing-master at the school where he was nurtured, Christ's Hospital, against strong competition, yet he fell into debt, absented himself from his post and in 1726 was dismissed. Shelley was an accomplished calligrapher and as an exponent of the Round Hand was an acknowledged master. He published several copy-books engraved by George Bickham, who also engraved the portrait of Shelley prefixed to *Natural Writing* (1709).

It must be mentioned here that More's *Essay on the Art of Writing* included in Shelley's *Second Part of Natural Writing* (1714) is embellished with printers' flowers which derive from Christoffel van Dyck but which W. A. Dwiggins ascribes to the credit of Caslon.[29] Shelley's work was printed and sold by Thomas Bowles in St. Paul's Church Yard and John Bowles at Mercers' Hall in Cheapside.[30]

George Bickham the Elder[31] (c. 1684–1758) was the most prolific engraver of writing-masters' copy-books of his time, excelling even his master John Sturt. Both Sturt and Bickham were also writing-masters, but it is as engravers of the work of their contemporaries that their fame survives. Joseph Champion tells us that George Bickham was the first English engraver who dared to cut the letter through the wax on to the copper (without first tracing it over as was the common practice) thereby transmitting the ease, spirit and nature of the master's original. Proof that he was also an expert penman lies in the fine series of plates signed 'G. Bickham fecit' in his *Universal Penman* and in other works. Bickham's monumental work *The Universal Penman*, which appeared in 52 parts between 1733 and 1741, presented the work of 25 contemporary writing-masters on 212 finely engraved folio plates, *The whole Embellish'd with beautiful Decorations for the Amusement of the Curious*. The first collected edition was pub-

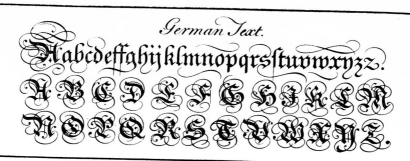

German Text.

Aabcdeffghijklmnopqrsstuvwxyzz.

ABCDEFGHJKLM
NOPQRSTVWXYZ.

Round Text.

Aabbcdefffghhhhiijkkkklllmn
oppqqrzsfstttuvvnxxyyyz

Square Text.

ABCDEFGHJJKLM,
abcdefffghijklmnopqrsstuvwxyz
NOPQRSTVWXYZ

Round Hand.

abbcddefoghhiijkkllllmnnoppqrsfstuvwxyz.

ABCDEFGHIJJKLMMCM
NoNOPQRSTUVWXXYYZ

Engrossing.

Aa.Bb.Ct.Dd.Ee.Ff.Gg.Lsh.Ji.Jij.Kk.Ll.Mm.Nn.Oo.
Pp.Qq.Rr.Sfs.TtUu.Vv.Ww.Xx.Yy.Zz.

Secretary

Aambnctndmeonfngmhimijmkmlmnompmqmrsmtmuvwxmyrz
ABCDEFGHIJKLMNOPQRSTVWXYZ.

Joseph Champion Scr.

PLATE 13

Specimens of Alphabets 'In all the usual Hands now practis'd.'
Copper-plate engraving from George Bickham's 'Universal Penman,' 1741.

Old English Print.

Aabcdefghijklmnopqꝛrſsſstubwxyz. &c.

ABCDEFGHIJKLMNOP
QRSTUWXYZZIC

Italick Print.

Aabcdefghijklmnopqrſstuvwwxyz.æœ

ABCDEFGHIJKLMNOPQR
RSTUVWXYYZÆ.

Roman Print

Aabcdefghijklmnopqrſstuvwxyz.

ABCDEFGHIJKLMNOPQ
RSTUVWXYZ.

Italian Hand

ABCDEFGHIJKLLMMN
NOP2RSTUVWWXXYZZ.

Court Hand

ſſaͤbͤcͤbͤcͤoffffghhhijkͤllͤmͤmͤ ſuͤoͤppͤqͤgͤqͤ2ͤſſ ſͤtͤbͤbͤvͤwͤyͤyz.

She Chancery

Aa Bb Cc Dd Ee Ffff Gg hh Jiij Kk Llll Mm Nn
Oo Pp Qq Rrz Sſs Tt Uuv Ww Xx Yy Zʒ &c. *Champion Scrip.*

PLATE 14

Further Specimens of Alphabets from George Bickham's 'Universal Penman,' 1741.
The Roman and Italic letters of copper-plate engravings provided a model for
Baskerville and the 'moderns,' Bodoni and Didot, who followed him.

HEBREW.

אֲבָרְכָה אֶת־יְהוָה בְּכָל עֵת תָּמִיד
תְּהִלָּתוֹ בְּפִי : בַּיהוָה תִּתְהַלֵּל נַפְשִׁי
וְשָׁמְעוּ עֲנָוִים וְיִשְׂמָחוּ : בְּרֹב־לִי־וְהוּא־אֶתִּי
וּנְרוֹמְמָה שְׁמוֹ יַחְדָּו :

א . ב . ג . ד . ה . ו . ז . ח . ט . י . כ .
ל . מ . נ . ס . ע . פ . צ . ק . ר . שׁ . ת .

RABINICAL.

קמיטו חלו וקחו ושמחם חל וקמן :
זס ענו קרס וקוח קעמ ועכל נרוחיו השעו :
יחח יוחון יקוח קמנ לירחיו ויקלמכ :
מעעו ולסו כו עוז יקוה חסזי קנבר יקקק נו :

ח . נ . נ . ד . ד . ו . ז . ח . ט . י . כ . ל . נ . ס . פ .
ע . פ . צ . ק . ר . ש . ת .

SAMARITAN.

(Samaritan text four lines)

ܐ . ܒ . ܓ . ܕ . ܗ . ܘ . ܙ . ܚ . ܛ . ܝ . ܟ . ܠ . ܡ . ܢ . ܣ . ܥ . ܦ .

SYRIACK.

ܠܦܟܟܘܣ ܠܚܙܟ ܘܕܘܘܣ ܘܟܘܠܠ ܠܐ
ܙܟܟ . ܟܬܝܟܠ ܘܝܬܟܬܠ ܠܐ ܟܕ ܟܠܠ
ܘܟܘܠܟ ܘܟܟܟܟܠ ܠܐ ܝܠܟ +

ܐ . ܠ . ܚ . ܘ . ܗ . ܙ . ܕ . ܓ . ܒ .
ܚ . ܝ . ܟ . ܠ . ܟ . ܟ . ܘ . ܟ . ܩ .
ܙ . ܠ . ܘ .

ARABICK.

اَلسَّلَامُ لَكِ يَامَرْيَمُ الْمَلِيَّةُ مِنَ اللُّغَةِ الرَّبِّ
مَعَكِ مُبَارَكَةٌ أَنْتِ فِي النِّسَاءِ وَمُبَارَكَةٌ
مَنْ بَطْنِكِ يَسُوعُ *

ا ، ب ، ت ، ث ، ج ، ح ، خ ، د ، ذ ، ر ، ز ، س
ش ، ص ، ض ، ط ، ظ ، ع ، غ ، ف ، ق ، ك ،
ل ، م ، ن ، و ، ه ، لا ، ي

ARMENIAN.

Հայր մեր որ յերկինս ես սուրբ
եղիցի անուն քո. եկեսցէ արքայու-
թիւն քո. եղիցին կամք քո որպէս
յերկինս եւ յերկրի.

ա . բ . գ . դ . ե . զ . է . ը . թ . ժ . ի . լ . խ .
կ . հ . ձ . ղ . ճ . մ . յ . ն . շ . ո . չ . պ . ջ . ռ .
ս . վ . տ . ր . ց . ւ . փ . ք . եւ .

Bickham Sculpsit

PLATE I 5
Specimens of 'Exotic' Lettering.
From a copper-plate engraving by George Bickham in the 'Universal Penman,' 1741.

GREEK.

Ἰστέον πιστεύειν τὸν κόσμον εἰ φθαρτὸν, ὅτι καὶ γέγονε μετὰ δὲ τὴν φθορὰν, εἰς ἀφθαρσίαν πάλιν μεταποιούμενον. οὐδὲν γὰρ τῶν παρὰ Θεοῦ γεγονότων εἰς ὃ μὴ ὂν χωρήσει, κἂν ὃ τῆς ἁμαρτίας παράπτωμα, ἅμα ἡμῖν, καὶ πᾶσαν τὴν κτίσιν τῇ διαλύσει συγκατέδησεν.

Α α.β C.γ Γ.Δ δ ∂.ε Θ ε.ζ ξ.ι η η.ϑ Ϲ θ φ.ι ι.Κ κ λ
μ.ν.ξ.ο ο.ϖ π.ρ ρ ς.C C ς σ.Τ] τ.∪ ∪ ν.φ φ φ.χ.ψ.ω

Α·Β·Γ·Δ·Ε·Ζ·Η·Θ·Ι·Κ·Λ·Μ·Ν·Ξ·Ο
Π·Ρ·Σ·Τ·Υ·Φ·Χ·Υ·Ψ·Ω·Ω·

Τῷ δὲ αὖ πονουῶτι χ θεὸς συλλαμβάνει

G. Bickham Sculpsit.

PLATE 16

Specimens of 'Greek' Letters.
From a copper-plate engraving by George Bickham in the 'Universal Penman,' 1741.

lished in book form in 1741. Eighteen of the plates appear to have been written by Bickham himself.

It is impossible in a slight sketch such as this to mention more than a few more of the numerous company of writing-masters working in London at the same time as Caslon. Charles Snell (1667–1733) was educated at Christ's Hospital and came under the influence of the copy-books of the French master Louis Barbedor; Major Ralph Snow (1670–1744) was an exponent of the Dutch hands; John Clark (1683–1736) was educated at Merchant Taylors' School, studied calligraphy under Ralph Snow, and succeeded to George Shelley's business at 'The Hand & Pen in Warwick Lane' when Shelley was appointed writing-master at Christ's Hospital; and Joseph Champion, Senior (1709–1765), was educated at St. Paul's School and Sir John Johnson's Free Writing School, and contributed no fewer than 47 plates (out of 212) to Bickham's *Universal Penman*.

It was recorded in Chapter 5 that in 1718 one Joseph Half-hide was apprenticed to William Caslon and it is of interest to note that Ambrose Heal lists[32] J. Halfhide as an engraver of writing-masters' copy-books, giving 1750 as the approximate date of his earliest work. By 1750 Caslon's former apprentice would be about forty-five years of age.

In 1964 Laurence Irving, O.B.E., Master of the Faculty of Royal Designers for Industry, delivered an oration to the Royal Society of Arts to which he gave the title *The Affectation of Imperfection*. Irving was stating his views *inter alia* on the un-tenability of Sir Charles Snow's theory of the 'two cultures,' and voicing his opinion that the environment of the study of fine art was becoming increasingly detrimental to talented young people who wish to make a contribution to the invention and design of industrial products, suggesting that the remedy may be not the artificial respiration of art colleges by the injection of scientific studies, but the creation of schools of industrial design remote and isolated from the enervating influence of an art no longer fine but committed to the deliberate affectation of unrefinement.

Whilst the whole oration is admirable in perception and feeling we have room here only for an excerpt of interest to typographers. 'I was puzzled recently,' said Irving, 'by photographs

of a work of graphic design in a medium that I believed to be immune from these corrupting influences : typography—which, after all, would seem solely to aim at perfection of legibility. We have lived through a period rich in distinguished typographers— Edward Johnston, Eric Gill, Reynolds Stone and Stanley Morison. It would be thought that these distinguished designers had provided a wide choice of fine lettering for printing, for inscription on stone or for casting in metal.

'I was surprised, therefore, to see a number of panels inscribed with biblical texts to decorate the nave of Coventry Cathedral— surprised because the lettering appeared to be a pastiche of pre-Christian graffiti and not very legible at that.

'Puzzled by this perversity but aware that this detail was as acceptable to young people as any in that tremendous expression of contemporary faith, I asked several of them how they reacted to this lettering. Their replies were remarkably similar. They said in effect that the typography of such texts had in a sense to be shocking, otherwise nobody would trouble to read it.'

The stupidity of such an answer is an eloquent match for the stupidity of educationists who can expect an intelligent answer from a body of youth nurtured on methods which are utterly relaxed by comparison with those of fifty years ago. By allowing educational theorists and voluble cranks to put their untried notions to the test on *all* the nation's children at the same time, the country is guilty of irresponsibility of criminal proportions. At one time it was accepted that time, discipline and some experience and learning were essential factors in acquiring a sound judgement but now that diligence is regarded as an inhibition and the opinions and performances of infants are heard and viewed as seriously as those of trained and responsible adults and the ignorant and irresponsible are allowed to be equal with the wise, what can the nation expect but anarchy? In *all* the new faculties set up in a crop of new universities I have not heard of any which has thought it worthwhile to recall the study of logic !

The answer Laurence Irving received from those young people merely said that their culture placed novelty above excellence. How could perfection evoke any response in minds untrained to absorb the lessons of history or to discriminate between

what was worthwhile and what was vulgar and commonplace. Their response confirmed that their attention could only be captured by something irrelevant to the message which the words on the panel were intended to convey. (See Plate 12a).

[1] E. H. Short, The Painter in History, 1948.

[2] History of British Civilization.

[3] W. T. Whitley, Artists and their Friends in England, 2 Vols. (1700–1799), 1928

[4] Ibid.

[5] E. H. Short, The Painter in History, p. 308.

[6] N. & Q. 6 March, 1880.

[7] C. J. Longman, The House of Longman, 1724–1800. Pub. 1936.

[8] D.N.B. art. John Gamble.

[9] Foster's Alum. Oxon. William Ellis, Mus. B.

[10] Groves' Dictionary of Music.

[11] Copy penes the writer.

[12] Copy penes the writer.

[13] Published by John and Paul Knapton.

[14] See Vertue in B.M. Add. MS. 23076.

[15] Those interested in the whole series of Oxford Almanacks should see Helen M. Petter, The Oxford Almanacks, 1674–1946, O.U.P. New York.

[16] Copy penes the writer.

[17] Accession No. M.28.

[18] Nash, Vol. I, pp. 533–4.

[19] Copy penes the writer, which is lightly tinted in water-colour in the manner previously described.

[20] D.N.B. art. William Sharpe.

[21] Bryan's Dictionary of Painters and Engravers.

[22] Memoir of Thomas Bewick, edited by Selwyn Image, John Lane, The Bodley Head Ltd., 1924.

[23] Chapter 5.

[24] Ambrose Heal, The English Writing Masters and Their Copy-Books, C.U.P. 1931, or facsimile reprint by Georg Olms Verlagsbuchhandlung, Hildesheim, 1962.

[25] Penes the writer.

[26] Penes the writer.

[27] A characteristic not mentioned by any other writer.

[28] Stanley Morison mistakenly calls him Charles in the Introduction to Ambrose Heal's work.

[29] See Chapter 15.

30 In 1758 Charles Green of Halesowen, Caslon's half-cousin, was appointed Assistant Clerk and Wardrobe Keeper at Christ's Hospital; he was a friend of Thomas Bowles, stationer, of Newgate Street, whom he appointed as his executor.

31 See App. I for George Bickham the younger.

32 App. II to Heal's book: Engravers of copy-books.

Chapter Nine

EASTERN TRAVEL, ARABIC SCHOLARSHIP AND
FOREIGN MISSIONS

IN VIEW of the tradition ascribing to William Caslon the cutting of
the punches for a fount of Arabic as his maiden effort, which is
discussed more fully later, some brief account of Arabic studies
in this country up to the time of Caslon will show to what sources
the S.P.C.K. might turn in order to afford some guidance on the
characters to be cut, for it will be appreciated that whereas the
characters of Hebrew and Greek had been long familiar to students
of the scriptures and of classical authors both inside and outside
the universities, the study of Arabic and other Oriental tongues
lay outside the normal curricula and was far more specialised in
character.

Merchants of the Levant and East India companies had
mastered a colloquial knowledge of the dialects of the countries
and provinces with which they had to trade, but the tongues in use
had not been grammatically analysed and reduced to rule to the
same extent as had the languages of classical antiquity and of
which all university graduates had much or little knowledge,
according to the bent of their studies and their diligence. It is sur-
prising, however, to what extent the speaking of Arabic and its
variant dialects had spread by the end of the seventeenth century.

Arab conquests in the seventh and eight centuries and the
expansion of Islam spread the Arabic language into many coun-
tries outside Arabia, and in some form or other it is spoken in

Mesopotamia, Syria, Palestine, Egypt, Malta, North Africa, and even in certain districts further south, for example, in the Sudan, Nigeria, the western Sahara, and Zanzibar. The fact that Arabic was formerly spoken in Spain resulted in important contributions to Arabic literature, in the Balearic Islands and Sicily (to the end of Arab domination), in the island of Pantellaria, between Sicily and Tunis (up to the eighteenth century) and in Madagascar. Whilst dialectic differences have developed to an extent roughly proportionate to their remoteness from the land of origin, the written language has almost invariably conformed to that type which has been conveniently denominated classical Arabic, characterised by a rich vocabulary combined with a logical systematic character in its grammatical structure.[1]

After the Reformation and the discoveries of the American Continent and the passage to India by doubling the Cape, the outlook of Christendom was magically changed. No longer were Christian nations in central and western Europe to be pent up in a corner with the Moslem hosts barring the way to an East virtually unknown to Christendom. The Roman church was earlier in the mission fields than the Anglican church because opportunities for imperial expansion came to Spain and Portugal earlier than to England or Holland, so that the missionary work of Ignatius Loyola (1491–1556) and Francis Xavier (1506–1552) and their disciples achieved results in Mexico, Peru and Paraguay, Canton in China, Malabar and Malacca and even in far-off Japan, before the Protestant churches had time or opportunity to define and consolidate their position. But even as early as Edward VI we see concern for missions in the instructions given to Willoughby's fleet, in the efforts of Raleigh in Virginia, and in Queen Elizabeth's charter given to 'the Governor and Company of Merchants trading with the East Indies' in 1600, having reference to higher duties than those of commerce. When James I granted letters patent for the occupation of Virginia it was directed that the 'word and service of God be preached, planted and used in the said colonies as also as much as might be among the savages bordering among them.'

In 1618 was published *The True Honour of Navigation and Navigators*, by John Wood, dedicated to the governor of the East

India Company, and about the same time appeared the famous treatise of Grotius, *De veritate religionis Christianae*, written for the use of settlers in distant lands. Dutch evangelists worked in Java, the Moluccas, Formosa and Ceylon.

The North American colonies also received some attention, first from Archbishop Laud who designed a scheme for a local episcopate, then during the Protectorate when a corporation for the propagation of the Gospel in New England was planned and renewed later in the Restoration period. Cromwell himself characteristically planned a council for the Protestant religion, to rival the Roman 'Propaganda,' and to consist of seven councillors and four secretaries for different provinces. Among the most eminent of the missionaries of the New England corporation was the famous John Eliot who produced the Bible in the Indian language in 1661–64. Eliot received much assistance from the Hon. Robert Boyle (1627–1691)[2] who gave other proof of his zeal for missionary work by contributing much to the expense of printing the Indian, Irish and Welsh Bibles (1685–6); of the Turkish New Testament, and of the Malayan version of the Gospels and Acts (Oxford, 1677). Boyle was a governor of the Corporation for the spread of the Gospel in New England and a director of the East India Company, and bestowed a splendid reward upon Edward Pococke for his translation into Arabic of Grotius' *De Veritate*. George Fox (1624–1691), the Quaker, also wrote to 'All Friends everywhere that have Indians or blacks, to preach the Gospel to them and their servants.'

It will be seen, therefore, that missionary work in foreign fields up to the late seventeenth century had been largely unorganised and therefore dependent on the inspiration and devoted service of a few men of passionate conviction. Any Christianising influence of the trading companies was exercised primarily for the English attached to the stations and only incidentally for the natives who served them, except where the conviction of an individual created a new situation. The religious Societies of London and Westminster founded in 1678 and the Societies for the Reformation of Manners originating about 1691, which were the direct antecedents of the Society for Promoting Christian Knowledge, were concerned only with social and moral improvement in the

home field and it was not until the early eighteenth century that the attention and energies of the S.P.C.K. and its sister society, the S.P.G., were harnessed to the cause of converting the heathen in distant lands, and here the trail had been blazed by Lutheran missions before them. It was not until as late as 1804 that the British and Foreign Bible Society was founded.

It will readily be understood, therefore, that in the seventeenth and eighteenth centuries reliable accounts of foreign travel and the topography, peoples and natural history of distant lands were somewhat rare. Ordinary folk gave currency to the richly garnished stories repeated by travellers who only half expected their exaggerated accounts to be believed. People who accepted stories of fairies, ghosts and goblins at home were quite ready to believe in the existence of monsters and other fabulous creatures abroad.

More reliable accounts of distant lands were those committed to writing on the spot and published after the travellers' return, such as those by men holding consular posts abroad and by agents or chaplains of the great trading companies. But even here illustrations of places and natural features have to be accepted with caution. A pictorial record of places and things seen was in those days very rarely recorded by a competent draughtsman or artist accompanying the traveller; whatever sketches were made often depended on the limited skill of the traveller himself, and if submitted to an artist or engraver for publication later, however skilful the latter might be, he had only his own imagination to substitute for the accurate observation which the traveller himself might have lacked. It was only well into the eighteenth century that it became more customary for parties undertaking foreign tours to engage a draughtsman to accompany the party, and many of the painters of the so-called 'topographical school' of artists gained valuable early experience in this way.

The necessity for reliable artistic illustration to be based on accurate observations is well illustrated in the work of George Stubbs (1724–1806) who is said never to have been excelled as a painter of horses. While in Italy in 1754 he made friends with an educated Moor, who took him to his father's house at Ceuto where, from the town walls, he saw a lion stalk and seize a white Barbary

horse about two hundred yards from the moat.[3] This incident made an indelible impression on his mind and formed the subject of several of his pictures. In 1758 he took a farm-house in Lincolnshire, where he began preparations for his great work on the *Anatomy of the Horse* on which he was engaged for a year and a half, with no other companion than a young woman, Mary Spencer, said to be his niece. He erected an apparatus by which he could suspend the body of a dead horse and alter the limbs to any position, as if in motion. He laid bare each layer of muscles one after the other until the skeleton was reached, and made complete and careful drawings of all. Many horses were required before he had finished, and he carried the whole work through at his own expense. He also engraved his own plates, working morning and night for six or seven years, and earning money by his painting during the remaining hours of each working day. *The Anatomy of the Horse* was published in 1766 by J. Purser (for the author) and met with great success. A second edition was published in 1853 and the work is still an acknowledged authority.

Benjamin Green (1739–1798) mezzotint engraver and drawing-master at Christ's Hospital, related to William Caslon through his mother, became well-known for his series of mezzotint engravings from the paintings of George Stubbs. One of these in the writer's collection, *The Horse before the Lion's Den*, is based on the incident which Stubbs witnessed in Morocco. The picture is a striking representation of a terrified and agonised horse, bringing out all Stubbs' masterly knowledge of that animal, but it fails in the representation of the lion, which in the head particularly has the appearance of a creature of fable rather than of reality. There were then few lions in captivity. Hector, the old lion in the menagerie at the Tower, was one of very few such creatures to be seen. Ellis, a relative of Hogarth's, had been rewarded for services he rendered to Walpole with the sinecure post of keeper of the lions in the Tower and no doubt Hogarth and other artists of his time took advantage of the opportunity of studying from the life, but if Stubbs at a later time did the same, the result of his observations was certainly not as convincing as his work on the horse.

A Turkey merchant of considerable experience and know-

ledge in the second half of the seventeenth century was Sir William Hedges (1632–1701).[4] Sir Charles Hedges, uncle of the traveller Henry Maundrell, mentioned below, was a relative. William Hedges began his career as a Turkey merchant, presumably in the service of the Levant Company, at Constantinople. In his diary he refers to his colloquial knowledge of Arabic and Turkish. He was in charge of the factory at Constantinople, but finding the pressure of business too heavy for him and his partner Palmer, he invited Dudley North (1641–1691), a leading merchant in the Turkey Company, who was then at Smyrna, to come and take a share. North was a remarkable linguist with a perfect command of Turkish and the dialects in use in the Levant. He was brother-in-law to Robert Foley, the Stourbridge ironmaster, and it was probably this influence that secured for William Hallifax, the Levant Company's chaplain, mentioned later, his preferment as rector of Oldswinford.

Hedges returned to England in 1672 and in 1685 was elected a director of the East India Company and shortly afterwards chosen agent and governor of the company's affairs in the Bay of Bengal, with instructions to stop the activities of the 'interlopers.' Some friction ensued with his colleagues, and he was recalled. In 1688 he was knighted by James II and then became a member of the Mercers' Company. In 1693 he was elected an Alderman of Portsoken Ward and in 1694 a director of the new Bank of England. Hedges is a typical example of the more prominent merchant and financier of the late seventeenth century who, after experience in the Levant and East India Companies, sought and obtained honours in the City.

One of the more reliable oriental travellers whose account has rarely been impugned was Henry Maundrell (1665–1701),[5] the son of Robert Maundrell of Compton Basset, near Calne, Wiltshire. After graduating at Exeter College, Oxford, Maundrell was ordained in the English Church, and having served as curate at Bromley in Kent from 1689 to 1695, he was then elected by the Company of Levant Merchants as chaplain to their factory at Aleppo in succession to William Hallifax. Leaving his friends at Richmond, where his uncle, Sir Charles Hedges, one-time M.P. for Calne, had a house on the Green, he made his way through

Germany, making a short stay at Frankfort, where he met Job Ludolf (1624–1704) the German orientalist, who suggested to him several points of topography in the Holy Land which required elucidation. Arriving at Aleppo, he found an English colony numbering about forty, with whom he performed daily service to a devout and large congregation. His celebrated journey to Jerusalem was begun, with fourteen other residents from the settlement, on 26 February, 1696–7. They arrived on 25 March, the day before Good Friday in the Latin style, and left on Easter Monday, 29 March, for Jordan and Bethlehem, but returned again on 2 April. Their second departure from Jerusalem was on 15 April, and the day of their return to the factory was about 20 May. Maundrell died, presumably of fever, at Aleppo early in 1701.

His narrative of the expedition, entitled *A Journey from Aleppo to Jerusalem at Easter, A.D. 1697,* was printed at Oxford in 1703, with dedications to Sprat, bishop of Rochester, and to Hedges. A second edition came out in 1707, and a third issue, with *An Account of the Author's Journey [April, 1699] to the Banks of Euphrates at Beer and to Mesopotamia,* appeared in 1714. Maundrell is entitled to considerable praise as a judicious and careful traveller.

Maundrell's companion, Richard Chiswell the younger (1673–1751), was the son of the famous bookseller Richard Chiswell (1639–1711), whom Dunton described as 'the metropolitan bookseller of all England,' dealing principally in theology and Bibles. His mother was Mary, daughter of Richard Royston, bookseller to Charles I and II. The younger Chiswell was a Turkey merchant, travelled much in the East, was a director of the Bank of England, and in 1715 Whig M.P. for Calne, Wiltshire, which Sir Charles Hedges, Maundrell's uncle, had also represented. Chiswell purchased Debden Hall, Essex, in 1715 and died in 1751. He married Mary, daughter and heiress of Thomas Trench, merchant of London, a marriage which brought him into relationship with Dr. Samuel Barton, died 1716, who was chaplain to Paul Foley when Speaker of the House of Commons. Dr. Barton had property at Clent and his brother Edward Barton was also a merchant of London who left a charitable bequest to Kinver Church.

Richard Chiswell wrote, but apparently did not publish: (1) Remarks on a voyage or journey to the river Euphrates, etc., in April and May, 1698 ; (2) Journal of travels through Germany and Italy to Scanderoon, in company with Henry Maundrell and others March-July, 1696 ; (3) Journal of a voyage from Aleppo to Jerusalem in company with Henry Maundrell in 1697.

Another account (*penes* the writer) similar to Maundrell's was published in 1736 and dedicated to William Fawkener, a Turkey merchant, whose brother, Sir Everard Fawkener, after leaving similar pursuits, became private secretary to William Augustus, Duke of Cumberland (the Culloden Duke). It is entitled *A Journey from Aleppo to Damascus; with a Description of those Two Capital Cities, and the neighbouring Parts of Syria, etc.* by J[ohn] G[reen].[6] Illustrated with Notes and a Map (by Emanuel Bowen), 1736.

Another man who became well-known in the West Midlands and had direct experience of the Levant was William Hallifax (1655–1722), born at Springthorpe, Lincolnshire.[7] In 1670 he was entered as a servitor at Brazenose College, Oxford, but in 1674 was admitted a scholar and in 1682 a fellow of Corpus Christi College, graduating B.A. in 1674, M.A. 1678, and B.D. in 1687. At Corpus he became friendly with Samuel Barton, who graduated B.A. in 1669, M.A. 1673, fellow, B.D. 1682, D.D. 1697, and held several preferments. In his will, 1716, Barton left a legacy to Hallifax. In January, 1688, Hallifax was elected chaplain to the Levant Company at Aleppo and held the post until 27 November, 1695, when he was succeeded by Henry Maundrell. Having in 1691 visited Palmyra in Syria, Hallifax sent an account to Professor Edward Bernard, which, with a sketch of the ruins taken by two of his travelling companions, was inserted in the *Phil. Trans.* for 1695.[8] He took the degree of D.D. by diploma in 1695, and on 17 August, 1699, he was presented by Thomas Foley of Witley Court to the richly endowed rectory of Oldswinford, Worcestershire, and held it with the rectory of Salwarpe in the same county, to which he was instituted on 18 July, 1713.[9] He was twice married but left no issue. By his will[10] he bequeathed to Corpus Christi College, Oxford, his oriental books and manuscripts, a silver-gilt basin, bought at Aleppo, and a collection of coins and medals.

Reference has already been made to the rarity of accounts of countries of the near East which are based on accurate observation. A notable eighteenth century traveller previously mentioned was Thomas Shaw (1694–1751), who was chaplain to the English factory at Algiers from 1720 to 1733 and made careful observations in a series of expeditions in North Africa and the Holy Land. In 1738 he published his *Travels or Observations relating to several parts of Barbary and the Levant,* Oxford, folio, described as a noble example of typography.[11] For his time his geological views are enlightened and the book was specially valued for its illustrations of natural history and descriptions of many mammals and insects (including the locust swarms) and even fishes ; he described 640 species of plants. Gibbon gives Shaw an honourable exception from the crowd of 'blind travellers,' and his accuracy was confirmed by later writers. In 1740 Shaw became principal of St. Edmund Hall, Oxford, which he raised from a ruinous condition by his munificence ; in 1741 he was appointed regius professor of Greek. Shaw died in 1751.

It should be noted that Thomas Shaw graduated B.A. at Queen's College, Oxford, in 1716, M.A. in 1720, the college of which Edward Rowe Mores, the historian of letter-founders, became an alumnus later, and of which he wrote a history. There are portraits in oils of Thomas Shaw at both Queen's College and St. Edmund Hall. [12] While Rowe Mores was collecting materials for a history of his College (among other projects) he commissioned the brothers James and Benjamin Green of Halesowen to engrave various plates for him, and it seems certain that the portrait of Thomas Shaw engraved by James Green in 1757, taken from the portrait at Queen's College, was one of those commissioned by him.

Alexander Drummond (died 1769) was British Consul at Aleppo from 1754 to 1756 and it is to him that we owe an attractive view of Aleppo in the mid-eighteenth century. He was the younger brother of George Drummond, six times lord provost of Edinburgh, and was the author of *Travels through the different Countries of Germany, Italy, Greece, and parts of Asia, as far as the Banks of the Euphrates: In a Series of Letters,* London, 1754.[13] His journeys were made in the years 1744–50, in excur-

sions at intervals in what appear to have been commercial pursuits. A copy of this book[14] contains some curious views which emphasise the remarks made earlier regarding accurate observations and competent draughtsmanship. The author apparently sent his sketches with the letters to his brother and they were then put into the hands of John Sebastian Müller, a German engraver, born about 1715, who worked in this country for many years, producing chiefly botanical and natural history plates and some antiquities. Müller evidently exercised some artistic licence, for one or two of the plates show mountain peaks with their tops bending over ! In other places Müller's work is competent, but the plate of the city of Aleppo excels all else in the book.[15] In the engraving of the Oxford Almanacks Benjamin Green of Halesowen succeeded on the death of his brother James in 1759, then J. S. Müller engraved the plates for 1763–4–5, but they were much below Miller's best standard, and Benjamin Green must have been recalled for the Almanack of 1766, exhibiting the well-known view of the Oxford Physic Garden.

In a letter written from Venice on 2 September, 1744, Drummond says : 'Hither I was favoured with the company of Mr. George Nelthorpe and Mr. Leigh, two English gentlemen for whom I have a very great regard.' This Mr Leigh was almost certainly Jared Leigh (1724–1769), an amateur artist and son of Jared Leigh, said to be of the family of Leigh of West Hall, Cheshire. He became a proctor in Doctors' Commons and like several others in and about the Inns of Court mingled with artists and interested himself in the theatre.[16] Ebenezer Forrest and his son Theodosius were both in the law ; the elder Forrest was friendly with John Rich, proprietor of Lincoln's Inn theatre and the younger Forrest was solicitor to Covent Garden theatre. Both had many artist friends, such as William Taverner, procurator-general of the Court of Arches and an amateur artist of high ability ; there were also Thornhill, Scott, Lambert, Hogarth and the Sandby brothers.[17] Jared Leigh painted chiefly landscapes and seascapes, selling some occasionally, and exhibited twenty-three pictures with the Free Society of Artists from 1761 to 1767, but died prematurely in 1767 and was buried in St. Andrew's Wardrobe.

This chance reference, however, to these two English gentlemen, George Nelthorpe and Leigh, meeting Drummond while on a foreign tour, forms another link between the Caslons, father and son, and the artist brothers Green of Halesowen, as well as providing a pointer to the way in which George Stubbs met his early patron Lady Nelthorpe. In 1764 William Caslon II, the *bête noire* of Edward Rowe Mores, was elected a member of the Society of Arts, Manufacturers and Commerce, one of his sponsors being Jared Leigh. The Society's MS. Subscription books and Minutes record as follows :[18]

'Mr. William Caslon Jnr., Letter Founder, Chiswell St.
Proposed by Mr. Machell, Mr. John Knapp and Mr. Jared Leigh.
 Elected 1st February, 1764.
 "Declined" 1766.'

Another entry five years later reads as follows :

'Amos Green Esq., Portman Street, Portman Sq.,
Proposed by Sir Edward Blackett, Sir Robert Foley and O. S. Brereton Esq., V.P. Elected 11 Jan. 1769.
 "Last payment 1776".'

It appears that neither William Caslon II nor Amos Green maintained an interest in the Society for long, but it will be seen that Green had substantial sponsors.

Something has been said about George Stubbs and his work on the anatomy of the horse, and about Benjamin Green's series of mezzotint engravings based on Stubb's paintings. It is not so well-known that Amos Green painted the landscape back-grounds to some of Stubbs' pictures. This degree of collaboration between them is evidence of a pretty close friendship. Stubbs was Amos Green's senior by ten years and senior to Benjamin Green by another five, yet Amos Green's connections were such that it seems fairly conclusive that both he and Caslon II were able to introduce Stubbs to worth-while patronage.

As early as 1744, Jared Leigh, then only about twenty years of age, was acting as travelling companion to George Nelthorpe, and as we have seen Leigh was friendly with the Caslons, who in turn were related to the Greens. Amos Green was intimate with most of the celebrated artists of his time, and both as freelance

artist and companion to Anthony Deane, moved freely in the highest circles. Anthony Deane, born in 1729, was the son of Anthony Deane, a wealthy ironmaster, of Whittington Forge and Slitting Mill, who had business dealings with Matthew Boulton, senior and junior.[19] His mother was Susannah, sister of Francis Clare, of Caldwell, near Kidderminster, who also had a residence at Clent, and to whose estates Anthony Deane, junior, eventually became heir. Amos Green's patron lived principally in London and at Bath, and Green thus had ample opportunities of improving his own talents in painting.

It seems probable, therefore, that George Stubbs was introduced to his patron Lady Nelthorpe, either through Jared Leigh and George Nelthorpe, or through Amos Green.

One further instance of a traveller in foreign parts in the eighteenth century must suffice. Richard Pococke (1704–1765) was born at Southampton, where his father was master of the free grammar school and curate of All Saints' Church. From 1733 to 1736 Pococke made tours in France, Italy and other parts of Europe with his cousin, Jeremiah Milles, dean of Exeter. He also travelled in the East, visiting Alexandria, Rosetta, Memphis, Thebes, Jerusalem (bathing in the Dead Sea to test a statement of Pliny's), Cyprus, Candia, parts of Asia Minor and Greece, Naples, Vesuvius, and the Alps (1737–42). Pococke came to be regarded as the pioneer of Alpine travel. He also travelled in later times to the more remote places of the British Isles and if his notes had been published he would have taken precedence of Thomas Pennant as the explorer of the more remote regions of these islands.[20] His 'Observations on the East, including Egypt, Palestine, Syria, Mesopotamia, Cyprus, Candia, Asia Minor, Greece, etc.,' were published in 1743–45. Gibbon described his work as of 'superior learning and dignity,' though he objected that its author too often confounded what he had seen with what he had heard.

Pococke was well acquainted with Charles Lyttelton (1714–1768), of the Hagley family, who became Bishop of Carlisle, and, as a well-known antiquary and historian, was a close friend of Jeremiah Milles, Lyttelton's successor as President of the Society of Antiquaries.

Having given a short account of a few of the chaplains,

merchants and travellers who have left more or less reliable impressions of the Levant and near East at the end of the seventeenth century and early in the eighteenth, mentioning known connections with Caslon and the West Midlands, we must now consider briefly the state of Arabic scholarship, particularly in England, up to the time when the S.P.C.K. undertook to provide an Arabic Psalter and New Testament for the use of the Eastern churches. This is best done in short compass by considering the achievements of four men whose life spans extend over the one hundred and fifty years before 1720.

The father of Arabic studies in England was William Bedwell (1561–1632),[21] a graduate of Cambridge who became rector of St. Ethelburgh's, Bishopsgate Street, in 1601. In 1604 he was selected as one of the Westminster company of translators of the Bible, of which the president was Dr. Lancelot Andrewes, who in 1607 presented Bedwell also to the vicarage of Tottenham High Cross. Bedwell's studies embraced several oriental languages, but were especially directed towards Arabic which, from the paucity of helps and texts, was then very little known in northern Europe.

He expresses just views of the use of Arabic in elucidating Hebrew words, as exemplified in the writings of the mediaeval Rabbis. His reputation as an Arabist had extended to the continent before 1603. Thomas Erpenius (or van Erpe) (1584–1624), the Dutch orientalist, visiting England about 1608, found particular satisfaction in meeting Bedwell, and Isaac Casaubon (1559–1614), Erpenius's bosom friend, waited impatiently for an Arab lexicon which Bedwell was compiling before 1610. Bedwell also pursued mathematical studies and was a personal friend of John Greaves (1602–1652) and Henry Briggs (1556–1630).

It is of particular interest to note that both Bedwell and Erpenius had their own founts of Arabic type. When Bedwell died in 1632 he left to his university his manuscript lexicon, together with his fount of Arabic to print it. This was never done, but by a grace of 25 June, 1658, it was lent to Edmund Castell (1606–1685) and Samuel Clarke (1625–1669), the first *architypographus* at the University of Oxford. Castell used the manuscript largely in his great *Lexicon Heptaglotton*, and in this way Bedwell secured a lasting place in the history of Arabic scholarship. Bed-

well's manuscript lexicon includes Hebrew, Syriac, Chaldee, and Arabic words, and in the original draught is entirely gathered from the author's own reading. Erpenius, described as Bedwell's partner in opening Arabic studies, was a pupil of Joseph Scaliger (1540–1609) and at Venice perfected himself in the Turkish, Persic, and Ethiopic languages. He was afterwards professor of Arabic and other oriental languages at Leyden University where he caused new Arabic characters to be cut at great expense and erected a press in his own house. Chief among his works were his *Grammatica Arabicae*, 1613, and often reprinted; *Rudimenta linguae Arabicae*, 1620; *Grammatica Ebraea generalis*, 1621; *Grammatica Chaldaica et Syria*, 1628; and an edition of Elmacin's *History of the Saracens*.

The writer has in his possession a copy of the *Rudimenta linguae Arabicae* by Erpenius, revised by the Dutch Hebraist, Albert Schultens (1686–1750), a work long in use in English universities. It was published by Samuel Luchtmans in 1733 with type cut by Isaac Vander Mijn. Several members of this family, including Herman Vander Mijn (1684–1741), employed their talents in painting and engraving, at least two of whom practised for a time in London in the 1720's.

The mantle of William Bedwell fell on Edward Pococke (1604–1691), born at St. Peter-in-the-East, Oxford, and an alumnus of Corpus Christi, graduating M.A. in 1626.[22] He was a student at Oxford under the German Arabist, Matthias Pasor, and later under William Bedwell. Charles Robson (1598–1638), of Queen's College, Oxford, was the first chaplain to be appointed to the Levant Company at Aleppo and in 1629 Pococke was appointed to succeed him and held the post for five years, becoming a master of Arabic, which he not only read but spoke fluently, and by studying Hebrew, Samaritan, Syriac and Ethiopic and associating with learned Muslims and Jews he was enabled to collect oriental manuscripts, including a Samaritan Pentateuch and a copy of Meydani's collection of 6013 Arabic proverbs, which he translated in 1635. About 1636 Pococke returned to England to accept Laud's offer to appoint him the first professor of the Arabic 'lecture' he had founded at Oxford.

In 1637, at Laud's wish, Pococke again journeyed east, this

time accompanied by his friend John Greaves previously mentioned, while Greaves's brother Thomas deputised for Pococke in the Arabic lecture in his absence. While at Constantinople he enjoyed the friendship and the fine library of Cyril Lucar until the latter's assassination in 1638. On Pococke's return to London in 1641, he found Laud confined in the Tower, but the archbishop was able to assure him that he had placed the Arabic chair beyond the reach of attainder. During the troubled years of the Civil War it was only the strong support of Dr. Gerald Langbaine, provost of Queen's, John Greaves and John Selden, that enabled Pococke to retain the Arabic and Hebrew lectureships. In 1655, when a few fanatics cited him under the new act for ejecting 'ignorant, scandalous, insufficient and negligent ministers,' the leading Oxford scholars headed by Dr. John Owen (1616–1683) warned the commission of the contempt they would incur if they ejected for 'ignorance and insufficiency' a man whose learning was the admiration of Europe. The charge was finally dismissed.

At the end of 1649 he published at Oxford, and dedicated to Selden, his *specimen historiae Arabum*, in which an excerpt from the *Universal History* of Abu-l-Faraj is used as a peg whereon are hung a series of elaborate essays on Arabian history, science, literature, and religion, based upon prolonged researches in over a hundred Arabic manuscripts, and forming an epoch in the development of Eastern studies. All later orientalists, from Reland and Ockley to S. de Sacy, have borne testimony to the immense erudition and sound scholarship of this remarkable work. The *Specimen* is interesting also for the history of printing, for Leonard Twells asserts,[23] it is believed correctly, that Pococke's *Specimen* and John Greaves's *Bainbrigii Canicularia*, 1648, were the first two books in Arabic type which issued from the Oxford University Press.[24] Similarly the *Porta Mosis*, or edition (Arabic in Hebrew characters) of the six prefatory discourses of Maimonides on the Mishna, with Latin translation and notes (especially on Septuagint readings), on which Pococke had been engaged since 1650, but which was not published till 1655, is believed to be the first Hebrew text printed at Oxford from type specially founded by the university at Dr. Langbaine's instance for Pococke's use.[25]

The great event for oriental learning in 1657 was the publication by Dr. Brian Walton of his *Biblia Sacra Polyglotta*, in which Pococke had taken a constant interest for five years, advising, criticising, lending manuscripts from his own collection, collating the Arabic version of the Pentateuch, and contributing a critical appendix to Vol. VI.[26]

The Restoration brought Pococke into permanent residence at Christ Church and he received the degree of D.D. on 20 Sept. 1660. In that year he published (at the cost of the Hon. Robert Boyle) an Arabic translation (with emendations and a new preface) of Grotius's tract, *De veritate religionis Christianae*. In 1661 appeared the text and translation of the Arabic poem *Lamiato 'l Ajem, Carmen . . . Tograi*, with grammatical and explanatory notes, produced at the Oxford Press under the superintendence of Samuel Clarke, *architypographu*s to the University, who appended a treatise of his own on Arabic prosody (separate pagination and title 1661); and in 1663 Pococke brought out the Arabic text and Latin translation of the *Historia compendiosa dynastiarum* of Abu-l-Faraj (Bar Hebraeus), of which an excerpt had formed the text of the *Specimen* thirteen years before.[27]

An engraving of Pococke, after a portrait by William Green, is prefixed to the 1740 edition of his works (Bromley). His valuable collection of 420 oriental manuscripts was bought by the university in 1693 for £600, and is in the Bodleian.

Edward Pococke (1648–1727) was expected to succeed to his father's Arabic professorship.[28] ' 'Tis said he understands Arabick and other oriental Tongues very well, but wanted Friends to get him ye Professorships of Hebrew and Arabick at Oxford,'[29] and Dr. Thomas Hyde (1636–1703), Bodley's librarian, was appointed. Pococke apparently abandoned further oriental researches, and died in 1727.[30]

In any account of the progress of Arabic studies in this country the name of John Postlethwayt (1650–1713), chief master of St. Paul's School, cannot be omitted. Born in Cumberland, Postlethwayt graduated B.A. at Merton College, Oxford, in 1674 and M.A. in 1678, after which he was appointed master of Dr. Thomas Tenison's school in the parish of St. Martin-in-the-Fields, where Tenison had become rector in 1680. On the resignation of

Dr. Thomas Gale in 1697, preferred to the deanery of York, Postlethwayt was chosen high master of St. Paul's School. The strong recommendation given him by Tenison is printed in Stow, ed. Strype, i.168. Evelyn, Bentley and Wake, the future archbishop, also gave him testimonials. At St. Paul's, Postlethwayt encouraged the study of oriental languages, especially Arabic, and it was here that Salomon Negri, Caslon's supervisor in Arabic letters, assisted in the teaching when he was in this country. Postlethwayt died unmarried in 1713, and was buried in St. Augustine's, Old Change.[31]

John Postlethwayt's correspondence, formerly in the possession of a collateral descendant, Albert Hartshorne, F.S.A., of Bradbourne Hall, Derbyshire, shows that the establishment of the lord almoner's professorship of Arabic at Oxford was due to Postlethwayt, the lord almoner at the time being archbishop Tenison. Through Postlethwayt's influence with William III, Arabic studentships, as they were at first called, were established at Oxford in 1699. The first holders of these offices under the crown were two of Postlethwayt's pupils, John Wallis and Benjamin Marshall. It is highly probable that Postlethwayt's deep interest in Arabic studies received considerable stimulus from the close connection which had always subsisted between St. Paul's School and the Mercers' Company.

Another scholar in the succession of English orientalists was Simon Ockley (1678–1720) who came of a Norfolk family. At fifteen years of age he entered Queen's College, Cambridge, where, according to Hearne, 'being naturally inclin'd to ye Study of ye Oriental Tongues, he was, when abt 17 years of Age, made Hebrew Lecturer in ye said College chiefly because he was poor and could hardly subsist.'[32] He took holy orders before he was twenty, and became curate at Swavesey, Cambridgeshire, under the vicar, Joseph Wasse, as early as 1701, succeeding in 1705 to the vicariate by presentation of Jesus College, Cambridge, on the recommendation of Simon Patrick, bishop of Ely, remaining vicar until his death. Lord-treasurer Harley appointed him his chaplain about 1711.

Hearne records that Ockley was 'admitted student into ye Publick Library' on 8 Aug. 1701, for the purpose of consulting

some Arabic manuscripts, and that in the spring of 1706 he again journeyed to Oxford where he was incorporated Master of Arts. 'This Journey was also undertaken purely for ye sake of ye Publick Library, wch he constantly frequented till Yesterday (17 May) when he went away. He is upon other Publick Designs, and for yt end consulted divers of our Arabick Mss^{ts} ; in wch Language he is said by some Judges to be ye best skill'd of any Man in England ; wch he has in a great Measure made appear by his quick Turning into English about half of one of ye Said Arabick Ms^{ts} in folio during his Stay with us, besides ye other Business upon his Hands. He is a man of very great Industry, and ought to be incourag'd, wch I do not question but he will if he lives to see Learning once more incourag'd in England, wch at present is not.' In spite of the grinding poverty of his domestic circumstances, Ockley devoted himself with passionate energy to oriental learning. As his grandson, Dr. Ralph Heathcote, says, 'Ockley had the culture of oriental learning very much at heart, and the several publications which he made were intended solely to promote it.'[33] They certainly were not calculated for profit, since Hearne observes of Ockley's first book, the *Introductio ad linguas orientales* (Cambridge, 1706), that 'there were only 500 printed, and conseqtly he ought to have recd a gratuity from some Generous Patron to satisfy him in yt wch he could not expect from a Bookseller when ye Number was so small.' The *Introductio* was dedicated to the Bishop of Ely, and the preface exhorts the 'juventus academica' to devote its attention to oriental literature, both for its own merits, and also for the aid which it supplies towards the proper study of divinity.

Ockley was a good French, Italian and Spanish scholar as well as an orientalist of whose acquaintance with eastern languages Adrian Reland (1676–1718) the Dutch orientalist, also testified. His dedication of *The Improvement of Human Reason, exhibited in the Life of Haiebn Yokdhan*, to Edward Pococke, 'the worthy son of so great a father' shows one source of his enthusiasm for oriental learning ; and he may fairly be classed as a disciple of 'the Reverend and Learned Dr. Pocock, the Glory and Ornament of our Age and Nation, whose Memory I much reverence.'[34]

In 1708 Ockley published the first volume of *The Conquest*

of Syria, Persia, and Egypt by the Saracens, the work which under its general but less accurate title, *The History of the Saracens*, achieved a wide popularity, and to all but specialists, constitutes Ockley's single title to fame. The second volume, bringing the history down to A.D. 705 (A.H. 86), did not appear till 1718 (London), together with a second edition of Vol. i. The work was based upon a manuscript in the Bodleian Library ascribed to the Arabic historian El-Wakidi, with additions from El-Mekin, Abu-l-Fida, Abu-l-Faraj, and others . . .

Ockley was admitted a B.D. at Cambridge in 1710 and in December, 1711[35] he was appointed to the chair of Arabic at his university. In his inaugural address as professor, Ockley expatiates with enthusiasm upon the beauty and utility of the Arabic language and literature, and pays tribute to the past labours of Erpenius, Golius, Pocock, and Herbelot. A fuller account of Ockley's labours is given in the D.N.B.

Finally in a letter to his daughter,[36] Ockley gives his scathing opinion of the general attitude to scholarship early in the eighteenth century: 'We are all swallowed up in politics; there is no room for letters; and it is to be feared that the next generation will not only inherit but improve the polite ignorance of the present.'

If Ockley's conclusion, confirmed, as we have seen, by Thomas Hearne, represents a fair judgment of the general attitude of his contemporaries to scholarship, it is not to be wondered at if the S.P.C.K. found it necessary to engage foreign scholars to supervise its Arabic translations. Certainly Ockley's own labours seem to have received little appreciation and the endowments of oriental studies at the universities, including the Laudian professorship and the lord almoner's studentships, had certainly inspired little practical result at the time of Ockley's death in 1720. If Ockley had lived a little longer, one wonders whether the S.P.C.K. would have used his talents to supplement those of Salomon Negri in the preparation of the Arabic Psalter and New Testament.

We must now look briefly at movements on the Continent parallel to those which in England led to the formation of the S.P.C.K., for England was not the only part of Europe which had been distracted by religious dissensions in the latter half of the seventeenth century. Indeed, it is only by looking at religious

movements on the Continent that we can appreciate how the S.P.C.K. came to be interested in continental missionary enterprise and alternatively, how Lutheran scholars came to be involved in the S.P.C.K.'s sponsorship of the Arabic Psalter and New Testament.

The reforming movement in Germany began with the activities of Philip Jakob Spener (1635–1705) at Frankfort,[37] whose attacks on Calvinism attracted much attention. Gradually adopting a more spiritual and less aggressive style, in 1670 he instituted the *collegia pietatis*, from which arose the sect called Pietists. In 1675 he published his *Pia Desideria*, pointing out the defects of the religious systems of the time, urging better attention to the teaching of youth and zealous application to Biblical interpretation and practical theology, as well as contending that a true theologian must be a regenerate man. He founded the University of Halle, which became a centre of 'pietism,' and where August Hermann Francke (1663–1727) became one of the first professors. Francke was born at Lubeck and graduated at Leipzig. Encouraged by Spener, he founded the Collegium Philobiblicum for the systematic study of the Bible, philologically and practically. Interdicted from preaching at Erfurt and Dresden he then found his place at Halle, first as professor of Greek and oriental languages and later also of theology. Here he remained for 36 years.

At Halle in 1695 he instituted what is often called a 'ragged school,' otherwise a charity school, to which he added an orphanage, a Latin school, and other educational institutions. In 1698 there were 100 orphans under his charge to be clothed and fed, besides 500 children who were taught as day scholars. Before his death there was a total of 2,300 scholars. The schools maintained their importance, having in 1905 over 3,000 scholars.

Anthony William Boehm (1673–1722)[38] was the son of the minister of Oestorff, in the county of Pyrmont, Germany, and in 1693 he became a student under Francke at the newly founded University at Halle. In 1701 he set out for London to teach the children of some German families here and opened a school in 1702. On his way to England he had made the acquaintance of Henry William Ludolf (1655–1710), secretary to Prince George of Denmark (1653–1708) and when the Prince, at the request of

Queen Anne, decided to introduce the common prayer book into his own chapel, Boehm, on the recommendation of the secretary, was appointed assistant chaplain to read the prayers, which the then chaplain found too hard for him. After the death of Prince George in 1708, the service was continued at the chapel at St. James's as before, and on the accession of George I no alteration was made, 'so that,' in the words of his biographer, 'he continued his pious labours to his dying day.' Boehm was a voluminous author, as well as the translator of Prof. Francke's *Pietas Hallensis*. He was also a member of the S.P.C.K., and was a valuable link between that body, the University of Halle, and Prof. Salomon Negri.

Joseph Downing, a printer in Bartholomew Close, was for many years the printer to both the S.P.C.K. and the S.P.G. A work sponsored by the Societies[39] gives an account of several of their missionary enterprises, letters and reports, many translated from the high Dutch, and contains numerous references to Boehm, whose various writings were published in 1731–2 by Professor Rambach at Halle.

It is not altogether surprising that the religious developments in Germany bore some resemblance to the movements in England, for Dr. Anthony Horneck (1641–97),[40] who was a principal supporter first, of the Religious Societies of London and Westminster founded in 1678 and then of the Societies for Reformation of Manners originating about 1691, was a German. Educated at Heidelberg, Horneck came to this country after the Restoration and attached himself to Queen's College, Oxford. He was vicar of All Saints, Oxford, for two years, later an incumbent in Devonshire, and in 1671 he was appointed to the Savoy in London. It was the young men whose minds had been stirred by the discourses of Horneck and of Dr. Smithies, curate of St. Giles's, Cripplegate, who became the pioneers in the S.P.C.K. and S.P.G.[41]

The connection between the S.P.C.K. and Salomon Negri came about in a curious way. The first founder of Protestant missions in India was Frederick IV, King of Denmark from 1699 to 1730, nephew of Prince George of Denmark, Queen Anne's consort. Frederick's chaplain, Dr. Lutkens, imparted to his royal pupil a great zeal for foreign missions, but the difficulty in those

days was to find men suitable to undertake such work. An approach being made, however, to Professor A. H. Francke of the University of Halle, he recruited as the first two missionaries for India two remarkable men, Bartholomew Ziegenbalg and Henry Plutschau, who embarked for India on November 29, 1705, arriving after many adventures at the Danish possession of Tranquebar on the coast of Coromandel on July 19, 1706.

The language was their first and principal difficulty. Portuguese was used in that part of the country by the half-castes and natives who had come across from Goa, and though they were fairly conversant with this, they could accomplish little till they had learnt Tamil. So they put themselves to school with a native teacher and sat day by day with the children, repeating the lessons, and writing the letters with their fingers in the sand. Ziegenbalg was the quicker learner, and in eight months he preached his first extempore sermon in Tamil. In 1708 Ziegenbalg began to translate the New Testament into Tamil, and by March, 1711, he had completed the task.

The letters sent home by the missionaries had aroused much interest in Germany and in 1709 they were translated into English by the Rev. A. W. Boehm, the German chaplain at St. James's, who dedicated the book to the S.P.G., and invited the Society to assist the Tranquebar Mission. The full narrative of these Danish Missionaries is given in the book previously mentioned.[42]

The activities of the S.P.G., however, were limited by its Charter to work in the English Plantations and Colonies, and it was decided that the Society could not extend its work to the East Indies. Then the S.P.C.K. was approached and as its Charter did not confine it to any particular field of work, the members took up the cause of the Danish Mission very warmly, so that the Society was enabled to have the Portugese version of the New Testament (by J. F. d'Almeida) reprinted at Amsterdam and many hundreds of copies sent to Tranquebar. In 1711 the S.P.C.K. also sent a printing press, with (Pica) roman letters and all necessary apparatus, as well as supplying a printer, Jonas Fincke, whom the Society had found and trained. Fincke, however, died on the voyage out while the ship was rounding the Cape. The press arrived safely in August, 1712, and the missionaries found and recruited a soldier in

the service of the East India Company who understood printing.[43]

It is somewhat remarkable that at so early a stage in the history of missions to India we read of printers and even letter-founders being at the missionary stations. For example, J. E. Grundler, writing from the Cape in April, 1709, while on his way to relieve Henry Plutschau, says "Tis pity we have no better Helps in Germany, for learning this Language (Portuguese and Malabarick) to Perfection, since it is so universally useful for such as may be appointed to follow us. Here at the Cape, we got one Copy of the New Testament in the Portuguese Tongue, printed at Amsterdam in 1681, which cost us three Specie-dollars . . .[44]

'As for the aforesaid New-Testament, you must know, that it was translated in Batavia (a province of Java colonised by the Dutch East India Company in the seventeenth century), by some Dutch Ministers there; but the first Impression proving very faulty, it was remitted to Amsterdam, and printed the Second Time, after it was revised. If a Founder and Printer could be sent over in Time, and readily provided with a Sett of Latin Types, it would effectually, and without any Delay, further our present Design : For the Portuguese Language being of so ample a Use, true and practical Christianity might be scattered by this Means throughout most of these Eastern Countries.'[45]

The following is an extract from a letter written by the missionaries Ziegenbalg and Grundler in April, 1713, and addressed to the Rev. George Lewis, Chaplain to the East India Company at Fort St. George.[46]

'The Society (at London) for Promoting Christian Knowledge, considering how necessary the Distribution of Books is to the Propagation of the Christian Faith, have sent us, last Year (from England) a Printing-Press, with a Font of Portuguese Letters, with which we have already printed four Books, for the Benefit of Christians in these Parts. And this Year we expect to receive, if it so please God, a set of Malabarick-Types, by the Ships that shall come from Europe, that we may likewise publish the Word of Salvation among the Malabarians, in their own Damulian Language and introduce the desirable Use of Books, for their temporal and spiritual Advantage . . .'[47]

The missionaries appended a list of 32 books which they had written and translated in the Malabarick language, together with 10 in Portuguese which they had likewise copied and written themselves.

In September, 1714, the same two missionaries wrote as follows:

'The Scarcity of Paper has hindered us from pursuing the Impression to the End of the Epistles: For of the seventy five Ream of the largest Paper you were pleased to send us last Year, only six remain; but of the lesser Size, which made up your first Present of Paper, we have thirty Ream left in our Store. For the setting-up a Paper-Manufacture here, though we do not think it altogether impracticable, yet our perpetual want of Money has not permitted us hitherto to attempt any such thing. The Malabar-Types which were sent from Germany proved so very large, that they consumed Abundance of Paper: To remove this Inconveniency, our Letter-Founder has, about two Months since, cast another Type of a smaller Size, wherewith we design to print the remaining Part of the New-Testament . . .'

It is clear that these early missionaries were men of exceptional resource and enterprise. In 1712 Henry Plutschau came home and was received on November 13 in a special Assembly of the S.P.C.K., on which occasion John Postlethwayt, M.A., Master of St. Paul's School and a member of the Society, delivered an address of welcome in Latin, to which Plutschau replied. In 1714 Ziegenbalg also paid a visit to England, and on December 29, 1715, he too was welcomed in a special Assembly of the Society. John Postlethwayt having died in 1713, the congratulatory address was spoken in Latin by William Nicols, M.A., (1655–1715) a Latin poet, who was rector of Stockport in Cheshire,[48] also a member of the Society, to which Ziegenbalg responded. Ziegenbalg returned to Tranquebar but died in 1719 when only 36 years of age. Plutschau remained at home and lived until 1747. Other missionaries early in the field were Benjamin Schultze, J. E. Geister, and J. A. Sartorius.[49] The last-named was ordained in London by the Lutheran Court Chaplain in 1730; he was connected with the well-known family of painters of race-

horses and sporting pictures who were descended from Jacob Christopher Sartorius (fl. 1694–1737), an engraver born in Nuremberg. John Sartorius, born about 1700, was the first of the family to make a name in this country.

Reviewing the circumstances in which the S.P.C.K. became involved in missions to the East Indies, it can be said that the Society's interest was stimulated largely through the agency of Lutherans in the service of Prince George of Denmark; indeed, it must be confessed that if that Prince had not become the consort of Princess, later Queen, Anne, missionary initiative in that part of the world would almost certainly have been deferred for a considerable time, possibly for half-a-century. It was indirectly through this marriage that the S.P.C.K. became the supporter of the Danish Mission to Tranquebar on the Coromandel coast; moreover, it was due to the shortage of Englishmen with the necessary linguistic qualifications that the Society had to look to a German University, namely Halle, for its agents, with the result that Salomon Negri and other foreign scholars were enlisted in the work.

John Postlethwayt, high master of St. Paul's School, seems to have been almost unique as a schoolmaster in encouraging the study of Arabic in addition to the usual classical tongues; indeed, there is plenty of evidence that of the hundreds of men who passed through the universities, having satisfied the traditional requirements in classics, there were but few who had a fluent knowledge even of Latin. As a single instance, we have seen that after Postlethwayt's death, the honour of delivering a Latin oration congratulating Ziegenbalg was entrusted to William Nichols, a Cheshire rector.

The foregoing brief account of the S.P.C.K.'s experiences in assisting the Danish mission by supplying Portuguese versions of the New Testament which proved defective, then in 1711 in supplying a printing press, some Pica roman type, and later a fount of Portuguese letters and other materials, together with the services of a printer (who died on the journey out), as well as in 1714 sending a set of Malabar types which had been made in Germany and were so large as to prove wasteful of paper; all these experiences must have caused the Society to consider seriously the revision of a policy which used up limited resources and disheartened

189

the missionaries abroad. It led to Salomon Negri leaving Halle and coming to England again to supervise the Society's new scheme of printing the Psalter and New Testament in Arabic. These considerations, however, were not the only ones influencing the policy of the Society, for radical changes had taken place in the traditions, status and practice in the allied trades of printing and book-selling.

Salomon Negri, on whose representation the S.P.C.K. undertook the printing of an Arabic Psalter and New Testament, was born at Damascus in Syria and baptised into the Greek church. Brought up among the Jesuits, he learnt something of Greek, Latin and Italian literature, and while only in his eighteenth year made a journey to Jerusalem. He seems to have suffered poor health throughout life. Leaving the Jesuits he studied philosophy and theology for four years at the Paris Academy and the Sorbonne, at the same time acting as librarian to the Abbot of Caumartin. He then began to teach Arabic privately, continuing his own studies meanwhile.

With the coming of the peace of Ryswick in 1697, he declined an offer by the Abbot of Louvois, the king's librarian, and came to England. For some time he taught Arabic and French at St. Paul's School under John Postlethwayt, where oriental studies were then much in favour. Meanwhile Henry William Ludolf (1655–1710), secretary to Prince George of Denmark (1653–1708), recommended him to the prince with a view to his going to the new university at Halle, in Saxony, opened in 1694. Here under the patronage of King Christian V, he translated Arabic for the best part of a year, but his health continuing poor, he felt compelled to travel to Italy, and thence to Venice, where a professor of the University of Padua gave him assistance and he remained three years perfecting his knowledge of Persian and Turkish. Disappointed about a promised appointment he decided to return to Germany, although Robert Sutton, Lord Lexington (1661–1723), who had been gentleman of the horse to Princess Anne, and became lord of the bedchamber to William III, afterwards acting as an envoy at Vienna and Madrid, tried to dissuade him, wishing to keep him in his own service. It was probably at this time that he visited England a second time and again engaged in teaching Arabic under John Postlethwayt at St. Paul's School. However,

he was deflected from his intention to return to Germany, at any rate for a time, and remained at Rome as professor of Syriac in the College Della Sapienzo and lecturer in Arabic in the College of Propagation of the Faith, as well as undertaking the duties of a librarian in the Vatican library. Despite promises of a handsome salary, he toiled on in Rome for four years, receiving less than half the emoluments he had been promised. Despite his early training under the Jesuits he had not adhered to Romish beliefs, but his experience under the papal authorities whilst he was in Rome completed his conversion to the Reformed Church. In these circumstances a friend, probably Lord Lexington again, communicated with Anthony William Boehm (1673–1722), German chaplain to Prince George of Denmark at St. James's, and later to George I, who had been one of the first students at Halle, with a view to Salomon Negri going to Halle a second time. He hoped to be able to accustom himself to the climate and thus settle down for the remainder of his life. In the course of his travels he had collected in England, Holland, and elsewhere as many books useful for teaching oriental languages as his circumstances had permitted, and these he took with him to the University of Halle. He failed, however, to adapt himself to the climate, which ultimately had such an adverse effect on his health that after sixteen months he decided to accept an invitation to come to England a third time, disposing of some of his works in Arabic to clear his expenses. Here, besides engaging again in teaching, he superintended the Arabic versions published by the S.P.C.K.

His correspondence, with that of several other oriental scholars was printed in 1721, and again in 1725, with the title, *An Extract of several Letters relating to the great charity and usefulness of printing the Nev Testament, and Psalter, in the Arabic language, etc.* His life, written by himself, was published in 1764, by G. A. Freylinghausen.[50]

The result of the application and correspondence of Salomon Negri was a resolution by the S.P.C.K. to print an edition of the Arabic Psalter and New Testament, for which proposals were accordingly issued, and towards which the benefactors were so liberal, the king himself (George I) contributing £500, that notwithstanding the expense which was calculated at £2,976–1–6½,

the Psalter was printed in 1725, in octavo, from a copy sent from Aleppo, as approved by the patriarch of Antioch, comprising an edition of 6,250 copies; the New Testament, from a copy sent by Mr Sherman from Aleppo and printed in 1727, in quarto, comprehending 10,000 copies; and 5000 Catechetical Instructions with an Abridgment of the History of the Bible annexed; the greater part of which were sent into the East, and distributed in the Holy Land, Persia, and other countries.[51] In preparing the New Testament and Psalter for the press, Salomon Negri had the assistance of a Mr Xeres, a Jewish convert, and a Mr Dadichi, of whom, unfortunately, nothing further seems to be known.

[1] Enc. Brit.
[2] D.N.B. art. Robert Boyle.
[3] D.N.B. art. George Stubbs.
[4] D.N.B. art. Sir William Hedges.
[5] D.N.B. art. Henry Maundrell.
[6] Not in D.N.B.
[7] D.N.B. art. William Hallifax.
[8] XIX, 83–110. Copy in the writer's collection.
[9] Nash, Vol. II, pp. 212, 214, 339.
[10] P.C.C. 28 Marlborough.
[11] D.N.B. art. Thomas Shaw.
[12] Illustrated Catalogue of a Loan Collection of Portraits, Oxford, 1906.
[13] D.N.B. art. Alexander Drummond.
[14] Penes the writer.
[15] The D.N.B. omits reference to these plates in its biography of Müller.
[16] D.N.B. art. Jared Leigh.
[17] D.N.B. art. Theodosius Forrest.
[18] Courtesy of R.S.A.—John Knapp was probably a relative by marriage of John Cookes, linen draper, of Leyton, and St. Peter's, Cornhill, See Chapter 13.
[19] See Chapter 4.
[20] D.N.B. art. Richard Pococke.
[21] D.N.B. art. William Bedwell.
[22] D.N.B. art. Edward Pococke.
[23] The Theological Works of Dr. Pococke, 1740, i. 44.
[24] The first title-page of the 'specimen' bears the imprint 'Oxoniae excudebat H. Hall impensis Humph. Robinson in Cemeterio Paulino, ad insignetrium Columbarum, 1650;' but the 'Notae' appended to it have a distinct title, 'Oxoniae excudebat

Hen. Hall, 1648,' which is doubtless the date at which the whole work was first set up.

25 Twells, ib. The title-page of the 'Porta Mosis' has the imprint of H. Hall Acadamiae Typographus, 1655, but the title-page of the Appendix is dated 1654.

26 'de ratione Variantium in Pent. Arab. lectionum.'

27 See D.N.B. for a testimony to his great learning by John Locke (1632–1704).

28 Clarke, Life and Times of Wood, iii. 373.

29 Hearne, ed. Doble, ii. 63.

30 Leonard Twells, rector of St. Matthew's, Friday Street, and St. Peter's, Cheap, London, used materials entrusted to him by Rev. John Pococke, grandson of the professor, for his biography, 1740.

31 D.N.B. art. John Postlethwayt.

32 Remarks and collections of Thomas Hearne, ed. Doble, i. 245.

33 Chalmers, Gen. Biogr. Dict. edit. 1815, XXIII, 294.

34 Ded. to Human Reason, London, 1708, with quaint woodcuts; but the British Museum copy has a later substituted title-page of a different publisher, dated 1711.

35 D.N.B. art. Simon Ockley.

36 Pub. by Heathcote, in Chalmers, Gen. Biogr. Dict. ed. 1815, XXIII, 296–8.

37 Enc. Brit.

38 D.N.B. art. Anthony William Boehm.

39 Propagation of the Gospel in the East, etc. Third Edition; Printed and sold by Joseph Downing, 1718. (Penes the writer).

40 D.N.B. art. Anthony Horneck.

41 Allen and McClure, Two Hundred Years, 1898.

42 Propagation of the Gospel in the East.

43 Allen and McClure, Two Hundred Years.

44 Propagation of the Gospel in the East.

45 Ibid.

46 Lewis was the brother of Erasmus Lewis (1670–1754), the friend of Swift and Pope, who was a sort of steward to Robert Harley, and married Anne Bateman, neé Jennings, widow of Thomas Bateman.

47 Propagation of the Gospel in the East.

48 D.N.B. art. William Nicols.

49 Allen and McClure, Two Hundred Years.

50 'Memoria Nigriniana, hoc est Salomonis Negri Damasceni vita, olim ab ipsomet conscripta, nunc autem accessionibus quibusdam illustrata, etc.' Halae Salicae-1764. (The biography of Negri has been translated and abbreviated from Freyling, hausen's account, from the copy at the London Library, St. James's Square, London).

51 From a letter pasted in the above-named book.

Chapter Ten

THE FOUNDERS OF THE S.P.C.K.
DR. THOMAS BRAY AND HIS LINKS
WITH HALESOWEN

IF WE REFER to *A Dissertation upon English Typographical Founders and Founderies*, by Edward Rowe Mores, 1778, the author says of Caslon 'He was originally a gun-lock-graver, and was taken from that instrument to an employment of a very different tendency, the propagation of the Christian faith. In the year 1720 the Society for promoting Christian knowledge, in consequence of a representation made by Mr. Salomon Negri, a native of Damascus in Syria, well skilled in the Oriental languages, who had been professor of Arabic in places of note for a great part of his life deemed it expedient to print, for the use of the Eastern Churches, the New Testament and Psalter in the Arabic language, for the benefit of the poor Christians in Palestine, Syria, Mesopotamia, and Egypt; the constitution of which countries allowed of no printing; and Mr. Caslon was pitched upon to cut the fount which in his specimens is distinguished by the name of English Arabic.'

Some account must now be given, therefore, of the leading figures in the early years of the S.P.C.K., and especially of that devoted servant of the movement, Dr. Thomas Bray, who was the parish priest of St. Botolph's Church, Aldgate, during the time William Caslon lived and worked in Vine Street, in the parish of Aldgate.

The wars which had desolated Europe throughout the seven-

teenth century had come to an end. The Thirty Years' War, one of the legacies of strife left by the Reformation, had been virtually a struggle for liberty of conscience, and the 'Peace of Westphalia' in 1648, in which it terminated, had settled the principle that men ought not to be persecuted for their religious faith. The later conflict which was ended by the 'Peace of Ryswick' in 1697 had a similar issue, resulting as it did in the recognition by Louis XIV of William III as the lawful king of England.

It was while the strains of rejoicing on account of this peace were resounding, on the 2nd December, 1697, in the choir of Wren's new cathedral church of St. Paul (the whole edifice was not completed until 1710), that 'the zeal of severall persons of the best Character in and about ye Cities of London and Westminster' was working towards a new religious organisation, which in the lull of warfare at the end of the century took shape as the Society for Promoting Christian Knowledge.[1]

William III had said, in his opening speech to Parliament, that he esteemed one of the greatest advantages of the Peace [of Ryswick] would be that it would leave him leisure to reform the internal administration and 'effectually to discourage profaneness and immorality.'[2] The zeal of the founders of the S.P.C.K. was thus stimulated to action, and the next year witnessed the inauguration of the Society.

The first meeting was held on 8 March, 1698–9, presumably 'at ye House of John Hook, Esqr., Serg[t] at Law,'[3] and there were present on the occasion the Right Honble the Lord Guildford, Sr Humphrey Mackworth, Mr Justice Hook, Dr. Bray, Col. Colchester. Dr. Bray was the only clergyman among the five.

Francis, Lord Guildford (1673–1729) was the son of the celebrated Sir Francis North (1637–1685), the lord chancellor, afterwards first Baron Guildford. The lord chancellor's sister Ann North had married Robert Foley (1651–1702), the Stourbridge ironmaster, so that she was Lord Guildford's aunt. Francis was educated at Trinity College, Oxford, taking his M.A. degree in 1690. He was lord lieutenant of Essex from 1703 to 1705 and president of the Board of Trade in 1714. His father was a man of vast knowledge and wide culture, an accomplished musician, a friend and patron of artists and especially of Sir Peter Lely, whom

he befriended in many ways, as well as showing an interest in the progress of natural science. If Guildford lacked his father's brilliance, it is evident that he displayed some of his interest in his fellow-men. He was rarely absent from the early meetings of the Society, and continued to attend them from time to time for several years.

John Hooke (1655–1712), serjeant-at-law, born at Drogheda, in Ireland, and educated at Trinity College, Dublin, became a student of Gray's Inn in 1674 and was called to the bar in 1681, rising to the degree of serjeant-at-law in 1700. In 1703 he was appointed chief justice of Carnarvon, Merioneth, and Anglesey, being re-appointed in 1706. It was at his house that the S.P.C.K. usually held its meetings from its origin until 1703, when 'the Serjeant removing from his House, Mr. Stubbs offers ye Society for ye present a Room in his House in Sion College,' which offer was accepted and 'thanks given to Serjt. Hooke for letting ye Society meet in his House to this day.'[4]

Colonel Maynard Colchester (1665–1715) was born at Westbury Court, Gloucestershire, succeeding his father, Sir Duncomb Colchester in 1694. In that year he became Colonel of 'the Red Regiment of Militia ffoot, raised for their Ma'ties service within the fforest Division'[5] of Gloucestershire by Charles Lord Berkeley. He was M.P. for Gloucestershire from 1701 to 1708. He was also Verderer of the Forest of Dean. He was a friend of John Evelyn, under whose advice the gardens of Westbury Court were set out in the Dutch style. From 1710 he resided at the 'Wilderness' House which he had built on his Mitcheldean Estate.

Prior to the foundation of the S.P.C.K. Colonel Colchester had established several charity schools, and a record of 1697 survives giving the names of sixty-seven country Jocks and Joans, engaged upon writing, Primer, Testament, Bible, and Hornbook; nearly all of them were receiving bread; eight received cloth, nine had books, viz., the *Catechism* and the *Whole Duty of Man*, and two had been bound apprentices.

Sir Humphrey Mackworth (1657–1727), a politician and capitalist, was the second son of Thomas Mackworth of Betton Strange, Shrewsbury, by Anne, daughter of Richard Bulkeley of Buntingsdale in the same county.[6] He was related through his

mother to Edmund Waller, the poet, while the poet Praed was among his descendants. He matriculated at Magdalen College, Oxford, in 1674, entered the Middle Temple in 1675, was called to the bar in 1682, and was knighted the same year. At this time Mackworth had a residence at Bentley, in the parish of Tardebigge, Worcestershire, and it seems probable that in addition to plying his legal work in London, he was also acting as a sort of factotum to Thomas Lord Windsor. His means, however, were inconsiderable until he married in 1686 Mary, daughter of Sir Herbert Evans of the Gnoll, Glamorganshire, who by the death of her four sisters became the sole heiress of her father's property. In 1695 he was engaged in the development of collieries and copper-smelting works at Neath and spent £15,000 in acquiring control of Sir Carbery Pryse's mines. The mines and smelting works were transferred to a company called 'The Corporation of the Governor and Company of the Mine Adventurers of England,' the Duke of Leeds being governor and himself deputy-governor. The company was already in difficulties when the S.P.C.K. was founded, and in 1710 the House of Commons, without a dissentient voice, voted Mackworth guilty of many frauds in violation of the company's charter. Mackworth was evidently but one of many who engaged in questionable financial enterprises at a period when shareholders were insufficiently protected from the consequences of rash speculation. Mackworth also engaged in the pamphlet warfare characteristic of his time, issuing political, financial and religious tracts, one of which provoked a reply entitled *Peace without Union* from the redoubtable Defoe. Through his connection with South Wales, Mackworth was appointed constable of Neath Castle in 1703, and sat in parliament for Cardiganshire for a time and later for the borough of Totnes in Devonshire. Mackworth was a church tory and for the first few years was one of the largest subscribers and one of the most active members of the S.P.C.K. The S.P.C.K. profited from Sir Humphrey Mackworth's company to the extent of having one share given to it by the Rev. Benjamin Ibbott, M.A., rector of St. Vedast, Foster Lane, at whose house the S.P.C.K. used to meet occasionally in 1703 ; luckily, the Society sold it before the difficulties came.[7]

Mackworth has been dealt with at this length because his

business connections with the Pryses of Gogerddan and Newtown bring him closer to Dr. Thomas Bray, the principal founder of the S.P.C.K.

Thomas Bray (1658–1730), was born at Marton three miles from Chirbury, in Shropshire, His baptism is thus recorded in the Chirbury register :

'Thomas Bray filius Riccardi et Mariae, bapt. 2 May 1658'[8].

The vicar of Chirbury at this time was one Edward Lewis, possibly the son of that Edward Lewis who graduated B.A. at Oriel College, Oxford, as early as 1597, proceeding M.A. in 1605. At any rate, Lewis, who was also schoolmaster in the parish, possessed a remarkable library of chained books, and it seems right to conclude that on noting Bray's studious disposition, he opened to him the treasures of this library, thus confirming in the lad that love for books which became the passion of his life. In 1677 Lewis bequeathed his library and the schoolhouse to the parish, and after having been long forgotten the books were discovered in 1889 in the roof of the old schoolhouse, were brought to the vicarage and there safely re-housed, with their chains still on them.[9]

In due course Bray was sent to Oswestry Grammar School, and in March, 1674–5, when he was 17 years of age, he matriculated at All Souls' College as a 'puer pauper.' All Souls' is unique among the Colleges, consisting wholly of Fellows, together with '3 clerks and 6 choristers' (in the fifteenth century) who became '4 Bible clerks' by the nineteenth century. The means whereby Bray found his way to All Souls will appear shortly, but the buttery books record his 'battling' in College in 1675–6.[10]

Bray graduated B.A. in 1678, and as he could not hope for a fellowship he left Oxford. The award of an M.A. at Hart Hall did not follow until 1693, when he was rector of Sheldon, and it was not until 1696 that under pressure from Colonel Francis Nicholson, in order to enhance his prestige as Commissary of Maryland, he proceeded to the degree of B.D. and D.D., this time from Magdalen College, a change probably due to the influence of Lord Digby, who had graduated there in 1681.

Existing accounts of Bray say that having received holy orders he served for a short time a curacy near Bridgnorth, and then became chaplain in the family of Sir Thomas Price of Park

Hall in Warwickshire. These slender facts concerning Bray's early career deserve some amplification. Thomas Bray was at Oswestry School almost entirely in the mastership of William Griffiths who served from 1661 to 1672. The Shropshire Hearth Tax list for 1672 shows that William Griffiths, cleric, paid for one hearth at 'Ryton' (Ruyton-of-the-Eleven-Towns) in Oswestry Hundred, so Bray could scarcely have served Griffiths as curate. Griffiths was followed by Thomas Clopton in 1672, a pluralist who was rector of Kilken (Cilcain), Co. Flint, 1673, and of Llanrwst, Co. Denbigh, 1667, etc. Clopton was succeeded in 1678 by John Evans, who was rector of Newtown, co. Montgomery, from 1666, canon in 1681, and rector of Berriew, also co. Montgomery in 1686,[11] so it seems certain that Bray kept in touch with his old school, for John Evans, as rector of Newtown, was obviously well acquainted with the family of Pryse, Prise or Price, of Newtown Hall, the same as that to which Sir Carbery Pryse belonged, whose mineral holdings were later acquired by Sir Humphrey Mackworth, and with which the family of Bray's patron, Sir Thomas Price of Park Hall, in 1679 became connected by marriage.

Although Bray's graduation in 1678 opened the way to ordination, he did not reach the canonical age of 23 until 1681, and it is probable that he spent the intervening years in teaching, most likely as usher in one of John Evans's parishes. He was ordained deacon in 1681, this qualifying him to serve as a curate, and the next year he became a priest.

As a deacon, we are told, he first served in a parish near Bridgnorth, and the Shropshire Hearth Tax roll again comes to our aid. One Thomas Bray was the most substantial man in Marton, being taxed on five hearths, a greater number than anyone else, and as such would be well-known at county level. There is no Richard Bray in the list, so Bray's father had probably died while Bray was still a boy at school.

However, another Thomas Bray having three hearths is listed at Hatton, in the Franchise of Wenlock, only two miles from Hope Bowdler and fifteen miles from Bridgnorth. Only four names occur in this tiny hamlet, but they include Mr Urian Baldwyn (6 hearths), of the well known Shropshire family of that name, and Mr John Hammond (3 hearths),

whose son became rector of Gawsworth, in Cheshire.

The rector of Hope Bowdler was Thomas Brompton, who had graduated B.A. from All Souls' College in 1636, proceeding M.A. in 1639. Foster's list of Oxford graduates also includes the rector's son: Edward Brompton, son of Thomas, of Langley, Salop, cler. All Souls' Coll. matric. March, 1675, aged 18 ; B.A. 1678.

Here we have the interesting revelation that Thomas Bray was at All Souls' with Edward Brompton and graduated at the same time. Indeed, it seems highly probable that Bray acted as Crompton's servitor, that they left College together, and that when Bray had taken deacon's orders he became Thomas Brompton's curate for a time. If the rector, described in his son's university record as of Langley, Salop, was also acting as chaplain to Sir Edward Smith in addition to performing his rectorial duties, he was probably needing help by 1681, when he would be well over sixty. Having noted the explanation for Thomas Bray's admission to All Souls', we can go further. No 'widow Bray' is included in the Hearth Tax returns, and it seems likely that after Richard Bray's death, young Bray's widowed mother found refuge with the lad's uncle, Thomas Bray of Hatton, who was probably also his godfather, after whom Bray was named. During the time he was a curate, therefore, he lived at home with his mother and uncle, and not at the old home in Marton. It would thus be a simple matter to walk the two miles to Hope Bowdler to carry out his parochial duties.

After ordination as priest in 1682, no doubt Bray would be looking for further patronage. Sir Thomas Price of Park Hall, Warwickshire, was the elder son of Sir Herbert Price (appointed Master of the Royal Household in 1675) by his wife Goditha, one of the four sisters and co-heiresses of Robert Arden of Park Hall. Elizabeth Arden married William Pooley of Boxted, Co. Suffolk, Dorothy married Hervey Bagot, second son of the Blythfield family, and Ann married Charles Adderley of Lea Marston.[12]

Sir Herbert Price's second son was named Basil and the link between Bray's patron, Sir Thomas Price, and the family of Pryse of Newtown Hall and Gogerddan is seen in the following marriage recorded in Chester's London Marriage Licences :

> 1678–9 — Basil Price (subs. Prise), of St. Martin-in-the-
> Fields, bachelor, 31, and 'The Lady Pryce,' of Newton
> (i.e. Newtown), co. Montgomery, widow — at St. Bride,
> London, 10 March, 1678–9. B.

It is pretty certain, therefore, that Bray was brought to the notice of the Pryses of Newtown by John Evans, master of Oswestry School and rector of Newtown. Then, at his wife's request, Sir Basil Price recommended him to his mother Goditha Arden, and his chaplaincy in the Price family and the curacy of Lea Marston, in the gift of Charles Adderley, followed. Although Goditha Arden was but one of four co-heiresses, it is strange that the Prices seem to have acquired the whole of Park Hall. When Sir Herbert Price died, Goditha continued living there with her son Sir Thomas, and the fact that Bray named one of his daughters Goditha confirms that she was one of the family when he became chaplain.

Bray's diligence at Lea Marston brought him to the notice of John Kettlewell, vicar of Coleshill, and also to Kettelwell's patron, Simon, Lord Digby, and Sir Charles Holt. In 1685, the year of his death, Simon Lord Digby purchased the tithes and glebe of Over Whitacre for the purpose of augmenting the vicarage, which was then valued at only £10, thus increasing it to £400 ; in 1715 the living was again augmented to £600 by the provision of £200 from Queen Anne's bounty.[13]

On the death of Simon Lord Digby, his brother William, the fifth lord, presented Bray to the vicarage. The Over-Whitacre registers seem to show that Bray took charge of the parish about Easter, 1686, and it was probably the security he now enjoyed that enabled him to marry, though no record of the time or place has yet been discovered. Perhaps the answer to this question is also to be found in Shropshire. The registers record the following baptisms :[14]

> 1687 — William the son of Tho: Bray Minister and
> Elenor his wife was born Oct. the 25th and baptized
> November the 15th.

> 1688–9 — Godith the daughter of Tho: Bray and Elenor his
> wife was born Jan. the 2 about 7 o'clock in the morn-
> ing and baptized Jan. the 13.

But only two months later, on 9 March, 1688–9, the register records the burial of Bray's wife.

Perhaps Bray's domestic anxieties deflected his mind temporarily from the tremendous events of the revolution of 1688, but it was the refusal of Digby Bull, Bray's neighbour at Sheldon, to take the oaths of allegiance to William and Mary, and his subsequent resignation, that enabled Lord Digby to offer Bray the vacant living. It is evident that Bray did not hold the scruples of the nonjurors and so in 1690 we find him removed into the rectory of Sheldon, a living he held for nearly forty years, though for the greater part of the time he was occupied elsewhere. At Sheldon, Bray composed the first volume of his *Catechetical Lectures*, dedicated to Lloyd, bishop of Lichfield and Coventry, a work which at once became popular and made Bray's name well-known in London.

In 1695 the governor and assembly of Maryland, having divided the province into parishes, requested the bishop of London, Henry Compton, to send over a clergyman to act as his commissary and the bishop selected Bray for the post. He was unable to set out immediately due to an obstacle in the constitution of the church of Maryland which could be rectified only by act of parliament and Bray occupied the interim in recruiting missionaries. He found that he could only enlist poor men who were unable to afford books and this seems to have prompted his scheme for the provision of parochial libraries at home as well as abroad. It was while he was thus engaged that he contracted his second marriage and in March of the following year, as already stated, the inaugural meeting of the S.P.C.K. was held.[15]

Although H. P. Thompson records Bray's second marriage, he seems to have missed its significance, for he suggests that the ceremony took place in the chapel of Lincoln's Inn through some connection with the bride's family. The entry in the register reads :

> Thursday, 3rd November, 1698. Were married by Dr. Maynard, Thomas Bray of the Parish of St. Martin-in-the-Fields, Doctor of Divinity, Agnes Sayers of the Parish of St. James' Clerkenwell, of the County of Middlesex.

The officiating clergyman at his marriage was Edward

Maynard, son of William Maynard of Daventry, co. Northampton, and was at Oxford for a short period at the same time as Bray, graduating B.A. at Magdalen in 1674, M.A. in 1677, and proceeding B.D. in 1688 and D.D. in 1691. He was fellow of Magdalen from 1678 to 1694 and bursar 1687–8. However, in August, 1688 he was expelled from his fellowship for non-residence, having been for some time chaplain to Lord Digby, who had also graduated at Magdalen in 1681. Maynard was restored to his fellowship in October of the same year. For about eight years, 1692 to 1700, he was preacher at Lincoln's Inn, so it is easy to see that Bray chose to be married in Lincoln's Inn Chapel by William Lord Digby's chaplain, with whom he must have been on intimate terms at Coleshill. In 1700 Maynard was installed precentor of Lichfield and for forty years was canon and precentor of that cathedral; from 1701–6 he was rector of Passenham and from 1696 till death rector of Boddington, both in co. Northampton. He died in 1740, aged 86. Maynard edited and published in 1716, fol., the second edition of Dugdale's *History of St. Paul's Cathedral*, and two volumes of sermons. He bequeathed to Magdalen College, his library and £500, as well as a silver flagon presented to him at Lincoln's Inn, and made charitable bequests to the S.P.G., to Daventry and to Boddington.[16]

Edward Maynard may have been related to Colonel Maynard Colchester, one of the co-founders of the S.P.C.K., whose mother was Elizabeth, the eldest daughter of Sir John Maynard (1602–1690), the judge.

Bray set sail for Maryland in December, 1699, arriving there in the following March, and setting to work at once in the settlement of the parochial clergy, was ably supported by the governor Nicholson. But it was widely felt that Bray would do better service to the church in Maryland by returning home and endeavouring to get the law, which had been twice rejected there, re-enacted with the royal assent. Bray therefore returned to England and at length the bill was approved.

Bray had borne all the cost of his voyage and outfit; it was rightly thought unfair to allow him to impoverish himself for the public good, so Viscount Weymouth presented him with £300, and two other friends with £50 each, but Bray characteristically

devoted it all to public purposes. By this time the work of the S.P.C.K. had so largely increased that it was deemed expedient in 1701 to separate the work for the foreign plantations, and thus was brought into being the Society for the Propagation of the Gospel in Foreign Parts, under a charter granted by William III.[17]

Some time in the winter of 1703–4 Bray returned with his family to Sheldon. He had been absent for eight years, and if he had paid any visits to it during that time, they must have been brief. Possibly a neighbour, such as Henry Carver of Church Bickenhill or Lord Digby's chaplain, officiated whenever one was available, but in 1698 Thomas Morrall arrived as curate.[17] Like Bray, he had been a 'puer pauper' at All Souls', and also like Bray, he was a native of Shropshire and, as the Hearth Tax Returns indicate, probably the son of Thomas Morrall of Barrowe Street, Wenlock. On Bray's return in 1704, Morrall went to Over Whitacre. As might be expected, soon after Bray's return, he interested himself in the foundation of a school. The deeds for its endowment were drawn up in July, 1704, and the school, with which later we shall be more closely concerned, was built on to the north aisle of the church. Bray's family, at this time, consisted of his wife Agnes, the two children of his first marriage, William and Goditha, and a daughter by his second marriage, Agnes, born in London. At Sheldon, two boys were born, the entries in the register, in Bray's own writing, being asfollows :

> 1705 — July 4. Baptized was Francis the son of Thomas and Agnes Bray.
>
> 1706–7 — Jan. 21. Baptized waas John the son of Thomas and Agnes Bray.
>
> But neither child lived for a year ; for again Bray's writing records :—
>
> 1705–6 — Feb. 16. Buried was Francis son of Thomas and Agnes Bray.
>
> 1706–7 — Feb. 4. Buried was John son of Dr. Bray and Agnes his wife.

Nor was this all, for close above the words 'John son of' an insertion is entered 'Mary his daughter,' so it seems to follow that besides Agnes, a second girl, Mary, had been born in London. Dugdale's *Warwickshire* records inscriptions to Francis and John

on a flat stone in the chancel of Sheldon Church, which disappeared in the restoration of 1867. With these sorrows in his home life, perhaps it was with relief that Bray returned to London.

He returned to Sheldon again, perhaps for reasons of health, between 1716 and 1720. His name appeared again in the registers ; he signed the parish accounts ; he appointed the schoolmaster ; he asserted himself to prevent waste of parish money by its officers when travelling on parish business to Coleshill, Birmingham, or elsewhere. But the appointment of a schoolmaster is the matter of primary interest here. In May, 1717, the registers record a meeting for this purpose, led by Lord Digby and Bray, at which one Samuel Butler was appointed on trial for six months, and was directed to write up the 'Preambulation'—that is, the orders for 'beating the bounds' or perambulating the parish.

The new schoolmaster was a native of Halesowen, baptized in April, 1678, as the son of Samuel and Alice Butler 'of the town.'[18] He was not a graduate, this fact probably accounting for his being appointed on trial, but he had two younger brothers, who both became graduates, recorded by Foster[19] as follows :

> John Butler, son of Samuel, of Halesowen, Salop, pleb. Pembroke Coll. matric. Feb. 1701–2, aged 18 ; B.A. from St. Alban Hall 1707, M.A. 1709, vicar of Pattingham, co. Stafford, 1709–18.

> Joseph Butler, son of Samuel, of Halesowen, Salop, pleb. Pembroke Coll. matric. Feb. 1701–2, aged 19 ; B.A. 1705, vicar of Pattingham, co. Stafford, 1718–55.

The Sheldon schoolmaster's father was a church-warden at Halesowen 1700–1701, his co-warden being Josiah Packwood,[20] whose grandfather Josiah had been vicar of Hampton-in-Arden until the Civil War, when he was ejected.[21] At the Restoration the vicar reappeared at Stone, near Kidderminster, where there are a number of baptismal entries of the name.[22] One Samuel Packwood was the schoolmaster at Hampton-in-Arden in the early years of the eighteenth century, his burial being recorded as follows :[23]

> 1719–20 — Feb. 24. Mr. Samuel Packwood 'Skoolmaster' buried.
> Affidavit Mr. Henry Karver.

There were other links between this part of Warwickshire and Halesowen, some of which can be traced in the Halesowen parish register, showing that the laws of settlement did not prevent the migration of people of means or influence. As early as 1655 Humfrey the son of Widdow Lowe (widow of Mr Humfrey Lowe of Cakemore) and Joyce, daughter of John Lea yeoman (of the Leas of Halesowen Grange) were married. Besides other children of this marriage, a son Paul was baptized in 1665, who later graduated at Emmanuel College, Cambridge,[24] and became curate of Packwood and schoolmaster at Balsall,[25] both Warwickshire, and in 1734 Paul's son, another Paul, was appointed master of Sutton Coldfield Grammar School.[26]

In 1685 the Halesowen register records the baptism of William son of Thomas Lowe 'de Hampton' and his wife Bridget, but by 1688 when their son John was baptized Thomas and Bridget are described as of Four Dwellings, a hamlet in Halesowen. This Thomas was a brother of the first Paul Lowe mentioned above.

As we have seen Philip Orton of Bickenhill had three children at John Underhill's school at Romsley in 1717; he was probably son of that Philip Orton who was vicar of Church Bickenhill before 1695. The Tristrams, Penns and Shenstones were connected by marriage and later William Shenstone the poet was involved in disputes about family property at Hampton-in-Arden. Two Thomas Tristrams, father and son, held church livings in Warwickshire, the elder at Allesley and the younger at Hampton-in-Arden, a connection which will be mentioned again later.

There are numerous entries of the name Butler in the Halesowen register. The identity of the Sheldon schoolmaster's mother Alice is not revealed in the register—the marriage possibly took place during the neglectful vicariate of the Rev. John Westwood. But in addition to Samuel and Alice Butler, there were Samuel and Margery, Samuel and Elizabeth, John and Elizabeth, Samuel and Jane, Samuel and Mary, John and Mary, all producing families between 1662 and 1700. The popularity of the name Samuel in the Butler family is a reminder that Samuel Butler (1612–1680), the author of *Hudibras*, was a Worcestershire man, and was educated at the King's School, Worcester, but it would be difficult to establish a connection.

Samuel, son of John and Elizabeth Butler of Cradley, who was baptized in 1679, was admitted at 9 years of age to Thomas Foley's Hospital at Oldswinford and in 1695 was bound apprentice to Ambrose Crowley at his premises in Thames Street, London,[27] but, unfortunately, we know nothing of the education of Samuel Butler, the Sheldon schoolmaster.

Although Thomas Bray had spent most of his time outside his parish of Sheldon, he was doubtless kept informed of what was happening there and renewed acquaintance with Warwickshire people and places during his visits to Sheldon and in the longer periods when he resumed his parochial duties. In view of the numerous links between Halesowen and Warwickshire parishes, it is probable that Bray was aware of some of the family relationships if as yet he had no direct knowledge of Halesowen itself. Before long, however, he was to become more closely connected with it. When Bray went to Aldgate in 1706, Thomas Morrall resumed his oversight of Sheldon, while Bray was engaged in what doubtless he regarded as his life's work in London. Morrall remained until Easter, 1721, when his signature appears for the last time.

His successor as curate-in-charge was Jonathan Carpenter, of Halesowen. H. P. Thompson says that Carpenter was licensed on 22 February, 1721, by Bishop John Robinson to the curacy of St. Botolph, Aldgate, adding in a footnote, however, that in the copy of the licence at Sheldon his name appears as John, not Jonathan. The university records of the Carpenters of Halesowen, together with parish register entries, have been used in compiling a family pedigree.[28]

> John Carpenter, son of J., of Halesowen, Salop, pleb. Pembroke Coll. matric. March 1675–6, aged 15 ; B.A. Feb. 1679–80 ; rector of Whitchurch, co. Warwick, 1684–88, vicar of Broxted, alias Chawreth, Essex, 1690, and rector of Checkney, Essex, 1693 until 1739.

> John Carpenter, son of Jon. (i.e. Jonathan), of Halesowen, Salop, pleb. Merton Coll. matric. Feb. 1713–14, aged 16 ; B.A. Feb. 1718–19, M.A. 1720 ; one of these names vicar of Pagham, Sussex, 1729. and rector of Bignor 1743, brother of the next-named.

Jonathan Carpenter, son of Jon. of Halesowen, Salop, gent. Pembroke Coll. matric. Feb. 1709–10, aged 16 ; B.A. Mar. 1713–14 ; incorp. at Cambridge 1717, M.A. from King's Coll. 1717 ; vicar of Brailes, co. Warwick, 1723, and rector of Sheldon, 1729, brother of the last-named.

The first John Carpenter listed above was the son of that John Carpenter, cordwainer, to whom William Caslon's grandfather had been apprenticed in the mid-seventeenth century. As previously noted, Caslon's great-grandmother, the wife of Edward Castledowne of Beoley, was Alice Carpenter and it seems reasonable to conclude that she was a close relative of the Halesowen cordwainer John Carpenter, who was a feoffee of the Free School from 1665 until his death in 1688. On the death of his father, John Carpenter the younger relinquished the living of Whitchurch, co. Warwick, although he was not presented to Broxted until 1690, but it can scarcely be supposed that he gave up the Whitchurch living to clear up his father's affairs and look after his mother, for his brother Jonathan and his sister Elizabeth Lea were still living in Halesowen.

The question of how priests secured livings in the seventeenth and eighteenth centuries is somewhat obscure and it might be wondered how the earlier John Carpenter came to be presented to two such distant livings as Broxted and Checkney in Essex. He was inducted on 20 May, 1690, on the presentation of William Warner, gent., and Maria Audley,[29] in succession to John Hanson, M.A. A John Hanson is recorded[30] as the son of Richard Hanson of Himley, co. Stafford, sacerd ; he was of Pembroke College, and matriculated in 1630, becoming rector of Himley in 1634 and was buried there in 1668. John Hanson, his son, was of St. John's College, Cambridge, B.A. 1660, M.A. 1664, becoming vicar of Broxted in 1663.[31] Himley being a seat of the Lords Dudley and Ward, it is obvious that this powerful influence brought about Hanson's presentation to the living. Apart from relations of the Dudleys being in Halesowen, both John and Zachariah Downing of Halesowen furnace, who looked after Lord Dudley and Ward's mineral interests in Halesowen and elsewhere in the West Midlands, were added to the feoffees of Halesowen Free School in 1685. It is quite possible that Carpenter knew the Hansons in his own district, and on relinquishing Whitchurch in

1688, he may have acted as Hanson's curate for the two years before his presentation to the living in 1690. The records of Carpenter's two nephews suggest that this procedure was not uncommon.

John Carpenter the younger was succeeded at Broxted in 1739 by Jeremy Parkins. The parish registers of Broxted record an amusing though somewhat bitter diatribe by Parkins about his predecessor and his misdeeds, saying, 'My predecessor, Mr Carpenter, who lived 50 years in this vicarage house left it me in a tumbling condition.' He was unable to get proper dilapidations 'through the deceitfulness of his (Carpenter's) son aided by his friend, Mr Beckford Kendall and Thomas Bush who was appointed to value.' There is more in similar vein.

We have noted the appointment of Jonathan Carpenter as curate-in-charge at Sheldon in place of Thomas Morrall. Jonathan was baptized in March, 1693, and William Caslon on the 23rd of the following month so, noting that the parents of both children were 'of the Town' and that Caslon's grandfather had served his apprenticeship to Jonathan's grandfather, nothing seems more likely than that the future typefounder and the future rector of Sheldon were playmates in childhood. The high rate of infant mortality is one of the sadder aspects of the history of the period and it may be further noted that the first-born child of George and Mary Caslon was an earlier William, baptized in January, 1689, who was buried in March following, also that Jonathan and Margaret Carpenter passed through the same sad experience when their first born child, an earlier John than he who became vicar of Pagham, was both baptized and buried in January, 1692. The family of Samuel and Alice Butler, also 'of the Town' included Jonathan, baptized in 1686, besides Samuel, the Sheldon schoolmaster, John, the vicar of Pattingham, and Joseph, who succeeded John as vicar of the same place.

There can be little doubt that the prior appointment of Samuel Butler as schoolmaster led to closer connections between the schoolmaster's friends at Halesowen and his associates at Sheldon and it was probably just before Jonathan Carpenter's appointment as curate that he married Thomas Bray's daughter Agnes. Their marriage, however, was short-lived for in 1724 Agnes died.

The licence naming John Carpenter as curate of St. Botolph's, Aldgate, should be taken to mean what it says. Curates were appointed to assist the incumbents of church livings to carry out their duties, often in the absence of the incumbents. Jonathan Carpenter's predecessor at Sheldon, Thomas Morrall, performed his duties only in Warwickshire. Another curate assisted in the parochial work at St. Botolph's, Aldgate. Jonathan Carpenter could scarcely undertake the cure of both places any more than Bray himself could.

The living of St. Botolph's, Aldgate, was a perpetual curacy in the gift of Dr. Samuel Brewster, one of the early members of the S.P.C.K. Bray had been offered the living before going to Maryland but had then declined.

George Hennessy[32] is not clear on the ministers who functioned at St. Botolph's, Aldgate. Thomas Brattell, M.A., was born in the Tower of London ; when at Oxford he succeeded Thomas Walker, who later became vicar of Clent and Rowley, as usher of Magdalen College School ; Brattell is recorded as having vacated St. Botolph's in 1703. White Kennett, a pluralist on a large scale, was the next perpetual curate, but Hennessy shows him to commence only in 1708, whereas the living was again offered to and accepted by Thomas Bray in 1706, and Hennessy does not list him at all. Hennessy then shows Benjamin Pratt as curate until his death in 1715, but gives no date of commencement, and Pratt was followed by John Hutchinson, one of Caslon's neighbours in Vine Street. The explanation for the confusion probably lies in the fact that the living was a perpetual curacy, the succession of whom were Brattell, Kennett, Bray, the next on the list being Thomas (or Robert)[33] Kynaston, who was appointed Bray's successor in March, 1729. Hutchinson, who was also lecturer of St. Catherine Coleman, must have vacated St. Botolph's, Aldgate, in 1721 to admit John Carpenter, unless Bray's state of health, uncertain by this time, and the volume of other work he undertook, justified the retention of two curates. The date of John Carpenter's presentation to the vicarage of Pagham, 1729, suggests that he remained at St. Botolph's until Bray's death, but in the absence of further documentary evidence it is impossible to be certain on this point. He died in 1785 at the Temple, London, aged 87.

A few years after the death of Bray's daughter Agnes, Jonathan Carpenter married again and his wife, Sarah, bore him five children before she, too, died in 1733. His son Jonathan, born about 1733, was a graduate of University College, Oxford, and three daughters were surviving in 1761, Caroline unmarried, Margaret, wife of John Wace Patteson of the Swan Inn, Birmingham, and Sarah, wife of the Rev. John Hepworth of Burton, co. Stafford.[34]

Sometime before 1723 Bray's wife Agnes had died, leaving £30 to the poor of Sheldon, while in that year Bray himself was gravely ill and, feeling that his life was very insecure, he nominated certain persons to carry out his work with him and after him. These were called 'Dr. Bray's Associates for founding Clerical Libraries and supporting Negro Schools,' their authority being later confirmed by a decree in Chancery. On his recovery he continued the work in his own parish at St. Botolph's and as late as 1727 applied himself to the relief of prisoners confined in Whitechapel prison, a work which brought him into touch with General James Oglethorpe, who became one of Bray's 'Associates' and recruited the help of others. It was probably owing to this acquaintance that to the two designs of founding libraries and instructing negroes, he added the establishment of a colony in America to provide for the necessitous poor who could not find employment at home.[35]

Jonathan Carpenter succeeded to the Sheldon rectory on 28 November, 1729, following Dr. Bray's resignation, and it was not long before Bray's long labours were over, his death occurring on 15 February, 1730. Bray's surviving issue were Goditha, who married James Martin, a prosperous upholsterer, and William, whom his father had put into business as a publisher and bookseller. William's name is recorded as a publisher at several addresses between 1709 and 1720.[36] It is strange, however, that in his will Bray left everything in his daughter's hands, making her responsible for William's welfare. It is touching to note, too, that when Goditha herself died she bequeathed some of her best silver and other possessions to the Sayers family, indicating that she had affectionate memories of her step-mother.

Such biographical details of Thomas Bray as are here given are intended only to render intelligible such new knowledge as has

been discovered about him and his associates, and especially of those near to him who must also have had a more or less intimate acquaintance with William Caslon. Those interested in a more extended account of Bray must be referred to the life of Bray by H. P. Thompson and to the authorities and bibliography given in the D.N.B.

Although no direct evidence has come to light that Bray was acquainted with Caslon before the young engraver and his wife became his parishioners in Vine Street, no doubt can remain that Caslon was not only well-acquainted with Samuel Butler before the latter's appointment as schoolmaster at Sheldon nor that he had a still closer connection with Jonathan Carpenter, Bray's son-in-law and successor at Sheldon, and his younger brother John Carpenter, whom the copy-licence at Sheldon shows to have become Bray's curate at St. Botolph's, Aldgate.

Whilst the most direct connections between Caslon and Bray were doubtless those explained in this chapter, the supporters enlisted to advance the objects of the S.P.C.K. were so widespread and numerous that to account for all the factors which might have influenced Caslon's career would be exceedingly difficult. As an example, while the Pattingham registers record no entries for John Butler between the years 1709 and 1718, there are entries of the baptisms of Samuel, Joseph, Jane and Martha, children of Joseph and Martha Butler, and other evidence of his living at Pattingham from 1721 to 1755.

What happened to John Butler is not known, but Joseph entered upon the living in 1718. From 1717 to 1722 there are entries of the family of William Mackworth Praed and his wife Anne, daughter of Robert and Anne Slaney of Rudge Hall, who were both buried at Pattingham. William Mackworth Praed was the youngest son of Sir Humphrey Mackworth, friend of John Praed of Trevethoe, Cornwall, who adopted the boy as his heir in the year of his birth (1694). Sir Humphrey Mackworth's eldest son, Herbert Evans Mackworth, married Juliana, one of the daughters of William Lord Digby.

While it would be easy to ascribe the presentation of the brothers John and Joseph Butler to the kind offices of their elder brother Samuel with Lord Digby at Sheldon, it must be remem-

bered that there were close connections between those who opera-
ted the Halesowen, Cradley and Grange furnaces. As shown in
Chapter 3, at the turn of the century the Downings had a part in
all the mineral getting, even for the Grange furnace, which was
situated on the Smestow, less than three miles from Pattingham.
Also Edward Maynard, once Lord Digby's chaplain, became a
canon of Lichfield, and might have helped the Butlers. It will be
seen that the influences were very complicated and would be most
difficult to trace without far more documentary evidence than is
available. Having resolved the principal connections, therefore,
between Caslon and Bray, we shall next explore Caslon's con-
nections with London printers and booksellers.

[1] Two Hundred Years: The History of the Society for Promoting Christian
Knowledge, 1698–1898, Allen and McClure, 1898.
[2] Ibid.
[3] Ibid.
[4] Ibid.
[5] Ibid.
[6] D.N.B. art. Sir Humphrey Mackworth.
[7] Two Hundred Years.
[8] H. P. Thompson, Thomas Bray, 1954.
[9] Ditto.
[10] 'Battels' were the accounts for food, etc., paid to the College.
[11] William Price, History of Oswestry, 1815.
[12] Dugdale, History & Antiquities of Warwickshire, revised by Thomas, 1730.
[13] Ibid. Vol. II, p. 1041.
[14] H. P. Thompson, Thomas Bray, 1954.
[15] D.N.B. art. Thomas Bray.
[16] D.N.B. art. Edward Maynard.
[17] H. P. Thompson, Thomas Bray.
[18] Halesowen Parish Register.
[18] Alum. Oxon.
[20] Somers, Halas, Hales, Halesowen, p. 118.
[21] Dugdale's Warwickshire.
[22] Stone parish register.
[23] Hampton-in-Arden parish register.
[24] Venn, Alum. Cantab.
[25] Hampton-in-Arden parish register.
[26] Foster, Alum. Oxon.

Chart 8.

Some Descendants of John Carpenter
of Halesowen

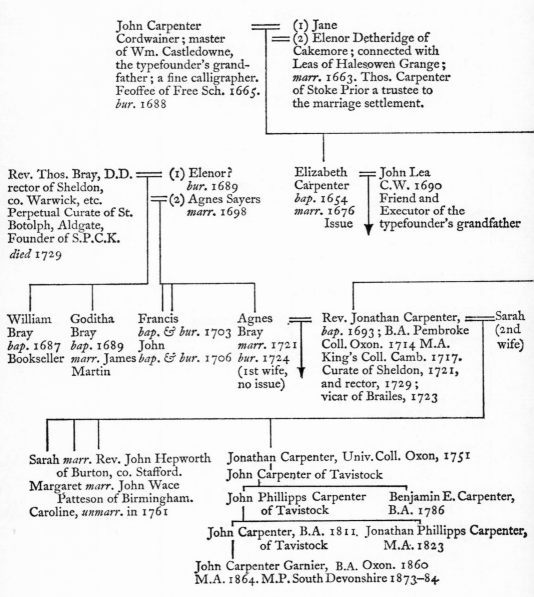

John Carpenter
Cordwainer ; master
of Wm. Castledowne,
the typefounder's grand-
father ; a fine calligrapher.
Feoffee of Free Sch. 1665.
bur. 1688

(1) Jane
(2) Elenor Detheridge of
Cakemore ; connected with
Leas of Halesowen Grange ;
marr. 1663. Thos. Carpenter
of Stoke Prior a trustee to
the marriage settlement.

Rev. Thos. Bray, D.D.
rector of Sheldon,
co. Warwick, etc.
Perpetual Curate of St.
Botolph, Aldgate,
Founder of S.P.C.K.
died 1729

(1) Elenor ?
bur. 1689
(2) Agnes Sayers
marr. 1698

Elizabeth
Carpenter
bap. 1654
marr. 1676
Issue

John Lea
C.W. 1690
Friend and
Executor of the
typefounder's grandfather

William
Bray
bap. 1687
Bookseller

Goditha
Bray
bap. 1689
marr. James
Martin

Francis
bap. & bur. 1703
John
bap. & bur. 1706

Agnes
Bray
marr. 1721
bur. 1724
(1st wife,
no issue)

Rev. Jonathan Carpenter,
bap. 1693 ; B.A. Pembroke
Coll. Oxon. 1714 M.A.
King's Coll. Camb. 1717.
Curate of Sheldon, 1721,
and rector, 1729 ;
vicar of Brailes, 1723

Sarah
(2nd
wife)

Sarah *marr.* Rev. John Hepworth
of Burton, co. Stafford.
Margaret *marr.* John Wace
Patteson of Birmingham.
Caroline, *unmarr.* in 1761

Jonathan Carpenter, Univ. Coll. Oxon, 1751
John Carpenter of Tavistock

John Phillipps Carpenter
of Tavistock

Benjamin E. Carpenter,
B.A. 1786

John Carpenter, B.A. 1811. Jonathan Phillipps Carpenter,
of Tavistock M.A. 1823

John Carpenter Garnier, B.A. Oxon. 1860
M.A. 1864. M.P. South Devonshire 1873–84

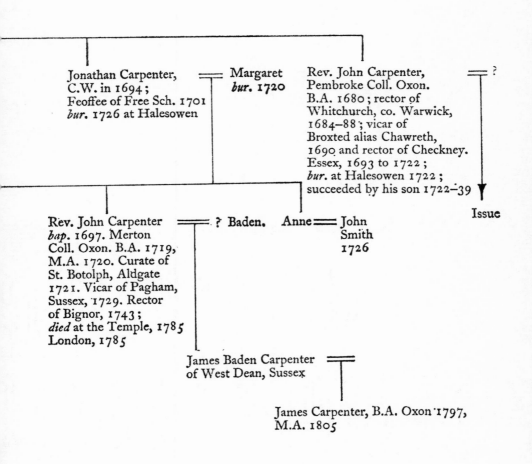

Jonathan Carpenter, ==== Margaret Rev. John Carpenter, ==== ?
C.W. in 1694; *bur.* 1720 Pembroke Coll. Oxon.
Feoffee of Free Sch. 1701 B.A. 1680; rector of
bur. 1726 at Halesowen Whitchurch, co. Warwick,
 1684–88; vicar of
 Broxted alias Chawreth,
 1690 and rector of Checkney.
 Essex, 1693 to 1722;
 bur. at Halesowen 1722;
 succeeded by his son 1722–39

 Issue

Rev. John Carpenter ==== ? Baden. Anne ==== John
bap. 1697. Merton Smith
Coll. Oxon. B.A. 1719, 1726
M.A. 1720. Curate of
St. Botolph, Aldgate
1721. Vicar of Pagham,
Sussex, 1729. Rector
of Bignor, 1743;
died at the Temple, 1785
London, 1785

 James Baden Carpenter ====
 of West Dean, Sussex

 James Carpenter, B.A. Oxon 1797,
 M.A. 1805

[27] Admission and Bindings Register, Oldswinford Hospital.
[28] Chart 8, appended to this Chapter.
[29] Inf. Essex Record Office.
[30] Foster, Alum. Oxon.
[31] Venn, Alum. Cantab.
[32] London Diocesan Clergy Succession, 1898.
[33] Foster, Alum. Oxon.
[34] Herald & Genealogist, Vol. 7, p. 270.
[35] D.N.B. art. James Oglethorpe.
[36] H. R. Plomer, Dictionary of Printers & Booksellers, 1922.

Chapter Eleven

BOOKSELLERS, AUTHORS AND THEIR MARKET

THE BEGINNING of a free press dates from 1694, the year after the birth of William Caslon, whose life and work were so closely concerned with improving the expanding productions of English printers and booksellers in the first half of the eighteenth century. In order to appreciate fully the environment in which Caslon's special skills were recognised, nurtured and brought to fruition, something must be said about conditions in the printing and bookselling trades before his appearance on life's scene and during his apprenticeship.

Accounts of the book trade in the mid-seventeenth century cause one to wonder why men continued to enter the trade. Even plague was a small matter compared with the ecclesiastical tyranny exercised over the press in the time of Charles I. Under Archbishop Laud and his party, authors and publishers were harassed unmercifully and few stationers, whether printers or publishers, escaped a fine or imprisonment. The Scottish divine Alexander Leighton, besides being twice whipped and branded, had his ears cut off and his nose slit, and was kept in prison until the Long Parliament released him. The celebrated Puritan, William Prynne, published his *Histrio-Mastix* in 1632, which was supposed to carry reflections on the Queen and Court. Prynne was sentenced to a fine of £5,000, to be degraded from the bar, to stand in the pillory at Westminster and Cheapside, where he was to have one of his ears cropped at each place, and to be imprisoned for life. His publisher, Michael Sparke, also had to pay a fine of £500 and to

stand in the pillory. Three years later Prynne managed to publish under a pseudonym the tract *Newes from Ipswich*, for which he incurred a second fine of £5,000, together with the renewed degradation of the pillory, the loss of what remained of the stumps of his ears and, the greatest humilation of all, the mutilation of both cheeks with the letters 'S.L.' which Prynne grimly interpreted as 'Stigmata Laudis,' though its official meaning was 'seditious' or 'scurrilous' libeller.

In 1637 the Star Chamber published the drastic decree concerning printing which preceded the darkest age in the history of the English book trade since Caxton set up his press at Westminster. This Act, while confirming existing ordinances, consisted of thirty-three additional clauses, the former decrees, it states, having

> 'been found by experience to be defective in some particulars : And divers abuses have sithence arisen, and been practised by the craft and malice of wicked and evill disposed persons, to the prejudice of the publicke ; and divers libellous, seditious and mutinous bookes have been unduly printed, and other bookes and papers without licence, to the disturbance of the peace of the Church and State.'

The number of printers was reduced to twenty-three, including the King's printers and the printers allowed for the Universities ; all books had to be licensed according to classification—law books, by the Lord Chief Justice and the Lord Chief Baron ; all books of English history or other books of State affairs, by the principal secretaries of state ; works dealing with heraldry, by the Earl Marshal ; and all other books,

> 'whether of divinitie, phisicke, philosophie, poetrie, or whatsoever, by the Archbishop of Canterbury, the Bishop of London, or the Chancellors or Vice-Chancellors of Oxford or Cambridge University.'[1]

Every book had still to be entered in the Stationers' Register, and to bear the name of the printer, the author, and the publisher. Native printers, however, were protected by a clause which prohibited the importation of English books printed abroad, and the interests of legitimate booksellers were also studied, in Clause X, to the following effect :

> 'That no haberdasher of small wares, ironmonger, chandler,

shop-keeper, or any other person or persons whatsoever, not having beene seven yeares apprentice to the trade of a book-seller, printer, or book-binder, shall within the citie or sub-urbs of London, or in any other corporation, market-towne, or elsewhere, receive, take or buy, to barter, sell againe, change or do away, any Bibles, Testaments, Psalm-books, Primers, Abcees, Almanacks, or other booke or books what-soever upon pain or forfeiture of all such books so received, bought or taken as aforesaid, and such other punishment of the parties so offending, as by this Court, or the said High Commission Court respectively, as the severall causes shall require, shall be thought meet.'[2]

To ensure good behaviour each of the master printers was bound in sureties of £300, and the penalties for all stationers and others who offended against this or any other decree of the kind included heavy fines, imprisonment, confiscation of stock, and such corporal punishment as a whipping at the cart's tail. The final clause marks an early stage in the evolution of the custom, prevailing at the present day, of sending copies of all new works to the British Museum, and four or five of the leading university libraries in the United Kingdom and Ireland.

The formidable Decree of 1637 soon lost its effect under the gathering clouds of the Civil War, and when the Long Parliament abolished the Star Chamber in 1641 the Act became to all intents and purposes a dead letter. This was not at all to the liking of the Stationers' Company, which was virtually left for the time being not only powerless to act, but in serious danger of losing its privi-leges. The most law-abiding stationers under the old régime began to print and sell both books and pamphlets without troubling either to obtain a licence or to enter them in the Company's Register, which showed an average of scarcely more than one entry a week. The more lawless members seized the opportunity to trade in books belonging to the monopolists.[3] To quote from 'The humble Remonstrance of the Company of Stationers' to Parliament 'in April, 1643,

'the affairs of the Presse have grown very scandalous and enormious, and all redresse is almost impossible if power be not given by some binding order to reduce Presses and Ap-prentices to the proportion of those times which did precede these last four years . . .'[4]

Parliament, as well as the Stationers' Company, had already taken alarm at the manner in which authors, printers, and publishers made use of their new-found freedom and, two months after receiving this Remonstrance, a new Ordinance was passed, 'to prevent and suppress the licence of printing.' As in the Star Chamber decree of 1637, censors were appointed for the various departments of literature.

This reactionary Ordinance, inspired by the very Presbyterians who, in other days, had been loudest in protesting against the wickedness of such restraints had scarcely been issued when Milton's offending treatise on the *Doctrine and Discipline of Divorce* was ready for publication. Milton had already treated the earlier Decree with contempt by issuing his Anti-Episcopal pamphlets without leave or licence from anyone. The idea of any censorship over books, which left the decision as to what should be published, and what suppressed, in the hands of a few men, filled him with indignation. Disregarding the new Act, he sent forth his Divorce treatise without either official sanction or entry in the Stationers' Register. The Company at once took action both against this and another unlicensed work but, though the matter was taken to Parliament and referred to a Commons Committee on Printing, nothing came of it. Milton, however, did not intend to let the matter rest there. He took his revenge in the finest piece of prose that he ever wrote, the *Areopagitica*, now one of the leading documents in the history of the liberty of the press. Milton seized the bull by the horns by addressing the *Areopagitica* to Parliament itself, and calling it *A Speech for the Liberty of Unlicensed Printing*. It was published in 1644 in his own name, but unlicensed, and without the name of either printer or bookseller— a small quarto breathing throughout its forty pages the author's ennobling love of liberty and letters.[5]

In 1649 Milton was swept into the whirlpool of politics as Latin Secretary to the Council of State, writing in the same year the best known of his official papers, *Eikonoklastes*, in reply to the famous *Eikon Basilike* of Charles I[6] which, appearing at the time of the King's execution, had a sale so remarkable that some fifty editions of it are said to have been exhausted in the same year. The manuscript copy of this mysterious book was not received by

Richard Royston the royal bookseller, at the Angel in Ivy Lane, until 23 December, 1648, and great efforts were made to issue it before the King's execution at the end of the following month. It was printed by William Dugard, headmaster of Merchant Taylors' School, where he had set up a private printing press ; and the work was ready, if not immediately before the day of execution (30 January, 1649) at least immediately after, for we have it on Toland's authority[7] that a copy was bought on 31 January. It has been suggested that had this book appeared a week sooner it might have saved the King's life. Dugard shortly afterwards printed Salmasius's *Defensio Regia*, whereupon the Council of State committed him to Newgate, turned his wife and family out of doors, seized all his printing plant, and ordered the Governors of the School to elect a new master. Subsequently Dugard made his peace with Parliament, and being reinstated at his school, and having his printing effects returned to him, he served the ruling powers with the loyalty which he had hitherto displayed for the Royalists. Among other things he printed Milton's official reply to Salmasius.[8]

The book trade, as sensitive then as now to outside disturbance was naturally affected during these years of strife. Most of the reading matter of the day took the form of controversial pamphlets or news-sheets, each side having its own organs, published two or three times a week. Yet it is remarkable what famous literary works made their appearance in spite of the storm and stress of national affairs. To the works of Shirley, Fuller, Cowley, Denham, and others, may be added the *Leviathan* of Thomas Hobbes, 1651, the *Monastican Anglicanum* of Sir William Dugdale, 1655, the best work of Jeremy Taylor, the *Compleat Angler* of Isaac Walton, 1653, and the great *Polyglot Bible* of Brian Walton, 1657.

The Restoration brought fresh trials to the book trade. The Licensing Act of 1662, in which the Royal Prerogative was strongly reasserted, was a crushing blow to the time-honoured administrative powers of the Stationers' Company, whose interests were practically ignored by it, a new office being created in 1663 under the title of 'Surveyor of the Imprimery and Printing Presses.' The number of printers at work in London, which had

then grown to sixty, was again reduced to twenty, and most of the clauses of the Star Chamber decree of 1627 were reinforced. The new Act and its administration were hotly debated and led, among other things, to a petition from the Stationers' Company for the restoration of their ancient privileges.

Roger L'Estrange was appointed to inquire into the whole matter, and on 3 June, 1663, he published his *Considerations and Proposals in order to the regulation of the Press*, in which he stated that

'both printers and stationers, under colour of offering a service to the publique, do effectually but design one upon another. The printers would beat down the bookselling trade by managing the press as themselves please, and by working upon their own copies. The stationers, on the other side, they would subject the printers to be absolutely their slaves; which they have effected in a large measure already, by so encreasing the number, that the one half must either play the knave or starve.'[9]

On 15 August, 1663, L'Estrange was appointed 'Surveyor of the Imprimery,' with similar police powers to those previously held by the Stationers' Company. In addition he was one of the licensers of the press, and had the sole privilege of printing and publishing anything in the shape of a newspaper or public advertisement. He was indefatigable in the pursuit of his victims, resorting to a variety of penalties for inflicting upon his offenders, such as death, mutilation, the pillory, stocks, whipping, carting, stigmatising, and 'standing under the gallows with a rope about the neck at a publique execution.' Until the outbreak of the Plague, when it was mercifully allowed to lapse, the new Act, under L'Estrange, was more vigorously enforced than the short-lived Star Chamber decree of 1637, the energetic Surveyor even making midnight raids on printing houses.

Worse disasters fell upon the book trade than the appointment of Roger L'Estrange. The Plague of 1665 ruthlessly thinned the ranks of all classes of stationers, and with the withdrawal of the Court to Oxford, and the wholesale flight of the citizens, the trade was brought practically to a standstill. It was during this stay at Oxford that Arlington, the Lord Chamberlain, licensed the publication of the *Oxford Gazette*, notwithstanding the exclusive

privilege held by L'Estrange, who had two similar sheets running in London—the *Intelligencer*, published on Mondays, and the *News*, which appeared on Thursdays. The Oxford rival was produced and reprinted in London, where, upon the King's return to his capital, it became the *London Gazette*, effectually silencing L'Estrange's publication, and continuing down to the present day. The disaster of the Plague was followed by the more sweeping disaster of the Great Fire, which, in addition to other book-selling quarters, wiped out the very centre of the trade in St. Paul's Churchyard. Here the booksellers lost an immense stock of books, which they had stored for safety in the vaults of the church.

It was in March of the year after the Great Fire that Milton signed his agreement with Samuel Simmons for the publication of *Paradise Lost*. Milton's old publisher, Humphrey Moseley, a Staffordshire man who had enjoyed a well-merited reputation as the foremost publisher in the middle of the century, had died six years before, and the struggle for supremacy in the trade was being waged between Richard Marriot of St. Dunstan's Churchyard, and Henry Herringman. Samuel Simmons, whose address was 'next door to the Golden Lion in Aldersgate Street,' was practically a beginner, but he was a nephew of the late Matthew Simmons, of the same address, who had published Milton's *Eikonoklastes*, as well as several of his earlier tracts, and had become official printer to the Commonwealth during the first year of Milton's secretaryship. *Paradise Lost* may have gone to Samuel Simmons, therefore, for old association's sake.[10] Here it is apparent that Birmingham was becoming aware that a literary world existed as well as a world of iron and fire for in 1652 there was a 'Thomas Simmons Bookseller at the sign of the Bible in Birmingham in Warwickshire' publishing for Thomas Hall, B.D., and in 1660 another of Hall's works, *The Beauty of Magistracy*, was published, with the imprint, 'London, printed by R. W. for Nevill Simmons Bookseller in Kidderminster and are to be sold by Thomas Johnson at the Key in Pauls Church-yard.' Several of Baxter's works were also printed by R. W. for this Nevill Simmons who also issued a token inscribed 'Nevill Simmons—Bookseller— Kidderminster—His Halfpenny—1663.'[11] The name of Nevill Simmons occurs in the records of the Stationers' Company, and it

is clear that much remains to be discovered regarding the relations between London and country booksellers.

About 1680 Simmons sold the copyright of *Paradise Lost* for £25 to Brabazon Aylmer, 'at the sign of the Three Pigeons in Cornhill,' and then, before the work was reprinted, it fell into the hands of Jacob Tonson, who had just started in business, and was destined to become 'the third man after Humphrey Moseley and Henry Herringman in the true apostolic succession of London publishers.'[12] Richard Tonson had opened his bookselling business at Gray's Inn Gate in 1676 and his brother Jacob followed suit at the Judge's Head in Chancery Lane in 1678. More ambitious than his brother, Jacob, after publishing for Otway and Nahum Tate, began to angle for Dryden, now Poet Laureate, and in 1679 landed *Troilus and Cressida*, then in 1683 came the half-share in *Paradise Lost*, though it was not until 1688 that Tonson turned this investment to profitable account with his handsome folio edition of the work. Later Jacob Tonson admitted that *Paradise Lost* brought him in more money than any other poem that he published. Dryden's monetary difficulties with his publisher are notorious. The poet, in lines written under Tonson's portrait, thus described him :[13]

> With leering looks, bull-faced, and freckled fair ;
> With two left legs, and Judas-coloured hair ;
> And frowsy pores, that taint the ambient air.

Sending this by a messenger, Dryden said, 'Tell the dog that he who wrote these lines can write more.' The threat, we are told, had the desired effect, affording the poet some of the money owing to him. Subsequently their relations became more friendly, as in 1697, when Tonson thanks him 'heartily for the sherry,' and in another note, hopes that his *Ode for St. Cecilia's Day* has done him service, 'and will do more.'[14]

The stringent Licensing Act of 1662, which had been allowed to lapse at the time of the Great Fire, never recovered its original strength, and was not, indeed, renewed by Charles II, though L'Estrange did his best as Surveyor of the Press to make things as lively as possible both for printers and booksellers. He found a monarch more in sympathy with him when James II came to the throne in 1685, the Act of 1662 being renewed for the first time

for twenty years on the new King's opening Parliament. Macaulay[1] describes the unlicensed press at this period as being worked in holes and corners, and producing large quantities of pamphlets which were a direct infraction of the licensing law.

'There had long lurked in the garrets of London a class of printers who worked steadily at their calling with precautions resembling those employed by coiners and forgers. Women were on the watch to give the alarm by their screams if an officer appeared near the workshop. The press was immediately pushed into a closet behind the bed; the types were flung into the coal-hole and covered with cinders; the compositor disappeared through a trap-door in the roof, and made off over the tiles of the neighbouring houses. In these dens were manufactured treasonable works of all classes and sizes, from halfpenny broadsides of doggerel verse up to massy quartos filled with Hebrew quotations.'

In the more open activities of the trade the struggle for the mastery between printer and publisher ended before the end of the century in victory for the publisher and a sterner contest followed between publisher and author. The new development had largely been brought about by that omnipotent person the general reader who, slowly but surely, had been altering the literary outlook. One factor promoting a wider readership was the growing number of charity schools of which, as already noted, hundreds were founded in the early years of the eighteenth century. Books which had been regarded as appealing only to the leisured and cultured classes began to have a wider and ever-increasing appeal, with the result that authors as well as publishers looked for a proportionate increase in their profits. How pronounced this change was is illustrated by the contrast between Milton's original £5 for *Paradise Lost*, and the £1,200 which Dryden, in the next generation, is said by Pope to have received, all told, for his *Virgil*, or the two hundred and fifty guineas which Tonson paid the same poet for the first edition of his *Fables*, with an agreement to bring that sum up to £300 on sending the book to a second edition.[16]

Tonson, despite his failings, did yeoman service in helping to develop a popular literary taste, and notwithstanding Dryden's grievances, his liberality to his leading authors fairly entitle him to be regarded as our first Prince of Publishers. Apart from his own

authors, he not only introduced Milton to a far larger public than he had ever known before but, with Rowe's octavo edition in seven volumes (1709), was practically the first to open Shakespeare to the general reader, the four folio editions, apart from their expense, having already become scarce.

The dawn of the eighteenth century found the book trade in a sorry state. The lapse of the old Licensing Laws in 1694 had left both authors and publishers without the uncertain protection which even those arbitrary measures afforded. In 1709, however, came the much-maligned Copyright Act of Queen Anne—the first copyright Statute ever passed in any country. It was time that something was done to put an end to the lawless state of things prevailing since the expiration of the old Licensing Laws. The Stationers' Company did its best to maintain its ancient usage in the matter of duly registered 'copies,' passing bye-laws forbidding any member to print, bind, or sell any book belonging to another member; but their printed regulations were as so much waste-paper. The freebooters of the press were never so openly defiant as now.[17] As Addison says in the *Tatler*, they were the 'set of wretches who print any book, poem, or sermon as soon as it appears in the world, in a smaller volume, and sell it, as all other thieves do stolen goods, at a cheaper rate.'

The London booksellers, finding their bye-laws wholly in-adequate as a means of protecting themselves against one another, applied to Parliament for a new Licensing Act in 1703, again in 1706, and for a third time in 1709, when they were at length re-warded with the Statute of Queen Anne. The Act did something which no other Act had ever done—it made some attempt to provide for the due recognition of the rights of authorship. Authors, as well as publishers—provided they had not parted with their property—were given the copyright of books already printed for a period of twenty-one years, dating from 10 April, 1710, and no longer. New books were placed on a different footing, copyright in this case lasting only fourteen years, with the proviso that in the event of the authors surviving the said term they were to be granted another period of fourteen years. Among other things, piracy was to be punished by forfeiture and the fine of a penny per sheet—half to go to the Crown and half to the informer; and registration at

Stationers' Hall was again demanded as a necessary condition of protection.

This well-meaning measure, though for the first time conferring upon authors statutory rights in their literary property, spoilt the whole case for perpetual copyright. Hitherto the belief in this perpetuity had been general, the booksellers believing that any literary property which they purchased became theirs and their successors' for all time. Authors held the same view, and sold or retained their copyrights accordingly. Amid all the judicial differences on the subject during the eighteenth century, there was a steady majority of judges in favour of the view that but for the Statute of Anne an author was entitled to perpetual copyright in his published works. This right, if it ever existed, the Act destroyed.

The bookselling localities were more specialised in the early eighteenth century than now. A contemporary writer[18] says, 'The booksellers of ancient books in all languages are in Little Britain and Paternoster Row ; those for divinity and the classics on the north side of St. Paul's Cathedral ; law, history, and plays about Temple Bar ; and the French booksellers in the Strand. It seems, then, that the bookselling business has been gradually resuming its original situation near this cathedral ever since the beginning of George I, while the neighbourhood of Duck Lane and Little Britain has been proportionately falling into disuse.' In its palmy days Little Britain was a favourite resort of Swift and other great bookmen and booklovers of his time. Scholars went there for their Greek and Latin texts, or their favourite French and Italian authors, afterwards foregathering in the old 'Mourning Bush' in Aldersgate to discuss both their spoils and the current gossip of the town. Swift[19] mentions several visits to Christopher Bateman, one of the best known of these Little Britain booksellers, in his *Journal to Stella*. On 6 January, 1711, he tells her that he 'went to Bateman's, the bookseller's, and laid out eight and forty shillings for books,' for which he seems to have bought 'three little volumes of *Lucien* in French, for our Stella.' A few months later he was at the same bookseller's, 'to see a fine old library he had bought, and my finger itched as yours would do at a china shop.'

Perhaps posterity has had to rely too much on the portraits presented by the satirists for a history of the book trade. Jacob

Tonson and Bernard Lintot, the two great publishers of the early eighteenth century, whatever their faults may have been, certainly helped to give a better tone to the trade. Against Lintot's benevolence and general moral character, says Dr. Young,[20] 'there is not an insinuation.' And Jacob Tonson, as we have seen, was a very worthy fellow, in spite of his latter-day snobbery. For Tonson, after Dryden's death in 1700, had entered upon a new and, from the social point of view, more dazzling phase in his career. He became secretary and probably had some share in the founding of the famous Kit Cat Club, hobnobbing with dukes and the leading men of wit and fashion among the Whigs, having his portrait painted, like every other member of the Club, by Sir Godfrey Kneller, and flattering his vanity to his heart's content in the celebrated room which he built for their meetings at his own villa at Barn Elms in Surrey.

The Club was not allowed to interfere with the course of Tonson's regular business, which he was doubtless shrewd enough to see would benefit by such friendly intimacy with writers of the stamp of Addison and Steele. In October, 1712, he became joint publisher of *The Spectator* with Samuel Buckley, of the Dolphin in Little Britain, who advertised the first number in his *Daily Courant* of that date as follows :[21]

> 'This day will be published a paper entitled *The Spectator* which will be continued every day. Printed for Samuel Buckley at the Dolphin in Little Britain, and sold by A. Baldwin in Warwick Lane.'

From the sixteenth number the imprint stated that it was also sold by 'Charles Lillie, Perfumer, at the corner of Beauford Buildings in the Strand.' Tonson's name as joint publisher was added from No. 499. The first two volumes of the revised edition in volume form, 'well bound and gilt, two guineas,' were issued to subscribers by Buckley and Tonson in January, 1713, the third and fourth following in April of the same year. In November, 1712 Addison and Steele sold a half share in these four volumes, and in three others not yet published, to Jacob Tonson, Junior—old Jacob's nephew and now his partner—for £575, Buckley taking the other half-share for a similar sum. Two years later Tonson junior bought Buckley's half for £500. The collected edition of *The Tatler* in

volume was also published by the Tonsons, being issued at a guinea a volume on royal paper, and ten shillings on medium paper. *The Guardian* came from the same busy press.[22]

It is not always easy to distinguish between Jacob Tonson I and Jacob Tonson II in their business dealings after the removal to the Shakespeare Head in 1709, but as the founder appears to have retired from active business in 1720 later references may be assumed to relate to his successor. In 1722 old Jacob assigned over to his nephew the privileges of his office as stationer, bookbinder, bookseller, and printer to a number of the great public offices—privileges which he had secured in 1719–20 as some reward for his devotion to the Whigs.

Jacob Tonson shared his printing in partnership with John Watts, with whom young Benjamin Franklin worked after his year's service at Palmer's, in Bartholomew Close. The partners Tonson and Watts, walking round the printing office together, doubtless noted this energetic young colonial at his work, but little dreamt of the part he was destined to play in the separation of the American Colonies from the mother country.

One government appointment—that of printing the votes—was shared from 1715 to 1727 between Jacob Tonson, Bernard Lintot, and William Taylor, the last of whom takes us back to Paternoster Row and the present-day publishing house of Longman. For it was William Taylor who built up the business bought by young Thomas Longman in 1724, Longman also taking over the emblem which the firm still bears today, the dual sign of the Ship and Black Swan. These were the signs of the two houses which Taylor had amalgamated out of the profits of *Robinson Crusoe*. The first part of that immortal tale was published on 25 April, 1719, when Defoe was nearly sixty years old, and a thoroughly discredited man. Taylor's enterprise was at once rewarded for so great was the run on the book that he had to employ several printers to cope with the demand. Three editions were exhausted within four months, bringing the publisher the handsome profit of over a thousand pounds. The second part appeared in August of the same year, and a third part, containing the *Serious Reflections of Robinson Crusoe*, now rarely printed with the narrative proper, in the following year.

We have seen that despite the severe restrictions on the book trade in the seventeenth century the period witnessed the publication of the works of some of our greatest writers. When a new era dawned for the publishing trade early in the eighteenth century the treasury of English authorship was opened to a wider reading public, promoting the re-issue of the works of earlier masters as well as the publication of the works of contemporary writers. Books were published in larger editions, greater profits were made, booksellers and printers increased in numbers, more presses were needed and more type was required in both quantity and variety.

Yet it was not the publication of such works as have been named which forms the best index to the literary consumption of the times ; important as these undoubtedly were, it was not the readers of Milton, Hobbes, Taylor, Walton, Dryden, nor even of Addison and Steele, Swift or Pope, who constituted the greater part of the reading public.

Whilst Defoe's *Tour through the Whole Island of Great Britain* is now meat for the early Georgian historian and his *Robinson Crusoe* long remained a best-seller, the majority of people in his own day were more excited by his political tracts. Whilst publishers and printers ate their Sunday dinners on bonus publications such as *Robinson Crusoe*, their meals mid-week were provided by journalists who had to make the most of greater and lesser events as they occurred day by day, and it was this kind of ephemeral publication, then as now, which constituted the literary consumption of the great majority. In order to present a more complete picture, therefore, of the publishing and printing trade, we must take some account, however briefly, of journalistic fashion in the late seventeenth and early eighteenth centuries.

[1] F. A. Mumby, Publishing and Bookselling, 1930.
[2] Edward Arber, Registers of the Stationers' Company, 1903.
[3] Those who traded under privilege, either by patent, grant, or purchase.
[4] F. A. Mumby, Publishing and Bookselling.
[5] Ibid.
[6] Or John Gauden, Bishop of Worcester, as seems more likely.

[7] John Toland (1670–1722), author of 'Life of John Milton,' 1698.

[8] Dugard is referred to at greater length in Chapter 14.

[9] F. A. Mumby, Publishing and Bookselling.

[10] The will of Joseph Symonds, 1652, confirms the relationship.

[11] Joseph Hill, Bookmakers of Old Birmingham, 1907.

[12] Dr. D. Masson, Life of Milton.

[13] D.N.B. art. Jacob Tonson.

[14] Ibid.

[15] Macaulay, History of England.

[16] F. A. Mumby, Publishing and Bookselling.

[17] Ibid.

[18] Macky, Journey through England, 1724.

[19] 'Journal to Stella'.

[20] Edward Young, author of 'Night Thoughts.'

[21] F. A. Mumby, Publishing and Bookselling.

[22] Ibid.

Chapter Twelve

NEWSPAPERS TO THE TIME OF CASLON

WHEN THE Licensing Act lapsed in 1694 writers and printers for the first time could publish without obtaining leave from civil or ecclesiastical authorities. Newspapers sprang into existence not only in London but in the leading provincial cities— the *Norwich Post* in 1701, the *Bristol Post-Boy* in 1702, the *Exeter Post-Man* in 1704, and many others in the following decade. The distribution of these early provincial weeklies is a reminder of the importance of the English towns and cities by comparison with the metropolis before the Industrial Revolution transformed the pattern of things. The contrast with the renaissance of 150 years later is striking. In 1855 the first provincial dailies appeared in Manchester, Liverpool, Sheffield and Edinburgh, with Birmingham, Glasgow and Newcastle-on-Tyne following two years later. Whilst the old rural England by this time had been submerged, it was not wholly obliterated, for to this day it has preserved a fine series of weekly newspapers in its market towns and cities.

Amongst the many newspapers that had appeared in London early in the eighteenth century the following so far improved upon their small and dingy predecessors as to be adorned with pictorial headings :— The *Post Boy*, 1720; the *Weekly Journal*, 1720; the *London Journal*, 1720; the *Weekly Journal or Saturday's Post*, 1721; *Read's Journal, or British Gazetteer*, 1718–31. The last-named appeared for many years as the *Weekly Journal, or British Gazetteer*; but the *Weekly Journal* was a favourite title, and was carried by so many other papers that the publisher altered the title

of his own paper to *Read's Journal, or British Gazetteer*, and gave it an engraved heading.

The freedom from censorship granted in 1694 seems, however, to have resulted from a fit of absent-mindedness. It took some time for the government to realise what they had done; but once the fact of a free press penetrated their consciousness, the politicians set about attempting to control it again. The story springs to mind about Faraday trying to explain a piece of electrical apparatus to Gladstone. He soon saw this was a forlorn hope when Gladstone's soaring mind strayed from technical details to high-sounding principles. 'But after all,' enquired the statesman, 'what *good* is it?' To which the scientist, in a flash of cynicism, replied, 'Why, Sir, presently you will be able to tax it.'

So the politicians of Queen Anne's day saw that the way to bring the new-born free press to heel was to tax it. In 1712, just as the provincial weeklies were getting under way, Parliament imposed the Stamp Act which put a levy of one penny per copy on a single-sheet newspaper or pamphlet. However, parliamentary draftsmanship, then as now, is an inexact science. The Act was so loosely worded that anything larger than a single sheet came under a merely nominal duty of Three Shillings per edition. So the printers of weekly newspapers simply increased the size of their publications and evaded the duty.

The paradoxical result of the original Stamp Act was, therefore, to enlarge the weekly newspaper and to set its pattern much as we know it today. Modes of communication in the early eighteenth century were, of course, comparatively slow, so that news was a scarce commodity. Consequently the printer who now had to fill additional space in his larger paper turned to literary features to supplement his scanty ration of news. So the combination of news and features which is a commonplace of our weekly or daily newspapers became established inadvertently by a slovenly Act of Parliament. By 1725, however, the legislature woke up to its blunder and the loopholes in the Act were stopped. Newspapers were required to pay $\frac{1}{2}$d. tax per half-sheet, and the price of the one-and-a-half sheet weeklies, which had been selling for a penny, was put up to $2\frac{1}{2}$d. per copy. But the pattern of newspapers, once fixed, remained. The subsequent history of the Stamp Duty, the Adver-

tisement Duty and the duty on paper, is the familiar story of steady increases, but falls outside Caslon's time and therefore outside the scope of this work.

We must now turn to the subject of journalistic fashion in the late seventeenth and early eighteenth centuries mentioned at the end of the last chapter, for it provides a vivid picture of contemporary events which possibly affords a better guide to things seen and experienced by the people of those days than some of the history which has been served up for our consumption in later times.

Sensational occurrences and uncommon events, even when traceable to natural causes, have always held great attractions for all classes of people, even though our capacity for wonder has diminished in face of modern scientific discoveries. In the seventeenth century, the writings even of educated men such as Robert Plot (1640–1696)[1] and Nathaniel Wanley (1634–1680)[2] show astonishing credulity, while the widely prevailing belief in fairies, goblins and ghosts among the uneducated classes has been already mentioned. It is scarcely to be wondered at, therefore, if in former times the talents of jounalists were most frequently exercised on mysterious appearances, and on accounts of floods, fires, frosts, and earthquakes. As an example, two broadsides described and illustrated the great frost of 1683–4, when the Thames was covered with ice eleven inches thick, the forest trees, and even the oaks, in England were split by the frost, most of the hollies were killed, and nearly all the birds perished. According to the testimony of an eye-witness,[3] 'The people kept trades on the Thames as in a fair, till February 4, 1684. About forty coaches daily plied on the Thames as on drye land.' The broadsides under notice give representations of the fair held on the Thames, and describe it in doggerel verse.

GREAT BRITAIN'S WONDER; LONDON'S ADMIRATION.

Being a True Representation of a Prodigious Frost, which began about the beginning of December, 1683, and continued till the Fourth Day of February following. And held on with such violence that Men and Beasts, Coaches and Carts, went as frequently thereon as Boats were wont to pass before. There was also a street of Booths built from the Temple to Southwark, where were sold all sorts of Goods imaginable—

namely, Cloaths, Plate, Earthen Ware ; Meat, Drink, Brandy, Tobacco, and a Hundred sorts of other Commodities not here inserted. It being the wonder of this present Age, and a great consternation to all the Spectators.'

The description opens as follows :—

'Behold the Wonder of this present Age
A Famous River now become a Stage,
Question not what I now declare to you,
The Thames is now both Fair and Market too,
And many Thousands dayly do resort,
There to behold the Pastime and the Sport.
Early and late, used by young and old,
And valued not the fierceness of the Cold.'

The illustration is a roughly executed woodcut, and represents a street of booths opposite the Temple, looking towards the Middlesex shore. On one side are men skating, sliding, riding on sledges and playing football ; whilst bull-baiting, skittle-playing, etc., are in progress on the other side. Coaches are driven across the ice, boats are dragged along as sledges, and an ox is roasted whole. The other broadside shows a woodcut of the same scene, but taken from a different viewpoint, viz., looking down the river, with London Bridge, the Tower, Monument, etc., in the distance. In addition to a description of Frost Fair, there is an account of all the great frosts from the time of William the Conqueror.

Some particulars of this great frost are recorded by contemporary writers. Evelyn describes the whole scene, and says that he crossed the river on the ice on foot on January 9th, in order to dine with the Archbishop of Canterbury at Lambeth ; and again, in his coach, from Lambeth to the horse-ferry at Millbank, on February 5th, when 'it began to thaw, but froze again.' Hackney-coaches plied between Somerset House and the Temple to Southwark. There was a printing-press set up in one of the booths, 'where the people and ladys took a fancy to having their names printed, and the day and year set down, when printed on the Thames. This humour took so universally that 'twas estimated the printer gained about £5 a day for printing a line onely at sixpence a name, besides what he got by ballads, etc.' A specimen of this printing has been preserved. It was executed for Charles II, who visited Frost Fair accompanied by several members of his

family. It includes, besides the names of the King and Queen, those of the Duke of York, Mary his Duchess, Princess (afterwards Queen) Anne, and Prince George of Denmark, her husband. The last name on the list is 'Hans in Kelder,' which translated means 'Jack in the Cellar,' and is supposed to have been the King's jocular allusion to the interesting condition of Princess Anne at the time; and we can imagine the swarthy face of the 'Merry Monarch' smiling in the frosty air as he gave vent to this piece of kingly humour.

In the Luttrell collection[4] of broadsides there is one with a large woodcut representing the battle of Sedgemoor and other incidents of Monmouth's rebellion, the letter-press being in wretched verse. The unfortunate issue in 1685 of the 'Protestant Duke's' rising excited the sympathy of the common people to whom he was endeared by his many amiable qualities and his handsome person.

The widely prevailing and lasting sympathy with the unfortunate Monmouth is illustrated by entries in the parish registers of Harborne and Halesowen. In March, 1698, a baptismal entry at Harborne records: 'Munmouth, son of Francis Allen.' Later, in the parish register of Halesowen we find that this same Monmouth Allen married and established a family there. Sympathy with the Stuart cause is reflected in the following baptismal entry in 1745 at Kinver: 'Sobieski, daughter of Charles and Sobieski Hillman baptised,' the parents being obviously supporters of the 'Old Pretender,' James Edward Stuart (1688–1766), who married Princess Maria Clementina, daughter of John Sobieski, the Polish patriot. It was only after the battle of Culloden and the flight of the 'Young Pretender' that Jacobite hopes of any strength and consequence in this country were finally extinguished.

Reverting to the press of the late seventeenth century, the slaughter at Sedgemoor and the execution of the Duke of Monmouth were partly forgotten in the greater horror excited by the unsparing severity of Judge Jeffreys (1648–1689) in condemning to death hundreds of persons who were charged with being concerned in the rebellion. An illustrated tract relating to the affair is inserted at the end of the volume of the *London Gazette* for 1685.[5] There is a rough woodcut on the title-page depicting eleven

portraits of martyrs of the 'Bloody Assizes,' and the title runs as follows :

THE PROTESTANT MARTYRS ; OR THE BLOODY ASSIZES

Giving an account of the Lives, Tryals, and Dying Speeches of all those eminent Protestants that suffered in the West of England by the sentence of that bloody and cruel Judge Jefferies ; being in all 251 persons, besides what were hanged and destroyed in cold blood. Containing also the Life and Death of James Duke of Monmouth ; His Birth and Education ; His Actions both at Home and Abroad ; His Unfortunate Adventure in the West ; His Letter to King James ; His Sentence, Execution and Dying-words upon the Scaffold ; with a true Copy of the Paper he left behind him. And many other curious Remarks worth the Readers Observation. London, Printed by F. Bradford, at the Bible in Fetter Lane.'

The pamphlet just quoted probably issued from a pirate press of the type described by Macaulay ; but he must have been a bold printer who dared to put his name and address to a work wherein Jeffreys was openly referred to as 'that bloody and cruel Judge Jefferies.' This fragment of contemporary history shows that though there were no regular newspapers to supply the people with illustrated news they obtained it in the form of cheap fly-sheets and broadsides.

Large broadsides continued to be the favourite form of illustrated journalism for some time after this. One gave a 'true and perfect relation' of the great earthquake which destroyed Port Royal, in Jamaica, which had been founded by Sir Charles Lyttelton (1629–1716) of the Hagley family, when he was Governor of the island. The catastrophe occurred on Tuesday, June 7, 1692, and was illustrated with a large woodcut.[6] It is therefore an example of the wretched standard of news-sheet typography and pictorial press about the time of William Caslon's birth. A few years after the Revolution newspapers began to increase rapidly. The art of wood-engraving, the readiest and least expensive method of illustration, was then in the lowest possible condition ; and the newspapers at the end of the seventeenth century contained scarcely any illustrations.

It is apparent, however, that the idea, in some shape, of illustrating the news of the day was never quite absent from the minds

of those who conducted newspapers. It might take the form of a rude map of the country where warfare was taking place, or the plan of a besieged city. In the *London Post* for July 25, 1701, is a map of the seat of war in Italy, which is reprinted in other numbers, and the *Daily Courant* for September 8, 1709, contains a large map of Mons. With the limited techniques at their disposal, even printers' lines were used to represent a plan of some place, or an event of unusual interest. Such an attempt at illustrated news was made in the *Dublin Journal* even as late as May 14, 1746, where there is a plan, set up in type and printers' lines, of the battle of Culloden; and in the number for March 28, 1747, there is a similar plan of the trial of Lord Lovat.[7] This is rendered more interesting as being Irish.

Engraving on copper, though it involved the expense of a double printing, was sometimes resorted to for enlivening the pages of the early newspapers and there was so much enterprise that even penny papers sometimes introduced engravings into their pages.

About the beginning of the eighteenth century caricatures began to increase in England. Religious animosities and political intrigues, always keen incentives to satire, had opened a wide field to the caricaturist in the years which followed the Revolution. But religious bigotry and party spirit, strong as they were at this period, were exceeded by the social follies which came afterwards. The trial of Dr. Sacheverell in 1710 occasioned the publication of numerous songs, squibs, and caricatures; but the South-Sea Bubble in 1721 surpassed it as a fruitful subject for lampoons and pictorial satire. The spirit of ridicule was fed by the political intrigues, the follies and vices of the Georgian era, and reached its highest pitch in the days of George III.

In *Read's Journal* for May 20, 1721, there was a large woodcut entitled 'Lucifer's Row-Barge,' which was a caricature on the South-Sea Bubble, depicting Robert Knight, the cashier of the South-Sea Company, as the central figure in a barge on the South-Sea rowed by Lucifer towards the gateway to Hell.[8] When the bubble burst in 1720 thousands of families were ruined, and the directors' estates, totalling over two million pounds, were seized in 1721 and sold. Knight absconded with £100,000, but later he compounded the fraud for £10,000 and returned to England in

1743. Almost all the wealthy people in the kingdom had become speculators, the artifices of the directors having raised the shares, originally at £100, tenfold to £1,000. As the result of a parliamentary enquiry in November, 1720, Aislabie, chancellor of the exchequer and several M.P.'s were in 1721 expelled the house.

Robert Knight (1675–1744) was the son of Robert Knight, citizen of London, and grandson of William Knight, of Barrells, Henley-in-Arden, Warwickshire, descended from a family resident at Beoley, Worcestershire, in the fifteenth and sixteenth centuries and allied to the Cookes family of Norgrove.[9] It is a better-known historical fact that the son of the defaulting cashier, another Robert Knight, was in 1746 created Baron Luxborough of Shannon, and in 1763 Viscount Barrells and Earl of Catherlough in the peerage of Ireland. He married, in 1727, Henrietta, daughter of Henry, Viscount St. John, a half-sister of the famous Lord Bolingbroke, but the marriage turning out unhappily, Lady Luxborough retired to Barrells, where she became the centre of the 'Warwickshire coterie,' and kept up a regular correspondence with William Shenstone (1714–1763), poet and landscape gardener, of the Leasowes, Halesowen. She died in 1756.

Returning to newspapers and their pictorial illustration in the early eighteenth century, there was a total eclipse of the sun in 1724, which seems to have excited much attention, and several notices of it appeared in the newspapers.[10] Parker's *London News*, published three times a week—on Mondays, Wednesdays, and Fridays, gave a long account, with a woodcut. The number for Monday, May 4, 1724, gave a description of eclipses in general, concluding with the following paragraph:

'Now to prevent any Consternation, which People, through Ignorance may fall under, by means of that great Eclipse which is now approaching; at which time it will be so dark, that the stars, (if the Air be clear) will be seen, and the Planets Mars, Venus, and the seldom to be seen Mercury, will appear a little above the Sun, towards the South; also Venus a little higher to the Left of Mercury, and Mars in the S.S.W. Parts of the Heavens. The several Appearances of this Eclipse will be according to the Types before inserted.'

Then follows a minute description of the various phases of the Eclipse, beginning as follows:

'The beginning of this Eclipse, according to the nicest Computation of the most Judicious, will happen at 39 Minutes past 5 in the Afternoon when the Limb of the Moon will just touch the Sun's Limb, as it is represented by the Uppermost Figure to the Right Hand . . . etc.'

The woodcut accompanying the article illustrates, as on a draughtsboard five squares by five, twenty-five phases of the eclipse, beginning at the top right-hand square, the moment of maximum eclipse at the middle square of the board, and terminating at the lower left-hand square.

The eclipse seems to have been the absorbing topic of the moment, for Parker's *London News* for May 8, besides carrying the account just quoted, also carried advertisements in which the eclipse was made the vehicle for advertising the shops of different tradesmen. The notices were published ostensibly 'to lessen the consternation of ignorant people,' but it is evident the advertisers also had an eye to business.

'An exact curious Draft' was to be 'given gratis at Mr. Garway's original shop, the Sign of the Practical Scheme at the Royal Exchange Gate, on Cornhill Side. Up one pair of Stairs at the Sign of the celebrated Anodyne Necklace for Childrens Teeth, next the Rose Tavern without Temple Bar. At Mr. Gregg's Bookseller, next to Northumberland House, at Charing Cross; and at R. Bradshaw's the author's Servant, at his House, next to the King's Head, in Crown Street, right against Sutton Street End, just by Soho Square. Note, it will not be given to any Boy or Girl.'

It will be observed how cumbersome was the method of locating premises in old London by the adoption of signs. Hatton's *New View of London* shows that as early as 1708, a few houses were distinguished by numbers instead of signs, but it was not until 1762 that a general movement began towards the replacement of signs by numbers, the first step being compulsorily to take down projecting signs and fix them to the front of the houses.[11] But old customs die hard, and shopkeepers and tradesmen continued to display their signs against or within their own premises, although numbering was in course of time generally adopted for houses.

By the end of the first quarter of the eighteenth century,

therefore, it is apparent that Londoners, at any rate, were made acquainted with the events of the day, the news being presented and illustrated in a fashion limited only by the crudity of the techniques employed.

In this and the previous chapter the writer has attempted to convey some idea of the manner in which booksellers and journalists worked from the time of rigid control and persecution of the trade in the mid-seventeenth century to the freer but clamorously competitive period of George I. In the first quarter of the eighteenth century the growing volume of published work emphasised the need for more and better type, and underlined the unfortunate dependence of English book-sellers on Dutch supplies. Ultimately the trade had to find its own solution to a problem which had been created earlier by governmental restrictions driving native letter-founders out of the trade.

[1] Historian of Oxfordshire and of Staffordshire.
[2] Author of 'The Wonders of the Little World', 1678.
[3] John Evelyn, Diary.
[4] British Museum.
[5] British Museum, Burney Collection.
[6] Ibid.
[7] Mason Jackson, The Pictorial Press, 1885.
[8] Ibid.
[9] Visitation of Warwickshire, Harl. Soc., Vol. 62, 1911.
[10] Mason Jackson, The Pictorial Press, 1885.
[11] J. Larwood and J. Camden Hotten, History of Signboards, 1866.

Chapter Thirteen

CASLON AMONG THE PRINTERS
AND BOOKSELLERS

IT HAS BEEN necessary to look at many aspects of national and local history in the late seventeenth and early eighteenth centuries in order to appreciate the precise nature of the situation which had arisen when Caslon's particular flair for the forms of letters and their spatial relationship—and his equally notable skill in making the hard steel punches to produce them—were so opportunely expressed that his achievements not only placed him in the forefront of the punch-cutters of his own day and made his fortune as a letter-founder, but handed the name Caslon down to later times as a pattern of perfection. This sort of eminence was expressed by George Bernard Shaw in a letter to Frederick H. Evans dated 27 August, 1895, 'my principles are old face type—Caslon's if possible,' the addition of the words 'if possible' almost hinting that the Caslon standard might be unattainable.[1]

We are shortly to meet Caslon as a protégé first of William Bowyer, one of the foremost booksellers, and second of Thomas Guy, another notable bookseller, especially in the Bible trade, certainly the most celebrated philanthropist of his time, and we are also to see him as an instrument in furthering the plans of the S.P.C.K. in supplying the needs of the Christians of the near East for an Arabic version of the Scriptures. Before doing so, however, we must re-examine the story of Caslon which has come down to us.[2] The summary of this by Reed-Johnson was corrected in part in Chapter 7 and taking up the account from that point[3] we read

that 'some of his (Caslon's) book-binding punches were noticed for their neatness and accuracy by John Watts, the eminent printer who, fully alive to the present degenerate state of the typographic art in this country, was quick to recognise the possibility of raising it once more to its proper position. He accordingly encouraged Caslon to persevere in letter-cutting, promising him his personal support, and favouring him meanwhile with introductions to some of the leading printers of the day.'

This suggestion is misleading, for English letter-cutting had never before Caslon's time occupied a high position, both printers and founders depending largely on foreign workmanship.

Continuing the account from Reed-Johnson, we read, 'About the same time, it is recorded that another great printer, the elder Bowyer "accidentally saw in the shop of Mr. Daniel Browne, bookseller, near Temple Bar, the lettering of a book, uncommonly neat ; and enquiring who the artist was by whom the letters were made, Mr. Caslon was introduced to his acquaintance, and was taken by him to Mr. James's foundery in Bartholomew Close. Caslon had never before that time seen any part of the business ; and being asked by his friend if he thought he could undertake to cut types, he requested a single day to consider the matter, and then replied he had no doubt but he could. From this answer, Mr. Bowyer lent him £200, Mr. Bettenham (to whom also he had been introduced) lent the same sum, and Mr. Watts £100".'

'With this assistance Caslon established himself in a garret in Helmet Row, Old Street, and devoted himself with ardour to his new profession. An opportunity for distinguishing himself presented itself shortly afterwards. In the year 1720 the Society for Promoting Christian Knowledge, acting on a suggestion made by Salomon Negri, a native of Damascus, and a distinguished Oriental scholar, "deemed it expedient to print for the Eastern Churches the New Testament and Psalter in the Arabic language for the benefit of the poor Christians in Palestine, Syria, Mesapotamia, Arabia and Egypt, the constitution of which countries allowed of no printing." A new Arabic fount being required for the purpose, Caslon, whose reputation as a letter-cutter appears already to have been known, was selected to cut it. This he did to the full satisfaction of his patrons, producing the elegant English Arabic which

figures in his early specimens. The Society was, according to Rowe Mores, already possessed of a fount of Arabic cast from the Polyglot matrices in Grover's foundry. But Caslon's fount was preferred for the text, and in it appeared, in due time, first the Psalter in 1725, and afterwards the New Testament in 1727.'

While it is difficult to unseat a tradition which has been accepted for two hundred years it must be admitted that the romantic element in the above account strains credibility. First Bowyer already knew that Caslon was capable of cutting punches, and when the account says 'he asked him if he could undertake to cut types,' it should surely have read 'to cast types.' Caslon already had his own establishment in Vine Street and he was no doubt already cutting punches there. It was therefore the equipment for a foundry for which Bowyer, Watts and Bettenham were supposed to supply the capital. Moreover, £500 was a great deal of money in those days and whilst one cannot doubt the kindly spirit which animated Caslon's three patrons, they were also all three business men who would look for some security for their loan, and it is on this question of security that history is silent. In order to appreciate what is said to have been done, this amount of £500 might be compared with the total subscribed to the Bowyer Relief Fund by the united charitable resources of the London bookselling and printing fraternity only a matter of about seven years before Caslon's foundry was established. Leaving out of account the sums Robert Nelson obtained for Bowyer, £25 from the Earl and Countess of Thanet; £20 from Lord Weymouth; £10 from Lord Guildford; and £412. 7. 0. besides; Mr Sherlock £48. 17. 6; Cambridge University £40; the Dean and Chapter of Canterbury £30 and his 'Cousin Scott' £10. 10. 0, but including £66. 3. 3. collected by Richard Sare as chiefly from those of his own kind,[4] the total collected from about 120 booksellers and printers was £371. 13. 3., an average of about three guineas apiece.

It is clear that while charity was active in those days, life was hard and money not easy to come by. William Bowyer the elder became one of the most eminent men in the printing trade, but they were not all as successful and many died the opposite of wealthy. In testimony to this it may be added that James Bettenham, one of Caslon's patrons, actually described as eminent,[5] left behind

him only £400 after sixty years labour. What John Watts was worth when he died in 1763, aged 85, has not been ascertained. Nevertheless, it is puzzling to conjecture what sort of security Caslon's patrons could see for their collective loan of £500, if this romantic tale is true.

What is perhaps an equally strange part of the story is that Bowyer was allowed to show Caslon the processes in operation at James's foundry. In those days type-founding was an 'art and mystery,' just as printing had been. The workmen were bound to silence ; so faithful were they that there appeared to be some risk of type-founding becoming one of the lost arts. Moxon wrote,[6] 'I cannot learn anyone hath taught it to any other, but that every one that has used it, Learnt it of his own Genuine Inclination.' Mrs Eleanor James presented a silver cup to the Bowyer Relief Fund, but however highly Mrs James esteemed Bowyer, it was an exceptional privilege for him to be allowed to show Caslon all the processes, which we must assume to have happened if the tradition is true and if the visit were to serve the purpose of enabling Caslon to make up his mind. The notion that a business man of Bowyer's standing would risk his own money and persuade his step-son-in-law Bettenham to do the same, putting up £400 between them, while John Watts, reputed to be the first to recognise Caslon's merits, staked only £100 on the venture, seems unlikely, to say the least, especially when the story suggests that Bowyer had only recently made Caslon's acquaintance.

Other legends have gathered round Caslon's name, for example, the Andalusian story of his origin, now disproved and the writer believes that a more rational explanation of the loan of £500 must be found before it can be accepted as a fact. In 1720 when Caslon is reputed to have started his foundry he was twenty-seven years of age and had been out of his time for seven years and a freeman of the city for three years. The list of booksellers and printers who were Bowyer subscribers conveys some idea of a numerous profession. The Company of Stationers formed a fraternity well-known to one another and had their hall in Farringdon Ward, not far from the King's Printing House. Reviewing all these names and circumstances it seems that Caslon was not a new star suddenly appearing to dazzle the printing world. It seems more likely that

from 1717 when he first became a freeman he had been steadily increasing his clientele among the stationers, making bookbinders' punches, possibly making music-printers' punches for Watts,[7] and letter punches to replace losses in defective founts, whilst at the same time continuing the bread and butter work of engraving on firearms and other articles.

William Bowyer the elder[8] (1663–1737) was the son of John Bowyer, citizen and grocer of London, by Mary, daughter of William King, citizen and vintner. He was apprenticed to Miles Flesher in 1679 and admitted to the freedom of the Stationers' Company in 1686. He had no issue by his first wife and by his second wife, Dorothy, daughter of Thomas Dawks (a printer who had been employed on Bishop Walton's Polyglot Bible) and widow of the bookseller Benjamin Alport, he was the father of William Bowyer the younger (1699–1777), 'the learned printer,' and of a daughter, Dorothy, married to Peter Wallis, a London jeweller.

As previously noted, Bowyer's printing office was in Dogwell Court, Whitefriars, and it was here that the disastrous fire occurred on 29 January, 1712–13, which was followed by a remarkable display of sympathy from his fellow printers and booksellers. After continuing his business at the houses of friends, he returned to Whitefriars in 1713, the year William Caslon completed his apprenticeship, and became the foremost printer of his day, until the fame of his learned son overshadowed his.

As was customary among prosperous tradesmen William Bowyer had a country house at Leyton in Essex, as well as the necessary accommodation for family, journeymen and apprentices at his printing office in Whitefriars, where one of the family lost his life in the fire of January, 1712–13.

Bowyer is said to have first seen Caslon's lettering on a book at Daniel Browne's at the Black Swan and Bible without Temple Bar. This was quite remote from the Minories and suggests that it might have occurred before Caslon went there, that is, while he was still in Farringdon Ward; indeed Farringdon Ward seems to have been well-populated by booksellers, which is understandable since so many congregated in and about St. Paul's Churchyard. A list of those appointed to administer the Oath of Abjuration in 1715[9] provides some indication of the standing of the booksellers,

for in the Ward of Farringdon Within, a total of nineteen names includes no less than seven booksellers or binders, viz., Thomas Simpson, Daniel Midwinter, John Baskett, Samuel Ashurst of Paternoster Row, John Williams of Blackfriars, John Taylor of Blackfriars, and Samuel Hoole, all of whom are named in the Bowyer list with the exception of Ashurst, who at this time was probably included as one of Baskett's associates at the King's Printing House. Booksellers appointed to administer the Oath in other wards are much fewer, and include John Morphew in Aldgate Ward, Awnsham Churchill in Castlebaynard, John Darby and Timothy Goodwin in Farringdon Without.

We must now make a brief return to the West Midlands. Caslon's earlier introduction to the London booksellers may have been influenced by someone from his own district who became established in the London trade at an earlier date. In view of this possibility the following entry in the Halesowen parish register should be noted :

'January, 1729-30 : Mary Williams of Bleakfryers, London, buried.'

We have learnt previously that it was a common practice for boys from country families to be apprenticed to a London master and it is not to be supposed that the cases mentioned in the course of this work were by any means exceptional. Nor does it follow that if someone named Williams from Halesowen found his way to London before Caslon's time, the two would necessarily be acquainted ; it is not even certain that the person Williams derived from Halesowen. All that can be said is that there was some connection between Halesowen and Blackfriars. However, further searching brought to light the following marriage at Halesowen :

'January, 1687—John Williams and Mary Holloway married.'

The pedigree of the Halesowen Caslons,[10] compiled from parish registers and probate records, shows that Caslon's father George Caslon, cordwainer, died in 1709 when forty-eight years of age, leaving a widow Mary who was only about forty years of age. There is no entry of Mary Caslon's burial at Halesowen under the name Caslon, so one surmises that she joined her son William in London, probably when he had completed his apprenticeship.

If she had there remarried and become Mary Williams of Black-friars, we have here another possible explanation for Caslon's introduction to the booksellers, for Blackfriars had notable connections with the book-trade, not only through its individual booksellers, but because the King's Printing House was situated there, and Stationers' Hall was also close at hand in Farringdon Ward.

Mary Williams probably died while on a visit to her relations; if she were the former Mary Caslon, she might have been visiting her daughter Mary, wife of Humphrey Coley.[11] What adds some support to this supposition is that only two months later, in March, 1730, 'Ralph Stephens of the Town' was also buried. This was the name of Mary Caslon's brother, the last of the Rowley Regis family of Stephens, Stevens, or Steven, to which Caslon's mother belonged, the last of three Ralph Stevens' in direct line and, more-over, the Halesowen register does not include any other Stevens having this Christian name. Ralph Stevens, baptized in 1670, having outlived two wives, his second wife Sarah Freeman having died in 1727, may have found a refuge in the last few months of his life in the home of his sister's family.

Burials in the parish where death occurred were then gener-ally the rule on account of the expense incurred and the time taken in carrying a deceased person back to his or her own parish. Caslon's first wife Sarah Pearman was buried in her native Clent in November, 1728, probably because she also died whilst visiting her relations. When Caslon contracted his second marriage in September, 1729, he may have thought it expedient for his mother to return to Halesowen and join her brother; if so, she survived only four months and her brother only six.

Blackfriars was a precinct or 'peculiar' within the Ward of Farringdon and maintained a separate identity until 1735, when it became merged in the city. About 1727 the precinct contained 393 houses but only two persons kept coaches.[12]

The Land Tax assessments for the precinct of St. Anne, Blackfriars for the years 1715–18 yield the following information[13] concerning John Williams of Blackfriars who is doubtless the same as that John Williams of Blackfriars who was appointed to administer the Oath of Abjuration in 1715.

1715–16
 Old Printing House ⎫
 New Printing House ⎬ These three bracketed
 John Williams ⎭ together as shown.
1716–17
 Exactly as above
1717–18
 His Majesties (sic) Old Printing House
 His Majesties (sic) New Printing House
 John Baskett
 John Williams.

Here, however, no slung bracket is inserted. Also, a Mary Williams is included in the same assessments.

The bracketing of the name of John Williams with the King's Printing House in 1715–16 and in the same context with John Baskett in 1717–18 may have had some significance in relation to Mary William's burial at Halesowen and William Caslon's position with the booksellers. The Land Tax assessments yield no information on the families of those assessed, so we do not know whether John Williams at the King's Printing House had a wife, Mary or other name, or a daughter Mary living with him, or whether the Mary Williams separately assessed was wife to John Williams (improbable unless his dwelling-house was assessed separately under her name), or whether Mary Williams was his daughter, daughter-in-law, or a widow of that name.

H. R. Plomer provides the following information on John Williams :[14]

John Williams, senior, bookseller at several places 1636–76 and finally at the Crown, St. Paul's Churchyard, 1676–83. Benjamin Tooke was one of the witnesses to his will.

John Williams, junior, Crown in St. Paul's Churchyard, 1672–84.

This is slender evidence, but we find also from Plomer that James Knapton was at the Crown in St. Paul's Churchyard as early as 1687 the same year that John Williams married Mary Holloway at Halesowen, so Williams evidently gave up publishing and he may have become a printer at the King's Printing House. Although there is no certainty that John Williams, junior, is the same as John Williams later of Blackfriars, the connection with

Tooke suggests that he was the same, as his name occurs again in connection with John Baskett.

John Baskett, King's printer, is first heard of as addressing a petition to the treasury praying that since he was 'the first that undertook to serve his Majtie with parchment cartridges for his Majties fleet, by which means he saved his Majtie severall thousand pounds,' he might be appointed 'one of the Comrs, Comptroller or Receiver,' being 'places to be disposed of by the late duty upon paper, etc.'[15] The petition was not dated ; but it must have been written about 1694, as the act for duties on vellum, paper, etc., was passed 5 William and Mary, C.21.[16] The origin of the Bible-patent dates from Christopher and Robert Barker,[17] in whose family it remained down to 1709. The patent was then held by Thomas Newcomb and Henry Hills, from whose executors John Baskett and some others purchased the remainder of their term. In 1713 Benjamin Tooke and John Barber were constituted queen's printers, to commence after the expiration of the term purchased by Baskett, that is, thirty years from 1709, or January, 1739. Baskett bought from Tooke and Barber the reversionary interest, and obtained a renewal of sixty years, the latter thirty of which were subsequently conveyed by the representatives of the Baskett family to Charles Eyre and his heirs for £10,000 (a sum which conveys some idea of the value of the Bible patent).

Henry Hills, one of those from whose executors Baskett and partners purchased the right to print Bibles, was appointed printer to Cromwell and at the Restoration became printer to Charles II. In 1660 the University of Oxford farmed out to Hills and to John Field, in consideration of £80 per annum, for four years, its privilege of printing Bibles. Hills was continued in the office of King's printer in the reign of James II. It is amusing to read that when, as a result of his conversion to Roman Catholicism, his confessor enjoined him by way of penance to trudge five miles with peas in his shoes, it was rumoured that he boiled his peas.[18] His conversion would certainly render him unpopular in Blackfriars, where he had his printing office 'near the waterside.' for the precinct was a stronghold of dissent in the seventeenth century. Hills regularly pirated and printed upon coarse paper every good poem and sermon that was published. In a poem in Lintot's *Miscellanies*,[19] the following lines occur :

'While neat old Elzevir is reckoned better
Than Pirate Hills brown Sheets and scurvy Letter.'[20]

The piracies of printers like Hills led to the direction in the statute of 8 Anne that 'fine paper copies' of all publications should be presented to the public libraries. The *Evening Post* of 12 Nov. 1713 announced that Henry Hills, 'printer in Black Fryers,' being dead, his stock was to be disposed of at the Blue Anchor in Paternoster Row.'[21]

Returning to John Baskett, we find that besides being connected with John Williams at the King's Printing House he was also linked with him in the printing of Bibles and other scheduled books for Oxford University. Falconer Madan informs us[22] that in 1688 the printing presses were removed from the Sheldonian Theatre for fear of injuring the building by their continued working. The Learned Press moved to a building at the North end of Cat Street, formerly known as Tom Pun's house, and the Bible Press to a house in St. Aldate's, but the Sheldonian imprint was still used. The Bible Press was leased for 21 years to the Stationers' Company. After that the succession of partners (or managers or undertakers, not necessarily the same persons as the actual printers) on the Bible side seems to have been, in 1715, Mark and John Baskett; 1716–41, John Baskett; 1742–4, Thomas and Robert Baskett. Further, Madan also informs us that the Learned Press was leased to Bp. Fell's executors on April 26, 1688; to Messrs. Isted, Mortlock and Bellinger on Jan. 27, 1691–2; to Messrs. Mortlock, Philips and Lownes on June 4, 1698; to Messrs. Philips, Mortlock and Andrews on Sept. 20, 1703; and Jan. 1, 1708–9; to Messrs. Williams, Baskett and Ashurst on Jan. 2, 1711; to Messrs. Baskett, Ashurst and Gosling on June 28, 1734; and to Thomas Baskett on Sept. 28, 1744 for 21 years. The above lists (says Madan) are not quite complete.

The progression of lessees of the two sides of the University Press are somewhat confusing and the state of things is rendered more confusing by mortgages on the leases. With reference to the concession by the University of the right to print Bibles and other scheduled books at Oxford to John Williams, John Baskett, and Samuel Ashurst, Stationers of London, an agreement, dated 2 January, 10 Anne (i.e. 1712–13) is recited in a deed in the possess-

ion of the University Press[23] transferring a mortgage by Baskett from James Brooks, Stationer, to Henry Latane.[24] The deed held by the University Press is dated 23 May, 1720, and it recites a deed of declaration of 6 January of the same year witnessing that Williams and Ashurst declared that their names were used in the agreement of 10 Anne only as trustees for Baskett of two-thirds of the profits from Bible-printing at Oxford and that they relinquished to him all their rights under it.

The above serves to establish that John Williams was a stationer, and therefore possibly identical with John Williams, junior, the former bookseller, last recorded in that capacity in 1684; moreover, it establishes that he was still alive on 6 January, 1719–20.

For the sake of brevity, what is known concerning John Williams is calendared below :

John Williams I (1636–83) stationer, Crown, St. Paul's Churchyard.

John Williams II, free by patrimony, 7 August, 1670.[25]

John Williams II, stationer, Crown, St. Paul's Churchyard (1672–84). Admitted to the Livery, 7 March, 1679–80.

John Williams and Mary Holloway married at Halesowen, January 1687.

John Williams II, Lessee with Baskett and Ashurst of the Learned Press at Oxford, Jan. 2, 1711.

John Williams II, Trustee with Ashurst for Baskett's lease of the Bible Press at Oxford, Jan. 2, 1713.

John Williams, bookseller, subscriber to Bowyer's Relief Fund 1713.

John Williams and John Taylor of Blackfriars appointed to administer the Oath of Abjuration in Blackfriars precinct, 1715.

John Williams and Mary Williams assessed for Land Tax in the parish of St. Anne, Blackfriars, 1715–18.

John Williams declares himself (with Ashurst) a trustee only for John Baskett, 6 Jan. 1719–20.

John Williams II voted as a Liveryman of the Stationers' Company at the 1724 election.[26]

John Williams II did not vote as a Liveryman of the Stationers' Company at the 1727 election, so he was most probably dead.[27]

A John Williams was buried at St. Anne, Blackfriars, 24

December, 1727, but his name does not appear in a rather
badly mutilated return of house-holders in that parish in
1727[28]

Mary Williams 'of Black-fryars, London,' buried at Hales-
owen Jan. 1729–30.

A search in the Principal Probate Registry for the years
1724–30 for the will of John Williams failed to produce any
tangible result,[29] so that apart from knowing that there was a link
between Halesowen and Blackfriars, we are still left to conjecture
what influence the connection had on Caslon's early career. The
extreme ubiquity of the names John and Mary Williams is, of
course, a formidable obstacle to finding a convincing answer to the
problem.

However, although we have failed to find positive evidence
of when and where William Caslon's mother was buried, this
investigation contributes something to knowledge of the book-
sellers with whom Caslon probably became acquainted. Henry
Hill's printing office until 1713 was 'near the Waterside' and while
the King's Printing House was a little further away, it should be
noted that Blackfriars Stairs and Whitefriars Stairs (near Bowyer's
printing office) were adjacent at the river-side, except that the New
River ran between. Blackfriars led down to the river from St.
Paul's Churchyard and Ludgate, the latter leading into Fleet
Street whence Water Lane ran down to Whitefriars and the river.[30]

John Taylor the bookseller, formerly of St. Paul's Church-
yard and father of William Taylor of the Ship in Paternoster Row,
retired about 1713 and moved to Blackfriars for we find his name
linked with John Williams's in 1715 in administering the Oath
of Abjuration. In 1703 he instituted an annual sermon at the Bap-
tist Chapel in Lincoln's Inn Fields to commemorate his escape from
death in the great storm. It is therefore a fair inference that he was
a Baptist. If Caslon had any connection with Williams it affords a
hint of how he became friendly with John Watts, who had his
printing-office cheek by jowl with the Little Wild Street Meeting.[31]

It has been seen that Caslon's connections in the West Mid-
lands also included those families at Clent associated with his
master Edward Cookes who had married Elizabeth Shenstone,
aunt of the future poet. First, there was Thomas Pearman, a but-

cher of Clent, who had married Edward Cookes' sister Mary, and whose daughter Sarah became Caslon's first wife and grandson John became Caslon's first apprentice : second, there was Thomas Pearman's brother Nicholas, a man of some standing who had married Sarah Waldron, and along with Thomas Nash, was a churchwarden in 1702, and Nicholas's son John had been apprenticed to him.

A search of the Clent register revealed the following interesting entry in the handwriting of the vicar, Thomas Walker :

'1688—John Buncker of Layton in the Diocese of Lyncoln and Barbara Walker were married the 31st of December'

As it turned out, the bride was a relative of the vicar and the question arises as to the parish of origin of the bridegroom, especially when it is known that William Bowyer lived at Leyton in Essex. Bacon's *Thesaurus Rerum Ecclesiasticarum*, 1786, shows that there is no such place as Layton or Leyton in the diocese of Lincoln and, in fact, no Leyton other than that known as Leyton or Low Leyton or Leytonstone, contiguous with Walthamstow in Essex. To assign Leyton in Essex to the diocese of Lincoln is a puzzle only unravelled by tracing the descent of the manor of Leyton.

The *History of Leyton* by John Kennedy, a former vicar, recites that Sir William Rider (or Ryther), Lord Mayor of London in 1600, dying in 1611, left the manor of Leyton to his two daughters, Mary, wife of Sir Thomas Lake, and Susan, wife of Sir Thomas Caesar. In 1649 the manor again changed hands, being purchased in three shares by Captain George Swanley, Bernard Ozler and Robert Abbot. John Smith, a merchant of London (who appears to have been a native of Lincoln), bought Abbot's share, and left it by will to the poor of the parishes of St. Swithin's and St. Peter's, Eastgate, in the city of Lincoln, and it thus became vested in the Mayor and six senior Aldermen of that city, together with the Overseers of that parish in the city. Abbot's share of the great tithes, with the right of presentation to the vicarage at every third vacancy also formed part of John Smith's bequest and the whole manor and the right of presentation were not reunited until John Pardoe's purchase of the moieties was confirmed by Act of Parliament in 1795.

It will be seen that Thomas Walker's reference to Leyton being in the diocese of Lincoln was not strictly accurate, but the error serves to confirm that the entry does in fact refer to Leyton in Essex.

Thomas Walker was the vicar of Clent for more than fifty years, actually from 1668 to 1719, and his diligence in carrying out his duties is reflected in the care with which he kept the parish register. Foster gives his university record as follows:

Thomas Walker, cler. fil. Wadham Coll. matric. 1657; chorister Magdalen Coll. 1658–9; clerk 1661–2, B.A. 1661; usher of the College School 1662–3; M.A. from St. Alban Hall, 1666.

In view of the Leyton connection it was thought worth while to refer to Walker's will,[32] of which an abstract is given below:

Abstract of Will of Thomas Walker, of Clent, co. Stafford, Clerk. Made 2 March, 1719; proved 6 Feb. 1720.
In the Name of God Amen ...
Body to be decently buried at the discretion of my executrix hereafter named.
My debts and funeral expenses to be fully paid and discharged.
To my cousin John Cox son of John Cox of Hollow Cross in the parish of Clent aforesaid sythsmith my great Bible.
All my study of books of what sort soever unto my nephew Humphry Pretty.
To my cousin Ann Cox wife of ye aforesaid John Cox the elder one of my cows within one month next after my decease. All other my household goods Money debts due and owing to me at my decease Implements of husbandry and personal estate whatsoever alive or dead within doors and without and of what nature kind or quality soever unto my niece Mary Bunker her executors and assigns for her care and trouble in waiting upon and looking after me.
Sole Executrix the said Mary Bunker.
Mr Roger Waldron to be Overseer.
Witnesses: Edward Sheward: Signed: Tho: Walker.
The Mark of Mary X Gopp
Wm. Waldron.

The family of Cox was widely dispersed long before the beginning of parish registers and they were especially numerous in the West Midlands. There are over sixty entries of the name in the

Chart 9.
Family of Cox
of Hollow Cross, Clent

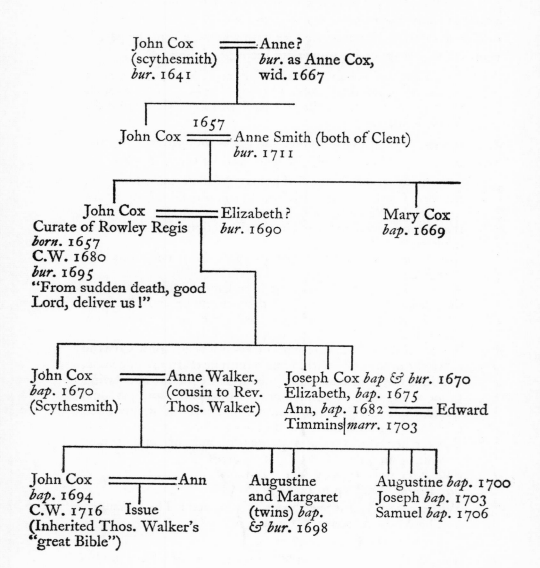

John Cox (scythesmith) *bur.* 1641 ══ Anne? *bur.* as Anne Cox, wid. 1667

1657

John Cox ══ Anne Smith (both of Clent) *bur.* 1711

John Cox
Curate of Rowley Regis
born. 1657
C.W. 1680
bur. 1695
"From sudden death, good
Lord, deliver us!"
══ Elizabeth? *bur.* 1690

Mary Cox *bap.* 1669

John Cox *bap.* 1670 (Scythesmith) ══ Anne Walker, (cousin to Rev. Thos. Walker)

Joseph Cox *bap & bur.* 1670
Elizabeth, *bap.* 1675
Ann, *bap.* 1682 ══ Edward
Timmins *marr.* 1703

John Cox *bap.* 1694 **C.W.** 1716 (Inherited Thos. Walker's "great Bible") ══ Ann Issue

Augustine and Margaret (twins) *bap. & bur.* 1698

Augustine *bap.* 1700
Joseph *bap.* 1703
Samuel *bap.* 1706

first volume of the Clent register 1561–1627, so it will be understood how difficult it is to differentiate between the several branches of the family even with the aid of probate records. Thomas Walker's will mentions his cousinship to John Cox senior of Hollow Cross, Clent (a hamlet between Clent and Belbroughton to which the Pearmans belonged). Fortunately, an early scribe has distinguished some of the Cox entries in the margin of the register by the initials 'H.C.,' signifying that they were of the Hollow Cross family, and enabling a skeleton pedigree to be constructed.

The Hollow Cross branch of the Coxes engaged in the traditional occupation of the district, namely, scythe-making, in which the Waldrons and Nashes were also engaged, families appearing among the earliest entries in the register. Nashes also appear in the registers of Waltham and Leyton, and Bowles Nash, son of Thomas Nash of Clent who was co-warden with Nicholas Pearman in 1702, married Palentis Ricketts in 1726 at St. Matthew, Friday Street, London. What Bowles Nash was doing in London is not known, but as in other branches of the iron trade it was customary for the scythe-smiths and other edge-tool makers to have a London warehouse or an agent to see to distribution and shipment of articles manufactured in the provinces and the makers also displayed and sold their wares at the principal fairs.

A certain John Cox was vicar of Leyton from 1662 to 1669, when he became rector of Stapleford Abbots in the same county, Charles II being the patron of the living.[33] Unfortunately this John Cox cannot be recognised as a graduate of Oxford or Cambridge, but since Charles Lyttelton of the Hagley family was high in favour with Charles II, it is tempting to believe that he was one of the Clent Coxes. However, John Cox was succeeded as vicar at Leyton by John Strype (1643–1737) the well-known ecclesiastical historian and biographer and although Thomas Walker was a graduate of Oxford while Strype was of the younger university, there can be no doubt that they knew each other, as will be seen presently.

Foster's list of Oxford graduates records one of the Hollow Cross Coxes as follows:

John Cox, s. of J. of Clent, co. Stafford, p.p., matric. at Balliol Coll. Oxford, April 1675, aged 17; B.A. Mar. 1678-9.

According to his age at matriculation, he must have been the son of John Cox and Ann Smith (see Chart 9) and born in 1657. In 1679 he was licensed to the Chapel of Rowley-Regis under the vicar of Clent, although his name does not appear in the Rowley register. He was a churchwarden at Clent in 1680 and died in 1695, when the vicar added to his burial entry:

From sudden death, good Lord, deliver us!

He was followed as curate at Rowley Regis by Henry Williams, M.A., of Jesus College, Oxford, a kinsman of Henry Williams, M.A., butler of Jesus College, who died in 1679. It was noted in Chapter 2 that John Underhill, another Clent graduate, was a tutor at Oxford for a number of years. It was John Cox, son of the former curate John Cox, who married Anne Walker and was named as 'cousin' in the vicar's will.

It will be seen that John Cox and Anne Walker gave two of their sons the unusual name Augustine and herein lies the clue to the antecedents of the vicar and his cousin Anne, of whom they were evidently quite proud. Joseph Foster comes to our aid again:

Augustine Walker, of Bucks., pleb. New Coll. matric. 1576, aged 18, scholar 1576, B.A. 1580, M.A. Jan. 1583–4; of the city of London, clerk, licensed 5 June 1591, to marry Barbara, daughter of Thomas Wykyn, of St. Ethelburgh, London; rector of Ilmington, co. Warwick, 1586–1632.

Thomas Walker's university record does not give his parentage nor his age at matriculation. He was, however, the son of a cleric, so that his father was almost certainly that Thomas Walker who became Vicar of Leamington Priors, co. Warwick, in 1634; he was also an Oxford man and also son of a cleric —as we have seen, son of Augustine Walker of Ilmington, co. Warwick. The name of Barbara Walker who married John Bunker of Leyton probably came down in the family from Barbara Wykyn.

In 1684 Thomas Walker married Anne Pretty of Churchill.[34] They had no children and at Anne's death in 1714 the burial entry shows that she had been an invalid for many years. The bereaved vicar appended the following text to the entry:

'*Heb 12:6, Whome the Lord loveth he chasteneth.*'

We have seen that there was a family link between the Vicar

258

of Clent and the parish of Leyton in Essex and at the time Caslon was an apprentice in London, Barbara Bunker of Leyton was probably nursing the vicar's invalid wife and at the time Caslon married Sarah Pearman of Clent was actually keeping house for the vicar. It seems highly probable, therefore, that whatever relations Caslon had with Bowyer at his printing house in White-friars, he first met him at Leyton through the Clent Pearmans.

It seems likely that in his more active years Thomas Walker kept in touch with friends in London, for the following advertisement appeared in the *London Gazette* for 10 April, 1690.

'Stolen or strayed from Mr Thomas Walker's stable, vicar of Clent, in Staffordshire, a black nag, 6 years old, about 14 hands, a small white star, the grease fallen into the hoof, and the hair cut off both fetlocks behind. Whoever gives notice of him to Mr Walker aforesaid, or to Michael Armestead at the *Angel and Rose* in Newgate-street, shall have 20 shillings.'[35]

The vicar was an ardent Royalist, of which evidence has survived in the following lines which he wrote on a blank page in the parish register :

'Upon y^e Martyrdome of King Charles y^e first,
 who was beheaded Jan. 30^th, 1648.

'Great, just & good, could I but sate
 my teares w^th thy too rigid fate,
I'de weepe y^e worle to such a straine
 y^t it should deluge once againe.'

Walker was at Wadham at a period when the College was the most flourishing in the University and he must have known some interesting characters. The warden was John Wilkins (1614–1672),[36] who held office from 1648 to 1659 and was one of the most tolerant intellectuals of his time. Youths of promise, including the sons of cavaliers, were attracted by his learning and versatility. During his wardenship the college numbered among its *alumni* Christopher Wren, Seth Ward, John, Lord Lovelace, Sir John Denham, Sir Charles Sedley, Thomas Sprat, Samuel Parker and William Lloyd. Musical parties were held in the college and foreign artistes welcomed there. Who can doubt that Thomas

259

Walker, as a student of Wadham and chorister of Magdalen, exercised his talents at these parties. Several of the London 'philosophers,' the 'Invisible College' of Robert Boyle, who were the seeds of the Royal Society, migrated to Oxford in these troubled years and their weekly meetings were resumed in the warden's lodgings. The London Society regularly corresponded with the Oxford branch, which counted among its members 'the most inquisitive,' to borrow a phrase of John Evelyn, members of the university. Prominent among these were Seth Ward, Robert Boyle, Sir William Petty, John Wallis, Jonathan Goddard, Ralph Bathurst, and Christopher Wren. Of this brilliant group Wilkins was the centre ; and he deserves, more than any other man, to be esteemed the founder of the Royal Society, which was incorporated in 1662, and of which Wilkins was the first secretary. In 1668 Wilkins was made bishop of Chester and at his death in 1672 he left bequests to Wadham and the Royal Society.

An Oxford man who must have been well-known to Thomas Walker was Edward Lowe,[37] a noted musician, who became organist of Christ Church, Oxford, as early as 1630, and in 1648 was described as 'master of the choristers.' Towards the close of the Commonwealth he took a leading part in the weekly concerts held chiefly at the house of Dr. William Ellis, organist of St. John's. On resigning his post at Christ Church in 1656 he acted as deputy to Dr. John Wilson, professor of music at Oxford, succeeding Wilson in 1661. At the Restoration he was appointed, along with William Child and Christopher Gibbons, one of the organists of the Chapel Royal, retaining this post till his death in 1682, when he was succeeded by Purcell. Lowe's first wife was Alice (died 1649), daughter of Sir John Peyton the younger of Doddington, Isle of Ely, by whom he had a large family. By a second wife, Mary, whose maiden name, unfortunately, is unknown, for this brings us back to our story, Lowe had a daughter Susanna, who married John Strype, the church historian and Vicar of Leyton. Knowing that Thomas Walker had relations in Leyton and recognising the interest in music shared by Walker and Edward Lowe, one wonders whether the vicar was the means of introducing John Strype to Susanna Lowe. It is a long shot which can go no further than conjecture until the name of Edward Lowe's second

wife is known. The marriage entry in the Leyton register reads as follows :

'7 Feb. 1681—John Strype Minister of this Par. Bachelor and Mrs Susan Lowe of Oxen Maiden, marr. at Oxen in Christs Church.'[38]

It is worth noting at this point that there are few entries of the name Low or Lowe in the Clent register in the seventeenth century. One of these few, however, left his name on record. The entry reads :

'Jan. 1656—Samuel, son of John Low and Margery born.'

This Samuel was at Pembroke College, Oxford, in 1675, but apparently did not graduate. In 1718 he became M.P. for Aldburgh which he retained till his death in 1731.[39] In the Staffordshire Hearth Tax Roll for 1668,[40] John Low was taxed on four hearths, so he was a fairly substantial man. Richard Amphlett, lord of the manor, had six hearths, Thomas Nash five, John Coxe (presumably of the Gatehouse) eight, John Waldron six, John Underhill five, the Vicar five, and two others four each.

There is evidence in the Clent register of the vicar's college friends coming to live in Clent. Nathaniel Wight was the son of a cleric and was at Magdalen Hall when Thomas Walker was a chorister there. He graduated from Merton in 1663, proceeded M.A. in 1667 and fellow. He became proctor in 1677 and at his death in 1682 was buried in the College chapel.[41] Nathaniel Wight's son, John Wight came to live at Hollow Cross about 1690 (sons William and Richard were baptized in 1691 and 1696). Nathaniel's son John (baptized before coming to Clent) had sons John and Nathaniel in 1719 and 1721. The first master of Amphlett's school at Clent in 1704 was Humphrey Pretty, Thomas Walker's brother-in-law ; the second master was William Waldron of Lower Clent who in 1722 married at Ilmington, co. Warwick (where Thomas Walker's ancestor Augustine Walker had formerly been rector), Mary Cox, only daughter of the Rev. William Cox, M.A. rector of Quainton, co. Glos. The third master of Amphlett's school was Nathaniel Wight, baptized in 1721 (grandson of Walker's college friend Nathaniel, the proctor of Merton) who married William Waldron's daughter Elizabeth. William Waldron's youngest daughter Sarah married Rev. John

Durant, rector of Hagley.[32] All this is another example of the nepotic influences prevailing in church and school appointments mentioned in Chapter 2.

John Strype (1643–1737), ecclesiastical historian and biographer, was the youngest child of John Strype by Hester Bonnell of Norwich. The future Vicar of Leyton was educated at St. Paul's school, was elected a Pauline exhibitioner of Jesus College, Cambridge, in 1661, migrated to Catherine Hall in 1663 and graduated B.A. in 1665 and M.A. in 1669, being incorporated M.A. at Oxford in 1671.[43] He was chosen perpetual curate of Theydon Bois, Essex, in 1669 but quitted it in the same year on being selected minister of Leyton where he remained for the long period of 68 years. He was probably presented to Leyton by Sir Charles Caesar, who was a benefactor of both Jesus College and St. Catherine College, Cambridge, and was of the same family as that Sir Thomas Caesar who earlier in the century had a share in the manor of Leyton.

These are not the only connections which strengthen the probability that Caslon met William Bowyer at Leyton. Caslon's master, Edward Cookes, was connected with the family of Cookes of Norgrove, Bentley and Feckenham, to which Sir Thomas Cookes, founder of Worcester College, Oxford, belonged, although the actual link with that family has not been found. On the death of Sir Thomas Cookes without issue in 1701, the male representation of the family devolved upon John Cookes of London, a linen draper of the parish of St. Peter's, Cornhill, where the register has a number of entries of the family of John Cookes and his second wife, Elizabeth, daughter of Sir William Russell, an alderman of the city.

Like William Bowyer, John Cookes had a country house at Leyton and there are references to him in the parish records there also. In 1716–1717 he was a church-warden along with Sir Harry Hicks and in 1717–18 his co-warden was Robert Bowyer, presumably one of the printer's family. Mary, daughter of John Cookes, married David Petty, citizen of London, and the Leyton register records that on 26 August, 1722, their only daughter Elizabeth (described as of St. Andrew's Undershaft, London) married George Carpenter, Esq. son and heir to George Lord

Carpenter, who was one of Bray's Associates. In 1729, another daughter Anne married John Smith, a widower, of St. Mary, Stratford Bow, co. Middlesex, and had a son John.

It should also be remembered that Edward Rowe Mores, the historian of letter-founding, was connected with Leyton. His father was rector of Tunstall in Kent, but had some property at Low Leyton, so that although Edward Rowe Mores did not live there until about 1760, he probably knew the place well and was doubtless acquainted with Caslon's connections there, thus heightening the interests he had formed at Oxford, matters dealt with more fully in Chapter 19.

Finally, it seems highly probable that in 1717 when William Caslon married Sarah Pearman, the ceremony was performed in the church of St. Peter, Cornhill, because the couple had friends in that parish, and it is quite possible that those friends were John Cookes and his family.

[1] Bernard Shaw: Collected Letters, 1874–1897, by Dan. H. Laurence; Max Reinhardt, London, 1965.

[2] John Nichols, Anecdotes of William Bowyer, 1782.

[3] Reed-Johnson, pp. 230–1.

[4] John Nichols, Literary Anecdotes of the Eighteenth Century, pp. 61–63.

[5] Reed-Johnson, p. 231; footnote 1.

[6] Ibid. p. 170.

[7] See App. 1.

[8] D.N.B. Art. William Bowyer: for further particulars of Thomas Guy see Chap. 16.

[9] Annals of King George, Year the Second, 1716.

[10] Appended to Chap. 2.

[11] Ibid.

[12] Maitland, London, 1739.

[13] Courtesy of the Guildhall Librarian, London.

[14] Dictionary of Booksellers and Printers, 1667–1725.

[15] Notes and Queries, 2nd Series, viii, 65.

[16] Cal. Treasury Papers, 1557–1696, p. 416.

[17] D.N.B. art. John Baskett.

[18] D.N.B. art. Henry Hills.

[19] Ascribed to Dr. Wm. King, (1663–1712).

[20] Plomer's Dictionary of Booksellers and Printers, 1667–1725.

[21] D.N.B. art. Henry Hills.

[22] A Chart of Oxford Printing, Bibliographical Society, Monograph No. 12, 1904.

[23] Obligingly communicated by Mr Harry Carter.

[24] Foster's Alum. Oxon. records Lewis Latane, s. of Henry, of 'Jouins Arguinne,' of Queen's Coll. matric. 1691. (The place names are doubtful but may refer to Jouan in Guyenne, France).

[25] Inf. from Clerk of the Stationers' Company.

[26] 27, 28, 29. Obligingly communicated by Mr R. E. F. Garrett.

[30] Ogilby's Map of London.

[31] Maitland, London, 1739.

[32] Worcester Record Office.

[33] John Kennedy, History of Leyton, 1894.

[34] Parish register of Churchill in Halfshire.

[35] John Amphlett, A Short History of Clent.

[36] D.N.B. art. John Wilkins.

[37] D.N.B. art. Edward Lowe.

[38] John Kennedy, History of Leyton.

[39] Foster's Alum. Oxon.

[40] William Salt Archaeological Society, 1923.

[41] Foster's Alum. Oxon.

[42] Sir Hugh Chance, The Coxes of Clent, 1961.

[43] D.N.B. art. John Strype.

Chapter Fourteen

SOME TECHNICALITIES OF PRINTING AND LETTER FOUNDING

ALTHOUGH IN THIS WORK the author has been principally con-cerned with biographical history rather than with the history of printing it will be necessary to explain briefly some of the technicalities of printing and letter-founding in order that the reader may understand Caslon's difficulties in embarking on a trade to which he had not been apprenticed. The few references to modern processes that occur are included solely for the purpose of seeing Caslon more clearly against his eighteenth century back-ground.

A printing type may be defined as a right-angled, prismatic piece of metal, having for its upper face a letter or other character, in reverse and usually in high relief, adapted for use in letter-press printing ; and type in the aggregate is an assemblage of the charac-ters used for printing. In a single type the chief points to be defined are the body, nick, feet, groove, face, counter, beard, shoulder, stem, hair-line, serif. (See Fig. 1).

The *body* (sometimes called the shank) comprises all the metal in the piece of type excluding the relief character on it. The *nick* is the slot across the front of the lower part of the body which forms a guide to the position in which it is to be set up. The *feet* are the projections on which the type stands and which are divided by the *groove*, this being the gap left between the feet when the jet formed in casting the type is removed. The *face* of the type is the surface of the character on its upper end which takes the ink to be

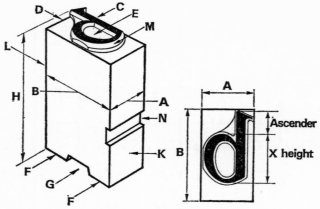

Fig. 1. Isometric view of letter 'b' in type

A – Set (adjustable in width for different letters)
B – Size of Body (stated as Point-size)
C – Face (the printing-surface here shown black)
D – Shoulder (supporting the reversed letter in relief)
E – Counter (the bottom of the well of enclosed characters)
F – Feet
G – Groove
H – Height to paper
K – Front (formerly Belly)
L – Back
M – Beard (or bevelled part of the letter in relief)
N – Nick (formerly semi-circular, now rectangular)

impressed upon the paper; the *counter* is the cavity or cavities between the members of the character on its upper end. The *beard* is the sloping part of the character in relief on the body between the face and the *shoulder*, this being the flat top of the body which supports the character in relief. The *stem* is the thick stroke of the printed character and the *hair-line* is the thin stroke of that character, the *serif* being the short cross-line at the terminals of members of the printed character.

A fount of book or newspaper type consists of all the charac-

ters usually needed in composition and includes the following sorts :

Roman capitals, small capitals and lower-case letters.
Italic capitals and lower-case letters.

Diphthongs	Punctuation marks or points.
Ligatures	Reference marks
Accented letters	Metal rules
Numerals	Leaders
Fractions	Braces
	Signs

together with spaces and quadrats.

It is unnecessary for the purpose of this book to deal fully with the number and combinations of characters which make up a fount of type for the compositor's use.

Ligatures are characters, such as fi and ffi which on account of one or both having overhanging parts are cast on one body. (See Fig. 11). Accented letters consist of the five vowels with certain marks over them, as acute, grave, circumflex, diræesis, long, and short, together with the cedilla with c, as in façade (from the French) and the tilde with the n, as in señ, cañon (from the Spanish). Characters are also cast representing accents only ; these are sometimes cast on separate bodies and used in combination with ordinary letters, particularly in Greek and Hebrew founts.

Every letter, ligature, punctuation mark or sign is a distinct character and these are placed side by side in a line according to the sense of the printing matter required. It has been said that the setting of the works of Charles Dickens will empty the vowel boxes long before those of the consonants, whereas the style of Lord Macaulay's matter will run heavily on the consonants. These are peculiarities which do not answer to analysis. Where indenting, termination of paragraphs, or other spaces are required, pieces of metal called spaces are inserted, which of course have no faces. Spaces are thick, middle, thin and hair spaces, these being respectively 3 to em (that is, three to make up the thickness of the lower-case m), 4 to em, and 5 to em ; the hair spaces range from 7 to 10 to an em. Spaces of one en (half an em), one em, two ems, three ems, and four ems are called quadrats or quads. Thus spaces and quads are concerned with the width of printed matter in a line.

The width of printed matter on a page is measured in pica ems, or in modern printing terminology it is stated as so many picas. If the compositor wishes to increase the proportion of white on a page he inserts between the lines thin strips of metal called 'leads,' the proportion of white depending on the thickness of the leads. The page impression can also be made to appear more open by casting a letter of the required 'point' size on a body of a larger point size. For example, the main text of this book is printed in 12 point Monotype Caslon cast on 14 point body.

Fig. 11. Ligatures and 'kerned' letters.

In italic and sloping founts some of the characters overhang the width of the body on which they stand and these overhanging parts must be supported by the shoulder of their neighbouring types, otherwise they would break off in the process of printing. Such characters are said to 'kern' or to be 'kerned.' (See Fig. 11) In the Ludlow machine these difficulties have been overcome by casting the italic characters on rhomboidal shoulders.

The British Standard Specification of Typeface Nomenclature (B.S. 2961 : 1967) was issued under the authority of the General Council following the deliberations of representatives of Government Departments, industrial and printing organisations, teachers of printing, The St. Bride Foundation Institute, and typographical experts.

The introduction states that 'from the earliest days of printing trade terms have been used which were passed orally from craftsman to apprentice; they related to the physical objects used in typographical printing processes, e.g. metal 'types.' Since the beginning of this century such terms have been used by designers and others outside the industry but, as they usually have no occasion to use the physical objects, they use the terms in more abstract

senses. For example, the word 'typeface' now commonly refers to the printed character left on the paper by the printing surface ('face') of the physical 'type.'

'Another factor which adds to the confusion is that (as in many other industries) established technical words are made to do service for new concepts that arise from new developments. Such confusion certainly arose after the invention of the pantographic mechanical punch-cutter and the hot-metal composing machine which largely replaced the hand-cut punch and hand composition. Photographic setting might have added to the danger of confusion in terminology, although the issue of the first edition of this standard reduced this to some extent.

'Often the context will prevent any misunderstanding of the sense in which a particular word is used, but this is not always the case, and confusion does arise in practice. It is now common practice for publishers, advertisers and other print buyers to give detailed specifications to the printers and it is, therefore, important to define terms in a manner that will avoid embarrassing and costly misunderstandings in commercial transactions.'

Then follows a paragraph on classification :

'The names of groups of typefaces now in general use have grown haphazardly over the past 150 years ; some of the names are descriptive but others are historical and, except to those well-versed in the history of printing and type design, have little meaning. Since the end of the last century, several attempts have been made to evolve a classification of typefaces, but none has found really wide acceptance. It has become increasingly evident, especially during the last ten years, that there is a real need for classification which can be accepted nationally, and preferably internationally, and which will facilitate discussions between typeface designers and printers, printers and print-buyers and teachers of typography and their students.'

The specification then mentions the classification proposals of Maximilian Vox in France and the Deutscher Normenausschuss plan of 1964 (DIN 16 518) saying that because of the importance the committee attached to international acceptance of a classification, it had itself accepted the Vox principles. See the specification for further details.

The author's impression of the specification is that the committee, like Horace's mountains, have laboured long to produce 'a laughable little mouse.' The way to rectify the confusion which has arisen over the years is not to change the meaning of terms which have their origins in the earliest customs of the trade but to ensure that the specification directs attention to the historical meaning of the terms used. From the invention of printing until long after Caslon's time and indeed into the present century printers used a system of mnemonics dependent on analogy to familiar things, for example, the printing used in the service of the church and the parts of human anatomy. If these terms seem childish to the moderns, they date from the childhood of the industry, and were simple enough to be understood by a child.

In some instances the committee seems to have made confusion worse confounded, as the following examples will show.

Type : 'A relief stamp of metal or other substance, cast or engraved, used in the composition of printed matter.'

The use of the term 'stamp' is unfortunate since it suggests a process quite different from the way the printers' type actually functions. A metal stamp produces an intaglio impression ; printers' type does not.

Fount : 'A collection of matrices, type or characters of a given type face and size [Note: From the compositor's point of view, this would be a case equipped with a sufficient quantity of types for the kind of work being undertaken.]'

Would it not be better to emphasise the difference between a fount of type and a fount of matrices by defining a fount as a collection of types or characters of a given typeface and size in sufficient quantity to carry out the work in hand or, by extension, the collection of matrices to cast it ?'

Typeface : 'A set of characters for printing intended to be used in combination, identifiable by their design, and usually available in a range of sizes.'

This definition would be much clearer if one or two examples were given, as Caslon 'Old Face'; Baskerville, etc. emphasising that the difference between typefaces refers to their appearance in print. Therefore replace 'A set of characters for printing' by 'A display of printed characters...etc.'; 'for printing' is imprecise.'

X-Height : 'The space allowed for the small letters of the lower case fount, e.g. x, z. This space is bounded by the base-line below and the mean-line above.'

It is a regrettable misuse of words to equate the height of those letters of the lower-case fount which have neither ascenders nor descenders to a *space*, a word which is applied indiscriminately to a surface area and a volume. When the writer was a five-year-old child he wrote his letters with a slate-pencil on a slate between lines scribed on its surface, so that what was then the most familar dimension to him has now become a mysterious X ! In those days the small letters were learned before the caps. But why define it? It is simply the minimum height of the lower-case letters of that typeface. And why fount?

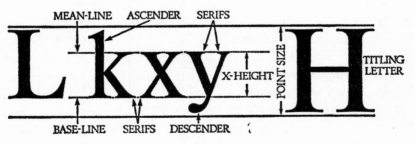

Fig. iii. Type-face nomenclature

Base-line : 'The line on which the base of most capitals and lower-case characters seems to rest.'

Mean-line : 'The line indicated by the top of the lower case x.'

Ascender : 'The part of certain lower-case characters, e.g., b, h, which rises above the mean-line.'

Descender : 'The part of certain lower-case characters e.g., y, g, which descends below the base-line.'

 In defining the X-height and the four succeeding terms, 'lower-case' is printed twice without the hyphen and three times with it. Such casualness should never occur in a set of definitions ; also the X- height is defined by making use of terms which are only defined below it, thus ignoring logical sequence. A diagrammatic illustration of these terms is all that is needed. See Fig. III.

Beard : 'This term refers to the physical type and indicates the distance between the base-line and the front of the body of the type.'

 To refer to that *surface* on the actual type which sometimes causes a bearded impression as a *distance* is absurd.

For the sake of brevity the definitions of Titling, Inline, Outline, Shadow, Monoline, Bracketed, Numerals, Latin, though not all exempt from criticism, will be passed over.

Roman is defined as 'That group of alphabets in the printers' fount which is distinguished from italic by verticality and the shape of certain lower-case letters.' Could anything be more ludicrous than to define the primary alphabets of the west by reference to the secondary italic?

Again, italic is defined as 'That lower-case and its accompanying capitals which is used as subsidiary in the printers' fount and is distinguished by the slope and, in the case of lower-case letters, by the shape of certain letters.' The phrase 'in the case of lower-case letters' should be deleted and the hyphenated word 'lower-case' inserted between 'certain' and 'letters.' Neither of these definitions, however, is satisfactory and students of typography should not be led to believe that the terms roman and italic can be properly defined without reference to their derivations.

A final example of unsatisfactory definition is taken from page 10, 'Classification of Typefaces.' In Category I, with reference to the 'Humanist' typeface, we read 'Typefaces in which the cross stroke of the lower case e is oblique ; *the axis of the curves is inclined*

to the left; there is no great contrast between thin and thick strokes ; the serifs are bracketed ; the serifs of the ascenders in the lower case are oblique.'

The meaning of the italicised sentence can be clarified only by stating the inclination of a line in relation to fixed axes of reference, usually horizontal and vertical intersecting lines. A specific inclination states the angle through which the axis of the curves rotates in the anticlockwise direction in relation to the fixed axes.

Some of the classifications of well-known typefaces are somewhat fanciful. Caslon, for instance, is listed under Category II— Garalde, in which again, one of the characteristics is that 'the axis of the curves is inclined to the left.' Caslon Old Face shows this characteristic in so few cases, lower-case b, c, e, p, and not at all in the capitals, that one must conclude it was not an intentional feature of the design, but rather incidental to the cutting of particular letters. Again, Baskerville is included in Category III— Transitional, along with Fournier, Bell, Caledonia, and Columbia, typefaces in which the axis of the curves is vertical or, again, 'inclined *slightly* to the left,' but Baskerville's lower-case b, c, e, show the same characteristic as Caslon's, confirming that neither Caslon nor Baskerville consciously designed their faces on these principles. Indeed, one can imagine Caslon returning to the scene of his former labours and, confronted with these theorists, settling the discussion by saying, 'Here are the tools, gentlemen, show me how you will cut the punches for roman lower-case c and e so that the axis of the curves is consistent with the other letters of the alphabet! The truth is that the men who cut these founts were concerned to make their designs harmonise throughout the alphabet ; to satisfy that requirement was sufficiently difficult. The printer generally selects his typeface because of certain qualities which are individual to that face in relation to the purpose which the printed matter has to fulfil, and not because it belongs to a certain class.

The origin of the letter forms used in English printing might be traced back to the origins of the alphabet but for our present purpose it will be sufficient to go back to the time when the medieval writing-hands began to divide into gothic and roman. This division was not the work of the early printers, for their aim was to

273

produce by mechanical means something which resembled as closely as possible a hand-written book, this being foisted on to their earliest clients with the object of selling a mechanical production at a price not suspiciously different from that of the hand-written article. That is, the early printers did not re-design letters, but imitated in type the pen-work of the calligraphers. The Gutenberg Bible was made to resemble a manuscript Bible of the same age. On the other hand our books distantly resemble manuscripts written for the Italian humanists of the fifteenth century which was a development of the Caroline minuscule.

When in 1575 our typographers, mainly foreigners, decided to print the English Bible in roman, producing what we know as the Genevan, or 'Breeches' Bible, they had evidently decided to favour the humanistic design and to reject the gothic or black-letter style. This was really the culmination of the competition between the two schools which had been going on for two centuries, for as early as 1366 we find Petrarch complaining of the lack of legibility in the European script then in vogue, later misnamed gothic. He and the calligraphers whom he employed wrote a rounder hand, with long ascenders and descenders, which was half-way to the script we know as roman. The men who wrote it and the first printers who cut it as type for texts other than Bibles and Liturgies were abandoning the medieval calligraphic standard of beauty for a standard of legibility. When reform was carried still further, the hand was evolved that we know as roman, the most legible of all scripts.

The calligraphers who used the formal gothic hands of the Middle Ages drew their letters with great deliberation. The upright character of these letters, set close together, resulted in a page which resembled a woven fabric; hence the German name *Textur* and the English word *Text*. Though the gothic pages cannot be matched for beauty, the quantity of reading matter which has to be scanned by the human eye commits us primarily to the standard of legibility.

As early as 1500 the Venetian roman had undergone modifications resulting in a type which is essentially the design to which we have reverted today. The roman types cut for Aldus were the direct ancestors of the French designs of Claude Garamond which

remained the standard European type for two centuries. The Dutch punch-cutters of the seventeenth century and through them our William Caslon accepted the Garamond design as their pattern.

The modern face, the letter of the nineteenth century and still dominant in book-types today, is an invention of the eighteenth century. Phillipe Granjean, working for the Imprimerie Royale, in 1702 produced the first design which showed a tendency towards the modern face. His principles were followed by Louis Luce and Fournier and by the beginning of the nineteenth century reached full development in the 'classical' style of Didot and Bodoni. Whilst the theorists place John Baskerville in the classical school we must remember his own statement that he worked in emulation of Caslon, seeking to improve his model; in fact, Baskerville was primarily an individualist, and only a schoolman by accident.

It has been said that the 'classical' school derived their design from the lettering of the engravers rather than from calligraphic tradition and the engraved title-pages reproduced in this book contrasted with their counterparts set in type will help the reader to appreciate this point. It is clear that the performances of calligraphers, engravers and printers must be to some extent functional, that is, the calligrapher must accept the limitations of his pen and writing-surface, the engraver those of his burin and copper-plate, and the printer those of his punch, matrix and type-metal. The boundaries of these processes are not sharply defined, so that the designer of any work intended to convey a visual message must exercise his judgment as to the best mode of doing it, allowing for all the factors operating in his particular circumstances, of which the economic factor is usually the most dominant. The typographer, therefore, has to recognise that the method he chooses for conveying his message, whilst allowing him some scope for exercising an artistic licence and satisfying his aesthetic taste, usually has to prove viable in a commercial climate. Baskerville, the brothers Fry and the later Caslons all had the mortifying experience of an unreceptive public bringing about a harsh economic squeeze.

We may note, then, that the followers of the 'classical' school cut flat serifs instead of the old bracketed serifs; they adopted

sharp contrasts between the thick and thin parts of letters, reducing the thin parts until they became hair-lines. In the round lower-case letters the thickest part was in the centre, as though made with a pen held at a right-angle to the line, so that the angle of shading was vertical. In the calligraphic tradition the pen was held at an angle to the line of less than a right angle, and the angle of shading was diagonally across the page. In the heyday of classical printers a critic of the Didot design claimed that the exaggerated contrast between the thick and thin strokes led to confusion between the m, n, and u, saying that the Garamond design was more easily read as well as more beautiful.

However, the exponents of the modern face ultimately prevailed and held their own with few exceptions throughout the nineteenth century. We had never led the way in typography and it is one of the accidents of history that we followed the French and adopted the roman letter at all. This is now almost our only letter, for italic, the other humanistic script, has taken a minor place, being used principally to emphasise certain words and phrases in a text wholly roman. All that our printers ask of italic today is that it shall harmonize with the roman, so that it tends to become little more than an inclined roman.

Yet italic was once an independent letter with a genealogy as ancient and in some ways more interesting than that of roman. Just because italic was not the principal type, it was less bound by tradition and could vary within wider limits. In origin it is as old as the roman, though it was later when it appeared in type. It was a cursive variety of the humanistic script adopted at the Papal Chancery for the indicting of briefs, and was thus named *Chancery Script*. Its essential characteristic was its cursive quality, whether it was written upright or inclined, but when it was rendered in type-metal and descended to the use of English printers, the word italic seems to have become synonymous with sloping. This may have been due to a tradition created by the French designers, who largely controlled European trends in typography including, through the Dutch, our own.

The application of modern-face principles to the design of italic faces dealt a death-blow to the adoption of any nineteenth century italic as a separate letter suitable for use as a book-type.

The modifications introduced by Baskerville in the eighteenth century were not as extreme as those of the later 'classical' school. Probably Baskerville was unconscious of setting any trend and it is also unlikely that he had any real knowledge of the historical development of letters otherwise he would not have used a curve of contra-flexure in the bowl of his roman lower-case a, although Fry made it much worse.

The book-types now used by publishers who make any aesthetic claims show that almost all the type-faces in use today derive from the eighteenth century, a confirmation that in due time history will pronounce its verdict on the numerous other type-faces that modern production methods have enabled designers to spawn on the world.

It is in the reading of books that the eye becomes most fatigued and it is therefore to type-faces for books that the test of legibility is most rigorously applied. The design of display faces admits of other considerations and yields more readily to what may prove to be no more than a current vogue. While a book-type should efface itself so as not to distract the mind of the reader from the message the text conveys, a display type is intended to arrest the attention and perhaps implant a thought before the sense of the words is properly grasped. But of course both should also aim to satisfy aesthetic requirements. In the author's view waywardness in the design of type-faces has been carried too far today.

Having considered very briefly the letter-forms which have come down for use in printing we must look at the process of printing itself. The invention of printing by movable type is rightly regarded as one of the most notable epochs in furthering western culture and it is now over five centuries since type was first cast in Europe for the printing of books. Yet it should be emphasised that the invention of printing ought to be called the invention of type-founding for that was the kernel to which all the other printing paraphernalia was merely the shell. And it can also be said that the principle of typefounding today is the same as it was before 1500—that is, there are the same three steps in type-founding—the cutting of the punch in steel, the making of the matrix in copper, and finally the casting of the type itself in a material in which lead is the basic metal. Moreover, as a comment

on the specialisation of today, the early punch-cutters did not have their designs prepared for them, whereas nowadays it is scarcely possible to find a single craftsman who is at the same time a capable punch-cutter as well as his own designer.

The classic method, still undoubtedly the best, is to cut punches by hand, a method which allows the most minute corrections to be made. The punches should be cut in close collaboration with the designer of the letter; almost daily meetings are necessary in order to interpret the type-designer's intentions aright. When Caslon cut his punches for the fount of Arabic, he met Salomon Negri, his supervisor for the outlines, and Samuel Palmer the printer, two or three times a week. Although the designer is obliged to make his drawings on a larger scale than the size of type required, the translation of a drawing into the reversed letter on a punch will always be a matter of strictly individual craftsmanship, and it is intimate cooperation combined with fine craftsmanship which finally produces a good printing type.

Various devices have been invented to cut both punches and matrices mechanically; but the distortion inseparable from the mechanical reduction of the design prevents a machine-made punch or matrix from reaching the same standards as one produced by hand. One method, that of taking a drawing or a photograph sharpened with Chinese white, enlarging it pantographically, correcting it in its details by mechanical curves and reducing and transferring it to a pattern arranged for the punch or matrix-cutting machine, has not by itself been sufficient to produce a meritorious result. Although this is not the only method which has been employed by modern type-founders no other method used in complete substitution for the arduous work of hand punch-cutting has produced a design of permanent value for the printing of books. New type-founding methods are therefore more suitable for the reproduction of existing types than for the creation of new ones.

Nothing can replace the trained eye of the designer and the experience of the skilled punch-cutter, so even if punch or matrix-cutting by machine can be effected with marvellous precision when the right model is at hand, a skilled punch-cutter should be on the spot continually to effect the refinements which the trained eye of the expert finds necessary.

The truth of this is proved in the execution of the Telegraph Modern type introduced in May, 1969, and illustrated in the June, 1969, issue of the *Journalist*. Whatever Walter Tracy the designer intended, the resulting type-face, produced by the most modern methods, displays faults which even the seventeenth century would have regarded as serious. Under a 96 point impression of capital M we read : 'Typical of Tracy's ingenuity is the opening-up of the "crotch" joins, as in the cap M here, so that ink fill-in will not blur the angle. To contrive the openings on the punches a special micro-tool was devised.'

Fig. iv. Specimens of Telegraph Modern Type.

Unfortunately, when cutting the crotch, the micro-tool was allowed to cut into the members on both sides of it, causing four quite visible blemishes in the letter. The impression of the lower-case n also shows faults, the upper right-hand edge of the left leg of the letter being cut off at an angle to the vertical. What is worse, the straight edges of the right-hand leg are not tangential to the inner and outer curves of the arch. A skilled hand punch-cutter could have rectified these faults.

Probably not one reader in a thousand appreciates the degree to which he is critical as to size and alignment of type. The ease with

which the eye detects want of alignment in two contiguous lines is used by the engineer in the simple vernier to assist him in obtaining the desired degree of accuracy. A difference of one thousandth or one two-thousandth of an inch in alignment is readily apparent, and a difference of one two-thousandth or one three-thousandth of an inch in the size of a character is easily noticeable. Not only must the character be of the correct size and truly spaced, but the proper proportions of thickness of stroke, length of serif, and so on, must be maintained throughout the fount. Moreover, the way in which our eyes play tricks with us when scanning the characters on a printed page must also be allowed for, thus adding to the difficulties of designing, punch-cutting and justifying. The characters on the printed page must be made *to appear* equal in size and *to appear* to be in alignment.

If the characters on the printed page were made equal in their dimensions and really true, they would appear unequal. In order to allow for these optical illusions deviations from true size, shape and thickness must be deliberately introduced to make the characters appear true and uniform. The Athenian architects recognised these requirements in designing their buildings. Almost all the characters in printing type have some optical peculiarity which must be allowed for if they are to appear true; for example, the round sorts must be larger than the square sorts if they are to appear the same size. The upper part of the lower-case s must be smaller than the lower part; the lower-case t must not be vertical, nor of uniform thickness in the main stroke, or it will appear to lean backward; the dot must not be placed centrally over the main stroke of the lower-case i or it will appear to be on one side; the strokes of the w must be slightly curved at the lower extremities in order that they may appear to be straight, and so on. In capital letters the vertex of A must rise above the height of the other letters while the vertices of V and W must descend below the base line; moreover, these allowances should not be the same proportion of letter height in all sizes of a particular alphabet.

An example of exaggeration in such allowances is seen in the *Monotype Newsletter*, Seventy-Ninth Issue, 1966, commemorating the bicentenary of the death of William Caslon. The word RAILWAY is printed twice in 42 point Garamond style on page

6 at different spacings ; owing to the exaggerated height given to the letters A and W, the out-of-line vertices obtrude on the eye. See Fig. v.

RAILWAY
RAILWAY

Fig. v. Exaggerated correction for optical illusion in letters.

It is clear that the elimination of optical distortions of the kind mentioned calls for long experience as well as skilful design and ingenuity. These considerations increase our admiration for William Caslon who, though not apprenticed to any branch of the printing trade and limited by the much cruder mechanical aids of his time, was enabled by superior ability to rescue English printing from its reliance on foreign workmanship.

It seems rather remarkable at first sight that in a period of nearly three hundred years so little has been written on the work of a letter-founder's punch-cutter that what Joseph Moxon (1627-1700) wrote in 1683 must serve as a guide to the way William Caslon set about his work in 1720. Mechanical trades changed very slowly, however, in Moxon's and Caslon's time, and the methods followed by their practitioners excited little interest as subjects of special study. The techniques of handiwork were not regarded as answering to specific principles but as trade secrets to be handed down only to apprentices bound by a certain ritual. While the Royal Society was founded to encourage more rational enquiry into natural phenomena and to try to relate cause and effect the Society was still in its infancy and many members entered into its deliberations in a dilettante spirit rather than one of true scientific enquiry.

Moxon was himself elected a Fellow of the Royal Society in 1678 and though he seems to have been a Jack-of-all-trades, he deserves high praise for the thoroughness with which he explained the mechanical trades of his own day. It can scarcely be doubted

that Caslon was quite familiar with Moxon's text-book ; indeed, one criticism of Caslon's italic is directed at the slope of his *A*, *V*, and *W*, in which the angle of the thicker down strokes is the same as the italic slope itself, viz., twenty degrees to the vertical, a design which conforms exactly to the drawing of those two letters in Moxon's book. So it will be worth while noting briefly what Moxon has to say on punch-cutting generally.

He noted the various kinds of steel available to smiths in his day, Flemish, Swedish, English, Spanish, and Venetian, concluding that they might all be of good or poor quality. Mentioning that the English steel was made in several places, including Yorkshire, Gloucestershire, Sussex, and the 'Wilde' of Kent, he testified that the best was made around the Forest of Dean.

The punches for letters of Great Primer size and upwards were forged as required, but for smaller letters they were made from steel in the form of square rods and cut off to the lengths required. Moxon also referred to the use of old files, especially mentioning the use of the three-square file as a counterpunch for capital A. He suggested that the length of a punch from the face to the hammer end should be about an inch and three-quarters, long enough for the larger letters and short enough for the smaller letters, adding, however, that the shank of the punch for the smaller letters must be stout enough at mid-length to resist bowing when it was driven into the copper.

It is interesting to see how carefully Moxon estimated the amount of steel he would need to make the punches for a fount of roman or italic. The size of the face of the punch depended first on the height and thickness of the body of the letter, whether an em, or an en, or a space or other thickness on which the resultant letter was to stand. For lower-case roman he considered the number of letters having ascenders in their respective thicknesses, those having descenders in their respective thicknesses, the long letters in their thicknesses and those only of minimum height also in their respective thicknesses : He noted which of these letters would require counter-punches, that is, those having enclosed counters such as the bowls of a, b, d, e, g, o, p, q, and ampersand and those having semi-enclosed counters such as c, h, m, n, s. For the roman capitals for which of course there were but two excep-

tions to the uniform height Moxon again analysed their widths, noting also the counterpunches required for A, B, D, O, P, Q, and R, and those for the semi-enclosed bowls of C, G, etc. He applied the same considerations to the numerals, diphthongs, ligatures and other special characters and in this way was able to arrive at a close estimate of the steel required in its several sizes for a particular fount.

In the case of any letter requiring to be counter-punched sufficient metal was left outside the outer profile of the letter scribed on the face of the main punch to resist the tendency for the counter-punch when struck to crack or burst the main punch. This allowance in some cases increased the height and thickness of the face to about twice its finished size. The extent to which the punch-cutter relied on counter-punching as opposed to engraving depended on the skill and predilections of each craftsman. No doubt the majority of craftsmen concluded that it was easier to reduce the outside of a counter-punch to the correct inner profile of a letter in the same way that the main punch was reduced to the correct outer profile of the letter than to cut and engrave the inner profile to the correct depth and precise shape direct on the face of the main punch.

Before working on the letter-punches or counter-punches with gravers, files, or other tools the steel was well annealed, that is, brought to a red heat and cooled as slowly as possible or, better still, by heating it and allowing it to cool in a crucible packed with bone-meal or soot.

The procedure in counter-punching small and large punches was different. For letters of less than Great Primer size the punching was done cold. After the completion of the counter-punch it was hardened and tempered. Then the letter-punch for which it had been made, still carrying the additional metal round the letter-shape, was gripped hard in the vice in an upright position. After carefully positioning the counter-punch on the face of the letter-punch the counter-punch was driven in (Moxon says two thin spaces deep)[2] with a hammer. The beard of the counter-punch being cut at an angle of about 100 to 110 degrees to its face forced the material of the letter-punch apart during penetration and the extra metal left on the letter-punch was designed to prevent crack-

ing. The letter-punch was then reduced to the correct outer profile of the letter on its face, the angle of the beard of the letter-punch being finished as close as possible to 100 to 110 degrees to the face.

If the letter to be counter-punched was of Great Primer size or larger the letter-punch was heated to blood-red, screwed quickly in the vice, and the counter-punch, this time hardened but not tempered and gripped in a hand-vice, was punched in as before. After completing the operation of counter-punching the punch-cutter was then able to set to work flattening and smoothing the face of the punch and removing the superfluous metal round the correct outline of the letter as before. As the engraving of the punch progressed the face was smoked with the soot from a candle-flame and an impression taken on a piece of fine surface paper and compared with an impression similarly taken from the corresponding standard character. The smokes were examined by a magnifier and the work continued until the required degree of accuracy was obtained.[3] Work of the necessary accuracy required the continued use of a magnifying glass, combined with the skill to produce the correct curves. At the beginning of this century it was considered essential to have an accuracy in handwork of this kind correct to three ten-thousandths of an inch.

In 1764 P. S. Fournier gave the proper depth for the counters of small types as one forty-eighth of an inch which seems small enough for that time; alternatively J. M. Fleischman (fl. 1740–1765) sank his counters to a greater depth. Both of these craftsmen had their advocates.

English punch-cutters used counter-punches until the early years of this century, yet many craftsmen, particularly of the German school preferred to dig out the counters with engraving tools. While the use of counter-punches was probably a safeguard against the nicking of the inside-edge of the face of the punch and the reproduction of the defect in the matrix and type, much depended on the skill and individual preference of the craftsman. These, however, were difficulties of a former age, for electro-deposition on originals cut in soft metal has been practised for many years, especially in the making of matrices for larger types. This and other modern processes, however, have no place in an account of Caslon's life and work.

A punch as completed by Caslon bore on its face the reversed design of a single character as it appeared in print. It was driven into a slab of copper, which became the matrix—that is, the mould in which finally was cast the type from which the printing was done. It will be appreciated that the metal displaced to form the impression in the copper when the hammer struck the punch flowed plastically into another place, thus distorting the copper slab. To allow for rectifying its shape—a process called *justification* — the depth of strike was in excess of the depth of impression necessary in the finished matrix. Under the old conditions of printing there was real risk of complex punches breaking under the pressure exerted from the interior of the metal in flowing into its ultimate form, for the printing of those days necessitated deep strikes. The depth of strike varied with the size of letter. In Moxon's time, for letters of Long Primer and less, he suggested a 'thick space,' that is, a quarter of a Pica body, or about 0.04 inch; for larger bodies up to Canon, he suggested a Pica en, or about 0.088 inch. Early this century a strike of only 0.02 inch was adequate for the bulk of newspaper work and less, of course, for process and half-tone blocks printed on a high surface.

The depth of the counter below the type face and the height of the typeface above the shoulder had a considerable bearing on sharp and clean printing. The beards of the counter-punches and main punches had to conform to an angle of 100–110 degrees with the face of the punch in order to avoid too great a stress on the edges of the face when sunk into the matrix as well as to allow for easy ejectment of the type from the matrix when cast; in short, this angle was a necessary evil, although it was one of the principal causes of bad printing.

It should be remembered that Caslon's types were made to meet the conditions of his own time. Until the eighteenth century the 'height to paper' of much of the type in use was far less uniform than it is today. Consequently the types had to be forced into the paper to ensure that the letters which were low in height printed with a sufficiently clear impression. Not only was softer paper used to assist this process but the paper was also dampened. The process of forcing the type into the paper was called giving it 'sock.'

Eliminating the effect of irregularity in 'height to paper,'

however, created other problems, for the effect of squeezing the damp paper caused it to swell between the lines, so that if the type was well inked some of it might be drawn from the beard of the types, causing a hairy impression, or if the counters of the larger letters were too shallow the ink in the counters might reach the swollen paper during printing. If the type was composed solid, that is, without leads, there was small risk of 'bearding' occurring between lines, but at the top, and especially at the bottom of a page where the swelling of the paper was not held by a higher or a lower line, what was called 'page-bearding' might occur.

Although Caslon achieved greater accuracy in 'height to paper,' than those before him, his types were still printing on the paper and with the ink of his predecessors, so that while the 'sock' was reduced, it was not until later in the century, when Baskerville's example led to printing with better inks and on harder and smoother papers that the amount of 'sock' was reduced substantially. Ultimately the improvement was so marked that no permanent indentation was left in the paper after printing, so that the former 'sock' impression became instead the 'kiss' impression. Caslon cut his punches to allow for the defects in the printing of his own time, so that if his types are used on present-day papers the resulting impression appears rather anæmic as compared with the printing of the same letters by eighteenth century methods.

In June, 1750, *The Universal Magazine* published an article on letter-founding, taken almost verbatim from Moxon, with an engraving showing the interior of Caslon's foundry. Doubtless this view is largely imaginary, since it shows in the foreground the two halves of a letter-mould, which again reproduce exactly the diagrams shown in Moxon's book.

The simplest form of hand-mould consists of two halves which are generally somewhat similar in appearance. Both halves are built up of pieces of hardened steel, ground, lapped true and screwed together. Type-moulds are made of definite size for 'body,' but they vary for the width or 'set,' the parts being fitted with stops which close on the matrix (previously justified, of course) and obtain from it the correct 'set' width ; the width of each matrix is therefore the set, plus a constant.

In the direction of the height of the type, the mould is wider

than the length of stem, so as to provide for the gate for the injection of the molten metal. In one part of the mould the raised beads for producing the nicks in the type are inserted, and in the counterpart grooves are ground and lapped to fit the raised beads, which are exposed in the mould for more or less length as the set of the type to be cast requires.

Modern type-metal will flow between surfaces only half-a-thousandth of an inch apart and even less than this under some conditions, so that when new the fit requires to be accurate to one ten-thousandth part of an inch. These figures convey some idea of the degree of skill required of a letter-founder's mould-maker. As in the case of lapidaries' work the finishing was usually done by means of lead laps. While in Caslon's time the composition of the type-metal was different and the cruder appliances in use resulted in the rubbers and dressers having more work to do to prepare the types for the compositor, the work of the mould-maker was still onerous and exacting. A different mould was required for each body, and since the nicks differed for different faces of the same body, separate moulds were required for each separate arrangement of nick. The moulds were also different for spaces and quads, owing to the fact that they were lower in height. It will be seen therefore that the number of moulds necessary for a foundry turning out many typefaces and of the ordinary range of sizes was very great and represented a large capital outlay.

Tradition states that William Caslon's brother Samuel was the type-founder's mould-maker, but the Halesowen parish register shows that Samuel was William's cousin. Unfortunately, defects in London parish registers prevent us from knowing as much about Samuel as we would like to do. His marriage is recorded at St. Paul's Covent Garden in 1734, when William Caslon issued his first and now famous specimen sheet, but then, owing to the defects mentioned, there is no further record of him until the baptism of a daughter at St. Luke, Old Street, in 1743, when Samuel is described as a cutler. Samuel Caslon was seven years William's senior, and therefore more knowledge of his whereabouts before 1734 might throw a clearer light on William Caslon's own beginning in type-founding. As it is, we can do no more than surmise that Samuel was mould-maker for his cousin William

287

during that busy decade prior to Caslon issuing his first specimen in 1734, but whether Samuel had any earlier experience as mould-maker to another type-founder is a question that still remains unanswered.

[1] See Reed-Johnson, pp. 32–36.

[2] A 'thin space' was one-seventh of the body and in finishing the punch the depth of the counter was reduced from two thin spaces to one thin space.

[3] Moxon describes in detail all the operations and the tools used in producing a letter-punch in the seventeenth century, even specifying the various files and their sizes. For our purpose, however, a general description will suffice.

Chapter Fifteen

SOME TITLE-PAGES OF BOOKS BEFORE THE CASLON ERA

THE PLATES IN this chapter are illustrations of the title-pages of books from the fifteenth century until the time when Caslon began to raise the quality of English printing in the eighteenth century. The sizes given are in inches, width by height, and represent the page area, not the print area, unless otherwise stated.

PRINTED IN VENICE, 1484

PLATE 17 shows a page of a Latin Vulgate Bible printed in black letter text at Venice in 1484. The Bible is open at Psalm LXXXXI (91), the page area being 6.6 x 9.4 inches. The initial letters of the paragraphs were written by hand in colour, the printer inserting a letter in type for the guidance of the illuminator; these guide-letters are partially obscured by the illuminator in some places, but in Psalm 94, the V of the word 'Venite' is clearly seen through the faded ink. In the earliest years of printing, books had no title-pages; the information which we usually see on the title-page of a book was originally given in the colophon. A translation of this colophon is given below:

'This copy of the Holy Bible translated from Hebrew and Greek sources has been accurately finished in the glorious city of Venice with most perfect printed characters. It was completed by Herbert Selgenstat of Germany a pupil of

the renowned Master John, easily surpassing all others at this time. This great work was accomplished in the year of the Lord of Heaven MCCCCLXXXIIII (1484) on the first day of May.'

The surname of Master John is of course conjectural, although John Gutenberg (1400-1468) was certainly the most renowned of the early printers named John and Venice was one of the earliest centres of the new art.

PRINTED IN SOUTHWARK, 1537

PLATE 18

THE COVERDALE BIBLE

THE BYBLE

that is the holye Scrypture of the
Olde and Newe Testamente faythfully
translated in Englysh and newly
ouersene and correcte.

MDXXXVII

Imprynted in Southwark by James Nycolson.
Set forth with the Kynges moost gracious licence.
Black letter 5.6 x 8

The Plate illustrates the New Testament title-page: 'The new testament faythfully translated and lately correcte by Myles Coverdale . . . etc.' This is generally considered the third edition of the Coverdale Bible, the second English Bible printed in England, but the first in the quarto size. There is no perfect copy of the Coverdale Bible in existence.

The border is a woodcut in four parts chosen without relevance to the contents of the book it is intended to embellish, a common practice at this date. The large black letter used in the first line was over-inked and probably stood high in relation to its neighbouring type and decoration.

290

PLATE 19

CHRISTOPHER RICHERII THORIGNEI SENONIS
Cubicularii regii & Cancellario Franciæ à secretis,
De rebus Turcarū ad Franciscum Gallorum regem
Christianiss.
Præfatio
5.1 x 7

The colophon reads as follows :
Excudebat Rob. Stephanus Hebraicarum et
Latinarum Literarum Typographus Regius
Parisiis, Ann. M.D.XL.III. Non. Martii.

Henry Estienne (1460–1520) and his second son Robert
(1503–1550) were two members of a notable family of scholar-
printers working in Paris during the golden age of French typo-
graphy. The house of Estienne, better known by the Latin form of
the name, Stephanus, became famous for the high scholarly
character of the Greek and Latin classics they produced. Robert
Estienne was especially noted for his compilation of Latin, Greek,
and Hebrew dictionaries which were soon adopted by the univer-
sities. His books, many of them printed with types designed by
Claude Garamond (d. 1561) and with borders, initials, and orna-
ments engraved by Geofroy Tory, are extremely beautiful. He
strove for accuracy as much as beauty and was accustomed, it is
said, to hang up his proof sheets near his shop and near the univer-
sity, and to offer a reward to anyone who could discover an error
in them. His typographic ability was recognised by his title,
'Printer to the King for Hebrew, Greek, and Latin.'

This is a fine specimen of the type design which, descending
through two hundred years of French and Dutch printing, ulti-
mately became a pattern for William Caslon to follow, and we are
amazed at the artistic and technical excellence of the best typo-
graphy of four centuries ago.

PLATE 20(a)

IOACHIMI PERIONII BENEDICT.

Cormoeriaceni de optimo genere
interpretandi Commentarij

PARISIIS

Apud Ioannem Lodoicum Tiletanum, ex
adverso collegii Remensis

M.D.XL.

CUM PRIVILEGIO

in quadriennium.

6 x 9

According to Philippe Renouard [Les marques typograph-
iques parisiennes des XVe et XVIe siècles, Paris, 1926–28],
Jean Lois was a native of Thielt who worked in Paris from 1535
to 1547 the year of his death. This title-page demonstrates the
tasteful layout of Parisian typographers even at this early date and
the printer's device has just the right weight to balance the text.
The over-inking of some of the type detracts from the overall
dignity of the page.

Joachim Perionius (1499–1559) was a Father in the Bene-
dictine Order whose work had evidently become a subject of study
in the College of Rheims in his own life-time.

In 1781 the book was in the Duke of Grafton's collection.

PRINTED BY THE ELZEVIRS, 1620

PLATE 20(b) shows a title-page by the famous house of Elzevir,
a family of Netherlandish printer-publishers whose dynasty lasted
over 150 years till 1712, including no less than fifteen printers
bearing the name. The founder of the family, Louis Elzevir, a
Protestant, had five sons who carried on the family activities in
Utrecht, Leyden, Amsterdam. The Elzevirs were not scholar-
printers like the Estiennes, but rather intelligent printer-publishers,
excellent men of business, who employed scholars to edit their
publications and see them through the press. They are chiefly
remembered for their pioneering of books in convenient *format*

and low price, while maintaining a reputation for clearness and solidity.

The example illustrated shows one of the family's best-known emblems, the 'sage' or 'hermit' standing beneath the branches of a tree, but the Elzevirs had at least five such emblems. One, a palm tree bearing the motto *Assurgo pressa*, was a device previously used by Erpenius, the professor of Oriental languages at Leyden, who conducted a printing office of which the Elzevirs took over the equipment. See Chapter 9.

Danielis Heinsii
ORATIONES;
Editio Nova ;
magna parte auctior.
Lugd. Batavorum
Ex officianâ Elzeviriana
4 x 6.5

Daniel Heinsius (1580–1655) was a Dutch Latin poet and historian. It is appropriate that an Elzevir title-page should be included here, for it was in 1733 that the complimentary title of the 'English Elzevir' was first applied to William Caslon.

PRINTED IN GENEVA, 1620

PLATE 21

NOVUM
JESU CHRISTI D. N.
Testamentum
The New Testament in Greek
with notes by Joseph Scaliger
GENEVAE
Apud Petrum de la Rouiere
CIƆ. IƆ C. XX
6.2 x 8.4

This title-page is again surrounded by a border built up in parts and more elaborate than that of the Coverdale Bible, PLATE 18. Considering the amount of text within the border the type is well-graduated down the page. It is also to be noted that the fragment of printers' flowers used as a cartouche occurs on George

Shelley's copy-book and was not despised by Caslon. On the whole the typography is satisfactory although the paper of the specimen described is extremely poor.

T. F. Dibdin (1776–1847), the bibliographer, writing in 1827, described this Greek Testament as the chief impression read by the modern Greeks; it was compiled from Plantin's folio edition of 1584, differing from it in about forty places. The remarkable advances made in textual scholarship since 1827, of course, do not deprive the specimen of typographical interest today.

PRINTED IN LONDON, 1635

PLATE 22, as the first illustration shown of a London imprint, forms a sad contrast with the examples of Estienne and Elzevir.

A COLLECTION OF EMBLEMES
ANCIENT AND MODERN
by George Wither

London, Printed by A. M. for Richard Royston, and are to be sold at his Shop in Ivie-Lane.

MDCXXXV

[1635–First edition–Small fol.] 6.6 x 11.3.

The page layout is quite creditable, but is ruined by the heavy inking of the large characters, amongst which some are battered. Richard Royston (1599–1686) was bookseller to three kings, Charles I and II, and James II, yet under the tyrannies which printers suffered he was unable, or unwilling, to guarantee better workmanship from his printer. The upper serifs of the M in 'emblemes' form an ugly feature of the letters and the N in 'moderne' shows two base serifs, a design not followed by Caslon. It may be noted here that the use of U and J in this country was not general until about 1630. In early times U and J did not exist, V being used for U, two V's for W, and I for J. From the eleventh to the sixteenth century I represented the vowel sound of I as well as the consonant sound of J. The curve of the J was one attempt to differentiate them in writing and the dot of the i survived in the

lower-case j when the tail was elongated. In compositors cases **J** and **U** still follow **Z**. So in George Wither's title page we find 'With' set with two V's side by side and in the name 'Wither' part of the limb of the first **V** is struck off so as to fit more closely to the second **V**.

The page also illustrates a restrained and dignified use of 'swash' capitals in the italic words, with a swash terminal *e* on the word *Divine;* it is odd, however, that the same word has not a swash capital *D*, and that the hyphenated Ivie-Lane has *Ivie* alone in italics.

The only perfect copy known of this book is in the British Museum. The plates were originally engraved by Crispin de Pas for the *Emblems* of Rollenhagius, and had appeared with mottoes in Greek, Latin, or Italian (Cologne, 1613, and Arnheim, 1616). They were purchased in 1634 by Henry Taunton, a London publisher, with a view to re-issue and George Wither (1588–1667), poet and pamphleteer, was employed by him to write illustrative verses in English, and published by Taunton in 1635. Wither was one of the few masters in English of the hepta-syllabic couplet.

LONDON, 1655

PLATE 23

STONE-HENG

The work of Inigo Jones (1573–1652) on the restoration of Stone Henge was originally commissioned by James I and this book was prepared from Jones's notes and diagrams by John Webb (1611–1672), his pupil and kinsman. The title-page shown is that of the first edition which appeared in 1655 in small folio 7 x 10.9, the author's copy having been in the Duke of Grafton's collection in 1781.

Here we see the lower-case form of the letter U used with capitals in the word 'ANTIQUITY'. This, a common practice in the seventeenth century, is a reminder that Garamond lower-case letters were the first used in the title of a book; before this titles had always been set in capitals. The title-page is dignified and entirely without decoration, although the upper part shows a little over-inking.

PLATES 24 and 25 show the type-set and engraved title-pages of the first edition of one of the most famous works in the English language. As a model of vigorous exposition, Hobbes' *Leviathan* probably still remains unsurpassed.

LEVIATHAN
or
The Matter, Forme, and Power
of a Commonwealth
Ecclesiastical and Civill,
By Thomas Hobbes of Malmesbury.
London : Printed for Andrew Crooke, at the Green Dragon
in St. Paul's Churchyard, 1651.
[First Edition—folio 7.6 x 11.9]

The letters are typical of the Dutch types in use in this country in the seventeenth century. The larger letters show the bearding which it was difficult to avoid in letters of larger size when irregularity in height to paper made it necessary to give the impression plenty of 'sock'. Otherwise, the page is dignified and well set-out ; of course, it is not now customary to punctuate titles.

The elaborately engraved second title-page almost fore-shadows the form taken by some of the early Oxford Almanacks, having the relevant information set out on a hanging banner. The printing well displays the greater contrast between thick and thin strokes characteristic of engravers' work, thus emphasising the functional difference between engraving and printing. The indifference of that age to correct spelling may also be noted, an additional letter L being used in the words 'civill' and 'ecclesiasticall' in the type-set title, whereas it is added to the word 'ecclesiasticall' only in the engraved version.

Thomas Hobbes of Malmesbury was born in the year of the Armada. His long life (1588–1679) spanned one of the most momentous periods of English history and he was one of its most conspicuous figures. It was not until the outbreak of the Civil War, when he fled to Paris and became tutor to the Prince of Wales, that he embarked on his greatest work, *Leviathan*, which was the

Uerútñ oculis tuis cósiderabis: z retributionez peccatoz videbis. Quil tu es dñe spes mea: altiísimü posuisti refugiü tuü. Nó accedet ad te mala z flagellü nó appropinquabit tabnaculo tuo Quil angelis suis mádauit de te: ut custodiát te in oibus vijs tuis. In manib⁹ portabüt te:ne forte offendas ad lapidé pedé tuä. Sup aspidé z basiliscü ambulabis: z cóculcabis leoné z draconé Quil in me sperauit liberabo eü; pregam eü quil cognouit nomen meü. Clamauit ad me z ego exaudiá eü: cü ipso sum in tribulatione: eripiä eum z glorificabo eü. Longitudine dierü replebo eü z ostendä illi salutare meü. Psalmus canticü in die sabbati. **LXXXXI**

Onü est cñfiteri dño: z psallere noi tuo altiísime. Ad annütiandü mane misericordiä tuä: z veritaté tuä p noctem. In decachordo psalterio: cü cántico in cithara. Quia delectasti me dñe in factura tua: z in operib⁹ manuü tuarü exultabo. Quä magnificata sunt opa tua dñe: nimis pfunde facte sunt cogitationes tue. Uir insipiés nó cognoscet: z stultus nó itelliget bec. Cü exoztñ fuerint peccatores sicut fenü: z apparuerüt oés q operantur iniquitaté. Ut intereant i seculü seculi: tu aut altissimus in eternum dñe. Quil ecce inimici tui dñe: qñ ecce inimici tui pibunt: z dispergent oés qui operantur iniquitaté. Et exaltabit sicut vnicornu cornu meü: z senectus mea in misericordia vberi. Et despexit oculus meus inimicos meos: z insurgétib⁹ in me malignantib⁹ audiet auris mea. Justus ut palma florebit sicut cedrus libani multiplicabit. Plantati i domo dñi: z atrijs domus dei nostri florebüt. Adhuc multiplicabunt in senecta vberi: z bene patiétes erüt ut annüciét. Quil rectus dñs deus⁹ noster: z nó est iniquitas in eo. Laus cántici dauid i die añ sabbati qñ fundata est terra. **LXXXXII**

Ominus regnauit decoré indutus é: indut⁹ é dñs fortitudiné z precinxit se. Etenim firmauit orbé terre: q nó cómouebitur. Parata sedes tua dñs ex tunc: a seculo tu es. Eleuauerüt flumina dñe: eleuauerüt flumina vocé suä. Eleuauerüt flumina fluctus suos: a vocib⁹ aquarü multarü. Mirabiles elationes maris: mirabilis in altis dñs. Testimonia tua credibilia facta sunt nimis: domü tuä decet sanctitudo dñe in longitudine dierum. Psalmus dauid quarto sabbati. **LXXXXIII**

Eus vltionü dñs: de⁹ vltionü libere egit Exaltare q iudicas terrä: redde retributioné superbis. Usqz peccatores dñe: vsq z peccatores gloriabunt. Effabunt z loquétur iniquitaté: loquentur oés qui opant iniustitiaz. Populü tuü dñe humiliauerüt: z hereditatem tuä vexauerüt. Uiduä z aduenä interfecerüt: z pupillos occiderüt. Et dixerüt nó videbit dñs : nec

intelliget de⁹ iacob. Intelligite insipiétes i pplo : z stulti aliqñ sapite. Qui plátauit auré nó audiet aut qui finxit oculü nó considerat. Qui corripit gétes non arguet: aut q docet boiem sciaz. Dñs scit cogitationes boium:qñ vane sunt. Beat⁹ bó qué tu erudieris dñe: z de lege tua docueris eü. Ut mitiges ei a dieb⁹ malis:donec fodiat⁹ peccatori fouea. Quia non repellet dñs plebé suaz: z hereditaté suä nó derelinquet. Quoadusqz iustitia cóuertat i iudiciü:z q iuxtä illä : oés q recto sunt corde. Quis cósurget mihi aduersus malignátes:aut q⁹ stabit mecü aduersus operantes iniqtaté. Nisi q⁹ dñs adiuuit me:paulomin⁹ babitasset in inferno aia mea. Si dicebä motus est pes meus:misericordia tua dñe adiuuabat me. Scdm multitudiné dolo⁹ meo⁹ i corde meo: cósolationes tue letificauerüt aiam meä. Nüqd adheret tibi sedes iuqtatis:q fingis laboré i pcepto Captabät in aiam iusti: z sanguiné innocenté códénabüt. Et factus é mihi dñs in refugiü: z de⁹ me⁹ in adiutoriü spei mee. Et reddet illis iniquitaté ipso⁹: z in malicia co⁹ dispdet eos: dispdet illos dñs deus noster. Laus cántici ipsi dauid. **LXXXXIIII**

Enite exultemus dño: iubilemus deo salutari nostro. Preoccupem⁹ facié eius in cófessione: z i psalmis iubilemus ei. Quil de⁹ magn⁹ dñs: z rex magn⁹ sup oés deos:qñ nó repellet dñs plebem suam. Quia in manu eius sunt oés fines terre: z altitudines montiü ipsius sunt. Quoniam ipsius est mare z ipse fecit illud z siccä manus ei⁹ formauerüt. Uenite adoremus z pcidam⁹ z ploremus ante dñm q fecit nos:qz ipse est deus noster. Et nos populus pascue eius:z oues man⁹ eius. Hodie si vocé eius audieritis:nolite obdurare cordave stra.Sicut in irritatione:sm dié téptationis i deserto.Ubi téptauerüt me patres vri:pbauerüt z viderunt opera mea. Quadraginta annis offensus fui generationi illi: z dixi semper bi errät corde.Et isti nó cognouerüt vias meas:ut iuraui in ira mea si introibüt in requié meä. Psalmus dauid quando domus edificabat post captiuitatem. **LXXXXV**

Antate dño cáticum nouü: cantate dño dis terra. Cátate dño z bñdicite nomini eius:annüciate de die in dié salutare eius Annütiate inter gentes gloriam eius: in omnibus populis mirabilia eius. Quoniam magn⁹ dñs z laudabilis nimis:terribilis est sup omnes deos.Quil oés dij gentiuz demonia : dñs aüt celos fecit.Confessio z pulchritudo in cóspectu ei⁹: sanctimonia z magnificétia in sanctificatione ei⁹ Afferte dño patrie gentiü:afferte dño gloriam z honorem:affrte domino gloriä nomini eius. Tollite hostias z introite in atria eius: adorate dominum in atrio sancto eius . Commoueatur

ꝑ 4

PLATE 17

The new testa=

ment faythfully translated
and lately correcte
by Myles Co
uerdale.
(∴)

Marke.xbi.

Go ye youre waye in to all the
worlde, and preache the Gospell
vnto all creatures.

Paull.Roma.i.

I am not aſhamed of y Goſpel of
Chriſt, for it is y power of God.

PLATE 18

De Tammerlanis

PARTHI REBVS GESTIS.

TAMMERLANES Parthus natione, genere obſcurus, in gladiatorium ludũ ab ineunte pubertate à parẽtibus miſſus, armis egregiè tractãdis ea vigilantia incubuit, vt pauculo etiam tempore cæteris longè ſuperatis, cognitu difficile reliquerit vtro magis, corporiſne viribus, an dexteritate vſu comparata, aut etiã aſtu atque feriendi induſtria valeret. Ea exercitatio ſtrenuo adoleſcenti tantam diſciplinæ militaris opinionem, famam nominis ac gratiam apud omneis armorũ ſtudioſos peperit, vt infinita propè hominũ omnis ætatis multitudo, ad illum tanquam ad conſummatiſſimum gladiatoriæ artis præceptorem, cum paſcẽdorum oculorum, tum præcipuè imitationis cauſa conflueret. Quorum cõciliatis animis, & eorũ præſertim qui militiam colebant:

f.ii.

PLATE 19

IOACHIMI PERIONII BENEDICT.
CORMOERIACENI DE OPTIMO GENERE
interpretandi Commentarij.

PARISIIS
Apud Ioannem Lodoicum Tiletanum, ex
aduerso collegii Remensis.
M. D. XL.

CVM PRIVILEGIO
in quadriennium

(a)

(b)

DANIELIS HEINSII

ORATIONES;

EDITIO NOVA;
magna parte auctior.

LVGD. BATAVORVM,
Ex officinâ ELZEVIRIANA,

ANNO cIↃ IↃC XX.

PLATE 20

product of those troubled times. The State, it seemed to Hobbes, might be regarded as a great artificial monster made up of individual men with an existence which could be traced from its generation through human reason under pressure of human needs to its destruction through civil strife proceeding from human passions. The individual, except to save his own life, should always submit to the State, because any government is better than the anarchy of the natural state. Hobbes' *Leviathan* has stimulated philosophers from Spinoza to the school of Bentham, who reinstated him in his position as the most original political philosopher of his time.

LONDON, 1657

THE GREAT EXEMPLAR

PLATES 26 and 27 illustrate the type-set and engraved title-pages of one of the best-known religious and devotional works of the seventeenth century, perhaps only excelled in popularity among works of this class by the same author's *Holy Living* and *Holy Dying*. The first edition appeared in 1649, the author's copy being a third edition, dated 1657. The type-set title-page reveals the usual faults in the press-work which have been previously mentioned, including the use of the lower-case design of the letter U in the words 'SAVIOUR' and 'DISCOURSES.' The engraved title-page deserves special attention; the engraver, William Faithorne the elder (1616–1691), seems to have deliberately excluded the form of printed characters from his mind so as to allow himself perfect freedom in the choice of his engraved characters. The page size is small folio, 7 x 11.5.

LONDON, 1657

PLATE 28

THE STATE OF CHRISTENDOM

Sir Henry Wotton (1568–1639), the author of *The State of Christendom*, was a diplomatist and poet, and a close friend of John Donne and Isaac Walton. The anonymous printer accomplished a creditable piece of work in this title-page, which

was carried out for Humphrey Moseley (d. 1661), the son of Samuel Moseley, a Staffordshire man, who became the publisher of the 'finer literature' of his age, including the first collected edition of Milton's '*Poems*'. (See Chapter 11). *The State of Christendom* was not published until eighteen years after the author's death, appearing in 1657. The author's copy is a first edition : small folio, 7 x 11.4. This title-page is a little more crowded than the last one but the printing is cleaner and the decoration is limited to simple rules.

This page and that of Stone Henge illustrate the discreet use of the swash capitals so much favoured later in the century by Joseph Moxon who, however, had not the ability to cut the punches or cast the types with any degree of accuracy. The slenderness and delicacy of these swash-italics emphasise their semi-calligraphic design, reminiscent of the work of the copper-plate engraver.

CAMBRIDGE, 1675

PLATE 29(a)

NEW TESTAMENT
of Our Lord and Saviour Jesus Christ, etc.
Cambridge, Printed by John Hayes,
Printer to the University

M.DC.LXXV.

6 x 8.8

This is the New Testament title-page of the Bible which has the Book of Common Prayer prefixed to the Old Testament and the whole Book of Psalms appended to the New Testament. The letters of the upper part of the page are heavily inked and bearded in places, some letters are battered, and we see again the lower-case form of the letter U mingled with capitals. Yet apart from the vertical crowding of the main title. the page is well displayed, the use of rules is simple, and plenty of space is given to the cartouche. As in most printing of the seventeenth century, the use of old type, defective locking-up of the formes and bad inking marred the quality of the pages.

PLATE 29(b)

OPUSCULA MYTHOLOGICA
PHYSICA ET ETHICA
Græce et Latine.
Amstelædami.
Apud HENRICUM WETSTENIUM.
CIↃ IↃ C LXXXVIII.
[1688]
4.4 x 8

This is the title-page of the Amsterdam edition of this important work edited by Thomas Gale (1635–1702), the famous high master of St. Paul's School; an earlier edition had appeared in parts from the Cambridge Press in 1671. The composition of the page is good although the printing shows the usual faults of the period. John Henry Wetstein (1649–1726) was a Swiss scholar and printer who established himself at Amsterdam and became notable for the quality of his printing, particularly of his Greek types, which are well displayed in this book. The non-ligatured Greek of Henry Wetstein is mentioned by Reed-Johnson, p. 224. The later Wetsteins are mentioned in Carter and Ricks, p. 20, note 3.

LONDON, 1678

A LATINE DICTIONARY

PLATE 30 illustrates the title-page of a work it would be impossible to omit from this series. The author, Dr. Adam Littleton (1627–1694) was the son of Thomas Littleton, vicar of Halesowen, at which place he was born and baptised. After serving under Busby at Westminster school he was rector of Chelsea from 1669 till his death and also served the church of St. Botolph, Aldersgate, from 1685 for about four years. His great work, the Latin Dictionary in four parts, first appeared in 1673 in massive quarto. This title-page is taken from the second edition, 1678. It conveys a good idea of the quality of the Dutch type commonly used in English printed books in the second half of the seventeenth century. The crowded setting is a very unsatisfactory feature of the page. The

italic capitals of the top line *LINGUÆ LATINÆ* are obviously printed from type having very worn shanks which have simply refused to lock up at the correct angle, and the lower-case form of the letter u is again seen mingled with roman capitals. The page size is 6.8 x 9.5.

THE MONUMENT

PLATE 31

At the time when the Monument on Fish Street Hill in commemoration of the Great Fire of London was being built, there appears to have been a sort of competition for the principal inscription. The inscription of the architect, Sir Christopher Wren, was rejected. Dr. Adam Littleton prepared an inscription which is preserved in Elmes's *Life of Wren* (pp. 294–7] and it is also noted by Robert Southey who, in his *Omniana* [1812, Vol. i, pp. 49–50], writes : 'At the end of Littleton's Dictionary is an inscription for the Monument, wherein this very learned scholar proposes a name for it, worthy for its length of a Sanscrit legend. It is a word which extends through seven degrees of longitude, being designed to commemorate the names of the seven Lord Mayors of London, under whose respective mayoralties the Monument was begun, continued, and completed—

QUAM NON UNA ALIQUA AC SIMPLICI VOCE,UTI ISTAM

QUONDAM *DUILIANUM*;

SED, UT VERO EAM NOMINE INDIGITES, VOCABULO

CONSTRUCTILITER HEPTASTEGO

FORDO—WATERMANNO—HANSONO—HOOKERO—VINERO—

SHELDONO—DAVISIANAM

APPELLITES OPPORTEBIT

Well might Adam Littleton call this an *heptastic vocable*, rather than a word.' [History of the Monument, Charles Welch, 1893]

PLATE 31 shows another link between the Monument and Halesowen ; it is a line engraving of the Monument by the Halesowen artist James Green, from a drawing by Samuel Wale, which was published in *London and Its Environs Described*, Vol. V, Frontispiece, 1761. Print area 3.3 x 5.8.

PLATE 32 shows the title-page of the first edition (1677) of *England's Improvement by Sea and Land,* by Andrew Yarranton (1616–1684), agriculturalist and engineer, a native of Astley in Worcestershire. The book was printed by Robert Everingham, the master of John Watts who became one of Caslon's patrons. It is to be noted that the name of Nevill Simmons is included in the imprint, whose name as a bookseller was also known at Kidderminster. Roger L'Estrange's licence mark and the date, Octob. 4, 1676, is prefixed to the title-page ; see Chapter 11 with reference to the licensing of the press in the seventeenth century. The title-page clearly shows the bearding of most of the larger letters, while the black-letter type, though in better condition than the roman, looks incongruous when mingled with it as in the main part of the title. The whole page exhibits the over-crowding too often evident at this period.

LONDON, 1713

RICHARD BAXTER

PLATE 33 shows the title-page of *An Abridgement of Mr Baxter's History of his Life and Times.* This abridgement of the famous Kidderminster divine's work was printed in 1713, the year when the London booksellers subscribed to Bowyer's Relief Fund ; William Caslon completed his apprenticeship in the same year. As was to be expected the imprint for this work of the great non-conformist included a prominent non-conformist printer, Ranew Robinson. John and Benjamin Sprint later knew Caslon through his association with the printer Samuel Palmer.

Although the press had been freed from the oppressive restrictions of the seventeenth century, the printers and publishers of the early eighteenth century who were desirous of raising the tone of the trade, such men as the Tonsons, uncle and nephew, the Bowyers, father and son, Lintot and others, had not yet exercised their full influence, nor had Caslon yet embarked on his career as a great engraver of letters.

So it is seen that this title-page still displays the slip-shod

press-work of most of its predecessors in England, especially in the larger types, which again show considerable bearding. It is essential for the press-work to be good if the beauty of black-letter is to be appreciated ; this example is very blotchy. The seventh line shows a very poor and mercifully anonymous attempt to produce some swash capitals and a bastard design of the final S, but there is so much bearding that it is difficult to be certain by what means these swash letters were produced. Page size 4.4 x 7.6.

LONDON, 1693

PLATES 34 and 35

THE LIFE OF CHRIST

An Heroic Poem in Ten Books.
Attempted by Samuel Wesley, Rector of South Ormsby in the County of Lincoln.
With Sixty Copper Plates.

London : Printed for Charles Harper, at the Flower-de-Luce, over against S. Dunstan's Church in Fleetstreet, and Benj. Motte in Aldersgate street.

[First Edition fol.]
7.5 x 12.3

The author was Samuel Wesley (1662–1735) divine and poet, father of John Wesley, the great methodist leader, and Charles Wesley, the hymn writer.

PLATE 34. Title-page set in type (red and black).

PLATE 35. Title-page engraved (probably by Nicholas Yeates, whose name appears on one of the sixty plates, none of the others being signed). The engraver has been too compromising in his attitude to the letters he has employed ; the rigidity of the word 'LIFE' in roman capitals and the words 'An Heroic Poem' in small roman do not mingle well with the calligraphic character of the other words in the title. These contrasts are greatly heightened by the extravagant decoration of the letter C in the name Christ.

PLATE 36(a)

THE CONQUEST OF SYRIA, PERSIA, AND EGYPT,
by the
SARACENS

containing the Lives of Abubeker, Omar and Othman,
the immediate successors of Mahomet, etc.
Collected from the most Authentick Arabick Authors,
especially Manuscripts, not hitherto publish'd.
By Simon Ockley, M.A., Vicar of Swavesey, in Cambridgeshire.
London, Printed for R. Knaplock in St. Paul's Church-yard,
J. Sprint in Little Britain, R. Smith in Cornhill, B. Lintott
in Fleetstreet, and J. Round in Exchange-Alley.
MDCCVIII
4.5 x 7.6

This is the title-page of a book more popularly known as
The History of the Saracens and the work of its author as a student
of Arabic is discussed in Chapter 9. The title-page is grossly over-
crowded. In the word 'CONQUEST' the tail of the letter Q has
had to be broken to admit the word 'OF' under it, and the letter
'U' is again a lower-case character. The three commas in the fourth
line belong to a much larger fount than the italic letters. Perhaps
it was because the larger sorts generally were expected to have a
longer life that they seem to be those which were often used in
battered state as in the letters 'N' in 'CONQUEST' and 'SARACEN'.

LONDON: FOR A WORCESTER BOOKSELLER, 1708

PLATE 36(b)

A SERMON
Preach'd Aug. 4th 1708 in the
CATHEDRAL CHURCH OF GLOUCESTER
At a Visitation of the Free-School and Hospital there,
By the Right Worshipful Benjamin Pearkes, Esq. Mayor,
and others of the Chamber of the City of WORCESTER
By Edw. Combe
Rector of St. Martins in the City of Worcester.
London : Printed for John Mountford Bookseller in Worcester,
1708
6 x 8.2

Although this title-page follows the fashion of presenting too much information, the anonymous London printer managed to preserve the dignity of the page by a judicious choice of sizes of roman and italic and placed his rules tastefully.

John Mountford the Worcester bookseller may have been connected with Samuel Mountford, M.A., a native of Kidderminster who, after serving as master of Stourbridge K.E. School, was appointed Upper Grammar Master of Christ's Hospital, London, in 1682, remaining there for the long period of 37 years, that is, until his death in 1719.

The event recorded in the title-page also emphasizes the close relationship which subsisted from early times between the cities of Worcester and Gloucester (and which also included Hereford), a bond strengthened through the annual Festival of the Three Choirs.

LONDON, 1717

WORCESTER CATHEDRAL

PLATE 37(a) shows the title-page of *The Antiquities of the Cathedral Church of Worcester* by Thomas Abingdon (or Habingdon), as published by Edmund Curll in 1717. The page size is 4.3 x 7.3.

Edmund Curll (1675–1747) was one of the least scrupulous of eighteenth century booksellers, and notoriously an enemy of Pope, who handed him down to posterity in the *Dunciad*. The boys of Westminster School once tossed him in a blanket for publishing in faulty Latin an oration spoken by the captain of the King's scholars. Though he was a prolific publisher and preserved in his books many of our national remains, they were for the most part printed carelessly on poor paper; he was also a printer of indecent literature, an offence for which he was brought to the bar of the House.

ΤΗΣ ΚΑΙΝΗΣ
ΔΙΑΘΗΚΗΣ
ἅπαντα.

NOVVM
IESV CHRISTI D.N.
Teſtamentum,

Cum notis Ioſephi Scaligeri in locos aliquot
difficiliores nunc primùm edita.

Additus etiam ſyllabus locorum Noui Teſta-
menti, de quorum ſenſu, & applicatione ad
controuerſia Religionis Chriſtianæ capita
hodie lis eſt.

GENEVAE,
Apud Petrum de la Rouiere,

CIƆ. IƆ C. XX.

PLATE 21

A
COLLECTION
OF
EMBLEMES,
ANCIENT AND
MODERNE:

Quickened
VVith METRICALL ILLVSTRATIONS, both
Morall and *Divine*: And difpofed into
LOTTERIES,

That *Inſtruction*, and *Good Counſell*, may bee furthered
by an Honeſt and Pleaſant *Recreation.*

By GEORGE WITHER.

The Firſt Booke.

LONDON,
Printed by *A. M.* for *Richard Royſton,* and
are to be fold at his Shop in *Ivie*-Lane.
MDCXXXV.

PLATE 22

D. of Grafton
1770.

THE
moſt notable

ANTIQUITY

OF

GREAT BRITAIN,

vulgarly called

STONE-HENG

ON

SALISBURY PLAIN.

RESTORED

By INIGO JONES Esquire,
Architeƈt Generall to the late
KING.

LONDON,
Printed by *James Fleſher* for *Daniel Pakeman* at the ſign of the
Rainbow in *Fleetſtreet*, and *Laurence Chapman* next door
to the Fountain Tavern in the *Strand*. 1655.

PLATE 23

LEVIATHAN,

OR

The Matter, Forme, & Power

OF A

COMMON-WEALTH

ECCLESIASTICALL

AND

CIVILL,

By THOMAS HOBBES *of* Malmesbury.

LONDON,

Printed for ANDREW CKOOKE, at the Green Dragon
in St. *Pauls* Church-yard, 1651.

PLATE 24

PLATE 25

THE
GREAT EXEMPLAR
OF
Sanctity and Holy Life

according to the Christian Institution :

Described in the History of the

LIFE and DEATH of the ever Blessed

JESUS CHRIST
THE
SAVIOUR of the WORLD.

WITH

CONSIDERATIONS and DISCOURSES
upon the several parts of the Story;

And PRAYERS fitted to the several MYSTERIES.

The Third Edition. In three Parts.

By JER: TAYLOR, *D. D.* Chaplain in Ordinary
to his late MAJESTIE.

LONDON,
Printed by R. *Norton*, for *Richard Royston*, at the signe of the
Angel in *Ivie-lane*. MDCLVII.

PLATE 26

THE
GREAT
EXEMPLAR

The Life and Death of the Holy JESUS

Τιμήσεις τὸν Θεὸν ἄριςα ἐὰν
τῷ Θεῷ τὴν διάνοιαν ὁμοιώσης
Hierocles

London Printed for R: Royston at the Angell in Ivie lane. 1657 W. Faithorne f.

PLATE 27

THE
STATE
OF
CHRISTENDOM:
OR,
A moſt Exact and Curious
Diſcovery of many Secret Paſſages, and Hid-
den Myſteries of the Times.

Written by the Renowned
Sᵗ HENRY WOTTON, Kᵗ.
Ambaſſadour in Ordinary to the moſt Serene Re-
publique of *VENICE,* And late Provoſt
of EATON COLLEDG.

LONDON,
Printed for HUMPHREY MOSELEY, and are
to be ſold at his Shop at the *Prince's Arms* in
Sᵗ *Paul's* Church-yard, 1657.

PLATE 28

THE NEW
TESTAMENT
OF OUR
LORD and SAVIOUR
Jefus Chrift,

Newly tranflated out of the Original Greek, and with the
former Tranflations diligently compared and revifed,

By His MAIESTIES *fpecial Command.*

¶ Appointed to be read in Churches.

CAMBRIDGE,
Printed by IOHN HAYES, Printer to the Univerfity,
M. DC. LXXV.

(a)

OPUSCULA
MYTHOLOGICA
PHYSICA
ET
ETHICA.
GRÆCE et LATINE.

Seriem eorum fiftit pagina Præfationem
proxime fequens.

Joseph Bromehead

AMSTELÆDAMI
Apud HENRICUM WETSTENIUM.
cIɔ Iɔ c LXXXVIII.

(b)

PLATE 29

LINGUÆ LATINÆ
LIBER DICTIONARIUS
Quadripartitus.

A LATINE
DICTIONARY,
In Four Parts:

I. An English-Latine.	III. A Latine-Proper.
II. A Latine-Classical.	IV. A Latine-Barbarous.

WHEREIN

The *Latine* and *English* are adjusted, with what care might be, both as to Stock of *Words* and *Proprieties* of *Speech*.

PARTICULARLY,

1. In the **English-latine**, more *Words* and *Proprieties* of our Language, as now spoken, are set down, by several Thousands, than in any other *Dictionary* yet extant.
2. In the **Latine-classick**, the *Etymologies*, *Significations*, and *Phrases* are fully and plainly, yet briefly, discoursed; together with the several Kinds and Constructions of the *Verbs*; a thing hitherto not much regarded.
3. In the **Latine-proper**, the Expressions of *Story*, which were taken mostly out of *COOPER*, are much amended; and many useful things are now added, which were formerly omitted; with two Mapps, one of ITALY, another of old ROME.
4. In the **Latine-barbarous**, those words which through Mistake of writing have been corrupted from the *Latine*, or by Ignorance or Boldness of later Authors have crept into the *Latine*, are exposed and expounded.

And in all Four Parts, many things that were utterly impertinent and cumbersom to *School-Institution* and to the true uses of *Learning*, are laid aside.

Of all which several performances, together with considerable Additions of new matter by way of Appendage *to the main Work, a fuller Account is given in the* Prefaces.

Operâ & Studio *Adami* **Littleton**, S. T. D. Capellani Palatini.

ΕΡΓΟΝ δ᾽ ΟΥΔΕΝ ΟΝΕΙΔΟΣ. Hesiod.
Quam quisque novit Artem, in eâ se Exerceat. Cic.

LONDON,
Printed, for *T. Basset* at the *George* in *Fleet-street*, *J. Wright* at the *Crown* on *Ludgate-Hill*, and *R. Chiswell* at the *Rose* and *Crown* in St. *Paul's* Church-yard. 1678.

PLATE 30

S. Wale delin. J. Green sc. Oxon.

Monument.

PLATE 31

ENGLAND'S
𝔍mprobement
BY
SEA and LAND.
TO
Out-do the *Dutch* without Fighting,
TO
Pay Debts without Moneys,

To set at Work all the POOR of *England* with the
Growth of our own Lands.

To prevent unnecessary SUITS in Law;

With the Benefit of a Voluntary REGISTER.

Directions where vast quantities of Timber are to be had
for the Building of SHIPS;

With the Advantage of making the Great RIVERS
of *England* Navigable.

RULES to prevent FIRES in *London*, and other Great CITIES;

With Directions how the several Companies of Handicraftsmen in *London*
may always have cheap Bread and Drink.

By *ANDREW YARRANTON*, Gent.

LONDON,

Printed by *R. Everingham* for the Author, and are to be sold by *T. Parkhurst*
at the Bible and three Crowns in *Cheap-side*, and *N. Simmons* at the Princes
Arms in S. *Paul*'s Church-yard, M DC LXXVII.

PLATE 32

AN
ABRIDGEMENT
OF
𝕸𝖗. 𝕭𝖆𝖝𝖙𝖊𝖗'𝖘
HISTORY
OF HIS
LIFE and *TIMES*.

WITH

An Account of the Minifters, &c.
who were Ejected after the Reftauration,
of King *Charles* II.

Their Apology for themfelves, and their Adherents,
containing the Grounds of their Nonconformity:
Their Treatment in the Reign of King *Charles*,
and King *James*; and after the Revolution: And
the continuation of their Hiftory, to the paffing
of the Bill againft Occafional Conformity, in 1711.

The 𝕾𝖊𝖈𝖔𝖓𝖉 𝕰𝖉𝖎𝖙𝖎𝖔𝖓: In Two VOLUMES. Vol. I.

By EDMUND CALAMY, *D. D.*

LONDON:

Printed for *John Lawrence*, at the *Angel* in the *Poultry*;
J. Nicholfon, and *J.* and *B. Sprint* in *Little-Britain*;
R. Robinfon in *St. Paul's* Church-yard, and *N. Cliffe*,
and *D. Jackfon* in *Cheapfide*. 1713.

PLATE 33

THE
LIFE
OF OUR
Blessed Lord & Saviour
JESUS CHRIST.

AN
HEROIC POEM:
DEDICATED TO
Her Most Sacred MAJESTY.

In Ten Books.

ATTEMPTED BY
SAMUEL WESLEY,
Rector of *South-Ormsby* in the County of *Lincoln*.

Each Book illustrated by necessary Notes, explaining all the more difficult Matters in the whole History: Also a Prefatory Discourse concerning Heroic Poetry.

With Sixty Copper-Plates.

LONDON:
Printed for *Charles Harper*, at the *Flower-de-Luce*, over against S. *Dunstan's* Church in *Fleetstreet*, and *Benj. Motte* in *Aldersgatestreet*. 1693.

PLATE 34

THE
LIFE
OF
Chrift.
An Heroic Poem.
In Ten BOOKS
with sixty Copper Plates.

London:
Printed for Charles Harper & Benj. Motte.

PLATE 35

THE
CONQUEST
OF
Syria, Persia, and *Ægypt,*
BY THE
SARACENS:
CONTAINING

The Lives of *Abubeker, Omar* and *Othman,*
the immediate Successors of *MAHOMET.*

GIVING

An ACCOUNT of their most remarkable
Battles, Sieges, &c. particularly those of *Aleppo,
Antioch, Damascus, Alexandria* and *Jerusalem.*

ILLUSTRATING

The Religion, Rites, Customs and Manner
of Living of that Warlike People.

Collected from the most Authentick *Arabick* Authors,
especially Manuscripts, not hitherto publish'd in any
European Language.

By *SIMON OCKLEY,* M. A. Vicar of
Swavesey, in *Cambridgeshire.*

LONDON, Printed for *R. Knaplock* in St. *Paul's
Church-yard, J. Sprint* in *Little Britain, R. Smith* in
Cornhill, B. Lintott in *Fleetstreet,* and *J. Round* in *Ex-
change-Alley.* M DCC VIII.

(a)

(b)

*The true Causes of the Establishment,
and of the Destruction of Nations.*

A
SERMON

Preach'd *Aug.* 4th 1708.

IN THE

Cathedral Church of GLOUCESTER,

At a VISITATION of the

Free-School and *Hospital* there,

By the Right Worshipful

BENJ. PEARKES, *Esq Mayor,*
and others of the Chamber of the City of
WORCESTER.

By *Edw. Combe* Rector of St. *Martins* in the City of
WORCESTER.

LONDON:

Printed for *John Mountfort* Bookseller in *Wor-
cester,* 1708.

PLATE 36

(a)

(b)

PLATE 37

THE NEW
TESTAMENT

OF OUR

Lord and Saviour Jeſus Chriſt:

Newly Tranſlated out of the

ORIGINAL GREEK:

And with the former TRANSLATIONS diligently

COMPARED and REVISED.

𝔅𝔶 𝔥𝔦𝔰 𝔐𝔞𝔧𝔢𝔰𝔱𝔶'𝔰 𝔖𝔭𝔢𝔠𝔦𝔞𝔩 𝔠𝔬𝔪𝔪𝔞𝔫𝔡.

Appointed to be Read in Churches.

UNIVERSITY of OXFORD,

Printed by JOHN BASKETT, Printer to the King's moſt Excellent Majeſty.

M DCC XVI.

PLATE 38

THE BOOK OF
COMMON·PRAYER
And Administration of the
SACRAMENTS
AND OTHER
Rites and Ceremonies of the CHURCH
According to the Use of the
Church of England
TOGETHER WITH THE
Psalter or Psalms
OF
DAVID
*Pointed as they are to be Sung
or Said in Churches.*

DIEU ET MON DROIT

LONDON
Engraven and Printed by the Permission of
Mr. John Baskett *Printer to the* Kings *most Excell-*
ent Majesty 1717. Sold by John Sturt *Engraver in*
Golden-Lion-Court *in Aldersgate Street.*

PLATE 39

THE TEMPLE

OF THE

MUSES;

OR,

THE PRINCIPAL HISTORIES OF

FABULOUS ANTIQUITY,

REPRESENTED IN SIXTY SCULPTURES;

Defigned and Ingraved by

BERNARD PICART LE ROMAIN,

And other Celebrated Mafters.

WITH

EXPLICATIONS AND REMARKS,

*Which difcover the True Meaning of the Fables, and their
Foundation in Hiftory.*

AMSTERDAM,

Printed for *ZACHARIAH CHATELAIN.*

MDCCXXXIII.

PLATE 40

THE
TEMPLE
OF THE
MUSES.

AMSTERDAM,
For Z: CHATELAIN.

PLATE 41

RUDIMENTA
LINGUÆ ARABICÆ
AUCTORE
THOMA ERPENIO.
FLORILEGIUM
SENTENTIARUM ARABICARUM
UT ET
CLAVIM DIALECTORUM,
ac præsertim
ARABICÆ,
adjecit
ALB. SCHULTENS.

TUTA SUB ÆGIDE PALLAS

LUGDUNI BATAVORUM,
Apud **SAMUELEM LUCHTMANS**, 1733.
Academiæ Typographum.

TYPIS
ISAACI vander MIJN.
LUGDUNI BATAVORUM.
M DCC XXXIII.

QVINTI

HORATII FLACCI

OPERA.

VOL. I.

LONDINI
AENEIS TABVLIS INCIDIT
IOHANNES PINE
M DCC XXXIII.

PLATE 43

THE Universal Penman.

Engrav'd

By GEORGE BICKHAM.

DELECTANDO · MONEMUS

London:

Printed for the Author, and sent to the Subscribers, if

Living within the Bills of Mortality.

PLATE 44

PLATE 37(b)

PIOUS BREATHINGS
being the
MEDITATIONS OF ST. AUGUSTINE
Made English by
George Stanhope, D.D. Dean of Canterbury,
and Chaplain in Ordinary to Her Majesty.
London : Printed for J. Knapton, R. Knaplock, J. Sprint,
B. Took, D. Midwinter, R. Smith, J. Tonson, W. Taylor,
W. Innys, J. Osborn, T. Bickerton, R. Robinson,
and T. Ward.
[Fifth edition]
4.4 x 7.4

Pious Breathings was first published in 1701 and dedicated to Princess, afterwards Queen, Anne. The wording of the title-page was evidently retained for this edition (wrongly described by the D.N.B. as the second) for Stanhope had lost his royal chaplaincy in 1718.

Typographically, this is a good example of the Dutch models on which Caslon based his designs. For example, compare letter by letter the Great Primer Italic in 'PIOUS BREATHINGS', in which the letter 'N', having one serif only at its base, is closely similar. The letters in 'GEO. STANHOPE 'show greater differences, the 'N' having two base serifs and the 'P' having a swash top. In the Roman capital letters the vertex of the 'A' in 'MEDITA-TIONS' is close to Caslon's, the bar of the 'E' is shorter, the 'N' has one base serif as in Caslon, though the serifs have less weight and the ends of the cross of the 'T' hang vertically, whereas Caslon's slope outwards.

The number of booksellers' names in the imprint is an indication of the growing fashion of sharing the financial risk in publishing books, at the cost, of course, of dividing whatever profits might accrue. This practice was the origin of those associations of booksellers called by the strange name of the 'Conger', a collection of individuals linked together by a common interest.

PLATE 38

THE NEW TESTAMENT
of our
Lord and Saviour Jesus Christ :
Newly Translated from the
ORIGINAL GREEK
and with the former Translations diligently
COMPARED and REVISED
By His Majesty's Special Command
Appointed to be Read in CHURCHES
University of OXFORD,
Printed by JOHN BASKETT, Printer to the King's most
Excellent Majesty,
MDCCXVI.

12.3 X 19.5

This is the *New Testament* title-page to Baskett's famous folio Bible, called the 'Vinegar' Bible, in which the running title of Luke XX reads, 'The parable of the vinegar.' Although of such quality typographically, it contained so many errors that it was also called a 'Baskett-full of errors.' The first title-page is as follows : *The Holy Bible, containing the Old Testament and the New, etc.* Oxford, Printed by John Baskett, Printer to the King's Most Excellent Majesty, for Great Britain ; and to the University, 1717, 2 vols. folio.

The page shows Burgher's well-known engraving of the Clarendon Building where the Oxford University Press operated from 1713.

ENGRAVED ON SILVER PLATES, 1717

PLATE 39

THE BOOK OF COMMON PRAYER
and Administration of the Sacraments—etc.
London. Engraven and Printed by the Permission of Mr. John Baskett Printer to the King's most Excellent Majesty 1717. Sold by John Sturt Engraver in Golden-Lion Court in Aldersgate Street. 4.9 x 8

This is the title-page to Sturt's famous Prayer Book engraved on 188 silver plates. (See Chapter 8). It will be noted that he required the sanction of the King's printer despite the unique character of the work and its dedication to the Prince and Princess of Wales. It would indeed be an unprecedented irony if John Sturt had been required to pay Baskett, one of the greatest Bible monopolists in the history of printing, for the privilege of undertaking the immense labour involved in producing this notable work.

It will be noted that the characters follow closely the pattern of the Dutch roman capital and small letters, even to the curly tail on the letter R, and that these and the common cursive letters are the only varieties Sturt adopted, restricting his decorations to the border. The rubrication of the pages has marred the effect of Sturt's finely engraved letters which should have been allowed to stand without lining. This page provides a good example of the style of lettering which later inspired the work of Baskerville, Bodoni and Didot—the *modern* school.

AMSTERDAM, 1733

THE TEMPLE OF THE MUSES

PLATES 40 and 41 display the fine title-pages of Bernard Picart's *Temple of the Muses* published by Zachariah Chatelain in Amsterdam in 1733. Picart was a French engraver who worked at Amsterdam after 1710, contributing a decorative note to early eighteenth century Dutch printing, and dying in the year this impressive work was published. Updike (Vol. 2, p. 34) describes the typography of this book as extremely handsome. The book is full of Picart's fine engravings and these, with the frameworks round them, were so highly esteemed as to be often utilised by later printers and decorators. Apart from the semi-colon after 'Muses,' which is an obtrusive feature, the type-set title-page is arranged with dignity and reveals a technical competence not matched by any English title-page so far shown. Yet perhaps this is an unfair comparison, for the book was intended as a luxurious piece of book-craft and PLATE 42(a) will show that the general run of Dutch printing did not at this period reach the same high standard.

Picart's engraved title-page for the same work is striking in

its three-dimensional quality, greatly superior to the engraved title-pages illustrated earlier, an impression increased by the pronounced shadows added to the sculptured figures. The open letters of the title, though admirably drawn, are insufficient to hold the eye against the decorations, and these should have been given a heavier shading, or even engraved as incised letters, in order to preserve a proper balance. Nevertheless, it is a very fine piece of work. The use of double title-pages continued until the second half of the eighteenth century, emphasising the close connections which had always existed between engravers and printer-publishers.

The page size is large folio, 11.5 x 18.2.

PLATE 42(a) shows the title page of an Arabic text-book in use in the universities in the eighteenth century:

RUDIMENTA LINGUÆ ARABICÆ
by Thomas Erpenius (1584–1624).
Revised by Albert Schultens
Lugduni Batavorum, Apud Samuelem Luchtmans, 1733.
Academiæ Typographum.

Updike (Vol. 2, p. 33) regarded both Wetstein and Luchtmans as good names in Dutch printing and publishing, but this example is scarcely better than English title-page printing of the same period. The body of the book, of course, forms a more difficult piece of setting with its variety of characters, including Arabic and Hebrew. Albert Schultens was doubtless quite well known to Salomon Negri, Caslon's supervisor in the outlines of his Arabic characters.

PLATE 42(b) reproduces the colophon of the book:
Typis
Isaaci Vander Mijn
Lugduni Batavorum
MDCCXXXIII

The *A* and *V* of the italic line *LUGDUNI BATAVORUM* reveal the Dutch source of Caslon's error in the inclination of those two letters.

Several members of the Vander Mijn family are recorded in the annals of art. Herman Vander Mijn was brought to this country about 1722 by William Lord Cadogan and his sister Agatha was a flower painter here; others were Adrian and Robert, all of which tends to confirm what has been said before in the course of this work regarding the close connections between practitioners in the fine arts and in various branches of applied art.

ENGRAVED TITLE-PAGE, LONDON

PLATE 43 shows the title-page of the works of HORATIUS FLACCUS, the Roman poet, by John Pine (1690–1756), the whole of which was engraved on copper plates and illustrated from gems and other antiquities. The first volume appeared in 1733 and the second in 1737. Pine's work was of exceptional merit and is highly valued by collectors. The size within the single line border is 6 inches x 9 inches and the high note of interest is the simplicity of the display and the ample margins. The vignette conveys the idea of poetry as a universal song. Pine's engraved letters may be compared with the type faces adopted by Baskerville and the *modern* school.

LONDON ENGRAVING PAR EXCELLENCE

PLATE 44 illustrates the engraved title-page of the famous *Universal Penman* (1733–1741) of George Bickham the elder (1684–1758), whose reputation as an engraver of writing-masters' copy-books excelled even that of his master, John Sturt. Bickham must have been well-known to William Caslon for during the last few years of his life he lived in Red Lion Street, Clerkenwell, and at his death was buried at St. Luke's, Old Street, where Caslon was himself buried in 1766. His son, George Bickham, junior, a well-known engraver of music, was a rival of Benjamin Green for the position of drawing-master at Christ's Hospital. Four plates of George Bickham's engraved letters are shown in Chapter 8 as further examples of the *modern* style in type design.

Chapter Sixteen

CASLON MAKES HIS NAME

As we have seen in the account of Dr. Thomas Bray and the beginnings of the S.P.C.K.'s support of the Danish Mission in Tranquebar in 1714, it was not long before the missionaries themselves found how costly it proved to print the New Testament for the Malabarians in unnecessarily large type.[1] In 1720, when the Society, responding to the urging of Salomon Negri, decided to print the New Testament and Psalter in Arabic, it seems that they had not learned the earlier lesson well enough, for it was not until the plans were well-advanced for printing in Great Primer size the fount of Arabic used in 1657 for Brian Walton's London Polyglot Bible that the Society realised that the cost of carrying through the enterprise on this scale would out-run the available funds. Typically, it was the printer Samuel Palmer who had run the Society into this trouble, for he seems always to have been running into trouble himself and ended by becoming bankrupt.

The archives of the S.P.C.K. give details of the proposals, differing somewhat from the numbers of New Testaments and Psalters figuring in the original resolution. The Society's scheme had already received the blessing of Archbishop Wake. In October, 1720, two estimates were laid before the Committee for 8,000 copies of the New Testament and the same number of Psalters. One was from a Dutch printer, Van de Water of Utrecht, the other from Samuel Palmer of Great Swan Alley near Charterhouse. The Dutchman's estimate was £91 less than Palmer's estimate of

£1,166, but it was noted that 'the Polyglott matrices are larger as well as more Beautiful than any of the 3 specimens sent from Utrecht,' and Palmer proposed that he would bear the expense of a new font of 'polyglot' Arabic.[2] When Archbishop Wake was again consulted, he considered 'that it would be more advisable for the Society to print the Arabick New Testament in England, notwithstanding the difference of the expense, because the benefactors will be better disposed to encourage a thing under their eye.'[3]

Joseph Downing, of Bartholomew Close, was the printer of the Society's publications, and it might be wondered where he was while all this was going on. Downing evidently got to know about the Dutch estimate and Palmer's being considered by the Committee because on 3 November the society agreed that he too should have 'the liberty of offering a proposal.' The sequel was that both Palmer and Downing came to the Committee on 8 November to say that they had agreed 'to engage as partners for the Arabic Testament and Psalter.' After checking Downing's assent to the terms already discussed with Palmer, point by point, the matter went for further consideration to the General Meeting. On 17 November the two men were examined separately. Palmer declared under examination that he 'would not have admitted Downing as partner, if he had not been afraid he would get the whole work.' The Society agreed that Palmer might take Downing as partner 'if he thinks fit.' This was the last mention of the projected partnership.[4] On 3 January a draft agreement with Palmer only was considered and approved, and on 19 January it was signed, the type in Great Primer size being cast at the foundry of Thomas James.[5]

When work began, Salomon Negri benefited from having suggested the scheme by being made 'supervisor and corrector of the press.'[6] He was lodged with Palmer in December, 1720, and paid £6 a quarter, £9. 10s. being advanced to pay his present and previous lodgings, 'besides what shall be thought necessary for apparel, linen and other necessaries,' all of this coming from the fund. In April, 1721, Palmer reported that the fount, which had been delayed by gout in James's hand, was nearly finished. In May, however, Negri found fault with thirty of the Polyglot types and James agreed to make up to forty new characters for £5, 'tho' the work would be worth twice that sum.'[7]

The question arises here as to who made the new characters, for punch-cutting was a part of the process of producing printers' type which founders in this country had studiously avoided, either for lack of the necessary skill or distaste for the labour involved. It was these difficulties which had led Jacob Tonson I in 1703 and Thomas James in 1710 to visit Holland for the purpose of buying type and matrices, especially the latter, to meet their printing needs, wants which they could not persuade the Dutchmen wholly to satisfy.[8] We must therefore infer that the gout in James's hand was holding up the casting and was not concerned with punch-cutting. So the question remains as to whom James employed to remake or remedy up to forty of the Polyglot characters. *Was it Caslon himself?*

In June Palmer prepared a corrected specimen of the type, the text being the Decalogue and 23rd Psalm in the Polyglot Great Primer Arabic.[9]

Palmer's prominence in printing at this time was probably influenced by his marriage to a member of the Sprint family of booksellers. John and Benjamin Sprint, sons of Samuel, were booksellers at the Blue Bell in Little Britain.[10] John Sprint was a Warden of the Stationers' Company in 1717 when Richard Mount, who had his business at the Postern on Tower Hill, dealing chiefly in paper and sea books, was Master of the Company. Richard Mount gave the Company the clock which hangs in the Court Room. It was during the term of office of Mount and Sprint in 1717 that Thomas Guy made his benefactions to the Company and it was on the Master and Warden that the Court laid most of the responsibility for negotiating the terms of Guy's benefactions.[11] John Sprint, therefore, was one of the more important booksellers of his time.

The parish register of St. Benet Sherehog and St. Stephen Wallbrook records the following marriage :

> '7 May, 1717—Mr. Samuel Palmer of St. Lawrence, Old Jury, wid., and Mrs. Sprint of St. Botolph without Aldgate (spinster). Witnesses : Mr. John Palmer, Mr. John Hollister, Mrs. Hollister, Mr. John Sprint, Mrs. Palmer. Lic. L.B.L.'

By this marriage, John Hollister, who had married Anne

Sprint,[12] became Palmer's brother-in-law, and in view of the events of the immediate future, it is important to note that John Hollister was to become the Treasurer of Guy's Hospital ; he was probably the son of John Hollister, citizen and merchant-taylor, and of a family which was strongly represented in Gloucestershire. Further, the bride is here described as of St. Botolph without Aldgate, the parish to which Caslon belonged while he lived in Vine Street, and of which the perpetual curate was Dr. Thomas Bray of the S.P.C.K. and the assistant curate John Hutchinson, also of Vine Street.

Returning now to the Arabic enterprise, while Thomas James, Samuel Palmer and Salomon Negri were occupied in correcting the fount and casting the type, Henry Newman, secretary of the S.P.C.K., had the difficult task of turning the subscribers' promises into money. Even though the Royal bounty had been promised for the scheme, governmental concern and public panic over the South Sea Bubble occupied the minds of officials far more than providing scriptures for an Eastern missionary enterprise, and it was nearly four years before the promised £500 was actually received.[13] Although Newman succeeded in raising the sum of £600 needed for the Arabic Psalter, the prevailing difficulties were causing great concern to the S.P.C.K. Committee, and it was realised before the Psalter was printed that the total funds likely to accrue would be insufficient to print both the Psalter and New Testament on as large a scale as the Great Primer size required.

The meetings of the Society early in the century were held at the house of John Hooke, Sergeant at Law, the Committee meeting at Child's Coffee House or in the Chambers of Samuel Brewster of Lincoln's Inn ,who as previously noted, held the advowson of the living of St. Botolph's Aldgate.[14] In 1703 Philip Stubbs (later Archdeacon) offered the Society his rooms in Sion College, where the Society met for some time, although St. Dunstan's Quest House and Rev. Benjamin Ibbot's house were also occasionally used. In 1704, the Rev. Henry Shute, the Treasurer of the Society, placed his house in Bartlet's Buildings at the Society's service, and there the Society met until 1714, while the Committee met during this period at the Chambers of Mr. Melmoth in Lincoln's Inn, at St. Dunstan's Coffee House, and at Nando's Coffee House.[14]

On 27 May, 1714, 'the Bishop of London having

313

granted Mr. Treasurer Shute leave to live in London House,[16] Aldersgate St., he shall quit yᵉ House in Bartlet's Buildings, and desires to know whether yᵉ Society will meet in Aldersgate St., or will accommodate themselves elsewhere.'[17]

It appears that the Society and its Secretary were being buffetted about in the earlier years. The Society found a temporary sanctuary in the same place as the Commissioners for Churches, at Mr. Brewster's Chambers, No. 6, Serle's Court, Lincoln's Inn. On 10 May, 1716, 'the Commissioners for Churches removing from this place to Westminster at Midsummer next, the Society must look out for a place to meet in.'

The meetings were held for a short time afterwards at St. Paul's Chapter House, the Quest House of St. Dunstan's being used alternately with it for a time. Although again offered the use of a room in a house to which the Treasurer was moving in Southampton Buildings, the Society continued to meet at St. Paul's Chapter House—the Committee sometimes assembling at St. Dunstan's Coffee House—until 4 April, 1728, when the Society first met 'at ye Society's House in Bartlet's Buildings.'[18]

On 12 April, 1722, the weekly meetings of the Society had been changed into monthly ones, on the first Thursday of every month at St. Paul's Chapter House, with intermediate Committee sessions every Tuesday at St. Dunstan's Coffee House. But before this change took place and actually while the fount of Great Primer Arabic was being prepared, a meeting was held on 6 March, 1721–2, at which a motion was made to consider means to contract the expense of printing the New Testament, etc., in Arabic, and the Rev. Richard Mayo was asked to prepare a specimen of an impression in such method as he should be advised, and should be allowed the expense of such new specimen not exceeding two guineas.

Fourteen days later, that is, on 22 March, Mayo came back with a specimen of a new Arabic Character, but then, so far as the Society's Minutes reveal, the matter goes to ground until 12 June, 1722, and it seems unlikely that it will ever be known with certainty what transpired behind the scenes between those two dates. At the Committee Meeting on 12 June, however, Minute 2 records as follows : 'Agreed that Mr. Caslon the Engraver, recommended by Mr. Guy to Mr. Mayo, be desir'd to give his Company

this Day Sennight in Order to be consulted hereon.'[19] This is the sole reference to Caslon in the Minutes on that occasion. Those present were Sir John Philipps, Mr Shute, Sir Daniel Dolins (in the Chair), Mr Chamberlayne, Mr William Tillard, Dr. Bray, Mr Watts of Great Gidding, Mr Wheeler, Mr Dean Maule, Mr Hales of Teddington, and the Secretary, Henry Newman. The names of Dr. Bray and Mr Hales were within brackets, presumably as being members of the Society present but not actually of the Committee on that occasion.[20]

At the Committee Meeting held on 19 June, Minute 1 of the proceedings was as follows: 'Mr. Caslon ye Letter Engraver attending without was called in, and after some Conference with him and Mr. Negri, the Committee agreed that he should make a Specimen of Letters to express the first two words *Sas Elberd* in *Avicene's Works*, Page 545, Line 6th, of the same Dimensions as they are in that Book.' At this meeting the attendance was Mr Shute, Sir John Philipps (in the Chair), Mr Mayo, Sir Daniel Dolins, Mr Hoare, Mr Watts of Great Gidding (the last-named within brackets), and the Secretary, Henry Newman.[21]

Ibn-Sina Avicenna (980–1037) was an Arabian physician and philosopher, and it is probably safe to assume that it was Salomon Negri's own copy from which Caslon was to prepare his specimen. The trial letters were produced on 3 July and satisfied Negri, who estimated that 300 characters would be required. A set of 'Proposals for Casting a Font of Arabick Letters made by William Caslon to the Society for Promoting Christian Knowledge' was drawn up, in which it was estimated that the work would take six months to complete.

As Secretary of the Society, Newman had been trying to secure 'a specimen of a fine Arabick letter, worthy of their imitation,' enquiring about Arabic manuscripts in the Bodleian Library, Oxford, and received 'beautiful Arabick copies of the Psalter and New Testament' from Rowland Sherman 'a learned English merchant at Aleppo,' and borrowed from Humphrey Wanley 'a very fine manuscript *Alcoran* in a small Arabick letter' out of the Earl of Oxford's library.[22] There were also the resources of Sion College Library to explore. All these must have been of considerable help to Caslon in modifying the characters as seen in Avicenna

to meet the criticism of Negri. Indeed, the Society must have placed implicit reliance on Negri's rendering of the Arabic characters, for John Postlethwayt and Simon Ockley were now dead and there seems to have been no consultation with any other Arabic scholar.

Having arrived at that point in Caslon's career when he first comes to notice as a letter-founder's punch-cutter, we must try to find to what influence he owed his selection for the work on the Arabic type. This is not to suggest that Caslon's success was not deserved but it remains a fact that many a deserving man has not achieved the success he merited for lack of opportunity and patronage. Moreover, the first half of the eighteenth century was an age of patronage and intrigue, and it must be granted that Caslon's selection against the trade in so difficult a task as cutting a fount of Arabic, even allowing for superlative merit and the dire condition of English letter-cutting at the time, was so exceptional as to justify careful investigation.

That the recommendation of Caslon to the S.P.C.K. should have come from Thomas Guy is, however, surprising, to say the least, when all the facts of the situation are considered. Caslon was Thomas Bray's parishioner at St. Botolph's, Aldgate, where William Caslon II had been baptised in June, 1720, and at the time when Caslon first met the S.P.C.K. Committee, his wife was expecting their second child. Moreover, in 1717, a Halesowen man, Samuel Butler had been elected school-master at Sheldon, Bray's Warwickshire parish and this was followed about 1721 by the marriage of Jonathan Carpenter, another Halesowen man, to Bray's daughter, by Jonathan's selection as curate to his father-in-law and by John Carpenter's appointment as curate at St. Botolph's Aldgate. Indeed, it is difficult to resist the conclusion that Bray and his daughter and son-in-law and John Carpenter, too, must occasionally have met Caslon in St. Botolph's Church where, no doubt, Caslon's musical interests would be known. Perhaps he played the organ there, this being a very fine instrument given by Thomas Whiting.

When Caslon first came to notice he was twenty-eight years of age and it cannot be believed that a man of his age and social qualities was so reticent that he could remain unknown in his own

church congregation. Indeed, the romantic element in the traditional account of Watts, Bowyer and Bettenham becoming Caslon's early patrons is increased by adding Guy to the list and confirms that Caslon had personality as well as outstanding ability as a craftsman. In the account of Caslon's part a few years later of the unsuccessful attempt by William Ged to establish his method of printing by stereotype, there is even some evidence of egotism. One would have expected, therefore, that Dr. Thomas Bray himself would have been able to recommend Caslon to the favourable notice of his own Committee, even allowing for the probability that Bray was entirely ignorant of letter engraving and punch-cutting.

In June, 1722, Guy was 77 years of age, and it can scarcely be thought that he was then taking any active part in the bookselling business at the Oxford Arms in Lombard Street. He would be devoting all his remaining strength to the furtherance of his philanthropic work, although continuing to live in Lombard Street, his mantle as a book-seller having fallen on John Osborn, who by this time was thirty-four or thirty-five years of age.

Guy's munificence to St. Thomas's Hospital and his other charitable bequests were certain to inspire the thought that his interest might be enlisted in the objects for which the S.P.C.K. and the S.P.G. were founded. The S.P.C.K. Archives show this conjecture to be true. On 6 May, 1721, Henry Newman wrote to Dean Maule in Dublin :[32]

> 'I am not Able as yet to give you an Acct of the particulars of Mr. Guy's Charity more than what is generally said, That he has appropriated 100.Thousand pounds for Building and Endowing an Hospital for Incurables, besides his Noble Benefactions to St. Thomas's Hospital in Southwark, where he has built 2 or 3 Sides of one of the Squares and given 100.£ p. ann. for several years past. Mr. Guy is still living at his house in Lombard Street, and can still walk half a Mile to save a Shilling Coach hire, when he is minded to take the Air.'

Six months later Newman wrote to Guy himself, dated Mid. Temple, 18 Oct. 1721 :[24]

> 'Sr.
>
> It is a debt due to so great a Benefactor to the Publick as Mr. Guy is to let him know what charitable designs are afoot for the good either of the Souls or Bodies of Mankind ; how

far what is recom̄ended in the Proposal herewith sent may deserve your regard is humbly submitted. Give me leave only to acq. you y^t about 500.pound has been already contributed or subscrib'd towards it, and there is reason to hope from several assurances given that his Maj'^t̄ȳ and the Prince will be Bountiful Benefactors to it.

'I have had the honour to be 2. or 3. times in your comp.^a but can scarcely be remember'd by you thō I am a great admirer of yr. magnificent Charities as well as

<div align="center">

Yr. most obed. humble Serv.

Henry Newman.'

</div>

An entry in the Abstract Letter Book[25] reveals that Newman's letter related to the Benefactions towards the Arabic Psalter and New Testament. However, the hopes of Newman and his Committee were disappointed for there is no evidence in the S.P.C.K. records that Guy contributed to that scheme or to any other sponsored by the Society. Nevertheless, Guy's reputation as a public benefactor would be certain to make him a notable sponsor for Caslon and influence the Committee towards acceptance of his recommendation.

Although it seems more probable that Caslon's work in the manufacture of bookbinders' punches brought him to the notice of Thomas Guy in his bookselling business at the Oxford Arms in Lombard Street, it must not be overlooked that Guy might have had relations in Halesowen. When Guy died on 27 December, 1724, it was revealed that his will mentioned one hundred and thirteen relatives, most of whom were given large legacies and some received annuities.

At a comparatively early age and by extreme parsimony he amassed a fortune from his publishing business. In the Bible trade he was in partnership with Peter Parker both at Oxford and in London, and although he was a pirate in the trade in that he had Bibles printed in Holland, delivered in sheet form, and bound here, he operated against worse sharks like John Baskett and other monopolists. He also dealt in seamen's lottery tickets and invested in the South Sea Company's stock, having the sense to sell out before the Bubble burst. In 1720 £54,040 South Sea Stock was sold for £234,428.

In 1704 he was a Governor of St. Thomas's Hospital and sixteen years before his death endowed rebuilding and

extensions costing between £2000 and £3000, besides subscribing to it for eleven years before beginning to build Guy's Hospital, completed after his death at a cost of £14,000. He also built almshouses at Tamworth and endowed Christ's Hospital and other charities.

The fullest and most reliable account of Guy is that contained in *A Biographical History of Guy's Hospital,* by Wilks and Bettany, 1892. The present writer deals here only with fresh additions to the received accounts,

The founder of Guy's Hospital was the eldest son of Thomas Guy, a lighterman and coal merchant in Southwark, and Anne Voughton, one of a family well-known in Tamworth and having branches in Birmingham and other West Midland parishes, including Halesowen. In the 1690's one Humphrey Vaughton was managing clerk to Humphrey Jennens, the wealthy Birmingham iron-master. In 1890, a book entitled *Vaughton's Hole* gave the story of mission work in the Deritend–Bordesley district of Birmingham for the previous twenty-five years. One wonders how long the district had borne this salubrious title.

Thomas Guy the elder died in 1652–3, when his son Thomas was about eight years of age, and the young widow returned to Tamworth, marrying a second time in 1661. On leaving Tamworth Grammar School young Guy was apprenticed to a London bookseller for eight years, afterwards setting up in business at the junction of Cornhill and Lombard Street.

Many apocryphal stories have been told regarding Guy's parsimony. Only one need be told here, that recorded by Anthony Highmore (1758–1829), author of *Pietas Londinensis,* and repeated by Thomas Allen.[26]

'To show what great events spring from trivial causes, it may be observed, that the publick are indebted to a most trifling incident for the greatest part of his (Guy's) immense fortune's being applied to charitable uses. Mr Guy had a maidservant whom he agreed to marry; and, preparatory to his nuptials, he had ordered the pavement before his door to be mended so far as to a particular stone which he marked. The maid, while her master was out, innocently looking on the paviours at work, saw a broken place they had not repaired, and mentioned it to them; but they told her that Mr Guy had told them not to go so far. "Well," says she, "do you mend it; tell him I bade you, and I know he will not be angry." It happened, however, that the poor girl presumed too much

319

on her influence over her wary lover, with whom the charge of a few shillings extraordinary turned the scale against her; for Guy, enraged to find his orders exceeded, renounced the matrimonial scheme, and built hospitals in his old age.'

No writer gives any authority for the story, but Charles Knight[27] thought that the order given in October, 1671, by the Common Council for compelling tenants to pave the foot pavements in front of their houses, six feet wide, may have been the occasion when the incident took place. However, the essential point in the story has been missed, viz., that if the incident occurred as a result of an order given by the Common Council, Guy was acting under compulsion in the first place, and like many another in like circumstances since, resented having to bear an expense not of his own choosing, and since he had then been in business only three years, he may have been unprepared to meet it. Indeed, it was scarcely in accord with his known character to improve his shop front preparatory to his marriage. It seems far more likely that, resenting the order, he gave instructions for the minimum amount to be paved which would satisfy the Council's demands.

It is easy to see that a story not committed to print for more than a century after the event became garbled during such a long period of oral transmission. Indeed, it is probable that Thomas Guy was actually a married man. At Hampden-in-Arden, Warwickshire, the following marriage entry occurs :—

'1669–70—Thomas Guy and Alice Kimberley married'

If this entry refers to the bookseller, he had been a freeman just over a year at the time he married and had enjoyed the married state only eighteen months when the Common Council issued its order and some little time longer when the paviours actually did the work. By that time it is possible that Guy's wife had grown tired of his extreme parsimony and returned to her friends in the Midlands. No issue of this marriage is shown in the Hampton-in-Arden register, but at the burial on 16 March, 1681–2, of Mr Richard Pretty, 'Clark,' (the minister of Hampton), Affidavit was sworn by Alice Guie of Hampton before Mr John Wilkison (sic) minister of 'Knoll.' She may have found the vicar's household more congenial than that of her frugal husband.

It may be asked how Thomas Guy the young London bookseller became acquainted with Alice Kimberley, a

question to which there is a very reasonable answer. Two families which rose to some prominence in the second half of the seventeenth century were those of Dugard and Kimberley, and both were connected with Bromsgrove and neighbourhood. The Dugards were originally of Rouen in Normandy and exhibited their pedigree at the Visitation of Warwickshire in 1682–3.[28] Henry Dugard of the Lickey in the parish of Bromsgrove, master of the Hospital at Worcester, married Elizabeth, daughter of William Kimberley, of Whitford, near Bromsgrove. Their issue included William Dugard (1606–1662), educated under his uncle Richard Dugard, B.D., at Sidney Sussex College, Cambridge, who later became the famous master of Merchant Taylors' School,[29] Thomas Dugard, M.A., rector of Barford, co. Warwick, and master of Warwick School, John, a citizen of London, Richard, an apothecary in London, George, a London stationer, and three daughters, of whom one, Alice, is said to have died an infant. William Dugard had a very varied career, for after being schoolmaster at Oundle, Stamford, and Colchester, he became headmaster of Merchant Taylors' School, from which he was dismissed for printing seditious literature, whereupon he set up a school of his own, taking many of his former pupils with him, and was later re-instated and, despite the disapproval of the governing body of the school, continued his printing activities for the rest of his life ; moreover, he had two sons by his first wife and no less than fifteen children by his second wife, the youngest of whom married her cousin Samuel Dugard, rector of Forton, Staffordshire, son of Thomas Dugard, rector of Barford, who afterwards married Elizabeth, daughter of William Kimberley. M.A., minister of Redmarley, co. Worcs., having previously been minister and schoolmaster of Kinver. Roger Kimberley, whose name also appears in the Kinver register, was at Pembroke College, Oxford, at the same time as John Hall, the future Bishop of Bristol, who was a scholar at Merchant Taylors' School under William Dugard. The bishop's father, John Hall, was rector of Bromsgrove 1624–57. Samuel Kimberley, son of William, of Bromsgrove, was also of Pembroke College, graduating B.A. 1668, M.A. 1671, B. & D. Med. 1685, while his brother Jonathan held many preferments, being chaplain to Charles II, vicar of Trinity Church, Coventry, canon of Lichfield and of Westminster, rector of Bagginton and vicar of Leamington, co. Warwick, etc.

Chester's London Marriage Licences informs us that William Dugard, in March, 1641–2, while schoolmaster at Colchester, had a licence to marry Lydia Tyler, of All Hallows, Lombard Street, a widow. The widow's maiden name was Parker, of a Gloucestershire family, and her first husband was a London goldsmith. This Lydia Parker was Dugard's second wife who bore him such a numerous progeny and it is immediately apparent that the marriage brought Dugard into close touch with the Lombard Street area of London, and he remained there and near at hand for twenty years. In a list of Merchants of London, 1677, of forty-four 'goldsmiths who kept running cashes,' twenty-seven were located in Lombard Street, and it was nearby, too, that from 1668 Thomas Guy conducted his business 'at the Corner-shop of Little Lombard Street and Cornhill, near Wool-church Market, 1678,' according to the imprint on *Howel's Familiar Letters*, 5th Edition, printed for Guy. In May, 1644, William Dugard was chosen to be headmaster of Merchant Taylors' School, then in Suffolk Lane, Cannon Street, again only a short distance from that noted triangle enclosed by Lombard Street, Cornhill and Gracechurch Street, and containing the churches of St. Michael and St. Peter, Cornhill, All Hallows, Lombard Street, and St. Edmund, as well as from 1669 the Royal Exchange which succeeded Gresham's Bourse. It seems highly probable that Dugard's wife used her influence with her former husband's associates among the goldsmiths to assist Dugard's appointment.

Thomas Guy's association with Peter Parker in the revival of Bible printing at the Oxford University Press is well-known. Whether Peter Parker was related to Dugard's wife is not known, but the possibility cannot be overlooked. We can glean a further snippet of information about Parker from Chester's London Marriage Licences:

'Peter Parker, of St. Mary Woolnoth, London, gent., bachelor, 24, and Mrs. Susanna Cripps, of same, widow, 28—at Hampstead, Middlesex, or St. Giles, Cripplegate, or St. Alban, Wood Street, London. 1 Dec., 1664. F.'

It seems certain that this refers to the bookseller, showing that he was attached to the same church as Guy, and that he was about four years Guy's senior. The earliest book known to have been printed conjointly by Guy and Parker is the third edition of John Ogilby's translation of *Virgil* in 1675, and the earliest Bible bearing their imprint is dated

1680. This, therefore, gives an approximate date for the change of Guy's shop-sign to the 'Oxford Arms, Lombard Street.'

William Dugard died in 1662, at the relatively early age of 54, when Guy had served two years of his apprenticeship to John Clarke, but John Dugard was also a citizen of London, Richard was an apothecary in London, and George was a London stationer. Besides these his nephew Samuel had married Lydia, William's youngest child, and later Elizabeth Kimberley, having issue by both.

There are also further evidences of links with London printers and booksellers. Thomas Dawks the younger, born in 1636, a well-known printer, was admitted to Merchant Taylors' School in 1649, when William Dugard was headmaster and two years later was apprenticed to a printer named Dugard, presumably George, the headmaster's brother. Between 1653 and 1657 he was employed as a compositor on Walton's Polyglot Bible and in 1674 he set up as a master in Blackfriars. Dawks married in 1660 and of his eleven children Ichabod (1661–1730), the eldest, also became a well-known printer, and a daughter, Dorothy, married first, Benjamin Alport, a bookseller, and afterwards the famous William Bowyer the elder, one of Caslon's principal patrons.[30]

In view of the connections between the Dugards and Kimberleys and the Lombard Street area of London where Thomas Guy operated as a bookseller, and the connections of these families with Warwickshire, it seems highly probable that the marriage of Thomas Guy and Alice Kimberley at Hampton-in-Arden was indeed that of the future founder of Guy's Hospital.

Guy's interest in his mother's family is seen in the number of beneficiaries named in his will who belong to Tamworth and Birmingham. Guy was born about 1645 and as he mentioned descendants of uncles, aunts and cousins, it becomes apparent how widely dispersed his relations might have become by the year 1700. In the Halesowen register there are 17 entries relating to Voughton between 1684 and 1713. Most of them relate to the family of a John Voughton who was a baker. After the death of his wife in 1712 and of his mother and an infant son in 1713, John Voughton and his surviving son Edward appear to have left the town. It is impossible to say whether the Halesowen Voughtons belonged to the same branch of the family as Thomas Guy's mother.

The Rev. Richard Mayo, D.D., through whom Guy made his recommendation of Caslon to the S.P.C.K. Committee, was the Chaplain of St. Thomas's Hospital, Southwark, to which Thomas Guy had been so munificent. Richard Mayo was the son of an earlier Richard, who had been 'Hospitaller' at St. Thomas's from 1707 to 1717. The younger Richard was connected with the Hospital from 1717 until his death on 10 May, 1727. From 1723 he was also rector of St. Michael, Crooked Lane. The Rev. Henry Shute, chaplain to Edward Harley, Earl of Oxford, and lecturer of Whitechapel, was Treasurer of the S.P.C.K. for more than twenty years until his death on 3 November, 1722. On 11 December following his death it was decided to divide the duties of the treasurership between four members, Richard Mayo being deputed to receive the contributions for the Society's general designs and for the Arabic Impression; he was one of the Residing Members, attending the Society's weekly meetings and taking an active part. On Mayo's death his place was filled by the Rev. John Deane, D.D., Archdeacon of Rochester.[31]

We must now look at the other members of the S.P.C.K. Committee who met on 12 June, 1722:

Sir John Philipps was of Picton Castle, Pembrokeshire, and was a member of the Society from as early as 1699, probably having been enlisted by Sir Humphrey Mackworth, a fellow Welshman. Lady Philipps was Mary, daughter of Anthony Smith, an East India merchant. In the late seventeenth century Anthony Smith, probably the same, gave a benefaction of £20 to St. Thomas's Hospital. Sir John Philipps's cousin was Katharine Shorter, first wife of Sir Robert Walpole. Sir John was a notable supporter of the Welsh charity school movement, maintaining a number at his own cost, and an increased demand for books in the native language followed, Newman organising the purchase and distribution of such as could be found. In 1717 the Society published 10,000 copies of a new impression of the 1630 Welsh Bible and another impression in 1728. These were printed at the King's Printing House by John Baskett, who had the sole right of printing these as well as English Bibles.[32] In 1717 John Williams and Samuel Ashurst were still trustees for Baskett and, as shown in the last chapter, there was a posssible connection between Williams and Caslon.

It seems that Sir John Philipps's interest in matters concerning the S.P.C.K., including the work of the foreign missions, was communicated to Oxford through the baronet's two sons, Erasmus and John, who matriculated from Pembroke College in August, 1720. Erasmus Philipps has left a record of his life at Pembroke[33] from which the following short excerpt is taken.

Journal of a Gentleman-Commoner

1720 Sept. 24	I was made free of the Bodleian Library, and took the usual Oath not to Embezzle the Books, etc.
— — 25	Made a present to the Bodleian Library of a Grammatica Damulica (a Malabar Grammar) a very great curiosity ...
Ditto —	Presented Pembroke College Library wth Mr Prior's works in Folio, neatly bound, w^{ch} cost me £1–3s. Rev. Mr Thomas Tristram, M.A., and Fellow and Librarian of the College, entered me on this occasion a Benefactor to its Library.
1720–21 Feb. 27	Died, Cosin Kitty Walpole at the Bath. She was daughter to the Rt Hon^{ble} Robert Walpole, Esq^{re} [Sir John Shorter, Lord Mayor in 1688, had married Elizabeth Philipps, and their daughter Katherine married Sir Robert Walpole.]
1721 July 19	Sent Mr Wm. Wightwick, Demy of Magdalene College, a Copy of Verses on his leaving Pembroke.
1721 July	Mr Solomon Negri (a Native of Damascus) a great Critic in the Arabick Language and perfect Master of the French and Italian Tongues, came to Oxford, to consult and transcribe some Arabick Manuscripts in the Bodleian Library; fell acquainted with this Gent. and with Mr Hill, an ingenious Friend of his that came down with him; and enjoyed abundance of satisfaction in their Conversation.
„ Aug. 7	I was Enter'd a Student of Lincoln's Inn.
„ „ 17	Went with Mr Tristram to the Poetical Club (whereof he is a Member) at the Tuns (kept by Mr Broadgate) where ...
„ „ 31	At Mr Tristram's Chambers wth Mr Wanley, the famous Antiquarian, Keeper of the Harleian Library, Mr Bowles, Keeper of the Bodleian Library, and Mr Hunt of Hart Hall, who is Skill'd in Arabick.

1721 Sept. – My Father, Brother Buckley, and Mr Bernewitz
came from London to Oxford, and lodg'd at Mr
Best's near our College.
 „ Sept. 7 Rid out with my Father, Mr Jorden, and Bro.
John to Shotover
. . . Show'd my Father the Colleges and Curiosi-
ties of the University.'[34]

The connection of the Tristrams [35] with Halesowen has been
touched upon in Chapter 4. Richard Tristram, son of Thomas
Tristram, rector of Belbroughton by his first wife, had three
wives. His daughter Sarah married Francis Pierce, M.A., who was
vicar of Halesowen from 1676 to 1685, afterwards rector of
Rushock and master of Hartlebury Grammar School, co. Wor-
cester. Richard Tristram's son John married Elizabeth, daughter
of Lancelot Nicholls of Bow Hills, Alveley, Shropshire, and their
son, also John, graduated B.A. at University College, Oxford, in
1700, M.A. 1703, becoming M.B. in 1706, and then practising
as a physician in London. In 1707 Dr. Tristram married Mary
Parker at St. Michael's, Cornhill,[36] London, the bride being of
the parish of St. John at Hackney, and daughter of Peter Parker.
It seems quite probable that this Peter Parker was none other than
the son of Thomas Guy's bookselling partner at the Oxford Arms
in Lombard Street, affording another link between Thomas Guy
and Caslon's home district. However, Mary Parker died in the
year following her marriage and was buried in the chancel at St.
Michael's, Cornhill, her husband then marrying Laetitia, daughter
of Thomas Jones, an apothecary of London. Dr. Tristram was a
friend and correspondent of Bishop Charles Lyttelton, and after
giving up his medical practice in London, resided at Moor Hall,
Belbroughton, and busied himself in literary pursuits.

Thomas Tristram, rector of Belbroughton, by his second
wife had three sons, John, a noted physician, William of Oldswin-
ford, and Andrew, Commonwealth minister of Clent. According
to a MS. left by Dr. John Tristram, the second son, William of
Oldswinford, 'invented the first round glass house in these parts,
and greatly improved the art of making flint glass, and of purifying
iron for making steel.' Besides a daughter, Mary, who married
William Penn of Harborough and was grandmother to William
Shenstone the poet, William Tristram had two sons, Thomas and

326

William. Thomas graduated B.A. at Pembroke College, Oxford, in 1689, and was rector of Allesley, co. Warwick, from 1692 to 1723. Thomas's son, also Thomas, graduated B.A. at Pembroke College in 1717, M.A. 1720, and it was this Thomas who was Librarian and Fellow of Pembroke College when Erasmus Philipps was writing his impressions of College life. In 1723 Thomas Tristram became rector of Castle Combe, Wiltshire, and in 1726 rector of Hampton-in-Arden, Warwickshire.[37]

In 1692, William, the second son of William Tristram of Oldswinford, married his cousin, Elizabeth Waldron of Clent. As shown in Chapter 5, Nicholas Pearman of Clent married Sarah Waldron in 1679, and it was their son John Pearman of Trinity Minories, London, who was William Caslon's co-apprentice; also William Waldron the Clent schoolmaster was a witness to Nicholas Pearman's will in 1724.

Although it is impossible on this slender evidence to attribute any influence from the Tristrams bearing on the S.P.C.K. Committee's selection of Caslon for his first major task in punch-cutting and founding, it is not improbable that through his relationship with the Pearmans the Tristrams were acquainted with him. This digression serves, however, to emphasise the necessity for the exhaustive searches undertaken in this work, in the absence of direct documentary evidence, if convincing conclusions are to be reached.

Sir Daniel Dolins, chairman at the first meeting, was connected with the law. He was admitted to Lincoln's Inn in 1713 and to Gray's Inn in 1720. As a deputy-lieutenant of the Tower Hamlets, he carried up an address of loyalty to George I after the Jacobite plot of 1722, on which occasion he was knighted. In 1700 he married Margaret, daughter of Sir Thomas Cooke of Hackney, whose sister Elizabeth in 1691, had married the famous banker Josiah Child.[38]

William Tillard was the son of Abraham Tillard of Street-End House, co. Kent; his relation Sir Isaac Tillard was knighted on the same occasion as Sir Daniel Dolins.[39]

John Chamberlayne (1666–1723) was a younger son of Edward Chamberlayne (1616–1703), author of *Angliae Notitia, or the Present State of England*, an annual publication which the son continued. In 1685 John published *The Manner of making*

Coffee, Tea, and Chocolate as it is used in most parts of Europe, Asia, Africa, and America, with their Vertues. Neuly done out of French and Spanish, an amusing tract which became widely popular. He chiefly studied modern languages of which he was reported to know sixteen. He was successively gentleman waiter to Prince George of Denmark, gentleman of the privy chamber, first to Queen Anne and then to George I. He was also secretary to Queen Anne's Bounty Commission, and a magistrate for Middlesex.

Chamberlayne was also the first secretary of the S.P.C.K. Although he relinquished the post to Humphrey Wanley in 1702 he continued to show a keen interest in its affairs until his death. He translated for the Society Osterwald's *Arguments of the Book and Chapters of the Old and New Testaments* 3 vols. 1716. He also published in 1715 at Amsterdam *Oratio Dominica in diversas omnium fere gentium linguas versa,* the Lord's Prayer in many different languages, and other works.[40]

Rev. Robert Watts (1683–1726), B.C.L. 1709, was the son of Thomas Watts, of London, and was described as of Great Gidding, co. Hunts, to distinguish him from Rev. Thomas Watts (1664–1739), vicar of Orpington, who was another regular attender, the son of a Robert Watts of Hereford. Neither of these is known to have any connection with John Watts, Caslon's early patron.[41]

Mr Wheeler was probably connected with Sir George Wheeler (1650–1724) of Charing, Kent, who had been an early member of the Society. Sir George had a son Thomas who graduated B.A. in 1709, as well as a younger brother Charles who was of Lincoln's Inn. [42]

Stephen Hales (1677–1761), described as a physiologist and inventor, was perpetual curate or minister of Teddington, Middlesex, where he lived for the greater part of his life. He was elected F.R.S. in 1718 and later a trustee for the colony of Georgia. Horace Walpole called him 'a poor, good, primitive creature.'[43]

Mr Dean Maule was a Dublin ecclesiastic and the Mr Hoare who was present at the second meeting on 19 June was probably Henry Hoare who succeeded to the banking business of his father Sir Richard Hoare (1648–1718), a former lord mayor of London.[44]

One would naturally expect that any of the committee members who had a personal interest in Caslon would make a point of being present at both meetings. Acceptance of this theory rules out John Chamberlayne, Wm. Tillard, Wheeler, Dean Maule Stephen Hales, Hoare and, surprisingly, Dr. Thomas Bray himself, though the last-named was now sixty-six years of age and in uncertain health. Those remaining under consideration were Sir John Philipps, Sir Daniel Dolins, Rev. Richard Mayo, Rev. Henry Shute, Rev. Robert Watts, and Henry Newman himself.

So far we have uncovered no direct evidence of any influence on the S.P.C.K. Committee supporting Caslon's selection against the other letter-founders in the trade, nor has any connection been found with William Bowyer and John Watts, traditionally regarded as Caslon's earliest patrons.

The only other person present on 12 June, 1722, was the secretary of the Society, Henry Newman, who was an American, a graduate of Harvard who had been for three years librarian of the College. One of the most material services Newman performed for his old College was in the recovery of legacies left to it in England. In 1710 the Corporation of Harvard had asked Newman to inquire about another legacy left to the College by Sir Robert Thorner. Newman replied to President Leverett that he had received full satisfaction from the trustees and added: 'Mr. Thomas Hollis, one of the trustees, at the Cross Daggers in Little Minories, desires his will may be inquired for after his decease.' This Thomas Hollis was the London merchant who founded in 1721 and 1725 the first two professorships at Harvard, in Divinity and Natural Philosophy; and Newman's news was very important, for it was the first hint of the beneficent intentions of the first of the six Hollises whose names were to be so closely linked with the prosperity of the College.[45]

Other references show that Newman was intimate with a Thomas Hollis who was also a scholar of Harvard. After the failure of the Jacobite Plot of 1722, the Corporation of Harvard College directed Henry Newman and Thomas Hollis to present an address to George I 'upon the discovery of the horrible and detestable conspiracy against His Majesty's life and Royal Family.'[46] In 1728 Dr. Benjamin Colman wrote from Boston to Thomas Hollis,

'a Harvard graduate living in London,' enclosing a letter for him to give to Newman.[47]

There can be no doubt regarding the intimacy between Newman and Thomas Hollis, as the archives of the S.P.C.K. reveal. In a letter dated 17 June, 1723, Newman tells Hollis that he has called to see him two or three times at the Amsterdam Coffee House to thank him for his recent hospitality and to return a borrowed book which he has left with the keeper of the coffee-house.[48] The Amsterdam Coffee House had three locations in the course of its life, all near to the Royal Exchange; in 1723 it was at Sweeting's Rents, Threadneedle Street. Banking, insurance, shipping and many other kinds of business were transacted there.[49]

The Hollises were members of the Drapers' Company, but were cutlers by trade, hence the sign of the Cross Daggers. However, some time between 1710 and 1723, Thomas Hollis had moved from Little Minories to Mansel Street, Goodman's Fields. In both places of his business there was a Caslon connection. John Pearman, Caslon's co-apprentice and his first wife's cousin, was in business as an engraver in Little Minories, attending Trinity Minories Church, where in 1727 he was a churchwarden. Edward Cookes, the former master of John Pearman and William Caslon, on leaving Farringdon Ward, continued his engraving business in Goodman's Fields. Both Pearman and Cookes may well have engraved for Hollis, although it is not known whether swords and bayonets were a branch of his business. Again, although it is known that William Caslon's cousin Samuel was also a cutler, little else is known about him.

The Sir Robert Thorner whose legacy Newman was pursuing in 1710 was Thomas Hollis's maternal uncle. He was a Baptist and the Hollises had Baptist sympathies too, as also had Thomas Guy. The Hollises were tolerant sectarians, however, for when Thomas Hollis made his will in 1723 he described himself as of Whitechapel, but left a benefaction to the poor of Trinity Minories where he had formerly lived.[50]

Thomas Hollis was a benefactor to deserving causes in this country as well as to Harvard. Before 1700, when he was known as Thomas Hollis, junior, he gave £250 to St. Thomas's Hospital[51]

330

which, as previously noted, Thomas Guy endowed munificently. Guy also nominated Hollis one of the executors and original governors to carry into effect what was to become Guy's Hospital. There was thus a close connection between Guy and Hollis.

The pattern of things becomes much clearer when we refer to Updike's account of William Caslon, where he says, 'William Bowyer the elder (1663–1737) was printer for Thomas Hollis, benefactor of Harvard College.'[52] However desirous Bowyer and Watts might have been to help Caslon towards being selected for the Arabic enterprise, the facts of their own situation had to be faced, for a direct recommendation from themselves to an Anglican Society would have carried insufficient weight. Watts was Caslon's senior by about fifteen years, but he was not even a liveryman of his own Company, and though Bowyer, who at this time was approaching sixty years of age, enjoyed much higher standing among his printer colleagues and in the Stationers' Company, it must be remembered that he was a Non-juror and as such might be regarded by some with less favour than an outright dissenter. Possibly Bowyer and Watts felt that they were acting in the best interests of Caslon not to identify themselves with a personal recommendation to the S.P.C.K. Although Samuel Palmer was the printer concerned in the Arabic venture, not themselves, Bowyer was quite familiar with Palmer, who shared in the printing of Selden's *Works*, and the fact that Bowyer printed for Hollis would make it easier to ask Hollis a favour. Bowyer and Guy no doubt held each other in mutual respect, but Hollis was on a different footing and his relations with Guy were likely to be well-known. As already noted, Hollis was already probably acquainted with Caslon through Sarah Pearman's family but, whilst willing to do the engraver a favour, he would require some assurances as to Caslon's ability to undertake such a formidable task; these assurances Bowyer would be able to give him. There can be little doubt that Henry Newman, who was on terms of more than mere acquaintance with Hollis, as we have seen, was also in the plan, but it was a master-stroke to bring in Thomas Guy. As an ancient in the profession and with his vast influence and reputation for supporting deserving causes—in which light the S.P.C.K. Committee doubtless hoped he would regard their own scheme—he was the

best possible supporter of Caslon's interests.

We must now return to Caslon's work on the Arabic fount. On 11 December, 1722, Caslon reported that 'he had made good Progress in the Puncheons and Matrices for Arabick Types, and that he should by Christmas next be able to furnish all the Types : that Mr. Negri attended him generally twice a week, and had enabled him to make more perfectly several Puncheons in Arabick than he could have done from the Patterns in Avicene's Works,'[53] a testimonial to Negri that was probably not unsolicited. These expectations, however, were not realised, for on 22 January, 1722–3, a letter was received from Caslon apologising for the delay and enclosing a specimen of the work he had completed. He asked the Society 'in Consideration of his great Expense for necessary Tools for the Foundery to Advance Twenty Guineas to enable him to finish the whole work without engaging himself in other Business to subsist his family.' There can be little doubt that Caslon was passing through an anxious time, for besides having a wife and young family to keep,[54] he had two apprentices to train, John Pearman and Joseph Halfhide, apprenticed in 1717 and 1718, obviously neither being yet ready to bring much grist to the mill. The Society paid the twenty guineas, and several anxious messages to Caslon followed, calling for early completion. Henry Newman wrote to Aleppo on 21 June, 1723, that the types had been delayed by the 'indisposition' of the founder, but Caslon was able to attend the Committee in person on 25 June. Throughout the summer and autumn he was kept busy supplying further alphabets and altering characters to suit Negri's requirements. On 17 September he brought the Committee a specimen of 344 characters single and compound, and told them that he had broken nine of the punches when he came to strike them, which took him three days to repair. On 15 October, he said that he was ready to begin casting, and by the end of the year the work was substantially complete, except for a few extra sorts which were hastily cut and cast in February and March, 1724, to comply with Negri's afterthoughts.[55]

On 14 April, 1724, Caslon's work for the Society consisted of 355 Puncheons and 361 Matrices, 6 of which had been cut on the Copper without the use of Puncheons. The bill at this stage

appears to have been £57. 4. 3, to which must be added the twenty guineas paid on account.

The actual amount advanced by Caslon's friends has possibly been confused with the amount of £500 collected towards the whole scheme for the Arabic impression mentioned in Newman's letter to Thomas Guy dated 18 October, 1721. Palmer's quotation for the whole impression was something less than £1200 and, as we have seen, Caslon's share for cutting the puncheons and sinking the matrices was a meagre £78. 4. 3 for a task begun in July, 1721 and lasting more than two years, which seems no more rewarding financially than the work Caslon had done earlier as an engraver of gun-locks for the Ordnance Office. It seems certain, therefore, that Caslon undertook other work side by side with the cutting of the Arabic punches, at least until the S.P.C.K. exerted pressure on him, thus compelling him to ask for Twenty Guineas to eke out his domestic needs. It seems certain, too, that Caslon would be buoyed up by the knowledge that the profits from the sale of type were more rewarding than the labour of punch-cutting, but that he could only hope to sell in quantity from the alphabets in regular demand; perhaps this prompted him to work on the Pica roman while he was still engaged on the Arabic.

At the completion of the Arabic enterprise, the S.P.C.K. retained a set of matrices and a mould of the Arabic type, while Caslon kept the punches. Samuel Palmer, the printer both of the Psalter, dated 1725, and of the New Testament, 1727, used both Arabic types in the printing, Caslon's for the text and the Polyglot for headings.

Such, then, is the account of Caslon's notable performance in making the punches and matrices and casting the type for a fount of English size Arabic, an achievement which set him on the high-road to fame.

[1] Chapter 9.
[2] S.P.C.K. Minutes, Vol. IV, pp. 4, 5, 7; quoted by James Mosley.
[3] L. W. Cowie; Henry Newman, An American in London, 1708–43, 1956.
[4] Kindly communicated by Mr A. E. Barker, Archivist to the S.P.C.K.

5 James Mosley, The Early Career of William Caslon, which see for an explanation of how Thomas James was able to cast from the Polyglot matrices.

6 L. W. Cowie, Henry Newman.

7 James Mosley, The Early Career of William Caslon.

8 Reed-Johnson, pp. 206–210.

9 A Plate showing the Ten Commandments in Arabic is shown in L. W. Cowie, Henry Newman, facing p. 54.

10 H. R. Plomer, Dictionary of Booksellers and Printers, 1668–1725.

11 Bettany and Wilks, Biographical History of Guy's Hospital.

12 Boyd's Marriage Index, Society of Genealogists.

13 L. W. Cowie, Henry Newman.

14 H. P. Thompson, Thomas Bray.

15 Allen and McClure, Two Hundred Years.

16 London House, originally Petre House, was acquired by the Bishop of London after the Restoration. Dr. Richard Rawlinson lived there (D.N.B.) and later Jacob Ilive the letter-founder.

17 Allen and McClure, Two Hundred Years.

18 Ibid.

19 Courtesy of Mr A. E. Barker, Archivist to the S.P.C.K.

20 Ibid.

21 Ibid.

22 L. W. Cowie, Henry Newman. (The Rev. Henry Shute was the Earl of Oxford's chaplain).

23 Courtesy of Mr A. E. Barker, S.P.C.K. Archivist (C.S.2. 10. 72).

24 Ibid. (C.S.2. 11. 40).

25 Ibid. (CR1. 11).

26 History of Surrey and Sussex, 1829.

27 Shadows of the Old Booksellers, 1865.

28 Harleian Soc. Vol. LXII, 1911.

29 D.N.B. art. William Dugard.

30 In 1644 Henry Overton and Katherine Dawks were married at Barcheston, Warwickshire, and it seems highly probable that the bridegroom was one of the Overtons prominent in London publishing, and the bride one of the London family of printers named Dawks. The D.N.B. refers to Richard, the pamphleteer, and John, Henry and Philip Overton, noted printsellers.

31 Allen and McClure, Two Hundred Years.

32 L. W. Cowie, Henry Newman.

33 Douglas Macleane, History of Pembroke College, Oxford, 1897. (N.B.—This journal of a gentleman-commoner was published in N. and Q., Second Series, Nov. 10, 1860: 'College Life at Oxford One Hundred and Thirty Years Ago').

34 Brother Buckley was Bulkeley Philippes of Abercover. Bro. John was his brother John Philippes, Mr Jorden was the Rev. Wm. Jorden, a Fellow of Pembroke, who was afterwards tutor to Samuel Johnson.

35 H. S. Grazebrook, Heraldry of Worcestershire

36 Register of St. Michael, Cornhill.
37 Foster, Alum. Oxon.
38 Burke's Commoners and inf. Guildhall Library.
39 Ibid.
40 D.N.B. art. John Chamberlayne.
41 Foster, Alum. Oxon. (where, however, Robert Watts is described as of Little Gidding).
42 Foster, Alum. Oxon.
43 D.N.B. art. Stephen Hales.
44 D.N.B. art. Sir Richard Hoare.
45 L. W. Cowie, Henry Newman, p. 191.
46 Ibid. p. 190.
47 Ibid. p. 45.
48 Courtesy of Mr A. E. Barker, S.P.C.K. Archivist.
49 Bryant Lillywhite, London Coffee Houses, 1963.
50 Kindly communicated by Mr R. E. F. Garrett.
51 Benjamin Golding, Historical Account of St. Thomas's Hospital, Southwark, 1819.
52 D. B. Updike, Printing Types, Vol. II, p. 201.
53 James Mosley, The Early Career of William Caslon.
54 Caslon's son William was baptised on 23 June, 1720, and his daughter Mary on 31 August, 1722.
55 James Mosley, The Early Career of William Caslon.

Chapter Seventeen

CASLON AS A PUNCH-CUTTER AND
LETTER-FOUNDER

A TRADITION in the Caslon family that William Caslon began his career as a letter-founder in 1716 induced Henry William Caslon, the last of the line, to adopt this as the date of the establishment of the foundry. This notion, however, must be rejected now it is known that Caslon, though completing his apprenticeship in 1713, was not admitted a freeman until June, 1717, and that he was still known to the S.P.C.K. in June, 1722, as an 'engraver,' or 'ye letter engraver.' Moreover, there is the clear announcement by Caslon himself that his foundry was begun in 1720; in the specimen book of 1764 the following advertisement appeared on the last page:

> 'This new Foundery was begun in the year 1720, and finish'd 1763; and will (with God's leave) be carried on, improved, and inlarged, by William Caslon, Letter-Founder, in London.—Soli Deo Gloria.'[1]

At this date, 1764, William Caslon II was undoubtedly taking the major part in the management of the foundry, but his father would scarcely have countenanced anything fictitious in the date of commencing the business and he might not have seen anything misleading in the literal interpretation which later times might put upon the word 'foundery.' 1720 was probably the date when Caslon's punch-cutting business, which a little later was combined with casting, was established, and as eighteenth-century

tradesmen were not concerned with precise verbiage there was no intention to deceive in applying the word 'foundery' in a loose sense to a business which soon afterwards included the casting of letters. Any other interpretation seems to lead the enquirer into greater difficulties. The Board of Ordnance records make no later reference to Caslon than 26 June, 1719,[2] so he seems to have abandoned gun-lock engraving before 1720.

The set of 'Proposals for Casting a Font of Arabick Letters made by William Caslon to the Society for Promoting Christian Knowledge' drawn up in July, 1722, estimated that the puncheons and matrices would take six months to make, but the work took more than three times as long, probably because Caslon had to maintain a growing family and keep his apprentices engaged on other work. Some time after seeing the processes in operation at James's foundry, Caslon had to acquire the small amount of equipment necessary for casting and to practise until he became adept, but there is no doubt that he did cast them in the circumstances related in the previous chapter.

The account of Caslon which has come down to us[3] also says that 'after he had finished his Arabic fount, he cut the letters of his own name in Pica roman, and placed the name at the bottom of a specimen of the Arabic, a circumstance, says Nichols,[4] which "has lately been verified by the American, Dr. Franklin, who was at that time a journeyman printer under Mr. Watts, the first printer that employed Mr. Caslon." Samuel Palmer (the reputed author of Psalmanazar's *History of Printing*), seeing this name, advised Mr Caslon to complete the fount of Pica. Mr. Caslon did so ; and as the performance exceeded the letter of the other founders of the time, Palmer—whose circumstances required credit with those who, by his advice, were now obstructed (that is, whose business was likely to suffer from this new rival)—repented having given the advice, and discouraged Caslon from any further progress. Caslon, disgusted, applied to Mr. Bowyer, under whose inspection he cut, in 1722, the beautiful fount of English (roman) which was used in printing Selden's *Works*.'[5]

This last statement is a mistake which has crept into most later accounts, even Updike repeating it in 1937 in his well-known work on Printing Types, for Caslon's English roman did not

337

appear until 1728, in *A Discourse of the Judicial Authority belonging to the Office of Master of the Rolls*.[6]

The fact that Franklin confirmed the story that Caslon's name in Pica roman was placed at the bottom of a specimen of the Arabic while he (Franklin) was employed by John Watts almost proves that Watts had a close connection with Caslon's beginning, for what is more likely than that Franklin had the story from Watts himself? In 1724 Samuel Palmer moved his printing office to Bartholomew Close from Great Swan Alley in Charterhouse, and as Franklin worked for Palmer in the Bartholomew Close office for a year before he became employed by Watts, the accuracy of Franklin's statement so far as the time of the event is concerned is confirmed by the dates in the S.P.C.K. minutes. Might not the further statement that Watts was 'the first printer that employed Mr Caslon' also be true?

Caslon was a loriner. Loriners' Hall was leased to a Baptist Congregation. Watts had his printing office close to the Baptist Meeting House in Little Wild Street, Lincoln's Inn Fields. We do not know whether Watts was a sectarian or not, but since both Thomas Guy and Thomas Hollis, one of Guy's executor's, had Baptist sympathies, this may have been one channel through which Caslon increased his connection.

Unfortunately, tradition is silent as to the kind of work Caslon did for Watts. He may have cut bookbinders' punches for him as he did for others, but it seems more probable that Caslon cut music punches for the stamped pewter plate music which formed a large part of Watts' trade at this time.[7]

Some doubt has been cast on the tradition that Watts was connected with Caslon so early in his career, but Nichols's account rather implies that Caslon turned to Bowyer for practical help only when he had become disgusted with Palmer, that is, when he had completed the fount of Arabic. This view also agrees with the evidence put forward later that Caslon received no financial help from Bowyer, Bettenham and Watts until 1725, that is, when he moved to Helmet Row.

In Chapter 13 the writer has questioned the tradition that Bowyer was allowed to show Caslon, a potential competitor, the process of type-founding as conducted at James's foundry, and

one hesitates to suggest that a man with Bowyer's upright reputation would stoop to deceit in explaining the reason for the visit. So much of the received account has been garbled that one must conclude there is some mistake here.

The earliest authenticated connection of Caslon with a printer was with Samuel Palmer in the Arabic enterprise. It has been already noted that Palmer moved to Bartholomew Close in 1724. His printing office occupied part of the former Lady Chapel of the Church of St. Bartholomew the Great.[8] Palmer was friendly with Thomas James whose foundry was in a small separate building at the east end of the same chapel. Salomon Negri was lodging with Palmer from December 1720, and Negri, Palmer and Thomas James were in close consultation during the alterations to the Polyglot characters and the subsequent casting from them by James before Caslon came on the scene. But if Caslon was concerned in the alterations to the Polyglot characters it is possible that Palmer connived at a piece of industrial espionage, enabling Caslon to view the casting process during the consultation with Negri.

'The evil that men do lives after them,' was never more aptly illustrated than in the account of Caslon's unsatisfactory dealings with Samuel Palmer the printer, for they are among the best authenticated incidents in the biography of Caslon which have come down to us. If Palmer did not foresee the effect of his encouragement of Caslon, he must have been as big a fool as he was a knave. Yet it must be allowed that Palmer was at least plausible, for we find Caslon still having dealings with Palmer years later and allowing Palmer to run deeply in debt to him.

The legendary account of the loan to Caslon has been previously mentioned, but it certainly could not apply to the period when Caslon was engaged on the Arabic type, for he was already provided with equipment for punch-making and would need very little foundry equipment for casting a single size of letter in a language which printers only infrequently required. Whatever type punches Caslon may have cut previously by way of odd sorts for Thomas James or anyone else, it was possibly a piece of good fortune that his first major effort was for characters infrequently called for, that his work was supervised by an Arabic scholar, and

that instead of Caslon having to make his type viable in a commercial market, his labours were subsidised by a society supported by public subscription.

However, there can be no withholding of our admiration for Caslon's performance. One must marvel that he was able to cut six characters direct into the copper so as to ensure that when cast the type faces were all of the correct shape and of uniform height. One wonders what the characters were which called for this exceptional treatment. One purpose of the punch and matrix method of producing type is to ensure that when the punch is driven into the copper the face of the letter at the bottom of the trench has the correct shape and is of uniform depth ; obviously, it is much easier to shape and proportion and true up the face of a punch, the male member, than to make the same adjustments in the mould or matrix, the female member.

With regard to Caslon's model, the folio *Avicenna*, it has been identified as that printed by the Typographia Medicea in Rome in 1593, for which the type was cut by Robert Granjon in 1586–9. James Mosley has a footnote on this,[9] also suggesting that Caslon's was a poorer type. Perhaps this is a little hard on Caslon, who was not copying Granjon, but rather Granjon modified by Negri. It is clear from the account that Negri was imposing his own Arabic on Caslon, as in the sixteenth century, some unknown Arabic scholar had probably imposed his on Granjon.

Whilst we are not here discussing the history of letter design from its calligraphic origins to functional forms developed by printers, some observations must be made on the suitability of certain characters for reproduction by the punch and matrix method. A great deal has been written about the letter-forms of the countries of Western Europe, much less about so-called exotic or oriental characters. We find ourselves handicapped in reasoning about aesthetic and functional aspects of the design of Arabic, whereas we appreciate much more readily the reasons why the sculptured forms of the inscription on the Trajan column are not so appropriate when seen as a printer's type specimen and we can enter easily into a discussion on whether Baskerville was justified, on the basis of his experience as a slate sculptor and writing master, in changing the contrast between thick and thin strokes in a

printed specimen of roman. It was just the same with Caslon, except that his day-to-day experience in punch-cutting for bookbinders had given him an acute perception of what was artistically and functionally satisfying in the letters he saw every day. Again, just like ourselves, he may have seen Arabic once or twice, yet he was called upon to produce a fount of characters to represent this strange language, probably the most unusual of the scripts he had ever seen.

Regarded structurally and architecturally, roman capital letters have exceptional rigidity, the serifs also having shapes which add to the strength of the principal members. In the lower case letters the bowls of a, b, d, g, o, p and q have the strongest structural form and the ascenders and descenders are not so long as to produce weakness ; these again are reinforced by the serifs, a feature which also applies to the open ended parts of the letters h, k, m, n, u, v, w, y.

Arabic characters, however, are much different. They exhibit extremely few closed shapes, many open ended loops, and numerous cusps, dots and detached pieces ; moreover, there are no serifs, but instead, many of the characters end in a tapered member which is certain to produce weakness in the punch. Unlike the roman character, in which the accent follows that of writing with the pen pointing over the shoulder, the Arabic has the strongest accent generally on the horizontal strokes, as made with the pen pointing across the page. Moreover, while there is a certain amount of variation in the thickness of the characters there is less contrast between thick and thin strokes, reducing in some characters the face area of the punch in relation to the total length of line. Whilst this made the punch a sharper instrument when driven into the copper it also made it necessary for the tool to be more delicately tempered. In all these circumstances, it is small wonder that Caslon

لا يكن لك الاُّ آخر غيري ۞ لا تاخذلك صورة ۞ ولا تمثيل كلّ مـا ـفي السّمآء من فوق ۞ وما ـفي الارض من اسفل ۞ ولا ما ـفي المـآء من تحت الارض ۞ لا تسجد لهنّ ۞ ولا تعبدهنّ ۞ فانّي انـا الرنّب الاهك الاُّ غيور۞ اجتزي ذنوب الابآء من

Fig. VI. Caslon's Arabic

341

broke a number of punches or that in a few cases he had to engrave the character direct on to the copper.

It appears to have been in the latter half of 1724, when the Arabic Psalter was in the hands of the printer, that Caslon was engaged on the fount of Pica roman, mingling it with the other work which he must have continued for a time, for it is improbable that Caslon himself yet realised what success would shortly attend his efforts. By the end of 1724 then, he had his punches for the Arabic type and a set of punches for the Pica roman. Caslon still continued the training of his two apprentices John Pearman and Joseph Halfhide and as both these men continued their career as engravers, here is proof that Caslon continued some of his previous work. Pearman completed his apprenticeship in 1724 and set up in business in Haydon Square, Minories, not far from his older half-cousin and namesake. Caslon's third child, a son John, was baptised and buried at St. Botolph's, Aldgate, in January, 1723–4, so Caslon was then still living in Vine Street. Halfhide completed his apprenticeship in 1725 and set up in the engraving business in Vine Street, facts which form strong presumptive evidence that Caslon moved to Helmet Row in 1725 and Halfhide took over his Vine Street premises.[10]

It seems highly improbable, both on the grounds of distance and expense, that Caslon had premises at Helmet Row, Old Street, at the same time that he maintained his engraving business at Vine Street. In 1723, while living near the Charterhouse, Negri, lodging with Palmer, complained of having to walk from Clerkenwell to the Minories to supervise Caslon's work. It is possible that when Guy's interest had been enlisted, Caslon's patrons hoped that Guy would come forward with financial assistance towards setting up the young engraver in the letter-founding business, as he was known to have helped other deserving young men. But Guy died on 24 December, 1724, after Caslon had completed the Arabic, but before the Psalter had appeared in print. If Guy had entertained such a notion, his failing health, pre-occupation with the designs for his hospital, and his ultimate death, prevented his carrying out his intention.

What seems certain, however, is that Caslon's completion of the Pica roman and Palmer's reaction to it mark the beginning of

the financial help given to Caslon by Bowyer, Watts and Betten-ham. Palmer was probably reflecting on the consequences of his encouragement of Caslon before the completion of the fount, a task which would take some time, and Caslon had probably also received some encouragement from Bowyer before the death of Guy, an event which made Caslon's need appear more desperate unless he abandoned letter-founding and returned to engraving.

Since Caslon had still only one commercially viable fount ready Bowyer probably encouraged him to continue at Vine Street for a longer period. The conclusion seems inescapable that Caslon, following his view of James's foundry, carried out the whole of the Arabic enterprise in his own premises and that after Caslon had proved that he could cast letters as well as cut punches and sink and justify the matrices, he followed this up by cutting a further set of punches for the Pica roman ; indeed, he may have been on the way to cutting his third fount before Bowyer, Watts and Bettenham invested any money in his enterprise.

It would appear, then, that Caslon moved to a small house[11] in Helmet Row (which Rowe Mores called a garret[12]) no earlier than 1725, where he was able to carry out his cutting and founding operations more exclusively. Bowyer having taken his son into partnership in 1722,[13] Caslon no longer had to depend on Salomon Negri for advice and help on oriental and learned types, for no doubt the younger Bowyer, 'the learned printer,' gave him any help of this kind he required. Doubtless Caslon cast his newly cut Pica roman here, which was first used in the notes at the end of the *Anacreon*, issued by Bowyer in 1725.[14] It was used also in William Baxter's *Reliquae Baxterianae*, 1726, and in the *Common Prayer*, J. Baskett, 1727.[15]

Melium, novis rebus ſtudentem, manu ſua occidit.
Fuit, fuit iſta quondam in hac repub. virtus, ut viri
fortes acrioribus ſuppliciis civem pernicioſum, quam

Melium, novis rebus ſtudentem, manu ſua occidit.
Fuit, fuit iſta quondam in hac repub. virtus, ut viri
fortes acrioribus ſuppliciis civem pernicioſum, quam a-

Fig. VII. Caslon's Pica roman and italic

Joannis 'Seldeni Opera omnia, edited by David Wilkins, was published in 1725 and 1726, but was begun in 1722. It was issued in three volumes, each in two parts, printed in double columns. The work includes a very large number of types. The first volume has the imprint of William Bowyer, the second that of Samuel Palmer, and the third that of Thomas Wood, who worked in Oxford as well as in London. In all the numerous types of the three volumes of the *Selden*, the only one cut by Caslon appears to be the Hebrew.[16] It is therefore a fair conclusion that this Hebrew without points was the third complete fount cut by Caslon, and thus falls in the Helmet Row period.

It must be remembered that the order in which Caslon's types appeared in print can afford only an approximate idea of the order in which they were cut. His output between 1726 and 1734 was astonishing. In 1727 Caslon moved to Ironmonger Row, as shown by the entries in the rate books,[17] having remained at Helmet Row no more than two years. He conducted his business at Ironmonger Row from 1727 to 1737, and then moved to the famous Chiswell Street Foundry.

Caslon's English roman, without the italic, next appeared. as previously stated, in *A Discourse of the Judicial Authority belonging to the Office of Master of the Rolls*, in 1728 ; and again, without the italic, in T. Bisse's *Sermon*, 1728 ; his roman and italic appear together in B. Motte's *Miscellanies in Prose and Verse*, and John Ecton's *Liber Valorem*, both 1728.[18]

Caslon's next performance was a fount of Pica Coptic for Dr. David Wilkins' edition of the *Pentateuch*, 1731, a letter which Rowe Mores commends as superior to the Oxford Coptic in which Dr. Wilkins' *New Testament* had been printed in 1716. This fount Caslon also cut under the direction of Bowyer, his generous patron, whom he always acknowledged as his master from whom he had learned his art.[19] Along with Caslon's Coptic we also find

ϧⲉⲛ ⲟⲩⲁⲣⲭⲏ ⲁ̀ϥ̇ϯ ⲑⲁⲙⲓⲟ̀ ⲛ̀ⲧⲫⲉ ⲛⲉⲙ ⲡⲕ-
ⲁ̀ϩⲓ⳯ ⲡⲓⲕⲁϩⲓ ⲇⲉ ⲛⲉ ⲟⲩⲁⲑⲛⲁⲩ ⲉ̀ⲣⲟϥ ⲡⲉ ⲟⲩⲟϩ
ⲛ̀ⲁⲧⲥⲟⲃ̇ϯ ⲟⲩⲭⲁⲕⲓ ⲛⲁϥⲭⲏ ⲉⲝⲉⲛ ⲫⲛⲟⲩⲛ ⲟⲩⲟϩ
ⲟⲩⲡ̅ⲛ̅ⲁ̅ ⲛ̀ⲧⲉϥ̇ϯ ⲛⲁϥⲛⲏⲟⲩ ϩⲓϫⲉⲛ ⲛⲓⲙⲱⲟⲩ ⳯ ⲟ-

Fig. VIII. Caslon's Coptic

344

his Small Pica roman. Caslon's Great Primer and Double Pica appeared in 1732, the first in M. Maittaire's *Marmorum Arundellianorum edito secunda*, and the second in the Dedication to Rapin's *History of England*.[20]

Caslon's business, thus established, rapidly advanced in fame and excellence. Although at the outset it depended mainly on the support of his three chief patrons, it was soon able to stand alone and compete with the best houses in the trade.

In 1728 Caslon narrowly escaped committing an error which might seriously have affected his after career. The foundry of the Grovers being then in the market, he contracted for the purchase of it. Fortunately for English typography he was then able to offer only a low price, so that his offer was not accepted. Caslon was thus still left a free man to pursue his own method, unburdened by the incubus of a large and useless stock of matrices which, had they been suffered to mingle with his own beautiful productions, would have degraded his foundry to a patchwork establishment little better than that of his competitors at home and abroad. As it was, he had the advantage of completing his specimens after his own plan, and impressing with the mark of his own genius every fount which bore his name.

His fame in 1730 was such that he had already eclipsed most of his competitors, had introduced his founts into some of the chief printing-houses of the metropolis, and even secured the custom of the King's printers to the exclusion of all others.[21] Although Ged's narrative goes to show that Caslon shared the scepticism of his contemporaries with regard to the utility of stereotyping, and was even ready to back his opinion with his money, he was no party to the discreditable persecution to which that unfortunate inventor was subjected by other members of the craft. Indeed, the only successful experiment made by Ged appears to have been a cast from Caslon's type.

Caslon's pre-eminence in 1733 is confirmed by the following extract from a letter written by Henry Newman to the President of Harvard College in New England,[22] addressed from Bartlett's Buildings, London, 19 October, 1733:

'. . . I have sent by this ship, the 'Sarah,' Capt. Wingfield, the Hebrew Types desired by Mr. Treasurer (Edward)

345

Hutchinson for our College. They are made, according to the Patern (sic) he sent, by Mr. Caslon the greatest artist in Eng[ld], if not in Europe, since Elzevir, for Letter-Founding, who furnishes all our Presses here, so that the Printers send no more to Holland as they used to do. . . .'[23]

Four days later Newman wrote again, this time to Edward Hutchinson himself, Treasurer of Harvard College:

'I have sent You a Specimen of the Letter in Print as well as other Letters and Types made by that Artist who seems to aspire to outvying all the Workmen in his way in Europe, so that our Printers send no more to Holland for the Elzevir and other Letters wch. they formerly valued themselves much on.'[24]

It must have been a source of considerable pride to Newman to realise that Caslon's name would henceforth be imperishably linked with the story of English typography and it is easy to understand why Caslon's types secured such a firm hold in American printing. First Benjamin Franklin was working in John Watts' printing office when Caslon was beginning to make his name. Then the elder Bowyer printed for Thomas Hollis who had close connections with Harvard and, as we have seen above, Newman himself was as good as a personal ambassador for the now famous letter-founder. Later in American history both the Declaration of Independence and the Constitution were first printed in Caslon type and Caslon italic and swash capitals are often used in the United States to convey a historic or American-antique feeling in printed matter. Franklin admired and recommended Caslon types and equipped his own office with them, and it was the typeface most commonly in use in American printing until about 1800.

In connection with the publication by Bowyer in 1736 of Bishop Hare's *Hebrew Psalter*, an anecdote has been preserved by Nichols confirming the unsatisfactory character of Samuel Palmer the printer, and tending also to show that Caslon's success was not achieved wholly without opposition. It seems that the Bishop's work was originally intended to be printed at Palmer's press and 'his Lordship had objected to the use of Palmer's Hebrew types which were of Athias' font, and a little battered, and insisted upon his having a new set from Caslon. But Palmer was

already so deeply in debt to Caslon that he did not know how to obtain it from him without ready money, which he was not able to spare. The Bishop also insisted upon having some roman and italic types cast with some distinguishing mark, to direct his readers to the Hebrew letters they were intended to represent, and these required a new set of punches and matrices before they could be cast ; and that would have delayed the work, which Palmer was in haste to begin so that he might the sooner finger some of his Lordship's money. Palmer therefore, represented Caslon to be an idle, dilatory workman, who would probably make them wait several years for those few types, if ever he finished them. He agreed that Caslon was indeed the only Artist that could supply him with those types, but that he hated work and was not to be depended upon, and that his Lordship would do better to make shift with substitutes of some sort which would answer his purpose, rather than run the risk of waiting so long, and even then being perhaps disappointed'.[25]

'The Bishop, however, being resolved, if possible to have the desired types, sent for Bowyer, and asked him if he knew a letter-founder who could cast him such a set out of hand, who immediately recommended Caslon ; and being told the character he had heard of him, Bowyer not only assured his Lordship that it was false and unjust, but engaged to get Caslon to cast the types he required, and a new font of his Hebrew ones, in as short a time as the thing could possibly be done. His Lordship accordingly sent for Caslon, who informing the Bishop of the time required for the new types to be made ready for use, produced them according to his promise, and the book was soon afterwards put to the press.'[26]

And be it further enacted by the Authority aforesaid, That all and every of the said Exchequer Bills to be made forth by virtue of this Act, or so many of them as shall from ABCDEFGHIJKLMNOPQRST

Fig. ix. Caslon's Pica Black

Among the other interesting founts cut by Caslon about this time may be mentioned the Pica black, which received special commendation for its faithful following of the traditional Old

347

English character first used by Wynkyn de Worde. He also cut
an Armenian for the two Whistons,[27] and an Etruscan for John
Swinton of Oxford, the learned antiquary and philologist,[28] as well
as a Gothic and several other of the foreign and learned characters.

ƆΛⴖ𐌓ꟼꟼ8 𐌕ꟼⴖ𐌕Υꟼꟼ 2ꟼꟼΜ𐌕Ʒⴖ
ꟼꟼ Ꟙꟼ 2Ʒ𐌕Λ8ΛƆ ꟄΛΥⴖꟼꟼ 𐌕ꟼ 𐌕ꟼ
𐌕𐌕Μ𐌕Ꟙ 𐌕𐌇 ⴖꟼꟼꟼ Ɔ𐌓Μ𐌕𐌓 ꟼꟼ

Caslon's Etruscan

Ա՟ր՟շ՟ա՟կ Թ՟ա՟գ՟ա՟ւ՟ո՟ր՟ ե՟ր՟կ՟ր՟ի՟ և ծ՟ո՟ւ՟ղ՟ւ, ո՟ր՟ո՟յ ա՟ն՟ձ՟ն
և ս՟ա՟ո՟կ՟ե՟ր՟ ո՟ր՟ս՟յ՟ս և է, ի՟ս՟կ ﬔ՟ր Ա՟ս՟ո՟ւ՟ծ՟ո՟յ՟
ի՟ս՟կ ք՟ա՟խ՟ս՟ և ս՟ա՟ս՟ա՟Հ՟ո՟ւ՟ﬕ ’ի վ՟ﬔ՟ր ք՟ա՟ն զ՟ա՟ս

Caslon's Armenian

Λ𐌕𐌕Λ ꟙꟙSΛꟘ ψꟙ ïN hIMINΛM ꟓƐIhNΛI
NΛMꟘ ψƐIN ᴜIMΛI ψIꟙᴧINΛSSꟙS ψƐINS
ꟓΛIꟘψΛI ꟓIΛGΛ ψƐINS SꟓƐ ïN hIMINΛ

Caslon's Gothic

Ο: ይኽዐⵗኗ: በኽዐⵗት: እፈሁ: እደፆ: እዋበትኪ: እየ
ፆⵕኳ: Ⴚⵕዐዘ: ዕፈረትኪ: እፆኵሉ: ከረⵕ:: ዕፈረት
ዘትⵕዐበ: ኽፆበ:: Ⴚበእኗትዘ: ደኗጋሴ: እፉቀሬከ: Ⴚ

Fig. x. Caslon's Ethiopic

All of these, with the exception of the Etruscan and an
Ethiopic cut by Caslon II, were completed before 1734, in which
year the first *Specimen* of his foundry appeared. This famous
broadside, of which very few copies survive, dates from Iron-
monger Row, to which address, as previously stated, Caslon had
transferred the Helmet Row Foundry in 1727.

The sheet is arranged in four columns and displays altogether
thirty-eight founts, namely:

Titlings.—Five-line Pica, four-line Pica, two-line Great
 Primer, two-line English, two-line Pica, two-line Long
 Primer, two-line Brevier.

Roman and Italic.—French Canon, two-line Great Primer,
 two-line English, Double Pica, Great Primer, English-
 Pica, Small Pica (2), Long Primer (2), Brevier, Non,
 pareil, and Pearl.

348

Saxon.—Pica and Long Primer.

Black.—Pica and Brevier.

Gothic, Coptic, Armenian, Samaritan—Pica of each.

Syriac and Arabic—English of each.

Hebrew.—English, English with points, Brevier.

Greek.—English, Pica, Long Primer, Brevier.

Flowers.—Seven designs.[29]

Of these, all, with three exceptions, are Caslon's own handi-work, and represent the untiring industry of about thirteen years. The specimen placed Caslon absolutely without rival at the head of his profession; 'and,' as Nichols says, 'for clearness and uni-formity, for the use of the reader and student, it is doubtful whether it has been exceeded by any subsequent production.'[30]

The three founts referred to as not the product of Caslon's hand were the Canon roman, from Andrews's foundry, formerly Moxon's, and exhibited in the *Mechanick Exercises;* the English Syriac; which is from the matrices of the Polyglot; and the Pica Samaritan, which is said to have been cut by a Dutchman named Dummers.[31]

Reference has been made previously to the specimen sheet included in the second edition of Ephraim Chambers's *Cyclo-paedia* in 1738, and in later editions.[32] Caslon made a further addition to his stock of matrices in 1739 by the purchase of half of Mitchell's foundry, the most interesting items being a Pica Greek, sets of music and flower matrices, and six sizes of black. The Long Primer black differs in design from Caslon's other blacks.

On the 1742 specimen sheet twelve of the specimens are signed 'W. Caslon junior sculp.,' no mean achievement when the younger Caslon was still only twenty-two years of age. Nichols says 'the abilities of the second Caslon appeared to great advantage in the specimen of the types of the learned languages in 1748.' It contains thirty-three founts of learned types, fourteen being signed: 'W. Caslon Junior Sculp.' A further specimen was issued in the following year, in broadside form, which displayed a large variety of letters, from Canon to Pearl, many of them being the handiwork of Caslon the younger.

Much ink has been spilled in discussion of the relative merits of the letter designs of different artists but most of it has centred

349

on variations in the Roman character. A few have extended their scrutiny as far as the correct rendering of the Hebrew and Greek cut by Caslon, but hardly any attention has been given to the characters of the other languages cut by him, including the so-called exotic types. Something has been said of the difficulties Caslon had to surmount when cutting his first fount, the Arabic, and no more need be added.

In cutting the punches for any type face it is essential to keep in mind its calligraphic origins as well as its adaptation to a functional form ; obviously, some limitations are inescapable in reproduction in type metal which can be avoided in engraving. Legibility imposes a limit on the decorative treatment of reading matter and while artistic licence can be indulged in the design of the initial letter of a chapter or a paragraph all letters after the first generally submit to the predominant requirement of legibility.

If one may venture to look at Caslon's letters with the eye of an artist, and in this respect the writer claims to have at least equal authority with those typographers who are not artists, the roman and italic seen in the 1734 specimen are almost exempt from criticism. In the roman capitals the middle bars of B, E, F, H are perhaps very fractionally too low, but to ensure harmony the consequential effects on A, K, P, R, and Y would also have to be carefully considered. The legs of K and R are an improvement on their Dutch forerunners, but the beaks of E, F and T probably slope a little too much, and the base leg of E is too long. The lower barb of C is very slightly obtrusive in certain sizes of the letter, but Caslon's C is superior to Baskerville's, whose barbs certainly form an obtrusive feature of this letter. Nevertheless, it has long been recognised that the principal merit of Caslon's letters is an uncanny ability to mingle harmoniously with their fellows, even though the design of different sizes of the same letter is not exactly uniform throughout the range. In Caslon's time precise measurement as we know it could not be applied to the production of letters. While the Imprimerie Royale and Joseph Moxon had their own methods of drawing letter enlargements on a meshed rectangle there was no such thing as pantographic or optical reduction on to the actual punch. Caslon had to rely on the use of a magnifying glass and his own acute vision to secure approximate

congruence between different sizes of the same letter.

In the roman lower-case letters Caslon has followed the Dutch 'a' too closely, making the bowl too much like a sagging bag—a healthier roundness could be effected without any risk of inking-up in the upper part; in view of this question of inking-up it is also difficult to see why the bar of the letter 'e' was cut quite so high; a glance at the diphthong 'æ' will show to what extent this criticism is valid. In order to show more conclusively that Caslon secured approximate congruence of his letters by eye, Fig. xi shows his roman lower-case 'g' in two sizes, 72 point and 48 point. The external common tangent to the bowl and loop has been drawn on the left of each letter, showing that when the link between the bowl and loop is on the right of the tangent and does not touch or cut it, the letter is better balanced, as in the 72 point size shown here.

Fig. xi. Diagram showing that congruence in different sizes of a Caslon letter was obtained by eye.

Nevertheless, it is mainly Caslon's range of roman and italic, in the reading matter seen by teeming millions of people, that has created such universal admiration and has enabled his letters to cling tenaciously to a long-term preference in popular esteem despite the fashionable standing accorded to other letter designs at different periods.

Caslon's italic is quite as notable as his roman. The hanging forms of *J* and *Q* in both roman and italic serve to emphasise the consistencies in both series. The letter *D* in the Double Pica italic is a shade too burly. Looking again at the calligraphic origins of the letters and comparing the Double Pica italic *G* with its counterpart in Great Primer size, the latter is a much better letter because the weight of the rounded back is brought below the mid-height, lowering the centre of gravity. The bars of *A, B, E, F, H*, are again

fractionally too low and the base of E is also fractionally too long. There is real charm in the italic \mathcal{J} and Q, particularly in the open loop in the tail of the larger sizes of Q, the loss of which in the smaller sizes reduces the interest of the letter. The fault in the slope of A, V, and W, has been already mentioned. Caslon's ampersand, &, in Great Primer italic is a typographic masterpiece, beautifully balanced, and for the amount of curvature in its total length of line, is remarkable for the right proportion of ink to spacing. In this respect a row of these ampersands would equal a line of his printers' ornaments.

James Mosley has suggested that Caslon's Pica italic in its earliest form included a vertical 'g' in the lower case characters,[33] but this does not seem to be borne out by close inspection. The upper part of the letter conforms to the italic slope and the illusion that the letter is vertical is created by the tail being carried to the right before completing the lower loop. Christoffel van Dijk's italic 'g' has the same characteristic, but here too the italic slope of the upper part of the letter is unmistakable. It seems to have been a device to reduce kerning.[34]

It has been concluded previously that the Hebrew without points was the third complete fount cut by Caslon. Structurally, as a descendant of the cuneiform character, its bold proportions would give Caslon no more difficulty than his native roman and with Bowyer at his elbow would be an easy task. As a matter of fact, the number of Hebrew founts in the possession of eighteenth century printers was not strictly proportionate to the demand and it seems a fair conclusion that punch-cutters had a stronger partiality for Hebrew than for some of the harder characters.

בראשית ברא אלהים את השמים ואת הארץ : והארץ
היתה תהו ובהו וחשך על־פני תהום ורוח אלהים
מרחפת על־פני המים : ויאמר אלהים יהי אור ויהי־אור:
וירא אלהים את־האור כי־טוב ויבדל אלהים בין האור
ובין החשך : ויקרא אלהים לאור יומולחשך קרא לילה

Fig. xii. Caslon's Hebrew without points

The matrices for Caslon's Hebrew with points appear to have been struck with the same punches as were used for the Hebrew without points. For the points below and above the radical ele-

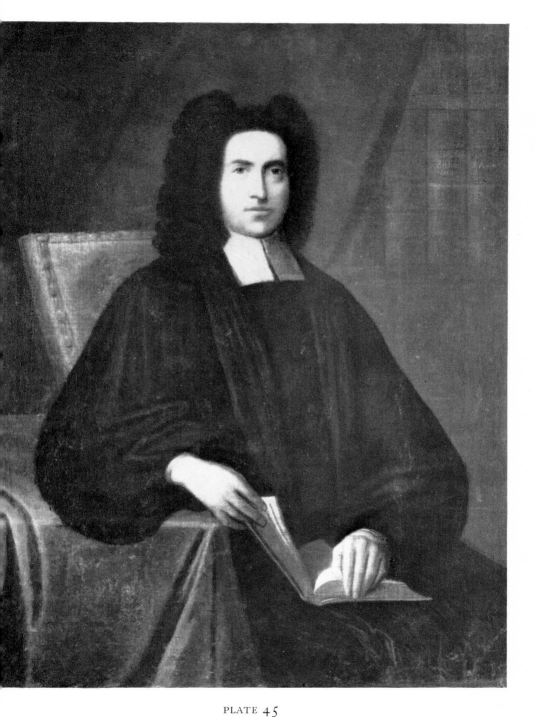

PLATE 45

Dr. Thomas Bray (1656–1730), founder of the S.P.C.K. and the S.P.G.,
father-in-law of the Rev. Jonathan Carpenter of Halesowen.
From the portrait in the possession of the U.S.P.G.

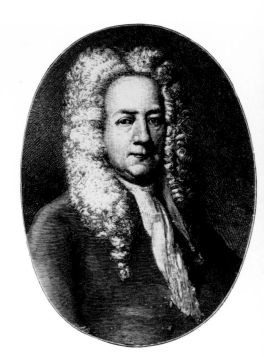

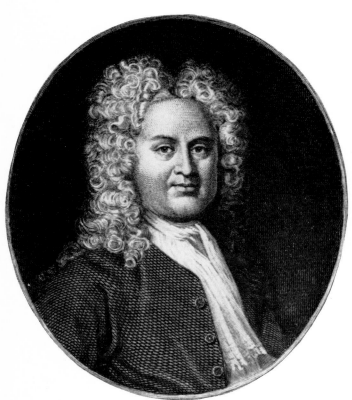

ments he evidently used secondary punches tied to the main punch, striking the two together into the copper, adding the few inside points by engraving them in the matrix direct afterwards, borrowing the method from his manner of producing the English Arabic.

Looking now at the Greek on the 1734 specimen, in Caslon's time the available models of Greek were chiefly Stephanus, the Elzevirs, Fell and Wetstein, but as the younger Bowyer must have had all the reference works necessary, including *Annales Typographici*, by Michael Maittaire (1668–1747), a writer who was then living in Orange Street, Holborn, and was intimate with Tonson and Watts,[35] Caslon could be at no loss for helps ready to his hand.

Πρόδικος ὁ σοφὸς ἐν τῶ συγγράμμαῖι τῶ περὶ τῆ Ηρακ-
λέης (ὅπερ δὴ κ᾽ πλείστοις ἐπιδείκνυῖαι) ὕτως περὶ τῆς
ἀρεῖης ἀποφαίνεῖαι, ὦρέ πως λέγων, ὅσα ἐγὼ μέμνημαι·
φησὶ μὲν Ηρακλέα, ἐπεὶ ἐκ παίδων εἰς ἥβην ὥρμᾶτο,
(ἐ ἧ οἱ νέοι ἤδη αὐῖοκράτορες γιῖνόμενοι δηλῦσιν, ἔιτε τὴν

Πρόδικος ὁ σοφὸς ἐν τῶ συγγράμμαῖι τῶ περὶ τῆ Ηρακλέης
(ὅπερ δὴ κ᾽ πλείστοις ἐπιδείκνυῖαι) ὕτως περὶ τῆς ἀρεῖης ἀπο-
φαίνεῖαι, ὦδέ πως λέγων, ὅσα ἐγὼ μέμνημαι· Φησὶ μὲν
Ηρακλέα, ἐπεὶ ἐκ παίδων εἰς ἥβην ὥρμᾶτο, (ἐν ἧ οἱ νέοι ῗδη
αὐῖοκράτορες γιῖνόμενοι δηλῦσιν, ἔιτε τὴν δὶ ἀρεῖης ὁδὸν τρέψουῖαι

Fig. XIII. Caslon's English and Pica sizes of Greek.

Caslon's Greek is beautifully cut except for one or two inconsistencies; for example φ [phi] is too large in all sizes except Brevier and τ [tau] has too much weight as compared with the other faces. Again, the symbols ος in the English and Pica sizes are rendered by the ligature ℯ in the Long Primer and Brevier sizes, and the ligature ℬ, representing συ, also has too much weight. However, since Caslon's day the number of Greek typographical ligatures has been enormously reduced, even to the simple letters of the alphabet, with a corresponding saving in the labour of the punch-cutter. Indeed, Wetstein had abandoned the use of Greek ligatures by 1700.

Caslon's black letter has been highly praised. In many respects it was a frank imitation of Moxon's design and of a face

acquired by the University of Oxford in 1701 which had a long ancestry going back possibly to Wynkyn de Worde. In the course of this long time the fount had acquired several bastard characters and Caslon's task was not an easy one in attempting to restore its consistency. Following Moxon's use of the lozenge as a space filler in capital 𝔐 , Caslon also added it to capital ·𝔓 in preference to having light strokes both vertically and across the letter. It is doubtful whether the continuance of the two kinds of lower-case ' 𝔯 ' is justified, despite the undeniable charm of the curly ' 𝔷 ' which usually follows the letter 𝔬 . Caslon's capital 𝔇 , from which he has omitted the second vertical stroke, appears an empty letter conveying the illusion that it is a larger sort, and his capital 𝔖 appears to be falling backwards. (See Fig. ix).

In the spate of founts which Caslon cut early in his career it is difficult to attach even an approximate date to the Pica and Long Primer Anglo-Saxon shown in his 1734 specimen, although we know that just before Caslon came to notice there was a revival of interest in Anglo-Saxon studies, Bowyer himself being an enthusiast. In 1709 Bowyer printed Elizabeth Elstob's *An English-Saxon Homily on the Birth-day of Saint Gregory* employing some Anglo-Saxon types—in their day remarkable.[36] *The Homily*—the two initial letters to which show the portraits of Edward Thwaites and the learned Elizabeth, engraved by Simon Gribelin—is set in double column, the original text on the left hand in Saxon types, and on the right hand the English translation in Roman types. These types were destroyed in Bowyer's fire. A new Anglo-Saxon fount, described by Updike as much more 'picturesque' that that of the *Homily*[37] was cut by Robert Andrews for Elizabeth Elstob's *Anglo-Saxon Grammar*, which appeared in 1715. These types were subsequently given by the younger Bowyer to the University Press, Oxford, where they still are.[38] The cost of the new types was defrayed by Lord Chief Justice Parker, afterwards Earl of Macclesfield. The characters were drawn by Humphrey Wanley, librarian to the Earl of Oxford,[39] who was Henry Newman's predecessor as Secretary of the S.P.C.K.

It seems that the new types were strongly criticised, but Wanley's description of Robert Andrews as 'a blunderer' was too

harsh, for an inspection of the type, displayed in Reed-Johnson, Fig. 43, and the letters of the alphabet, shown in Rowe Mores' *Dissertation* (Carter and Ricks, Introduction, page 36), prove that Andrews' Anglo-Saxon was more consistent in its characters than was Caslon's. Updike's imprecise description of it as 'picturesque' misses the point, and does less than justice to Andrews. Caslon's Anglo-Saxon shows the same inconsistency in the weight of the characters as in his Gothic, more marked in the Saxon versions of f, g, s, and t. Moreover, Caslon's Saxon fount is a bastard one, including several faces from the corresponding sizes of roman lower case alphabets, such as a, c, h, i (without the dot) m, n, o, u, y, and the diphthong æ. He appears to have made his Saxon type-faces from Elizabeth Elstob's 1709 version of the *Homily*, which displayed the same defects, whereas in 1715 Andrews cut every character of the required alphabet substituting no bastards, at the same time securing greater uniformity in the series. (See Caslon specimens pp. 385 and 401).

The story of the younger Bowyer's presentation of the 1715 Saxon types to Oxford may be mentioned briefly. Bowyer made his gift in 1753 through the medium of Rowe Mores, who had suggested it to the donor, but owing to Mores' procrastination and, let it be said, his brazen excuses to the donor and assumption of the honour of the gift to himself, the types were not deposited at Oxford till 1764. It should be noted here that amongst the copperplate engravings commissioned by Rowe Mores between 1750 and 1754 from James Green of Halesowen were those of fifteen drawings preserved in the Bodleian Library from Caedmon's *Poetical Paraphrase of the books of Genesis and Daniel* (10th Century).[40] So it looks as if Rowe Mores might have kept back Bowyer's Saxon types for his own purposes of comparison and study for part of this long period.

The death of Elizabeth Elstob's brother William in 1715, the same year in which her *Anglo-Saxon Grammar* appeared, removed the main source of her support and put a stop to any plans she may have entertained for further Anglo-Saxon publications. William Elstob had himself planned a new edition of the Saxon laws published by Lambarde in 1568 and Wheelocke in 1644, the realisation of which had been also stopped by his death at the early

age of 42. The Elstobs were related[41] to George Hickes, the Nonjuror, so it is easy to trace the connection between them and Bowyer the printer, who was also a Nonjuror. Elstob's design, however was executed in 1721 by David Wilkins, in his *Leges Anglo-Saxonicae*, etc., who mentions Elstob's plan in his preface. This date is interesting, particularly as David Wilkins (1685–1745), a Prussian,[42] was also the editor of the *Works of John Selden* (3 vols.), of which the printers were William Bowyer, Samuel Palmer and Thomas Wood, and in which Caslon's Hebrew types are first seen. The Selden appeared in 1725–6, but was begun in 1722. The Anglo-Saxon used in Selden is of English size,[43] but the connection of Wilkins with Anglo-Saxon publishing apart from the Selden may lead to more precise dating of Caslon's Pica size Anglo-Saxon which seems to have been earlier than the smaller size. If Caslon cut an Anglo-Saxon as early as 1721, it may have been cast by Thomas James, with whom Palmer was on close terms; if Caslon's fount was cut later, it would be instructive to learn in what published work it first appeared.

Judged as a type face, Caslon's Coptic (See Fig. VIII) must be pronounced one of his most successful efforts in exotic types, especially having regard to the period when it was cut. While the shapes of a few of the characters have been revised in the light of more recent knowledge, the calligraphic emphasis Caslon was able to introduce, though not entirely uniform throughout the series, is quite praiseworthy. The filled-in loops of the letter Mi, corresponding to our M, and the single loop of Ypsilon, corresponding to Y or U, are a little too fat, and distract the eye from the merit of the series in general. The weighted downstroke of the letter Tau, corresponding to our T, similar to the weighted downstrokes of John Seddon, the seventeenth century English writing master, is also fractionally overdone. Caslon may have used Dr. David Wilkins's Coptic *New Testament* of 1716[44] as a model, with some revisionary supervision from Wilkins himself and, as previously stated, the fount was also cut under the watchful eye of Bowyer.

The Armenian type cut by Caslon for the Whiston's edition of *Moses Chorenensis*, printed in 1736, seems to present few difficulties from the cutting point of view. One peculiarity of the script is that capital letters are vertical, while the lower case characters

have the slope of an italic letter. A few characters have both ascenders and descenders and here the difficulty of kerning appears to have been overcome by the use of ligatures, though on the whole not to the same extent as in our roman, for naturally with an oriental script he did not understand, Caslon would be restrained from any artistic expression, so that the face has no more character than that of a modern typewriter.

Caslon's Gothic is probably the least satisfying of his many type faces. A script dating back to the fourth century cannot afford complete satisfaction when attempting to render it in type metal and submit it to the exigencies of printing. But instead of minimising the discrepancies between the weights of different characters, they seem to have been accentuated, so as to have the appearance of sorts from different founts straying into the same line of type. If the younger Bowyer was Caslon's supervisor for this fount he produced a disappointing result.

Coming now to Caslon's Etruscan, on the 1742 specimen sheet cut for John Swinton of Oxford, we may first note what Rowe Mores, writing in his usual quaint style, has to say of it: 'Pleasing would it be to us, though we fear the wish is vain, to view the next emotions of grief or joy conceived in Phoenician, Palmyrene, or Samnian brought forth by lead and regulus and not by copper.'[45] What Rowe Mores meant is that the alphabet of a people dating from pre-Christian times, of which the only slight remains are a few sculptured forms, is better rendered when engraved on copper than when reproduced in type. It may be true that Caslon has cut some symbols which are entirely without character, but the sources were so scanty that little more than the mere shape of the character could be attempted either on copper or in type. In such circumstances no calligraphic emphasis or decoration could be attempted and inevitably the symbols are without feeling. As an exercise in punch-cutting it was child's play to Caslon by comparison with the highly developed Latin faces.

A few words might be added here regarding the Ethiopic cut by William Caslon II, and included on the 1742 specimen sheet.[46] It has been fashionable in some quarters to depreciate the abilities of the second Caslon when compared with his father's, but no reproach can be directed against his Ethiopic as an example of

punch-cutting and his fount remained one of only four in England at the time Hansard wrote in 1825.[47] Even though one would wish the face had a little more weight for legibility, it is most delicately and evenly cut.

The English Syriac included on the 1734 specimen, taken from the matrices of the Polyglot, is scarcely worth mentioning beside the work of either of the Caslons, but this want in their range of type-faces was not remedied until a Long Primer Syriac was cut and supplied to Oxford in 1768–70.

Fig. xiv. Caslon's Syriac, 1767

Apart from the roman and italic and the founts of the learned languages, which have been critically examined by others, the only fount of the 1734 specimen remaining to be discussed is the Pica Samaritan, said by Rowe Mores to have been cut by Dummer.[48] A few pages further on the same writer says,[49] here adding a final 's' to the name, 'Mr. Dummers and Mr. Jalleson were both foreigners, but they founded in England, and the former who was a Dutch-man cut the Samaritan exhibited in Mr. Caslon's specimen . . . but they both retired to their native countries.' In a footnote on p. 75, Carter and Ricks add the following: 'Gijsbert Dommer, a son of the Widow Clyburg who owned the type foundry in Amsterdam derived from Christoffel van Dyck, was in England by 1723 and died here in 1725: Gemeente Archieve, Amsterdam, Not. Arch. No. 6171, Act No. 3 (information from Miss N. Hoeflake). He is not recorded as a punchcutter, but he was in business supplying type; Mr. Don McKenzie tells us that he wrote two letters (now in the University Archives at Cambridge) from Brownlow Street in 1723 to Cornelius Crownfield, the Cambridge printer.'

If Dummer died in 1725 as stated here, it seems highly improbable that it was the Dutchman of that name who cut the fount of Samaritan for Caslon, who was still at Vine Street until that year. That such a story was able to pass into common currency is prob-

ably due to the very limited circulation of the *Dissertation*. Only eighty copies were printed, and these did not appear until after the death of Rowe Mores in 1778, when Nichols bought them up and published them. Moreover, there were few others still alive who might have been able to correct the mistake. William Bowyer, the learned printer, died in 1777, and William Caslon II in 1778, while the third generation of the Caslons was unlikely to be interested in such a question. The difficulty in accepting Rowe Mores' account is that whereas he says the Dutchman returned to his own country, recent evidence says he died here as early as 1725.

There is an alternative possibility which has not previously been considered. There is an English family named Dummer which originated at the village of Dummer near Winchester, a branch of which was at Overton in Hampshire in the fifteenth century.[50] From this branch descended Jeremiah Dummer, born in Boston, America, in 1681, the son of a silversmith. Jeremiah graduated from Harvard in 1699 and after studying in Europe was awarded a doctorate in philosophy at Utrecht. Coming to this country in 1708, from 1710 to 1721 he was official Agent for the Province of Massachusetts in London and in 1712 began to serve Connecticut in the same capacity, a post from which he was dismissed in 1730. He was a distinguished colonial agent, one of the wits of the day, and an intimate friend of the celebrated statesman Henry St. John, 1st Viscount Bolingbroke (1678–1751), from whom he had promises of high promotion. But in 1714 the Queen died and Bolingbroke fled in disgrace to France, thus blasting Dummer's hopes of a political career. His relations and friends in America had tried to persuade him to give up his associations with the profligate Bolingbroke, but without avail. Moses Coit Taylor[51] says that when Bolingbroke left England Dummer felt too ashamed to confess his failure by a return to his native land and in England he remained for the rest of his days where, so it is reported, 'his behaviour was not always to his credit.'[52]

Dummer was the author of several works which it is not necessary to detail here. The preface to one of his works is dated from the Middle Temple, 23 Feb. 1721, where he had a suite of rooms, and where also from 1714, Henry Newman, Colonial Agent for New Hampshire, was one of his neighbours.[53] Dis-

tressed New Englanders sometimes solicited help from the Colonial agents, as for instance, Deodat Lawson, who said he would 'frequent the New England Coffee House' until he heard from them.[54] The agents for these two New England colonies would necessarily see a great deal of each other, and though their dispositions seem to have been entirely different, and sometimes they differed on matters of policy, there seems no reason to doubt that on the whole they would be prepared to assist each other.

There were also Dummers occupying government posts in this country. Thomas Dummer was Deputy-Master of the Great Wardrobe in 1720 and Edmund Dummer a clerk there.[55] In 1734 Thomas Dummer was still there, Thomas Lee Dummer was Clerk and Thomas Dummer Junior was another Clerk. Edmund Dummer, of Lincoln's Inn, was M.P. for Arundel 1695–1708, and died in 1724. Thomas Lee Dummer was M.P. for Southampton 1737–41 and for Newport, Isle of Wight, from 1747 until his death in 1765.[56] All these were related to Jeremiah Dummer.

Dummer was a generous benefactor to the College in Connecticut which became Yale University. His first gift sent from London in 1714 consisted of 800 valuable books, about 120 of them at his own cost and the rest solicited from friends, including Sir Isaac Newton, Sir Richard Blackmore, Sir Richard Steele, Dr. Burnet, Dr. Woodward, Dr. Halley, Dr. Bentley, Dr. Kennet, Dr. Calamy, Dr. Edwards, the Rev. Henry and William Whiston. It appears he was the first to press upon Elihu Yale the needs of the infant college, as a result of whose benefactions it was named Yale College. When not engaged with merchants, traders and sea captains at the coffee houses in connection with his two agencies Dummer would be buying books for himself and friends in America, and in this way he doubtless had a wide acquaintance among London book dealers. A list of some of the books sent by Jeremiah Dummer to what is now known as the Yale University Library was privately printed in America as recently as 1938.

Jeremiah Dummer died unmarried at Plaistow in 1739, aged 58, and was buried at West Ham. In his will [57] he leaves among other legacies 'To my worthy Countryman Henry Newman, Esq., £20.' He made no disposition of the bulk of his estate, being content that it should go according to the Act of Assembly in New

England for distributing the estates of Intestates.

This sketchy account of the Dummers and especially of the colonial agent Jeremiah Dummer will suffice to show his connection with Henry Newman, Secretary of the S.P.C.K., although much remains to be discovered about New England interests and connections with merchants and traders in London in the first half of the eighteenth century.

It seems probable that the Dummer who was credited with the cutting of the Pica Samaritan fount had some connection with Jeremiah Dummer, legitimate or illegitimate; that Dummer had requested his opposite number, Henry Newman, to solicit this favour and that Caslon had complied out of gratitude for services rendered to him by Newman. The young man in Caslon's service may have returned to America, but Dummer's will suggests that he was dead before 1739. What is certain, however, is that the Dutchman Gijsbert Dommer who died in 1725 could not have been the man who cut the Pica Samaritan.

Whoever cut the fount, it was done by a competent hand. Whilst not presenting the same difficulties as the Arabic, it is a size smaller and displays more calligraphic feeling than the equal size Pica Armenian. Finally, more research on Caslon's assistants before William Caslon II, Thomas Cottrell and Joseph Jackson would throw some welcome light on what still remains an obscure period in his history.

The layout of Caslon's first specimen of 1734 was a frank imitation of the four-column Sale Specimen of Elzevir Types: Amsterdam, 1681 (a reduced copy of which is shown in Updike.)[58] The heading of the specimen reads:

> *Proofs of types cut by the late Christoffel van Dyck such as will be sold at the residence of the widow of the late Daniel Elzevier, on the Canal, near the Papenbridge, at the Elm, Wednesday, March 5, 1681.*

Perhaps Bowyer had a copy of this specimen in his possession when his son was assisting Caslon in the arrangement of his first broadsheet. The only noticeable alteration in the arrangement is that Caslon distributed his flowers along the bottom of the specimen instead of crowding them together at the bottom of the fourth

column. And it should also be added that some of Caslon's flowers are an adaptation of those on this specimen.

Although the relationship between printers' flowers and the arabesques used to decorate the outside covers of books is obvious, the subject deserves a more extensive treatment than can be afforded here. But Updike[59] says that Caslon's ornaments or flowers deserve in their way as much praise as his types and goes on to quote W. A. Dwiggins, 'To a designer's eyes they have, taken as individual patterns, an inevitable quality, a finality of right construction that baffles any attempt to change or improve . . . Excellent as single spots, the Caslon flowers multiply their beauties when composed in bands or borders as ornamentation for letterpress. They then become a true flowering of the letter forms—as though particular groups of words had been told off for special ornamental duty and had blossomed at command into intricate, but always typographical patterns. This faculty possessed by the Caslon ornaments of keeping an unmistakable type quality through all their graceful evolutions sets them apart from the innumerable offerings of the type founders' craft as a unique group . . . From the point of view of the pressman, as practical working types for impressing ink into paper, they may claim to be better, so far as English and American designs are concerned, than any typeflowers made since their period. The proportion of printing surface to open paper . . . is excellently adapted for the purpose of clean, sharp impression. Certain ones have elements broken by tint-lines into a clear-printing gray, and it will be observed that this tint is not the gray of copper-plate, but has the weight and solidity of a printing surface backed by metal.'[60] Much of this is, of course, blurb, because few of Caslon's ornaments were original ; many of them descended from the early printers.

It was probably on the specimen of 1766 that Rowe Mores founded his summary of the contents of the Caslon foundry, and this list is reproduced here, as it presents a view of the state of the foundry as it was at the time of Caslon's death and, at the same time, distinguishes the artists who cut the several founts or alternatively their origin if the name of the punch-cutter is not known. Footnotes are appended at the end of the list.

ORIENTALS

Hebrew.—2-line English	Caslon I
Double Pica	Caslon II
Great Primer	Caslon II
English	Caslon I
English open[1]	Caslon I
Pica	Caslon II
Long Primer[2]	Caslon II
Brevier	Caslon II
2-line Great Primer	Caslon II
Samaritan.—Pica	Ascribed to Dummers
Syriac.—English	Polyglot
Arabic.—English	Caslon I
Armenian.—Pica	Caslon I

MERIDIONALS

Coptic.—Pica	Caslon I
Ethiopic.—Pica	Caslon II

OCCIDENTALS

Greek.—Double Pica	Caslon II
Great Primer	Caslon II
English[3]	Caslon I
Pica[4]	Head-Mitchell
Long Primer	Caslon I
Brevier	Caslon I
Small Pica	Caslon II
Nonpareil	Caslon II
Etruscan.—English	Caslon I
Roman and Italic.—All the regulars	
Irregulars and Titlings.—5-line	Caslon I
4-line[3]	Caslon I
Canon	Moxon-Andrews
2-line Double Pica	Caslon II
2-line Great Primer[3]	Caslon I
2-line English[3]	Caslon I
2-line Pica full face	Mitchell
2-line Pica	Caslon II

Paragon		Caslon II
Small Pica		Caslon II
Bourgeois		Caslon II
Minion		Caslon II
Nonpareil		Caslon II
Pearl[5]		Caslon II
Proscription.—20-line to 4-line[6]		Caslon II

SEPTENTRIONALS

Gothic.—Pica		Caslon I
Anglo-Saxon.—English		Caslon II
	Pica[7]	Caslon I
	Long Primer[7]	Caslon I
	Brevier	Caslon II
English.—	Double Pica	Caslon II
	Great Primer	Caslon II
	English	Head-Mitchell
	English Modern[8]	Caslon II
	Pica[8]	Caslon II
	Long Primer	Caslon II
	Brevier	Caslon I
	2-line Great Primer	Caslon II
	Small Pica[9]	Caslon II
MUSIC.—	Round Head	Caslon II

FLOWERS and the rest of the Apparatus.

Footnotes :

[1] Mores calls this 'excavated' or 'Hutter's leading-string' Hebrew. A specimen may be seen in *The Scholar's Instructor. An Hebrew Grammar of Israel Lyons*, Cambridge, 1735. 8vo. The open Hebrew is here used to distinguish the servile from the radical letters. Lyons in his preface deprecates Hutter's method of printing the entire Bible in this character, thereby keeping the learners 'too long in leading-strings.'

[2] Mores omits a Small Pica Hebrew, which is the same as the Brevier shown in the sheet of 1734.

[3] These founts are not Head's or Mitchell's, as Mores states, but were cut by Caslon I, and shown on the 1734 sheet.

⁴ The Pica Greek shown on the 1734 sheet was discarded in favour of this fount.

⁵ 'But,' adds Mores, 'Mr. Caslon is cutting a *Patagonian* which will lick up all these diminutives as the ox licketh up the grass of the field.' But no such type is found in the specimens and one suspects that Mores is again indulging in a sly dig at Caslon II. (See Chap. 19).

⁶ 'Supported by arches.' Doubtless cast in sand.

⁷ These were not cut, as Mores states, by Caslon II, but by Caslon I, and appeared on the sheet of 1734, when Caslon II was but 14 years of age.

⁸ 'These,' says Mores, 'are one and the same. The Acts of Parliament are printed in them, therefore we call them as Dr. Ducarel and the Act call them, "the common legible hand and character".'

⁹ Mores omits here the Pica Black, cut by Caslon I, and shown on the sheet of 1734.

John Smith, in his *Printer's Grammar* in 1755, goes out of his way more than once to commend the founder by whose genius 'letter is now in England of such a beautiful cut and shape as it never was before.' Baskerville, in a passage quoted elsewhere,⁶¹ frankly acknowledges him as the greatest master of the art. Ames, in a startling phrase, says, 'The art seems to be carried to its greatest perfection by Mr. William Caslon, and his son, who besides the type of all manner of living languages now by him, has offered to perform the same for the dead, that can be recovered, to the satisfaction of any gentleman desirous of the same.'⁶² Mores, soaring into realms of mythology, styles him the Coryphaeus of modern letter-founders, and Lemoine,⁶³ following in the steps of Henry Newman, awards him the title of the English Elzevir.

In 1750 Caslon's reputation was such that His Majesty George II placed him on the Commission of the Peace for Middlesex, an office he sustained with honour to himself and advantage to the community till the time of his death.

In June of the same year the *Universal Magazine* contained an article on Letter-Founding,⁶⁴ extracted chiefly from Moxon, and accompanied by a view purporting to show the interior of Caslon's foundry and six of his men at work. The view shows four

casters ; one rubber (Joseph Jackson), one dresser (Thomas Cot-trell), and three boys breaking off. The fiction that these represent portraits should be discarded. The *Universal Magazine* about this time published accounts of other industrial processes, such as coin-minting, framework knitting, etc., and if these are examined it will be seen that the figures, including the balding head, repre-sent a type repeated by the engraver. The processes of punch-cutting and justifying were conducted in private by the Caslons themselves ; yet not, as history shows, in such secrecy as to prevent their two apprentices, Cottrell and Jackson, from observing and learning the manual operation of the 'art and mystery.'

Chart 10 shows the family and descendants of the great type-founder. As previously noted, his first wife was Sarah Pearman, daughter of Thomas Pearman, a butcher of Clent, and his wife Mary Cookes, sister of Caslon's master Edward Cookes. By her he had three sons, of whom one died in infancy, and one daughter. William was his successor at Chiswell Street and through him was continued the Caslon line. Thomas, whose baptism has not been traced, was a noted bookseller in Stationers' Hall Court, served the office of Master of the Stationers' Company in 1782, and died the following year. Caslon's daughter Mary (or Polly) married first Godfrey Shewell, one of the original partners in Whitbread's brewery, Chiswell Street, and doubtless connected with Thomas Shewell who was a partner with Thomas Longman the publisher for a short time about 1745. After Godfrey Shewell's death Polly Caslon married Thomas Hanbey, a wealthy ironmonger.

In 1728, just when Caslon was at the height of his powers and rising to fame, his wife died and was buried at Clent. The following year he married Elizabeth Long, the Bishop of London, then Edmund Gibson, officiating. Nothing seems to be known of the bride's family, and none of the three children of the marriage appear to have survived.

Caslon married thirdly, on 9 July, 1741, Elizabeth Warter of St. James, Clerkenwell, the ceremony being performed by Gilbert Burnet, M.A., who was not the son of the famous bishop of that name, though doubtless a relative. The marriage is recorded in the register of Lincoln's Inn Chapel, suggesting that the bride had legal connections. Several members of the family of Warter,

of Cruck Meole, co. Salop, were barristers of the Inner Temple. One of the family, Richard, was a citizen and goldsmith of London, dying in 1747, and leaving two daughters, un-named in Burke's Commoners; there may be a connection here, since William Caslon II married the daughter of a London goldsmith.

William Caslon I, having lived to see the result of his talent and industry in the regeneration of the art of printing in England, retired, universally respected, from the active management of the foundry, and took up his residence first in a house opposite the Nag's Head in the Hackney Road, removing afterwards to Water Gruel Row, and finally settling in what was then styled a country house at Bethnal Green.

Caslon's musical connections and his concerts are described in Appendix II, but his hospitalities were not confined to his musical friends only. His house was a resort of literary men of all classes, of whom large parties frequently assembled to discuss matters relating to art, literature and antiquities. He was esteemed as an honest, friendly, and benevolent man.

Caslon died at Bethnal Green on 23 January, 1766, at the age of 72, not 74 as inscribed on his memorial in St. Luke's Church-yard, Old Street. Middlesex. The monument to his memory is kept in repair by the bequest of his daughter Mary Hanbey.

WILLIAM CASLON'S WILL

This is the last Will and Testament of me William Caslon of Bethnal Green in the County of Middlesex Esquire Whereas I have for many years last past been in partnership with my son William Caslon in the Art or Mistery of letter founders Now I do order and direct that my part or share in the said Business shall survive to my said son William and that no other value shall be put upon the Tools Instruments or Utensils in the said Trade that what shall appear they were valued at upon making up and settling the last yearly Rest or account of the said copartnership And whereas I am an ancient ffreeman of the City of London I do in pursuance of an ancient custom of the said city Give devise and bequeath to my wife Elizabeth Caslon one third part of my personal Estate which is in my power to dispose of according to the said Custom and the other third part of my said personal Estate I Give to my said Son William my Daughter Mary the wife of Thomas Hanbey and my son Thomas Caslon to be equally divided between them share and share alike and I do make and appoint

my said Son William Caslon sole Executor of this my Will and I do revoke all former and other wills In Witness whereof I have hereunto set my hand and seal this twenty second day of January in the year of our Lord One thousand seven hundred and sixty six W^m. Caslon.

Signed sealed published and declared by the said Testator as and for his last Will and Testament in the presence of Tho^s Stagg Attorney in Red Cross Street London W^m. Bailey Serv^t to Mr Stagg and W^m. Broughton serv^t to Mr Caslon.

This Will was proved at London on the thirty first day of January in the year of our Lord One thousand seven hundred and sixty six before the Worshipful ffrancis Simpson Doctor of Laws Surrogate of the Right Worshipful George Hay Doctor of Laws Master Keeper or Commissary of the Prerogative Court of Canterbury lawfully constituted by the Oath of William Caslon the son of the said deceased and sole Executor named in the said Will to whom administration was granted of all and singular the Goods Chattels and Credits of the said deceased having been first sworn duly to administer.

<div align="center">Ex^d</div>

PARTICULARS FROM MEMORIAL IN ST. LUKE'S CHURCHYARD, OLD STREET

(On top) W. Caslon, Esq., ob. 23rd Jan., 1766, aetat. 74. Also W. Caslon, Esq. (son of the above) ob. 17 Aug. 1778, aetat. 58 years)
Miss Elizabeth Mary Caslon, daughter of Wm. and Elizabeth Caslon and grand-daughter of above Wm. Caslon Esq. died 30 October, 1780, aged 7 months and 18 days.
Mr. Thomas Caslon son of above Wm. Caslon Sen. died 29 March, 1783 aet 56.
Miss Harriett Caslon daughter of Henry and Elizabeth Caslon and grand-daughter of above Wm. Caslon Esq. died 1 May, 1785, aged 2 months and 9 days)
Edward Caslon, son of above Henry and Elizabeth Caslon died 20 October, 1787, aged 12 weeks and 3 days)
Elizabeth widow of William Caslon Esq., son of William Caslon senior died 24 October, 1795, aged 65.

(South side) Thomas Hanbey Esq. of Hackney died 25 December, 1786, aged 74.

ABCDEFGHIJ
KLMNOPQRSTUV
WXYZ

abcdefghijklmnopqr
stuvwxyz

ABCDEFGHIJ
KLMNOPQRSTU
VWXYZ

ABCDEGFKM
NPQRTY

abcdefghijklmnopqrstu
vwxyz

PLATE 47

Caslon's roman and italic alphabets with a selection of his decorative swash italic capitals.

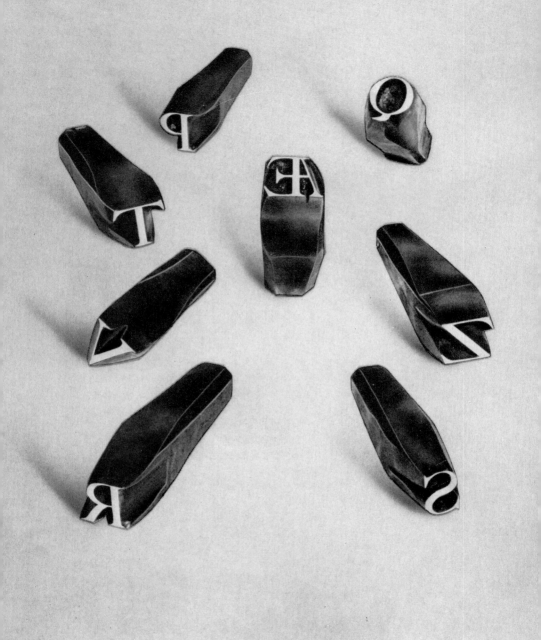

PLATE 48

Selection of Caslon steel punches—Canon Roman (48 point) size.
Only sixteen of these interesting relics of William Caslon's handiwork survive.
The Q-punch clearly shows the bulging at the shank end
caused by the blows of the hammer when sinking it.
Enclosed counters necessitate heavier blows to displace the copper effectively

Mary his widow died 14 January, 1797, aged 75, and Also relict of Godfrey Shewell Esq., late of this Parish, and likewise daughter of Wm. Caslon, Sen. Esq., formerly of this Parish.

(North side) Mary Anne Caslon wife of Henry Caslon son of Henry and Elizabeth Caslon born 21 August 1785, died 31 March, 1816.

Henry Caslon Esq. of Higham Hill, Waltham-stow, Essex, only surviving child of Henry Caslon and Elizabeth his wife, eldest daughter of William Rowe Esq. of Higham Hill. Born in Gower Street, London, 15 May, 1786, died at Boulogne-sur-mer 28 May, 1850.

NOTES FROM THE GENTLEMAN'S MAGAZINE

1779—Mr. Wm. Caslon, to Miss Wittenoom (Married).

8 Dec. 1787—Mr. Henry Caslon, of Gower Street; a younger son of the late Mr. Wm. Caslon, a celebrated letter-founder (Died).

1 June, 1809—Mr. W. Caslon, jun., of Salisbury-square, Fleet Street, letter founder, to Miss Bonner, daughter of Mr. Bonner of Fleet Street (Married).

1800—Mr. Strong, apothecary, to Mrs. H. Caslon, both Chiswell Street, Moorfields (Married).

1809—After a few days of illness, in his 45th year, Mr. Nathaniel Catherwood, of Charles Square, Hoxton, one of the partners in the letter-foundry of Caslon and Co. of Chiswell Street (Died).

NOTES FROM 'TWO CENTURIES OF TYPE-FOUNDING,' BY J. F. MCRAE

William Caslon III, born 1754, married Elizabeth Wittenoom, died 1833.

William Caslon IV (son of above), born 1781, married Miss Bonner (see Gent. Mag 1 June, 1809), and died in 1869 at Stoke-on-Trent.

Henry Caslon I (son of William Caslon II and younger brother of William Caslon III), married Elizabeth Rowe, and died in 1788.

Henry Caslon II (son of above), born circa 1786, married Mary Anne . . .? died 28 May, 1850.

Henry William Caslon (son of above), born 1814, died 14 July, 1874, at Medmenham, Bucks, aged 59.

[THE LAST OF THE CASLONS, GREAT-GREAT-GRANDSON OF THE GREAT TYPE-FOUNDER].

ADDENDUM

The following brief notes may prompt further research into possible connections between the family of Thomas Hollis, cutler at the Cross Daggers, Little Minories, Thomas Hanbey (Hanby), second husband of Mary, daughter of William Caslon I, and the Sheffield firm of typefounders Stephenson Blake & Co. Ltd. (formerly Blake, Garnett & Co.). It is curious that both Thomas Hollis and Thomas Hanby came from Sheffield and that the Caslon Letter Foundry was transferred to the same place. (See Chart II).

If we refer to William White's *Directory of Sheffield*, 1833, page 109, we read as follows : "Hollis's Hospital, in Newhall-street, sometimes called the Brown Hospital, from the dress of its inmates, was founded in 1703, by Mr Thomas Hollis, a native of Sheffield, who had acquired his property as a vendor of Sheffield cutlery, in London. He was a very religious character, and performed many acts of benevolence, amongst which this stands the most remarkable. He founded the charity some years before his death, having purchased a deserted chapel called New Hall, and a house adjoining, which he converted into sixteen dwelling houses, for as many elderly women, widows of cutlers, or others connected with the trade. . . ."

Considerable additions were made in 1726 by Thomas Hollis, son of the founder and John Hollis, his relative, and again in 1732 by Thomas Hollis, grandson of the founder, and subsequently by Timothy Hollis and Thomas Brand. These names establish the identity of Thomas Hollis, founder of Hollis's Hospital, as Thomas Hollis (1634–1718), cutler of Whitechapel, whose son Thomas Hollis, of the Cross Daggers, Little Minories, was Thomas Guy's friend and executor, and William Caslon's patron.

On page 95 of the same *Directory* reference is made to the Boys' Charity School in Sheffield, erected in 1710.

"Until 1796 only 54 boys were admitted, but in that year Thomas Hanby, Esq. of London (said to have been educated in this school) bequeathed £3,000, three per cent Bank annuities, and directed the yearly dividends to be appropriated as follows, viz. £10 to augment the master's salary, £1 for a sermon, 10s. to the clerk and sexton, £5 for a dinner for the trustees (the Cutlers' Company) on the day of distribution of his charity, and the residue to be employed in maintaining, clothing, and educating such an additional number of poor boys of the parish of Sheffield as it would extend to. Six boys were accordingly added, making the total number 60, to which no augmentation was made till after the erection of the present large and commodious school, which

was built in 1825, on the site of the old one, at the cost of £3000. . . .
The six boys on Hanby's foundation have the same uniform as the
boys of Christ's Hospital in London, viz. blue cloth gowns, with
belts, bands and caps."

Included in White's *Directory* are the following names :—
Blake & Stephenson, type founders, 46 Allen Street.
Bower & Bacon, type founders, Nursery Lane.
Hanby & Cowley, saw and cutlery mfrs, Nursery Lane.
Abraham Hanby, saw, & c. mfr. h(ouse), 12 Nursery Street.

The above notes strengthen the author's evidence that
Thomas Hollis, cutler at the Cross Daggers in Little Minories
and later at Goodman's Fields, Whitechapel, friend of both
Thomas Guy and William Bowyer, was an active supporter of
William Caslon, and suggest that Mary Caslon met her second
husband Thomas Hanby through the Hollis connection.

1 Reed-Johnson, p. 239.
2 James Mosley, The Early Career of William Caslon, App. III.
3 Reed-Johnson, pp. 231-2.
4 Anecdotes of William Bowyer, p. 317.
5 Reed-Johnson, p. 232.
6 Ibid. p. 256.
7 See Appendix I.
8 James Mosley, The Early Career of William Caslon.
9 Ibid.
10 Half hide took his first apprentice in 1726: see Loriners' apprentices, Chapter 5.
11 Nichols, Literary Anecdotes of the Eighteenth Century.
12 Dissertation, Carter and Ricks Version, p. 60.
13 See Chapter 16.
14 Reed-Johnson, p. 256.
15 Ibid.
16 Ibid. pp. 253-6.
17 Reed-Johnson, p. 235, footnote.
18 Ibid. p. 256.
19 Ibid. pp. 232-3.
20 Ibid. p. 256.
21 Biographical Memoirs of William Ged, London, 1781.
22 Rev. Benjamin Wadsworth (1669-1739).
23 Allen and McClure, Two Hundred Years, p. 249.
24 S.P.C.K. New England Letter Book, p. 57, quoted by James Mosley.
25 Reed-Johnson, p. 234.
26 Psalmorum Liber in Versiculos metrice divisus, etc. (Heb. et Lat.). 1736, 2 Vols.,
8vo, Reed-Johnson, p. 234.
27 Moses Chorenensis Historiae Armeniacae Libri III. Armeniacé ediderunt, Latiné
verterunt notisq: illust. Guil. et Geo. Whistoni, London, 1736, 4to.

Chart 10.

Family and Descendants of William Caslon the Typefounder

William Caslon ═══ 1. Sarah Pearman, dau. of Thomas,
bap. Halesowen, butcher, and his wife Mary Cookes,
23 April, 1693. *bap.* Clent, 1689; *marr.* at St. Peter,
Appren. 1706; Cornhill, 29 Aug. 1717; *bur.* at Clent
Completed his term 16 Nov. 1728 as "Sarah Castleton"
1713; granted freedom ═2. Elizabeth Long, *marr.* Sept. 1729.
of the city, 1717. Loriner, Issue Joseph 1730, Anne 1731,
engraver and letter-founder. Frances 1732, *died* in infancy.
Magistrate for co. Mdx. ═3. Elizabeth Warter, *marr.* July, 1741.
1750. *bur.* at St. Luke's, No issue.
Old Street, Mdx. Jan. 1766

William Caslon II, ═══ Elizabeth Cartlich,
bap. 23 June 1720 at *born* 31 May, 1730, dau. of
St. Botolph, Aldgate; Wm. Cartlich, citizen &
Letter-founder; goldsmith of the Royal Mint;
died 17 Aug. 1778; *marr.* 25 June, 1751 at St. Mary-
bur. St. Luke's Old Street. le-Bowe; *died* 24 Oct. 1795

William Caslon III ═══ Elizabeth Wittenoom
(1754–1833) Letter- *marr.* 22 May 1779
founder; of Finsbury Sq.
and of Dorset St.,
Salisbury Square

William Caslon IV ═══ 'Miss' Bonner, Elizabeth Mary Caslon
(1781–1869) Letter- dau. of — Bonner, *died* in infancy, 1780
founder; of Salisbury of Fleet Street;
Square, Fleet St; *died* *marr.* 1 June, 1809
at Stoke-on-Trent.

No issue

Mary Caslon ═══════ 1. Godfrey
bap. 31 Aug. 1722 Shewell, of
at St Botolph, Whitbread's
Aldgate, *died* brewery
14 Jan. 1797: *bur.* ? 2. Thomas Hanbey,
at St. Luke, Old St. iron-monger *died* 1786

John Caslon
born & bur.
1723–4

Thomas Caslon
born circa 1726–27;
bookseller; Master
of the Stationers' Co. 1782;
died 29 Mar. 1783;
bur. at St. Luke, Old St.

Henry Caslon I ═══════ Elizabeth Rowe,
(–1787) Letter- dau. of Wm. Rowe, Esq.
founder, of of Higham Hill,
Gower St., London Walthamstow, Essex

Henry Caslon II ═══════ Mary Anne?
Letter-founder; *born* (1785–1816)
in Gower St., London,
1786; *died* at Boulogne-
sur-Mer 28 May, 1850

Harriet
Caslon
born & died
1785

Edward
Caslon
born & died
1787

Henry William Caslon, Letter-founder, *born*
1814, *died* 14 July, 1874, aged 59, at
Medmenham, co. Bucks.
The last of the CASLON DYNASTY

28 Shown on the Caslon specimen-sheet of 1748, of which a few letters appear in Swinton's 'De primogenio Etruscorum alphabeto,' 1746.

29 Reed-Johnson, p. 235.

30 Ibid.

31 For fuller references to Caslon's various specimens, see Reed-Johnson.

32 For a discussion of the various states in which the 1734 specimen has been found, see James Mosley, The Early Career of William Caslon.

33 The Early Career of William Caslon.

34 Reed-Johnson, p. 46, fig. 8.

35 D.N.B. art. Michael Maittaire.

36 Updike, Vol. 2, p. 134.

37 Ibid. p. 135, footnote.

38 The part played by Rowe Mores in this affair is told more fully in the 'Dissertation,' edited by Carter and Ricks.

39 Reed-Johnson, p. 148, a statement, however, denied by Elizabeth Elstob herself in a letter to George Ballard, 4 Dec. 1756. (Anglo-Saxon types, 1566–1715, Cat. of Exhibition. at Corpus Christi Coll. Cambridge).

40 Thomas Astle, Origin and Progress of Writing, 1784, p. 110.

41 D.N.B. art. Elizabeth and William Elstob.

42 D.N.B. art. David Wilkins.

43 D.N.B. art. John Selden.

44 D.N.B. art. David Wilkins.

45 Dissertation, Carter and Ricks version, p. 34.

46 Also shown in Reed-Johnson, p. 235.

47 Reed-Johnson, p. 62.

48 Dissertation, Carter and Ricks version, p. 75.

49 Ibid. p. 80.

50 Typescript biography of Jeremiah Dummer of West Ham. (Donated to Society of Genealogists by C. H. Crouch, 1943).

51 History of American Literature, New York, 1879, Vol. 2, p. 118.

52 Ibid.

53 L. W. Cowie, Henry Newman, p. 41.

54 Ibid, pp. 158–9.

55 Chamberlayne's Magnae Britanniae Notitia, 1735.

56 Foster, Alum. Oxon.

57 P.C.C. 126 Henchman.

58 Vol. 2, Fig, 207, pp. 20–21.

59 Vol. 2, p. 106.

60 Updike, Vol. 2, Figure 265–6, facing pp. 106–7.

61 Chapter 16.

62 Joseph Ames, Typographical Antiquities, London, 1749, p. 371.

63 D.N.B. art. Henry Lemoine.

64 The Universal Magazine of Knowledge and Pleasure, London, June, 1750, p. 274 (reproduced as the Frontispiece to Reed-Johnson).

Chapter Eighteen

TITLE-PAGES OF SOME BOOKS IN
THE CASLON ERA

Now that we have traced Caslon's career it will be instructive to examine some further title-pages of books, noting the improvements which took place when Caslon's type came into regular use by comparison with those described and illustrated in Chapter 15. It should be noted that all the improvement which took place in English typography was not to be ascribed solely to the use of Caslon's letters, for as time went on there was also parallel improvement in English press-work. Nevertheless the ready availability of new type of English manufacture was in itself a stimulus to printers to improve other branches of the printing craft, so that as the century advanced there were improvements in ink, paper, and later still, in the mechanics of printing itself.

PLATE 49 shows a folio size title-page of 1739. By this time Caslon's type was coming into almost universal use in English printing, although on the larger types used in title-pages the use of sorts from different founts continued for a longer period. In this title-page of William Maitland's well-known *History of London*, compare 'T' in 'FOUNDATION' with 'T' in 'PRESENT' and in 'TIME'; Caslon's 'A' in' FOUNDATION' with 'A' in 'ROMANS'; 'R' in 'ROMANS' with Caslon's 'R' in 'PRESENT'. While it was more common for the compositor to run 'out of sorts' of larger type, certain kinds of copy were also harder on 'sorts.' Page size 9.4 x 15.8. (See Plates between pages 384 and 385).

The printer of the book was Samuel Richardson (1689–1761), the well-known author of *Pamela*, 1740; *Clarissa*, 1748; *Sir Charles Grandison*, 1753, who was a printer and publisher as well as an author.

Richardson was closely connected with the printing and bookselling fraternity of his time. His first wife was Martha, daughter of John Wilde, a printer of Aldersgate Street to whom he had been apprenticed; his second was Elizabeth, daughter of John Leake, another printer; he was a life-long friend of Charles Rivington, and he entered into partnership with Catherine, daughter of Henry Lintot. He could scarcely have been more tightly bound into the book trade.

CASLON TYPE

PLATE 50

M. MANILII

ASTRONOMICON

ex recensione et cum notis

RICHARDI BENTLEII

Londini,

Typis Henrici Woodfall,

Sumptibus Pauli et Isaaci Vaillant.

MDCCXXXIX

[1739—First edition]

7.6 x 10.3

This is the title-page of the first edition of the last work published by Richard Bentley (1662–1742), the famous critic and master of Trinity College, Cambridge. The work was printed in Caslon type by Henry Woodfall, at the sign of the Rose and Crown in Little Britain, one of the foremost printers of the eighteenth century. In the same year his son, Henry Sampson Woodfall, who became a famous journalist, was born. The booksellers Isaac and Paul Vaillant were among the high-class men of the trade at this period. The type was too freely inked in the printing of the page displayed.

PLATE 5 I

THIRTY TWO NEW AND ACCURATE MAPS
of the Geography of the Ancients as contained
in the Greek and Latin Classics : etc.
By Herman Moll, Geographer.
London : Printed for, and Sold by T. Bowles, Print and Map-
Seller, near the Chapter-House in St. Paul's Church-Yard ;
and J. Bowles, Print and Map-Seller, at the Black-Horse,
Cornhill.
1739
5.9 x 7.2

This is another example of a crowded title-page, a weakness
extending to most of the text-book printing of the eighteenth
century.

Thomas Bowles, later of Newgate Street, was a friend of
Charles Green (1719–1778), Wardrobe-keeper and Assistant
Clerk at Christ's Hospital, eldest brother of the Halesowen
artists James, Amos and Benjamin Green, and was one of the
executors named in his will.

PLATE 52(a)

THE DUNCIAD
An Heroic Poem to
Dr. Jonathan Swift
with the Prolegomena of Scriblerus
and Notes Variorum
London : Printed for Lawton Gilliver, in Fleetstreet,
1736
4 x 6.6

This is the title-page of the last edition in this form of the
well-known work by Alexander Pope (1688–1744).

The 'U' in 'DUNCIAD' shows the persistence of unsuitable
sorts in book-titles long after one would have expected them to be
destroyed.

377

PLATE 52(b)

TRIFLES

viz.

The Toy-Shop.	The Chronicle of the Kings
The King and the	of England.
Miller of Mansfield.	The Art of Preaching, in
The Blind Beggar	Imitation of Horace's Art of
of Bethnal Green.	Poetry.
Rex and Pontifex.	The Right of Mankind to do
	what they will, asserted.

With several others, not more Considerable.

By R. Dodsley

At Tully's Head in Pall-mall,

MDCCXLV

[1745–First edition.]

4.4 X 7.5

The date of this collected work, containing 32 pieces, corrects the date given in the D.N.B., viz. 1748.

With the exception of the larger sorts in the word 'TRIFLES' the type is that of Caslon. The body of the book is also printed in Caslon type, except for certain larger headings and the ornaments.

PLATE 53 (a) and (b) illustrate the title-pages of two editions of the celebrated Fables of John Gay (1685-1732), which were first written for the edification of Prince William Augustus, Duke of Cumberland. The first edition was published in 1727, when the Prince was six years old, by Jacob Tonson II and John Watts, an early patron of Caslon, in their well-known printer-publisher relationship.

The first title-page, (a), is that of the fourth edition, which was published in 1751 by J. and P. Knapton and T. Cox. It is simple and dignified, with the text nicely graduated down the page and having a vignette drawn by H. Gravelot and engraved by G. Scotin, the design being taken from the monument to Gay's memory which was erected at the expense of the Duke and Duchess of Queensberry. It shows the head of Gay decorated with bays and the symbols of poetry and drama.

The second title-page, (b), is that of the seventh edition, which was published in 1753 by J. and R. Tonson and J. Watts. This title-page is also simple, having an engraving showing the light of knowledge projected through the mask of drama, with the sole addition of printer's rules.

PLATE 54

POLYMETIS:
Or, An Enquiry concerning the
AGREEMENT
Between the Works of the
ROMAN POETS
and the REMAINS of the
ANTIENT ARTISTS.
By the Rev.ᵈ Mr. Spence
London : Printed for R. and J. Dodsley, in Pall-Mall.
MDCCLV
[1755—Second edition]
10.1 x 16.5

Joseph Spence (1699–1768), himself patronised by William Fawkener, a wealthy London mercer, was an early patron of Dodsley, and a friend of Pope and Shenstone. Apart from his *Anecdotes,* Spence's *Polymetis,* of which the first edition appeared in 1747, was the author's only considerable contribution to classical scholarship. The numerous large plates in *Polymetis* were engraved by Louis Peter Boitard, a Frenchman working in this country. By this time, 1755, Dodsley had improved his stock of larger sorts. The 'Q' in 'ENQUIRY' is not Caslon's. Although the size of the page here guarantees its legibility, a shorter title and the omission of quotations would have added to its dignity.

SHENSTONE'S WORKS IN CASLON TYPE

PLATE 55 shows the title-page of the first edition of the works in verse and prose of William Shenstone (1714-1763), poet and landscape gardener of the Leasowes, Halesowen. The two volumes were published in 1764 by Robert and James Dodsley. Robert Dodsley (1703-64), was Shenstone's friend and executor as well as his publisher. The volumes appeared the year after Shenstone's death, but Dodsley barely survived the publication, dying himself in 1764.

It was appropriate that the first edition of Shenstone's works should appear in Caslon type, for Caslon was apprenticed to Shenstone's uncle, Edward Cookes, and it was to Edward Cookes' son, another Edward Cookes of Edinburgh, that Shenstone willed his estate.

The title-page, 4.6 x 7.8, shows that the size of the vignette rather crowds the lettering, VOL. I actually encroaching on the plate-mark. Shenstone mentioned the drawing of a kingfisher in a letter dated 24 April, 1759, to John Scott Hylton and that Amos Green had been critical of it. Who was responsible for the final version is not clear.

PRINTED AT DUBLIN, IN CASLON TYPE

PLATE 56(a)

THE WORKS OF SALLUST
translated into English,
with Political Discourses upon that Author.
To which is added, a
Translation of Cicero's Four Orations
against Catiline.
Dublin : Printed by A. Reilly.
For John Smith at the Philosophers Heads on the Blind-Quay.
MDCCXLIV

[1744—First edition]
4.6 x 7.8

Thomas Gordon (d. 1750), the translator, was 'large and corpulent' and is supposed to be the 'Silenus' of Pope's line in the *Dunciad*, 'where Tindal dictates, and Silenus snores.' His translation of *Tacitus* in 2 vols. folio, 1728, in spite of an affected style, seems to have been the standard translation till the end of the century and was used by Gibbon in his youth.

The title-page illustrated is the average standard of the middle of the century in England, but it is clear that the printer has run short of space in the lower half of the page and, in particular, the words 'Cicero's Four Orations' are too crowded. The use of Caslon type was already widespread by 1744.

380

PRINTED AT EDINBURGH, IN CASLON TYPE

PLATE 56(b)

THE WORKS IN VERSE AND PROSE

of William Shenstone, Esq ;

Edinburgh : Printed by A. Donaldson, and sold at his shops at the corner of Arundel-Street, Strand, London, and Edinburgh.

MDCCLXX

[1770]

3.9 x 6.8

The title-pages of Volumes I and II are dated 1768, and the title-page of Volume III, the letters, is dated 1770.

A POET FRIEND OF CASLON

PLATE 57(a)

A YEAR'S JOURNEY THROUGH FRANCE

and Part of Spain by

Philip Thicknesse, Esq.

The Second Edition with Additions.

Vol. I.

London : Printed for and sold by W. Brown in the Strand.

MDCCLXXVIII

[1778]

4.9 x 8.4

Among the relics of the Caslon Foundry is a copy of the 1764 specimen-book presented by Caslon to his friend Phil. Thicknesse the poet. At the end of the book appears Thicknesse's letter of thanks to the donor, execrably printed by the poet himself, in type given him by Caslon. [Reed-Johnson ; footnote p. 241].

THOMAS CASLON'S IMPRINT

PLATE 57(b)

THE POETICAL WORKS OF MATTHEW PRIOR; ETC.

IN CASLON TYPE

London : Printed for W. Strahan, T. Payne, J. Rivington and Sons, J. Dodsley, T. Lowndes, T. Cadell, T. Caslon, J. Nichols, and T. Evans in the Strand.

MDCCLXXIX

[1779]

4.3 x 6.9

Thomas Caslon was a bookseller in Stationers' Hall Court

and was Master of the Stationers' Company in 1782, dying in 1783. He was a partner in a number of publications of the day, including Johnson's *Shakespeare*.

CASLON TYPE

PLATE 58

THE
ANTIENT and PRESENT STATE
of the
CITY OF OXFORD

This is the half-title of a work which appeared in 1773 from the press of J. and F. Rivington, London. It was prepared from the MS. notes of Anthony à Wood by the Rev. Sir John Peshall (1718-1778), who was born in Halesowen as John Pearsall, son of Thomas Pearsall of Hawne, of a family long established there, and who assumed the title and style of a baronet. He took holy orders and in 1771 was presented to the rectory of Stoke Bliss in Herefordshire; he was also a schoolmaster at Guildford, but spent most of his time at Oxford. His contribution to Wood's *History* was slight but useful.

The lines of ornament above and below the text in the half-title are the same as those used on some of Baskerville's titles. (See Plate 61)

A FAMOUS BOWYER TAILPIECE

PLATE 59

MISCELLANEOUS TRACTS
by the late William Bowyer Printer, F.S.A.
and several of his learned Friends;
By John Nichols, Printer, F.S.A. Edinb.
London : Printed by and for the Editor,
MDCCLXXXV
[1785]
8 x 10.7

This title-page exhibits one of the famous tail-pieces, representing a phoenix rising from the flames, engraved for the elder Bowyer in remembrance of the kindness of his fellow-printers after the fire of January, 1712–13. The setting shows the more dignified spacing and ample margins of a larger title page although still much too wordy.

382

PLATE 60

THE
HOLY BIBLE
CONTAINING THE
OLD TESTAMENT
AND
THE NEW
WITH THE
APOCRYPHA
Translated out of the
ORIGINAL TONGUES
WITH
ANNOTATIONS
BIRMINGHAM; Printed by JOHN BASKERVILLE
MDCCLXXII
[1772—large fol.]
10 X 16.5

This is not the coveted edition of Baskerville's Bible, which appeared in imperial folio in 1763. The 1772 edition is judged inferior, both paper and general appearance being considered unsatisfactory. The words 'Holy Bible' and 'Original Tongues' were printed by xylograph and display the influence of the former writing master.

PRINTED BY BASKERVILLE

PLATE 61

C. CRISPUS
SALLUSTIUS
ET
L. ANNAEUS
FLORUS
BIRMINGHAMIAE: Typis JOANNIS BASKERVILLE
MDCCLXXIII
9 X 11.5

This title-page exhibits Baskerville's principle of well-spaced letters and lines, wide margins, and minimum decoration. His roman capitals are splendid considered individually but when set on a title-page convey the impression that each is a monument unconnected with its fellows, and this effect is still more strongly conveyed by his italic capitals arranged in a title; they stand like victims of malnutrition. In mass, however, mingled with their

lower-case partners they attain the distinction which has been widely accorded them.

With regard to ornaments, while one might concur or otherwise with Baskerville's restrained use of them, it should be remembered that he had a very limited range from which to choose and this might have influenced his attitude to them. [See Updike, Vol. II, p. 116–7].

CASLON TYPE IN AMERICA

PLATE 62

ISAIAH THOMAS'S SPECIMEN

The title-page of the *Specimen of Printing Types* issued in 1785 by Isaiah Thomas (1749-1831) of Worcester, Massachusetts, reflects the high esteem in which Caslon's types were held in America. We have seen in Chapter 17 that both Henry Newman, secretary of the S.P.C.K., and Benjamin Franklin recommended Caslon type in their own country. But the title-page shown demonstrates that even good types needed to be used properly by good workmen in order to secure the best results. The specimen shown was badly inked and the inclusion of a single word of black-letter mingled with roman and italic letter was ill-chosen. It is displayed here as an additional American testimonial to Caslon's abilities.

PRINTED IN BIRMINGHAM

PLATE 63

THE
HOLY BIBLE
containing the
Old and New Testaments ;
and also the
APOCRYPHA:
Translated out of the
ORIGINAL TONGUES,
With
ANNOTATIONS
Birmingham, PRINTED BY PEARSON AND ROLLASON.
MDCCLXXXVIII
[1788]
7.9 x 9.8

The words 'HOLY BIBLE' in this title-page are printed

THE

HISTORY

OF

LONDON,

FROM ITS

FOUNDATION

BY THE

ROMANS,

TO THE

PRESENT TIME.

CONTAINING

A Faithful Relation of the *Publick Tranfactions* of the CITIZENS; Accounts of the feveral *Parifhes;* Parallels between LONDON and *other* Great Cities; its *Governments,* Civil, Ecclefiaftical and Military; *Commerce,* State of *Learning, Charitable Foundations,* &c.

With the feveral ACCOUNTS of

WESTMINSTER, MIDDLESEX, SOUTHWARK,

And Other PARTS within

The BILL *of* MORTALITY.

In NINE BOOKS.

The Whole Illuftrated with a Variety of FINE CUTS.

With a COMPLEAT INDEX.

BY

WILLIAM MAITLAND, *F. R. S.*

LONDON:
Printed by SAMUEL RICHARDSON, in *Salisbury-Court* near *Fleetstreet.* MDCCXXXIX.

PLATE 49

M. MANILII
ASTRONOMICON

EX RECENSIONE

ET

CUM NOTIS

RICHARDI BENTLEII.

LONDINI,
Typis HENRICI WOODFALL,
Sumptibus PAULI et ISAACI VAILLANT.
MDCCXXXIX.

PLATE 50

THIRTY TWO
New and Accurate M A P S
O F T H E
GEOGRAPHY
O F T H E
A N C I E N T S,

As contained in

The *Greek* and *Latin Classics:*

W H E R E I N

The Several Empires, Kingdoms and Provinces, the Chief Cities, Towns, Rivers and Mountains mentioned in *Homer, Herodotus, Justin, Virgil, Ovid, Florus, Nepos, Cæsar, Livy, Lucan, Plutarch*, and many other Ancient Authors, are reprefented.

An Undertaking much wanted, as being very neceffary for the more Eafy, Expeditious, and Right underftanding of Ancient Authors; *Principally defigned for the Service of* S C H O O L S; and alfo ufeful to Perfons of Riper Years who delight to read the Claffics.

Performed according to the Lateft and moft Exact Obfervations, and adapted to the ready Underftanding of the Ufe of Ancient and Modern Maps together.

By *HERMAN MOLL*, Geographer.

L O N D O N:

Printed for, and Sold by T. Bowles, Print and Map-Seller, near the *Chapter-Houfe* in *St Paul's Church-Yard*; and J. Bowles, Print and Map-Seller, at the *Black-Horfe, Cornhill.* 1739.

PLATE 51

THE

DUNCIAD.

AN

HEROIC POEM.

TO

Dr. JONATHAN SWIFT.

With the

Prolegomena of SCRIBLERUS,

AND

NOTES VARIORUM.

LONDON:

Printed for LAWTON GILLIVER,
in Fleetstreet. 1736.

(a)

(b)

TRIFLES:

VIZ.

The TOY-SHOP.	The CHRONICLE of the KINGS of ENGLAND.
The KING and the MILLER of MANSFIELD.	The ART of PREACHING, in Imitation of HORACE'S ART of POETRY.
- The BLIND BEGGAR of BETHNAL-GREEN.	The Right of Mankind to do what they will, asserted.
REX & PONTIFEX.	

With several others, not more Considerable.

By R. DODSLEY.

The least, the lowest of the tunefull Train.

At TULLY's Head in Pall-mall.

M.DCC.XLV.

PLATE 52

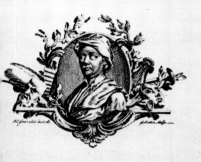

FABLES.

By the late Mr GAY.

VOLUME THE SECOND.

THE FOURTH EDITION.

LONDON:
Printed for J. and P. KNAPTON, in *Ludgate-ſtreet*;
and T. Cox, under the *Royal-Exchange.*
M.DCC.LI.

(a)

(b)

PLATE 53

P O L Y M E T I S:

OR,

An ENQUIRY concerning the

A G R E E M E N T

Between the WORKS of the

R O M A N P O E T S,

And the REMAINS of the

A N T I E N T A R T I S T S.

BEING

An ATTEMPT to illuſtrate them mutually from one another.

IN TEN BOOKS.

By the Rev^d. Mr. SPENCE.

The SECOND EDITION, correċted by the AUTHOR.

Omnes artes, quæ ad humanitatem pertinent, habent quoddam commune vinculum;
& quaſi cognatione quâdam inter ſe continentur. Cicero; pro Arch.

The Verſe and Sculpture bore an equal part;
And Art reflecẗed images to Art.
 Pope; of Poetry and Statuary.

——Each from each contracẗ new ſtrength and light.
 Id. of Poetry and Painting.

LONDON:

Printed for R. and J. DODSLEY, in Pall-Mall.
M.DCC.LV.

PLATE 54

THE
WORKS
IN
VERSE AND PROSE,
OF
WILLIAM SHENSTONE, Efq;

Moft of which were never before printed.
IN TWO VOLUMES,
WITH DECORATIONS.

——His ego longos
Cantando puerum memini me condere foles. Virg.

VOL. I.

LONDON:

Printed for R. and J. Dodsley in Pall-mall.

M DCC LXIV.

PLATE 55

PLATE 56

A

YEAR'S JOURNEY

THROUGH

F R A N C E,

AND

PART OF SPAIN.

BY

PHILIP THICKNESSE, Esq.

THE SECOND EDITION WITH ADDITIONS.

VOL. I.

L O N D O N:
PRINTED FOR AND SOLD BY W. BROWN, IN THE STRAND.
M DCC LXXVIII.

(a)

(b)

T H E

POETICAL WORKS

O F

MATTHEW PRIOR:

NOW FIRST COLLECTED,

WITH EXPLANATORY NOTES.

A N D

MEMOIRS OF THE AUTHOR,

IN TWO VOLUMES.

VOLUME THE SECOND.

L O N D O N:
PRINTED FOR W. STRAHAN, T. PAYNE, J. RIVINGTON
AND SONS, J. DODSLEY, T. LOWNDES, T. CADELL,
T. CASLON, J. NICHOLS, AND
T. EVANS IN THE STRAND.
MDCCLXXIX.

PLATE 57

THE

ANTIENT and PRESENT STATE

OF THE

CITY of OXFORD.

THE WHOLE CHIEFLY COLLECTED

By Mr. ANTHONY à WOOD;

WITH ADDITIONS

By the Rev. Sir J. PESHALL, Bart.

PLATE 58

MISCELLANEOUS
TRACTS,

BY THE LATE

WILLIAM BOWYER, PRINTER, F. S. A.

AND SEVERAL OF

HIS LEARNED FRIENDS;

INCLUDING

LETTERS, ON LITERARY SUBJECTS,

BY MR. MARKLAND, MR. CLARKE, &c. &c.

COLLECTED, AND ILLUSTRATED WITH OCCASIONAL NOTES,

BY JOHN NICHOLS, PRINTER, F. S. A. EDINB.

" It is my pride, my joy, my only plan,
" To lose no drop of this immortal Man." GARRICK.

LONDON,
PRINTED BY AND FOR THE EDITOR.
MDCCLXXXV.

PLATE 59

THE

Holy Bible,

CONTAINING THE

OLD TESTAMENT

AND

THE NEW;

WITH THE

APOCRYPHA:

Tranſlated out of the

Original Tongues,

WITH

ANNOTATIONS.

BIRMINGHAM;

Printed by J O H N B A S K E R V I L L E,

MDCCLXXII.

PLATE 60

C. CRISPUS

SALLUSTIUS;

ET

L. ANNÆUS

FLORUS.

BIRMINGHAMIÆ:
Typis **JOANNIS BASKERVILLE.**
MDCCLXXIII.

PLATE 61

A

SPECIMEN

OF

ISAIAH THOMAS's

PRINTING

𝕿𝖄𝕻𝕰𝕾.

Being as *large* and *complete* an ASSORT-
MENT as is to be met with in any one
Printing-Office in AMERICA.

Chiefly MANUFACTURED by that great Artiſt,
WILLIAM CASLON, Eſq;
of LONDON.

PRINTED at *WORCESTER*, MASSACHUSETTS,
By ISAIAH THOMAS.

MDCCLXXXV.

PLATE 62

THE

Holy Bible,

CONTAINING THE

Old and New Testaments;

AND ALSO THE

APOCRYPHA:

TRANSLATED OUT OF THE

ORIGINAL TONGUES,

WITH

ANNOTATIONS.

Birmingham,

PRINTED BY PEARSON AND ROLLASON.

MDCCLXXXVIII.

PLATE 63

1635-6.

He *Hollanders* have fent an Embaffy and a noble Prefent on the occafion of the *Queene* having another Daughter: there are rare pieces of China and Paintings, one by *Tytian*.

There is talk of a By-pofte from *Wickham*, to join the North Pofte, which is expected to run night and day betweene *Edinburgh* and *London*, to go thither and come back againe in fix days: Men and Horfes will fcarce be found to doe this.

Young Mr. *Gage* is put into the *Baftille*. The Earle of *Leycefter* hath kindly written to his Mother; he being Ambaffador at this time fhe did apply to him for help in this troublous Affaire.

Baby walked a few fteppes alone, and did

1635-6.

January.

Feb. 23,
Tuefday.

June 6,
Monday.

c

PLATE 64

A S P E

By WILLIAM CASLON, Letter-F

ABCD
ABCDE
ABCDEFG
ABCDEFGHI
ABCDEFGHIJK
ABCDEFGHIJKL
ABCDEFGHIKLMN

French Cannon.

Quouſque tan-
dem abutere,
Catilina, pati-
Quouſque tandem
abutere, Catilina,

DOUBLE PICA ROMAN.

Quouſque tandem abutere, Cat
lina, patientia noſtra ? quamd
nos etiam furor iſte tuus eludet
quem ad finem ſeſe effrenata ja
ABCDEFGHJIKLMNO

GREAT PRIMER ROMAN.

Quouſque tandem abutêre, Catilina, p
tientia noſtra ? quamdiu nos etiam f
ror iſte tuus eludet? quem ad finem f
ſe effrenata jactabit audacia ? nihilne
nocturnum præſidium palatii, nihil u
bis vigiliæ, nihil timor populi, nihil co
ABCDEFGHIJKLMNOPQR

ENGLISH ROMAN.

Quouſque tandem abutêre, Catilina, patien
noſtra? quamdiu nos etiam furor iſte tuus elud
quem ad finem ſeſe effrenata jactabit audaci
nihilne te nocturnum præſidium palatii, ni
urbis vigiliæ, nihil timor populi, nihil conſe
ſus bonorum omnium, nihil hic munitiſſim
ABCDEFGHIJKLMNOPQRSTVU

PICA ROMAN.

Melium, novis rebus ſtudentem, manu ſua occî
Fuit, fuit iſta quondam in hac repub. virtus, ut v
fortes acrioribus ſuppliciis civem pernicioſum, qu
acerbiſſimum hoſtem coërcerent. Habemus enim
natuſconſultum in te, Catilina, vehemens, & gra
non deeſt reip. conſilium, neque autoritas hujus
dinis: nos, nos, dico aperte, conſules deſumus. I
ABCDEFGHIJKLMNOPQRSTVUW

SMALL PICA ROMAN. No 1.

At nos vigeſimum jam diem patimur hebeſcere aciem ho
autoritatis. habemus enim hujuſmodi ſenatuſconſultum,
rumtamen incluſum in tabulis, tanquam gladium in vag
reconditum: quo ex ſenatuſconſulto confeſtim interfectu

patientia nostra?

Two Lines Great Primer.

Quousque tandem
abutere, Catilina,
patientia nostra ?
quamdiu nos etiam

Quousque tandem a-
butere, Catilina, pa-
tientia nostra? quam-
diu nos etiam furor

Two Lines English.

Quousque tandem abu-
tere, Catilina, patientia
nostra ? quamdiu nos e-
tiam furor iste tuus elu-

Quousque tandem abutere,
Catilina, patientia nostra?
quamdiu nos etiam furor

dam, fed ad confirmandam audaciam. Cupio, P. C.,
effe clementem : cupio in tantis reipub. periculis non
ABCDEFGHIJKLMNOPQRSTVUWXY

SMALL PICA ROMAN. No 2.

At nos vigefimum jam diem patimur hebefcere aciem ho
autoritatis. habemus enim hujufmodi fenatufconfultum,
rumtamen inclufum in tabulis, tanquam gladium in va
reconditum : quo ex fenatufconfulto confeftim interfectun
effe, Catilina, convenit. Vivis : & vivis non ad deponend
fed ad confirmandam audaciam. Cupio, P. C., me
clementem : cupio in tantis reipub. periculis non diffolu
ABCDEFGHIJKLMNOPQRSTVUWXY

LONG PRIMER ROMAN No 1.

Verum ego hoc, quod jampridem factum effe oportuit, cer
caufla nondum adducor ut faciam. tum denique interficiam te,
jam nemo tam improbus, tam perditus, tam tui fimilis invenir
terit, qui id non jure factum effe fateatur. Quamdiu quifquam
qui te defendere audeat, vives: & vives, ita ut nunc vivis, m
meis & firmis præfidiis obfeffus, ne commovere te contra rem
poffis. multorum te etiam oculi & aures non fentientem, ficut
fecerunt, fpeculabuntur, atque cuftodient. Etenim quid eft,
ABCDEFGHIJKLMNOPQRSTUVWXYZ

LONG PRIMER ROMAN. No 2.

Verum ego hoc, quod jampridem factum effe oportuit, cer
caufla nondum adducor ut faciam. tum denique interficiam te,
jam nemo tam improbus, tam perditus, tam tui fimilis invenir
rit, qui id non jure factum effe fateatur. Quamdiu quifquam
qui te defendere audeat, vives : & vives, ita ut nunc vivis, n
meis & firmis præfidiis obfeffus, ne commovere te contra ren
poffis. multorum te etiam oculi & aures non fentientem, ficut
fecerunt, fpeculabuntur, atque cuftodient. Etenim quid eft, C
ABCDEFGHIJKLMNOPQRSTVUWXY

BREVIER ROMAN.

Novemb. C. Manlium audaciæ fatellitem atque adminiftrum tuæ? num me f
Catilina, non modo res tanta, tam atrox, tam incredibilis, verum, id quod
magis eft admirandum, dies? Dixi ego idem in fenatu, cædem te optimatun
tulifle in ante diem v Kalend. Novemb. tum cum multi principes civitatis
non tam fui confervandi, quam tuorum confiliorum reprimendorum caufla
gerunt. num inficiari potes, te illo ipfo die meis præfidiis, mea diligentia c
clufum, commovere te contra rempub. non potuiffe; tu difceffu cete
noftra tamen, qui remanfiffemus, cæde contentum te effe dicebas ? Quid?
ABCDEFGHIJKLMNOPQRSTVUWXYZÆ

Nonpareil Roman.

O dii immortales ! ubi-nam gentium fumus ? quam rempub. habemus ? in qua urbe v
hic, hic funt in noftro numero, P. C., in hoc orbis terræ fanctiffimo graviffimoque confi
de meo, noftrumque omnium interitu, qui de hujus urbis, atque adeo orbis terrarum ex
gitent. hofce ego video conful, & de republica fententiam rogo : & quos ferro trucidari op
eos nondum voce vulnero. Fuifti igitur apud Leccam ea nocte, Catilina : diftribuifti pa
liæ : ftatuifti quo quemque proficifci placeret : delegifti quos Romæ relinqueres, quos
educeres : defcripfifti urbis partes ad incendia : confirmafti, te ipfum jam effe exiturun
paululum tibi effe etiam tum moræ, quod ego viverem. Reperti funt duo equites Roman
ifta cura liberarent, & fefe illa ipfa nocte paulo ante lucem me in meo, lectulo inter
pollicerentur. Hæc ego omnia, vix dum etiam coetu veftro dimiffo, comperi : domur
ABCDEFGHIKLMNOPQRSTVUWXYZÆ

Pearl Roman.	Pearl Italick.
O dii immortales ! ubi-nam gentium fumus ? quam rempub. habemus ? in qua urbe vivimus ? hic, hic funt in noftro numero, P. C., in hoc orbis terræ fanctiffimo graviffimoque confilio, qui de meo, noftrumque omnium interitu, qui de hujus urbis, atque adeo orbis terrarum exitio cogitent. hofce ego video conful, & de republica fententiam rogo : & quos ferro trucidari oportebat, eos nondum voce vulnero. Fu-	*O dii immortales ! ubi-nam gentium fumus ? in qua urbe vivimus ? funt in noftro numero, P. C., in hoc orbis terræ fanctiffimo graviffimoque confilio, qui de meo, que omnium interitu, qui de hujus urbis, & urbis terrarum exitio cogitent. hofce ego vid & de republica fententiam rogo : & quos cidari oportebat, eos nondum voce vulnere*

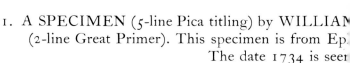

1. A SPECIMEN (5-line Pica titling) by WILLIAM
(2-line Great Primer). This specimen is from Ep
The date 1734 is seer

نأتي انا الرب الاهك الاه غيور ∗ اجتزي ذنوب الاباء من

Small Pica Italick. No 2.

At nos vigesimum jam diem patimur hebescere aciem horum au-
toritatis. habemus enim hujusmodi senatusconsultum, verumtamen
inclusum in tabulis, tanquam gladium in vagina reconditum:
quo ex senatusconsulto confestim interfectum te esse, Catilina, con-
venit. Vivis: & vivis non ad deponendam, sed ad confirman-
dam audaciam. Cupio, P. C., me esse clementem: cupio in tantis
reipub. periculis non dissolutum videri: sed jam meipsum inertiæ
ABCDEFGHIJKLMNOPQRSTVUW XYZ

Long Primer Italick. No 1.

Verum ego hoc, quod jampridem factum esse oportuit, certa de caussa
nondum adducor ut faciam. tum denique interficiam te, cum jam nemo
tam improbus, tam perditus, tam tui similis inveniri poterit, qui id
non jure factum esse fateatur. Quamdiu quisquam erit qui te defen-
dere audeat, vives: & vives, ita ut nunc vivis, multis meis &
firmis præsidiis obsessus, ne commovere te contra rempub. possis. multo-
rum te etiam oculi & aures non sentientem, sicut adhuc fecerunt, spe-
culabuntur, atque custodient. Etenim quid est, Catilina, quod jam
ABCDEFGHIJKLMNOPQRSTVUW XYZÆ

Long Primer Italick. No 2.

Verum ego hoc, quod jampridem factum esse oportuit, certa de caussa
nondum adducor ut faciam. tum denique interficiam te, cum jam nemo
tam improbus, tam perditus, tam tui similis inveniri poterit, qui id
non jure factum esse fateatur. Quamdiu quisquam erit qui te defendere
audeat, vives: & vives, ita ut nunc vivis, multis meis & firmis
præsidiis obsessus, ne commovere te contra rempub. possis. multorum te
etiam oculi & aures non sentientem, sicut adhuc fecerunt, speculabuntur,
atque custodient. Etenim quid est, Catilina, quod jam amplius exspectes,
ABCDEFGHIJKLMNOPQRSTVUW XYZ Æ

Brevier Italick.

Novemb. C. Manlium audaciæ satellitem atque administrum tuæ? num me fefellit,
Catilina, non modo res tanta, tam atrox, tam incredibilis, verum, id quod multo magis
est admirandum, dies? Dixi ego idem in senatu, cædem te optimatum contulisse in ante
diem v Kalend. Novemb. tum cum multi principes civitatis Rom. non tam sui conser-
vandi, quam tuorum consiliorum reprimendorum caussa profugerunt. num inficiari potes,
te illo ipso die meis præsidiis, mea diligentia circumclusum, commovere te contra rempub.
non potuisse; cum tu discessu ceterorum, nostra tamen, qui remansissemus, cæde contentum
te esse dicebas? Quid? cum te Præneste Kalend. ipsis Novembris occupaturum nocturno
ABCDEFGHIJKLMNOPQRSTVUW XYZÆ

Nonpareil Italick.

O dii immortales! ubi-nam gentium sumus? quam rempub. habemus? in qua urbe vivimus? hic, hic
sunt in nostro numero, P. C., in hoc orbis terræ sanctissimo gravissimoque consilio, qui de nostrum
omnium interitu, qui de hujus urbis, atque adeo orbis terrarum exitio cogitent. hosce ego video consul, et de
republica sententiam rogo: et, quos ferro trucidari oportebat, eos nondum voce vulnero. Fuisti igitur apud
Leccam ea nocte, Catilina: distribuisti partes Italiæ: statuisti quo quemque proficisci placeret: delegisti quos
Romæ relinqueres, quos tecum educeres: descripsisti urbis partes ad incendia: confirmasti, te ipsum jam esse
exiturum: dixisti, paululum tibi esse etiam tum moræ, quod ego viverem. Reperti sunt duo equites Ro-
mani, qui te ista cura liberarent, et se ista ipsa nocte paulo ante lucem me in meo lectulo interfecturos
pollicerentur. Hæc ego omnia, vix dum etiam cætu vestro dimisso, comperi: domum meam majoribus præ-
sidiis munivi, atque firmavi: exclusi eos, quos tu mane ad me salutatum miseras, cum illi ipsi venissent,
ABCDEFGHIJKLMNOPQRSTVUW XYZ

Long Primer Saxon.

Ða he ða mið ᵹrimmum �⁊ tint
neᵹum pæceð pær ꝼ he ealle þa
pitu ðe him man oð̵ðe ᵹeþyldelice
ꝼ ᵹeꝼeonde þon ðhitne abæn aꞃ

Pica Saxon.

Ða he ða mið ᵹrimmum
ꝼꞃinᵹlum ꝼ tintneᵹum pæ
ceð pær ꝼ he ealle þa pitu

Hebrew with Points.

בְּרֵאשִׁית בָּרָא אֱלֹהִים אֵת הַשָּׁמַיִם וְאֵת הָאָרֶץ : וְהָאָרֶץ
הָיְתָה תֹהוּ וָבֹהוּ וְחֹשֶׁךְ עַל־פְּנֵי תְהוֹם וְרוּחַ אֱלֹהִים
מְרַחֶפֶת עַל־פְּנֵי הַמָּיִם : וַיֹּאמֶר אֱלֹהִים יְהִי אוֹר וַיְהִי־אוֹר :
וַיַּרְא אֱלֹהִים אֶת־הָאוֹר כִּי־טוֹב וַיַּבְדֵּל אֱלֹהִים בֵּין הָאוֹר
וּבֵין הַחֹשֶׁךְ : וַיִּקְרָא אֱלֹהִים לָאוֹר יוֹם וְלַחֹשֶׁךְ קָרָא לָיְלָה

Hebrew without Points.

בראשית ברא אלהים את השמים ואת הארץ : והארץ
היתה תהו ובהו וחשך על־פני תהום ורוח אלהים
מרחפת על־פני המים : ויאמר אלהים יהי אור ויהי־אור :
וירא אלהים את־האור כי־טוב ויבדל אלהים בין האור
ובין החשך : ויקרא אלהים לאור יום ולחשך קרא לילה

Brevier Hebrew.

בראשית ברא אלהים את השמים ואת הארץ : והארץ היתה תהו
ובהו וחשך על־פני תהום ורוח אלהים מרחפת על־פני המים :
ויאמר אלהים יהי אור ויהי־אור : וירא אלהים את־האור כי־טוב
ויבדל אלהים בין האור ובין החשך : ויקרא אלהים לאור יום ולחשך

English Greek.

Πρόδικος ὁ σοφὸς ἐν τῷ συγγράμματι τῷ περὶ τῶ Ἡρακ-
λέως (ὅπερ δὴ κ πλείςοις ἐπιδείκνυίαι) ὕτως περὶ τῆς
ἀρετῆς ἀποφαίνεἰαι, ὧρέ πως λέγων, ὅσα ἐγὼ μέμνημαι,
φησὶ μὲν Ἡρακλέα, ἐπεὶ ἐκ παίδων εἰς ἥβην ὡρμᾶτο,
(ἐ ἣ οἱ νέοι ἤδη αὐλοκράτορες γιλνόμενοι δηλῶσιν, εἴτε τὴν

Pica Greek.

Πρόδικος ὁ σοφὸς ἐν τῷ συγγράμματι τῷ περὶ τῶ Ἡρακλέως
(ὅπερ δὴ κ πλείςοις ἐπιδείκνυίαι) ὕτως περὶ τῆς ἀρετῆς ἀπο-
φαίνεἰαι, ὧδέ πως λέγων, ὅσα ἐγὼ μέμνημαι· φησὶ μὲν
Ἡρακλέα, ἐπεὶ ἐκ παίδων εἰς ἥβην ὡρμᾶτο, (ἐν ἣ οἱ νέοι ἤδη
αὐλοκράτορες γιλνόμενοι δηλῶσιν, εἴτε τὴν δί ἀρετῆς ὁδὸν τρέψοίαι

Long Primer Greek.

ΠρόδικͰ ὁ σοφὸς ἐν τῷ συγγράμματι τῷ περὶ τῶ Ἡρακλέως (ὅπερ δὴ κ
πλείςοις ἐπιδείκνυίαι) ὕτως περὶ τῆς ἀρετῆς ἀποφαίνεἰαι, ὧδέ πως λέγων, ὅσα
ἐγὼ μέμνημαι· φησὶ μὲν Ἡρακλέα, ἐπεὶ ἐκ παίδων εἰς ἥβην ὡρμᾶτο, (ἐ
ἣ οἱ νέοι ἤδη αὐλοκράτορες γιλνόμενοι δηλῶσιν, εἴτε τὴν δί ἀρετῆς ὁδὸν τρέψοίαι

Brevier Greek.

ΠρόδικͰ ὁ σοφὸς ἐν τῷ συγγράμματι τῷ περὶ τῶ Ἡρακλέως (ὅπερ δὴ κ πλείςοις ἐ-
πιδείκνυίαι) ὕτως περὶ τῆς ἀρετῆς ἀποφαίνεἰαι, ὧδέ πως λέγων, ὅσα ἐγὼ μέμνημαι·
γιλνί μὲν Ἡρακλέα, ἐπεὶ ἐκ παίδων εἰς ἥβην ὡρμᾶτο, (ἐν ἣ οἱ νέοι ἤδη αὐλοκράτορες
σόνμενον δηλῶσιν, εἴτε τὴν δί ἀρετῆς ὁδὸν τρέψοίαι ἐπὶ τὸν βίον, εἴτε τὴν διὰ 1734.

ASLON, Letter-Founder in Chiswell Street, London.

n Chambers, Cyclopaedia, 5th edition (1741-43).

the foot of column 4.

IMEN

nder, in Chiſwell-Street, LONDON.

Double Pica Italick.

Quouſque tandem abutere, Catili-
a, patientia noſtra ? quamdiu
os etiam furor iſte tuus eludet ?
uem ad finem ſeſe effrenata jac-
ABCDEFGHJIKLMNO

Great Primer Italick.

Quouſque tandem abutére, Catilina, pa-
ientia noſtra ? quamdiu nos etiam fu-
or iſte tuus eludet ? quem ad finem ſeſe
frenata jactabit audacia ? nihilne te
octurnum præſidium palatii, nihil ur-
is vigiliæ, nihil timor populi, nihil con-
ABCDEFGHIJKLMNOPQR

Engliſh Italick.

youſque tandem abutere, Catilina, patientia noſ-
a ? quamdiu nos etiam furor iſte tuus eludet ?
uem ad finem ſeſe effrenata jactabit audacia ?
ihilne te nocturnum præſidium palatii, nihil ur-
s vigiliæ, nihil timor populi, nihil conſenſus bo-
orum omnium, nihil hic munitiſſimus habendi ſe-
ABCDEFGHIJKLMNOPQRSTVU

Pica Italick.

ſelium, novis rebus ſtudentem, manu ſua occidit.
uit, ſuit iſta quondam in hac repub. virtus, ut viri
rtes acrioribus ſuppliciis civem pernicioſum, quam a-
rbiſſimum hoſtem coërcerent. Habemus enim ſenatuſ-
nſultum in te, Catilina, vehemens, & grave: non deeſt
ip. conſilium, neque autoritas hujus ordinis: nos, nos,
ico aperte, conſules deſumus. Decrevit quondam ſenatus
ABCDEFGHIJKLMNOPQRSTVUWXYZ

Small Pica Italick. No 1.

t nos vigeſimum jam diem patimur hebeſcere aciem horum
utoritatis. habemus enim hujuſmodi ſenatuſconſultum, verum-
men incluſum in tabulis, tanquam gladium in vagina recon-
tum: quo ex ſenatuſconſulto confeſtim interfectum te eſſe, Ca-

Pica Black.

And be it further enacted by the Authority
afoꝛeſaid, That all and every of the ſaid Ex-
chequer Bills to be made foꝛth by virtue of
this Act, oꝛ ſo many of them as ſhall from
ABCDEFGHJIKLMNOPQRST

Brevier Black.

And be it further enacted by the Authority afoꝛeſaid, That all and every
of the ſaid Exchequer Bills to be made foꝛth by virtue of this Act, oꝛ ſo
many of them as ſhall from time to time remain undiſcharged and uncan-
celled, until the diſcharging and cancelling the ſame purſuant to this Act,

Pica Gothick.

ΛΤΤΛ ΠΝSΛΚ ΦΠ ΪΝ ҺΙΜΙΝΛΜ ΥΕΙҺΝΛΙ
ΝΛΜꝹ ΨΕΙΝ ЦΙΜΛΙ ΨΙΠΔΙΝΛSSΠS ΦΕΙΝS
ΥΛΙΚΨΛΙ ΥΙΛGΛ ΦΕΙΝS SΥΕ ΪΝ ҺΙΜΙΝΛ

Pica Coptick.

Ϧⲉⲛ ⲟⲩⲁⲣⲭⲏ ⲁ̅ϥⲧ̅ ⲑⲁⲙⲓⲟ̅ ⲛ̅ⲧⲫⲉ ⲛⲉⲙ ⲡⲕ-
ⲁ̅ϩⲓ̈· ⲡⲓⲕⲁϩⲓ ⲇⲉ ⲛⲉ ⲟⲩⲁⲑⲛⲁⲩ ⲉⲣⲟϥ ⲡⲉ ⲟⲩⲟϩ
ⲛ̅ⲁⲧⲥⲟⲃ†ⲟⲩⲭⲁⲕⲓ ⲛⲁϥⲭⲏ ⲉⲝⲉⲛ ⲫⲛⲟⲩⲛ ⲟⲩⲟϩ
ⲟⲩⲡ̅ⲛ︦ⲁ̅ ⲛ̅ⲧⲉϥ†ⲛⲁϥⲛⲏⲟⲩ ϩⲓⲝⲉⲛ ⲛⲓⲙⲱⲟⲩ ꝥ ⲟ-

Pica Armenian.

Ապշակ Թագաւոր' երկիր և ծովու, որոյ առԶ
և պատուեր' որպէս և է իսկ մեր Աստուծոյ
իսկ բանս' և պատուՀանՃ 'ի վեր բան qիմ
Թագաւորաց. և ձմայ լայխումԹ, որպէս երկին

Engliſh Syriack.

ܐܝܬܝ ܐܪܥܐ ܐܣܦ ܐܟܘܐ ܐܡܝܕܐ ܐܡܫܟܐ
ܐܒܚܙܐ ܣܝܒܐ ܢܐܘܐ ܢܐܘ ܐܝ ܘܡܚܣܡܕܐ
ܠܐ ܐܠ ܣܐܚܡ ܐܠ ܟܐܘܐ ܐܪܐ ܣܐ ܢܚܫܚܐ

Pica Samaritan.

ⵣⵏⵣⵣⵣⵉ ⵀⵣⵉⵏ ⵣⵣⵣ ⵎⵕⵣⵕⵉ ⵣⵏⵣⵣⵣⵣⵣ ⵣⵏⵣⵕ
ⵣⵣⵣⵣ ⵀⵉⵕⵉ ⵣⵉⵣ ⵣⵣⵣⵣⵣ ⵉ ⵉⵏⵣ ⵣⵣⵉⵕⵉ ⵀⵎⵣⵉ
ⵣⵣ ⵉⵕ ⵣⵣⵎⵉ ⵀⵉⵏⵣⵉ ⵉⵣⵎ ⵏⵎ

Engliſh Arabick.

لا يلي لك الاّ آخر غيري ۞ ولا تاخذلك صورة ۞ ولا تمثيل كلّ ما
يِّ السّماء من فوق ۞ وما يِّ الارض من اسفل ۞ ولا ما يِّ

with the same xylograph as that used in Baskerville's Bible of 1772. The Bible is illustrated with plates from the old masters, engraved by Hancock from drawings by Moses Haughton. The date of publication, 1788, corrects the date 1780 given by Joseph Hill, *The Bookmakers of Old Birmingham*. It will be noted that the attempt to use a xylograph designed for a large folio page on a smaller title page and to proportion the other lettering accordingly has resulted in tight spacing both in depth and width of page. The bowl of the lower-case roman 'a,' containing a curve of contra-flexure, is obviously designed in breach of its calligraphic origin.

CASLON TYPE IN THE NINETEENTH CENTURY

Charles Whittingham (1767–1840) and his nephew Charles Whittingham (1795–1876) were the principal revivers of Caslon Old Face. The elder Whittingham had been assisted financially by the Caslon firm on his commencing business. A publisher who respected the aims and standards of the Whittinghams was William Pickering (1796–1854), and he established a long and intimate connection with the younger Whittingham which proved fruitful in the quality of the productions issuing from their respective houses.

PLATE 64(a)

THE NEW TESTAMENT IN GREEK

William Pickering was responsible for a series of miniature volumes called the *Diamond Classics* in 48mo or 32mo. To these he added a *Greek Testament*, an extraordinary little book of which the text closely follows that of the first Elzevir edition of 1624, and of which each sheet was revised eight times. The Caslon firm, then trading as Caslon, Son, and Livermore, cut the punches and cast the type, C. Corrall being the printer.

Although later than the time of William Caslon I and II a specimen page is shown as a curious example of the punch-cutter's skill and the printing art.

Pickering. Londini. 1826. 48 mo. Typis Corrall.

1.75 x 3

Chart II.

Genealogical chart of the Principal English Type-Founders

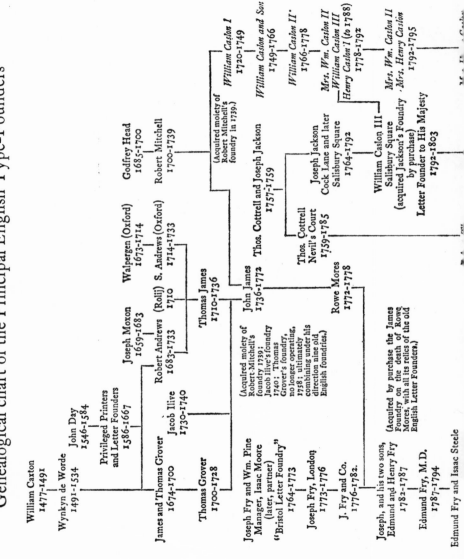

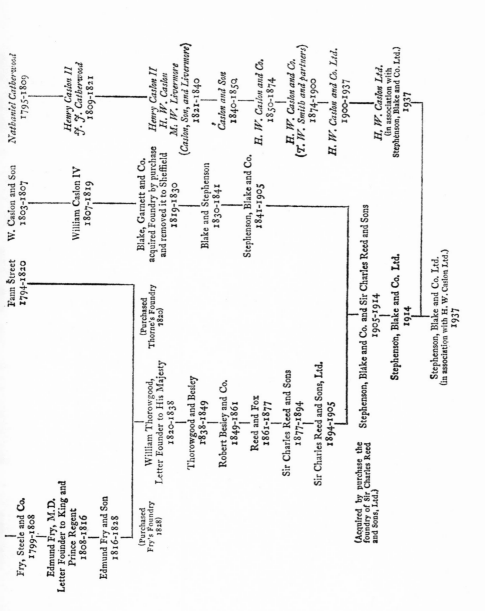

In 1844, Pickering and Whittingham proposed to issue an edition of *Juvenal* and requested the Caslon foundry, then trading as Caslon and Son, Livermore having withdrawn, to cast some of the original Caslon types which they wanted for it. This Latin edition of the *Satires of Juvenal and Persius*, in quarto, was delayed, however, and not published until 1845. So the great primer 'old face' Caslon type intended for it appeared first in 1844 in *The Diary of Lady Willoughby*. Old style type was thought appropriate for this fictitious journal of a seventeenth century lady of quality, and the *Diary* proved a success, both artistically and commercially. This was the beginning of the popular revival of Caslon founts, and ever since Caslon type has had the popularity it merits, and indeed, Updike describes this revival of the earliest Caslon types as the chief typographic event of the mid-nineteenth century.

PLATE 64(b)

THE DIARY OF LADY WILLOUGHBY

Specimen page of Caslon type (revived by Whittingham in 1844) taken from p. 17 of the edition published in smaller *format* by the Chiswick Press in 1873 for Longmans, Green, Reader, and Dyer, Paternoster Row, London.

4.9 x 7.1

Chapter Nineteen

LINKS BETWEEN BASKERVILLE, SHENSTONE, ROWE MORES, AND CASLON

THE BOOK *A Dissertation upon English Typographical Founders and Founderies*, by Edward Rowe Mores, 1778, is a singular work by a most singular man, but it must be regarded as an essential reference for the letter-founder historians, for had Rowe Mores not produced his work at this particular time in the eighteenth century, later historians would have been faced with an almost insuperable task. However dubiously we may regard Rowe Mores as a person, he has left a body of fact and opinion which renders the task of his successors less difficult, though some of his statements have been shown to need qualification and re-assessment.

Before 1957 the *Dissertation* was a work of great rarity, but in that year it was edited with an introduction and notes by Harry Carter and Christopher Ricks for the Oxford Bibliographical Society.[1] A very full introduction devotes forty-five pages to the author of the *Dissertation* and those interested should refer to the work of his editors.

There are, however, some references to connections of William Caslon which point more directly to the beginning of Mores' interest in letter-founding. Quoting from Carter and Ricks,[2] 'In 1751 Mores is said to have employed an artist, James Green, to make drawings in water-colour of partly ruined medi-aeval buildings of Queen's College; though the buildings had in fact been demolished many years before, Green's drawings were

389

until lately preserved in the college. The Bodleian has copper-plates engraved by James Mynde evidently made from them. One of these, which has a legend describing Mores as patron of the artist's work, is reproduced facing p. xlvi of this book. So far as is known, prints from the plates were never published. Mores also commissioned from Green twenty-eight drawings, now in the Bodleian, of old buildings in Oxford.'

James Green (1729–59) was the son of William and Sarah Green of Halesowen, and served an apprenticeship to Isaac Basire the map engraver. Green's father was usher of the local free school and also carried on the business of a maltster. His mother kept the local coaching inn. Moreover, she was herself an artist and was first cousin to William Caslon.[3] The master of the Halesowen free school was the Rev. Benjamin Lea whose son William Arch Lea (1732–1802) matriculated in 1750 at All Souls' and graduated B.A. in 1754, becoming a chaplain in the Royal Navy and later curate of Frankley and St. Kenelm's chapels near Halesowen.

In all the circumstances it seems probable that James Green went to Oxford with William Arch Lea and established himself there as a line engraver, but he must have been introduced to Rowe Mores as soon as he had finished his apprenticeship.[4] An allegorical plate for the library of All Souls' College, designed by Samuel Wale and engraved by James Green is described as a very pleasing bit of line engraving and fine cross-hatched work.[5] As recorded in Chapter 8, Green engraved the Oxford Almanacks from 1752 to 1759 and was appointed official engraver to the University in 1756 and to the Society of Antiquaries in 1757, through the influence of Charles Lyttelton (1714–68), later to become Bishop of Carlisle and president of the Antiquarian Society. Green's death in 1759 before his thirtieth birthday was a distinct loss to English art.

It was Rowe Mores' antiquarian work which brought him into touch with Lyttelton, who wrote to Ballard on 5 February, 1752,[6] with reference to a proposal to publish the Bodleian manu-script of *Caedmon*[7] with engravings, that *Caedmon* 'will, I make no doubt, fully answer the charge of Engraving, and be the noblest Specimen of Saxon antiquity. I would not have all the Drawings engraved but those only which illustrate the Work and point out

the mode of Building, Habits etc., of that age. Mr. Green will be a very proper Person to do the Work.'

In a footnote here Carter and Ricks confuse James Green with his youngest brother. Their reference 'Green was recommended to Mores by Lyttelton, 13 Jan. 1749–50: "He will work for very little Money" (Bodl. M.S. Ballard 42, fol. 112)' obviously refers to James Green. Benjamin Green (1739–98) whom they say drew and engraved for Mores, was only ten years of age in 1749. He learned his art under his brothers James and Amos (1734–1807) and certainly engraved for Mores after James's death and engraved the Oxford Almanacks for 1760–61–62 and 66. In 1762 Benjamin Green began his long association, lasting thirty-six years, with Christ's Hospital, London, succeeding Thomas Bisse as Drawing Master in 1766. Charles Green, the eldest brother of the artists, had been appointed Assistant Clerk and Wardrobe Keeper at the Hospital in 1758. It seems probable that Benjamin Green's later appointment and his freelance work saved him from becoming too dependent on Mores' stinginess.

Returning to the *Caedmon*, the complete scheme was not carried out because of the waning interest of the Society of Antiquaries, but James Green carried out the engraving, fifteen plates being issued in 1754, as *Figurae Quaedam Antiquae ex Caedmonis Monachi Paraphraseos*; and Mores stressed his own part by having in large print a phrase on the title-page: *Mores Ritus atque Aedificia*.[8]

A reproduction of a specimen of Green's engraving of *Caedmon* can be seen in *The Origin and Progress of Writing*, Thomas Astle, 1784,[9] brief reference to which is made on p. 110 of that work.

The circumstances of the Green brothers coming to notice point strongly to the Lyttelton influence. The coaching inn at which 'mine host' was the father of the artists and for whom his able wife deputised while he performed his slender duties at the free school was the Lyttelton Arms, of which William and Sarah Green were the lessees under the Lord of the Manor, Lord Lyttelton. The Greens named their eldest son Charles, born 1719, presumably after Charles Lyttelton, born 1714, the future antiquary, the third son of Sir Thomas Lyttelton. The work which

first brought James Green to notice was an engraving of the south-east view of Halesowen Church, published in 1746 when he was but seventeen years of age and dedicated to Sir Thomas Lyttelton, the patron thereof.[10] No doubt Sir Thomas Lyttelton called at the inn occasionally and there would be opportunity for Sarah Green, herself an artist, to exhibit her son's work and crave a favour. Charles Lyttelton doubtless called more frequently in the course of his historical work, either alone or in company with one of his antiquarian friends, and he not only commissioned James Green to make drawings for him, but recommended him to others, notably to William Borlase, for whom Green engraved the plates for the *History and Antiquities of Cornwall*, 1754.

Charles Lyttelton and Rowe Mores, as fellow-members of the Society of Antiquaries, must have been well aware of the relationship between the Green brothers and Caslon, and Lyttelton was on friendly terms with Caslon some years before James Green began his engraving work at Oxford. Lyttelton wrote to Joseph Ames, 25 April, 1744, 'Some unforeseen business prevents Dr. [Richard] Pococke and myself dining with Mr. Caslon tomorrow. I give you this notice that you may defer your visit till some day next week, when we will endeavour to meet there.'[11]

Carter and Ricks tell again the story of Mores' dilatory handling of the matter of Elizabeth Elstob's Saxon puncheons and matrices which William Bowyer II presented to Oxford.[12] Although it emphasises principally Mores' eccentric and procrastinating ways there is also evidence of interest in punches, matrices and printing dragging on for about fourteen years from 1753. But it was not until after the death of John James, the last of the old race of letter-founders, in June, 1772, that his interest in type became more obsessive. Mores' acquisition of the stock of the foundry from Mrs James took place sometime before the date announced for the auction, 20 December, 1773. From this collection, and from James's manuscripts, Mores' composed his *Dissertation on English Typographical Founders and Founderies*, of which John Nichols published eighty copies in 1779, after Mores' death.

Rowe Mores, therefore, had barely five years in which to prepare the materials for his principal work, before his death at his house at Low Leyton on 28 November, 1778, little

enough time for a scholar and antiquarian, albeit only an amateur, to classify and arrange the immense collection of punches and matrices which had come into his hands, material which has always been especially difficult of accurate scrutiny and judgment to anyone not brought up in the trade. That Mores did his work so well is one reason why the *Dissertation* has been regarded as indispensable to all later letter-founder historians. Perhaps in some respects his conclusions and statements have been accepted too unquestioningly, for as late as July, 1777, he was writing to Bowyer questioning the origin of the names of type-bodies and asking for book-references for other information.

Carter and Ricks[13] put the question of Mores' qualifications in a nutshell: 'As an historian of this matter Mores had severe handicaps. He was at the end of his life, given to some sort of dissipation, incurably dilettante and unequal to the effort of studying in libraries. Even in the great libraries and record offices the books that would have helped him were few and the documents not calendared: with better facilities we can see that he misleads us here and there. He had slight acquaintance with the techniques of typefounding and was not the man to overcome the shyness or suspicions of their practitioners, so that he could not interpret the evidence of the printed pages or of the punches and matrices at his disposal to the full. Unlike Moxon or Talbot Baines Reed, he cannot describe the arts and crafts that produced the types either as they were in his day or in retrospect. He was nothing of an art critic: he passes scant judgment on the quality of the types and gives no hint that he was drawn to them by the beauties of their design or execution or wished to guide his readers to these things. In some places, spite, snobbery, and prejudice make him deliberately perverse.'

One instance where Mores and later writers have misled their readers is of particular interest in reminding us that Caslon early in life made tools for workers in precious metals. 'At the beginning,' Mores says, 'Printing . . . included every article of the printed book from the punch to the binding, that the inventors of this art so considered it and exercised it is beyond dispute: the conjecture then may be favoured that their immediate successors followed their example.'[14] On this point Carter and Ricks say,

'This is still the common view. Modern writers are apt to imagine, as he did, that printers of the fifteenth and early sixteenth centuries cut their own punches, struck and justified the matrices, and had journeymen who cast the types. Recent researches in the great centres of printing have brought to light facts, even from very early times, pointing more often and with more certainty to punch-cutting and matrix-making by workers in precious metals than by printers and to casting by specialist workmen whom printers only rarely needed to employ casually. The printers who cut punches, Nicholas Jensen, Henric de Lettersnider of Rotterdam, Jean Brito of Bruges, were the exception not the rule. From Hans Dünne, the gold-smith who earned a hundred gulden from Gutenberg in three years "wholly on account of printing," onwards there were engravers who furnished the printers. Jost Bernhart, sealcutter, made letters for Bernhard Richel of Basle; Hans von Unkel, goldsmith of Strasbourg, offers to justify matrices for Johann Amerbach in 1493; in Italy the goldsmiths' mint at Florence makes matrices for the monastery at Ripoli and the goldsmith Francesco da Bologna cuts punches for Aldus, for Gershom Soncino, and for the Giunte. On the other hand, there were thirteen *fondeurs de lettres* at Lyons between 1498 and 1550. In 1582 we hear of a *maitre fondeur* there.'

It is at least an interesting parallel that Caslon in the early part of his career made tools for silversmiths and that he and his son were on intimate terms with the family of William Cartlich, goldsmith and master-melter of the Royal Mint, although it must be confessed that we have as yet no certain knowledge of any previous business relationship which might account for William Caslon II meeting his future wife Elizabeth Cartlich. There are perhaps insufficient grounds for concluding that once Caslon was launched on his letter-founding career, he abandoned entirely the manufacture of punches, chasers, etc., for workers in precious metals. After all, the eighteenth century was not an age of specialisation and Caslon did not immediately realise his destiny.

Carter and Ricks[15] continue 'The more interesting part of typefounding history is the creative part, the making of new designs and their rendering in metal. In early days these were generally the province of the independent punch-cutter. Typefoundries

attained to their full glory when they took charge of this branch of the work, employing the punch-cutters and providing the designs. This stage was reached in the lifetime of Mores : Caslon, Baskerville, Cottrell, Jackson, and Fry were designers and either were punch-cutters or employed them.'

Of these, Cottrell and Jackson can scarcely be reckoned apart from Caslon. Fry only just comes within the life-time of Mores, while Baskerville is scarcely admitted by Mores to be a letter-cutter at all. 'Mr. Baskerville . . . made some attempts at letter-cutting, but desisted, with good reason. The Greek cut by him or his for the University of Oxford is execrable. Indeed, he can hardly claim a place amongst letter-cutters. His typographical excellence lay more in trim, glossy paper to dim the sight.'[16]

It must have been a mortifying experience, therefore, for Rowe Mores to be rebuffed by William Caslon II when he sought a closer acquaintance with the foundry than was afforded by the firm's 1766 specimen, and he re-acted in characteristic fashion.

'Of the present Founders the senior is Mr. Will. Caslon, the son of the late Mr. Caslon. "This new foundery was begun in the y. 1720. and finished, 1763." so we are told in a note at the end of their specimen published in 1764. although the same note tells us that though it was finished yet it was not finished, "but would (with God's leave) be carried on, etc."—*Amen.*'

'In the specimen of their characters, excellent as we have said before, is nothing censurable but the silly notion and silly fondness of multiplying *bodies* : as if the intrinsic of a foundery consisted in the numerosity of the heads !—we reduce the specimen to method, and hope that the arrangement (of the languages at least) will be pursued in the next edition : . . .'

After cataloguing the contents of the Caslon foundry according to his own method, Mores adds, 'This is the best account we can give of this capital and beautiful foundery, the possessor of which refused to answer the natural questions because, forsooth, answering "would be of no advantage to us. if we wanted letter to be cast he would cast it." but this we can do ourselves.—it is to be observed (adds Mores) that the querist was ⊏— xv.'[17]

Such animadversions, however, say Reed-Johnson,[18] leave untouched the younger Caslon's reputation as an able and success-

ful typefounder, which was, indeed, so well established that during the later years of his father's life he appears to have had the sole management of the business. In saying that Rowe Mores was not the man to overcome the shyness or suspicions of typefounders, Carter and Ricks may have had in mind his experience with Caslon II, but it should also be remembered that the younger Caslon moved in the circle of artists of his own day and became a member of the Society of Arts in 1764. Although James Green was long dead and Charles Lyttelton had died in 1768, there were many others, including Caslon's cousins Amos and Benjamin Green from whom Caslon II had heard accounts of the unpleasant humours and idiosyncrasies of 'the Reverend' Rowe Mores. Probably Caslon concluded in the circumstances that a closed door was the best answer to what might have proved a difficult acquaintanceship.

In order to balance, so to speak, Rowe Mores' account of the Caslon foundry as he assessed it, it will be appropriate to insert here two later opinions, the first by T. C. Hansard,[19] and the second by Carter and Ricks : 'It is difficult,' says Hansard, 'to appreciate the obstacles which Mr. Caslon encountered at the commencement of his career. At present the theory and practice of letter-founding are not, as in his time, an "art and mystery," and efficient workmen in every branch are easily procured. He had not only to excel his competitors in his own particular branch of engraving the punches, which to him was probably the easiest part of his task, but to raise an establishment and cause his plans to be executed by ignorant and unpractised workmen. He had also to acquire for himself a knowledge of the practical and mechanical branches of the art, which require, indeed, little genius, but the most minute and painful attention to conduct successfully. The wishes and expectations of his patrons were fulfilled and exceeded by his decided superiority over his domestic rivals and Batavian competitors. The importation of foreign types ceased : his founts were, in fact, in such estimation as to be frequently, in their turn, exported to the Continent.'

Secondly, Carter and Ricks[20] add their opinion : 'John James and his father before him had succumbed to the rivalry of William Caslon. Since 1725 Caslon had given a new sense to the word

"typefounder" as it was known in England because he was able and willing to make new types when inducement offered. By making them himself or having them cut, struck, and justified on the premises under his control he was able to build up a stock united by a harmonious, if not quite uniform, design, and so he gave to our books a variety that French books had had since the time of Garamond nearly two centuries earlier. The firm of Fry, coming just within the life-time of Mores, carried uniformity farther and offered our printers a complete range of types of a common design ; but it was a design much inferior to Caslon's.'

Reverting to the source of Rowe Mores' interest in typography, whilst allowing for a bias which certain branches of his antiquarian researches would give, it seems probable that his curiosity was first aroused at Oxford when he had frequent contact with Caslon's relation, James Green. In *Aris's Gazette*,[21] February 3, 1752, the year before Mores received his M.A. degree, the following advertisement appeared :

'This day is published, Price Five Shillings—on two sheets of Imperial paper,

'A new plan of the University and City of Oxford, from an accurate Survey taken in 1750, in which is described the Ichnography of every College and Hall, Inn Yard, Garden, etc., with the number of Houses and Inhabitants, with four views, one of the Radcliff's Library, one of the Magdalen New Building, and two general views of the Town.

'To be had of G. Anderton, Engraver, at the Upper End of Temple Street, Birmingham ; J. Taylor, of Moor Street; the printer of this paper, and the men who deliver it.'

Timperley[22] mentions George Anderton, 'William Caslon had a brother, Samuel Caslon, who was his mould-maker, and afterwards lived with Mr. George Anderton, of Birmingham, in the same capacity.' Reed-Johnson,[23] too, deriving their information from Rowe Mores, say, 'George Anderton, an engraver, of Birmingham, appears to have been one of the earliest of English provincial letter-founders. He lived in Temple Street between 1740 and 1753. In 1752 he published *A New Plan of the University of Oxford*. Mores says he "attempted" letter-founding, and in the year 1753 printed a little specimen of Great Primer

397

roman and italic. No copy of this specimen appears to have survived. Samuel Caslon, brother to Caslon I, worked as a mould maker in this foundry after having left the latter on account of some dispute.'

It has been noted previously that Samuel Caslon was the typefounder's cousin, not his brother.

No copy of the new plan of the University and City of Oxford is known, but it need not be assumed, because it was to be had of G. Anderton, Engraver, that he must have produced it. Indeed, it is probable that Anderton was an engraver of gun-locks as Caslon himself had been. The workshop and premises held by Anderton were connected with some shopping which, in the *Gazette* of July 6, 1752, were advertised to be let as 'Two working Shops, lately occupied by Mr. John Grice, near the New Church. Apply to Mr. G. Anderton, Temple Street.' Grice was a gun-maker, and had removed to Bull Street.[24]

John Grice was one of a family of Birmingham gun-makers contracting for their manufacture with the Ordnance Office at the Tower of London for many years.[25] The Andertons were a family settled in Birmingham by the middle of the seventeenth century, who with the Fenthams and the Hunts, attained some prominence in the town.

It was in June, 1750, that *The Universal Magazine* published an article, *The Art of Cutting, Casting, and preparing Letters for Printing*, accompanied by a folding plate,[26] *A true and exact Representation of the Art of Casting and Preparing Letters for Printing*, which purported to represent the interior of the Caslon Letter Foundry. Four pages of text, taken largely from Moxon, gave a description of the tools needed, the manner of making gauges, punches, moulds and matrices, and the method of casting the type. Caslon's success in London would, of course, be known to the better-informed in the Halesowen community, to his relatives, to Shenstone and the Leas, as well as to those of similar inclinations, interests and abilities in Birmingham.

It was about this time that John Baskerville began to turn his attention to the subject and William Bennett, in his biography of John Baskerville,[27] conjectures that Baskerville, seeing the article in *The Universal Magazine*, and having a natural interest

in the subject of calligraphy, felt stimulated to use the profits of his japanning business to finance a letter-founding and printing enterprise. Whilst Baskerville's earlier experience as a writing master and his natural bent were without doubt the principal forces urging him towards this new enterprise, the writer believes there was another potent factor, for in 1748, Amos Green (1734–1807), of Halesowen, Caslon's relation, was apprenticed to Baskerville, and like so many other Midland artists occupied his early years in painting trays and snuff-boxes. Green early displayed a superior talent and as a friend of Shenstone, he would soon be on privileged terms with his master; moreover, Shenstone's uncle Edward Cookes had been Caslon's master and the subject of Caslon's success would be a natural topic of conversation.

Baskerville had acquired his new estate, which he called 'Easy Hill,' in 1745, and it is conjectured by William Bennett that Shenstone advised him in the layout of the grounds, but it is scarcely likely that he would do this before 1748, when Amos Green joined him.

In 1752, when Amos Green had been with Baskerville four years, the new printer wrote to his friend Robert Dodsley, to whom he had been introduced by Shenstone :[28]

'October 2nd, 1752. The press is slowly creeping to perfection . . . I have sent you an impression of 14 punches of the two-lines great primer . . . Pray put it in no one's power to let Mr. Caslon see them.'

On October 19th, 1752, Baskerville wrote to Dodsley :

'As I proposed in my last I have sent you impressions from a candle of 20 two-lines Great Primer Italick.'[29]

As an act of justice let it be noted that the name of Baskerville's punchcutter was John Handy.

It seems a curious fact deserving of emphasis that both George Anderton and John Baskerville were engaged at Birmingham in 1752 in attempts to emulate Caslon. George Anderton had in his employment and living with him Samuel Caslon, who had left his cousin in London on account of a quarrel concerning pay. Baskerville's apprentice Amos Green was Caslon's relation, an ingenuous youth who might easily be persuaded to give away any information he might possess regarding the Caslon establishment ; moreover, he

visited his brother James periodically in Oxford, in which city his own artistic abilities were held in rising esteem.[30] Precisely at this time, James Green was executing engravings for Edward Rowe Mores who, as we have seen, later became obsessed with producing a work concerning letter-founding history. James Green had served his apprenticeship to a well-known map engraver Isaac Basire, and shortly after completing his term and starting in business in Oxford, a new map of the University and City of Oxford was offered for sale in Birmingham. It seems highly probable, therefore, that the new map was engraved by James Green.

Amos Green was not without useful connections. Samuel Derrick in a letter[31] written to the Earl of Cork, July 15, 1760, says, 'Baskerville is a great cherisher of genius . . . One of his workmen has manifested fine talents for fruit painting in several pieces which he showed me.' This certainly refers to Amos Green, though by 1760 he had left Baskerville's service and had set up in the iron-trade with one of his brothers. That Shenstone wished to patronise him is shown in one of his letters[32] to the Rev. Richard Graves, dated about 1757, ' . . . The person, then, who, I *suppose*, will be the bearer of this letter has, by dint of mere ingenuity, risen to a considerable eminence in fruit pieces, etc. He has been employed by Lord Lyttelton, and is much admired at Oxford.' Amos Green, however, showed no desire to be patronised by Shenstone ; at any rate, he did not go to Bath on his recommendation nor, despite Shenstone's urging, did he partner Edward Alcock, a Birmingham painter, in any professional painting venture, but continued as an amateur.

As a youth in Baskerville's establishment Amos Green had been accepted as a friend of the family, so much so that he was a witness, along with John Eaves, Baskerville's adopted son and intended successor, at the marriage of Mary Eaves to her cousin Edward Ruston on 7 May, 1758.[33] This friendship brought him into contact with Matthew Boulton (1728–1809), destined later to become master of the Soho Works, partner with James Watt in the development of the steam engine and one of the chief architects of the industrial revolution, for it was from Edward Ruston and John Eaves that Boulton leased his earlier mill called Sarehole. A friendship was thus promoted between Matthew Boulton

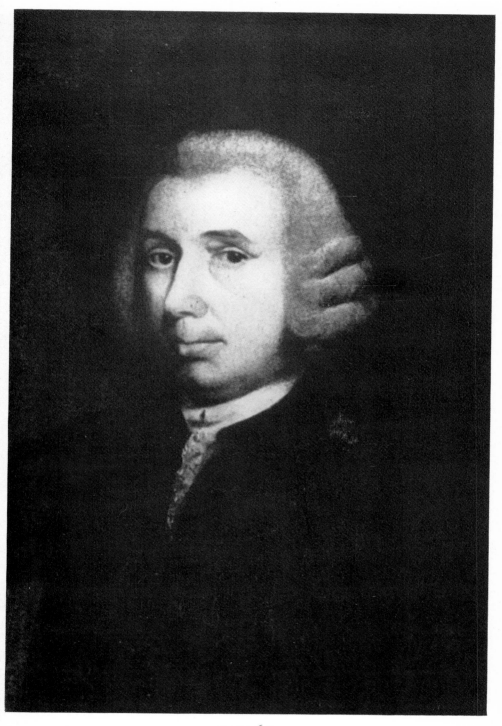

PLATE 65

William Caslon II (1720–1778)
Reproduced from 'Two Centuries of Typefounding,' J. F. McRae, 1920.
The original portrait was destroyed in World War II

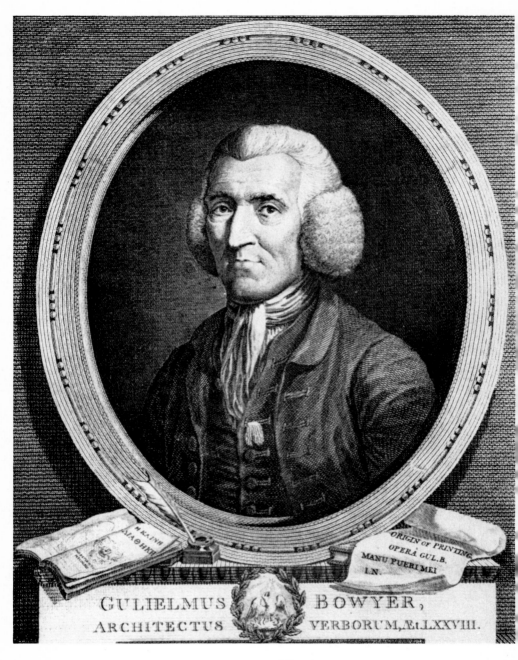

GULIELMUS BOWYER,
ARCHITECTUS VERBORUM, Æt. LXXVIII.

PLATE 66

William Bowyer the younger (1699–1777), 'Architectus Verborum.'
From the engraving in 'Biographical Anecdotes of William Bowyer,' J. Nichols, 1782

A S P E C

By W. CASLON, Letter-Founder

ABCD
ABCDE
ABCDEF
ABCDEFG
ABCDEFGHI
ABCDEFGHIJK
ABCDEFGHIJKL
ABCDEFGHIKLMN
ABCDEFGHIKLMNO

French Cannon.

Quoufque tan-

Quoufque tandem

Two Lines Double Pica.

Quoufque tand

Quoufque tandem

W. Caflon *Junier Sculp.*

DOUBLE PICA ROMAN.

Quoufque tandem abutêre, Cati
lina, patientia noftra? quamdiu
nos etiam furor ifte tuus eludet
ABCDEFGHIJKLMNOP

PARAGON ROMAN.

Quoufque tandem abutêre, Catilina
patientia noftra? quamdiu nos etiam
furor ifte tuus eludet? quem ad finem
ABCDEFGHIJKLMNOPQR

W. Caflon *Junior Sculp.*

GREAT PRIMER ROMAN.

Quoufque tandem abutêre, Catilina, pa
tientia noftra? quamdiu nos etiam furo
ifte tuus eludet? quem ad finem fefe ef
frenata jactabit audacia? nihilne te noc
ABCDEFGHIJKLMNOPQRSTV

ENGLISH ROMAN.

Quoufque tandem abutêre, Catilina, patienti
noftra? quamdiu nos etiam furor ifte tuus eludet
quem ad finem fefe effrenata jactabit audacia
nihilne te nocturnum præfidium palatii, nihil ur
bis vigiliæ, nihil timor populi, nihil confenfus bo
norum omnium, nihil hic munitiffimus habend
ABCDEFGHIJKLMNOPQRSTVUW

PICA ROMAN. No 1.

Quoufque tandem abutêre, Catilina, patientia noftra
quamdiu nos etiam furor ifte tuus eludet? quem a
finem fefe effrenata jactabit audacia? nihilne te noc
turnum præfidium palatii, nihil urbis vigiliæ, nih
timor populi, nihil confenfus bonorum omnium, nih
hic munitiffimus habendi fenatus locus, nihil horur
ABCDEFGHIJKLMNOPQRSTVUWXY

PICA ROMAN. No 2.

Quoufque tandem abutêre, Catilina, patientia noftra
quamdiu nos etiam furor ifte tuus eludet? quem
ad finem fefe effrenata jactabit audacia? nihilne t

Quousque tandem

Quousque tandem a-

Two Lines English.

Quousque tandem abutere, Catilina, patientia

Quousque tandem abutere, Catilina, patientia nostra?

Two Lines Pica.

Quousque tandem abutere, Catilina, patientia nostra? qu-

Quousque tandem abutere, Catilina, patientia nostra? quam-

W. Caslon *Junier Sculp.*

Double Pica Black.

And be it further enacted by the Authority aforesaid, That all

W. Caslon *Junier Sculp.*

Great Primer Black.

And be it further enacted by the Authority aforesaid, That all and

W. Caslon *Junier Sculp.*

English Black.

And be it further enacted by the Authority aforesaid, That all and every of the said Exchequer Bills to be made forth by vir-

Pica Black.

And be it further enacted by the Authority aforesaid, That all and every of the said Exchequer Bills to be made forth by virtue of

Long Primer Black.

And be it further enacted by the Authority aforesaid, That all and every of the said Ex-

Brevier Black.

And be it further enacted by the Authority aforesaid, That all and every of the said Exchequer Bills to be made forth by virtue of

nocturnum præsidium palatii, nihil urbis vigiliæ, ni-
hil timor populi, nihil consensus bonorum omnium,
nihil hic munitissimus habendi senatus locus, nihi
ABCDEFGHIJKLMNOPQRSTUVWXY

SMALL PICA ROMAN. No 1.

Quousque tandem abutere, Catilina, patientia nostra?
quamdiu nos etiam furor iste tuus eludet? quem ad
finem sese effrenata jactabit audacia? nihilne te noctur-
num præsidium palatii, nihil urbis vigiliæ, nihil timor
populi, nihil consensus bonorum omnium, nihil hic
munitissimus habendi senatus locus, nihil horum or
ABCDEFGHIJKLMNOPQRSTUVWXYZA
W. Caslon *Junier Sculp.*

SMALL PICA ROMAN. No 2.

Quousque tandem abutere, Catilina, patientia nostra? quam-
diu nos etiam furor iste tuus eludet? quem ad finem sese ef-
frenata jactabit audacia? nihilne te nocturnum præsidium
palatii, nihil urbis vigiliæ, nihil timor populi, nihil consen-
sus bonorum omnium, nihil hic munitissimus habendi sena-
tus locus, nihil horum ora vultusque moverunt? patère tu
ABCDEFGHIJKLMNOPQRSTUVWXYZ

LONG PRIMER ROMAN. No 1.

Quousque tandem abutere, Catilina, patientia nostra? quamdiu
etiam furor iste tuus eludet? quem ad finem sese effrenata jactab
audacia? nihilne te nocturnum præsidium palatii, nihil urbis vi-
liæ, nihil timor populi, nihil consensus bonorum omnium, nihil h
munitissimus habendi senatus locus, nihil horum ora vultusque mo
verunt? patère tua consilia non sentis? constrictam jam omniun
ABCDEFGHIJKLMNOPQRSTUVWXYZÆ

LONG PRIMER ROMAN. No 2.

Quousque tandem abutere, Catilina, patientia nostra? quamdiu no
etiam furor iste tuus eludet? quem ad finem sese effrenata jactabi
audacia? nihilne te nocturnum præsidium palatii, nihil urbis vig-
liæ, nihil timor populi, nihil consensus bonorum omnium, nihil h
munitissimus habendi senatus locus, nihil horum ora vultusque mo
verunt? patère tua consilia non sentis? constrictam jam omnium
ABCDEFGHIJKLMNOPQRSTUVWXYZÆ

BREVIER ROMAN. No 1.

Quousque tandem abutere, Catilina,
patientia nostra? quamdiu nos etiam
furor iste tuus eludet? quem ad fi-
nem sese effrenata jactabit audacia?
nihilne te nocturnum præsidium pa-
latii, nihil urbis vigiliæ, nihil timor
W. Caslon *Junier Sculp.*

Brevier Italick. No 1.

Quousque tandem abutere, Catilina, pa-
tientia nostra? quamdiu nos etiam furor
iste tuus eludet? quem ad finem sese ef-
frenata jactabit audacia? nihilne te noc-
turnum præsidium palatii, nihil urbis vi-
giliæ, nihil timor populi, nihil consul

Nonpariel Roman. No 1.

Quousque tandem abutere, Catilina, pati-
entia nostra? quamdiu nos etiam furor iste
tuus eludet? quem ad finem sese effrenata
jactabit audacia? nihilne te nocturnum præ-
sidium palatii, nihil urbis vigiliæ, nihil
timor populi, nihil consensus bonorum om-
nium, nihil hic munitissimus habendi sen-

Nonpariel Italick. No 1.

Quousque tandem abutere, Catilina, pati-
tia nostra? quamdiu nos etiam furor ist-
eludet? quem ad finem sese effrenata jactab
audacia? nihilne te nocturnum præsidium pa
latii, nihil urbis vigiliæ, nihil timor populi
nihil consensus bonorum omnium nihil hic mu
nitissimus habendi senatus locus, nihil horum

Nonpariel Roman. No 2.

Quousque tandem abutere, Catilina, patientia
nostra? quamdiu nos etiam furor iste tuus elu-
det? quem ad finem sese effrenata jactabit au-
dacia? nihilne te nocturnum præsidium pala-
tii, nihil urbis vigiliæ, nihil timor populi, ni-
hil consensus bonorum omnium, nihil hic mu-
nitissimus habendi senatus locus, nihil horum

Nonpariel Italick. No 2.

Quousque tandem abutere, Catilina, patient
nostra? quamdiu nos etiam furor iste tuus eluan
quem ad finem sese effrenata jactabit audac
te nocturnum præsidium palatii, nihil
urbis vigiliæ, nihil timor populi, nihil consen
bonorum omnium, nihil hic munitissimus haben
di senatus locus, nihil horum ora vultus que no

Pearl Roman.

Quousque tandem abutere, Catilina, patientia nos-
tra? quamdiu nos etiam furor iste tuus eludet?
quem ad finem sese effrenata jactabit audacia? ni-
hilne te nocturnum præsidium palatii, nihil urbis
vigiliæ, nihil timor populi, nihil consensus bono-
rum omnium, nihil hic munitissimus habendi se-
natus locus, nihil horum ora vultusque moverunt?
datere tua consilia non sentis? constrictam jam om-

Pearl Italick.

Quousque tandem abutere, Catilina, patient,
nostra? quamdiu nos etiam furor iste tuus eludet
quem ad finem sese effrenata jactabit audac,
nihilne te nocturnum præsidium palatii, nihil
horum omnium, nihil hic munitissimus habendi
senatus locus, nihil horum ora vultus que move-
runt? patere tua consilia non sentis? constricta

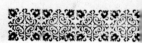

2. A SPECIMEN (5-line Pica titling) by WILLIAM C
(2-line Double Pica Black). 1742. Twelve

CIMEN

in Chiſwel-Street, LONDON. 1742.

Double Pica Italick.

Quouſque tandem abutêre, Catili-
na, patientia noſtra? quamdiu
nos etiam furor iſte tuus eludet?
ABCDEFGHIJKLMNO

Paragon Italick.

Quouſque tandem abutêre, Catilina,
patientia noſtra? quamdiu nos etiam
furor iſte tuus eludet? quem ad finem
ABCDEFGHIJKLMNOPQR

W. Caſlon *Junior Sculp.*

Great Primer Italick.

Quouſque tandem abutêre, Catilina, pa-
tientia noſtra? quamdiu nos etiam furor
iſte tuus eludet? quem ad finem ſeſe effre-
nata jactabit audacia? nihilne te noctur-
ABCDEFGHIJKLMNOPQRS

Engliſh Italick.

Quouſque tandem abutêre, Catilina, patientia noſ-
tra? quamdiu nos etiam furor iſte tuus eludet?
quem ad finem ſeſe effrenata jactabit audacia?
nihilne te nocturnum præſidium palatii, nihil urbis
vigiliæ, nihil timor populi, nihil conſenſus bo-
norum omnium, nihil hic munitiſſimus habendi ſe-
ABCDEFGHIJKLMNOPQRSTVUW

Pica Italick. No 1.

Quouſque tandem abutêre, Catilina, patientia noſtra?
quamdiu nos etiam furor iſte tuus eludet? quem ad finem
ſeſe effrenata jactabit audacia? nihilne te nocturnum præ-
ſidium palatii, nihil urbis vigiliæ, nihil timor populi, ni-
hil conſenſus bonorum omnium, nihil hic munitiſſimus ha-
bendi ſenatus locus, nihil horum ora vultuſque moverunt?
ABCDEFGHIJKLMNOPQRSTVUWXYZÆ

Pica Italick. No 2.

Quouſque tandem abutêre, Catilina, patientia noſtra?
quamdiu nos etiam furor iſte tuus eludet? quem ad finem
ſeſe effrenata i· ·it audacia? nihilne te nocturnum præ-

Double Pica Greek.

ΔΘΦΞΨΣ

Ρόδικος ὁ σοφὸς ἐν τῷ συγγράμ-
μαῖι τῷ περὶ τῶ Ηεακλέῦς (ὅπερ
δὴ κ πλείςοις ἐπιδείκνυῖαι) ὕτως περὶ

W. Caſlon *Junior Sculp.*

Great Primer Greek.

ΔΘΦΞΨΣΩ

Ρόδικος ὁ σοφὸς ἐν τῷ συγγράμμαῖι τ
περὶ τῶ Ηεακλέῦς (ὅπερ δὴ κ πλείςο
ις ἐπιδείκνυῖαι) ὕτως περὶ τῆς ἀρεῆῆς ἀποφα
ίνεῖαι, ὧδέ πως λέγων, ὅσα ἐγὼ μέμνημαι. Φ

W. Caſlon *Junior Sculp.*

Engliſh Greek.

ΓΔΘΞΣΥΦΨΩ

Ρόδικος ὁ σοφὸς ἐν τῷ συγγράμμαῖι τῷ περὶ τῶ
Ηεακλέῦς (ὅπερ δὴ κ πλείςις ἐπιδείκνυῖαι)
ὕτως περὶ τῆς ἀρεῆῆς ἀποφαίνεῖαι, ὧδέ πω; λέγων, ὅσα
ἐγὼ μέμνημαι. Φησὶ μὲν Ηεακλέα, ἐπεὶ ἐκ παίδων εἰς

Pica Greek.

ΓΔΘΞΣΥΦΨΩ

Ρόδικος ὁ σοφὸς ἐν τῷ συγγράμμαῖι τῷ περὶ τῶ Ηεακλέῦς
(ὅπερ δὴ κ πλείςοις ἐπιδείκνυῖαι) ὕτως περὶ τῆς ἀρεῆῆς
ἀποφαίνεῖαι, ὧδέ πως λέγων, ὅσα ἐγὼ μέμνημαι. Φησὶ μὲν
Ηεακλέα, ἐπεὶ ἐκ παίδων εἰς ἥβην ὥρμαῖο, (ἐν ᾗ οἱ νέοι ἤδη

Long Primer Greek.

ΑΔΓΘΜΕΞΣΥΖΦΨΩ

Ρόδικος ὁ σοφὸς ἐν τῷ συγγράμμαῖι τῷ περὶ τῶ Ηεακλέῦς (ὅπερ δὴ
κ πλείςοις ἐπιδείκνυῖαι) ὕτως περὶ τῆς ἀρεῆῆς ἀποφαίνεῖαι, ὧδέ
πως λέγων, ὅσα ἐγὼ μέμνημαι. Φησὶ μὲν Ηεακλέα, ἐπεὶ ἐκ παίδων εἰς
ἥβην ὥρμαῖο, (ἐν ᾗ οἱ νέοι ἤδη αὐτοκράῖορες γιγνόμενοι δηλῶσιν, ἔιτε τὴν

Brevier Greek

Ρόδικος ὁ σοφὸς ἐν τῷ συγγράμμα-
ῖι τῷ περὶ τῶ Ηεακλέῦς (ὅπερ δὴ
κ πλείςοις ἐπιδείκνυῖαι) ὕτως περὶ τῆς
ἀρεῆῆς ἀποφαίνεῖαι, ὧδέ πως λέγων, ὅσα

Nonpareil Greek

Ρόδικος ὁ σοφὸς ἐν τῷ συγγράμ-
μαῖι τῷ περὶ τῶ Ηεακλέῦς (ὅπερ δὴ
κ πλείςοις ἐπιδείκνυῖαι) ὕτως περὶ τῆς
ἀρεῆῆς ἀποφαίνεῖαι, ὧδέ πως λέγων, ὅσα

W. Caſlon *Junior Sculp.*

Hebrew with Points.

רֵאשִׁית בָּרָא אֱלֹהִים אֵת הַשָּׁמַיִם וְאֵת הָאָרֶץ׃

אֱלֹהִים מְרַחֶפֶת עַל־פְּנֵי הַמָּיִם: וַיֹּאמֶר אֱלֹהִים יְהִי

Hebrew without Points.

בְּרֵאשִׁית בָּרָא אֱלֹהִים אֵת הַשָּׁמַיִם וְאֵת הָאָרֶץ:
וְהָאָרֶץ הָיְתָה תֹהוּ וָבֹהוּ וְחֹשֶׁךְ עַל־פְּנֵי תְהוֹם וְרוּחַ
אֱלֹהִים מְרַחֶפֶת עַל־פְּנֵי הַמָּיִם: וַיֹּאמֶר אֱלֹהִים יְהִי

Brevier Hebrew.

בְּרֵאשִׁית בָּרָא אֱלֹהִים אֵת הַשָּׁמַיִם וְאֵת הָאָרֶץ: וְהָאָרֶץ הָיְתָה תֹהוּ
וָבֹהוּ וְחֹשֶׁךְ עַל־פְּנֵי תְהוֹם וְרוּחַ אֱלֹהִים מְרַחֶפֶת עַל־פְּנֵי הַמָּיִם:
וַיֹּאמֶר אֱלֹהִים יְהִי אוֹר וַיְהִי־אוֹר: וַיַּרְא אֱלֹהִים אֶת־הָאוֹר כִּי־טוֹב
וַיַּבְדֵּל אֱלֹהִים בֵּין הָאוֹר וּבֵין הַחֹשֶׁךְ: וַיִּקְרָא אֱלֹהִים לָאוֹר יוֹם וְלַחֹשֶׁךְ

Small Pica Italick. No 1.

Quousque tandem abutere, Catilina, patientia nostra? quamdiu nos etiam furor iste tuus eludet? quem ad finem sese effrenata jactabit audacia? nihilne te nocturnum præsidium palatii, nihil urbis vigiliæ, nihil timor populi, nihil consensus bonorum omnium, nihil hic munitissimus habendi senatus locus, nihil horum ora vultusque moverunt? patere tua consilia non sentis?
ABCDEFGHIJKLMNOPQRSTVUWXYZÆ

English Syriack.

ܘܒܪܐ ܐܠܗܐ ܝܬ ܫܡܝܐ ܘܝܬ ܐܪܥܐ ܘܐܪܥܐ
ܗܘܬ ܬܘܗ ܘܒܘܗ ܘܚܫܘܟܐ ܥܠ ܐܦܝ ܬܗܘܡܐ ܘܪܘܚܐ
ܕܐܠܗܐ ܡܪܚܦܐ ܥܠ ܐܦܝ ܡܝܐ ܘܐܡܪ ܐܠܗܐ

Small Pica Italick. No 2.

Quousque tandem abutere, Catilina, patientia nostra? quamdiu nos etiam furor iste tuus eludet? quem ad finem sese effrenata jactabit audacia? nihilne te nocturnum præsidium palatii, nihil urbis vigiliæ, nihil timor populi, nihil consensus bonorum omnium, nihil hic munitissimus habendi senatus locus, nihil horum ora vultusque moverunt? patere tua consilia non
ABCDEFGHIJKLMNOPQRSTVUWXYZ

English Arabick.

لا يبلى لك الد اخر غبرى يى لا تاخذ لك صورة * ولا تمثل كل ما
يى السماء من فوق * وما يى الارض من اسفل * ولا ما يى
الماء من تحت الارض * لا تسجد لهن * ولا تعبدهن *

Long Primer Italick. No 1.

Quousque tandem abutere, Catilina, patientia nostra? quamdiu nos etiam furor iste tuus eludet? quem ad finem sese effrenata jactabit audacia? nihilne te nocturnum præsidium palatii, nihil urbis vigiliæ, nihil timor populi, nihil consensus bonorum omnium, nihil hic munitissimus senatus locus, nihil horum ora vultusque moverunt? patere tua consilia non sentis? constrictam jam omnium horum conscientia
ABCDEFGHIJKLMNOPQRSTVUWXYZÆ

Pica Gothick.

𐌰𐍄𐍄𐌰 𐌿𐌽𐍃𐌰𐍂 𐌸𐌿 𐌹𐌽 𐌷𐌹𐌼𐌹𐌽𐌰𐌼 𐍅𐌴𐌹𐌷𐌽𐌰𐌹
𐌽𐌰𐌼𐍉 𐌸𐌴𐌹𐌽 𐌵𐌹𐌼𐌰𐌹 𐌸𐌹𐌿𐌳𐌹𐌽𐌰𐍃𐍃𐌿𐍃 𐌸𐌴𐌹𐌽𐍃

Long Primer Italick. No 2.

Quousque tandem abutere, Catilina, patientia nostra? quamdiu nos etiam furor iste tuus eludet? quem ad finem sese effrenata jactabit audacia? nihilne te nocturnum præsidium palatii, nihil urbis vigiliæ, nihil timor populi, nihil consensus bonorum omnium, nihil hic munitissimus habendi senatus locus, nihil horum ora vultusque moverunt? patere tua consilia non sentis? constrictam jam omnium horum conscien-
ABCDEFGHIJKLMNOPQRSTVUWXYZÆ

Pica Armenian.

Արդեակ Թագաւորի երկիրն և ծովուն, որով անձն
և պատակեր որպէս և է իսկ մեր Սանուծոյ
իսկ բանին և պատառունեւն ի վեր բան զաւ

Pica Æthiopick.

ዐ፡ ፅሐዐኁ፡ በሐዐማ፡ አፈሕ፡ አፈም፡ አማብፅኁ፡ አፈ
ማፍኁ፡ ፍማዐ኿፡ ዐፈረ኿ኁ፡ አማበሕ፡ ኁፈማ፡፡ ዐፈረ኿
ኁፐዐማ፡ ኁማ኿፡፡ ፀበፈኁ኿ኁ፡ ፅረኀዐ፡ አፈፈረዐ፡
W. Caslon Junior fec.

Brevier Roman. No 2.

Quousque tandem abutere, Catilina, patientia nostra? quamdiu nos etiam furor iste tuus eludet? quem ad finem sese effrenata jactabit audacia? nihilne te nocturnum, præsidium palatii, nihil urbis vigiliæ, nihil timor popu-

Brevier Italick. No 2.

Quousque tandem abutere, Catilina, patientia nostra? quamdiu nos etiam furor iste tuus eludet? quem ad finem sese effrenata jactabit audacia? nihilne te nocturnum præsidium palatii, nihil urbis vigiliæ, nihil timor populi, nihil consensus

Pica Samaritan.

ࠁࠓࠀࠔࠉࠕ ࠁࠓࠀ ࠀࠋࠄࠉࠌ ࠀࠕ ࠄࠔࠌࠉࠌ ࠅࠀࠕ ࠄࠀࠓࠑ
ࠅࠄࠀࠓࠑ ࠄࠉࠕࠄ ࠕࠄࠅ ࠅࠁࠄࠅ ࠅࠇࠔࠊ ࠏࠋ ࠐࠍࠉ ࠕࠄࠅࠌ

English Saxon.

Ða he ða mið ᵹnimmu
m ꝼꝼinᵹlum Ᵹ cincꝥe
ᵹum pæceð pæꝽ Ᵹ he e

Pica Saxon.

Ða he ða mið ᵹnimmum
ꝼꝼinᵹlum Ᵹ cincꝥeᵹum
pæceð pæꝽ Ᵹ he ealle ꝥa

Pica Coptick.

ϩⲉⲛ ⲟⲩⲁⲣⲭⲏ ⲁϥⲧ ⲟⲩⲁⲃⲟ ⲛ̄ⲧϥⲉ ⲛⲉⲙ ⲡⲕ-
ⲁϩⲓ⸱ ⲡⲓⲕⲁϩⲓ ⲇⲉ ⲛⲉ ⲟⲩⲕⲟⲛⲁⲩ ⲉⲣⲟϥ ⲡⲉ ⲟⲩⲟϩ
ⲛⲁⲧⲥⲟⲃ̄ⲧ ⲟⲩⲭⲁⲕⲓ ⲛⲁϥⲭⲏ ⲉⲭⲉⲛ ⲫⲛⲟⲩⲛ ⲟⲩⲟϩ

Long Primer Saxon.

Ða he ða mið ᵹnimmum ꝼꝼin
ᵹlum Ᵹ cincꝥeᵹum pæceð pæꝽ
Ᵹ he ealle ꝥa piꞇu ðe him man
byðe ᵹeꝥylðelice Ᵹ ᵹeꝼeonðe

Brevier Saxon.

Ða he ða mið ᵹnimmum Ᵹ cincꝥeᵹ
um pæceð pæꝽ Ᵹ he ealle ꝥa piꞇu ð
e him man byðe ᵹeꝥylðelice Ᵹ ᵹeꝼ
eonðe ꝼeꝽ ꝥiꞇne aꞇeꝽn apaꝼaꝽe ꝥ

...ASLON, Letter-Founder in Chiswel (sic) - Street, London.
... of the specimens are by William Caslon II.

and Amos Green which lasted through life. Several letters survive
in the Boulton and Watt Collection at the Birmingham Assay
Office[34] which testify to the intimacy of their early days. Following
Matthew Boulton's visit to Bath in 1784, when he called upon
Amos Green, the latter writes, 'Your visit to Bath reminds me of
the whistling and laughing evenings we spent together in the days
of our youth when engaged in the important business of drawing
an inlaid button or mounting a pretty-shaped bit of steel.' Amos
Green's later career has been briefly referred to earlier and does
not concern us further here. What is important is that the part
served by the Green brothers—six of them survived to maturity—
as links between Caslon in London, Rowe Mores in Oxford, and
John Baskerville and George Anderton in Birmingham, has been
overlooked. Unfortunately, so much of Birmingham's eighteenth
century history has been lost or neglected that the whole truth of
the matter is unlikely to be recovered.

A letter written by Shenstone[35] in 1753 suggests that Caslon
kept in touch with and visited his native place.—

'To Mr. . . . The Leasows, Jan. 1753.
Dear Sir,

The Letter with which you favoured me deserves my
earliest acknowledgements, and will prove not a little ser-
viceable, in regard to the Subscription we have in Hand. The
whole Account of that Affair is as follows: I have been
assured by Persons of Veracity, (amongst whom I may safely
name Lord Dudley, Mr. Pixell, and Tho. Cotterel) that you
had generously made an Offer of twenty Guineas towards
the Addition of two new Bells to our present Set; and that
in case the Parish would supply what was wanting, it would
be a Pleasure to you, Sir, to have your Offer accepted. Upon
this Encouragement, I determined to make Trial of what a
Subscription would produce, and accordingly drew up a
Form for that Purpose; intending to write you an Account
of the Undertaking, so soon as I could form a Conjecture of
its Success. This I was upon the Point of doing, when I had
the Pleasure of a Letter from you, which, nevertheless, was
extremely seasonable, as it immediately removed a Doubt
that began to spread, in Regard to your Concurrence.

There is now subscribed, (exclusive of your Benefaction) the Sum of fifty Guineas; and I make no Scruple of raising twenty more, by an Application to such Persons as have not yet been solicited. Be our Progress what it will, I purpose in a few Weeks to give you a further Account of it; in the mean Time, can assure you, that the Subscription will be pushed forward with all possible Diligence, that it may give us the earlier Chance for the Pleasure of your Company. I have only to add, that the Bells will never sound more agreeably, than when they ring for your Arrival; will be heard no where more advantageously than from some Parts of my Farm, and that you will find no one more desirous of making the Country agreeable to you than

Your most obedient humble Servant,

W. Shenstone.'

Thomas Cotterel (or Cottrell) was a Birmingham tradesman who became High Bailiff in 1754, in succession to Edward Jordan, one of the gun-making family.[36] There were many Cottrells in the district and it is not known with certainty if Thomas Cottrell, Caslon's apprentice, was a relation. Mr Pixell was John Pryn Parkes Pixell (1725–84) who married Anne, daughter of the Rev. Thomas White, Vicar of Edgbaston. His father was a Birmingham tradesman and his mother a Halesowen woman named Parkes. Pixell was a musician and a friend of Shenstone. In Dodsley's Collection V, 83–4, a poem is headed, 'transcribed from the Rev. Mr. Pixell's parsonage garden near Birmingham, 1757.[37]

It seems certain that Shenstone's unknown correspondent in the letter just quoted was no less a person than Caslon.[38] William Harris, writing in 1836, says of the church bells: 'There is at the present time, a musical set of eight bells, on the key of E, with three flats,—justly admired for the clearness of their tone. Six of these bells were placed in the steeple in the year 1707, and very likely the ancient bells were re-cast at that time. About half a century after this, a gentleman from London of the name of Skittleton, came on a visit to Hales-Owen;—admiring the sweetness of their tone, and at the same time lamenting that they were not a perfect octave, he generously made the inhabitants a present of the first and second bells.'[39] It will be seen that in the course of

eighty years tradition ascribed to the donor the gift of the whole of the two bells, not the twenty guineas gratefully acknowledged by Shenstone. Recalling that Caslon's first wife was buried at Clent in 1728 as Sarah Castleton it seems certain that in course of time the name by which the typefounder was known in his own district became 'Spoonerised' into Skittleton.

John Baskerville, in the preface to his edition of Milton's *Paradise Lost,* published in 1758, gives an interesting account of his own labours and ambitions as a letter founder.[40] He says :

'Amongst the several mechanic Arts that have engaged my attention, there is no one which I have pursued with so much steadiness and pleasure as that of *Letter Founding.* Having been an early admirer of the beauty of Letters, I became insensibly desirous of contributing to the perfection of them. I formed to myself ideas of greater accuracy than had yet appeared, and have endeavoured to produce a *Sett* of *Types* according to what I conceived to be their true proportions.

'*Mr. Caslon* is an artist to whom the Republic of Learning has great obligations ; his ingenuity has left a fairer copy for my emulation, than any other master. In his great variety of *Characters* I intend not to follow him ; the *Roman* and *Italic* are all I have hitherto attempted ; if in these he has left room for improvement it is probably more owing to that variety which divided his attention, than to any other cause. I honor his merit and only wish to derive some small share of Reputation, from an Art which proves accidentally to have been the object of our mutual pursuit.

'After having spent many years, and not a little of my fortune, in my endeavours to advance this art : I must own it gives me great satisfaction to find that my edition of *Virgil* has been so favourably received . . .

'It is not my desire to print many books ; but such only as are *books* of *Consequence,* of *intrinsic merit,* or *established Reputation,* and which the public may be pleased to see in an elegant dress, and to purchase at such a price, as will repay the extraordinary care and expense that must necessarily be bestowed upon them . . . If this performance shall appear to

persons of judgment and penetration, in the *Paper, Letter, Ink,* and *Workmanship* to excel; I hope their approbation may contribute to procure for me what would indeed be the extent of my Ambition, a power to print an Octavo *Prayer Book,* and a FOLIO BIBLE.'

If later writers on typography had been content to accept Baskerville's own statements regarding his limited aims, fewer extravagant claims would have been made for his merits. When Baskerville refers to the great variety of characters Caslon designed, cut and founded, he diverts attention from the variety of tasks he undertook himself, stone cutting, japanning, letter design, paper-making, ink-making, founding, printing and binding. Caslon began as a toolmaker and punch-cutter, and though he later merged these activities in the work of his foundry, he remained a punch-cutter, something which Baskerville never was.

As we have seen in the account of the cutting of the punches for the fount of Arabic type, Caslon the punch-cutter, Salomon Negri the Oriental expert, and Samuel Palmer the printer were in close consultation throughout, meeting generally twice a week. Baskerville knew perfectly well that there was no prospect of emulating Caslon in cutting exotic types, for such assistance as Caslon had was not available in Birmingham, so Baskerville very sensibly lowered his sights accordingly, mentioning only the Roman and Italic he had attempted.

In 1758, however, Baskerville proposed to the Delegates of the Oxford Press the cutting and casting of a new Greek fount, for which in 1761 he was paid £210.[41] Considerable expectation was aroused by this order, which was considered of sufficient importance to deserve mention in the public press, as the following extract from the *St. James's Chronicle* of 5 September, 1758, testifies :[42]

'The University of Oxford have lately contracted with Mr. Baskerville of Birmingham for a complete Alphabet of Greek Types of the Great Primer size : and it is not doubted but that ingenious artist will excel in that Character, as he has already done in the Roman and Italic, in his elegant edition of *Virgil,* which has gained the applause and admiration of most of the literati of Europe, as well as procured him the

esteem and patronage of such of his own countrymen as distinguish themselves by paying a due regard to merit.'

The anticipations thus expressed were destined to be disappointed ; for Baskerville's ability appears to have failed him in his efforts to reproduce a foreign character. Even before the appearance of the Oxford *Greek Testament,* which did not occur till 1763, rumours of the failure of this undertaking had begun to circulate.[43] Writing in 1763, respecting a forthcoming *Greek Testament* of his own, Bowyer says, 'Two or three quarto Editions on foot, one at Oxford, far advanced on new types by Baskerville,—by the way, not good ones.'[44]

The appearance of the work in question largely justified the criticism. Regular as the Greek character is, Baskerville's is stiff and cramped and, as Dibdin says, 'like no Greek characters I have ever seen.' As already noted, Rowe Mores goes to the length of styling it 'execrable ;' and Bowyer appears to have had it specially in mind when he said to Jackson that the Greek letters commonly in use were no more like Greek than English. Be this as it may, Baskerville made no further excursions into the foreign and learned languages and, fortunately (as we consider) for his reputation, confined his talents to the execution of the characters of his native tongue.[45]

It is therefore apparent that no worthwhile comparison can be made between Caslon and Baskerville. Caslon began his work as a young man and acquired a skill in punch-cutting that met a national need at a critical period in British typographic history and his flair for letters was applied to a very wide range of founts. Moreover, like the cobbler, he stuck to his last. The case of Baskerville was much different. Like his friend Dodsley, he served no regular apprenticeship, but is said to have been a footman, a beginning that might have served to bind their friendship by feelings of mutual admiration. Baskerville then became a writing-master and a carver of inscriptions on slate headstones. About 1740 he turned to the japanning business, in which he made a moderate fortune, and it was not until about 1750, when he was forty-four years of age, that Baskerville began his printing venture and his first work did not issue from the press until 1757 when he was already in middle age.

Great as were these differences between them, there were

still greater in the scholastic resources on which the two men could call to aid them in their letter forms. In the London world of book-sellers and scholars, Caslon had at his elbow the manuscript resources of great collections and libraries, the guidance of scholars who had passed through the universities, and the advice of the best printers of the metropolis. In Birmingham, Baskerville had no scholars of greater capacity than Shenstone and Dodsley ; indeed, his reputation as an infidel must have cut him off from many in the West Midlands who might otherwise have been disposed to help him. Consequently, he had to be content with such meagre help as infrequent visits and correspondence might afford him. It seems, therefore, that any further comparison of two such different men is unlikely to lead to any useful result and as a fuller account of the letter-founding and printing career of John Baskerville is outside the scope of the present work we must now return to William Caslon.

At this point it will be opportune to look again at Caslon's good fortune in securing the patronage of William Bowyer. In June, 1716, Bowyer placed his son as a sizar at St. John's College, Cambridge, where he was under Dr. Christopher Anstey and Dr. Newcome, and in 1719 obtained Roper's exhibition, but did not take a B.A. degree. In 1722, when Caslon had embarked on the Arabic project, the younger Bowyer was still at College without a degree, and about this time he began to help his father in correcting learned works for the press, Dr. Wilkins's great folio edition of Selden's works, for which Caslon cut the Hebrew, being the first. His father took him into partnership towards the end of 1722, retaining the management of the business, and delegating the learned work to his son. In 1727 he wrote and published *A View of a Book entitled Reliquiae Baxterianae* which was highly approved by Dr. Wotton, Samuel Clarke and other men of letters.[46] In 1729 he was appointed, through Onslow, the speaker, to print the votes of the House of Commons, an office he held under three speakers, and for nearly fifty years, in spite of efforts to prejudice him, for he held the same non-juring beliefs as his father. In 1736 he was appointed printer to the Society of Anti-quaries. We cannot be concerned here with the whole of the long list of works of which he was the author, but only with the works

and events which lead us to a fuller knowledge of the Bowyer influence on Caslon.

Caslon's first specimen sheet appeared in 1734 and marked a new departure. It displayed at a glance the entire contents of the new foundry; and by printing the same passage in each size of roman, gave the printer an opportunity of judging how one body compared with another for capacity.[47] Caslon was the first to adopt the since-familiar *Quousque tandem* for his roman specimens, and it is here we detect the hidden hand of the younger Bowyer, for he showed his predilection for Cicero when, in 1767, owing to lack of room, Bowyer's printing-office was moved from Whitefriars to Red Lion Passage, where he placed the sign of 'Cicero's Head,' and styled himself 'Architectus Verborum.' There can be little doubt, therefore, that the venerable Ciceronian denunciation was chosen for Caslon by the younger Bowyer, and it held its ground on letter-founders specimens till comparatively recent times.

The roman type face is certainly shown to best advantage when presented in Latin, for the letters will convey a different impression when displayed in any other tongue. Dibdin drew attention to this, saying that Caslon and Fry after him 'should have presented their specimens of printing-types in the *English* language and then, as no disappointment could have ensued, so no imputation of deception would have attached.'[48]

'The Latin language,' says Dibdin, 'presents to the eye a great uniformity or evenness of effect. The m and n, like the solid sirloin upon our table, have a substantial appearance; no garnishing with useless herbs ... to disguise its real character. Now, in our own tongue, by the side of the m or n, or at no great distance from it, comes a crooked, long-tailed g, or a th, or some gawkishly ascending or descending letter of meagre form, which are the very flankings, herbs, or dressings of the aforesaid typographical dish, m or n. In short, the number of ascending or descending letters in our own language—the p's, l's, th's, and sundry others of perpetual recurrence—render the effect of printing much less uniform and beautiful than in the Latin language.

Despite the truth of what Dibdin says regarding the visual impression created by the same passage presented in Latin and English, Caslon and Bowyer should be exonerated from any sus-

picion of intent to deceive. Although it is a fact that almost the whole of the two middle columns of the 1734 specimen is devoted to Caslon's extensive range of roman and italic founts, it should also be noted that it displays the type faces of no less than ten other languages; but, while the Latin is displayed in nine sizes, the learned and exotic types are displayed in only one or two, and up to four sizes in the Greek. Bowyer was not called 'the learned printer' for nothing; it was as natural for Bowyer to write in Latin as in his native English. In any event the other founders, including Baskerville, followed Caslon in adopting the Latin in their specimens, so that thereafter the letter-founders' displays were judged on the same visual basis.

Alexander Wilson is credited with being the first to break through the traditional *Quousque tandem*[49] in 1772, by adding a passage in the same-sized letter in English, but the writer has a Wilson specimen dated 1783 which still maintains the Caslon tradition.

Finally, on the question of an appropriate text for letter-founders' specimens, if Dibdin returned today, opened a type-founder's specimen book and read page after page of 'The quick brown fox jumps over the lazy dog,' however rational the explanation might be for this choice of phrase, the writer feels sure Dibdin would immediately call for the return of the venerable Ciceronian denunciation on the grounds that to the moderns, who are unused to reading the Latin, the visual appearance of the letters would make a stronger impression than their sense, thus promoting the letter-designers' intention, whereas the nonsense of the modern jingle, repeated *ad nauseam*, detracts from the letter-designers' purpose by diverting the reader's attention from the visual appearance of the letters.

[1] Printed for sale in 1961 by the Oxford University Press.
[2] Introduction, p. 16.
[3] See Chart 2.
[4] See later.
[5] Burgess, Old Prints and Engravings, p. 180.
[6] Dissertation, Carter and Ricks, p. xxi.

7 MS. Junius 11.

8 Mentioned in Chapter 17.

9 Section VIII, Plate XIX.

10 See Chapter 8.

11 Nichols's Illustrations of Literature, IV, 231.

12 Briefly related in Chapter 17.

13 Dissertation, p. lxii.

14 Dissertation, p. 3.

15 Dissertation, p. lxv.

16 Dissertation, p. 86.

17 That is, over 15 years of age, the sign ⊏ being formerly used in mathematics to signify 'more than.'

18 P. 239.

19 'Typographia,' 1825.

20 Dissertation, p. lxiii.

21 Birmingham.

22 Encyclopaedia of Literary and Typographical Anecdote, 1842.

23 P. 341.

24 Joseph Hill, The Bookmakers of Old Birmingham.

25 H. L. Blackmore, British Military Firearms, 1650–1850.

26 See Plate 68.

27 Birmingham School of Printing, 1937.

28 William Bennett.

29 Ibid. p. 71.

30 See later.

31 Chambers, Biographical Illustrations of Worcestershire, p. 370.

32 Marjorie Williams, Letters of William Shenstone, p. 474 (who is mistaken, however, in saying, p. 466, that Amos Green was employed by Matthew Boulton to paint boxes, etc.).

33 William Bennett: John Baskerville.

34 Courtesy of the Assay Master.

35 Marjorie Williams, Letters of William Shenstone, pp. 350–1.

36 William Hutton, History of Birmingham, previously quoted.

37 'A Collection of Songs with their Recitatives and Symphonies for the German Flute, Violins, etc., with a Thorough Bass for the Harpsichord set to Music by Mr Pixell,' was published by Baskerville, 1759. Courtney, 119, gives a short account of the Rev. John Pixell.

38 See Appendix II for Caslon's musical interests.

39 History and Antiquities of Halesowen.

40 William Bennett: John Baskerville.

41 Ibid.

42 Ibid.

43 Reed-Johnson, p. 273.

44 Nichols's Lit. Anec. ii, 411.

[45] Reed-Johnson, p. 273.
[46] D.N.B. art. William Bowyer the younger.
[47] Reed-Johnson, p. 44.
[48] Bibliographical Decameron, ii, 381–2.
[49] Reed-Johnson, p. 45.

Chapter Twenty

WILLIAM CASLON'S PUPILS AND FOLLOWERS

THIS CONCLUDING CHAPTER gives a brief account of Caslon's later apprentices and those followers who had a direct or indirect connection with him. William Caslon II is the first and most important of these, but since his life and work can scarcely be considered apart from his father's and have been so treated in the account already given, little more need be said. It should be mentioned here that the account is limited to those who were actually punch-cutters, and as none of the Caslons after Caslon II were craftsmen in the same sense that the first two Caslons were, this forms a convenient termination to the present work. However, Caslon's successors down to his last male descendant bearing the Caslon name, and the vicissitudes of the Caslon business and its successors, are conveniently exhibited in the complete pedigree of English letter-founding shown in Chart II at the end of this chapter.

Caslon took his elder son William Caslon II into partnership in 1742 and as it was not until about 1749 that Thomas Cottrell became an apprentice to the Caslons it is probable that Caslon II had quite as much to do with his training as Caslon I. It is said that the Caslons employed Cottrell as a dresser.

The Halesowen register records in June 1715 the marriage of Thomas Cotterill and Sarah Gibbins, both of Halesowen, followed in March 1716 by the baptism of a son Thomas, a daughter Hannah following in 1717. The parents were then described as of Lapal, on the Birmingham side of Halesowen. In 1719

Thomas Cotterill,* now described as of Ridgacre, still nearer to Birmingham, died and there is no further record of his family in the Halesowen register. It seems a reasonable surmise that like many other boys of Halesowen, Thomas Cotterill the younger was apprenticed in Birmingham and, making his mark in that rapidly expanding hub of England, became a man of consequence in the town. Maintaining his connection with Halesowen, he cultivated an acquaintance with Shenstone, whose estate was at Lapal, and in 1754 was elected High Bailiff of Birmingham. Since it has been previously shown that Caslon kept in touch with his native town, what can be more likely than that Thomas Cotterill, Caslon's apprentice, was a close relative, possibly the son, of the Birmingham tradesman who was himself a native of Halesowen.

The only other entries of the name Cotterill in the Halesowen register relate to the family of Humphrey and Elizabeth Cotterill of Warley Wigorn, Halesowen, who had sons Joseph and Fielding baptized in 1719 and 1721. In 1752 Fielding Cotterill was living at Ridgacre and had a son Joseph baptized at Halesowen. The above-named Humphrey was probably he who graduated B.A. at Trinity College, Oxford, in 1705, proceeding M.A. in 1707, and described as the son of John Cotterill of Birmingham.[1] This family was probably descended from that Joseph Cotterill who married Mary, one of the Birmingham Caslons, in 1655; the name Fielding suggests a connection with the well-known family of Barnacle, Warwickshire, to which 'Beau Fielding' belonged.

Joseph Jackson was a fellow-apprentice with Cottrell. The Caslons, father and son, kept the operation of punch-cutting a profound secret, always locking themselves in the room in which they practised it. But the two apprentices, Cottrell and Jackson, wishing to master the whole art of the trade in which they were engaged to perform only a minor part, bored a hole in the wainscot and, observing the Caslons at work, thereafter practised assiduously and qualified themselves in the whole art.

In 1757 Cottrell and Jackson headed a deputation to the elder Caslon at his home at Bethnal Green, arising from a dispute among all the workmen concerning the rates of pay. The

*The parish register spelling of the name has been followed here, not necessarily the same as the London spelling.

412

Caslons, concluding that Cottrell and Jackson were ringleaders in the dispute, dismissed both and they were thus thrown unexpectedly on their own resources. The two recalcitrants remained in partnership for a short time assisted by a Dutchman, Baltus de Graff, a former apprentice of Voskens of Amsterdam. In 1759 Jackson left the business to go to sea.

Cottrell's first fount was an English roman, a production of considerable merit for a self-trained hand. In 1758, the punches and matrices of Elizabeth Elstob's Saxon types, which had remained untouched for several years at the Caslons, were brought to Cottrell to be fitted up ready for use, a task which Cottrell performed satisfactorily, returning with them a small fount of the letter cast in his own mould, as a specimen of the improvement he had made in them. Cottrell then proceeded with his series of romans down to the Brevier size, 'which', says Rowe Mores, 'he thinks low enough to spoil the eyes.' He also cut a two-line English Engrossing in imitation of the Law-Hand, and several designs of flowers.

The Engrossing, styled by Mores the Base Secretary, was designed for Cottrell by a law printer named William Richardson, a nephew of the novelist Samuel Richardson, and was intended to take the place of the lately abolished Court Hand in legal documents. When Mores wrote in 1778 it was the only fount of the kind in England.

Cottrell is said to have been the first to produce large poster letters cast in sand, some as large as twelve-line Pica. His Domesday fount, which is headed 'The Character used in the time of William the Conqueror,' was cut under the supervision of Dr. Charles Morton, and begun in 1773. He also cut a Double Pica Latin Script about 1774, which was probably the first of the kind to be cut in England, although Mores in his *Dissertation* dated 1778, says that at the time of his writing Cottrell's Script was not ready.

Cottrell died in 1785. He is described as obliging, good-natured, and friendly, rejecting nothing because it was out of the common way, and an expeditious craftsman. Nichols, in recording his death, says 'Mr Cottrell died, I am sorry to add, not in affluent circumstances, though to his profession of a letter-founder were

superadded that of a doctor for the toothache, which he cured by burning the ear ; and had also the honour of serving in the Troop of His Majesty's Life Guards.'[1]

Having given an account in the broadest of terms of Cottrell's performance as a punch-cutter, it is not proposed to give a catalogue of his foundry, nor to deal with its further history. These can be studied in Reed-Johnson, p. 292.

Joseph Jackson, Cottrell's co-apprentice in surreptitiously observing the Caslons during their process of punch-cutting, was a craftsman of a different stamp from his friend Cottrell. While the latter's capacity might be justly rated as diligent and competent, Jackson was an artist of outstanding ability, and it is regrettable that so little is known of his origins. Jackson was born in Old Street, London, on 4 September, 1733, and is said to have been the first child baptized at St. Luke's on the separation of that parish from St. Giles, Cripplegate. The entries of some of Caslon's own children were divided between those two parishes, so Jackson's family were parochially close to Caslon's before the boy reached the age for apprenticeship.

While the name Jackson, being so prolific, is genealogically unpromising, it appears likely that like Cottrell, who was probably apprenticed through the influence of friends, so also Jackson might have been similarly placed. In the eighteenth century kissing went by favour to a greater extent than today, and as we have seen that Caslon's success in London inspired imitators both there and in Birmingham we can readily believe that his favour was solicited more often than he could grant it.

Most of the Jacksons in the Halesowen register descend from Edmund and Thomas Jackson in the mid-seventeenth century and in 67 entries of the name between 1654 and 1730 the name Joseph occurs no less than 22 times. In 1671 'Mr Sampson Allkin and Bridgett Jackson' were married. Later we find Sampson Alkin located at Fostell (Foston) in Derbyshire, for his son John proceeded to Oxford,[3] graduating B.A. from Pembroke College in 1704 and M.A. from Clare Hall, Cambridge, in 1710. In 1707 John Alkin became vicar of North Mimms, Hertfordshire, and if Bridgett Jackson kept in touch with her Halesowen relations it is possible that one of them migrated to London via

Hertfordshire or through the Alkin connection. Possibly the famous artists in aquatint came from this family. Samuel Alken flourished in the last quarter of the eighteenth century and produced some very spirited landscapes in aquatint, for example, those in Whitaker's *History of Craven in Yorkshire*. Henry Alken and his sons practised in the first half of the nineteenth century, publishing many sporting prints in aquatint, some of those of a humorous character being of his own composition as well as after Thomas Rowlandson. Alken prints are now highly valued by collectors.

We must now return to Joseph Jackson, Caslon's apprentice. After the dismissal of the two young journeymen from the Chiswell Street foundry, Jackson received some help from his mother, who bought him what tools were necessary and he practised at her house whenever he had an opportunity. We therefore conclude that his father was already dead.

As already stated, Jackson and Cottrell entered into a partnership which went on happily until the death of Jackson's mother brought it to an end and in 1759 he entered on board the frigate 'Minerva,' as an armourer, transferring in 1761 to the 'Aurora.' Quitting the navy after a severe bout of illness, and having about £40 prize money to receive at the Peace of 1763, he rejoined his old comrade Cottrell, now a fully established typefounder in Nevil's Court, Fetter Lane. After working for some time under Cottrell he determined to set up in business for himself, taking a small house in Cock Lane.

When he had carried on business for about six months, he was visited by William Bowyer the younger, who was so impressed by Jackson's punches that he promised to employ him, adding, 'My father was the means of old Mr Caslon riding in his coach, how do you know but I may be the means of your doing the same?'

Jackson issued his first specimen-sheet about 1765, but no copy seems to have survived. His business increasing, Jackson removed from Cock Lane to Dorset Street, Salisbury Square, and here his foundry and reputation made rapid advances. The story goes that about 1771 the Duke of Norfolk asked him if he could undertake to make a mould to cast a hollow square, adding that he had applied to all the skilful mechanics in London, including Mr

Caslon (Caslon II) who declared it impossible. Jackson told the Duke that he thought this was practicable, and in the course of three months produced what his Grace had been years in search of, and was ever after held in great estimation by the Duke, who considered him the first mechanic in the kingdom.

In 1773 Jackson issued another specimen including Hebrew, Persian, and Bengalee, as well as the more usual Greek, Roman, Italic and English, together with a Script of which now nothing seems to be known. With regard to the Bengalee letter, Rowe Mores states that this was cut by Jackson 'for Mr William Bolts, Judge of the Mayor's Court of Calcutta.' Bolts, however, proved unequal to the rendering of this intricate character, and though no fault attached to Jackson, the work was abandoned for the time being, to be revived and executed a few years later in a more masterly manner by Charles Wilkins of the East India Company.

Jackson was employed to cut several varieties of letter for producing the Parliamentary records and he was also responsible for producing the type for the splendid facsimile of the Domesday Book, begun by Cottrell in 1773. The work occupied ten years in printing, and appeared in 1783, in two folio volumes, but the type was later destroyed in the fire which consumed the printing office of Nichols in Red Lion Court, Fleet Street, in 1808.

It was probably Jackson's success in cutting the Domesday fount which led to his selection to cut the type for Dr. Woide's facsimile of the *New Testament* of the *Codex Alexandrinus* in the British Museum. This priceless relic has a romantic history. Sir Thomas Rowe (1581–1644), when ambassador to the Ottoman Porte in the time of James I, was a warm friend of the Greek Church and on intimate terms with the celebrated Cyril Lucar, patriarch of Constantinople, who as a former patriarch of Alexandria, had acquired the famous *Codex Alexandrinus*. It was through Rowe that the gift of the manuscript was made to James I, though it did not reach this country till Charles I was on the throne. It is of particular interest to note that Sir Thomas Rowe was born at Low Leyton, in Essex, and that Edward Rowe Mores, the typographical historian, who was connected through his mother with the Rowe family, also lived at Low Leyton. Henry Caslon I married Elizabeth Rowe, another descendant.

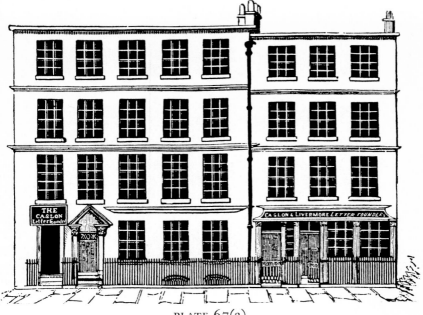

PLATE 67(a)

The Caslons' Chiswell Street Foundry in 1825.
From a wood-engraving in the St. Bride Printing Library

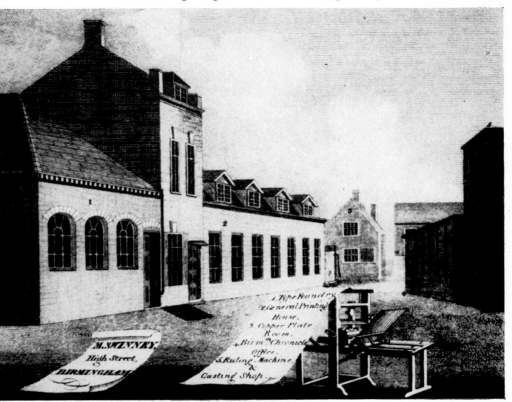

PLATE 67(b)

Miles Swinney's Type Foundry, High Street, Birmingham, 1800.
From Bisset's 'Magnificent Directory of Birmingham.'

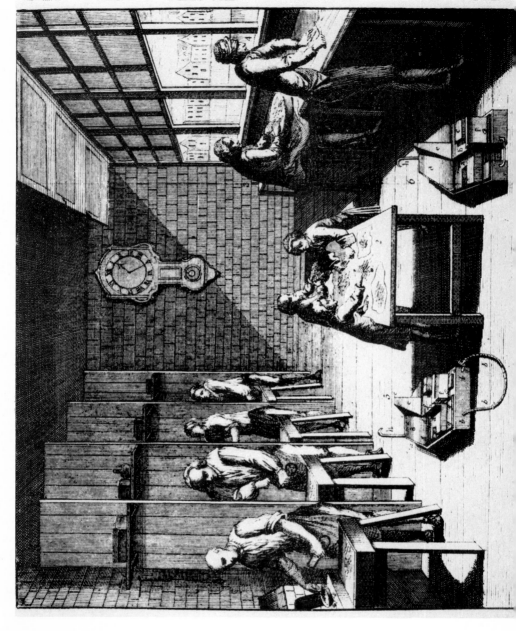

PLATE 68

'A True and Exact Representation of
the Art of Casting and Preparing
Letters for Printing'. Engraved
for the Universal Magazine, 1760.

Jackson proved fully equal to this new task, the work being issued from Nichols's press in a splendid folio edition in 1786, with the imprint 'typis Jacksonianis' in the title-page.

Jackson, having now become famous for his skill in this particular branch of letter-cutting, was called upon shortly before his death to cut the punches for Dr. Kipling's facsimile of the almost equally celebrated *Codex Bezae*, a sixth-century manuscript presented in 1581 by Théodore Beza of Geneva to the University of Cambridge. This assignment Jackson also completed with the utmost fidelity, despite the character of the manuscript being less regular than the Alexandrian. Unhappily, Jackson's death in 1792 prevented him from seeing in print the fruit of his labours, the work being published in 1793 at Cambridge in two beautiful folio volumes.

Jackson's reputation was by no means wholly dependent on the rendering in type the character of ancient and difficult manuscripts. Amongst other works, he cut a beautiful fount of Pica Greek for Bowyer. Under the direction of Joseph Steele, the author of *Prosodia Rationalis*, he had also augmented the number of musical notes by such as represent the emphasis and cadence of prose. This curious work, designed to show how the recitation of Garrick and other eminent speakers might be transmitted to posterity in score, was printed by Nichols in 1779, being an amplified edition of a treatise published four years previously, in which Jackson's 'expression symbols' were made use of.

The most important work of his later years was the splendid fount of two-line English roman, cut for Bensley, about the year 1789, for Macklin's *Bible*. As in the case of the Beza *Gospels*, he did not live to see the completion of his labours in the publication of this grand edition, which appeared some years after his death in a type not wholly his own, but supplemented, in close facsimile, by a fount cut by his former apprentice and manager, Vincent Figgins. Jackson's fount was used to the end of *Numbers* and his letter is justly counted a pattern of the most perfect symmetry to which the art had at that time arrived.

A crowning monument to Jackson's skill is Robert Bowyer's sumptuous edition of Hume's *History of England*, printed by Bensley in 1806. On the execution of this Double Pica fount

Jackson appears to have staked his reputation, for according to his biographer in the *Gentleman's Magazine*,[4] he had declared it should 'be the most exquisite performance of the kind in this or any other country.' His death occurred on 14 January, 1792, in his fifty-ninth year, and while the immediate cause was scarlet fever, there can be no doubt that his vitality had been sapped by his great application and the anxiety of this undertaking.

The occasion demonstrated a rare instance of a letter-founder becoming the object of a poetical tribute:

> Patrons of merit, heave the sadden'd sigh!
> Ye brilliant dewdrops, hang on Beauty's eye!
> Let heavy hearts beat with the tolling bell,
> And mourn the fatal hour when *Jackson* fell!
> His were the gifts the Gods alone impart—
> A *tow'ring genius* and a *tender heart*!
> A greatness equalled only by his skill—
> A goodness greater than his greatness still;
> An ardent zeal each purpose to *obtain*,
> Which Virtue and the Arts might entertain.
> But Fate in jealous fury snatched him hence
> The moment he accomplished excellence!
> *Tenax propositi*—his art he tried,
> Achieved perfection—and achieving died!

Jackson was a deacon at the Meeting-House in Barbican, where a funeral sermon was preached by the Rev. John Towers. He died possessed of considerable property, which was divided between fourteen nephews and nieces, for he had no issue. Jackson was twice married—first to Elizabeth Tassell, originally a whinster (or windster), of Spitalfields, who had contributed to his first setting up in business. She died in 1783, and in the following year Jackson married Mary Pasham, widow of a well-known printer in Blackfriars, a union which also materially assisted his business.

In 1790 Jackson's foundry was destroyed by a fire in which his moulds and matrices were seriously damaged. This shock affected both his health and his energy, and during his last years, the management of his business was left largely in the hands of his trusted servant Vincent Figgins. When, after Jackson's death in

1792, the foundry was offered for sale, Figgins found himself unable to purchase, and the business passed into the hands of William Caslon III, who had recently disposed of his share of the Chiswell Street foundry. Caslon removed the foundry from Dorset Street to Finsbury Square, where it remained for about two years. In 1794 Caslon III became bankrupt and the house in Finsbury Square was bought and converted by James Lackington, the celebrated bookseller, into the 'Temple of the Muses,' one of the largest and most popular bookshops of the day. Caslon III started again in the old quarters in Dorset Street.

Another letter-founder having an undoubted connection with Halesowen was Isaac Moore, who is first heard of as manager of the type-foundry established in Bristol by Fry and Pine in 1764. Joseph Fry, a promising and enterprising Bristolian, was the son of John Fry, and was born in 1728. He entered the medical profession and, we are told, soon secured a large practice amongst the highest class of his fellow citizens. He took a part in many new scientific undertakings and his enterprising spirit induced him in 1764 to turn his attention to letter-founding which, though it was scarcely a new scientific undertaking, was certainly a novel enterprise for a provincial city. Baskerville's activity at Birmingham was undoubtedly an incentive to Fry and Pine at Bristol, whose first founts were avowedly cut in close imitation of the Baskerville models.

William Pine, Fry's partner, was a practical printer from 1753, of some note in his native city, for he was the first printer of the *Bristol Gazette*, and carried on a considerable business at his premises in Wine Street. The new foundry was attached to his office, and its productions may be traced in several works which issued from his press between 1764 and 1770. Rowe Mores informs us that Fry and Pine's manager was one Isaac Moore who was originally an ingenious whitesmith of Birmingham before he removed to Bristol. The practical superintendence of the foundry, if not the actual cutting of its punches, devolved on him, we are told, and his services appear to have been acknowledged by his admission into the partnership at an early stage of the undertaking, the business being carried on in his name.

Rowe Mores' ascription of Isaac Moore to Birmingham can

have been only approximate; anyone born within a few miles of the town might easily in the imprecise manner of the time be regarded as near enough to be a native. As a single example, Jane Webb (1807–1858), the horticultural writer and authoress of *The Mummy, a Tale of the Twenty-second Century,* who became the wife of J. C. Loudon the landscape gardener, was born at Bartley Green, then part of Halesowen, but is often described as belonging to Birmingham.

Several families named Moore lived on the Birmingham side of Halesowen. Between 1686 and 1725 there are thirteen entries relating to Moore which include the name Isaac. Robert and Mary Moore of Ridgacre, John and Sarah Moore, Isaac and Mary Moore of Ridgacre, Isaac and Ann Moore of Ridgacre, Thomas and Margaret Moore of Warley Wigorn, and Richard and Martha Moore of Cradley, each had a son whom they christened Isaac. The popularity of the name can be ascribed to the prominence of a 'Mr' Isaac Feldon of Warley Wigorn who was buried in 1715, one of a family connected with the Jessons, noted ironmongers (that is, ironmasters) at that period.

In 1722 Isaac Moor of Warley, Worcestershire (that is Warley Wigorn, part of Halesowen), migrated to Birmingham,[5] and though we do not know what trade he followed, there seems little doubt that he was the father of Isaac Moore, the future partner of Fry and Pine at Bristol.

Moore issued his first specimen at Bristol in 1766, but by 1768 he had removed the foundry to London, for in the Sohmian Collection at Stockholm there is a broadside *Specimen by Isaac Moore and Co. in Queen Street, near Upper Moorfields, London,* showing the roman series from five-line to Brevier, bearing the same date. Two years later, the progress of the undertaking was shown by the issue of a fresh broadside sheet containing the complete series of romans, cut after the Baskerville models, from eight-line to Pearl, with italics to most of the founts, besides a fair display of flowers. The general appearance of the letters is elegant, say Reed-Johnson,[6] especially in the larger sizes.

Appended to the specimen, in the form of a postscript, is the following address to the public, in which the proprietors announce the principles on which their venture is to be conducted, and refer

with satisfaction to the success already achieved by their productions :

'The Proprietors of the above Foundery having nearly compleated all the Roman and Italic Founts, desire with great Deference, to lay this Specimen before the Trade ; and intreat the Curious and critical, before any decisive Judgement be passed, on the Merits or Demerits of the Performance, to make a minute Examination and Comparison of the respective letters and founts of each size, with the same Letters and Founts of the most respectable Founders in the Kingdom ; For as all Letters, whether Roman or Italic, bear a great Similitude to each other, to apprehend the peculiar Beauty or Deformity of them are only to be discovered by such a Comparison. In making which they hope the candid and Judicious will set aside the influence of Custom and Prejudice (those Great Barriers against Improvement) and attend to Propriety, Elegance and Mathematical Proportion. And as these have been objects particularly attended to in the Course of the Work, they apprehend it will appear on such a Disquisition, that all the above sizes bear a greater Likeness to each other, than those of any other Founder. They have been already favoured with the Encouragement and Approbation of several very respectable printers, who have wrought off many large Editions on their Founts, which have been Experienced to wear extremely well ; owing to the Letter being clearly and deeply cut and to the Goodness of the Metal, which they make of an Extraordinary Composition ; the Singular Advantage of which cannot but be obvious. Therefore hope that others will likewise make Trial of them, as they doubt not but they also will find it greatly to their Satisfaction.'

It is evident that in referring to the composition of the metal Isaac Moore's former experience was being utilized. It is doubtful, however, whether the encouragement accorded to the new foundry came up to the expectations of the proprietors, for we find from a circular issued shortly afterwards by two of the partners that some fillip was deemed necessary to awaken a more extended patronage. This curious document is entitled *Proposals for dis-*

covering a very great Improvement which William Pine, printer of Bristol, and Isaac Moore, Letter Founder, in Queen Street, Upper Moorfields, London, have made in the Art of Printing, both in the Construction of the Press and in the Manner of Beating and Pulling, and publicly offers the secret of the invention to any customer of the new foundry ordering type to the value of ten pounds and upwards.[7]

The precise nature of this invention does not appear, nor is it recorded how far this ingenuous offer had the effect of stimulating the type business. It was not long, however, before the proprietors were forced to recognise the necessity for adopting other and surer methods for gaining the public favour, for there was then a growing prejudice amongst London printers against the Baskerville form of letter and it became evident that if the proprietors were to retain public favour at all, it must be by adapting themselves to public taste and abandoning the models of Baskerville for the more serviceable, dashing characters of Caslon. This costly and laborious task occupied several years. during which time the original founts continued in use.

Among the productions of the printing-office connected with the foundry at this time were two highly interesting Bibles, the one a folio, published in 1774, and the other an octavo, in five volumes, published in 1774–6. The general appearance of the folio edition may be compared not unfavourably with the Baskerville Bible of 1772.

In 1774 Pine printed at Bristol a very neat Bible in the Pearl type of the foundry, 'being,' according to the preface, 'the smallest a Bible was ever printed with, and made on purpose for this work.'

Moore's connection with the business appears to have terminated in 1776, after which the style of the firm became J. Fry & Co. In 1782 Pine had also withdrawn from the business. He continued to print the *Bristol Gazette* in Wine Street until his death in 1803 at the age of 64.

The further history of the Frys does not concern us here and, indeed, only a little more can be added to the account of Isaac Moore. In 1777 appeared James Kenton, *An Essay on Death. Printed and sold by I. Moore, letter founder and printer, No. 43 Drury*

Lane. In 1785, Moore is still entered as a letter-founder, in Drury Lane, in Pendred's *Printers' Vade Mecum*. There was also a Joseph Moore, probably a relation, later J. Moore & Son, at No. 134 Drury Lane, styled letter-founder, in Holden's *Directory*, from 1799 until after 1820.

We have almost reached the end of these annals of William Caslon, the greatest artist in letters English typography has so far seen. Beginning in 1560 with the earliest known reference to the Caslon family in West Midlands parishes, its representatives are traced through ninety years in the Worcestershire parish of Beoley, then with the arrival in Halesowen of the typefounders' grandfather during the period of the Commonwealth the account gathers greater certainty and detail, until in 1693 William Caslon himself enters upon life's scene. Every aspect of Caslon's life which painstaking research has been able to reveal has been exposed to view, the contemporary record of his native place, his associates and connections in youth and manhood, his apprenticeship and his various occupations before and after his rise to fame, his London connections and professional career, his family and social interests, together with a detailed discussion of his technical accomplishment in the large number of founts for which he was personally responsible. Then with less detail, the performance of his immediate successor, his apprentices and followers, especially those having West Midland connections, have been considered, with incidental reference to Caslon's relations who, though practising in other branches of visual art, manifested some of the Caslon talent.

As stated in Chapter I, the earliest known parish register entry concerning the Caslons occurs at Kinver, and in bringing this account to a close it will be appropriate to quote from a quaint entry on the fly leaf of one of the registers of that same parish concerning a Kinver incumbent named Jonathan Newey who was the minister for over fifty years, which reads: 'Jonathan Newey was never remembered by me—R. Bate.' We have reached a time when none of the punch-cutters at work had any memory of Caslon I. Moreover, the fashion of the trade was changing and the operations of the type foundry were not conducted in such secrecy as in the time of Thomas James and William Caslon. The testimony of

Vincent Figgins II, writing in 1855,[8] illustrates again the mystery once attaching to the art of type-founding:

'The mystery thrown over the operations of a Type foundry within my own recollection (thirty-four years), and the still greater secrecy which had existed in my father's experience, testifies that the art had been perpetuated by a kind of Druidical or Masonic induction from the first. An anecdote of my father's early struggles may illustrate this. At the death of Mr Joseph Jackson, whom my father had served ten years as apprentice and foreman, there was in progress for the University Press of Oxford a new fount of Double Pica Greek, which had progressed under my father's entire management. The then delegates of that Press—the Rev. Dr. Randolph and the Rev. W. Jackson—suggested that Mr Figgins should finish the fount himself. This, with other offers of support from those who had previously known him, was the germ of his prosperity (which was always gratefully acknowledged). But when he had undertaken this work, the difficulty presented itself that he did not know where to find the punch-cutter. No one knew his address; but he was supposed to be a tall man, who came in a mysterious way occasionally, whose name no one knew, but he went by the *sobriquet* of '*The Black Man.*' This old gentleman, a very clever mechanic, lived to be a pensioner on my father's bounty—gratitude is, perhaps, the better word. I knew him, and could never understand the origin of his *sobriquet*, unless Black was meant for dark, mysterious, from the manner of his coming and going from Mr Jackson's foundry.'

It will be seen that when typefounders no longer cut their own letter-punches, the cutter became an anonymous mechanic. Richard Austin, who worked as a punch-cutter from 1786, serving first John Bell, then Simon and Charles Stephenson at the British Letter Foundry, and finally began a foundry of his own about 1819, says in the preface to his specimen of that year that one reason for the faults in the new modern faces was because the founders themselves no longer cut punches.[9]

[1] Foster, Alum. Oxon.

[2] Nichols, Lit. Anec. ii, 358.

[3] Foster, Alum. Oxon.

[4] 1792, p. 166.

[5] R. A. Pelham, The Immigrant Population of Birmingham, 1686–1726. Trans. Birm. Arch. Soc. Vol. LXI, 1937.

[6] P. 299.

[7] See Abridgments of Specifications for Printing, 1617–1857, London, 1859, p. 88.

[8] Remarks appended to Vincent Figgin's facsimile reprint of Caxton's 'Game of the Chesse.'

[9] Reed-Johnson, p. 331.

Appendix One

TYPE-SET, ENGRAVED AND PUNCHED-PLATE MUSIC

WILLIAM CASLON'S MUSICAL interests are so well-known that it is a matter of surprise that no suggestion has been made that he might actually have cut music punches early in his career, especially as one of his early patrons, John Watts, was a printer of plays and ballad operas, and the printing of music from punched pewter plates was in vogue early in Caslon's life-time. It will not be out of place, therefore, to present a short review of music-printing in this country, dealing only very briefly, however, with developments outside Caslon's period.

The first instance of English music printing is very insignificant. In 1482 Caxton printed a book, *Higden's Polychronicon*, which required a certain music illustration of eight notes. He left a space for this and had it filled in by hand. Some copies were missed, so the space remained blank. Thirteen years later the book was republished by Wynkyn de Worde, and he ingeniously made up the short stretch of stave by the use of ordinary printers' 'rules,' and for the notes used the square under-surface of ordinary type, that is, he turned pieces of letter-type upside down, using the print of the square bottom as a note.[1] Pierre Attaignant of Paris was the first to print the words of vocal music under the notes to which they belonged.

English music printing and publication were hindered during the late sixteenth and early seventeenth centuries by being created a monopoly. Queen Elizabeth conferred the sole right of

music printing and importing, for twenty-one years, on two of her Gentlemen of the Chapel Royal, Byrd and Tallis. During the Commonwealth a new and vigorous period of both vocal and instrumental music opened. In 1651 John Playford published *The English Dancing Master*, remaining from this time until 1686 the most important music publisher in England. Playford was not a printer or engraver himself, his music being printed by Thomas Harper from 1650 to 1655 and by William Godbid from 1658 to about 1679. John Playford, nephew of John the publisher, was apprenticed to Godbid, and after Godbid's death young Playford and the widow Anne Godbid printed for the elder Playford until about 1683, afterwards the nephew alone printing his uncle's publications. Henry Playford, son of John the elder, followed his father in the publishing business (of which he was given control with Richard Carr in 1684) until 1707, using as his printers John Playford the younger in 1685, Charles Peregrine in 1687, Benjamin Motte in 1687, Edward Jones from 1687 to 1697, John Heptinstall from 1692 to 1698, and William Pearson from 1699 to 1707. The publications of John and Henry Playford, with very few exceptions, were printed from movable type, examples of the few engraved works being Henry Purcell's *A Choice Collection of Lessons for the Harpsichord or Spinnet*, 1696, and *The A'la mode Musician*, 1698.[3]

In the printed works of the Playfords, as a rule, each note with its portion of the stave was printed separately from rather crude type, no attempt being made to set the type so as to give continuous stave lines, all quavers and semi-quavers being separately printed and, if necessary, tied with a semi-circular slur, the heads of the notes being lozenge-shaped. The 'tied note' was not an English invention, but had been in use on the Continent for about forty years when Thomas Moore of London introduced it in 1681. It was used in *Vinculum Societatis or the tie of good company. Being a Choice Collection Of the Newest Songs now in Use*. Printed by F. Clarke, T. Moore, and J. Heptinstall, for John Carr and R. C [arr], 1687. In their prefatory address 'to all true lovers of musick,' John Carr and R.C. 'thankfully acknowledg the kind reception our labours have hitherto found from the Ingenious, and the good natur'd; by which we have been so far

encouraged, as yet to add One (Ornament at least) to our many former Attemps, and that is, this new Character of the Notes of the Songs in this Book, less troublesome to the Eye, than those of the Old Way, which (if acceptable) will add fresh vigour to our future industry . . .' In this work, the type of which was a great improvement on that used for the Playfords, not only were the notes tied and the heads oval, but the breaks of the staves were not so obvious.[4] John Heptinstall was active as a printer in London between 1671 and 1712. In 1713 he contributed four guineas to the Bowyer relief fund. Dunton spoke of him as a 'modest humble man, and very ingenious in his calling' and who made 'the best ink for printers of any man in London'.

William Pearson carried out further improvements in the use of tied notes with oval heads when he published *Twelve New Songs* by Blow and others in 1699, 'chiefly to encourage' his 'New London Character,' which he also used for the later Playford song-books. Pearson can be considered one of the best music printers of his time, and the quality of his workmanship did much to establish the style of musical typography.[5] In an address 'To All Masters and Encouragers of Music,' Pearson makes high claims for his new type. 'What I have to say to the rest of the World is this : That the Charge of this New Character, will be much easier, than what is possible to be done on copper ; and I leave the Note next to the Masters Opinion, so to speak for it self : And as the Noble Art is now more Flourishing than ever, and spreads it self into foreign parts from our Nation, yet by the general false Writing and the clearness of Engraving, with the mean collections of some others ; the Honour of our English Composers is darkned . . .' Pearson's work can be seen in *Orpheus Britannicus . . . The Second Book*, which he printed 'For Henry Playford,' 1702. The matrices of the type are in the collection of the University Press, Oxford.[6]

While these developments were taking place in London, a Dutch punch-cutter named Peter Walpergen (or Walperger) was producing music-type at Oxford. Walpergen, who was a letter-founder as well as a punch-cutter, had been brought over at the instance of Bishop Fell in 1676 and is known to have printed in 1672 at Batavia in the East Indies a Portuguese version of *Æsop's*

Fables.[7] Impressions of Walpergen's music type appear in the University 'Specimen' of 1695.

In 1698 Leonard Lichfield the Oxford University printer issued in folio *Musica Oxoniensis, a collection of songs for One and Two voices, with the Thorough-Bass*, 'published by Francis Smith, and Peter de Walpergen letter-founder, by whom 'twas cut on steel and cast, by the directions of the former.' In a dedication to Thomas Hinxman, Esq., of Trinity College, Oxford, Smith and Walpergen write that 'the following sheets, being the first of this kind that have been published, we make bold to recommend them to the world, by prefixing your name to them . . .'

In a notice 'to all Lovers of Music,' printed in a splendid italic, they say : 'The character with which all music has been as yet printed, not being comparable to that which is generally written ; we have been induced to consider of a new way, how any music may be printed, so as to be more convenient and more beautiful than any yet publish'd, if not equal to any in manuscript. Whether the effect has answer'd the design, we leave to the censure of those, who will, without prejudice, compare this specimen with any printed music ; and we doubt not but the neatness of the character, the regularity and evenness of the lines, the natural division of the several syllables to their proper notes, etc. will easily be seen ; and the great expense and trouble, we have hitherto been at, be in some measure rewarded by a candid reception and encouragement.'

And at the end : 'If any person has a valuable collection of music, and is willing to have it printed with this character, if it be sent to our printer, it shall be carefully and correctly done.'[8]

Although the appearance of the music is as elegant as the originators claimed, their character made little headway. The notes were the shape of upright and inverted candle-flames, both white and black, having tapered stems which were thinnest at the base of the flame. The punches and matrices of this interesting fount are still preserved at Oxford, and are singular relics of the old letter-founders' art. Walpergen died in 1714.

The earliest extant music printing in the U.S.A. appeared in the ninth edition of the *Bay Psalm Book* which was printed in Boston in 1698, by B(artholomew) Green and J. Allen, for Michael Perry, under 'the West-End of the Townhouse.' It

'includes a selection of thirteen psalm-tunes in two-part arrangements and a few rudimentary instructions for their proper performance.' There is some evidence to suggest that there was an earlier 'as yet unlocated edition of the *Bay Psalm Book* containing music.' There has been considerable difference of opinion about the methods used to print the music, but it is now generally accepted that it was taken from wood blocks.[9]

Whilst musical typography was making such progress as has been here described it was always having to compete with the use of engraved plates. The reproduction of music by this method actually proved the more successful down to the lithographic processes of the nineteenth century. Music was first engraved by Simon Verovio at Rome in 1586, and engraved music first appeared in England in Gibbon's *Fantasia for Viols* dated 1606 and 1609, and other madrigals of English composers from 1590 to 1620 were all so printed. The plates in *Parthenia*, 1611, were engraved by William Hole. These two methods of music printing persisted side by side until the second half of the seventeenth century when the increasing complexity of musical composition made it difficult to reproduce it by means of separate small pieces of metal, so that the engraving method secured a pronounced lead. It proved easier to use a set of punches for the many different musical signs than to fit these signs together in the form of loose type, and a more uniform and sightly effect was produced by good workmen both on plates which were wholly engraved and on plates which were partly engraved and partly punched. Some musicians engraved their own music as, for example, J. S. Bach (1685–1750) and his contemporary G. P. Telemann (1681–1767).[10]

So far as is known, music was first printed in America in 1690 from plates imported from England and the first music engraver there was Paul Revere as late as 1764.[11]

In 1710 John Walsh the elder (working 1692–1736) and John Hare (working 1695–1725) are said to have introduced to England the method of printing music from punched pewter plates. The practice of stamping the notes is said to have originated with Estienne Roger (died 1725), of Amsterdam, who was established before the end of the seventeenth century and whose music

was engraved on copper. According to Hawkins, Dutch artificers 'contrived by some method, which to others is yet a secret, so to soften the copper, as to render it susceptible of an impression from the stroke of a hammer on a punch, the point whereof had the form of a musical note.'[12]

Thomas Cross (flourished 1683–1733) was the son of Thomas Cross (flourished 1632–1682) a line engraver of portraits who is also credited with introducing sheet-music engraved on copper. Thomas Cross the younger is said to have been the first to engrave music on the softer pewter and almost maintained a monopoly in the publishing of engraved music. He set a standard of artistic workmanship that was rarely equalled by his contemporaries and successors. In 1683 Cross junior engraved an edition of Purcell's *Sonatas in four Parts for the Harpsichord*. To Dr. Blow's *Amphion Anglicus*, 1700, there are prefixed some verses by Henry Hall, organist of Hereford Cathedral, in which occur the lines—

'While at the shops we daily dangling view
False concord by Tom Cross engraven true ;'[13]
and again in some verses prefixed to Purcell's *Orpheus Britannicus*, 1701—

'Then honest Cross might copper cut in vain.'[14]

Walsh and Hare are credited with combining the advantages of Dutch technique and Cross's innovation. They punched the notes into the softer pewter plates and engraved the other details, staves, ties, etc., by hand, which resulted in the quicker and cheaper production of plates. This development caused alarm amongst the engravers. Thomas Cross engraved on one of his sheets 'Beware of ye nonsensical puncht ones. Cross Sculp.'[15]

In 1724, William Croft (1678–1727), then 'Organist, Composer and Master of the children of His Majesty's Chapel-Royal, and Organist of St. Peter's, Westminster,' published by subscription in two volumes folio *Musica Sacra: or Select Anthems in Score, consisting of 2, 3, 4, 5, 6, 7, and 8 Parts: To which is added, The Burial-Service, as it is now occasionally performed in Westminster Abbey*. It was printed for and sold by John Walsh.[16]

In the preface to the first volume the composer claims that his work was 'the first essay of publishing Church Music in

England after the manner of printing wherein this performance is done,' namely, in Score. It was 'not for want of excellent compositions in church music' that so few of them had been made public in score : 'But for want of the art of regularly placing and ranging the notes, a nicety which the old way of printing would not admit of. The old music (especially that which consisted of divers parts, as three parts, or more) was printed in, and performed from single parts, allotted to each performer by himself : in which way of printing them, their performances were liable to great uncertainty ; and besides (for want of marking out their music properly by bars) great mistakes were committed, both in their written and printed copies, which not being easily reconciled for want of a score, some excellent compositions have been rendered useless . . .' '. . . it must necessarily follow, that this new way of conveying the same to posterity, by printing it in a complete score will greatly tend to the improvement and advantage of music in general ; which art of printing by the indefatigable industry of our present undertaker, is brought to much greater perfection in England than in any other part of Europe ; the manifold advantages whereof may best be known, and will be most effectually explained by the use and practice of it.' Croft then goes on to explain the musical advantages of publishing in score. Croft was granted a 'Royal licence for the sole printing and publishing of the said anthems for the term of fourteen years.'[17]

John Watts (1678 ?–1763). whose name is linked with William Bowyer the elder and his step son-in-law James Bettenham as an early patron of Caslon, has not been given a place in the D.N.B. He was the son of William Watts of St. Martin-in-the-Fields and served an apprenticeship of seven years to Robert Everingham, after which, in 1707, he was made free of the Stationers' Company but never became a liveryman.[18] Watts' printing office was on the south side of Wild Court, a turning out of Great Wild Street, near the western end of Great Queen Street, in Lincoln's Inn Fields. Sir Godfrey Kneller (1648–1723) lived there and it was in the same street in 1711 that he established the first drawing academy in England. Next door lived Dr. John Radcliffe, founder of the Radcliffe Library at Oxford. In 1690, in the same street, was born Sir Martin Ffolkes, who became the

first President of the Society of Antiquaries. Nearby Duke Street, later called Sardinia Street, is rendered famous from its having been inhabited by Benjamin Franklin when he was a journeyman printer in Watts' office. Franklin's lodging, as he tells us himself, was at the back of an Italian Warehouse, where he paid 3/6d. a week, later reduced by his landlady to 2/- per week.[19]

Watts' was one of the most important printing houses in London in the first half of the eighteenth century, a school in which several eminent printers learnt their art. Among those who worked in his office, besides Franklin, were Thomas Gent of York and Chalmers, father of James Chalmers, printer to the city of Aberdeen. Some of the works printed by Watts in partnership with Tonson and illustrated by Elisha Kirkall have been already noted. Nichols[20] mentions the duodecimo editions of Maittaire's Classics 'ex officina Jacobi Tonson et Johannis Watts,' saying they alone would have been sufficient to immortalize his memory, both for correctness and neatness. But there are works of still higher importance, Clarke's *Caesar* for example, and several beautiful works of English classics. In the field of music publishing Watts issued works on engraved plates as well as on wood blocks. Watts' *The Musical Miscellany*, 6 vols. 1729–31, and John Sadler's *The Muses Delight*, 1754, are splendid examples of the wood block method, which was also used for some of the music of the ballad operas, in literary magazines and in some psalm-books.[21] The introduction of the ballad opera at Lincoln's Inn Fields Theatre brought Watts a brisk trade in the publication of the operas performed there. He published the first and later editions of *The Beggars Opera*, 1728, (music engraved) and after this practically the whole of the ballad series as they were performed. Airs for the songs in the opera printed from engraved wood blocks are especially valuable for giving the old names of the tunes.[22] Watts died in 1763 at eighty-five years of age.

The Lincoln's Inn Fields Theatre stood on the dividing-line of the parishes of St. Giles-in-the-Fields and St. Clement Danes, and it seems certain, even if no written records have survived, that William Caslon, with his artistic background, musical interests and social qualities, knew many of the celebrities of his time. The possibility cannot be disregarded that Caslon might have obtained

433

some backing through these social interests as well as through his trade connections.

There is an interesting reference to Caslon[23] which may be a clue to his becoming acquainted with Watts. Heckethorn says, with reference to Clement's Inn, 'The Inn has not been without distinguished inhabitants. Caslon, the great type-founder, lived there.' The source of this statement is not given, nor has it so far been traced. Caslon's various places of residence from his settling in Vine Street to his retirement to Bethnal Green seem to be well documented, so if he lived in the neighbourhood of Clement's Inn, one presumes it was early in his career. The registers of St. Clement Danes, however, yield no mention of the name in the years 1717 to 1720, when an earlier child than William Caslon II might have been baptized and buried.

Returning to an account of music printing, in January, 1737, George Bickham, junior (died London, 1758), began to issue in folio *The Musical Entertainer*, the first and the finest of the English illustrated song books. The work was issued in parts, each part containing four songs. Every song (occasionally with an instrumental part) was embellished with a picture, sometimes simple, sometimes elaborate, reflecting the mood of the words and music, or illustrating the action and the physical setting in which it took place. Altogether 200 songs were published in this way before the work was completed in December, 1739. The words, music and decoration were all engraved by Bickham and each plate was laid out with rare skill and taste. The parts were collected into two volumes : Vol. I, printed for and sold by George Bickham, and Vol. II, printed for C. Corbett.[24] In 1766 George Bickham senior was a candidate for the post of Drawing-Master at Christ's Hospital when Benjamin Green was appointed.[25]

Despite the popularity of printing music from engraved plates and wood blocks in the first half of the eighteenth century, music printing from movable type had never completely died out and it took a new lease of life at the middle of the century. In 1754 J. G. I. Breitkopf (1719–1794), of Leipzig succeeded in casting a music-type, in which the notes were composed of several pieces. Hitherto, music had been set up by using sorts on which a note head, stem and stave lines were all cast together. A melody was

composed by assembling in the correct order the required note and other symbols, such as sharps, flats, naturals, rests, repeats, clefs and time values. When the type was new and well set the result was often agreeable, but the joins between the sorts were usually all too visible. Breitkopf looked at music as a pattern and saw that it could be broken down into a grid of intersections, forming cells in which the sides derived from stave lines and parts of note stems and bar lines. He cast these intersections as separate pieces of type and devised related note heads and tails and all other necessary symbols to work with them. These pieces were then 'built up' by the compositor. Although Breitkopf's method was not widely adopted, he gave an impetus to further improvements in printing music from type.[26]

J. M. Fleischman cut an improved music type on the same principle for the Enschedes at Haarlem. J. F. Rosart (1714–1777) of Brussels, and P. S. Fournier (1712–1768) of Paris, succeeded in reducing the number of pieces of a fount to 300 and 100 respectively.[27]

Henry Fougt (1720–1770), described by Hawkins as a native of Lapland, established himself as a music printer and publisher in London and obtained a patent for his improved types in 1767, having previously worked in Sweden and invented a system of sectional types which divided so as to admit the staff lines, working on similar lines to Breitkopf. Fougt used his types for sheet songs and other music, selling at a penny a page, or eighteen pages for a shilling. About 1770 his plant was bought and the business continued by Robert Falkenor. The principal improvements after Fougt's time aimed at overcoming the hiatus caused by the joining of the lines. Attempts were made to cast the notes separately from the lines, or to adopt a logographic system of casting several notes on one piece. After the beginning of the nineteenth century the production of music-type was left in the hands of specialists, amongst whom Hugh Hughes, as late as 1841, had the reputation of possessing the best founts in the trade. Of the plain chant and psalm music, both Dr. Fry and Hughes had matrices in several sizes while, since about 1820, the London firm of Clowes has been noted for its artistic use of music type.[28]

In 1796 Alois Senefelder (1771–1834), a German actor and

dramatist, wishing to reproduce his own plays, invented the lithographic process of printing from stone, and this method was soon applied to music printing, which, with technical improvements such as the use of metal plates and photography, remains the popular method today. The fact that, despite lithography, type is still in use for certain kinds of work is due to the introduction of stereotyping, the process of first setting in type and then casting a metal block from it. Thus the actual type is not used in the press and hence does not suffer damage ; moreover, it does not need to be put aside and to remain useless until the demand arises for another edition. The saving effected in these two particulars makes it possible to use highly finished and expressive type and thus to obtain far better results.[29]

[1] Scholes, The Oxford Companion to Music, O.U.P., 1938.

[2] Ibid.

[3] Grove, Dictionary of Music and Musicians, ed. Eric Blom, Vol. VI, 1954.

[4] Ibid.

[5] Humphries and Smith, Music Publishing in the British Isles, 1954.

[6] Berry and Poole, Annals of Printing, 1966.

[7] Copies in the Bodleian Library and British Museum.

[8] Berry and Poole, Annals of Printing.

[9] Music and Musicians in Early America, Irving Lowens, N.Y., 1964.

[10] Scholes, The Oxford Companion to Music.

[11] Ibid.

[12] Berry and Poole, Annals of Printing.

[13] D.N.B. art. Thomas Cross.

[14] Ibid.

[15] Berry and Poole, Annals of Printing.

[16] Ibid.

[17] Ibid.

[18] Records of the Stationers' Company.

[19] C. W. Heckethorn, Lincoln's Inn Fields, 1896.

[20] Literary Anecdotes of the Eighteenth Century.

[21] Grove, Dictionary of Music and Musicians, Vol. VI.

[22] Oxford History of Music, Vol. IV, 1902.

[23] C. W. Heckethorn, Lincoln's Inn Fields, p. 129.

[24] Berry and Poole, Annals of Printing.

[25] Archives of Christ's Hospital.

[26] Berry and Poole, Annals of Printing.

[27] Ibid.

[28] Ibid; also Grove, Dictionary of Music, and Scholes, Oxford Companion to Music.

[29] Scholes, Oxford Companion to Music.

Appendix Two

CASLON'S MUSIC CONCERTS

'Such sweet compulsion doth in music lie'—Milton.

IN ENGLAND, MORE than in most countries, musical activity has centred in the metropolis, so that London is full of memories of the music-making of nearly four centuries. Of our great Elizabethan school of composers, nearly all lived and worked, and many died, in London. Thomas Tallis (1510–85), whose preces and responses are still in daily use in the English Church, was organist of Waltham Abbey, later of the Chapel Royal, and was buried in Greenwich Church. William Byrd (1583–1623), generally accounted the greatest Elizabethan, was joint organist with Tallis of the Chapel Royal, and was buried near Ongar n Essex. Thomas Morley (1557–1604), madrigalist, was a Londoner, a gentleman of the Chapel Royal, and one-time organist of St. Paul's Cathedral. John Dowland (1563–1626) was a native of Westminster and had a continental reputation as lutenist and song-writer. John Bull (1563–1628), the first professor of music at Gresham College, also had a European reputation as a keyboard composer and virtuoso. Orlando Gibbons (1583–1625), gentleman of the Chapel Royal and organist of Westminster Abbey, died on a visit to Canterbury and was buried in the cathedral. Henry Lawes (1595–1662), friend of Milton and composer of the original music to *Comus*, is buried in the cloisters of Westminster Abbey.[1] Our greatest composer, Henry Purcell (1658–95), served the abbey in turn as chorister, copyist, and organist, and is buried in its precincts. Near

him is also his master, John Blow (1648–1708). In the north aisle, or the cloisters, are buried the succession of organists who served the abbey in their generation, from William Croft (1677–1727) to Sir John Frederick Bridge (1844–1924), who was a native of Oldbury, a parish which was part of Halesowen until the boundary changes of 1844.[2]

The Worshipful Company of Musicians of London was incorporated by letters patent of James I in 1604, being the successor of a gild of minstrels of London first heard of in 1350. The Company may therefore claim the continuous existence of bodies controlling the performance, practice and teaching of music from the days of early minstrelsy and through the trade gilds for at least five hundred years. Such control is evidenced in the following warrant :[3]

28 June, 1699.

'Warrant to apprehend George Smyth, Francis Pendleton, Mosse, Caesar Duffil, and Josiah Priest, for teaching, practising, and executing music in companies or otherwise, without the approbation or lycence of the Marshall and Corporation of musick, in contempt of His Majesty's authority and the power granted to the Marshall and Corporation.'

Sir John Hawkins refers to Josiah Priest, as follows :—

'In the pamphlet, so often referred to in the course of this work, entitled *Roscius Anglicanus*, or an *Historical View of the Stage*, written by Downes the prompter, and published in 1708, we have an account of several plays and entertainments, the music whereof is by that writer said to have been composed by Purcell. It does not appear that he had any particular attachment to the stage, but an occasional essay in dramatic music drew him into it. One Mr. Josias Priest, a celebrated dancing-master, and a composer of stage dances, kept a boarding school for young gentlewomen in Leicester-fields ; and the nature of his profession inclining him to dramatic representations, he got Tate to write, and Purcell to set to music, a little drama called *Dido and Æneas*; Purcell was then of the age of nineteen, but the music of this opera had so little appearance of a puerile essay, that there was scarce a musician in England who would not

have thought it an honour to have been the author of it. The exhibition of this little piece by the young gentlewomen of the school to a select audience of their parents and friends was attended with general applause, no small part whereof was considered as the due of Purcell.

'At this time Bannister and Lock were the stage composers; the former had set the music to Dr. D'avenant's opera of *Circe*, and the latter to *Macbeth*; but the fame of *Dido and Æneas* directed the eyes of the managers towards Purcell, and Purcell was easily prevailed on by Mr. Priest to enter into their service. He composed the music to a variety of plays mentioned in Downes's account, of which the following is an abstract:—

' "*Theodosius*,[5] *or the Force of Love*, written by Nat. Lee, the music by Mr. Henry Purcell, being the first he ever composed for the stage. *King Arthur*, an opera written by Dryden, the musical part set by Mr. Henry Purcell, and the dances composed by Mr. Josiah Priest. *The Prophetess*, an opera wriiten by Mr. Betterton, the vocal and instrumental music by Mr. Henry Purcell, and the dances by Mr. Priest. *The Fairy Queen*, an opera altered from the *Midsummer Night's Dream* of Shakespeare, the music by Mr. Purcell, the dances by Mr. Priest".'

Hawkins extends the list further, but sufficient is here given to show at this period of reawakening of the arts in England, how poets, dramatists, composers of music, opera, and dancing, combined their talents, stimulating the movement as well as deriving inspiration from it. A similar combination of native and foreign talent in the field of visual art was preparing the stage for the great eighteenth-century revival of all the arts.

Samuel Pepys (1633–1703) makes frequent reference to music of the Restoration period in the London pleasure-gardens on the numerous occasions of his dining out, while Ned Ward (1667–1731), that disreputable author of the time of Queen Anne, tells us something of London music houses when Caslon was young.[6]

'A Description of a famous Musick House in Wapping.'

'As soon as we came to the Sign of the "Spiritual

Helmet", such as the High Priests us'd to wear when they bid defiance to the Devil, we no sooner enter'd the House, but we heard Fidlers and Hoitboys (Hautboys), together with a Hum-drum Organ, make such incomparable Musick, that had the Harmonious Grunting of a Hog been added as a Base to a Ravishing Concert of Catterwauling Performers, in the height of their Extasie, the unusualness of the sound could not have render'd it, to a nice Ear, more Engaging. Having heard of the Beauty and Contrivance of the Public Musick-Room, as well as other parts of the House, Very highly Commended, we agreed first to take a view of that which was likely to be most Remarkable. In order to which we Ascended the Grades, and were Usher'd into a most Stately Apartment, Dedicated purely to the Lovers of Musick, Painting, Dancing, and t'other things too. No Gilding, Carving, Colouring, or good Contrivance, was here wanting to Illustrate the Beauty of this most Noble Academy ; where a good Genius may learn with safety to abominate Vice ; and a bad Genius (with as much danger) to Practice it. The Room, by its compleat Order and costly Improvements, looks so far above the use its now converted to, that the Seats are more like Pews than Boxes ; and the upper-end, being divided by a Rail, looks more like a Chancel than a Musick-Box ; that I could not but imagine it was Built for a "Fanatick" Meeting-House, but that they have for ever destroy'd the Sanctity of the place by putting an Organ in it ; . . .'

Divesting this account of the exaggeration to which we know Ward was always prone, it still conveys a pretty good idea of the musical entertainment provided in those inns which when Caslon was young set out to provide more than drinking facilities. Ward also gives the words of *A Song against Music*, of which the Chorus runs as follows :—

'The Organ's but Humming,
Theorbo but Thrumming,
The Viol and Voice
Is but Jingle and Noise,
The Bagpipe and Fiddle

Goes Twedle and Diddle,
The Hoitboy and Flute
Is but Toot and Toot Toot,
Your Scales and your Cliffs, Keys, Moods, and Dull Rules,
Are fit to please none but Madmen and Fools.'

There was no charge for admission to these music houses, customers ordered what food and drink they liked and rewarded the musicians who had entertained them, or refrained, just as they felt inclined.

The practice of providing music concerts for the public at fixed prices and for money taken at the doors dates back no further than the end of the seventeenth century. The Music Feast on St. Cecilia's Day, 22nd of November, for which Dryden wrote his celebrated *Ode*, was held for nearly twenty years at Stationers' Hall, being last performed there in 1703.[7]

It is not known how Caslon first cultivated that interest in music which became so prominent a feature in his social life, but the fact that he installed an organ in his own house as early as the Ironmonger Row period, 1727 to 1737, suggests that his musical tastes were implanted early and that he actually played the organ. It has been already suggested that he might have played the organ at St. Botolph's, Aldgate, where there was a fine instrument bequeathed by Thomas Whiting. In the remoteness of his native Halesowen the most likely sources of musical inspiration and tuition were the church and the homes of the local gentry, of whom there could be very few who might aspire to owning an organ, but the musical activities and traditions of Halesowen when Caslon was young are lost in obscurity.

Thomas Walker, M.A., the vicar of Clent and Rowley from 1668 to 1719, had been a chorister of Magdalen College and usher of the College School when at Oxford. Naturally he took an interest in the musical side of his parish; one of the galleries was called the 'singing gallery' and during Walker's long incumbency the bells were re-cast. These two parishes, six miles apart, were combined as a single living until 1841, the vicar generally residing at Clent while a curate officiated at Rowley Regis. As we have seen, John Pearman of Clent was Caslon's co-apprentice, and his cousin, Sarah Pearman, also of Clent, was Caslon's first wife.

441

Caslon's mother was of Rowley Regis, but we have no knowledge that she maintained any continuous connection with her native parish after her marriage to George Caslon.

It will help to put Caslon's concerts in historical perspective if a short account is given of Thomas Britton (1654–1714),[8] the celebrated 'musical small-coal man.' Britton's premises were a stable in Clerkenwell, at the north-east corner of Jerusalem Passage, divided into two stories, the lower of which he used as his coal shop, while the upper formed a long low room to which access was gained by a ladder-like staircase from the outside. In these unpromising quarters, he established, in 1678, his celebrated musical club, the idea of which was encouraged by Roger L'Estrange, himself a good performer on the bass viol. Here on every Thursday for nearly forty years were held those remarkable concerts of vocal and instrumental music which are so curious a feature in the social life of the time. The greatest performers of the day, both professional and amateur, might be heard there. Handel played the organ (which had only five stops), Pepusch presided at the harpsichord, 'a Rucker's virginal, thought the best in Europe,' Banister played first violin, and John Hughes, Abel Whichello, J. Wollaston, and many other amateurs took part in the performances, while leaders of fashion like the Duchess of Queensberry were amongst the audience. But Britton's tastes were not confined to music alone. His knowledge of bibliography brought him into touch with Harley, Earl of Oxford, the Duke of Devonshire, and the earls of Pembroke, Winchelsea and Sunderland. Every Saturday throughout the winter these noblemen formed book-hunting expeditions in the city. Their meeting-place was at Christopher Bateman's in Paternoster Row, where they were often joined by Britton, who would appear in his blue smock and with a coalsack in his hand; for in spite of his literary and artistic tastes he continued until his death to sell coal in the streets of London.

Ned Ward was his neighbour and at Britton's death, Ward sold his music collection and his instruments by auction; his books to the number of about 1,400 were sold later. Britton's portrait was painted by his friend Wollaston, from which Thomas Johnson engraved in mezzotint, efforts which inspired the following lines[9]

by Matthew Prior, for Wollaston was not a great artist:

'Tho' doom'd to small-coal, yet to arts ally'd,
Rich without wealth, and famous without pride;
Musick's best patron, judge of books and men,
Belov'd and honour'd by Apollo's train;
In Greece or Rome sure never did appear
So bright a genius in so dark a sphere;
More of the man had probably been sav'd,
Had Kneller painted and had Vertue grav'd.

Prior scribbled these lines, we are told, with a view to recommending George Vertue, then a rising young man.

The John Hughes mentioned above was the author of the *Siege of Damascus*, and other performers at Britton's concerts were Philip Hart, Henry Needler of the Excise Office, Henry Symonds, Obadiah Shuttleworth, a fine player on the violin, and Mr Corbett.

On the death of Britton, some of those who frequented his concerts started similar enterprises.[10] Wollaston the portrait painter was, according to Hawkins, a sound performer on the violin and flute, though an indifferent painter. He gave concerts on Wednesday evenings at his house in Warwick-court, in Warwick Lane, Newgate-street, which were frequented by the best families in the city, especially Dissenters, and these continued till the establishment of the 'Castle concert' which had a successful career of many years at the Castle Tavern in Paternoster Row from 1724, begun a few years before that in the house of Talbot Young. Another venture was organised at the Angel and Crown Tavern in Whitechapel, where the performance was both vocal and instrumental; the performers here were Mr Peter Prelleur, then a writing-master in Spitalfields, but who played on the harpsichord, and afterwards made music his profession, and by study and application became so proficient as to be ranked among the first masters of his time. John Gilbert, a mathematical instrument maker, and clerk to a Dissenters' meeting in Eastcheap, and John Stephens, a carpenter in Goodman's-fields, both of whom had good voices, and who sang Purcell's songs, were also of the number.[11] It can be regarded as certain that Caslon attended this concert before establishing his own, for his master Edward

443

Cookes had his business in Whitechapel for some years.

J. A. Fuller-Maitland,[12] writing of Caslon's concerts, says they seem to have been more in the nature of musical clubs—analogous to the Italian *accademia*, than regular public concerts; but of the latter there had been instances in the 'great room' in York Buildings, from 1700 to 1720. We must, however, turn to Hawkins for the best account, which is contemporary.

Hawkins' well-known work[13] was published in 1776. Charles Burney's history appeared in the same year, a circumstance which inevitably led to unpleasant comparisons, but it is now recognised that Hawkins, though not so good a writer as Burney, was a more painstaking antiquary, and his book has achieved a more permanent value for students of musical history, though it is recognised that both works are of the highest value and form the foundation of nearly every English work on musical history which has appeared since.

The connection of Hawkins with Edward Cave and the *Gentleman's Magazine*, brought him the acquaintance of Dr. Johnson who, however, describes him as a 'most unclubable man.'[14] Although Hawkins was unpopular, harsh to his inferiors and obsequious to his superiors, he had compensating good qualities. In 1761 he was made a magistrate for Middlesex, declining to accept fees until he found that his generosity encouraged litigation, whereupon he took the money but gave it to the poor of the parish. As a magistrate he must have been well-acquainted with Caslon, who had been appointed to the bench about ten years before him; the account he gives of Caslon's chamber concerts can therefore be accepted as reliable; indeed, he probably had first-hand experience of Caslon's hospitality.

Following the account of Britton and the several musical clubs which were formed after his death, Hawkins continues,

'Others of Britton's friends accepted a hospitable invitation to the house of Mr. William Caslon, the letter-founder. This person had been bred to the business of engraving letters on gun-barrels, and served his apprenticeship in the Minories; but being an ingenious man he betook himself to the business of letter-founding, and by diligence and unwearied application, not only freed us from the necessity of importing types from Holland, but in the

beauty and elegance of those made by him surpassed the best productions of foreign artificers.

'Mr. Caslon meeting with encouragement suitable to his deserts, settled in Ironmonger-row, in Old Street, and being a great lover of music, had frequent concerts at his house, which were resorted to by many eminent masters ; to these he used to invite his friends, and those of his old acquaintance, the companions of his youth. He afterwards removed to a large house in Chiswell-street, and had an organ in his concert-room ; after that he had stated monthly concerts, which for the convenience of his friends, and that they might walk home in safety when the performance was over, were on that Thursday in the month which was nearest the full moon, from which circumstance his guests were wont humorously to call themselves *Lunatics*.

'The performers at Mr. Caslon's concert were Mr. Wollaston, and often times Mr. Charles Froud, organist of Cripplegate church, to whom whenever he came, Mr. Wollaston gave place, and played the second violin ; Mr. William De Santhuns, who had been an organist in the country,[15] and suceeded Mr. Prelleur as organist of Spitalfields ; Mr. Samuel Jeacock, a baker at the corner of Berkeley-street in Red Lion-street, Clerkenwell, and many others, who occasionally resorted thither. The performance consisted mainly of Corelli's music, intermixed with the overtures of the old English and Italian operas, namely, *Clotilda, Hydaspes,. Camilla,* and others, and the more modern ones of Mr. Handel. In the intervals of the performance the guests refreshed themselves at a side-board, which was amply furnished and, when it was over, sitting down to a bottle of wine, and a decanter of excellent ale, of Mr. Caslon's own brewing, they concluded the evening's entertainment with a song or two of Purcell's sung to the harpsichord, or a few catches, and about twelve retired.'

Sir John Hawkins gives us some further particulars of Samuel Jeacocke, one of the performers at Caslon's concerts,[16] in which he refers to the formation in 1741 by John Immyns, an attorney, of the Madrigal Society.

'Mr. Samuel Jeacocke, another member of this fraternity, was a man not less remarkable for singularities of another kind ; this man was a baker by trade, and the brother

of Mr. Caleb Jeacocke, now living, and who for many years was president of the Robin Hood disputing society. The shop of Samuel was at the south-west corner of Berkeley-street, in Red-lion street, Clerkenwell. He played on several instruments, but mostly the tenor-violin; and at the Madrigal Society usually sang the bass part. In the choice of his instruments he was very nice, and when a fiddle or a violin-cello did not please him, would, to mend the tone of it, bake it for a week in a bed of sawdust. He was one of the best ringers and the best swimmer of his time; and, even when advanced in years, was very expert in other manly exercises; he was a plain, honest, good-humoured man, and an inoffensive and cheerful companion, and, to the grief of many, died about the year 1748.'

The D.N.B.[17] gives the following further particulars of Caleb Jeacocke. Born in 1700, he carried on the business of a baker in High Street, St. Giles's, London, and became a director of the Hand-in-Hand fire office, and a member of the Skinners' Company. At the Robin Hood debating society, Butcher Row, Temple Bar, it is said his oratory often proved more effective than that of Edmund Burke and others who acquired celebrity in the House of Commons. To this society Goldsmith was introduced by Samuel Derrick[18] at a time when Jeacocke was president. Struck by the eloquence and imposing presence of Jeacocke, who sat in a large gilt chair, Goldsmith thought nature had meant him for a lord Chancellor. 'No, no,' whispered Derrick, who knew him to be a baker, 'only for a master of the rolls.'[19] Jeacocke died in 1786 in Denmark Street, Soho.

[1] William Kent, An Encyclopaedia of London, 1951.
[2] F. W. Hackwood, Oldbury and Round About, 1915.
[3] Scholes, The Oxford Companion to Music.
[4] History of Music, p. 745.
[5] The obvious source for the name of Theodosius Forrest (1728–1784), attorney and amateur artist, whose father was a friend of John Rich and Hogarth and an habitué of the theatre. See also D.N.B. art. Theodosius Forrest.

[6] The London Spy, 1703.

[7] Timbs, Curiosities of London, 1868, p. 421.

[8] D.N.B. art. Thomas Britton.

[9] Hawkins, History of Music.

[10] Ibid.

[11] Ibid.

[12] Oxford History of Music, 1902, Vol. IV.

[13] The General History of the Science and Practice of Music.

[14] D.N.B. art. Sir John Hawkins.

[15] William de Santhuns had been organist at St. Philip's Church, Birmingham.

[16] History of Music, p. 887.

[17] Quoting from Prior's Memoir of Edmund Burke, 1826, i. 127.

[18] Beau Nash's successor as master of ceremonies at Bath.

[19] Forster, Life of Goldsmith, 1888, i. 287–8.

Appendix Three

CHRONOLOGY OF CASLON'S ANCESTRY,
LIFE AND CONNECTIONS.

25 July, 1560 The earliest known entry of the Caslon name in West Midlands parishes: Kinver, Staffs.—'Denys Castelldon and Christobell Atkys, widdo, married.' This is the first marriage recorded in the Kinver register and names the probable ancestors of the typefounder.

1592 Edward Castledowne, son of Nicholas, probable grandson of Denys, baptised at Beoley; buried 1661 at Beoley.

1593 Denys Castelldon buried at Beoley.

1608 Edward Castledowne and Alice Carpenter, great-grandparents of the type-founder, married at Beoley, the bride being related to John Carpenter, the future cordwainer of Halesowen and to Thomas Carpenter of Stoke Prior.

7 Oct. 1654 William Castledowne, shoemaker of Halesowen, son of Edward Castledowne, yeoman, of Beoley, married Elenor, daughter of William Greene, whirler, of Belbroughton.

1654 Elizabeth, daughter of John and Jane Carpenter of Halesowen baptised, (married John Lea in 1676).

1655 William, son of William and Elenor Castledowne of Halesowen baptised (father of Samuel Caslon who became mould-maker to his cousin William and to George Anderton of Birmingham).

1655 Alice, daughter of William and Elenor Castledowne baptised, (grandmother of the artists, James, Amos and Benjamin Green).

1656 Adam Bell baptised at Stoke Prior (the future loriner who became master to William Caslon's master).

c. 1657 Jonathan, son of John and Jane Carpenter of Halesowen baptised.

448

1658 Joane, daughter of William and Elenor Castledowne of Halesowen, baptised.

1659 John, son of John and Jane Carpenter of Halesowen baptised. (He became B.A. Oxon, rector of Whitchurch, Warwicks, vicar of Broxted and rector of Checkney, Essex).

1661 Edward Castledowne, yeoman, of Beoley buried.

1661 George, son of William and Elenor Casteldowne of Halesowen baptised. (The typefounder's father).

1663 John Carpenter, cordwainer, of Halesowen, and Elenor Detheridge of Cakemore, married. (No issue known of this second marriage).

1665 John Carpenter elected a feoffee of the Free School.

1669 Edward Cookes baptised at Stoke Prior. (The future loriner who became William Caslon's master).

1674 George Casteldine, husbandman, of Beoley, buried, leaving by will £20 to brother William Casteldine of Hailes, to William's son George £10 and to his other children William and Jone Casteldine £5 each.

1675 William Shenstone (grandfather of the poet) of Halesowen and Elizabeth Pearman of Clent, married at Alvechurch. (She became aunt to William Caslon's first wife).

1676 Thomas Pearman, butcher, of Clent (brother to Elizabeth, above) and Mary Cookes married at Stoke Prior. (The bride was sister of Edward Cookes who became Caslon's master).

1676 Elizabeth Carpenter and John Lea married at Halesowen. (John Lea was of the family of Halesowen Grange and was friend and executor of the type-founder's grandfather).

1676 Elizabeth, daughter of William Shenstone and Elizabeth (née Pearman) of Illey baptised (the future wife of Edward Cookes, William Caslon's master).

1683 Edward Cookes apprenticed to his cousin, Adam Bell, citizen and loriner, both formerly of Stoke Prior.

May, 1684 John 'Bascorvile' and Sarah Whitefoot married. (The first marriage at Halesowen of the father of the Birmingham printer, not previously recorded).

1686 Thomas, son of William Shenstone and Elizabeth, of Illey, baptised (the father of the future poet).

17 April, 1688 George Caslon of Hales and Mary Steven married at Rowley Regis (parents of the future typefounder).

29 June, 1688 Elenor Caseltoune buried (the typfounder's grandmother).

Nov. 1688 John Carpenter, cordwainer, calligrapher and former master of William Castledowne, buried.

29 June, 1689 Sarah, daughter of Thomas Pearman, butcher, of Clent, and Mary, baptised (the future wife of the typefounder).

19 Jan. 1689–90	William, child of George Casseltoune de Cradley by Mary his wife baptised.

Mar. 1689–90 William Casseltoune infant buried.

[This child was an earlier William than the typefounder and the reference to Cradley in his baptismal entry, the only such reference against any Caslon entry, has evidently given rise to the mistaken tradition that the typefounder was born at Cradley The property of William Castledowne the shoemaker was at Halesowen, his executors were of Halesowen, and the connections of the future typefounder, the Carpenters, the Shenstones, etc., were all at Halesowen, and the legend that William Caslon was a native of Cradley must, on all the evidence, be abandoned].

1690 Thomas Bray, M.A., presented to the rectory of Sheldon, Warwickshire.

6 Nov. 1692 William Milward and Alice Casseltoune married. (Grandparents of the artists, James, Amos and Benjamin Green).

Mar. 1692–3 Jonathan, son of Jonathan Carpenter and Margaret, baptised. (He became B.A. Oxon., M.A. Cantab., Vicar of Brailes and Rector of Sheldon, co. Warwick).

23 April, 1693 William, child of George Casselon by Mary his wife baptised.

[This refers to the future typefounder, correcting the accepted legend that he was born in 1692. It will thus be noted that these two, Jonathan Carpenter and William Caslon, almost the same age, were the grandsons respectively of John Carpenter the calligrapher and cordwainer, and his apprentice and relation William Castledowne of Beoley].

1694 Jonathan Carpenter, senior, a churchwarden at Halesowen.

15 April, 1696 Mary, child of George Casselon by Mary his wife baptised.

26 Sept. 1696 Edward Cookes and Elizabeth Shenstone married at Chaddesley-Corbet.

15 Oct. 1696 John Pearman, son of Nicholas Pearman of Clent, husbandman, and Sarah (née Waldron) apprenticed to Edward Cookes, citizen and loriner of London, his aunt's brother; John Pearman was cousin to Sarah Pearman who became William Caslon's wife.

16 May, 1697 Sarah, daughter of William Milward and Alice (née Casseltoune) baptised. (The future mother of the artists James, Amos and Benjamin Green).

Aug. 1697 William, son of Edward Cooke (sic) and Elizabeth of Illey, baptised at Halesowen.

Aug. 1697 John, son of Jonathan Carpenter and Margaret baptised [He became B.A. Oxon., M.A. Oxon., Curate of St. Botolph, Aldgate, London, 1721 (licensed by Bishop John Robinson, copy of licence at Sheldon). Vicar of Pagham, Sussex, 1729, Rector of Bignor, 1743. Died at the Temple, London, 1785].

1698 The Society for Promoting Christian Knowledge (S.P.C.K.) founded.

26 Nov. 1698 William Castleton de le Town buried [leaving his son George one shilling and his (George's) three children (including the future typefounder) twelve pence apiece].

1700–1701 Samuel Butler, senior, a church warden at Halesowen.

1701 Jonathan Carpenter, senior, elected a feoffee of the Free School.

1701 William Shenstone, grandfather of the poet, elected a feoffee of the Free School (signed his name by mark).

1703 Elizabeth Shenstone, née Pearman, wife of William Shenstone, of Illey, buried at Halesowen.

1703 John Pearman completed his apprenticeship but continued as a journeyman with his master Edward Cookes.

1705 William Shenstone, grandfather of the poet and father-in-law of Edward Cookes the loriner, churchwarden at Halesowen.

26 Jan. 1705–6 John Baskerville born at Sion Hill, Wolverley, co. Worcester.

17 May, 1706 William Caslon apprenticed for seven years to Edward Cookes, citizen and loriner of London. [Caslon was only 13 years of age on the 23 April before, so he completed his seven year term when only twenty years of age].

1706 Thomas Bray, D.D., rector of Sheldon, co. Warwick, founder of the S.P.C.K., presented to the perpetual curacy of St. Botolph, Aldgate, London.

1707 Edward Cookes contracts to engrave gun-locks for the Ordnance Office, Tower of London.

1708 Henry Newman of Harvard appointed Secretary of the S.P.C.K. in succession to Humphrey Wanley.

7 Mar. 1709 George Caslon, cordwainer, father of the future tyepfounder, buried at Halesowen, aged 47, leaving a widow, Mary, aged about 40. ['George Castlon de la Town' buried].

1713 Thomas Shenstone of Halesowen and Anne, daughter of William Penn of Harborough, married at Pedmore. (Parents of the poet).

May, 1713 William Caslon completed his seven-year apprenticeship to Edward Cookes, but probably continued as journeyman until 1716.

1713	Samuel Butler, senior, again a churchwarden.
12 Oct. 1714	Thomas Pearman, butcher, of Clent buried. (Father of Sarah, Caslon's first wife).
18 Nov. 1714	William, son of Thomas and Anne Shenstone 'of Lappal' baptised. (The future poet and landscape gardener).
1716	Thomas, son of William Hilliard of Newington, victualler, apprenticed to Edward Cookes.
1716	William Caslon started in business as an engraver in Vine Street, The Minories, London.
Jan. 1716–17	William Caslon contracted to engrave gun-locks for the Ordnance Office at the Tower of London.
1717	Adam Bell a Warden of the Company of Loriners.
May, 1717	Samuel Butler, junior, of Halesowen, appointed school-master at Sheldon, co. Warwick.
June, 1717	William Caslon admitted to the freedom of the City of London by apprenticeship in the Company of Loriners.
29 Aug. 1717	William Caslon, of St. Botolph, Aldgate, and Sarah Pearman of St. Michael, Rude Lane (Wood Street), London, married by Licence, at St. Peter, Cornhill.
1717	John Pearman, son of Ambrose Pearman, butcher, of Stoke Green, near Stoke Prior, apprenticed to William Caslon. (John Pearman the younger was Caslon's wife's nephew.).
1718	Joseph Halfhide, son of Edward Halfhide, yeoman, of Little Parndon, Essex, apprenticed to William Caslon, citizen and loriner.
30 June, 1719	Humphrey Coley and Mary Caslon, the typefounder's sister, married at Halesowen.
1719	William Green of Harborne and Sarah Milward of Halesowen married at St. Philip's, Birmingham. (Sarah Milward, whose mother was a Caslon, was herself an artist, and was the mother of the artists James, Amos and Benjamin Green).
1719	Charles, son of William and Sarah Green of Halesowen baptised. (In 1758 he was appointed Assistant Clerk and Wardrobe-Keeper at Christ's Hospital, London).
June, 1719	William Caslon completed his last known contract for gun-lock engraving for the Ordnance Office at the Tower of London.
Mar-June, 1720	The S.P.C.K. resolved, after consideration of a letter from Salomon Negri, submitted by A. W. Boehm, to print the Psalter and New Testament in Arabic for the use of the Christians in Eastern Countries.
23 June, 1720	William Caslon II baptised at St. Botolph, Aldgate, as son of William and Sarah Caslon of Vine Street.

452

1720	William Caslon now known to the principal London printers and booksellers as a bookbinders' punch-cutter and letter engraver.
1720	John Pearman the elder, former apprentice of Edward Cookes, started in business in Little Minories, became attached to Trinity Minories Church, and took his first apprentice, Edward Hawes, son of Edward Hawes, citizen and founder.
Oct. 1720	The S.P.C.K. considered estimates for the Psalter and New Testament in Arabic.
1 Jan. 1721	Thomas Walker, M.A., Vicar of Clent, died.
22 Feb. 1721	John Carpenter of Halesowen licensed to the curacy of St. Botolph, Aldgate.
Easter 1721	Jonathan Carpenter of Halesowen presented to the curacy of Sheldon, co. Warwick.
1721	Jonathan Carpenter of Halesowen, and Agnes, daughter of Thomas Bray, D.D., rector of Shelson, perpetual curate of St. Botolph, founder of the S.P.C.K., marr. (Place not known).
1721	Josiah, son of William and Sarah Green of Halesowen baptised. (Josiah Green became a saddler, was a churchwarden 1760–1, and a feoffee of the Free School in 1767).
4 Oct. 1721	William Green, father of the artists, appointed usher of Halesowen Free School.
6 Mar. 1721–2	The S.P.C.K. met to consider means of reducing the cost of the Arabic Psalter and New Testament.
22 Mar. 1721–2	The S.P.C.K. considered a specimen of a smaller Arabic character submitted by Rev. Richard Mayo, chaplain of St. Thomas's Hospital.
6 May, 1721	Henry Newman, Secretary, and the S.P.C.K. Committee showed interest in Thomas Guy's charities.
12 June, 1721	The S.P.C.K., on Thomas Guy's recommendation, decided to interview William Caslon concerning the cutting of a new fount of Arabic.
18 June, 1721	The S.P.C.K. Committee and Salomon Negri interviewed Caslon 'the letter engraver' and called upon him to submit a specimen of Arabic letters, which was made and produced on 3 July to the satisfaction of Salomon Negri, and Caslon was engaged to cut the whole fount of Arabic.
1721	Thomas Hollis, citizen and draper, a cutler trading at the Cross Daggers in Little Minories, later of Goodman's Fields, a benefactor to St. Thomas's Hospital, friend and later executor to Thomas Guy, and a friend of Henry Newman, endowed the first professorship at Harvard College, Cambridge, Mass.

1722	William Bowyer the elder took his son William Bowyer, 'the learned printer', into partnership.
June, 1722	John Carpenter de Town—clerk, buried at Halesowen. (Vicar of Broxted aud Rector of Checkney; his son John succeeded him).
25 July, 1722	Joseph, son of Thomas and Anne Shenstone, Langley, baptised. (Brother of the poet).
31 Aug. 1722	Mary, daughter of William and Sarah Caslon of Vine Street, baptised at St. Botolph's Aldgate.
22 Jan. 1722–3	William Caslon requested and was granted 20 Guineas by the S.P.C.K. for necessary tools for his foundry and to enable him to complete the fount of Arabic.
1723	William, son of William and Sarah Green of Halesowen baptised. (He became a Collector of Excise at Lichfield and died in 1802).
Jan. 1723–4	John, son of William and Sarah Caslon of Vine Street baptised at St. Botolph's, Aldgate, and buried the same month.
Mar. 1723–4	The Arabic fount completed and cast by Caslon.
1723–4	Thomas Shenstone a churchwarden at Halesowen. (Father of the poet).
1724	Thomas Shenstone elected a Feoffee of the Free School.
1724	Thomas Shenstone 'of Lappal' buried at Halesowen.
1724	Agnes, wife of Jonathan Carpenter, curate of Sheldon and vicar of Brailes, co. Warwick, buried at Sheldon.
1724	John Pearman the younger completed his apprenticeship to Caslon and set up in business as an engraver in Haydon Square, Minories.
1724	Edward Cookes renewed his gun-lock engraving for the Board of Ordnance, and continued until 1734.
27 Dec. 1724	Thomas Guy, benefactor to St. Thomas's Hospital, founder of Guy's Hospital, and one of Caslon's patrons, died.
1725	The Arabic Psalter appeared, printed by Samuel Palmer in type cut and cast by William Caslon.
1725	William Caslon established his first foundry, distinct from his engraving business, in Helmet Row, Old Street, financed, so far as is known, by his three patrons William Bowyer, John Watts and James Bettenham.
1725	Thomas Hollis, cutler, of Mansel Street, Goodman's Fields, endowed a second professorial chair at Harvard College.
1725	Joseph Halfhide completed his apprenticeship to Caslon and set up in business as an engraver in Vine Street, probably in the premises vacated by Caslon.

1725 Caslon's Pica roman appeared in the 'Anacreon', printed by William Bowyer.

1726 Caslon's Hebrew (without points) appeared in Dr. David Wilkins' edition of the works of John Selden, begun in 1722 and published in 1725–6.

1726 John Carey, son of John Carey deceased apprenticed to Joseph Halfhide, engraver and loriner.

April, 1726 Adam Bell, former master of Edward Cookes, buried at Stoke Newington.

April, 1726 Jonathan Carpenter, father of the brother-clerics, Jonathan and John, buried at Halesowen.

1727 John Pearman a churchwarden at Trinity Minories Church, London.

1727 Thomas Caslon, son of William and Sarah Caslon born. (His baptismal entry has not been found, but has been deduced from the Caslon memorial at St. Luke's, Old Street, Middlesex).

1727 The Arabic New Testament appeared, printed by Samuel Palmer in Caslon's English Arabic type.

1727 William Caslon removed his foundry to Ironmonger Row, at that time in the parish of St. Giles, Cripplegate, and here he began his famous concerts.

1727 William Caslon, having successfully established his foundry, possibly now took an apprentice named Dummer, related to Jeremiah Dummer, Colonial Agent for Massachusetts, at the request of Henry Newman, Secretary of the S.P.C.K. and Colonial Agent for New Hampshire.

1727 John, son of William and Sarah Green of Halesowen baptised. (John Green died in early manhood).

11 Aug. 1727 William Shenstone, senior, of Lappal, buried. (Grandfather of the poet).

1728 Caslon's English roman, without the italic, first appeared in print.

1728 Caslon's English roman and italic appeared together in print the same year.

16 Nov. 1728 William Caslon's first wife, Sarah Pearman, buried at St. Leonard's, Clent, as 'Sarah Castleton'.

1729 James, son of William and Sarah Green of Halesowen baptised. (He became engraver to the University of Oxford and to the Society of Antiquaries, dying at Oxford in 1759 in his thirtieth year).

1729 Thomas Bray, D.D., resigned the rectory of Sheldon and Jonathan Carpenter, M.A., of Halesowen, was presented to the living.

455

Sept. 1729	William Caslon and Elizabeth Long married at St. Giles', Cripplegate, by the Bishop of London. (Dr. Edmund Gibson). (Caslon's second marriage).
Jan. 1729–30	Mary Williams of 'Bleak-fryers, London', buried at Halesowen.
15 Feb. 1729–30	Thomas Bray, D.D., founder of the S.P.C.K., died.
7 Sept. 1730	Joseph, son of 'William Caslon, letter-founder', and Elizabeth baptised at St. Giles', Cripplegate. (The child died of convulsions on 6 October).
1730	By this time Caslon had already eclipsed most competitors, had introduced his founts into the chief printing houses of the metropolis and had secured the custom of the King's printers (John Baskett) to the exclusion of all others.
21 Jan. 1730–31	Thomas Hollis, cutler of Goodman's Fields, benefactor to Harvard College and to Trinity Minories church, an executor to Thomas Guy and a governor of Guy's Hospital, died.
1731	Sarah, daughter of William and Sarah Green of Halesowen baptised.
1731	Caslon's Pica Coptic and Small Pica roman appeared in print.
27 Aug. 1731	Ann, daughter of 'William Caslon loriner' and Elizabeth baptised at St. Giles, Cripplegate.
18 June, 1732	Mrs. Anne Shenstone, widow 'of Lappull', buried at Halesowen. (Mother of the poet).
16 Oct. 1732	Frances, daughter of 'William Loriner' (sic) and Elizabeth baptised at St. Giles, Cripplegate. [No children of Caslon's second marriage appear to have survived. In 1732 that part of the parish in which Caslon lived was detached from St. Giles, Cripplegate, and became St. Luke, Old Street, the records for which for the first eleven years appear to be missing].
1732	Caslon's Great Primer and Double Pica appeared in print.
Oct. 1733	Earliest comparison of Caslon with the Dutch type-founders and printers, the Elzevirs. (In a letter of Henry Newman's to Harvard).
1727–34	Caslon's other founts cut not later than 1734 included Titlings, several designs of printers' ornaments, several sizes of roman and italic, two sizes of Saxon, two sizes of Black, Gothic, Coptic, Armenian, Samaritan (ascribed to Dummer) two sizes of Hebrew with points and several Greeks, an astonishing output.
1734	Samuel Caslon and Elizabeth Higginson married at St Paul's, Covent Garden, London. (Samuel was William Caslon's cousin).

456

1734　Caslon's first specimen, displaying thirty-eight founts, all except three cut by Caslon himself, issued from Ironmonger Row.

1734　Amos, son of William and Sarah Green of Halesowen baptised. (Amos Green became freelance artist, painter in oils and water-colours, collaborator with George Stubbs, friend of Matthew Boulton, and died in 1807.

1736　Harry, son of William and Sarah Green of Halesowen baptised. (Harry Green became an iron merchant in Birmingham, churchwarden at Halesowen 1781–2 and in 1787, a feoffee of the Free School 1789, and died in 1803).

1737　William Caslon removed his foundry to Chiswell Street, where he installed an organ in his concert room.

22 Dec. 1737　William Bowyer the elder, Caslon's patron, died and was buried at Low Leyton, Essex.

1738　Caslon's first specimen re-issued as an inset plate in the second edition of Ephraim Chamber's 'Cyclopaedia'.

1739　Benjamin, son of William and Sarah Green of Halesowen baptised. (Benjamin Green became a painter and engraver, was a prolific worker and was Drawing-Master at Christ's Hospital, London, from 1766 until his death in 1798).

1739　John Carpenter, B.A., formerly of Halesowen, rector of Checkney, Essex, died.

1739　William Caslon added to his stock of matrices by purchasing half of Mitchell's foundry.

19 May, 1739　Jeremiah Dummer, formerly Colonial Agent for Massachusetts Bay in New England, died at Plaistow and was buried at West Ham.

Aug. 1739　Edward Cookes, citizen and loriner and engraver, of St. Mary's, Whitechapel, the former master of John Pearman the elder and of William Caslon, buried.

June, 1741　William Caslon II came of age.

1741　William Shenstone the poet and Samuel Butler elected feoffees of Halesowen Free School.

9 July, 1741　William Caslon of St. Luke's, Middlesex, widower, and Elizabeth Warter, of St. James's, Clerkenwell, spinster, married at Lincoln's Inn Chapel. (Caslon's third marriage).

1742　William Caslon took his son William Caslon II into partnership and the firm became 'William Caslon & Son'.

1742　The Caslons issued a second specimen sheet in which twelve of the specimens were signed 'W. Caslon junior sculp.'

18 April, 1743　Elizabeth, daughter of Samuel Caslon, cutler, and Elizabeth baptised at St. Luke, Old Street, Middlesex.

457

15 June, 1743	Henry Newman, Secretary of the S.P.C.K. from 1708, died and was buried at St. Andrew, Holborn.
1746	James Green, 17 years of age, an apprentice of Isaac Basire the map-engraver, published an engraving of the South-East Prospect of Halesowen Church, inscribed to Sir Thomas Lyttelton.
9 Feb. 1747–8	Mary Caslon, spinster, of St. Luke, aged 22, and Godfrey Shewell, of same, bachelor, 28, married by Licence. [Godfrey Shewell was one of the original partners in Whitbread's brewery. His brother Thomas Shewell became partner to Thomas Longman the publisher in 1746, but in 1747 Thomas Shewell disappeared from view and there is then no further record of him. (The House of Longman, 1724–1800). It was probably this connection which gave rise to the legend that William Caslon's second wife was Elizabeth Longman; her name was, however, Elizabeth Long. After Godfrey Shewell's death, Mary (Polly) Caslon married Thomas Hanbey, a wealthy ironmonger].
1748	William Caslon and Son issued a specimen containing thirty-three founts of learned types, of which fourteen were signed 'W. Caslon Junior Sculp.'
1748	Amos Green apprenticed to John Baskerville, the japanner of Birmingham.
1750	William Green, usher of the Free School, a church-warden at Halesowen.
1750	William Arch Lea, son of Benjamin Lea, master of Halesowen Free School matriculated at All Souls' College, Oxford, July, 1750, graduated B.A. 1754, became chaplain in R.N., and later curate of Frankley and St. Kenelm's Chapels and died in 1802.
1750	James Green, son of the usher of the Free School, settled at Oxford, engraving a new map of the University and City, the Oxford Almanacks from 1752 to 1759, etc.
1750	William Caslon appointed a Justice of the Peace for Middlesex.
June, 1750	The Universal Magazine published an article on Letter-founding, accompanied by an illustration purporting to represent the interior of Caslon's foundry.
1750	Edward Rowe Mores graduated B.A. at Queen's College, Oxford, proceeding M.A. 1753. (He became a founder of the Society of Antiquaries and the author of 'A Dissertation upon English Typographical Founders and Founderies', 1778).

458

25 June, 1751 William Caslon, Junr., of St. Luke, Middlesex, and Elizabeth Cartlich of St. Michael, Bassishaw, London, married by Licence at St. Mary le Bowe, London.

1751 Edward Rowe Mores first commissioned James Green to illustrate his antiquarian researches at Oxford.

1 Dec. 1751 Joseph Shenstone buried at Halesowen. (Brother of the poet, an attorney at Bridgenorth, but had never practised).

circa 1752 John Baskerville began his typefounding and printing enterprise, employing a punch-cutter named John Handy.

1753 George Anderton of Birmingham printed a small specimen of Great Primer roman and italic, employing Samuel Caslon as his mould-maker.

1753 William Caslon, still known as Castleton in his own district, subscribed twenty guineas to William Shenstone's subscription list for two additional bells for Halesowen Church.

1753 Benjamin Green became a pupil of his brother James at Oxford and the two continued to execute drawings and line engravings for Edward Rowe Mores and others.

28 Feb. 1754 William Green buried at Halesowen, aged 57. (Maltster, innkeeper, usher of the Free School, and father of the artists James, Amos and Benjamin).

circa 1755 Amos Green completed his apprenticeship to Baskerville and about 1757 joined his brother Harry in the iron trade in Birmingham, but continued as an amateur artist.

1756 Henrietta Knight, Lady Luxborough, correspondent of William Shenstone, died.

1756 James Green appointed engraver to the University of Oxford.

1757 James Green appointed engraver to the Society of Antiquaries.

1757 William Caslon and Son discharged Thomas Cottrell and Joseph Jackson from their employment, following a dispute over pay. Both subsequently set up in business for themselves as typefounders.

1757 Edward Cookes apprenticed to Charles Gardner, Gunmaker in London. (His father, Edward Cookes was a loriner by patrimony and was named in the will of William Shenstone as 'my Dear Cousin Edward Cooks of Edinburgh').

1758 Baskerville's adopted daughter Mary Eaves and her cousin Edward Ruston married at Handsworth, Amos Green being a witness.

1758 Charles Green appointed Assistant Clerk and Wardrobe-Keeper at Christ's Hospital, London.

459

1758 John Baskerville paid tribute to Caslon's genius in the preface to his edition of Milton's 'Paradise Lost'.

Jan. 1759 James Green buried at Oxford.

1760 Amos Green appointed companion, art tutor and general factotum in the household of Anthony Deane, junior, of Hagley, the son of Anthony Deane of Whittington Slitting Mill, and remained with the Deane family at East Bergholt, Suffolk, in London, and at Bath until Green's marriage, at 62 years of age, in 1796.

1762 Benjamin Green appointed assistant to Thomas Bisse, Drawing-Master at Christ's Hospital, London.

11 Feb. 1763 William Shenstone, poet, letter-writer, landscape gardener, and correspondent of Henrietta, Lady Luxborough, of 'The Leasowes', Halesowen, died, and was buried 15 February at Halesowen.

1763 William Caslon and Son issued a further specimen in book form.

1764 William Caslon and Son issued yet another specimen book displaying more than twice as many founts as in 1734, many of them by William Caslon II.

July, 1765 Edward Cookes "from Birmingham" buried at Halesowen (identical with "my Dear Cousin Edward Cooks of Edinburgh" mentioned in Shenstone's Will).

23 Jan. 1766 William Caslon died at his country house at Bethnal Green at the age of 72 (not 74 as on the family memorial) and was buried in the churchyard of St. Luke's, Old Street, Middlesex.

31 Jan. 1766 Benjamin Green appointed Drawing-Master at Christ's Hospital, London, in succession to Thomas Bisse, deceased.

8 Jan. 1775 John Baskerville died at Easy Hill, Birmingham, and was buried privately in his own grounds.

18 Nov. 1777 William Bowyer, 'the learned printer' died, and was buried in the family vault at Low Leyton, Essex.

17 Aug. 1778 William Caslon II died and was buried in the family vault in the churchyard of St. Luke, Old Street, Middlesex.

30 Oct. 1778 Charles Green of Christ's Hospital was buried at Halesowen.

28 Nov. 1778 Edward Rowe Mores died at Low Leyton, and was buried at Walthamstow.

29 Mar. 1783 Thomas Caslon, son of William Caslon I, died and was buried in the family vault in St. Luke's churchyard. (He was a bookseller in Stationers' Hall Court and served the office of Master of the Stationers' Company in 1782).

May, 1785 John Carpenter, M.A., the younger, formerly of Halesowen, vicar of Pagham and rector of Bignor, Sussex, died

at the Temple, London, aged 87, and was buried at St. Marylebone. His will witnessed in Kentish Town in the parish of St. Pancras 1 May, 1779.

9 Jan. 1788 Mrs. Sarah Green, widow, buried at Halesowen, aged 90, as 'the oldest inhabitant', (mother of the artists James, Amos and Benjamin Green), and first cousin to William Caslon).

Bibliography

This bibliography includes all books, broadsheets, printed matter and manuscripts used in the compilation of this work. Works from which the title-pages or other pages have been used for purposes of illustration are not included unless they have been otherwise quoted in the text.

Reference Books, Diaries, Institutional and General History

E. Chambers	— Cyclopaedia: or, An Universal Dictionary of Arts and Sciences, 2 vols. fol., 5th Ed. Vol. I, 1741, Vol.II, 1743
- - -	— Encyclopaedia Britannica, 1949 edition
Malachy Postlethwayt	— The Universal Dictionary of Trade & Commerce, from the French of Mons. Savary, 2 Vols. fol., 1751
- - -	— Biographia Britannica, 1760
- - -	— The Dictionary of National Biography, Edited by Sir Leslie Stephen and Sir Sydney Lee
A.M. Hyamson	— A Dictionary of Universal Biography, 1916
Joseph Foster	— Alumni Oxonienses, 1500-1886 (1891-2)
John and J.A. Venn	— Alumni Cantabrigienses, 1500-1900
Col. J.L Chester	— London Marriage Licences (1581-1869). Edited Joseph Foster, 1887
William Munk	— The Roll of the Royal College of Physicians of London, 2 vols., 1861
Rev. Geo. Hennessy	— London Diocesan Clergy Succession, 1898
Burke	— Dormant & Extinct Peerages, 1883, New Edition
Burke	— Royal Descents & Pedigrees of Founders' kin, 1847
Burke and L.G. Pine	— Burke's Landed Gentry, 1 vol., 1952
Benjamin Golding	— An Historical Account of St. Thomas's Hospital, Southwark, 1819
Bettany and Wilks	— Biographical History of Guy's Hospital, 1892

Arthur Merlott Chitty Donated to Soc. of Genealogists	— Typescript on Thomas Guy of Heckfield co., Southampton, and Thomas Guy, Founder of Guy's Hospital, 1947
Joan Evans	— A History of the Society of Antiquaries, 1956.
Sir Michael McDonnell	— The Annals of St. Paul's School, 1959
Rev. William Trollope	— A History of the Royal Foundation of Christ's Hospital, 1834
E.H. Pearce	— Annals of Christ's Hospital, 1908
Edmund Blunden	— Christ's Hospital — A Retrospect
Hamish Hamilton	— The Christ's Hospital Book, 1953 (For a Committee of Old Blues)
Barker & Stenning	— The Record of Old Westminsters, 2 vols. and Suppl., 1928
Wm. H. Brown	— Charterhouse Past and Present, 1879
Gerald S. Davies	— Charterhouse in London, 1921
Rev. C.J. Robinson	— Register of Scholars of Merchant Taylors' School, 1562-1874, 2 vols., 1882
Douglas Macleane	— History of Pembroke College, Oxford, 1897.
Bishop Burnet	— History of his own Time, 4 vols, 1818
Brian FitzGerald	— Daniel Defoe — A study in Conflict, 1954
Edit. by J.S. Keltie	— The Works of Daniel Defoe with Chalmers' Life of the Author, 1883
J.H. Plumb	— England in the Eighteenth Century (1714- 1815), 1955
G.M. Trevelyan	— History of England, 1929
G.M. Trevelyan	— English Social History, 1946
E.N. Williams	— Life in Georgian England, 1962
J.R. Green	— A Short History of the English People, 1892
Lord Mahon	— History of England from the Peace of Utrecht to the Peace of Aix-la-Chapelle, 2 vols, 1841
H. de B. Gibbins	— The Industrial History of England
William Bray and H.B, Wheatley	— Diary of John Evelyn, Esq., 4 vols, (1879)
H.B. Wheatley edit.	— The Diary of Samuel Pepys (with Lord Braybrooke's Notes) with Index and Volume of Pepysiana, 10 vols, 1920
J.R. Tanner edit.	— Private Correspondence, etc., of Samuel Pepys, 2 vols, 1926
H.B. Wheatley	— Samuel Pepys and the World he lived in, 1889
Celia Fiennes	— Through England on a Side-saddle in the time of William and Mary, 1888
James Boswell	— Life of Johnson
W.T. Franklin	— The Private Correspondence of Benjamin Franklin, 1817

George Carter	— Outlines of English History
S.J. Low and F.S. Pulling	— Dictionary of English History, 1889
John Bacon	— Thesaurus Rerum Ecclesiasticarum, 1786

Annuals and Magazines

The Annals of King George, Year the Second, (1716), Containing a list of those appointed to administer the Oath of Abjuration in the several Wards of the City	
The Present State of the British Court, or an Account of the Civil & Military Establishment of England, 1720	
John Chamberlayne	— Magnae Britanniae Notitia: Or, the Present State of Great Britain, 1735
The Gentleman's Magazine	— Passim
The London Magazine	— Passim

London Records and Topography

John Stow	— A Survay of London, 1598, edit. by Henry Morley
John Strype	— Stow's Survey of London, 5th edit. 2 vols, 1720
William Maitland	— The History of London, folio, 1739
William Maitland	— The History of London, 2 vols, fol., 1756
John Timbs	— Curiosities of London, 1868
William Kent	— An Encyclopaedia of London, 1951
R & J. Dodsley	— London and Its Environs Described, 6 vols, 1761
Charles Welch	— History of the Monument, 1893
John Camden Hotten	— The Little London Directory of 1677
John Timbs	— Clubs and Club Life in London, 2 vols, 1872
Edward Ward	— The London Spy, 1703
John Kennedy	— History of the Parish of Leyton, 1894
Rev. Daniel Lysons	— The Environs of London, 5 vols. 1792-1800 and Supplement, 1811
Thomas Pennant	— Of London, 1790
Rev. W. Denton	— Records of St. Giles', Cripplegate, 1883
Rev. Canon Thompson	— History and Antiquities of the Collegiate Church of St. Saviour (St. Marie Overie) Southwark, 1904
William McMurray	— The Records of Two City Parishes, SS. Anne and Agnes, Aldersgate, and St. John Zachary, London, 1925
A.E. Daniell	— London City Churches, 1907
T.F. Bumpus	— Ancient London Churches
Margaret E. Tabor	— The City Churches, 1917
W.G. Bell	— Unknown London, 1920
E. Beresford Chancellor	— The Annals of Fleet Street, 1912
E. Beresford Chancellor	— The Eighteenth Century in London, 1920

Warwick Wroth and A.E. Wroth	— The London Pleasure Gardens of the Eighteenth Century, 1896
Tom Taylor	— Leicester Square, Its Associations and Worthies, 1874
F.G.H. Price	— Temple Bar, or Some Account of 'Ye Marigold' No.1 Fleet Street, 1875
C.W. Heckethorn	— Lincoln's Inn Fields and the Localities Adjacent 1896
Malcolm T. Salaman	— London Past & Present 'The Studio Ltd', 1916

The Tower of London

John Bayley	— The History and Antiquities of the Tower of London, 2 vols, 1821
William H. Dixon	— Her Majesty's Tower, 2 vols, 1869
J.C. Fox, edit, for the Royal Historical Society	— The Official Diary of Lieut-General Adam Williamson, Deputy-Lieut. of the Tower of London, 1722-1747. Camden Third Series, vol. 22, 1912

The London City Companies

Bryan Pontifex	— The City of London Livery Companies, 1939
J.L. Green	— The Rural Industries of England, circa 1880
W.A.D. Englefield	— The History of the Painter-Stainers' Company of London, 1923
Arthur Adams	— The History of the Worshipful Company of Blacksmiths, 1951
J. Aubrey Rees	— The Worshipful Company of Grocers, 1923
Col. R.J. Blackham	— London's Livery Companies, N.D.

Cartography of London, England and Wales

John Ogilby	— Britannia, Volume the First: Or, An Illustration of the Kingdom of England and Dominion of Wales, 1675 (Facsimile by Alexander Duckham and Co; Ltd., 1939)
J. Bartholomew	— The Survey Gazetteer of the British Isles
W. & A. K. Johnston	— Road Atlas of Great Britain, 3 miles to the inch
W. Crawford Snowdon	— London 200 years ago. Circa 1927 (Compiled from John Rocque's map of 1746)
G. E. Mitton edit.	— Maps of Old London, A & C Black, 1908

The S. P. C. K., Christian Missions and The Arabic N. T.

Propagation of the Gospel in the East	— An Account of the Success of Two Danish Missionaries sent to the East-Indies for the Conversion of the Heathens in Malabar. Printed and Sold by Joseph Downing in Bartholomew Close near West-Smithfield, 1718, 3rd Edition

465

Rev. T. T. Carter	— The Life and Times of John Kettlewell with the History of the Nonjurors, 1895
W. O. B. Allen and Edmund McClure	— Two Hundred Years: The History of the Society for Promoting Christian Knowledge, 1898
W. K. Lowther Clarke	— A History of the S. P. C. K., 1959
Leonard W. Cowie	— Henry Newman, An American in London, 1708-1743. 1956
H. P. Thompson	— Thomas Bray. 1954
William Cathrall	— The History of Oswestry, 1855
Printed and Published by William Price	— The History of Oswestry, 1815
E. H. Pearce	— Sion College and Library, 1913
G. A. Freylinghausen (copy at The London Library)	— Memoria Nigriniana hoc est Salomonis Negri Damasceni vita, olim ab ipsomet conscripta nunc autem accessionibus quibusdam illustrata & c. Halae Salicae Impensis Orphanotrophei, 1764
C. H. Crouch: Donated to Soc. of Genealogists	— Typescript on Jeremiah Drummer of New England, London agent for Massachusetts Bay
British and Foreign Bible Society	— The Gospel in Many Tongues, 1890

Writing and Writing-Masters

Wolffgang Fugger	— Handwriting Manual (Facsimile of 1553 edition: Lion & Unicorn Press, 1955)
John Seddon	— The Penman's Paradise both Pleasant and Profitable, 1694-5
George Shelley	— The Second Part of Natural Writing, 1714
George Bickham	— The Universal Penman, 1743 (Facsimile Edition, 1941)
William Massey	— The Origin and Progress of Letters, 1763
Andrew Wright	— Court Hand Restored, 1776
Thomas Astle	— The Origin and Progress of Writing, 1784
Vere Foster	— Copy Book of Plain and Ornamental Lettering, N.D.
Hilary Jenkinson	— Palaeography and the Practical Study of Court Hand, 1915
Charles Johnson & Hilary Jenkinson	— English Court Hand, Parts I & II, 1915
Lewis F. Day	— Alphabets Old and New, 1898
Edward Johnston	— Writing and Illuminating and Lettering, 1908
Alfred Fairbank	— A Book of Scripts, 1949 (King Penguin)
Wilfrid Blunt	— Sweet Roman Hand, 1952

466

Ambrose Heal	— The English Writing-Masters and their Copy Books, 1570-1800. 1962 (A reprint of the London edition of 1931).

Letter Founding, Printing, and the Book Trade

William Blades	— The Biography and Typography of William Caxton, 1897
Henry R. Plomer	— Wynkyn de Worde and his Contemporaries, 1925
William Blades	— The Pentateuch of Printing with a Chapter on Judges, with a Memoir of the Author and list of his Works by Talbot B. Reed, 1891
Talbot Baines Reed revised and enlarged by A. F. Johnson	— A History of the Old English Letter Foundries, 1952
Daniel B. Updike	— Printing Types, Their History, Forms and Use, Second Edition, 2 vols, 1937
Edward Rowe Mores	— A Dissertation upon English Typographical Founders & Founderies (1778): Edited with an Introduction and Notes by Harry Carter and Christopher Ricks, 1961
Joseph Moxon	— Mechanick Exercises on the whole Art of Printing (1683–4). Edited by Herbert Davis and Harry Carter, 1962
Stanley Morison	— Four Centuries of Fine Printing, 1949
Stanley Morison	— Type Designs of the Past and Present, The Fleuron Ltd., 1926
Stanley Morison	— A Review of Recent Typography, The Fleuron Ltd., 1927
T. F. Dibdin	— The Bibliographical Decameron, 3 vols., 1817
T. F. Dibdin	— Introduction to the Knowledge of the rare and valuable editions of the Greek & Latin Classics, etc., 2 vols., 1827
Christopher Anderson	— The Annals of the English Bible, 2 vols., 1845
Henry Cotton	— Editions of the Bible and Parts thereof in English, 1852
Henry Stevens	— The Bibles in the Caxton Exhibition, 1877, London, 1878
John Dunton	— Life and Errors, 1705
John Nichols	— Biographical and Literary Anecdotes of William Bowyer, Printer, 1782
John Nichols	— Literary Anecdotes of the Eighteenth Century 9 vols., 1812–15
John Nichols	— Illustrations of the Literary History of the Eighteenth Century, 4 vols., 1817

Falconer Madan	— A Chart of Oxford Printing—Bibliographical Society Monographs, No XII, 1904
Falconer Madan	— A Brief Account of the University Press at Oxford, 1908
Falconer Madan	— Some Account of the Oxford University Press, 1468–1921: At the Clarendon Press, 1922
Henry Curwen	— A History of Booksellers, 1873
John Power	— A Handy-Book about Books, 1870
J. Larwood and J. C. Hotten	— The History of Signboards, 1866
Mason Jackson	— The Pictorial Press: Its Origin and Progress, 1885
Francis Meynell	— English Printed Books, 1946
J. Southward and A. Powell	— Practical Printing, 2 vols., 1900
R. B. McKerrow	— An Introduction to Bibliography, 1949
John P. Harthan	— Bookbindings—Victoria & Albert Museum. H.M. Stationery Office, 1950
F. Harrison	— A Book about Books, 1946
Smith and Benger	— The Oldest London Bookshop, 1928
Frank A. Mumby	— Publishing and Bookselling, 1930
Douglas C. McMurtrie	— The Book—The Story of Printing and Bookmaking, 1950
C. J. Longman & J. E. Chandler	— The House of Longman, 1724–1800. 1936
Septimus Rivington	— The Publishing House of Rivington, 1894
The Times	— The Times Literary Supplement Printing Number, October 13, 1927
The Times	— Printing in the Twentieth Century, 1930 (Reprinted from the Special Number of The Times, October 29, 1929)
The Times	— The Times Printing Number, 40,000th issue, September 10, 1912
J. B. Lieberman	— Types of Typefaces, 1967
British Standard 2961: 1967	— Typeface Nomenclature and Classification
John Milton	— 'Areopagitica' Printed for Sydney Humphries: Published by Adam & Charles Black, 1911 (A Re-issue of Milton's famous speech for the liberty of unlicenced printing, 1644, the profit from the sale of which was devoted to 'The London Library')
Henry R. Plomer	— A Dictionary of the Printers & Booksellers in England, Scotland and Ireland. Bibliographical Society: Vol. II, 1668–1725 (1922) Vol. III, 1726–1775 (1932)

468

John Pendred	— The Earliest Directory of the Book Trade, 1785: Edited by Graham Pollard: The Bibliographical Society, 1955
A. W. Pollard and G. R. Redgrave	— A Short-Title Catalogue of Books printed in England, Scotland and Ireland, and of English Books printed Abroad, 1475–1640. The Bibliographical Society, 1950
W. Turner Berry and H. Edmund Poole	— Annals of Printing, 1966
A. F. Johnson	— French Sixteenth Century Printing, 1928
A. F. Johnson	— One Hundred Title-Pages, 1500–1800, 1928
Linotype & Machinery Ltd.	— A Calendar for the Year 1923
Vincent Steer	— Printing Design and Layout, N.D.

William Caslon

J. F. McRae	— Two Centuries of Typefounding—Annals of the Letter Foundry established by William Caslon in 1720. (1920)
William Bennett	— William Caslon, 1692–1766, ornamental engraver, typefounder and music lover. City of Birmingham School of Printing, 1935
Universal Magazine of Knowledge & Pleasure London, Vol VI, June, 1750	— Article on Letter Founding with view of the interior of a letter foundry, purporting to be that of Caslon
Henry Carter	— Caslon Punches: An Interim Note. Journal of the Printing Historical Society, No. 1, 1965
The Monotype Corporation Limited	— Bill of Fare for the Luncheon on the occasion of the Annual General Meeting of the London and District Monotype Users' Association, Wednesday, 16th March, 1966, printed in Caslon type in commemoration of the bicentenary of William Caslon's death
James Mosley	— The Early Career of William Caslon. Journal of the Printing Historical Society, No. 3, 1967
H. W. Caslon & Co. Ltd. 82–83 Chiswell Street, London, E.C.1	— Caslon Old Face Roman & Italic Booklet published February, 1924

John Baskerville

Talbot Baines Reed	— John Baskerville, Printer. Transactions of the Birmingham and Midland Institute—Archaeological Section—Vol. 18, 1892
William Bennett	— John Baskerville, The Birmingham Printer, His Press, Relations, and Friends. Vol. 1, 1937, Vol. II, 1939

Thomas Cave	— John Baskerville, The Printer, 1706–1775: His Ancestry, 1936
Dr. Hans H. Bockwitz translated by Herbert Woodbine	— Baskerville in Letters, 1934
Philip Gaskell	— John Baskerville—A Bibliography. 1959

LETTER-FOUNDERS' SPECIMENS

1. A SPECIMEN (5-line Pica titling) // by WILLIAM CASLON, Letter-Founder in Chiswell-Street, LONDON. (2-line Great Primer). Watermark IDB. This specimen is from Ephraim Chambers, Cyclopaedia, 5th edition (1741–43). There is a blank space across the centre of the sheet to allow for binding in the Cyclopaedia. The date 1734 is seen at the foot of column 4.

2. A SPECIMEN//by WILLIAM CASLON, Letter-Founder, in Chiswell-Street, LONDON. No watermark. This specimen is from Ephraim Chambers, Cyclopaedia, 6th edition (1750). Printed from the same setting as (1) except that the space across the centre has been closed up. For a more precise identification of Caslon specimens see 'The Early Career of William Caslon', by James Mosley: Journal of the Printing Historical Society, No. 3, 1967.

3. A SPECIMEN (5-line Pica titling) // by WILLIAM CASLON, Letter-Founder in Chiswel (sic) -Street, LONDON. (2-line Double Pica Black). 1742. (Twelve of the specimens are by William Caslon II).

4. A SPECIMEN of Printing Types
 From the Letter Foundry of Dr. Alexander Wilson, Glasgow, 1783.

5. A SPECIMEN OF PRINTING TYPES, by Joseph Fry and Sons, Letter-Founders, Worship-Street, Moorfields, London, 1785. (Printed on both sides, thus displaying eight columns).

6. SPECIMENS OF PRINTING TYPES from STEPHENSON BLAKE THE CASLON LETTER FOUNDRY SHEFFIELD 1950

ARTISTS AND ENGRAVERS

Horace Walpole with additions by James Dalloway	— Anecdotes of Painting in England, with some Account of the Principal Artists: Wornum's Edition, 3 vols., 1876
Michael Bryan	— A Biographical and Critical Dictionary of Painters and Engravers 1849; grangerised to 3 vols.
Matthew Pilkington	— A General Dictionary of Painters, 2 vols, 1824
William T. Whitley	— Artists and their Friends in England, 1700–1799, 2 vols, 1928
R. H. Wilenski	— English Painting, 1964
Ernest H. Short	— The Painter in History, 1948

Thomas Wright	— Caricature History of the Georges, 1867
Whitman and Salaman	— Print Collector's Handbook, Revised and Enlarged, 1921
Basil Grey	— The English Print, 1937
— Burgess	— Old Prints and Engravings
Derek Hudson & K. W. Luckhurst	— The Royal Society of Arts, 1754–1954, Published 1954
Printed by order of the Society	— A List of the Society for the Encouragement of Arts, Manufacturers and Commerce, 1772
Helen M. Petter	— The Oxford Almanack, 1674–1946. New York, O.U.P. 1946
Laurence Irving	— The Affectation of Imperfection—Address to the Royal Society of Arts, March, 1964

Music Characters and Musical History

Sir John Hawkins	— The General History of the Science & Practice of Music
J. A. Fuller-Maitland	— Oxford History of Music, Vol IV, 1902
Eric Blom edit.	— Grove's Dictionary of Music and Musicians, Vol. VI, 1954
Percy A. Scholes	— The Oxford Companion to Music, 9th Edition, 1955
A. Bacharach edit.	— The Musical Companion

Halesoniana

F. and K. M. Somers	— Halas, Hales, Hales Owen, 1932
F. W. Hackwood	— Oldbury and Round About, 1915
H. Ling Roth	— Bibliography and Chronology of Hales Owen, 1887
William Harris	— The History and Antiquities of Hales-Owen, 1836
John Amphlett	— A Short History of Clent, 1907
William Timings	— A Guide to Clent Hills, 1836
William Timings	— The History and Antiquities of St. Kenelm's, 1839
I. H. Jeayes	— Catalogue of the Charters and Muniments of the Lyttelton Family at Hagley, 1893
H. M. Colvin	— The White Canons in England, 1951
James Davenport	— The Grove Family of Halesowen, 1912
R. Mountford Deeley	— A Genealogical History of Montfort-sur-Risle and Deeley of Halesowen, 1941
Hans and Lena Schwarz	— The Halesowen Story, 1955
Johnson Ball	— Catalogue of Exhibition held in 1950 illustrating the History of Halesowen
Johnson Ball	— Catalogue of 1951 Festival Exhibition of Pictures by James, Amos and Benjamin Green with Monograph of the Artists

471

Johnson Ball	— Amos and Harriet Green—Topographical painters of the late eighteenth century: Published in the Leeds Arts Calendar, No. 44, 1960, by the Libraries and Arts Sub-Committee, Temple Newsam House

Shenstoniana

William Shenstone	— The Works of, In Verse and Prose, 2 vols, 1764
Lady Luxborough	— Letters written by, to William Shenstone, 1775
Marjorie Williams	— Lady Luxborough goes to Bath, 1946
Edit. by Marjorie Williams	— The Letters of William Shenstone, 1939
Marjorie Williams	— William Shenstone—A Chapter in Eighteenth Century Taste, 1935

Birmingham History

Conrad Gill and Asa Briggs	— History of Birmingham, 2 vols. 1952
William Hutton	— An History of Birmingham, 1795
Robert K. Dent	— Old and New Birmingham, 1880
Joseph Hill and Robert K. Dent	— Memorials of the Old Square, 1897
Joseph Hill	— The Book Makers of Old Birmingham—Authors, Printers and Book-Sellers, 1907
J. Bisset	— A Poetic Survey round Birmingham, accompanied by a Magnificent Directory: 1808.
R. A. Pelham	— The Immigrant Population of Birmingham, 1686–1726. Reprinted from Trans. of the Archaeological Society, Vol. LXI. 1937. (1940)
Clive Harris edit.	— History of the Birmingham Gun-Barrel Proof House, 1949
Howard L. Blackmore	— British Military Firearms, 1650–1850. 1961

County, Local and Family History

T. R. Nash	— Collections for the History of Worcestershire 2 vols., Second Edition with Supplement, 1799
Stebbing Shaw	— History and Antiquities of Staffordshire, 2 vols., 1798–1801
William Dugdale Revised by Wm. Thomas	— The Antiquities of Warwickshire, 2 vols., 1730
R. Clutterbuck	— History and Antiquities of Hertfordshire, 3 vols., 1815–27
J. E. Cussans	— History of Hertfordshire, 3 vols., 1870–81
Edit. J. W. Willis-Bund	— The Victoria History of the County of Worcester, 4 vols. plus Index vol.
John Chambers	— Biographical Illustrations of Worcestershire, 1820
Thomas Allen	— History of the Counties of Surrey and Sussex, 2 vols., 1829

John Nichols	— The History and Antiquities of the Town and County of Leicester, 8 vols., 1815
William Pitt	— History of Staffordshire, 1817
William White	— Directory of Staffordshire, 1834 and 1851
Rupert Simms	— 'Bibliotheca Staffordiensis', 1894
W. B. Bickley	— The Register of the Guild of Knowle in the County of Warwick, 1451–1535. 1894
Andrew Yarranton	— England's Improvement by Sea and Land, 2 vols., 1677
Thomas Abingdon	— The Antiquities of the Cathedral Church of Worcester, etc., 1717
The Bromsgrove Messenger	— Notes and Queries for Bromsgrove and the district of Central Worcestershire, 4 vols., 1909–1914
Margaret Dickins	— A Thousand Years in Tardebigge, 1931
Sir Hugh Chance	— The Coxes of Clent, 1961
Mrs F. F. Milward-Oliver	— Memoirs of the Hungerford, Milward and Oliver Families. Privately printed, 1930
P. W. L. Adams	— A History of the Jukes Family, 1927
C. S. James	— The Turton Family: Reprinted from Trans. of the Birmingham Archaeological Society, Vol. 50, 1924
Gerald Lozano Read	— A Register of Reads and some Connections, Privately printed, 1937
Edmund Calamy Revised by Samuel Palmer	— The Nonconformist's Memorial, 3 vols., 1802
Daniel Neal	— The History of the Puritans, 2 vols., 1754
Samuel Smiles	— The Huguenots, 1881
Samuel Smiles	— Industrial Biography, 1863
Arthur Raistrick	— Dynasty of Iron Founders, 1953
G. Chandler and I. C. Hannah	— History of Dudley, 1949
J. R. Burton	— A History of Bewdley and some neighbouring parishes, 1883
J. R. Burton	— A History of Kidderminster and some neighbouring parishes, 1890
John S. Roper	— Dudley Probate Inventories, 1544–1603, Dudley, 1965
John S. Roper	— Stourbridge Probate Inventories, 1541–1558, Dudley, 1966
Shropshire Archaeological and Parish Register Society, 1949	— The Shropshire Hearth-Tax Roll of 1672
William Salt Archaeological Society, 1923	— Lay Subsidy 256/31 Hearth Tax, Seisdon and Offlow Hundreds, co. Stafford

H. E. Palfrey	— Foleys of Stourbridge, 1945. Reprinted from Trans. of the Worcestershire Archaeological Society for 1944
B. L .C. Johnson	— The Stour Valley Iron Industry in the late Seventeenth Century: Trans. of the Worcestershire Archaeological Society for 1950
The Herald and Genealogist, H. S. Grazebrook	— Vol. 7, p. 270. Letter to the Editor relating to the family of Pearsall, of Hawne, Halesowen. Footnote on the family of Carpenter of Stoke Prior and of Halesowen
H. S. Grazebrook	— Collections for a Genealogy of the Noble Families of Henzey, Tittery and Tyzack, 1877
H. S. Grazebrook	— The Heraldry of Worcestershire, 2 vols., 1873
J. M. Woodward	— The History of Bordesley Abbey in the valley of the Arrow, near Redditch, Worcestershire, 1866
E. A. B. Barnard	— The Sheldon Tapestry Weavers and their Work, 'Archaeologia' Vol. 78, 1928
John Humphreys	— Elizabethan Sheldon Tapestries, 1929 Reprinted from 'Archaeologia' Vol. 74
Robert Hudson	— Memorials of a Warwickshire Parish (Lapworth) 1904
Alleyn Lyell Reade	— The Reades of Blackwood Hill and Dr. Johnson's Ancestry, 1906
Richard Sims	— A Manual for the Genealogist, Topographer and Antiquary, 1888
W. E. Tate	— The Parish Chest, 1946
A. M. Burke	— The Ancient Parish Registers of England and Wales, 1908
J. C. Cox	— The Parish Registers of England, 1910
Society of Genealogists	— Catalogue of Parish Register Copies in the possession of the Society, 1963

Local Parish Registers in Print

Staffordshire Parish Register Society	— Tamworth Parish Register, 1558–1614
	— Rowley Regis Parish Register
	Vol. 1, 1539–1684
	Vol. 2, 1685–1771–2
	Vol. 3, 1772–1812
Worcestershire parish Register Society	— Over Arley Parish Register, 1564–1812
Phillimore and Carter	— Worcestershire Marriages, Vol. 1, 1901
W. F. Carter	— The Register of Aston-juxta-Birmingham, 1540–1640 (1900)

St. Peter, Cornhill	1538–1774
St. Michael, Cornhill	1546–1754
St. James, Clerkenwell	1627–1710
St. Olave, Hart Street	1563–1700
St. Matthew, Friday Street	1538–1812
St. Benet and St. Peter, Paul's Wharf	1607–1837
St. Mary-le-Bowe, Cheapside	1538–1852
St. Nicholas Acons	1539–1812
St. Paul Covent Garden	1653–1752
St. Stephen's, Walbrook and St. Benet Sherehog	1557–
St. Mary the Virgin, Aldermanbury	
St. Mary Woolnoth and	1538–1760
St. Mary Woolchurch Haw	
St. Christopher Stocks	1558–1780
St. Lawrence Jewry	1538–1812
St. Mildred, Bread Street	1558–1853
St. Vedast, Foster Lane	1558–1837
St. Dunstan in the East	1558–1654

List of Manuscript Sources
Worcester Record Office

Reference

008.7 — 19b. 1593	— Administration of Dennis Castledine of Beoley, 1593
008.7 50b. 1593	— Administration of Henry Castlone of Lapworth (with Inventory), 1593
008.7 — 1664.98	— Will of George Castledine of Beoley, 1664
Will dated 31 July, 1698, proved 28 June, 1699	— Will of William Castleton of Halesowen, co. Salop, shoemaker, 1698
008.7 — 5 Oct. 1694	— Will of John Shenstone of Halesowen, co. Salop, Yeoman, 1693
008.7 — 29 Dec. 1713	— Will of Joseph Shenstone of Illey in the parish of Halesowen, co. Salop, Yeoman, 1713
008.7 — 25 Nov. 1727	— Will of William Shenstone of Halesowen, co. Salop, 1727
008.7 — 31 July, 1732	— Certificate of guardianship of William Shenstone, signed by John Spencer and Thomas Dolman, 1732
008.7 — 1743	— Will of John Spencer of Oldswinford, co. Worcester, gentleman
008.7 — 1675. 48	— Will of Richard Pearman, of Clent, co. Stafford, Yeoman, 1675
008.7 — 30 Dec. 1714	— Will of Thomas Pearman of Hollow Cross in the parish of Clent, co. Stafford, butcher, 1714

oo8.7 — 13 June, 1724	— Will of Nicholas Pearman of Clent, co. Stafford, Yeoman, made 5 January, 1722–3
oo8.7 — 6 Feb. 1720	— Will of Thomas Walker, Vicar of Clent, made 2 March, 1719

Testamentary evidence from the Principal Probate Registry, Somerset House

P.C.C.66. Plymouth	— Abstract of Will of Adam Bell, citizen & loriner, made 2 March, 1715–16; proved 15 April, 1726
P.C.C.175. Henchman	— Abstract of Will of Edward Cookes, citizen and loriner and engraver, made 23 June, 1739; proved 29 August, 1739
Photostat Copy	— Will of William Caslon of Bethnal Green in the County of Middlesex, Esquire, made 22 January, 1766, proved 31 January, 1766

Other Manuscript Sources

The Palfrey Collection (now at Worcester Record Office — copy by the writer)	— 'An assessment then made in the purshute of an act of parlement for granting to his Majestey King George severall rates or duties upon houses for mackeing good ye deficiency of ye Clipped money' 1721 Cradley, Frankley & Hagley Window Tax
The Palfrey Collection (copy by the writer)	— 'A copy of the Poll for the County of Worcester 20 May, 1741, between Edmund Lechmere, Esq., Edmund Pytts, Esq., Lord Deerhurst, and George Lyttelton, Esq., Candidates for Knights of the said County'
Extracts by the writer (By courtesy of C. Emmott, B.Litt., Headmaster of Halesowen Grammar School)	— 'The Booke for the Accounts of the Rents and Revenewes belonginge to the ffree schole there lately setled and of stock of money gyven and to be gyven for the mayntenace thereof and of other Charytable and pyous works in the pishe of Halesowen aforesaid'
Extracts by the writer (By courtesy of the Rector)	— The Parish Registers of Halesowen. (Approximately two-thirds of the entries between 1653 and 1761)
Transcript by the writer (By conrtesy of the vicar)	— The Parish Registers of Clent (Transcribed completely from 1561 to 1812)
Transcript by the writer (By courtesy of the vicar)	— The Parish Registers of Kinver (Transcribed completely from 1560 to 1649, together with all marriages 1653–1754, and selected baptisms and burials, 1653–1775)

Partial transcript. Copied by courtesy of Mr H. J. Haden from one made by A. A. Rollason & F. A. Homer	— The Parish Registers of Oldswinford 1602–1852
Transcript by the writer	— Oldswinford Marriages, 1602–1692
The Palfrey Collection (now at Worcester Record Office—Copy by the writer	— The Parish Registers of Kingswinford—A partial transcript, 1651–1811, made by A. A. Rollason
The Palfrey Collection (now at Worcester Record Office—Copy by the writer)	— Index to the Parish Registers of Hagley, 1538–1889, made by W. Wickham King
The Palfrey Collection (now at Worcester Record Office—Copy by the writer)	— Index to the Parish Registers of Pedmore, 1539–1886, made by W. Wickham King
Extracts by the writer	— The Parish Registers of Harborne, 1538–1766. Photostat copy at Birmingham Reference Library
Extracts by the writer	— The Parish Registers of St. Martin's in the Bull-Ring, Birmingham, 1554–1708, by Joseph Hill & W. B. Bickley
Extracts by the writer	— The Parish Registers of Hampton-in-Arden, co. Warwicks., 1600–1730. Typescript copy at Birmingham Reference Library
Extracts by the writer	— The Parish Registers of Beoley, co. Worcester, 1566–1730
Extracts by the writer	— Stoke Prior, co. Worcester. M.S. Index and transcript at Worcester Record Office, 1615–1709
Extracts by the writer	— Chaddesley-Corbett, co. Worcester. Bishops' transcripts at Worcester Record Office
Extracts by the writer	— Tardebigge, co. Worcester. Bishops' transcripts at W.R.O., 1639–1705
Extracts by the writer	— Alvechurch, co. Worcester. Bishops' transcripts at W.R.O., 1662–1700
Extracts by the writer	— Frankley, co. Worcester. Bishops' transcripts at W.R.O., 1615–1700
Extracts by the writer	— Belbroughton, co. Worcester. Bishops' transcripts at W.R.O., 1627–1689
Extracts by the writer	— Stone, co. Worcester. Bishops' transcripts at W.R.O., 1625–1700
Extracts by the writer	— Wolverley, co. Worcester. Bishops' transcripts at W.R.O., 1611–1700

Extracts by the writer (By courtesy of the Head- master, L. W. Sheppard, M.A.)	— Oldswinford Hospital. (a) Admissions & Bindings Register; (b) Minute Books of the Feoffees
Society of Genealogists Extracts by the writer	— St. Botolph without Aldersgate Marriages, 1640–1755, in MS.

Index

484

INDEX OF PLACE NAMES

INDEX OF SUBJECTS

494